British Painting

in the Philadelphia Museum of Art

THIS PUBLICATION WAS SUPPORTED BY
GRANTS FROM THE NATIONAL ENDOWMENT
FOR THE ARTS, A FEDERAL AGENCY, AND
THE J. PAUL GETTY TRUST

British Painting

in the Philadelphia Museum of Art

From the Seventeenth
through the Nineteenth Century

RICHARD DORMENT

PHILADELPHIA MUSEUM OF ART

Cover: *Hound Coursing a Stag* by George Stubbs (no. 107)

Edited by Jane Iandola Watkins
Composition by Circle Graphics, Washington, D.C.
Printed in Great Britain by Balding + Mansell, Wisbech, Cambs.

Library of Congress Cataloging-in-Publication Data

Philadelphia Museum of Art.
 British painting in the Philadelphia Museum of Art.

 Bibliography: p.
 Includes index.
 1. Painting, English—Catalogs. 2. Painting, Modern—17th–18th centuries—Great Britain—Catalogs. 3. Painting, Modern—19th century—Great Britain—Catalogs. 4. Painting—Pennsylvania—Philadelphia—Catalogs. 5. Philadelphia Museum of Art—Catalogs. 6. Painters—Great Britain—Biography.
I. Dorment, Richard. II. Title.
ND466.P5 1986 759.2′074′014811 86-8105

ISBN 0-8122-8035-0 (University of Pennsylvania Press)
ISBN 0-87633-065-0 (paperback)

CONTENTS

This volume publishes one of the most comprehensive public collections of British painting in the United States. The Philadelphia Museum of Art is fortunate to possess celebrated examples of the work of Gainsborough, Stubbs, Reynolds, Romney, Constable, and Turner as well as a host of paintings that offer fresh delight for the viewer and the reader, in their less familiar images and their lively histories, so well documented here.

This book has been long in the making. Richard Dorment joined the staff of the Philadelphia Museum of Art in 1973 as an Assistant Curator in the Department of European Painting before 1900. While the pressure of his duties during the next years allowed little time for extensive research on the British pictures, his scholarly interest in and affection for the collection were formed at that time. We were, therefore, particularly happy that he was able, following his move to London in 1976, to accept the invitation to produce a full catalogue of the Museum's British paintings from the seventeenth through the nineteenth century; the fruits of his scholarship and enthusiasm are amply revealed in the present volume. The author has acknowledged his thanks elsewhere in the book to many people, both members of the Museum staff over the past ten years and a large group of colleagues and friends, who encouraged and assisted with this project. Particular note should be made here of Jane Watkins, Senior Editor of the Department of Publications, who saw the book from earliest manuscript through its final run on the presses with exemplary care and skill.

Any publication on this scale is of necessity a costly undertaking, and the importance of the generous financial contributions received for this project cannot be sufficiently emphasized. The National Endowment for the Arts made a crucial grant in 1978 to support the research and preparation of the manuscript, followed by a second, larger grant to help realize the publication itself. A substantial grant from the J. Paul Getty Trust has made the book possible in its present handsome format. We are profoundly grateful to both the National Endowment and the Getty Trust, whose demonstrated concern for scholarship in museums is of vital encouragement to the field.

This catalogue is the most recent in a sequence of major publications intended to document and to illuminate sections of the Museum's collections, which began in 1976 with the appearance of the catalogue of the Rodin Museum by John Tancock and continues next with equally ambitious books on the collections of Oriental carpets and Northern paintings. Each of these books, while addressing the same urgent need to publish in depth important aspects of the Museum's holdings, has a strongly individual character, derived both from the nature of the material discussed and from the happy diversity of approach and wealth of experience among the scholars invited to write them. Overriding consistency in format or pattern of investigation has been waived in order to reflect different attitudes to the collections themselves and the nature of a catalogue appropriate to each.

In the present case, we are indebted to Richard Dorment for having brought his deeply personal and humane interest in British painters and their subjects to bear on the Museum's collection. We trust that his perseverance and patience in keeping at so large a task for so long a time will prove amply rewarded by the interest awakened in readers of this volume. Finally, the occasion of the publication of this catalogue provides a splendid opportunity to express our warmest gratitude to the many collectors and donors whose gifts of works of art or the funds wherewith to acquire them continue to enrich the Museum's fine collection of British painting.

Anne d'Harnoncourt
The George D. Widener Director

Joseph J. Rishel
Curator of European Painting before 1900

It is necessary at the outset to say something about the scope and quality of the holdings of British paintings in the Philadelphia Museum of Art and the method adopted here to catalogue the collection. The overwhelming strength lies in a range of eighteenth-century portraits by Romney, Raeburn, and Gainsborough, totaling thirty paintings, and in nine glorious landscapes: four by Gainsborough, two by Stubbs, and one each by Crome, Turner, and Constable. Two important early conversation pieces by Hogarth and an outstanding portrait by Reynolds fill in the gaps in the eighteenth century, while the small Blake *Nativity* (no. 8) of 1799–1800 stands out as a gem, all the more valuable within the setting of a collection containing few religious or historical pieces. If one adds the two fine portraits by Lely and Kneller on one end of the chronological scale and two masterpieces of the later nineteenth century—a seductive portrait by Leighton and an exuberant setpiece by Alma-Tadema—one finds oneself dealing with a holding that encompasses superb examples of the range of British art primarily from the mid-seventeenth through the nineteenth century.

On another level, a collection that has been formed relatively slowly, from gifts and purchases over a century, inevitably also contains paintings of great beauty by lesser artists such as Dance, Morland, Harlow, or Marshall, as well as slighter works by artists of great stature such as Wilson or Constable. This adds an unusual depth and a richness to the Museum's holdings rarely found in American collections of British paintings, enabling Philadelphia to take its place alongside the collections of the Yale Center for British Art, the Metropolitan Museum of Art in New York, the National Gallery of Art in Washington, D.C., or the Henry E. Huntington Library and Art Gallery in San Marino, California.

Faced with the task of cataloguing this collection, I felt that here was an opportunity to write not the standard museum catalogue—that is, to follow a format comprising a short biography of the artist, a brief identification of the sitter or landscape under discussion, plus the inevitable treatment of provenance, authenticity, and dating—but to attempt something more ambitious. My method has been to present a picture of the artist's life and work in a critical biography preceding the texts on the paintings, and then to illustrate some part of his achievement by using the specific examples from the collection in Philadelphia. To do this I make no apology for indulging in rather full biographies of the artists and, in the case of portraits, of the sitters. In the process, I have become absorbed with the notion that much of the study of English painting before the mid-nineteenth century should be approached through the medium of biography and not stylistic analysis alone.

A portrait is a record of a man or a woman who actually lived; for the sitter's family and friends, the interest of the painting lay in the way in which the artist captured, or failed to capture, or interpreted the personality of an individual. For us to understand their portraits, we too must try to learn as much as we can about the sitter, his or her personality, social position, profession, or aspirations. But this is a truism and, in any case, it is not enough. The artists to whom these people sat brought to their studios not merely artistic technique, but lives and sensibilities that inevitably interacted with those of their clients. To take into account Romney's brooding, obsessional personality adds immeasurably to the interest of his ravishing sketch of *Lady Hamilton as Miranda* (no. 89)—the sheer force of whose personality seems to have electrified him. But just as interesting for me was to compare this sketch with his slightly later portrait of another beauty, *Mrs. Tickell* (no. 97); although the two pictures superficially resemble each other,

Sarah Tickell's more vacuous personality, as we know it from contemporary descriptions of her, simply does not draw from the artist a performance of authentic vivacity.

Examples abound. We know not from any document, but by standing in front of the curiously flat portrait of *John Wesley* (no. 94) how bored Romney was when confronted by the cheerful and "wondrous clean" leader of the English Methodists. Or, can we blame Romney for his aversion to portrait painting when we learn from Lady Grantham's (no. 87) letters that her appointments for sittings occupied a space in her consciousness about as important as a visit to the hairdresser and, for that matter, much less important than her shopping expeditions in London?

In dealing with Reynolds's portrait of *Master Bunbury* (no. 82), it is not incidental to know that the child was the aging artist's godson and that Reynolds kept the picture in his studio until his death: that knowledge is an essential element in the way we see and respond to the picture. Nor is the boy's pose and expression fully comprehensible unless we know that Reynolds kept the three-year-old spellbound during their sittings by telling him fairy tales.

Two contrasting examples illustrate well what fascinated me about this process of digging into the lives of the sitters. When cataloguing Gainsborough's portrait of *Mrs. Clement Tudway* (no. 29), I came to realize, only by reading her letters in the Somerset Record Office, how truly Gainsborough captured the very essence of her shy and retiring personality in a picture I have come to love. On the other hand, a case in which the artist and sitters colluded in a fiction is equally interesting: who would guess from Harlow's outrageously overblown portrait of *The Misses Leader* (no. 36) that his subjects were two middle-class teen-age girls living in a London suburb?

I have been surprised at how much could be discovered about the lives of so many of these sitters from papers still in the possession of their descendants or in libraries and record offices throughout Britain. In one case, that of Raeburn, the use of documents provided more than informative biographies. Raeburn's account books have disappeared, his style is not notably varied, and little recent scholarly work on him has appeared. As Philadelphia owns twelve good portraits by his hand, the dating of these pictures presented a formidable problem. On two long visits to Scotland, I worked not on Raeburn, but on his sitters—and in doing so I hope I have established the dates when most of the Philadelphia portraits were painted. This group will now act as a linchpin around which students may work in the future to establish the chronology of this very considerable and underestimated artist.

As with the portraits, so with the landscapes. In every possible case I visited the site of the landscape, occasionally making some original observations. Gainsborough, for example, in a famous statement to Lord Hardwicke, wrote that he never painted "*real Views* from Nature," and scholars of Gainsborough have assumed to a man that all his landscapes are fantasies. But we can now say without doubt that one landscape owned by the Philadelphia Museum of Art, the *View near King's Bromley-on-Trent, Staffordshire* (no. 28), painted 1768–70, depicts just what its old title always told us, a view of the river Trent, taken from the garden of the first owner of the picture. Or, to choose a very different example, William Bell Scott's *Gloaming: Manse Garden in Berwickshire* (no. 102) shows a real (if Victorian) castle from the garden of the local manse. But what is important in Scott's case is not how accurately he depicted the view, but what alterations he made in the topography that suggest he intended to infuse a "real" landscape with symbolic meaning.

I have included all the British pictures from the mid-seventeenth through the nineteenth century owned by the Philadelphia Museum of Art. The British paintings in the John G. Johnson Collection, which is housed by the Museum

but not part of it, are not catalogued herein, nor are the twentieth-century British paintings. One exception to this last rule seemed to me unavoidable: Philip de László's portrait of John H. McFadden (no. 46), although painted in the early twentieth century, belongs with the McFadden pictures, first as a portrait of the benefactor and second because the portrait belongs in style and intention to an earlier tradition of British portraiture. The mention of De László's name introduces the eternal question of just who should be considered a British artist. Following the system adopted by the Witt Library, only artists born in the British Isles or who became British subjects are included in this catalogue. For example: the Museum owns a charming eighteenth-century conversation piece showing a circle of English friends by the Dutch-born artist working in England Van der Puyl. However, Van der Puyl will be treated in the Museum's forthcoming catalogue of Northern pictures. More controversial will be the exclusion of the Philadelphia-born Benjamin West, whose working life was spent in England (he succeeded Reynolds as president of the Royal Academy) and who yet, by this rule, belongs to the American school. The same applies to James Abbott McNeill Whistler and John Singer Sargent, both born of American parents and both of whom pursued careers primarily in London.

Having said all this, I must conclude by admitting that the bulk of the catalogue entries is taken up with questions of attribution, condition, and dating—and that in the long run this work of art-historical scholarship may be what gives the catalogue its lasting value. I have come away from my four years' work on this catalogue with an immense respect for the collection at Philadelphia, and what is perhaps of more value to me, a great affection for the pictures. I hope that some of this affection is communicated in the following pages.

Richard Dorment
March 1986, London

The history of the formation of the collection of British paintings in the Philadelphia Museum of Art is, primarily, the story of John H. McFadden's passionate interest in one school of art. McFadden was surely one of the great American collectors. Unable to collect on the scale of John G. Johnson, and not possessing the wealth of a Frick or a Mellon, he turned his limitations into trump cards. Rather than compete with the giants, he bought in depth to bequeath to his native city of Philadelphia a rich and unified group of paintings containing superb examples of late eighteenth- and nineteenth-century British portraiture and landscape. McFadden's collection put Philadelphia, as it were, on the map. Years after his death, William L. Elkins was able to add several masterpieces of the British school and these, together with individual gifts of exceptional importance, have created a collection of the first rank. Before considering these later additions, we must look at McFadden's extraordinary achievement.

John H. McFadden (1851–1921), cotton king, philanthropist, and art collector, was the great-grandson of George H. McFadden, founder of a family hardware store in Memphis, Tennessee. After the Civil War, when cash was short, farmers paid the McFaddens in cotton, which was, of necessity, brought by mule train to the mills near Philadelphia. Soon brokering—buying raw cotton in the south to sell to the mills in the north—became the family business.

John H. McFadden and his brother George turned the firm of George H. McFadden into a world-wide operation, selling American and Egyptian cotton to industrial centers in America and the north of England. George ran the American side of the business, while John lived and worked mainly in Liverpool. John had become a member of the Cotton Exchange in 1881, and there he was caricatured in the press as one of its best-dressed members, for "no one recalls seeing him without [a silk top hat] . . . always carefully ironed."

By 1910 McFadden had begun to finance the researches of Dr. Hugh Campbell Ross into cancer, and to donate heavily to the Lister Institute of London for work on cancer and measles. In 1914 he helped to finance Sir Ernest Shackleton's (1874–1922) imperial trans-Antarctic expedition. He was a trustee of the Jefferson Hospital, the Pennsylvania School of Industrial Art, and the Pennsylvania Academy of the Fine Arts.

But the most colorful of John McFadden's philanthropic activities was his art collecting. He began in a desultory fashion, in September 1892, purchasing from the Bond Street firm of Thomas Agnew and Company an oil by his Victorian contemporary J. C. Horsely (1817–1903) and a watercolor by Robert Anderson (1842–1885).

The purchase of his first important eighteenth-century English picture, Gainsborough's *Lady Rodney* (no. 32) on June 5, 1893, put McFadden on the path to serious collecting. By 1895 he was confining his purchases to major pictures of the British school, adding in that year Romney's *Mrs. Finch* (no. 96), Raeburn's *Lady Elibank* (no. 72) and *Lady Belhaven* (no. 67), and Stark's *Landscape with Cattle* (no. 104). Of the seven oils he acquired before 1900, however, only Crome's *Blacksmith's Shop near Hingham, Norfolk* (no. 18), acquired in 1896, was comparable in importance to *Lady Rodney*.

The acquisitions of the years 1900 to 1913 formed the backbone of the collection: in 1900 Cox's *Going to the Hayfield* (no. 17); in 1901 Constable's *Sketch for "A Boat Passing a Lock"* (no. 11) and three more important Romneys, *Mrs. Champion De Crespigny* (no. 91), *Mrs. Crouch* (no. 98), and, in 1907, *Lady Hamilton as Miranda* (no. 89); in 1904 Gainsborough's *Pastoral Landscape* (no. 33); in 1909 Reynolds's *Master Bunbury* (no. 82); in 1909–13 Stubbs's *Laborers Loading a Brick Cart* (no. 108) and Turner's *Burning of the Houses of Lords and Commons* (no. 111).

The First World War interrupted McFadden's collecting, because he spent the years 1913–16 in America, and as far as we know he always saw his pictures before buying them. But in 1916 he revisited England, with the idea of establishing a gallery of art in Philadelphia. This, and his decision to have his collection catalogued by William Roberts, induced him to buy seven important pictures in one year from Agnew's including Constable's *Dell at Helmingham Park* (no. 14) (now thought to be a forgery), Romney's *Shepherd Girl* (no. 86) and *Lady Grantham* (no. 87), and Wilson's *View of the Thames: Westminster Bridge under Construction* (no. 115).

The formation of the McFadden Collection thus took twenty years. The only firm the collector dealt with during this period was Agnew's, relying for advice on his close friendship with William Lockett Agnew (1858–1918). The policy's reward is that few of the attributions under which he bought the pictures have been challenged, and most of the pictures are still in sound condition. On the other hand, the McFadden Collection is extremely conservative, consisting entirely of portraits and landscapes by the most distinguished British artists. He gave the Museum no history or subject pictures, only one genre scene (Morland's *Fruits of Early Industry and Economy*, no. 57) and two conversation pieces (Hogarth's *Assembly at Wanstead House*, no. 39, and *Conversation Piece with Sir Andrew Fountaine*, no. 40). No artist who in 1900 was not fully appreciated was included by McFadden: Wright of Derby (q.v.), Fuseli, or Wilkie, for example. Only a few pictures did McFadden buy privately: Hogarth's *Conversation Piece with Sir Andrew Fountaine* (no. 40), in 1909–13 from Robert Langton Douglas, and Harlow's *Misses Leader* and *Leader Children* (nos. 36, 37), which he bought directly from Lord Westbury in 1913.

By 1916 the collection was complete and McFadden hired William Roberts to catalogue it. The choice of Roberts, an antiquarian bookseller and art historian, was shrewd: Roberts was a man of high integrity and his knowledge of English paintings was profound. His catalogue is still of great value and authority.

In dealing exclusively with Agnew's, McFadden was following the example of Edward Cecil Guinness, 1st Earl of Iveagh (1847–1927), who in the late 1880s assembled his collection of eighteenth-century English pictures now at Kenwood in London, relying entirely on Agnew's advice. McFadden's collection should in many ways be seen as comparable to Lord Iveagh's: the chronological perimeters are, of course, the same, and the artists chosen by each man overlap in most cases. The differences between the two collections may simply reflect the difference in the art markets of the later 1890s to 1916, when the fashion for English paintings of the eighteenth century forced McFadden to compete with such rivals as Henry E. Huntington and J. Pierpont Morgan, and that of the 1880s, when English pictures were only just beginning to be appreciated and realize enormous prices at auction. Thus, Iveagh was willing or had the opportunity to buy full-length portraits by Reynolds and Gainsborough, and secured more masterpieces of the highest quality by both artists. Except for Harlow's *Misses Leader* and *Leader Children* (nos. 36, 37), McFadden never bought a great full-length exhibition picture, and this is a gap still felt in the Philadelphia collections today. On the other hand, McFadden, unlike Iveagh (or, for that matter, Huntington or Morgan), possessed more of the finest examples of English landscape art, in Gainsborough's *Pastoral Landscape* (no. 33), Turner's *Burning of the Houses of Lords and Commons* (no. 111), Crome's *Blacksmith's Shop* (no. 18), and Constable's *Sketch for "A Boat Passing a Lock"* (no. 11).

The collection was first housed in the McFadden mansion on Rittenhouse Square, Philadelphia, on the corner of Nineteenth and Walnut streets. When

the house was demolished in 1916, the pictures were exhibited at the
Metropolitan Museum of Art in New York during the summer, and the
Pennsylvania Academy of the Fine Arts in Philadelphia during the autumn. On
the site of the old house McFadden built the Wellington apartments, taking
the top floors for his own use. On the thirteenth and fourteenth floors ("above
the city dust line, and where there is no possibility of the light being cut off by
buildings," as the press wrote) he installed rooms faithfully reproduced from
those where the pictures had been displayed in the demolished mansion, with
each picture hung in relatively the same position as in the old gallery. The
public was allowed to visit the collection every Wednesday, when McFadden's
daughter Alice served tea.

The private gallery inevitably encouraged Philadelphians in their plans to
build a city art museum. When he died in 1921, McFadden added an incentive
to the speedy completion of the new museum in Fairmount Park, now the
Philadelphia Museum of Art, by leaving his collection intact to the city of
Philadelphia, but only when the museum was built and the pictures could be
displayed in a fitting way. The city was given seven years to comply with the
terms of the bequest, after which the entire collection was to be offered to the
Metropolitan Museum of Art in New York. The city of Philadelphia directed
its energies to erecting the great structure on the Parkway and the first galleries
opened to the public in 1928.

McFadden had three children, Philip, John H., Jr. (Jack), and Alice
McFadden Brinton. John H. McFadden, Jr., was also a donor to the Museum,
presenting, with his wife, a number of British pictures, including De László's
portrait of his father (no. 46), the Dance *Conversation Piece* (no. 22), Raeburn's
portrait of *Ellen Cochrane* (no. 73), and Paul Sandby's *North Terrace at Windsor
Castle* (no. 100) in the 1940s and 1950s.

The other great benefactor to the Museum's collection of British paintings
was William L. Elkins. Unlike McFadden, he was not a collector who confined
his purchases to one school or period; the most famous pictures in the Elkins
Collection are works of the Impressionists. Yet Elkins had an astonishing eye
for quality. To his love for Gainsborough (perhaps the most impressionist of
English eighteenth-century painters) the Museum owes its wonderful
View near King's Bromley-on-Trent, Staffordshire (no. 28). Elkins bought
from the Marquand sale a picture one would think, on the face of it, the
antithesis of the Impressionists he loved—Alma-Tadema's *Reading from Homer*
(no. 1); but its presence among the English pictures delightfully enriches the
collection and may be classed as the most important work by this artist in
America. Even when Elkins was buying on a smaller scale his eye was superb.
To that eye we owe two landscapes by Richard Wilson (nos. 116, 117) of great
beauty.

The other major source of the English pictures is the W. P. Wilstach
Collection, which brought as early as 1895 Gainsborough's *Rest by the Way*
(no. 26) and then in 1896 Constable's *Sketch for "The Marine Parade and Chain
Pier, Brighton"* (no. 12), as well as a number of other interesting, if minor
works such as Thomas Barker of Bath's fascinating *Gypsies on the Heath* (no. 2),
in 1903.

Finally, the collection has been immeasurably enhanced by what might be
called the wild cards—those pictures that entered the Museum individually,
and not through the donation of whole collections. In this category we would
put Mrs. William T. Tonner's gift of *The Nativity* (no. 8) by William Blake, or
the precious gifts from Mr. and Mrs. Wharton Sinkler of Mason
Chamberlin's portrait of *Benjamin Franklin* (no. 10) and Gainsborough's
Landscape with Rustic Lovers (no. 27). In this category is the generous gift in

1978 from the grandchildren of George D. Widener of a masterpiece by
Benjamin Marshall, *The Weston Family* (no. 56). And the collection is always
being added to. Since this catalogue was begun, the Museum has purchased
the remarkable *Hound Coursing a Stag* (no. 107), a masterpiece by Stubbs that
is at once a sporting picture and a landscape of the greatest refinement, adding
significantly to the depth and range of Philadelphia's holdings.

Consult "Bibliographical abbreviations" for full references of abbreviated citations. Unless indicated otherwise, auction sales were held in London. The year in which a painting was acquired by the Museum is indicated by the initial digits of its accession number: for example, the accession number 44-9-1 indicates that the painting bearing that accession number was acquired in 1944. After the year 1976, the century is repeated to prevent confusion with 1876: for example, 1978-40-1 indicates that the painting was acquired by the Museum in 1978.

Dimensions are given in inches and centimeters with height preceding width.

The mediums of paintings mentioned in the text but not in the Museum's collections are oil on canvas unless indicated otherwise.

In the condition notes, the support fabrics are considered to be a single piece of linen, unless noted. The fabrics are plain weave with tacking margins present, unless stated otherwise. Thread counts are stated without reference to warp and weft unless clear evidence of a selvage is present. In reference to the lining, aqueous refers to a fabric adhered to the original support with a glue and/or paste mixture. Mention of the condition of a lining support or adhesive beyond this generally has been omitted unless that condition directly affected the appearance of a painting (staining or darkening of a support by a wax adhesive, for instance). Relining is stated if evidence for prior linings is present or is available through documentation. Ground color is given where microscopic examination revealed obvious pigmentation. Generally, "off-white" refers to the appearance of essentially white grounds that either through age or pigmentation appear slightly yellow or cream colored. Paint mediums are drying-type oil, unless stated otherwise. Abrasion as a surface phenomenon generally is given in terms of severity, not in terms of type (such as solvent or mechanical) unless evidence for a specific type of damage is available. Crackle is given as either fracture type (mechanical in derivation) or traction type (due to a drying phenomenon of a paint mixture, usually particularly rich in medium). Aperture of the crackle refers to the width of the actual fissures themselves. Lean, paste, or rich-vehicular paint consistencies refer to paint mixtures in terms of pigment/medium ratios. The presence of a varnish coating over the paint film is generally assumed, but no reference is made to its condition. Where evidence of a recent cleaning exists, and is well documented, that fact is noted. All paint additions in terms of restoration to the original surface (inpaints, overpaints, etc.) are generally referred to as retouches unless clear documentation exists indicating the restoration to be restricted to damage or loss only. Results of examination with ultraviolet light are noted only when they reveal retouching, or other significant information, which is usually located on the surface of the varnish. Retouchings lying beneath an aged natural resin varnish are unlikely to be visible under ultraviolet light.

The condition notes are derived from primarily three sources: direct observation in the laboratory with the aid of analytical equipment (x-radiography, ultraviolet-light photography, microscopy), materials drawn from conservation and curatorial files, and recent conservation treatment reports on individual paintings. David Rosen, of the Walters Art Gallery in Baltimore, Maryland, worked on Philadelphia Museum of Art paintings in the late 1930s and early 1940s. Theodor Siegl was Conservator at the Philadelphia Museum of Art from April 1, 1955, to his death, September 4, 1976. Marigene Butler became Conservator at the Philadelphia Museum of Art on July 3, 1978.

British Painting

in the Philadelphia Museum of Art

Born in central Friesland, Holland, in 1836, Laurens Tadema (the Alma was added later and his first name anglicized) studied and made his early reputation entirely on the Continent. By the time he was thirteen in 1849 he had begun to paint his first pictures in oil, and as early as 1852 he confidently labeled an oil painting Opus Number One and henceforth numbered his works consecutively up to Opus CCCCVIII, painted in the year of his death, 1912. At sixteen Tadema entered the Antwerp Academy to work under Gustave Wappers (1803–1874), the former teacher of Ford Madox Brown (1821–1893), later one of the foremost exponents of the Pre-Raphaelite style in England. From Wappers, Tadema learned to emulate the techniques of the great Dutch and Belgian painters and to seek precision in his draftsmanship as well as luminosity in his coloring. By 1856 he had left the academy to work on his own.

His early works in Antwerp were genre subjects taken from Merovingian history such as *Clotilde at the Tomb of Her Grandchildren* (Opus VIII, 1858, 31½ x 43″, location unknown). During the same period, under the influence of the distinguished Egyptologist Georg Ebers (1837–1898), he painted his first pictures on Egyptian themes. From 1860 to 1862 he worked in the studio of Baron Hendrik Leys (1815–1869), helping to execute the meticulously drawn frescoes for the Hôtel de Ville in Antwerp, which illustrate in an angular, archaizing style the history of the city. By 1861 he had been elected a member of the Amsterdam Academy and in 1862 paid his first visit to London both to see the International Exhibition and to view the Elgin Marbles and Egyptian antiquities in the British Museum. The following year he spent his honeymoon in Florence, Rome, Naples, and Pompeii; and in 1864 he was in Paris to collect the gold medal that his painting *Pastimes in Ancient Egypt: 3,000 Years Ago* had won at the Salon (Opus XVIII, 1863, 39 x 53½″, Preston, Harris Museum and Art Gallery). There he met and was befriended by Jean Léon Gérôme (1824–1904), whose technique was profoundly to affect his own.

In 1864 through the intermediary of the animal painter Rosa Bonheur (1822–1899), Alma-Tadema met the art dealer Ernest Gambart (1814–1902), who put him under contract to produce a certain number of pictures each year. As his agent, Gambart promoted Alma-Tadema, exhibiting his work in London at the French Gallery in Pall Mall in 1864, 1865, and 1866. As a result, to the gallery-going Englishman of the later 1860s Alma-Tadema's name was one of the best known of Continental artists.

From 1865 he had lived in Brussels, but after the death of his first wife in 1869 Alma-Tadema planned to settle permanently in Paris. The outbreak of the Franco-Prussian war in 1870, however, forced him to set up his studio and home in London. He married in 1871 as his second wife an Englishwoman, Laura Epps (1854–1909), became a British subject (1873), secured admission to the Royal Academy as an Associate (1876) and full Academician (1879), and, to jump ahead, was knighted in 1899 and received the Order of Merit in 1905.

England in 1870 was well beyond the first phase of the neo-classical revival of the 1860s. Closest in spirit to Alma-Tadema as an artist was Edward Poynter (1836–1919), trained at Charles Gleyre's (1806–1874) academy in Paris, who specialized in historical subjects in an antique setting. Another Continentally trained artist, the English-born Frederic Leighton (q.v.), painter of mythological subjects in an ideal style, might be described as a distant follower of Ingres (1780–1867), while the greatest of the neo-classicists Albert Moore (1841–1893) and James Abbott McNeill Whistler (1834–1905) used the timelessness of Greek drapery as a vehicle for exploring color harmonies and subtle rhythmic balances. Furthest away from Alma-Tadema were those artists like Edward Burne-Jones (1833–1898) and G. F. Watts (1817–1904), who grew out of a Pre-Raphaelite milieu, and whose work in the 1860s attempted to fuse

the high moral seriousness and intensity of Pre-Raphaelite themes with the forms of the classical ideal.

The question of how well and which of these pictures sold before the advent of Alma-Tadema himself is one well worth probing: certainly his success predated that of his English rivals. The reasons for his popularity are obvious: anyone could see what a craftsman he was and with what wonderful technical skills he produced his pictures. Within his own narrow specialty—the bourgeois domestic subject set in the ancient world—he was unrivaled. These pictures are fascinating still to pore over for their interpretation of antiquity. Even though they are not archaeologically accurate by today's standards, Alma-Tadema's works captured the triviality of the late Roman Empire. Somehow he got its godless, worldly soul "right." The corollary, however, is also true: however sensuous his handling of paint, however brilliant his light, and whatever pleasure we feel in his use of gaudy, creamy colors, his work has in it no trace of spirituality; it is charming and spirited, but utterly finite. John Singer Sargent (1856–1925) is said to have replied, when Sir Edmund Gosse asked him what he thought of Alma-Tadema's painting: "I suppose it's clever, of course it *is* clever . . . but of course it's not art."[1]

In 1884 Alma-Tadema moved into James Tissot's (1836–1902) old house and studio on the corner of Abbey and Grove End roads in St. John's Wood. This house he then rebuilt in—to say the least—an eclectic taste. One room was Gothic, another Dutch, another Pompeian, and each was called by its Roman name—the library was the atrium, the dining room the triclinium, and so on. There he worked hard, for though himself an easygoing, jocular man who loved knock-knock jokes, Alma-Tadema was also a perfectionist who repainted his pictures over and over until he felt satisfied with them. He always worked from nature, and so, for example, when his *Roses of Heliogabalus* (Opus CCLXXXIII, 1888, 52 x 84⅛″, France, private collection) called for the depiction of thousands of roses, three boxes of roses were sent from the Riviera every week for four winter months while he worked.

In certain of his historical subjects, particularly *A Roman Emperor* (Opus LXXXVIII, 1871, 33 x 68⅛″, Baltimore, Walters Art Gallery), which shows a Roman mob proclaiming emperor the cringing Claudius while his murdered nephew Caligula lies at his feet, Alma-Tadema created dramatic compositions as powerful and subtle as those of Gérôme. Perhaps the best and last word to describe Alma-Tadema's work is *theatrical* and it is worth noting that toward the end of his life he, like Edward Burne-Jones, designed sets for Henry Irving's plays.

1. Evan Charteris, *John Sargent* (New York and London, 1927), p. 77.

BIBLIOGRAPHY: James Dafforne, "The Works of Laurence Alma-Tadema," *The Art Journal*, 1875, pp. 9–12; Edmund W. Gosse, "Lawrence Alma-Tadema, R.A.," in F. G. Dumas, ed., *Illustrated Biographies of Modern Artists* (London and Paris, 1882), pp. 73–96; "The Works of Laurence Alma-Tadema, R.A.," *The Art Journal*, 1883, pt. 1, pp. 33–37, pt. 2, pp. 65–68; Ebers, 1886; Zimmern, 1886; Stephens, 1895; Spielmann, 1896, pp. 42–50; Monkhouse, 1899; Frederick Dolman, "Illustrated Interviews LXVIII. Sir Lawrence Alma-Tadema," *The Strand Magazine*, vol. 18, no. 108 (December 1899), pp. 603–14;

Zimmern, 1902; Standing, 1905; Dircks, 1910; Collier, 1913, pp. 597–607; M[alcolm] B[ell], *Dictionary of National Biography,* suppl. (1912–21), s.v. "Alma-Tadema, Lawrence"; Amaya, 1962; Russell Ash, *Alma-Tadema: An Illustrated Life of Sir Lawrence Alma-Tadema, 1836–1912,* Life Lines 24 (Aylesbury, 1973); Jeremy Maas, *Gambart: Prince of the Victorian Art World* (London, 1975); Swanson, 1977.

EXHIBITIONS: London, Grosvenor Gallery, *Collection of the Works of L. Alma Tadema, R.A.,* winter 1882–83; London, Royal Academy, *Works by the Late Sir Lawrence Alma-Tadema, R.A., O.M.,* winter 1913; New York, Robert Isaacson Gallery, *An Exhibition to Commemorate the 50th Anniversary of the*

Death of Sir Lawrence Alma-Tadema, April–May 1962; New York, The Metropolitan Museum of Art, *Victorians in Togas: Paintings by Sir Lawrence Alma-Tadema from the Collection of Allen Funt,* March–April 1973; Leeuwarden, Gemeentelijk Museum, Het Princessehof, *De Wereld Van Alma Tadema,* July–September 1974; Sheffield, Mappin Art Gallery, Newcastle, Laing Art Gallery, *Sir Lawrence Alma Tadema, O.M., R.A., 1836–1912,* July 3–September 13, 1976 (by Anne L. Goodchild).

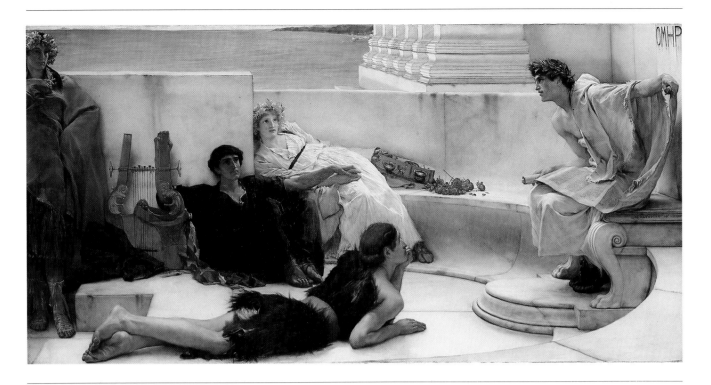

I SIR LAWRENCE ALMA-TADEMA *A READING FROM HOMER,* 1885
Oil on canvas, 36 x 72⅜" (91.8 x 183.5 cm.)
Inscribed at right: *OMHP L. ALMA TADEMA op. CCLXVII*
The George W. Elkins Collection, E24-4-1

On February 7, 1885, the correspondent for *The Athenaeum* described a picture
on which Alma-Tadema was then at work, to be called "Plato." The setting
was Sicily, in the forecourt of a temple on a cliff overlooking the sea, girt
round with ilex and gray olive trees. Plato himself was shown seated between
the shafts of two marble Doric columns expounding philosophy to an
audience of a mother, a daughter, and a reclining brunette, with other figures
listening.

But when the Royal Academy opened three months later, Alma-Tadema
was represented by *A Reading from Homer,* "painted in little more than a
month," according to the same critic for *The Athenaeum,* May 2, 1885, who
added that "the picture of Plato addressing his disciples, which we described
some time ago, has given place for a season to that before us." Helen
Zimmern (1886, p. 25) noted that *A Reading from Homer* had actually been
painted in the space of two months (March–April 1885): "This actual canvas
was completed in so short a space, [but] the preliminary studies, including an
abandoned picture that was to have been called 'Plato,' occupied eight months
of work."

The origins of the picture, however, are much earlier. On March 2, 1882,
Charles W. Deschamps (1848–1908), one of the European agents of the New
York banker Henry Gurdon Marquand (1819–1902), who commissioned this
painting, wrote to his employer: "I have just heard from Tadema: he is
working at the 'Singer of Homer,' he says, and is getting on well with it."
Deschamps remarked that Alma-Tadema "has left other work for it," but "does
not know yet whom the picture is for, as I have not forwarded your letter to
him."[1] Thus the picture was under way at least by the early months of 1882.

Almost three years pass before we hear again of the Homer/Plato picture,
in a letter from Alma-Tadema to Henry Marquand dated September 29, 1884.
The picture described by the artist here is clearly the aborted "Plato":

Your picture was in great progress when thoroughly dissatisfied with the results I have quite remodelled it. The marble seat is gone. The Rapsod[ist?] still sits in a marble seat & there is some sort of a seat left for two women instead of one besides I have added four more figures to the auditory [audience], which seems to me a great improvement. The ilex grove which showed above the seat is now much clearer & makes a beautiful background for the figures, especially that through the stems of the trees. I intend showing a bit of [unintelligible word] sea & sunny distance through the columns of temple & amongst the trees an altar & statue of a God appropriate to the place. Somehow the thing looks more natural & that is of course a great gain I am sure you will like it better.

FIG. 1-1 Infrared photograph (detail) of *A Reading from Homer*, Philadelphia Museum of Art, Conservation Department, 1965

Alma-Tadema never got the picture right. He abandoned it and started afresh on the canvas that became *A Reading from Homer*. The composition of "Plato," now presumably destroyed, however, may have looked roughly like that of *A Reading from Homer*. Infrared photographs taken in 1965 (fig. 1-1) reveal a number of pentimenti showing that Alma-Tadema had trouble resolving details even in this second attempt at the composition. Several of the alterations are slight, such as the change in the position of the cithara; but others, such as the discarded position of the right arm of the reader, which was flung out in an emphatic and declamatory gesture, perhaps are holdovers from the "Plato" composition. Likewise, the round Doric columns visible in the infrared photograph at the left and center left background may reflect the positions of similar columns in the lost "Plato."

The reasons for the abandonment of the "Plato" were largely technical, although the subject may also have had something to do with the difficulty Alma-Tadema had in completing it. In 1895 F. G. Stephens (1828–1907) explained that "Plato" was left unfinished because after eight months' work "the proportions of the figures and the background [were] out of harmony, [and] the whole had lost that interest which an artist must feel if he is to proceed with a picture."[2] But it is irresistible not to remark that Alma-Tadema's "Plato" is definitely a Victorian, expounding his philosophy to that family audience of mother, daughter, and unidentified brunette: no sign here of the symposium, no hint of Alcibiades.[3] And this is all the more pronounced as Alma-Tadema certainly knew one of the three versions (or the print after one of them) of a contemporary representation of the scene—the masterpiece of the German artist Anselm Feuerbach (1829–1880), *The Banquet of Plato* (fig. 1-2) or the second version, 1873, Berlin, Staatliche Museen, Nationalgalerie.[4] Feuerbach's frank depiction of Plato greeting the sensuous Alcibiades and his revelers is a long way from Alma-Tadema's near-domestic genre scene. Still, Feuerbach's marble atrium, richly decorated with wall paintings and archaeologically correct tables, chairs, and lamps, his philosopher crowned with laurels greeting the garlanded guests, and the centralized marble columns in the background are elements one might find in any number of pictures by Alma-Tadema. But Feuerbach's long, low format and the large scale of his picture find no echoes in works by the Dutch-born artist before *A Reading from Homer*.

FIG. 1-2 Anselm Feuerbach (1829–1880), *The Banquet of Plato*, 1869, oil on canvas, 116 x 235⅝″ (295 x 598 cm.), Karlsruhe, Staatliche Kunsthalle

The present painting is a splendid example of Alma-Tadema's eclectic imagination at work "re-creating" everyday life in ancient times. If its close predecessor showed Plato, the setting, as Monkhouse (1899) thought, must be Greek and the date toward the end of the seventh century B.C. But as Richard Jenkyns points out, it is itself revealing that although Alma-Tadema pretended to archaeological accuracy, one can rarely date his scenes even to the nearest century or two on the basis of the setting or props.[5] The effect, therefore, is

FIG. 1-3 Lawrence Alma-Tadema, *Girl and Boy Seated by a Cithara*, lithograph?, location unknown. Photograph: London, Witt Library

one of viewing masqueraders at a fancy-dress party; and indeed Alma-Tadema is known to have loved dressing up in costume and is said to have surprised Whistler by appearing before him in a toga, sandals, and spectacles. Perhaps it is significant that the one work on paper related to *A Reading from Homer* is Alma-Tadema's undated cover (presumably a lithograph) for a program for the Royal Academy's Student Dramatic Society (fig. 1-3). It shows the young girl who reclines on the marble exedra, her fingers entwined with those of the young man seated by the cithara.

The rest of the audience in *A Reading from Homer* consists of two young men: one standing at the left, half cut off by the edge of the picture, and the other dressed in goat skins (and so perhaps intended for a shepherd) lying flat out on the marble, chin in hand, in what must be an extremely uncomfortable position. All are garlanded as for a festival and listen to a young poet crowned with laurels declaiming from Homer in a spot dedicated to the poet, as we can see from the Greek letters incised into the marble above his head.

Helen Zimmern (1902, p. 40) was the first to trot out the cliché that "these dead-and-gone folk were in all fundamental essentials like ourselves," but what she really meant was that they were like a small clique of Victorian aesthetes, led by Oscar Wilde and satirized in George du Maurier's (1834–1896) cartoons and in Gilbert and Sullivan's *Patience* (1881). Zimmern unconsciously saw that the theme of the picture is that the Greeks were as *greenery yallery* as certain of Alma-Tadema's clients. This is aptly demonstrated in the notes to the picture in the Marquand sales catalogue of 1903, where the potential purchaser was informed that "The spirit of the old Greek life, its grace of living, & beautiful environment are revived," for in the spot dedicated to poetry, "hither he, who has some fine thought, & those who desire to 'hear some new thing,' can resort."[6]

The reviewers were all delighted with *A Reading from Homer* and praised the artist for working up "his accessories to a higher pitch of realism than ever he has obtained."[7] The key word here is *accessory*. Thereafter they had little to do but list the amazing things Alma-Tadema could describe with his brush: the veined and semitransparent marble, the "pure luminosity" and "fine fidelity of the flesh painting." Characteristically, Alma-Tadema went to enormous lengths to depict accurately an ancient cithara, but then included, in a lovely still life by the side of the tambourine, a type of rose that did not exist before the nineteenth century.

Percy Standing (1905) suggested that *A Reading from Homer* was a companion picture to Alma-Tadema's *Sappho and Alcaeus* (Opus CCXXIII, 1881, 26 x 48″, Baltimore, Walters Art Gallery) and, indeed, both pictures have as their theme a performance of a poet's works before an audience seated round an exedra. However, *A Reading from Homer* had no pendant, and the theme of the artist and his audience was one that Alma-Tadema returned to again and again throughout his career. As early as 1862 in *Venantius Fortunatus Reading His Poems to Radagonda* (Opus XV, 1862, 25½ x 32¾″, Dordrecht, Dordrechts Museum) he treated the subject in a Merovingian setting, but one could also point to *Anacreon Reading His Poems at Lesbia's House* (Opus LXXX, 1870, oil on panel, 15½ x 19″, England, private collection) or *The Pyrrhic Dance* (Opus LXIX, 1869, oil on panel, 16 x 32″, London, Guildhall Art Gallery) as variations on the same theme. One may see this preoccupation with the theme of the performer and audience as part of a wider tendency in English painting in the latter half of the nineteenth century. One thinks of Edward Burne-Jones's *Laus Veneris* (1873–75, 47 x 71″, Newcastle upon Tyne, Laing Art Gallery), Albert Moore's *Musician* (fig. 1-4), or, later, J. W. Waterhouse's (1847–1917) *Saint Cecilia* (1895, 48½ x 78½″, London, Maas Gallery).

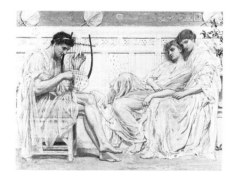

FIG. 1-4 Albert Moore (1841–1893), *A Musician*, c. 1867, oil on canvas, 10½ x 15″ (27 x 38 cm.), New Haven, Yale Center for British Art

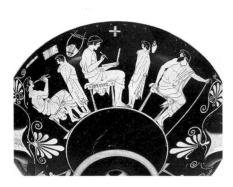

FIG. 1-5 Cup (kylix), c. 490–485 B.C., by Douris, terra cotta, Berlin (West), Antikenmuseum, Staatliche Museen Preussischer Kulturbesitz

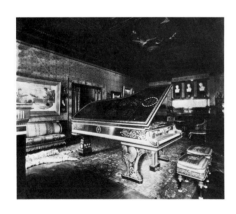

FIG. 1-6 Music Room from the Marquand House. Photograph: New York, The Metropolitan Museum of Art

The composition of this painting is indebted to, but does not directly depend upon, Greek vase paintings. One example that Alma-Tadema could have known was a kylix in the Berlin museum by the painter Douris, discovered in 1872, which depicts a reading from the Hermesian poet (fig. 1-5).[8] *A Reading from Homer* was one of the first large pictures to have been completed in Alma-Tadema's new studio in St. John's Wood. The dome of this studio was covered in aluminum to give a cold, silvery light to the room and resulted in a cooler, whiter light in his pictures painted after 1884.

The first owner of the picture was Henry Gurdon Marquand (1819–1902), whose entry in the *Dictionary of American Biography* identifies him simply as a capitalist. Marquand, to be more specific, was a banker and broker on Wall Street and made his fortune financing railroads, owning the St. Louis, Iron Mountain & Southern Railroad from 1874 to 1882.[9] Around 1881 Marquand began to retire from business to devote his time to philanthropy, particularly to the Metropolitan Museum of Art in New York, whose second president he was from 1889 to his death. Marquand has been called "without a doubt the most discriminating collector and art patron of his time."[10] He filled his red sandstone and brick mansion at Sixty-eighth Street and Madison Avenue, built for him in the French Renaissance style by Richard Morris Hunt (1827–1895), with his collection of English and old master paintings, including works by Vermeer, Van Dyck, Rembrandt, Hals, Ruisdael, Cuyp, Turner (q.v.), and Gainsborough (q.v.).

The famous gray and gold music room housed part of Marquand's collection of Greek vases, terra-cottas, and Roman marbles. In 1884 Marquand commissioned furniture and decorations for this room, including wall hangings, from Alma-Tadema to be executed in the purest neo-Greco-Roman style. It was for this room that Alma-Tadema designed his famous piano, made of black ebony, inlaid with ivory, mother-of-pearl, box- and sandalwood, with raised scrollwork in ebony and ivory, and painted by Edward Poynter, an extravaganza the *Furniture Gazette* in 1887 called "one of the most superb specimens of elaborately artistic workmanship it has ever been our good fortune to see." The artist also designed a suite of matching furniture in the same materials.[11] In this room, together with another small Alma-Tadema in his collection, *Amo Te, Ama Me* (Opus CCXXXIV, 1881, oil on panel, 6⅞ x 15″, England, private collection),[12] hung *A Reading from Homer,* a suitable subject for a room devoted to recitals and private concerts (fig. 1-6). To continue the theme of music in a classical setting, Marquand commissioned from the president of the Royal Academy, Sir Frederic Leighton (q.v.), a mythological triptych illustrating the theme of music (the central panel showing the muses Mnemosyne, Melpomene, and Thalia; the right panel, Terpsichore, and the left panel, Erato, completed 1886).[13]

The correspondence between Marquand and Alma-Tadema, and then with Leighton, survives. It shows that Alma-Tadema was in charge of the entire decorative scheme, and it was he who commissioned Leighton on Marquand's behalf. We have already quoted from a letter written by Marquand's agent Charles Deschamps of March 2, 1882, acknowledging the commission for *A Reading from Homer* and a letter of September 29, 1884, from Alma-Tadema to Marquand describing his progress on that commission. In a letter also of September 1884 Leighton thanked Alma-Tadema for arranging the commission to decorate the music room with ceiling panels: "Your note . . . gives me great pleasure for it shows me that the friend [Marquand] who desires my work, and for whom I will do my very best is a true and devoted lover of art whose acquaintance I had the pleasure of making this summer."

The next two letters from Leighton to Marquand concern the ceiling panels, not *A Reading from Homer*. One, dated May 17 [1886], reveals that Leighton himself was responsible for choosing the theme of the ceiling panels: "Let me briefly describe the subjects to you. I have thought that in a room dedicated to the performance of music the Muses were the perfect presiding spirits in as much as with the Greeks Music and Poetry always went hand in hand." Leighton stressed to Marquand that his panels "are emphatically not *pictures* but *decorations,*" and when Marquand wrote suggesting that the center panel be treated in the style of Leighton's large easel picture *Cymon and Iphigenia* (c. 1884, 64 x 129″, New South Wales, National Museum), Leighton became much firmer with his patron, betraying the strength and clarity of his own notions about the kind of picture suitable for such a commission and not hesitating to "educate" Marquand:

> I gather from what you say that you have formed a different idea from mine how that effect should be attained—you speak of a subject in the centre after the manner of my "Cymon & Iphigenia"—now this is eminently *a picture* and wholly unlike a Greek wall decoration—nor indeed would any class of decorative painting comport the introduction of a work of so pictorial, or, shall I say, picturesque a character, or in which subtle facial expression is a chief element. My notion in this instance would be to design something which would have the decorative definiteness and aspect of a *Greek Vase, plus* the richness of colour in the figures would be more or less isolated and very firm in outline and would have no *pictorial* background—only instead of being black blots on a red ground or white on black—they should be of full rich tone on a *gold ground*—the effect would be rather that of the old mosaics and I think very telling.—Of course therefore I should not select *incidents* for my subjects but rather symbolical figures bearing upon the various aspects of Music—grave or gay, pastoral or heroic.[14]

1. Letters from Deschamps, Alma-Tadema, and Leighton addressed to Marquand and quoted in this entry are among the Marquand papers in the Archives of the Metropolitan Museum of Art, New York.
2. Stephens, 1895, p. 17.
3. For a discussion of Plato and the Victorians, see Richard Jenkyns, *The Victorians and Ancient Greece* (Oxford, 1980).
4. Karlsruhe, Staatliche Kunsthalle, *Anselm Feuerbach, 1829–1880, Gemälde und Zeichnungen,* June 5–August 15, 1976, cats. 53, 59, Z33. The first drawing for *The Banquet of Plato* is dated 1865 (cat. Z33). The picture was engraved by Otto Reim.

5. Jenkyns (see note 3), p. 318.
6. New York, American Art Association, January 23–31, 1903, lot 88.
7. *The Art Journal,* 1885, p. 190. The column "Fine Art Gossip," in *The Athenaeum,* May 23, 1885, noted that several pictures in the Royal Academy exhibition for that year had been damaged by being scratched with a sharp instrument Among them was *A Reading from Homer,* scratched on the foot of the man lying on the floor.
8. J. D. Beazley, *Attic Red-Figure Vase-Painters,* 2nd ed. (Oxford, 1963), vol. 1, p. 431, no. 48. See also J. D. Beazley, "Hymn to Hermes," *American Journal of Archaeology,* vol. 52, no. 2 (1948), pp. 336–37.

9. Calvin Tomkins, *Merchants and Masterpieces: The Story of the Metropolitan Museum of Art* (New York, 1970), pp. 73ff.

10. Ibid., p. 73.

11. The piano and furniture were made by the firm of Johnstone, Norman and Co. in London. See the sales catalogue Sotheby Parke Bernet, New York (PB Eighty-Four), *Victorian International VII,* March 26, 1980, lots 535–39. The contemporary art press took a tremendous interest in Alma-Tadema's designs for the Marquand music room. See, for example, *The Art Journal,* 1885, p. 290.

12. Sold, Sotheby's Belgravia, April 18, 1978, lot 89.

13. Ormond, 1975, p. 124.

14. Leighton to Marquand, May 23, 1886, Archives, The Metropolitan Museum of Art, New York.

PROVENANCE: Henry Gurdon Marquand; his sale, American Art Association, New York, January 23, 1903, lot 88; M. Knoedler and Co.; George W. Elkins.

EXHIBITIONS: London, Royal Academy, 1885, no. 276; on loan to New York, The Metropolitan Museum of Art, 1890–93; Buffalo, Albright Art Gallery, *Inaugural Exhibition,* 1905; Philadelphia, Philadelphia Museum of Art, *Popular Favorites,* summer 1946; Providence, Rhode Island School of Design, *Isms in Art Since 1800,* 1949; Los Angeles, Municipal Art Gallery, *Old Favorites Revisited,* 1959, no. 1; New York, Robert Isaacson Gallery, 1962, no. 8; Ottawa, National Gallery of Canada, *An Exhibition of Paintings and Drawings by Victorian Artists in England,* 1965, no. 3.

LITERATURE: "Fine Art Gossip," *The Athenaeum,* February 7, 1885, p. 191; "Royal Academy (First Notice)," *The Athenaeum,* May 2, 1885, p. 571; "Fine Art Gossip," *The Athenaeum,* May 23, 1885, p. 670; "The Royal Academy," *The Art Journal,* 1885, p. 190; Henry Blackburn, ed., *Academy Notes 1885* (London, 1885), p. 9; Claude Phillipps, "Fine Art: The Royal Academy," *The Academy,* May 9, 1885, pp. 335–36; Claude Phillipps, "Expositions de la Royal Academy et de la Grosvenor Gallery," *Gazette des Beaux-Arts,* 27th year, 2nd ser., vol. 32 (1885), p. 94; Zimmern, 1886, pp. 24–25; Ebers, 1886, p. 90; C. Stuart Johnson, "Famous Artists and Their Work, XI: Lorenz Alma-Tadema," *Munsey's Magazine,* no. 3 (December 1892), repro. p. 258; Stephens, 1895, pp. 14, 17, p. 7 pl. XV; Spielmann, 1896, pp. 49–50; Monkhouse, 1899, p. 209; New York, The Metropolitan Museum of Art, *Handbook No. 6, Part 2: Loan Collections and Recent Gifts to the Museum, in the Old Eastern Gallery,* [Gallery] X, November 1890–April 1891, no. 44 (and four subsequent editions of *Handbook No. 6, Part 2,* May–November 1891, no. 56, November 1891–April 1892, no. 20, May–October 1892, no. 53, [November 1892–April 1893], no. 53); Zimmern, 1902, pp. 57–58, 71, repro. opp. p. 16; Thomas E. Kirby, ed., *Illustrated Catalogue of the Art and Literary Property Collected by the Late Henry G. Marquand* (New York, American Art Association, January 23–31, 1903), p. 12, lot 88, repro. (introduction by Russell Sturgis, catalogue of paintings by Charles Coffin); Florence N. Levy, "Art in America," *The Burlington Magazine,* vol. 7, no. 29 (August 1905), p. 400; Standing, 1905, pp. 78–79; Dircks, 1910, p. 31; Collier, 1913, p. 603; Elkins, 1925, no. 1; Elkins, 1935, p. 5; "Popular Favorites," *The Philadelphia Museum Bulletin,* vol. 41, no. 210 (May 1946), p. 83, repro. p. 89; A. Hyatt Mayor, "Collectors at Home," *The Metropolitan Museum of Art Bulletin,* vol. 16, no. 3 (November 1957), repro. p. 110; John Woodward, *A Picture History: British Painting* (London, 1962), repro. p. 137; Stuart Preston, "Current and Forthcoming Exhibitions: New York," *The Burlington Magazine,* vol. 104, no. 711 (June 1962), p. 275; Amaya, 1962, pp. 773, 777 fig. 7; Staley, 1974, pp. 38, 39 fig. 8, nn. 13, 14, 15; Swanson, 1977, pp. 26–27, 139, repro. p. 26; Rykle Borger, *Drei Klassizisten: Alma Tadema, Ebers, Vosmaer, mit Einer Bibliographie Der Werke Alma Tadema's* (Leiden, 1978), p. 14; Potter, 1979, p. 143; Richard Jenkyns, *The Victorians and Ancient Greece* (Oxford, 1980), p. 318, repro. between pp. 178–79.

CONDITION NOTES: The original support is medium-weight (20 x 20 threads/cm.) linen. The painting was lined with a wax-resin adhesive and medium-weight support in 1965. A thick, evenly applied white ground is present and extends uniformly onto the tacking margins. The paint is in good condition overall. Some areas of traction crackle are present, particularly in the dark transparent brown area around the cithara. An irregular web of narrow-aperture fracture crackle with slight associated cupping extends over the surface. Textural pentimenti indicate a change in the curve of the marble cove beneath the reader on the right. Infrared reflectography reveals additional changes to the position of the right arm of the reader, which had been extended, to the position of the cithara, and to the distant background detail (columns have been deleted). Under ultraviolet light, retouching is visible in the seated figure clothed in blue and in the figure standing at the far left. Retouchings to bottom of proper left foot, heel and arch, of the prone figure are slightly darkened.

ENGRAVINGS

1. Carl Dietrich after Lawrence Alma-Tadema, *A Reading from Homer,* 1886, engraving.

LITERATURE: Zimmern, 1886, repro. opp. p. 28.

2. James D. Smillie after Lawrence Alma-Tadema, *A Reading from Homer,* c. 1888, etching. Published by Appleton and Co.

LITERATURE: Letter from Smillie to Henry Marquand, May 31, 1898, Archives, The Metropolitan Museum of Art, New York.

RELATED WORK: Lawrence Alma-Tadema, *Girl and Boy Seated by a Cithara,* lithograph?, location unknown (fig. 1-3).

INSCRIBED: *Alma Tadema.*

DESCRIPTION: Cover of the Royal Academy's Student Dramatic Society program. Photograph: London, Witt Library.

Thomas Barker's father, Benjamin (d. 1793), an animal painter and decorator of japanware, was not, wrote an early biographer, "one of those *dull, sober, steady* mortals, that would sit down and be content to reap with industrious toil his moderate gains."[1] Originally from Newark upon Trent in Staffordshire, Benjamin Barker, Sr., was living in Pontypool, Monmouthshire (Wales), when his first son, Thomas, was born in 1769; around 1783 he moved with his family to Bath, perhaps prompted by signs of artistic talent in the thirteen-year-old boy. Soon Thomas caught the eye of a rich coachbuilder, Charles Spackman. In consideration of a stipend to the Barker family, Spackman took Thomas to live with him, educated him—perhaps at Shepton Mallet Grammar School—until he was about fifteen, and then employed him to turn out copies of the Italian and Flemish pictures in his own collection. Barker's biographers never quite make clear whether these copies were purely educational exercises or whether Spackman sold them as originals.

In either case, Spackman was an entrepreneur. In the spring of 1790 he put on an exhibition of his protégé's work in rooms he built for the purpose in Kingsmead Street, Bath. The press, making the most of the publicity given to the discovery of "natural geniuses" such as John Opie and, more recently, Thomas Lawrence of Bath (q.q.v.), sensed a story in Thomas Barker. One London newspaper, referring to the exhibition of 1790, trumpeted the appearance of "a very extraordinary genius ... [who] imitates all the ancients and excels all the moderns in their own style."[2] And from the 1790 exhibition, Thomas Macklin bought his *Woodman and His Dog in a Storm* (c. 1787, 93 x 58½″, London, Tate Gallery) and had it engraved by Francesco Bartolozzi (1727–1815).

In 1791 his patron sent him to Rome to copy old masters and to sketch in the galleries and in the Campagna. There he helped to set up the Society of English Art Students, a group that met on the first Saturday of every month for supper.[3] Of these artists, Barker was among the most industrious. In addition to the evidence of his many Italian scenes and sketches exhibited back in England, Shum tells us that Barker was the first of his countrymen to study the medium of fresco. Later, in 1825, he was to paint a thirty-by-twelve-foot fresco, *Inroad of the Turks upon Scio in April 1822,* on the walls of his house at Sion Hill in Bath. When in the 1840s English artists began to take an interest in the medium for the decoration of the new Houses of Parliament, Barker was one of the few Englishmen who could offer advice on how to proceed.[4]

While he was in Rome, a four-hundred-page book about him was published by a stranger, Sir Edward Harington (1793), called *A Schizzo on the Genius of Man*. The gist of Harington's panegyric can be summed up in one sentence: "It is astonishing to find a genius like [Barker's] breaking through the cloud of birth and situation! it shews that nothing can totally conceal or overcome the *divine fire* given by nature."[5] Also, in 1793, public curiosity to see the productions of the young genius was satisfied by a second exhibition, which showed his early works and pictures sent from Rome, held at 28 Haymarket in London in March. Even by this date, his big pictures were sold for three hundred guineas, which, as John Hayes remarks, was "every bit a Gainsborough price."[6] On his return to England in the spring of 1794, Barker was a much-publicized, up-and-coming young man; to cap all his good fortune, Spackman now consented to Barker's engagement to his daughter and left the couple everything in his will.

But in 1796 a double tragedy blighted these hopes: the father went bankrupt and the daughter died. Barker moved to London and stayed there until 1799, exhibiting regularly at the Royal Academy his landscapes painted from sketches made in Italy and trying to make his way alone in the London marketplace.

He succeeded brilliantly. The president of the Royal Academy, Benjamin West (1738–1820), bought two landscapes, which he called "most masterly,"[7] and Barker's patrons included the great collectors the Marquis of Stafford (1758–1833) and Sir John Leicester (1762–1827), as well as lords Egremont, Essex, Howard, and Dartmouth: "All...declared, that there never had appeared a genius in this kingdom of half his abilities."[8]

Financial security enabled Barker to return to his hometown where he stayed for the rest of his life. Between 1800 and 1803 he rented a house at 9 Camden Crescent. On October 12, 1803, he married Priscilla Jones and moved with her into the house at Sion Hill, designed for the bridegroom by Jason Gandy (1771–1843). Here Barker constructed an art gallery where in 1805 he opened the first of many exhibitions of his work, often joined by his brother Benjamin (1776–1838), the landscape painter, and later by his sons.[9] After 1800 he sent no more pictures to the Royal Academy but did exhibit eighteen works at the Suffolk Street Gallery and submitted pictures to the British Institution until the year of his death, 1847.

Sir Joshua Reynolds (q.v.) in his Discourses never tired of warning his young academy students to believe not in their own genius but in hard work and steady application—good advice, which Barker never took. He attempted to conceal weak draftsmanship with flashy brushwork and pseudodramatic effects of light and shade and never betrayed any knowledge of how the human body is made. His obituary remarks, "Barker never took a lesson in drawing or painting; his own genius and the examples furnished him by Mr. Spackman being his only instructors."[10] One who visited Thomas Barker at Sion Hill was Constable's (q.v.) friend John Fisher, who described him to Constable in a letter of January 27, 1825: "There is no art...out of London: & no doubt this poor man has lived with himself, & Bath Idol worshippers, until he thinks himself quite equal to Raphael."[11]

Yet he was a landscape artist, occasionally, of rare originality; one or two of his surviving works, such as the *Landscape, near Bath* (c. 1798, 32 x 42″, London, Tate Gallery), astonish us with their strange, lovely colors, ranging from deep purple to poison green. But the area of his work that deserves the most study, and has not received it, is his genre painting and lithographs. On the surface, these seem no more than crudely drawn variations on Gainsborough's (q.v.) late fancy pictures: wood gatherers, gypsies, and country bumpkins engaged in their picturesque occupations. But a second look shows us that these peasants are in no way idealized—indeed, that they are unlike any peasants in English painting. They stare back at us, looking out of the pictures with vacant, sometimes menacing, eyes, forcing us to look beyond their picturesque clothes and weathered faces. We feel confronted not so much by social conditions that may or may not have produced these outcasts but by the psychological reality of people dispossessed. Emotions found in such a picture as *Crazy Kate* (oil on paper on canvas, 41 x 30″, York, City Art Gallery)—despair, anger, and madness—are not associated with Gainsborough, and the artist who seems to have looked closest at Barker of Bath is the Victorian painter Richard Dadd (1817–1886).

Barker himself was apparently a mild and gentle man who bore a long marriage to a woman "with little mind and still less energy."[12] Toward the end of his long life, the decline of Bath as a spa left him on hard times, and he was eventually reduced to accepting a pension of one hundred pounds granted by the Prime Minister, Sir Robert Peel. Material for a biography—never completed—was compiled by George Vere Irving (1816–1869) in the 1850s. Vere's papers have not yet come to light. As a result, the two standard sources for Barker's life are still Harington (1793), which covers only the early years, and Shum (1862), which is only partly accurate.

1. Harington, 1793, pp. 123–24.
2. Shum, 1862, p. 7.
3. Ibid.
4. Ibid., p. 8.
5. Harington, 1793, pp. 331–32.
6. Bath, Victoria Art Gallery, *Barker of Bath: An Exhibition of Paintings and Drawings by Thomas Barker, 1769–1847,* June 7–30, 1962, p. 3.
7. Shum, 1862, p. 9.
8. Harington, 1793, p. 133.
9. Thomas had eight children, four of them boys. The most accomplished artist was Thomas Jones Barker (1815–1882).
10. *The Art-Union,* vol. 10 (February 1, 1848), p. 51.
11. Beckett, ed., 1962–68, vol. 6, p. 193.
12. Shum, 1862, p. 11.

BIBLIOGRAPHY: Reginald Wright, "Index of Bath Artists," n.d., Victoria Art Gallery and Bath Reference Library, Bath; Harington, 1793; Thomas Barker, *Forty Lithographic Impressions from Drawings by Thomas Barker, Selected from His Studies of Rustic Figures after Nature* (Bath, 1813); Thomas Barker, *Thirty-Two Lithographic Impressions from Pen Drawings of Landscape Scenery* (Bath, 1814); Obituary, *The Art-Union*, vol. 10 (February 1, 1848), p. 51; Shum, 1862; Percy Bate, "Thomas Barker, of Bath, Part I," *The Connoisseur*, vol. 10 (October 1904), pp. 107–12; Percy Bate, "Thomas Barker, of Bath, Part II," *The Connoisseur*, vol. 11 (February 1905), pp. 76–81; R[obert]

E[dmund] G[raves], *Dictionary of National Biography*, s.v. "Barker, Thomas"; Whitley, 1928, vol. 2, p. 87; John E. Barker, "Barker of Bath," *The Bath Critic*, vol. 2, no. 2 (1952), pp. 46–48; Dallett, 1968, pp. 652–55; Philadelphia and Detroit, 1968, pp. 179–80; Herrmann, 1973, pp. 127–28, pls. 113–14; Mary Holbrook, "Painters in Bath in the Eighteenth Century," *Apollo*, vol. 98 (November 1973), pp. 382–84.

EXHIBITIONS: Bath, Kingsmead Street, *Exhibition of Pictures by Thomas Barker*, 1790; London, 28 Haymarket, *Exhibition of Pictures by Thomas Barker*, March 1793; London, 20 Brook Street, Grosvenor Square, *Catalogue of Mr. Barker's Pictures*, April 1799; Bath, Victoria Art Gallery, *Barker of Bath: An Exhibition of Paintings and Drawings by Thomas Barker, 1769–1847*, June 7–30, 1962 (introduction by John Hayes).

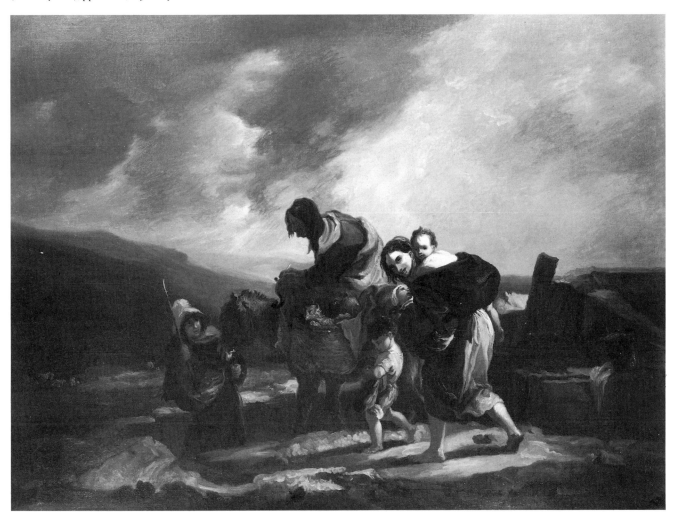

2 THOMAS BARKER OF BATH

GYPSIES ON THE HEATH, c. 1810–15
Oil on canvas, 30 x 41⅛" (76.2 x 105.1 cm.)
W. P. Wilstach Collection, W03-1-5

Thomas Barker is perhaps best known for his scenes of gypsy life. The inventory of Sir Robert Cockburn's collection (1931) records a drawing of gypsies dated as early as 1786, with at least three other gypsy subjects.[1] In 1793, Harington singled out *Gypsies Traveling* (49¼ x 40¼", Bath, Holburne of Menstrie Museum) for special praise,[2] and in the 1799 exhibition of Barker's work four pictures had gypsy themes. He also exhibited gypsy subjects at the British Institution in 1815, 1821, 1829, and 1830.

FIG. 2-1 Thomas Barker of Bath, *Lansdown Fair near Bath,* 1812, oil on canvas, 29¾ x 40¾" (75.6 x 103.5 cm.), London, Victoria and Albert Museum.

The catalogue of the John G. Johnson Collection, Philadelphia (1892), dates *Gypsies on the Heath* to 1815, presumably because at the exhibition in 1815 at the British Institution, number 55 was entitled *Traveling Gypsies.* But that canvas measured forty-five by fifty-seven inches, and so cannot be identical with *Gypsies on the Heath.* Nevertheless, a date of c. 1810–15 would be acceptable for *Gypsies on the Heath*; it might be compared stylistically to Barker's *Lansdown Fair near Bath* of 1812 (fig. 2-1) in which the same coarse and broad painting, the creamy pigment, and rather murky colors occur. But so little is known about the chronology of Barker's work that any date assigned to this painting must be treated with caution.

A picture entitled *A Showery Morning, with Gypsies Traveling* was exhibited at the Boston Athenaeum in 1827 (no. 15) and then again in 1832 (no. 183), from the collection of Patrick T. Jackson, who owned at least four other works by Barker of Bath.[3] Patrick Jackson's pictures descended to his wife and son Edward, each of whom lent pictures by Barker with gypsy themes to the Boston Athenaeum in 1850, 1852, and finally in 1869. It may be that *Gypsies on the Heath* was originally Jackson's picture, but since the printed catalogues of the Athenaeum give no dimensions, this is guesswork. In Philadelphia the dealers Shaw and Scarlett specialized in paintings by Barker of Bath, exhibiting his work sixteen times between 1822 and 1850. Thus it is possible that this picture came to Johnson from Jackson by way of Shaw and Scarlett, but no proof in the form of exhibition labels or inscriptions on the painting exists.

The picture itself is not typical of the picturesque gypsy scenes popularized by Morland or Shayer (q.q.v.); here the landscape is barren, the weather harsh. The homeless, barefoot gypsies walk away from a collapsed hovel or debris left by their camp on the right toward the desolation on the left. Nowhere does Barker idealize or sentimentalize his subject; nowhere does he allow us to grasp an easy reference to such traditional subjects as the Flight into Egypt. The situation of the young girl turning to look out at the spectators is realistically observed; we can imagine such a woman having to carry an infant in her arms, a baby on her back, while a toddler walks at her side. The toothless old grandmother, with her scraggly hair and smoking clay pipe can scarcely have been an image for a patron to contemplate with pleasure in the comfort of his drawing room. Surely Barker aimed to suggest qualities not usually treated at this date in English painting: resignation, defeat, isolation.

1. Files on the paintings, "Copy of the Catalogue in the Possession of Sir Robert Cockburn Bart. of Pictures by Thomas Barker and Other Members of the Barker Family," 1931, Holburne of Menstrie Museum, Bath.
2. Harington, 1793, p. 167.
3. Pointed out by Dallett, 1968. See also Robert F. Perkins, Jr., and William J. Gavin III, *The Boston Athenaeum Art Exhibition Index, 1827–1874* (Boston, 1980), pp. 16, 207.

PROVENANCE: John G. Johnson, by 1892; gift to the W. P. Wilstach Collection, September 15, 1903.

LITERATURE: *Catalogue of a Collection of Paintings Belonging to John G. Johnson* (Philadelphia, 1892), no. 273 (as "Gipsies on the March" painted in 1815); Wilstach, 1904, no. 13; Wilstach, 1922, p. 5, no. 11; Dallett, 1968, p. 654 fig. 5.

CONDITION NOTES: The original support is medium-weight (10 x 10 threads/cm.) linen. The tacking margins have been removed. The painting is lined with an aqueous adhesive and medium-weight linen. The white ground is visible along the cut edges. The paint is in excellent condition. Local areas of a very narrow-aperture traction crackle are evident in the foreground brown/black shadows. The pattern of crackle and paint-film flow in these areas suggest that a synthetic asphalt was used in the artist's palette.

Thomas Beach (sometimes called "Beach of Bath") was born in Abbey Milton (now Milton Abbas) in Dorset in 1738. Under the patronage of Lord Milton, a governor of the local grammar school where Thomas was educated, he entered the studio of Joshua Reynolds (q.v.) in 1760. There Beach stayed for two years, studying also at the academy in St. Martin's Lane. His earliest known work is a portrait of his mother dated 1761, but he does not emerge as an artistic personality in his own right until we find him working in Bath in 1772. There, at a concert in Beach's studio featuring the famous castrato Tenducci, Beach met Horace Walpole on June 8, 1781. Walpole noted that "most of the popular persons which frequent this gay place [Bath] have, at different times, sat to him."[1] So it was Beach who filled the vacancy in the portrait trade left by Gainsborough's (q.v.) departure for London in 1774, and Beach whose success drove Joseph Wright of Derby (q.v.) from Bath in 1777. In addition to his spa clientele, he made regular summer tours through the West Country, painting the gentry in their country houses. He is also known to have made annual trips to London in search of business.

Little is known about Beach personally: his obituary extols him as a man possessed of a "benevolent disposition," who was "exemplary in the exercises of religion and charity," but adds that "no man more enjoyed the social circle, or more contributed to its mirth."[2] He apparently employed no assistants, and not a single letter or preliminary sketch was known to his descendant and biographer Elise Beach in 1934. Miss Beach listed 308 portraits by her ancestor.

Beach first exhibited at the Incorporated Society of Artists in 1772, becoming a member in 1775, and submitting work there every year until 1777 and twice more in 1780 and 1783. In 1785 he first exhibited at the Royal Academy.

Beach's style is modeled on that of Reynolds; it has Reynolds's solidity and command of form, without having Reynolds's intellect or imagination. Then too, Beach's portraits are harder, glossier than his master's—and much less technically complex. The influence of Gainsborough is evident in his pretty, flattering colors, but he made no attempt to emulate the subtle glazes and scumbles employed by the greater artist. Although he reminds one of other artists, Beach's style is easy to recognize, if hard to define. Walpole, who liked the man and his work, wrote that his "portraits never require the horrid question of—*Pray whose is that Sir?* They always explain themselves."[3]

1. Walpole, 1937, p. 21.
2. "Obituary, with Anecdotes of Remarkable Persons," *The Gentleman's Magazine,* suppl., vol. 76 (1806), p. 1,252.
3. Walpole, 1937, p. 21.

BIBLIOGRAPHY: "Obituary, with Anecdotes of Remarkable Persons," *The Gentleman's Magazine,* suppl., vol. 76 (1806), p. 1,252; Whitley, 1928, vol. 1, pp. 247, 394, vol. 2, p. 367; "List of Portraits by Thomas Beach, compiled by Elise S. Beach, January 1931," Witt Library, London; Beach, 1934; Walpole, 1937, pp. 20–22; Waterhouse, 1978, pp. 230–31.

3 THOMAS BEACH

HON. MRS. LAMBERT OF BOYTON MANOR, WILTSHIRE, 1771
Oil on canvas, 30 x 25″ (75.5 x 62.8 cm.)
Gift of Mrs. Henry W. Breyer, 74-98-1

The sitter in this portrait was the wife of Edmund Lambert (d. 1802) of
Boyton House in Wiltshire. It is probable but not certain that she was his first
wife, Hon. Bridget Bourke, only daughter and heiress of John, 8th and last
Viscount Bourke of Mayo. The title under which the picture has been known,
Hon. Mrs. Lambert, would confirm that she was a peer's daughter. The first
Mrs. Lambert married on May 11, 1758, and bore one son, Aylmer-Bourke
Lambert. She died in May 1773. If the plausible date, 1771, assigned to this

picture by Elise Beach is correct, then the sitter, assuming she married at the usual age of about twenty, might be around thirty-three years old in Beach's portrait.

Curiously, however, the picture descended not through the children of the first Mrs. Lambert but of the second, also Bridget, daughter of Henry Seymer, Esq., of Hanford, Dorset. She bore Edmund Lambert two daughters, Anne-Elizabeth (died young) and Lucy (d. 1827). The portrait passed to Lucy, who in 1801 married John Benett, Esq., Member of Parliament for Wiltshire, and it was inherited by Lucy's eldest daughter (d. 1845), who married in 1832 Rev. Arthur Fane of Boyton Manor, near Boyton House, the original home of Edmund Lambert. This may suggest that the sitter was Lucy's mother or may have no more significance than a daughter's inheritance of her father's pictures.[1]

This picture is a fine example of Beach's style: workmanlike, well wrought, a portrait of real sensitivity but little imagination. Matronly and homely, Mrs. Lambert wears a gray rucked silk dress with black lace fichu, an ornament in her hair, and a white rose at her breast.

1. See *Burke's Genealogical and Heraldic History of the Landed Gentry,* 15th ed. (London, 1937), s.v. "Fane of Boyton Manor"; John Burke, *A Genealogical and Heraldic History of the Commoners of Great Britain and Ireland* (London, 1836), vol. 1, s.v. "Lambert."

PROVENANCE: By descent to Maj. Neville Fane, Boyton Manor, Wiltshire; and then to Capt. G. W. Penruddocke, Compton Park, Salisbury; his sale, Robinson and Fisher, Willis's Rooms, London, November 13, 1930, lot 64; Frost and Reed, 1934; Mrs. Henry W. Breyer.

EXHIBITION: Possibly London, Incorporated Society of Artists, 1772.

LITERATURE: "List of Portraits by Thomas Beach, Compiled by Elise S. Beach, January 1931," no. 136, Witt Library, London; Beach, 1934, pp. 12, 65, no. 189, repro. opp. p. 12.

CONDITION NOTES: The original support is twill-weave, medium-weight (10 x 10 threads/cm.) linen. The tacking margins have been removed. The painting has been lined with an aqueous adhesive and very fine linen. A thick and evenly applied off-white ground is visible along the cut edges. The paint is generally in poor condition. There are severe abrasions overall, most obvious in the mid-tone areas of the face. The weave texture of the support has been emphasized by lining throughout the bottom two-thirds of the design area; the top one-third still retains its smooth, even profile. Stretcher creases have formed on all four sides. A narrow-aperture traction crackle is present in the lace across the bodice. There is an irregular web of fracture crackle overall.

RELATED WORK: Thomas Beach, *Edmund Lambert,* 1771, oil on canvas, 30 x 25″ (76.2 x 63.5 cm.), location unknown.
 PROVENANCE: As for no. 3 except Penruddocke sale, Robinson and Fisher, Willis's Rooms, London, November 13, 1930, lot 63, bt. Waters.
 LITERATURE: Beach, 1934, p. 65, no. 188.
 DESCRIPTION: Pendant to *Hon. Mrs. Lambert* (no. 3).

Few artists of his generation probed more subtly the characters of their sitters than did William Beechey in his portraits of his friends, the brothers *Paul Sandby* (1789, 29 x 24½") and *Thomas Sandby* (1792, 35¼ x 27½", both London, National Portrait Gallery). His portraits of the daughters of George III (each 36 x 28", Her Majesty Queen Elizabeth II), commissioned by the Prince of Wales and exhibited at the Royal Academy in 1797, radiate a sense of gentle intimacy. And his full-length portrait of *Mrs. Siddons with the Emblems of Tragedy* (exhibited R.A. 1794, no. 127, 96½ x 60½", London, National Portrait Gallery), in which the aging actress stalks from right to left across the picture, dagger in hand, stopping to confront us with a bold stare, is Beechey's homage to Reynolds's (q.v.) famous seated portrait of the actress as *The Tragic Muse* of 1784 (93 x 57½", San Marino, California, Henry E. Huntington Library and Art Gallery) and also his challenge to Lawrence's (q.v.) recently exhibited masterpiece *Eliza Farren* (exhibited R.A. 1790, no. 171, 94 x 57½", New York, The Metropolitan Museum of Art).

Born in Burford in Oxfordshire in 1753, Beechey was trained to the law, entering a conveyancer's office in Stow-on-the-Wold, Gloucestershire, in the later 1760s, but leaving at once to work for a succession of solicitors in London. By chance he met a few students at the Royal Academy and left the service of his employer, a Mr. Owen of Tooke's Court, Curistor Street, to enter the Royal Academy schools in 1772 at nineteen. He married young, making his way in London by painting panel ornaments on coaches. His first patron was Dr. Strachey, a clergyman from Norwich and later archdeacon of Suffolk, who employed the young man to paint his family. Probably through Strachey, Beechey received other Norwich commissions, moving there in 1782 to set up a fashionable and successful practice in painting conversation pieces in the manner of Johann Zoffany (1733–1810).[1] By 1787 he was back in London, installed in a studio at 20 Lower Brook Street and then (from 1789) at Hill Street off Berkeley Square. Like Hoppner (q.v.), he may well have expected to succeed to the practices of the blind Reynolds and tired Romney (q.v.). And like Hoppner, his hopes were battered by the appearance in London of the young Thomas Lawrence, who in 1791 was elected Associate Royal Academician.

Each member of the royal family seems to have required his own official portrait painter. George III appointed Lawrence Principal Painter in 1792; the Prince of Wales chose Hoppner in 1789; and Queen Charlotte took up Beechey in 1793. Rarely were painter and patron so well matched. His portrait of the queen, exhibited at the Royal Academy in 1797 (no. 92, 98¾ x 62⅝", Her Majesty Queen Elizabeth II), shows an ordinary old lady holding her Maltese terrier in both arms. She looks like what she probably was: plump and housewifely, with a sweet nature. As she approved of Beechey's sympathetic but straightforward depiction of her, it is little wonder that she disliked Lawrence's 1789 full-length portrait (exhibited R.A. 1790, no. 100, 94½ x 58", London, National Gallery) in front of which the naive viewer might conclude that the queen possessed both beauty and glamour.

Queen Charlotte became a personal friend of the Beechey family, visiting their house in Harley Street (where they moved in 1798) and consenting to act as godmother to one of their children. Through her influence Beechey secured steady employment at court. In 1797 George III sat for Beechey's monumental equestrian group portrait *George III and the Prince of Wales Reviewing the Tenth Dragoons* (exhibited R.A. 1798, no. 178, 163½ x 197½", Her Majesty Queen Elizabeth II). In 1798 ("at the express intimation of the Queen"[2]) the king knighted him—the first artist to be so honored since Reynolds's death. He continued to work for the royal family until the 1830s, with one brief fall from

favor when in 1804 the unstable king told the artist that he "wanted no more of his pictures."[3]

Beechey first exhibited at the Royal Academy in 1776 and, apart from the years 1783–84, showed there regularly until his death in 1839, aged eighty-six. He was elected full Royal Academician in 1798, and in the 1830 election for the successor to Lawrence as president of the Royal Academy, he received the second largest number of votes—he was beaten by Martin Archer Shee (1769–1850). He also exhibited fancy pictures, genre, history, and landscapes at the British Institution, beginning in 1806. Once, in 1785, he sent pictures to the Society of Artists.

1. Turner, 1848, p. 74, states that Beechey actually worked for a time in the studio of Zoffany.
2. See Millar, 1969, vol. 1, p. xxii.
3. Ibid., p. 5.

BIBLIOGRAPHY: Farington Diary, [1793], passim; "Biographical Sketch of Sir William Beechey, R.A. with a Portrait," *The Monthly Mirror*, vol. 6 (1798), pp. 5–8; E. W. Brayley, ed., *The Works of the Late Edward Dayes: Containing . . . Professional Sketches of Modern Artists* (London, 1805), p. 319; "Sir William Beechey," *Public Characters of 1800–1801* (London, 1807), pp. 356–66; [Alaric A. Watts, ed.], "Notice of the Works of Sir William Beechey, R.A.," *The Cabinet of Modern Art and Literary Souvenir*, 1836, pp. 97–105; Obituary, *The Gentleman's Magazine*, n.s., vol. 11 (1839), pp. 432–33; Pilkington, 1840, p. 37; Turner, 1848, p. 74; Redgrave, 1878, p. 35; Roberts, 1907; E[rnest] R[adford], *Dictionary of National Biography*, s.v. "Beechey, R.A., Sir William"; Whitley, 1928, vols. 1, 2, passim; Whitley, 1928, *1800–1820*, passim; Whitley, 1930, passim; Waterhouse, 1953, pp. 226–27; Millar, 1969, vol. 1, pp. xix, xxii–xxiii, xxvii n. 81, xxviii, xxx–xxxi, 5–11; Burke, 1976, p. 278.

4 SIR WILLIAM BEECHEY

ELIZABETH, LADY LEDESPENCER, c. 1795–97
Oil on canvas, 24¾ x 19⅛″ (62.8 x 48.5 cm.)
Bequest of Helen S. Fennessy in memory of her stepfather, Horace
Trumbauer, 74-161-1

Elizabeth Eliot, born in Antigua about 1758, married Thomas Stapleton, 22nd
Baron LeDespencer (1766–1831), on July 29, 1791, at St. Marylebone Church in
London. She bore her husband four sons and six daughters. Their country
seat was Mereworth Castle, Maidstone, Kent, and their London address was
Hanover Square. Elizabeth died in Bath on July 3, 1848, aged ninety.[1] This
straightforward biography hides a life of flamboyant extremes, which we can
read about through the surviving correspondence of her husband, preserved in
the archives office, Maidstone, Kent.[2]

Sir Thomas Stapleton inherited the barony of LeDespencer in 1788 at the
age of twenty-one, succeeding to vast estates in Kent, Oxfordshire, Yorkshire,
and Devonshire, and to an income of about £8,000 per year. By 1796 he was
deeply in debt, hounded by his creditors, insulted by tradesmen. His bills in
eighteenth-century terms seem today incredible: £237 to a perfumer in Bond
Street, £1,139 to a clothier, also in Bond Street, £1,143 to a coachmaker in
Long Acre. To meet the cost of maintaining Mereworth and his huge town
house, he sold off his lands in great chunks but without modifying his mode
of life. By 1806 his solicitor was writing to his steward, stating plainly that
LeDespencer was on the verge of being arrested. But still the extravagance
continued. By 1813 his debts had risen to £45,416 and by 1815 LeDespencer had
fled with his wife to Brussels, leaving his agents to deal with the law as best
they could. By 1817 he was living abroad on £800 a year.

LeDespencer squandered a fortune, ruining this branch of an ancient
family by his ostentatious living. Although Lady LeDespencer's letters are not
preserved with his in Maidstone, it is clear from references to her in letters
from family agents that she was as incapable of moderation in financial
matters as her husband.

The Philadelphia picture probably dates from the most flamboyant period
of the couple's married life, when the first mountain of debts had not yet
made inroads on their health or confidence. The sitter wears a simple white
muslin dress with a red turban on her head and a sash at her waist. These were
the fashions in England toward the end of the 1790s, and a comparison with
the clothes and style of Beechey's portraits of *Charlotte, Princess Royal* (1797,
36 x 27½″) and *Princess Augusta* (1797, 36½ x 28″, both Her Majesty Queen
Elizabeth II)[3] shows that our *Lady LeDespencer* should be dated to about
1795–97. In all three pictures the artist has set off the strongly focused and
realistic face against a smoky and slightly hazy background. This portrait has
been cut down and was originally in a feigned oval.

1. *Complete Peerage*, 1910–, vol. 4 (1916), p. 286.
2. H. G. Hunt, "The Finances of Sir Thomas Stapleton in the Early Nineteenth Century," *Archaeologia Cantiana, 1961*, vol. 76 (1962), pp. 169–79.
3. Millar, 1969, vol. 2, pls. 163, 164.

INSCRIPTION: *Ellsth Lady Le Despencer / wife of Thomas 22 Baron Le Despencer / about the year 1795 / by Romney* [in a modern hand on the canvas]; and the remains of an old label on the stretcher identifying the sitter.

PROVENANCE: Anonymous sale [Sir Miles T. Stapleton, Bart.], Christie's, November 18, 1927, lot 131 (as by Hoppner [q.v.]); bt. Agnew; Agnew, 1928.

CONDITION NOTES: The original support is medium-weight (16 x 16 threads/cm.) linen. The tacking margins have been removed, and the support cut down on all four sides. Traces of the feigned oval format are visible in the lower left and right corners. The painting is lined with an aqueous emulsion adhesive and medium-weight linen. An off-white ground can be seen along the cut edges of the support. The paint is in only fair condition. There are

pinpoint losses around the head of the figure and abrasion in the thinnest areas of the background. An irregular web of narrow-aperture fracture crackle with slight associated cupping is present overall. The brushwork texture is varied in profile and has been flattened by lining. Under ultraviolet light, pinpoint retouches are evident overall. The area above the figure's head has been substantially overpainted.

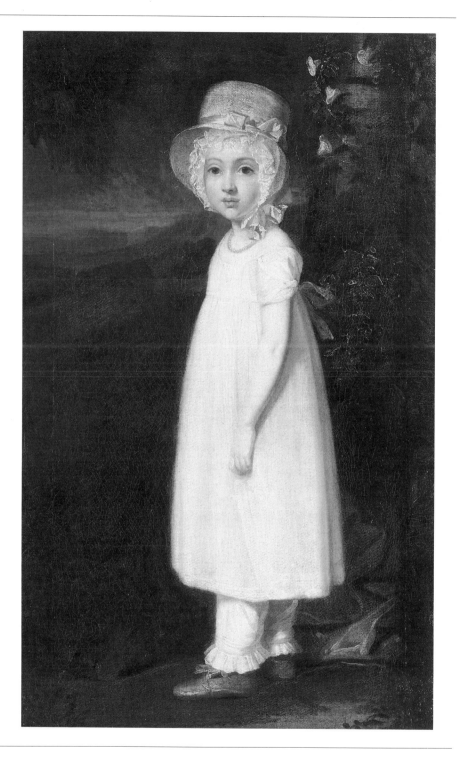

5 SIR WILIAM BEECHEY

PORTRAIT OF A LITTLE GIRL (LITTLE MARY), c. 1810–15
Oil on canvas, 42½ x 25¾" (108 x 65.5 cm.)
Gift of Mrs. John S. Williams, 46-88-1

Beechey's *Little Girl* is a fragment of a much larger portrait group, part of
which is still visible in x-radiographs (fig. 5-1). To the left of the standing
child, a barefoot girl (?) in a loose white chemise sits on a woman's (probably
her mother's) lap. The hands of the mother can be seen encircling the child's
waist. Sprawled at the mother's feet is a little boy, whose shoes and trousers
are still visible in the x-radiograph. The very free overpaint covering these
figures extends up to the standing child, but not to her other side. The border

FIG. 5-1 X-radiograph of *Portrait of a
Little Girl,* Philadelphia Museum of Art,
Conservation Department

strips added left and right have some painting on them (bits of loosely painted foliage) and seem in canvas weave possibly to belong to the remaining fragment. Neither the figure of the standing child nor the foliage at the right seems to have been tampered with. The identity of this child or her family is not known. From her costume it is possible to date this picture to c. 1810–15.

INSCRIPTION: Various labels on the stretcher with the name of the painter, title, bibliography, and exhibition history, and various warehouse or inventory stickers.

PROVENANCE: Henry J. Pfungst, by 1900; D. H. Farr, Philadelphia, 1928; Mrs. John S. Williams, Hewlett, Long Island, New York.

EXHIBITION: Birmingham, Museum and Art Gallery, *Illustrated Catalogue of a Loan Collection of Portraits by Sir Joshua Reynolds, George Romney, Thomas Gainsborough, John Hoppner, Sir Henry Raeburn, and Other Artists,* 1900, no. 41, pl. XXII (by Whitworth Wallis and Arthur Bensley Chamberlain).

LITERATURE: C. Hubert Letts, *The Hundred Best Pictures,* 2nd ser. (London, 1902), p. 154, repro. p. 155 (as "Little Mary"); Roberts, 1907, p. 219, repro. opp. p. 164.

CONDITION NOTES: The support consists of four pieces of twill-weave, medium-weight (10 x 10 threads/cm.) linen. The largest piece carries the figure, while three smaller strips, one along the length of the right edge and the other two butted together and along the left edge, were added to extend the present composition. By x-radiograph all four pieces appear to have been cut from a larger composition and have painted elements similar in nature. The painting has been relined with an aqueous adhesive and medium-weight fabric. A previous aqueous lining has been retained as well. A thick, off-white ground is visible along the cut edges of the support. The paint is in only fair condition. Extensive abrasion has occurred in the dark background and is most evident along the joins between support pieces. A wide-aperture traction crackle is present throughout the bonnet area and brown shadow areas of the background on the right, suggesting a natural bitumen pigment in the artist's palette. An irregular web of fracture crackle extends over the entire surface. The entire left-hand side of the composition has been overpainted up to the edge of the figure, with a distinctly different bituminous pigment from that in the right-hand side; areas of this pigment appear glossy, resinous, and have flowed with age. With infrared reflectography and x-radiography, the partial underdrawing of a mother and other children is revealed to the left of the figure.

ENGRAVING: F. G. Stevenson after Sir William Beechey, colored mezzotint. Published: Dickens.

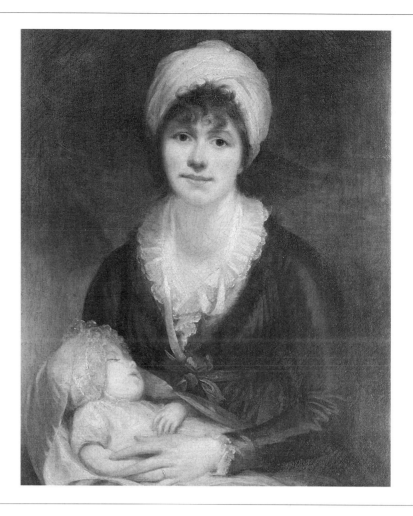

6 AFTER SIR WILLIAM BEECHEY

LADY BEECHEY AND HER CHILD, after 1800
Oil on canvas, 29⅞ x 24⅜" (75.8 x 62.4 cm.)
Gift of Mrs. S. Emlen Stokes, 73-264-1

Lady Beechey and Her Child is a version from Beechey's studio (and possibly from his hand) after Beechey's painting in the Detroit Institute of Arts. It is the Detroit picture, presumably, that the writer of "Public Characters, 1800–1801" described as "A portrait of Lady Beechey, with the youngest of eight children in her arms, [which] we cannot omit noticing, as a strong example of the manner in which an artist succeeds when he paints *con amore*: in point of drawing, resemblance, colouring and character, it is a *chef d'oeuvre*. If it came into our plan to enumerate this lady's performances in miniature, (for she also is an artist, and a good one) many admirable little pictures might be added to this list."[1] The picture was generally praised, and one critic wrote that "the appearance of nature is ably represented in the child, and there is a pleasing expression of parental tenderness in the mother."[2]

Lady Beechey is shown in half length, holding her infant daughter Anna Dodsworth Beechey, who was born in 1800. She is dressed in black satin trimmed in brown fur with a white ruffled collar, a brown embroidered shawl, and wears a fashionable white turban. The child wears a lace bonnet and is wrapped in a pink coverlet. In 1825 this daughter married John Jackson of Hambleton, Rutlandshire, and Queen Anne Street, London.

Roberts (1907, p. 194) described a portrait of Anna Dodsworth Beechey as a baby "being nursed by her mother" in the collection of Rev. Hippisley Jackson of Stagsden Vicarage, Bedford. It is not clear whether this is the Detroit or the Philadelphia picture, although Rev. Hippisley Jackson would

certainly be a descendant of Anna Beechey Jackson. (*Lady Beechey and Her Child* was sold in 1930 as *Mrs. Tennant and Child,* but this identification is clearly wrong.)

This is a portrait of Beechey's second wife, born Anne Phyllis Jessop (1764–1833/4) in Thorpe, near Norwich. As a miniature-painter she first exhibited at the Royal Academy under her maiden name in 1787. She married Beechey, with Paul Sandby (q.v.) as a witness, in St. George's Church, Hanover Square, on February 27, 1793, and thereafter exhibited under her married name from 1795 to 1805. She bore fifteen children, twelve of whom lived to maturity.[3]

FIG. 6-1 Sir William Beechey, *Lady Beechey and Her Baby,* oil on canvas, 29½ x 24½" (74.9 x 62.2 cm.), Detroit, The Detroit Institute of Arts, Gift of Mr. and Mrs. A. D. Wilkinson

1. "Sir William Beechey," *Public Characters of 1800–1801* (London, 1807), p. 362.
2. Quoted by Roberts, 1907, p. 187, who mistakenly suggested that no. 179 in the Royal Academy exhibition of 1800, the portrait of Lady Beechey, is a half-length portrait formerly in the collection of E. G. Raphael (30 x 25", Roberts, 1907, repro. opp. p. 26). This shows a lady with sketching book and crayon, but it cannot be no. 179 because the newspaper descriptions of that portrait, quoted by Roberts himself, pp. 71–72, mention the child.
3. Daphne Foskett, *A Dictionary of British Miniature Painters* (London, 1972), vol. 1, p. 159. See also Roberts, 1907, pp. 7–8, 184–88; "Sir William Beechey," *Public Characters of 1800–1801* (London, 1807), p. 362.

INSCRIPTION: . . . *apman Bros. / Chelsea Ltd. / Picture restorers / Carvers, gilders, etc. / 241 Kings Rd., Chelsea / No. 4134* [on a printed sticker with penciled-in number, pasted on the stretcher].

PROVENANCE: Arthur Edwin Bye; Dr. and Mrs. S. Emlen Stokes, purchased 1930.

CONDITION NOTES: The original support is twill-weave, medium-weight (12 x 12/cm.) linen. The tacking margins have been removed. The painting is lined with an aqueous adhesive and medium-weight linen. An off-white ground is evident along the cut edges. The paint is in good condition. A fine web of fracture crackle extends over the entire surface and radiates inward from each corner. Some abrasion is present and most evident in the mid-tones of the mother's face. Microscopic examination in the area of the mother and child's hands shows retouching to these details, probably covering dark varnish residues in the interstices of the canvas weave.

VERSION: Sir William Beechey, *Lady Beechey and Her Baby,* oil on canvas, 29½ x 24½" (74.9 x 62.2 cm.), Detroit, The Detroit Institute of Arts (fig. 6-1).

PROVENANCE: Possibly Anna Dodsworth Beechey Jackson, and then by descent to Rev. Hippisley Jackson of Stagsden Vicarage, Bedford, by 1907; Mr. and Mrs. Edgar B. Whitcomb; Mrs. Harriet W. Wilkinson; her gift to the Detroit Institute of Arts, 1953.

EXHIBITION: Presumably London, Royal Academy, 1800, no. 179 (as "Lady Beechey").

LITERATURE: Roberts, 1907, pp. 71–72, 184–86, 194; Walter Heil, *Art in America,* vol. 16 (February 1928), pp. 49ff.; Walter Heil, "Catalogue of the Works of Art in the Collection of Mr. and Mrs. Edgar B. Whitcomb," MS., p. 58, Archives, The Detroit Institute of Arts, Detroit; Detroit, The Detroit Institute of Arts, *Bulletin of the Detroit Institute of Arts,* vol. 34, no. 1 (1954–55), p. 13, repro. (cover).

Born in 1755, William Redmore Bigg entered the Royal Academy schools in 1778 to study there with the professor of painting Edward Penny (1714–1791), who was a foundation member of the Royal Academy in 1768. Despite an apparently intimate friendship with Joshua Reynolds (q.v.), remarked upon by all Bigg's biographers, and a prolific output as an artist, Bigg was not elected an Associate at the academy until 1787 and then waited twenty-seven years, until 1814, for full membership. He died in his house on Great Russell Street on February 6, 1828. C. R. Leslie (1794–1859) described him as "an admirable specimen, both in look and manner, of an old fashioned English gentleman. A more amiable man never existed."[1] But otherwise, this bare outline constitutes almost all that is known of his life.

From the beginning of his career, Bigg emulated Penny's subject matter, exhibiting scenes exemplifying moral good, such as his first picture at the Royal Academy of 1780 (no. 303), *Schoolboys Giving Charity to a Blind Man* (30 x 36″, location unknown). Often the titles of the works he exhibited throughout his long career sum up the artistic intentions of this gentle and modest master: *The Gallant Sailor Boy, Returning Home with His Mother and Sister, Attacked by Robbers, Bravely Defends His Prize Money* (exhibited R.A. 1803, no. 173, location unknown). Between 1806 and 1828 he exhibited at least one picture every year at the British Institution. But as the fashion for sentimental cottage scenes passed, Bigg found little market for his pictures. In later life he became a restorer of pictures but barely made ends meet. John Constable (q.v.), who was a close friend, called him "a sad melancholy man," whom he might find of an evening dining on bread and cheese.[2]

1. Beckett, ed., 1962–68, vol. 4, p. 244.
2. John to Maria Constable, September 5 and 6, 1825, in Beckett, ed., 1962–68, vol. 2, pp. 384–85.

BIBLIOGRAPHY: E. W. Brayley, ed., *The Works of the Late Edward Dayes: Containing . . . Professional Sketches of Modern Artists* (London, 1805), p. 320; Obituary, *The Gentleman's Magazine*, vol. 98 (1828), p. 376; G. D. Leslie and Frederick A. Eaton, "The Royal Academy in the Present Century," *The Art Journal*, 1899, pp. 42–43; E[rnest] R[adford], *Dictionary of National Biography,* s.v. "Bigg, William Redmore"; J. E. Hodgson and F. A. Eaton, *The Royal Academy and Its Members, 1768–1830* (London, 1905), pp. 268, 272–73; Beckett, ed., 1962–68, vols. 2, 4, passim.

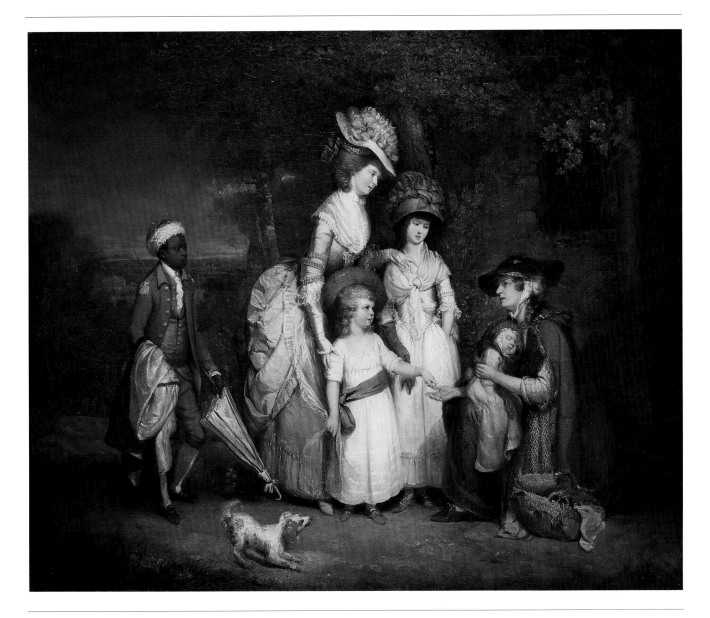

7 WILLIAM REDMORE BIGG *A LADY AND HER CHILDREN RELIEVING A COTTAGER*, 1781
 Oil on canvas, 29¾ x 35½" (75.5 x 90.2 cm.)
 Inscribed lower right on basket: *WR Bigg 178* [1?]
 Gift of Mr. and Mrs. Harald Paumgarten, 47-64-1

Apart, perhaps, from Chastity, only two virtues seem to have been regularly
celebrated by English painters of moralizing genre from Hogarth to Morland
(q.q.v.): Industry[1] and Charity. William Redmore Bigg's *Woman and Her
Children Relieving a Distressed Cottager*, exhibited at the Royal Academy in
1781, is among the earliest paintings to illustrate the second of these virtues.

As in Greuze's *La Dame Bienfaisante*, published in Massard's engraving of
1778 (fig. 7-1), Bigg's mother teaches her two children to be charitable to one
less fortunate than they: in this case to a poor, red-haired (perhaps Irish)
cottager and her baby. The duties of the upper classes are thus recognized, but
so are the obligations of the lower—for the poor cottager is not sitting by her
doorstep[2] but kneeling in grateful appreciation for the money taken from the
hands of the younger child. We are left in no doubt about the relative stations
of the donor and the recipient, for the lady is clearly mistress of the great
house and park seen in the distance, and perhaps the owner of the black
servant at the left who carries her cloak and parasol. That this confrontation
with poverty is not only heartrending but also slightly frightening to the

FIG. 7-1 J. Massard after Jean Baptiste Greuze (1725–1805), *La Dame Bienfaisante*, 1778, line engraving, 21¼ x 24¾″ (54 x 63 cm.), London, British Museum

smaller child is underscored by the gentle push she receives from her mother and the alarm of the barking spaniel in the foreground.

Nevertheless, the whole is far from realistic, and we should perhaps compare the artist's choice of a trivial domestic situation, his interest in every detail of the fashionable clothing of the rich lady and her children, to a post-rococo tradition developing in France in this decade, exemplified by the paintings of Marguérite Gerard (1761–1837). On another level, the decorative intent of the picture is underscored not so much in the loving description of the bustles and bonnets and sashes of the rich family, or the execution of the painting in tones of silver, green, and lilac, as it is in the unnaturally clean and tidy look of the peasant and her child. John Barrell points out that this way of looking (or not looking) at the poor by English artists of the late eighteenth century is precisely the element that sold prints after their pictures. He also calls attention to the "embarrassing paradox at the centre of the late eighteenth-century attempt to define the image of the deserving poor . . . that [those] who need the least help, will attract the most."[3] Barrell quotes the writer of religious tracts Hannah More (1745–1833), who wrote that it is a "common mistake, that a beggarly-looking cottage, and filthy-ragged children" raise most compassion "for it is neatness, housewifery, and a decent appearance, which draws the kindness of the rich and charitable, while they turn away disgusted from filth and laziness."[4]

The theme of Charity Relieving Distress was popular in English painting through the 1780s and then developed in the nineteenth century into one of the most common forms of genre painting, revived in Victorian times by an art-buying public influenced by the evangelical cast of Victorian religion which, as Ruskin in all his writings demonstrates, insisted on finding moral instruction in works of art. Eighteenth-century artists who worked the theme include Bigg's teacher Edward Penny (1714–1791) in *The Generosity of Johnny Pearmain* (exhibited R.A. 1782, no. 30, 36 x 31″, New Haven, Yale Center for British Art); Thomas Gainsborough (q.v.), *Charity Relieving Distress* (1784, 39 x 30″, Sir Francis Cassel, Bart. Collection); and George Morland, *The Benevolent Lady* (see fig. 7-2). Perhaps the most famous and effective variation on the theme is William Mulready's (1786–1863) *Train Up a Child* (exhibited R.A. 1841, no. 109, oil on panel, 25½ x 31″, Sotheby's, November 27, 1984, lot 1,176). When Bigg's picture was exhibited at the Royal Academy in 1781 the Ear-Wig called it "a sweet picture—Nature pursued with taste and real sentiment."[5]

FIG. 7-2 E. I. Dumee after George Morland (q.v.), *The Benevolent Lady,* 1788, stipple engraving, 9⅜ x 8⅜″ (24 x 21 cm.). Published: February 1, 1791

1. See no. 57, Morland's *Fruits of Early Industry and Economy.*
2. As, for example, in Morland's *Happy Cottagers,* no. 60.
3. Barrell, 1980, p. 76.
4. Quoted by Barrell, 1980, p. 76.
5. Ear-Wig, 1781, p. 7, no. 18.

PROVENANCE: Sold by W. Webb under Diff. Properties, Christie's, April 18, 1848, lot 134, bt. H.P.; sold by Miss M. Paine under Diff. Properties, Christie's, December 21, 1928, lot 65, bt. Colnaghi; Robinette; Mr. and Mrs. Harald Paumgarten.

EXHIBITION: London, Royal Academy, 1781, no. 18.

LITERATURE: Ear-Wig, 1781, p. 7; "In the Saleroom," *The Connoisseur,* vol. 83 (February 1929), p. 115.

CONDITION NOTES: The original support is medium-weight (15 x 15 threads/cm.) linen. The tacking margins have been removed. The painting has been relined with a wax-resin adhesive and medium-weight linen. A previous aqueous adhesive lining has been retained. The wax-resin relining was found to be delaminating in 1984 and was locally reattached with an additional wax-resin adhesive. An off-white ground is present and is evident along the cut edges. The paint is in only fair condition. An irregular net of wide-aperture traction crackle is present overall. Much of the original paint profile has been flattened somewhat by lining. Some surface alteration has resulted from filling and overfilling of the traction crackle. Local areas of abrasion are evident in the highlights of the figures. Under ultraviolet light, retouches are visible in much of the traction crackle throughout the figures and the background. In addition, microscopic examination under normal light conditions reveals more retouches in the figures, which are not readily visible in ultraviolet light but cover areas of old abrasions.

VERSION: After William Redmore Bigg, *A Lady and Her Children Relieving a Cottager,* oil on canvas, 35¼ x 43½″ (89.5 x 109 cm.), location unknown.

INSCRIPTION: *E. PENNY R.A.*

PROVENANCE: Sotheby's, July 9, 1980, lot 61 (as by W. R. Bigg).

DESCRIPTION: Perhaps after Smith's 1782 engraving.

ENGRAVINGS: 1st state, J. Raphael Smith after William Redmore Bigg, 1782, mezzotint, 17⅞ x 21″ (45.4 x 53.3 cm.).

INSCRIPTION: *Painted by W. Bigg / Engraved by J.R. Smith / A Lady and her Children relieving a Cottager. London Publish'd July 1st 1782 by JR Smith No. 83 Oxford Street and J. Burchell No 473 Strand.*

2nd state: Publication line altered to *Published 1784 by J. Burchell.*

3rd state: Publication line altered to *Published 1st March 1784.*

EXHIBITION: London, Free Society of Artists, 1782, no. 119.

LITERATURE: Julia Frankau, *An Eighteenth Century Artist and Engraver: John Raphael Smith: His Life and Works* (London, 1902), pp. 42, 154–55.

RELATED WORK: J. Raphael Smith after William Redmore Bigg, *Schoolboys Giving Charity to a Blind Man,* mezzotint, 17⅞ x 21″ (45.4 x 53.3 cm.).

EXHIBITION: London, Free Society of Artists, 1782, no. 121.

DESCRIPTION: Smith's engraving of Bigg's painting (exhibited at the Royal Academy in 1780) *Schoolboys Giving Charity to a Blind Man* was exhibited at the Free Society of Artists in 1782 as a pendant to Smith's engraving of *A Lady and Her Children Relieving a Cottager.* The oil paintings were not, however, pendants.

William Blake was born in Soho on November 28, 1757. His father, a hosier, sent him at twelve to Henry Pars's (1734–1806) drawing school in the Strand, then at fifteen apprenticed him to the engraver James Basire (1730–1802). From Basire, Blake absorbed an austere style of line engraving, highly appropriate for his earliest works, the representations of Gothic effigies in Westminster Abbey engraved for the Society of Antiquarians in 1774–75. Working alone in the ancient abbey, he developed a love for the uncompromising spirituality of medieval art and this together with only limited experience in drawing from casts and from life at Pars's and during a brief spell at the Royal Academy schools (1779) combined to form a style at once visionary and naive.

In 1779 Blake set up on his own as an engraver and in 1782 married the daughter of a market gardener, Catherine Boucher (1762–1831). With money inherited upon his father's death in 1784 he and Catherine ran a small business selling prints at 27 Broad Street, Soho, from 1784 to 1785. There followed a period living at 28 Poland Street, Soho, from 1785 to 1790, and then a move to 13 Hercules Buildings, Lambeth, where they lived from 1790 to 1800. At intervals throughout this first part of his career he exhibited watercolors at the Royal Academy.[1]

As early as 1784 we hear of Blake, introduced by his friend John Flaxman (1756–1826) into the intellectual and artistic circle surrounding the family of Rev. A. S. Mathew (1733–1824), singing his own songs to Mrs. Harriet Mathew's guests. It was she who paid for the publication of his earliest poems, preludes to the radiant works of his first maturity, the *Songs of Innocence* (1789) and *Songs of Experience* (1794). These are among the most beautiful poems in English, belying in their simple language and childlike meter profound moral and philosophical themes. Blake illustrated the songs with his own designs showing shepherds, children, nurses, and comic animals—illustrations deceptively like those for children's books and reminiscent of the sweetly sentimental style of such artists as Francis Wheatley and William Redmore Bigg (q.q.v.). But just as no one word in the poems is without import and weight, no detail of the illustrations can be overlooked for its contribution to the meaning of the poems. The illustrations and text blend into a perfect artistic whole.

Three strands in Blake's life—art, religion, and politics, which in another man might have remained parallel and separate—he wove into one fabric of thought in the late 1780s. In 1787 Blake and his wife began their first experiments in printmaking, and in the following year they were briefly connected with the New Jerusalem Church of the Swedish mystic Emanuel Swedenborg (1688–1772), a connection that, although soon repudiated by the artist, encouraged in him a typological cast of mind and affirmed for him the existence of a parallel universe of spirits and visions. Finally, Blake, with his friends Flaxman and Henry Fuseli (1741–1825), moved in radical political circles, particularly among those men and women sympathetic to the American and French revolutions: Tom Paine (1737–1809), William Godwin (1756–1836), and Mary Wollstonecroft (1759–1797). Yet Blake's vision was even more profound and comprehensive than those more actively involved in politics, perhaps because he saw the great changes of his age through the eyes of one imbued with visionary as well as humanist ideals. Long before most of his contemporaries, he saw how the government, the military, and the industrial states would combine to destroy a green and rural nation, forcing men to work like machines for the owners of "dark satanic mills."

In his prophetic books of the late 1780s and 1790s, *Tiriel* (1789), *Thel* (1789), *America* (1793), *Europe* (1794), and *Urizen* (1794), Blake's theme was, broadly, the alienation of man from his true nature. In them he wrote of the

modern concept of the personality unable to love, forgive, imagine, or create. In these myths he postulated a self originally male and female split into fragments at the time of the creation, a self continuing to splinter and fragment until man's feelings, at war with each other, spread pain and chaos throughout the world. The prophetic books are also illustrated, although the word *illustrate* somehow implies a subordination of design to text, whereas the two are equal in conveying Blake's meaning. It is true that the prophetic books have a reputation for incomprehensibility, yet, in Gilchrist's words, even the most difficult poems have "a grandeur ... as of the utterance of a man whose eyes are fixed on strange and awful sights, invisible to bystanders."[2] In the same way, the illustrations usually require a knowledge of the text and quite often need critical interpretation, and yet are in themselves beautiful in invention and color. In 1863 Gilchrist described Lord Houghton's copy of Blake's *America:* "Turning over the leaves, it is sometimes like an increase of daylight on the retina. ... The skies of sapphire, or gold, rayed with hues of sunset, against which stand out leaf of blossom, or pendent branch, gay with bright-plumaged birds."[3]

The culmination of Blake's work as an illustrator came in 1795 when he produced the Large Color Prints, a series of twelve subjects, many inspired by passages from the Bible, Shakespeare, and Milton but some unrelated to any text. All are executed in Blake's most extreme Fuselian style, and the most famous images, *The Ancient of Days, Newton,* and *Nebuchadnezzar,* are among the most beautiful and unforgettable works of art of the eighteenth century. These prints are almost visual poems, as dense and rich in meaning as the written poems, and in many ways as impenetrable without critical guidance.

The question of Blake's spiritual life, and particularly of his famous visions, cannot be omitted from any discussion of the composition of the prophetic books. Speaking of these visions, his wife reminded him, "You know, dear, the first time you saw God was when You were four years old And he put his head to the window and set you ascreaming."[4] On Peckham Rye, Dulwich Hill, at the age of eight or ten he saw a tree filled with angels,[5] and as an adult he maintained that his works were dictated to him by the spirits: "When I am commanded by the Spirits then I write, And the moment I have written, I see the Words fly about the room in all directions."[6] Yet on another occasion when a woman at a party asked him where he saw one of his more flamboyant visions, he touched his forehead and said, *"Here,* madam."[7] Thus, in speaking of his visions, Blake was speaking of an unusually vivid visual imagination. In the descriptive catalogue from 1809 of his works he wrote: "A Spirit and a Vision are not, as the modern philosophy supposes, a cloudy vapour or a nothing: they are organized and minutely articulated beyond all that the mortal and perishing nature can produce. He who does not imagine in stronger and better lineaments, and in stronger and better light than his perishing mortal eye can see does not imagine at all."[8] Finally, the experiences and feelings he described are those of mystical writers whom he is known to have read such as Emanuel Swedenborg, Jakob Böhme (1575–1624), and Saint Teresa of Ávila (1515–1582).

While he was working on the prophetic books, Blake supported himself by engraving and by commissions from his great patron Thomas Butts (1757–1845). He also undertook commissions to illustrate the works of other poets, in his ravishing watercolors for Edward Young's *Night Thoughts* (1795–97) and engravings for Robert Blair's *The Grave* (1805). But none of these publications made much money and when engraving work dried up around the turn of the century he accepted the invitation of the poet William Hayley (1745–1820) to live and work near him at Felpham in Surrey. Hayley, a poet, in Byron's words, "for ever feeble," but a patron of rare though

misguided imagination, had in the 1780s and 1790s taken Romney (q.v.) under his wing and patronized both the poet William Cowper and the painter Joseph Wright of Derby (q.v.). Now he turned to Blake. Hayley may be held responsible not only for employing Blake in the first place but also for employing him only in menial tasks such as engraving Romney's portrait of Cowper or decorating Hayley's library. More seriously, he failed to comprehend the greatness of the poet he had befriended.

In a letter of January 10, 1803, Blake complained to Butts that Hayley objected to his "doing any thing but the mere drudgery of business"[9] and by the end of the year he was back in London, where he took up residence at 17 South Molton Street off Oxford Street. There followed years of the deepest obscurity, illuminated for us by his one-man exhibition of 1809, held at his brother James's shop in Broad Street, Soho, and accompanied by a catalogue containing a manifesto summing up his artistic beliefs. Few visitors were attracted to Blake's exhibition, and Robert Hunt in *The Examiner* for September 17, 1809, called him "an unfortunate lunatic; whose personal inoffensiveness secures him from confinement."[10] The exhibition was a failure, and from this time forward Blake seems not to have yearned for, not to have sought, and certainly not to have achieved fame.

In 1818 a surprising new element entered the sixty-one-year-old artist's life; his patron, the dilettante George Cumberland (1754–184?) introduced him to the young portrait painter John Linnell (q.v.), who in turn brought Blake into contact with a circle of young visionary artists called the Ancients, who would honor and esteem Blake as a true seer and artist. Indeed, the intense visions of pastoral beauty painted by the Ancients owed their greatest debt to Blake's miraculous woodcuts illustrating Dr. Robert Thornton's edition of Virgil's *Pastorals* of 1820–21. Furthermore, Linnell became, after Butts, Blake's greatest patron, commissioning two of Blake's most famous and beautiful series of illustrations—the second set of the *Book of Job* (1820) and the illustrations to Dante (begun in 1825 and left unfinished at Blake's death).

The most brilliant of the Ancients, Samuel Palmer (1805–1881), left this moving description of Blake in a letter to Gilchrist of August 23, 1855: "He was energy itself, and shed arounds him a kindling influence; an atmosphere of life, full of the ideal. . . . He was a man without a mask; his aim single, his path straight-forwards, and his wants few; so he was free, noble, and happy."[11]

Blake died on August 12, 1827, at age sixty-nine, in his rooms at 3 Fountain Court, Strand, where he had moved with Catherine in 1821. Another Ancient, George Richmond (1808–1896), described Blake's death to Samuel Palmer in a letter of August 15, 1827: "Just before he died [at six in the evening] His Countenance became fair. His eyes Brighten'd and He burst out into Singing of the things he saw in Heaven. In truth He Died like a Saint."[12]

1. Blake first exhibited at the Royal Academy in 1780.

2. Gilchrist, 1942, p. 107.

3. Ibid., p. 94.

4. Henry Crabb Robinson, "Reminiscences" (1852), in Bentley, ed., 1969, p. 543.

5. Gilchrist, 1942, p. 6.

6. Henry Crabb Robinson, "Reminiscences" (1852), in Bentley, ed., 1969, p. 547.

7. Gilchrist, 1942, p. 317.

8. London, 1809–10, p. 37.

9. Keynes, ed., 1980, p. 48.

10. Bentley, ed., 1975, p. 66.

11. Keynes, ed., 1980, p. 174.

12. Ibid., p. 171.

BIBLIOGRAPHY: B. H. Malkin, *A Father's Memoirs of His Child* (London, 1806), pp. xvii–xli (repr., Bentley, ed., 1969, pp. 421–32); J. T. Smith, *Nollekens and His Times* (London, 1828) (repr., Bentley, ed., 1969, pp. 455–76); Wilson, 1927; Cunningham, 1830–33, vol. 2, pp. 140–79 (2nd, expanded ed. [1830], vol. 2, pp. 143–88 [repr., Bentley, ed., 1969, pp. 476–508]); Frederick Tatham, "The Life of William Blake," MS., c. 1832, first published in Archibald G. B. Russell, ed., *The Letters of William Blake* (London, 1906), pp. 1–49 (repr., Bentley, ed., 1969, pp. 508–35); Gilchrist, 1863; Scott, 1878; Alfred T. Story, *The Life of John Linnell*, 2 vols. (London, 1892); Fry, 1904, pp. 204–11; Wilson, 1927; Gilchrist, 1942; Geoffrey Keynes, ed., *The Complete Writings of William Blake* (London, 1957; repr. with additions and corrections, London, 1966); Martin Butlin, *William Blake: A Catalogue of the Works in the Tate Gallery* (London, 1957) (introduction by Anthony Blunt); Blunt, 1959; S. Foster Damon, *A Blake Dictionary* (Providence, Rhode Island, 1965; 2nd ed., London, 1973); Bentley, ed., 1969; Geoffrey Keynes, ed., *Blake Studies, Essays on His Life and Work* (Oxford, 1971); Bo Lindberg, *William Blake's Illustrations to the Book of Job* (Abo, Sweden, 1973); Morton D. Paley and Michael Phillips, eds., *William Blake: Essays in Honor of Sir Geoffrey Keynes* (Oxford, 1973); Bentley, ed., 1975; Bindman, 1977; David V. Erdman, *Blake: Prophet against Empire, A Poet's Interpretation of the History of His Own Times*, 3rd ed. (Princeton, 1977); David Bindman, *The Complete Graphic Works of William Blake* (Neuchâtel, 1978); Paley, 1978; Wilson, 1978; Keynes, ed., 1980; Martin Butlin, *The Paintings and Drawings of William Blake*, 2 vols. (New Haven and London, 1981).

EXHIBITIONS: London, 1809–10; London, Burlington Fine Arts Club, *The Works of William Blake,* 1876; Boston, Museum of Fine Arts, *Drawings, Water Colors, and Engravings by William Blake,* June 1880; Boston, Museum of Fine Arts, *Books, Water Colors, Engravings, Etc., by William Blake,* February–March 1891; London, Carfax and Co., *Works by William Blake,* January 1904; New York, Grolier Club, *Books, Engravings, Water-Colors and Sketches by William Blake,* January–February 1905; London, Tate Gallery, Manchester, Whitworth Institute, Nottingham Art Museum, Edinburgh, National Gallery of Scotland, *Works by William Blake,* October 1913–July 1914; New York, Grolier Club, *William Blake,* December 1919–January 1920; London, Burlington Fine Arts Club, *Blake Centenary Exhibition,* 1927; Paris, Bibliothèque National, Vienna, Albertina, *Water-Colours by Turner, Works by William Blake,* January–April 1937; Philadelphia, Philadelphia Museum of Art, *William Blake, 1757–1827: An Exhibition of the Works of William Blake Selected from Collections in the United States,* 1939 (by Elizabeth Mongan and Edwin Wolf II, introduction by A. Edward Newton); Paris, Galerie René Drouin, Antwerp, Musée Royal des Beaux-Arts, Zurich, Kunsthaus, London, Tate Gallery, *William Blake (1757–1827),* March–September 1947; Washington, D.C., National Gallery of Art, *The Art of William Blake,* October–December 1957; London, British Museum, *William Blake and His Circle,* April 1957–March 1958; London, 1978.

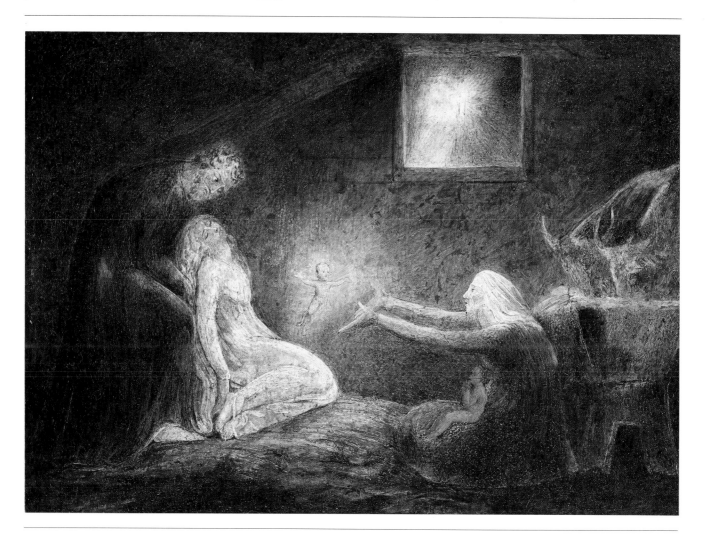

8 WILLIAM BLAKE

THE NATIVITY, 1799–1800
Tempera on copper, 10¾ x 15″ (27.3 x 38.2 cm.)
Gift of Mrs. William T. Tonner, 64-110-1

On August 26, 1799, Blake wrote to George Cumberland, "As to Myself, about whom you are so kindly Interested, I live by Miracle. I am Painting small Pictures from the Bible.... My Work pleases my employer, & I have an order for Fifty small Pictures at One Guinea each."[1] The employer for whom Blake was working was Thomas Butts, a clerk in the War Office Department of Mustering, living in Fitzroy Square, who may be cited as one of the most imaginative and important patrons of his age for his almost single-handed support of Blake—a man who, in Samuel Palmer's words, "for years stood between . . . the greatest designer in England & the workhouse."[2]

Within Blake's oeuvre, the Butts Bible illustrations of 1799–1800 signify a radical departure from the heroic classicism of the Large Color Prints of 1795 on the one hand and the modified return to that style after 1803 on the other. Moreover, in the Bible pictures Blake attempted to place himself within the mainstream of the European tradition of religious painting—although paradoxically their small format and scale, and the use of copper as the support in several of the illustrations, recall not the conventions of sacred art but Dutch or Italian cabinet pictures, invariably decorative subjects executed for the private collector.[3]

In this series, Blake was drawn to emulate both Venetian and Dutch paintings, relying for his effects on strong chiaroscuro and rich, glowing

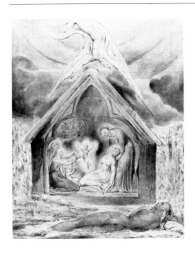

FIG. 8-1 William Blake, *The Descent of Peace*, c. 1815, pen and watercolor, 6¼ x 4⅞" (15.8 x 12.5 cm.), San Marino, California, Henry E. Huntington Library and Art Gallery

FIG. 8-2 William Blake, *The Flight of Moloch* c. 1815, pen and watercolor, 6⅛ x 4⅞" (15.7 x 12.4 cm.), San Marino, California, Henry E. Huntington Library and Art Gallery

FIG. 8-3 William Blake, *Glad Day,* c. 1795, color printed line engraving, with pen and watercolor, 10¾ x 7⅞" (27.3 x 20 cm.), London, British Museum

colors. Writing to a potential patron, Rev. John Trusler (1735–1820), on August 16, 1799, while engaged on the Butts commission, Blake referred to himself as "a Scholar of Rembrandt & Teniers, whom I have Studied no less than Rafael & Michael angelo."[4]

In a letter to Butts of November 22, 1802, Blake discussed the series he had painted two years previously:

> I have now given two years to the intense study of those parts of the art which relate to light & shade & colour, & am Convinc'd that . . . the Pictures which I painted for you Are Equal in Every part of the Art, & superior in One, to any thing that has been done since the age of Rafael. . . . Be assured, My dear Friend, that there is not one touch in those Drawings & Pictures but what came from my Head & my Heart in Unison; That I am Proud of being their Author and Grateful to you my Employer. . . . You will be tempted to think that, as I improve, The Pictures, &c., that I did for you are not what I would now wish them to be. On this I beg to say That they are what I intended them, & that I know I never shall do better; for, if I was to do them over again, they would lose as much as they gain'd, because they were done in the heat of My Spirits.[5]

But Blake's estimation of the Butts series changed. In August 1803 he visited the Truchsessian Gallery, an exhibition of old master paintings including a number of works by Northern primitives, an experience that, he wrote, "enlightened [me] with the light I enjoyed in my youth"[6] and led to his repudiation of the Venetian and Dutch influences so evident in the Butts Bible series of 1800. In the catalogue of his exhibition of 1809 Blake referred to the Butts works as "experiments" produced as "the result of temptations and perturbations, labouring to destroy imaginative power, by means of that infernal machine called Chiaro Oscuro, in the hands of Venetian and Flemish Demons . . . [who] cause that the execution shall be all blocked up with brown shadows."[7] And in the same catalogue he wrote, "The great and golden rule of art, as well as of life, is this: That the more distinct, sharp, and wiry the bounding [boundary] line, the more perfect the work of art."[8]

Blake seems to have associated the Butts series with a loss of direction in his own life, a failure of inspiration, which he felt took place in the late 1790s and continued through his three years' "slumber" at Felpham, 1800–1803. One of his biographers, Mona Wilson, points out that the later Lambeth years were years of melancholy and depression manifested by the pessimistic tone of the great prophetic books written at this time.[9] In 1804 he began to emerge from his despair: "I have indeed fought thro' a Hell of terrors & horrors . . . in a Divided Existence; now no longer Divided, nor at war with myself I shall travel on in the strength of the Lord God."[10]

Blake painted the Butts pictures in a medium he called "fresco," a technique by which he hoped to avoid the blurring and darkening process common with oil paints in the eighteenth century, and which he mistakenly believed to be the medium used by the fresco painters of the Italian Renaissance. He used a ground composed of whiting and carpenter's glue applied several times in thin layers. Then he painted in tempera and laid on a mixture of glue and water over the surface.[11] Ironically, this method echoed the disastrous technique of Sir Joshua Reynolds (q.v.), and particularly in the case of works painted by Blake on copper such as *The Nativity,* the surface has darkened and cracked.

FIG. 8-4 William Blake, *The Finding of Moses: The Compassion of Pharaoh's Daughter*, c. 1805, watercolor, 12¾ x 12⅝" (32.4 x 32 cm.), London, Victoria and Albert Museum

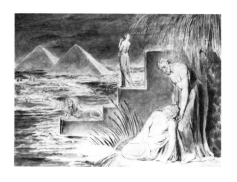

FIG. 8-5 William Blake, *Moses Placed in the Ark of the Bulrushes*, c. 1824, pen and watercolor over pencil, 11⅜ x 15⅝" (28.9 x 39.7 cm.), San Marino, California, Henry E. Huntington Library and Art Gallery

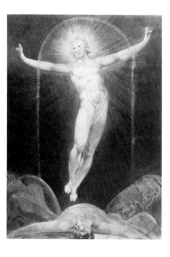

FIG. 8-6 William Blake, *The Resurrection*, c. 1805, pen and watercolor, 16½ x 11⅞" (42 x 30.2 cm.), Cambridge, Massachusetts, Fogg Art Museum, Harvard University

The iconography of the Butts Bible series is more traditional and less intensely personal than is usually the case with Blake, though certainly not devoid of uniquely Blakean interpretations of biblical events. The emphasis throughout is on the role of Christ as a loving redeemer, but there does not seem to have been an overall iconographic plan necessitating the choice of subjects.

The dramatic crux of the series is *The Nativity,* which, since there is no Annunciation, separates the Old from the New Testament. The unorthodox design is a good example of how Blake infuses into a biblical event his own philosophical gloss. Here the child Jesus is shown as spiritually born in the stable in Bethlehem, leaping forth in ecstasy from Mary's womb to be received by the exultant Saint Elizabeth with Saint John in her lap. Joseph supports the swooning Mary, in a tableau that has no textual source.

The motif of the leaping Christ child is unique in Western art, but the leaping babe recurs continually in Blake's art and poetry. In the poem "Infant Sorrow" from *Songs of Experience,* he wrote:

> My mother groand! my father wept.
> Into the dangerous world I leapt:
> Helpless, naked, piping loud;
> Like a fiend hid in a cloud.

Blake shows the leaping child in other depictions of the infant Jesus, such as in the first illustration to the Butts set of illustrations to Milton's poem "On the Morning of Christ's Nativity," *The Descent of Peace* (fig. 8-1), or again, in the same series, the illustration to *The Flight of Moloch* (fig. 8-2), where the Christ child bounds out of Moloch's furnace in both triumph and resurrection.

The flung-out arms also recall Blake's famous print *Albion Rose,* also called *Glad Day* (fig. 8-3), in which the youthful Christ/Albion figure assumes the attitude of the Crucifixion on the one hand and through his gesture symbolizes Dawn driving out Darkness on the other.

Within his own work, Blake repeats the attitude of Christ in *The Nativity* in the watercolor *The Finding of Moses: The Compassion of Pharaoh's Daughter* (fig. 8-4), where Moses leaps forth from the bulrushes like the babe in the manger. Moses, of course, is the Old Testament type for Christ as redeemer and liberator from sin. Blake connects through their poses the figures of Moses and Christ as redeemers in, respectively, the Old and New Testaments. This typological dimension is also stressed in the pose of Mary, who leans back supported by Joseph just as the mother of Moses swoons in Blake's *Moses Placed in the Ark of the Bulrushes* (fig. 8-5). Presumably these visual connections were easier to make when all the Butts series hung together, as we assume they did, in one room.

Moses' mother swoons from grief at the loss of her son, whereas in traditional Nativity scenes Mary is shown as a joyful mother. Bindman (1977) suggests that Blake parallels the grief of Moses' parents, who must leave him unattended in the land of Egypt, with the grief of the parents of Christ at his eventual suffering on earth. Moreover, Mary's pose, leaning back and supported by Joseph, is actually the traditional pose not of Mary at the Nativity but of Mary at the foot of the cross, fainting into the arms of Saint John. Mary's swoon thus looks backward to the *Moses Placed in the Ark of the Bulrushes* to prefigure the revelation of Christ at the Nativity and forward to the Crucifixion. Likewise, Christ's exultant leap looks backward to the leap of Moses and forward to the Crucifixion and Resurrection (fig. 8-6).

In the leap of Christ here one also recognizes Blake's Orc, personification or embodiment in the prophetic books of revolutionary energy and the

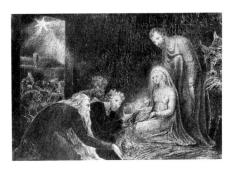

FIG. 8-7 William Blake, *Adoration of the Three Kings*, 1799, pen and tempera on canvas, 10½ x 15″ (26.6 x 38.1 cm.), Brighton, Royal Pavilion, Art Gallery and Museum

proclaimer of a new order, whose Christian equivalent is Christ the Redeemer. This is most clear in the illustration to Blake's poem *The Marriage of Heaven and Hell*, plate 3,[12] where Orc is shown actually emerging from Enitharmon's womb in the ecstatic pose of the Christ child in the Butts *Nativity*. Orc, like his antagonist Urizen, is a type recognizable, whether as an infant or grown man, by his pose—once again the ecstatic pose of *Albion Rose*.

The next scene in the series is the *Adoration of the Three Kings* (fig. 8-7), which Bindman suggests Blake intended as a pendant to *The Nativity*. In it the three kings worship at the feet of Christ, but they continue to wear their earthly crowns, and one king bears the unmistakable features of Blake's Urizen, symbol of power and reason, who makes a show of worshiping Christ but retains his primary allegiance to the trappings of the world.

The Nativity has two light sources, one from the nimbus around Christ, the other from the star of Bethlehem at the window. The use of the double light source recalls Rembrandt's *Adoration of the Shepherds* (1646, 25¾ x 35⅛″, London, National Gallery), which Blake could have known from a print. But if there are echoes of Rembrandt, the primary spiritual reference is to Fra Angelico (c. 1387/1400–1455). There is no direct quotation here from a work by Fra Angelico, but the austerity and simplicity both derive from him. Samuel Palmer wrote that Blake "loved the early Christian art, and dwelt with peculiar affection on the memory of Fra Angelico, often speaking of him as an inspired inventor and as a saint."[13]

1. Keynes, ed., 1980, p. 11.

2. Palmer to William Abercrombie, February 5, 1881, in Keynes, ed., 1980, p. 179.

3. Bindman, 1977, pp. 125–26.

4. Keynes, ed., 1980, p. 8.

5. Ibid., pp. 40–42.

6. Blake to William Hayley, October 23, 1804, in Keynes, ed., 1980, p. 101.

7. London, 1809–10, p. 55.

8. Ibid., pp. 63–64.

9. Wilson, 1978, p. 143.

10. Blake to Hayley, December 4, 1804, in Keynes, ed., 1980, p. 104.

11. Bentley, ed., 1969, p. 33.

12. Bindman, 1977, fig. 53.

13. Palmer to Gilchrist, August 3, 1855, in Keynes, ed., 1980, p. 176.

INSCRIPTION: *Don't place this picture in the sun or near the fire, or it will crack off the Copper / W.B.S. 1865* [in the hand of William Bell Scott on the reverse].

PROVENANCE: Thomas Butts; Thomas Butts, Jr.; Foster's, June 29, 1835, lot 72, bt. in; Foster's, March 8, 1854, lot 13, bt. in; J. C. Strange, 1863; Francis Harvey, bookseller, 30 Cockspur Street, Charing Cross, 1864 or 1865; William Bell Scott, by 1865; Sotheby's, July 14, 1892, lot 237, bt. Sydney Morse; Christie's, July 26, 1929, lot 37, bt. Gabriel Wells; Sessler's; bt. Mrs. William T. Tonner, December 1938.

EXHIBITIONS: London, Burlington Fine Arts Club, 1876, no. 89; Edinburgh, *International Exhibition of Industry, Science and Art: Pictures*

and Works of Art, 1886, no. 1,475; London, Carfax and Co., *Works by William Blake*, January 1904, no. 24; London, Tate Gallery, Manchester, Whitworth Institute, Nottingham, Art Museum, Edinburgh, National Gallery of Scotland, *Works by William Blake*, October 1913–July 1914, no. 19; London, Burlington Fine Arts Club, 1927, no. 13; Pasadena, California, Little Museum of La Miniatura, *Books and Works of Art by William Blake*, March 1936, no. 1; Philadelphia, Philadelphia Museum of Art, 1939, no. 153.

LITERATURE: William Michael Rossetti, in Gilchrist, 1863, vol. 2, p. 225, no. 133, p. 255, list 3, no. 6; William Michael Rossetti, in Gilchrist, 1880, vol. 2, p. 238, no. 159, p. 275, list 3, no. 7; Scott, 1878, pp. 4, 6, pl. IV; Irene Langridge, *William Blake: A Study of His Life and Work* (London, 1904), pp. 162–63 (W. B. Scott etching after Blake repro. between pp. 162–63); Fry, 1904, p. 206, repro. p. 211; W. Graham Robertson, "Supplementary List" [to Rossetti's "Annotated Catalogue"] in Alexander Gilchrist, *Life of William Blake* (London, 1907), p. 446, no. 133; Laurence Binyon, *The Drawings and Engravings of William Blake* (London, 1922), pl. 14; Darrell Figgis, *The Paintings of William Blake* (London, 1925), pl. 39; Geoffrey Keynes, *William Blake's Illustrations to the Bible* (Clairvaux, 1957), pl. 91 opp. p. 26, p. 26, cat. 91; Blunt, 1959, p. 67, pl. 35b; Kathleen Raine, *William Blake* (London, 1970), p. 122, fig. 89; Geoffrey Keynes, *Blake Studies*, 2nd ed. (Oxford, 1971), p. 156; Martin Butlin, "The

Blake Collection of Mrs. William T. Tonner," *Bulletin, Philadelphia Museum of Art*, vol. 67, no. 307 (July–September 1972), pp. 16–18, pl. 1; Jean H. Hagstrum, "Christ's Body," in Morton D. Paley and Michael Phillips, eds., *William Blake: Essays in Honour of Sir Geoffrey Keynes* (Oxford, 1973), p. 145, n. 26; Bindman, 1977, pp. 121–22, 126, 128, 193–94, pl. III; Milton Klondsky, *William Blake: The Seer and His Visions* (London, 1977), p. 69, repro. p. 69; Paley, 1978, p. 54; Martin Butlin, *The Paintings and Drawings of William Blake* (New Haven and London, 1981), vol. 1, no. 401, pp. 324–25, 393 no. 541 1, vol. 2, pl. 502.

CONDITION NOTES: The painting is in tempera medium on copper panel. A thin white ground is present overall and evident at the edges of losses and along the panel's edges. The paint is in extremely poor condition. A fine, irregular net of fracture crackle with associated cupping is present overall. The surface has a reticulated, raised texture, distinct from its original smooth profile. A wax-resin adhesive was applied in 1967 to consolidate an actively cleaving surface; this darkened the overall tonality of the image. Active cleavage and cupping of the paint film was again treated in 1981. Pinpoint losses are present overall. Under ultraviolet light, retouching is extensive overall and most evident in the upper-right corner.

ENGRAVING: William Bell Scott (q.v.) after William Blake, *The Nativity*, 1878, etching.
 LITERATURE: Scott, 1878, pl. IV.

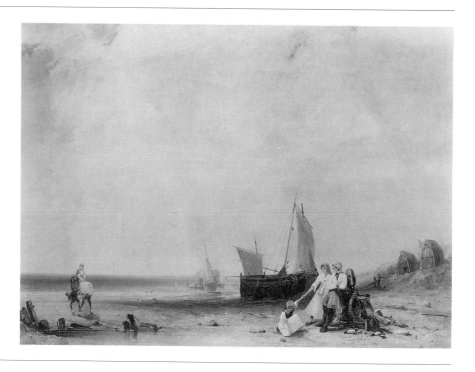

9 STYLE OF
 RICHARD PARKES BONINGTON

A COAST SCENE, c. 1828–40
Oil on canvas, 24 x 33″ (61 x 83.7 cm.)
John H. McFadden Collection, M28-1-1

A Coast Scene has traditionally been ascribed to Richard Parkes Bonington
(1802–1828), but that attribution has been rejected by Marion Spencer, who
points out that the overall effect is slightly "bitty," and that unlike Bonington,
whose soft, clear colors are used to suggest the underlying structure of rocks,
pilings, and the ripples on the calm sea, here in *A Coast Scene* these elements
are treated in a thinner, more linear manner.[1] Bonington, on the other hand,
was already executing assured, delicate landscapes in watercolor by the time he
left the École des Beaux-Arts in Paris in 1822, studying under Baron Gros
(1771–1835), and beginning to turn out his first oils, painted with a loaded
brush in cool, clear tonalities, foretelling, as Marion Spencer points out, the
early work of Corot (1796–1875). By 1823 his characteristic method in oil
emerged: the precise sepia underdrawing with the forms then broadly handled
in pure color. Bonington is the most elegant of landscape artists; technically
assured from the very outset of his brief career, his art is precise, sensitive, but
also an art of deep feeling. His works were painted mainly in the studio, yet
they possess a wonderful freshness and vivacity. To these observations one
might add that in this painting neither the horse nor rider is characteristic of
Bonington, or in the correct proportions for their distance from the
foreground group. The costumes worn by the figures are fanciful, not
costumes worn by fisherfolk in Normandy; the upturned boats used as shelters
are not features seen in genuine pictures by Bonington of certain Normandy
setting. However, one might compare this picture to Bonington's *Coast Scene
in Picardy* (fig. 9-1) in the Ferens Art Gallery, Kingston upon Hull, as the kind
of work by Bonington that the artist here is seeking to imitate.

 A Coast Scene is not a copy but an independent work of art, executed after
1828 when a vogue in England for beach and coast scenes led to the attribution
of a number of these pictures to Bonington. There is no necessity to assume
either that this is a fake or that the artist had any direct link with Bonington,
but rather it should be treated as a charming object in its own right, at the
moment unattributed.

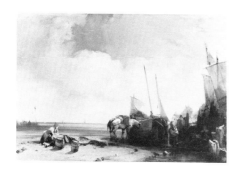

FIG. 9-1 Richard Parkes Bonington
(1802–1828), *Coast Scene in Picardy,* c. 1826, oil
on canvas, 26⅛ x 39″ (66.4 x 99 cm.),
Kingston-upon-Hull, Ferens Art Gallery

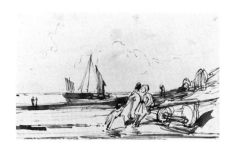

FIG. 9-2 *Style of Richard Parkes Bonington,*
Seashore, after 1828, sepia ink on paper, 4½ x 7½″
(11.4 x 19 cm.), Sir Hickman Bacon, Bart.
Collection

In the Witt Library there is a photograph of a drawing for the right-hand side of the composition, which belonged in 1937 to Sir Hickman Bacon (fig. 9-2). The group of three foreground figures (clearly in the poses of models in a studio) are posed just as they appear in *A Coast Scene,* but the fishing boat behind these figures in the oil painting is placed farther to the right, thus strengthening and tightening the composition. The boats at the right, upturned for shelters, appear in both compositions. The changes between drawing and painting once again underline the status of this painting as a work of art created through a conscious artistic process. We must also reject this drawing as by Bonington, for it is too diffuse, scratchy, and generally too weak to be by his hand. However, it is fair to assume that the artist who drew the sketch also painted *A Coast Scene.* According to an inscription on the verso of the drawing, it belonged until 1906 to the line engraver John Sadler (1813–1892), who as a boy worked for the noted engraver of Bonington's work George Cooke (1781–1834).

The painting also belonged to a famous engraver, the mezzotinter Thomas Oldham Barlow, Royal Academician (1824–1889). As far as we know, *A Coast Scene* never passed through the salerooms before Barlow acquired it sometime before 1884, suggesting that it came to him privately. It is tempting to suggest that he may have found the picture through his connections with other engravers—even from John Sadler himself. Although it is difficult to attribute either the painting or the sketch, it may be that at some future date the artist will turn out to have been an engraver, or in some way connected with the engraving profession.

1. Letter, August 24, 1965, and letter to author, October 1, 1981, Accession File, Philadelphia Museum of Art, Philadelphia.

PROVENANCE: Thomas Oldham Barlow, by 1884; his sale, Christie's, March 22, 1890, lot 13, bt. Agnew; Robert Rankin, Liverpool, by 1896, his sale, Christie's, May 14, 1898, lot 22, bt. Agnew; David Jardine, Liverpool, his sale, Christie's, March 16, 1917, lot 70, bt. Agnew; John H. McFadden, May 14, 1917.

EXHIBITIONS: London, Royal Academy, *Exhibition of Works by the Old Masters, and by Deceased Masters of the British School,* winter 1884, no. 23 (as "French Coast Scene," on panel [*sic*], lent by Thomas Oldham Barlow); Dundee, Scotland, Dundee Museum, *Fine Art Exhibition,* 1895 (lent by Robert Rankin); New York, 1917, no. 1; Boston, 1946, no. 201.

LITERATURE: "Remarkable Art Sale: Gainsborough and Bonington," *Daily Telegraph,* March 17, 1917; Roberts, 1917, pp. 1–2, repro. opp. p. 95; Roberts, 1918, "Additions," p. 117, p. 115 fig. 5; Dubuisson, 1924, pp. 198, 199, 202, repro. opp. p. 54; Hans Tietze, ed., *Masterpieces of European Painting in America* (London, 1939), p. 325, repro. p. 238; Shirley, 1940, pp. 145–46.

CONDITION NOTES: The original support is medium-weight (12 x 12 threads/cm.) linen. The painting is lined with twill-weave, medium-weight linen and an aged oil and lead white adhesive mixture. A white ground, with moderate and even application, extends partially onto the tacking margins. The paint is in very good condition. Much of the original brush marking and moderate to low relief of the paint profile have been preserved. Major elements have been rendered with direct paste vehicular mixtures; details were added with glazes of vehicular rich medium. Ultraviolet light reveals that retouching is restricted primarily to scattered losses throughout the sky, especially in the areas above the two figures at the right and around the sails of the ship in the foreground.

RELATED WORK: Style of Richard Parkes Bonington, *Seashore,* after 1828, sepia ink on paper, 4½ x 7½″ (11.4 x 19 cm.), Sir Hickman Bacon, Bart. Collection (fig. 9-2).

INSCRIPTION: *Original Sketch by R. P. Bonington / John Sadler, one of the last of the old Line-engravers, sold me this / sketch, along with 2 others in 1891. He said that when a youth of / 15 he was articled to George Cooke, the well known Engraver of many / of Bonnington's Pictures. In 1828 Bonnington called about the Plate of one / of his pictures for he seemed very ill & depressed, to amuse him Cooke gave / him a bottle of Walnut Juice & with this he made 2 or 3 drawings & then / threw them into the Waste paper Basket. Sadler rescued them & preserved / them until they became mine. Bonnington died in the following weeks & this / is probably one of his last works. George H. Shepherd. 1906.* [on verso].

PROVENANCE: John Sadler; George Shepherd, 1891; Sir Hickman Bacon, Bart., 1937.

EXHIBITION: London, Burlington Fine Arts Club, 1937, no. 74.

DESCRIPTION: A sepia sketch for the right-hand side of *A Coast Scene* (no. 9).

The primary source for Mason Chamberlin's life is Edward Edwards's biography of 1808 to which little can be added, even today. Edwards tells us that Chamberlin started as a clerk in a merchant's countinghouse but later became the pupil (like Nathaniel Dance and, perhaps, Gainsborough [q.q.v.]) of Francis Hayman (1708–1776).[1] From 1760 to 1768 he exhibited at the Society of Arts, winning the second premium for a historical picture in 1764. He exhibited once at the Free Society in 1764. From 1769 until his death Chamberlin showed his portraits at the Royal Academy, of which he was a foundation member.

Chamberlin lived in the East End of London, in Stewart Street Spitalfields near Bishopsgate Street—an odd place for an artist's studio in the eighteenth century, since all the fashionable world, the clients of Reynolds or Romney (q.q.v.), nestled and rarely strayed from the theaters and shops in the West End. Apart from two portraits of royal children he exhibited at the academy in 1771, the class of client Chamberlin attracted were men connected with the city and with trade. The titles of their portraits as listed in the Royal Academy catalogues are enough to tell us this, for in the 1780s we find a biscuit baker (1782), a carpetmaker (1782), and a clerk of the Bricklayers Company (1780), in addition to Dr. William Hunter, the surgeon (1781), Dr. Richard Chandler, the archaeologist, and, earlier, Benjamin Franklin. What was required by this kind of patron was a no-frills portrait, a competent job, straightforward realism. These men may scarcely have bothered about, and perhaps were slightly suspicious of, niceties such as brushwork, surface texture, or lively coloring; and Chamberlin gave them what they wanted. His known portraits seem nicely fitted to what we know to have been his temperament. One contemporary, quoted by Whitley, says that he was a Presbyterian, a pious and a good man, who lived an exemplary life and loved retirement.[2]

1. Edwards, 1808, pp. 121–22.
2. See Whitley, 1928, vol. 2, p. 83.

BIBLIOGRAPHY: Edwards, 1808, pp. 121–22; Whitley, 1928, vol. 2, p. 83; Waterhouse, 1953, pp. 194–95.

10 MASON CHAMBERLIN

BENJAMIN FRANKLIN, 1762
Oil on canvas, 50⅜ x 40¼" (127.9 x 103.5 cm.)
Inscribed lower left: *M. Chamberlin pinx.*[t] *1762*
Gift of Mr. and Mrs. Wharton Sinkler, 56-88-1

Between 1757 and 1762 (and again from 1764 to 1775) Benjamin Franklin was in England, acting as agent for the interests of the Pennsylvania Assembly, which was seeking the right to tax proprietary estates (that is, to force the Penn family to pay taxes). At this time he became the friend of Robertson, Hume, Garrick, and the painter Benjamin Wilson (q.v.).

This portrait of Franklin was commissioned by his friend and neighbor in London (at 7 Craven Street, Strand) Philip Ludwell III (1716–1767), a Virginia planter and Indian negotiator who had moved to London in 1760.[1] In a letter

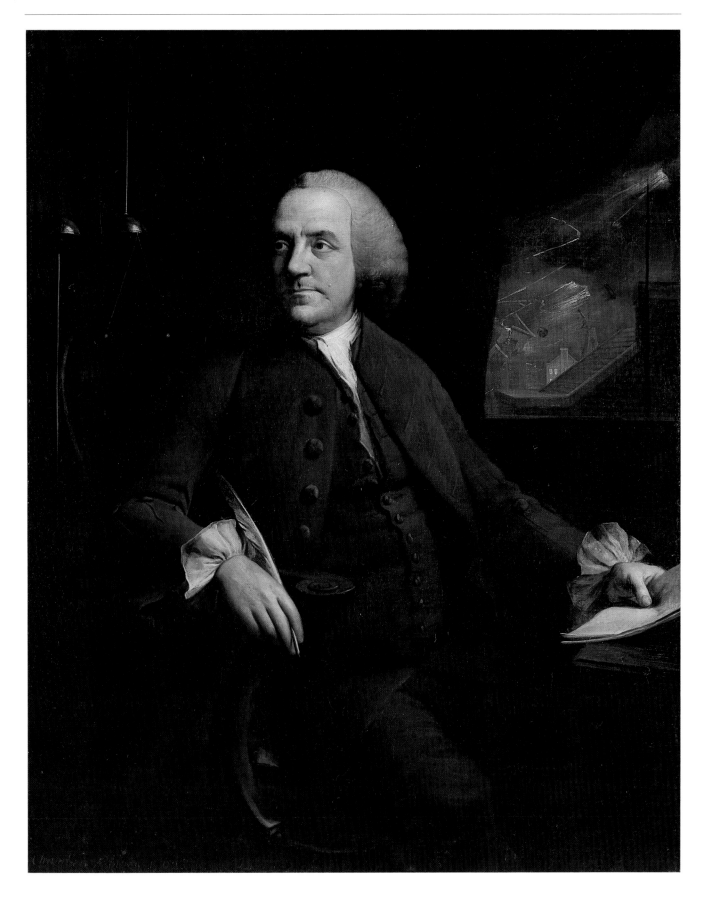

written from Philadelphia on February 24, 1764, to Jonathan Williams in Boston, Franklin described the origins of the commission: "Just before I left London [i.e., in late July or early August 1762], a Gentleman requested I would sit for a Picture to be drawn of me for him by a Painter of his choosing. I did so, and the Pourtrait was reckon'd a very fine one. Since I came away, the Painter has had a Print done from it, of which he has sent a Parcel here for Sale. I have taken a Dozen of them to send to Boston and it being the only way in which I am now likely ever to visit my Friends there, I hope a long Visit in this Shape will not be disagreeable to them."[2] Franklin was so well pleased with his portrait by Chamberlin that he ordered a replica for his son William Franklin and continued for the next decade to distribute prints of the Fisher mezzotint to his friends.[3]

Franklin's later career as a diplomat and patriot has made his name familiar to every American schoolchild. However, the author and signer of the Declaration of Independence has perhaps overshadowed the Franklin whose earlier achievements as printer, philosopher, scientist, and inventor had little to do with politics; it takes some effort to see and describe the man as he was when Ludwell knew him and Chamberlin portrayed him in 1762.

Born in Boston in 1706, apprenticed to his brother James, a printer, from 1718 to 1723, Franklin left Boston in the latter year for Philadelphia, and then, in 1724, for London. His mature career began on his return to Philadelphia in 1726 to set up as a printer. There he lived until his appointment to London in 1757. A partial list of his achievements during these thirty-one years in Philadelphia is breathtaking: not only was he a printer of books and newspapers, the editor of *Poor Richard's Almanack,* and founder of the Library Company (1731), the American Philosophical Society (1743), the Pennsylvania Hospital (1751–55), and the academy that would later become the University of Pennsylvania (1751), but also to this period belong his most famous inventions, the Philadelphia fireplace and the lightning rod. Above all else, Franklin's researches into the nature of electricity between 1746 and 1753 made him by the early 1750s one of the most distinguished scientists in America or Europe, leading to honorary degrees in America from Harvard and Yale in 1753, and in Great Britain to membership in the Society of Arts in 1755, the Royal Society in 1756, honors at Edinburgh University and St. Andrews in 1759, and finally, in the year Chamberlin's portrait was painted, to an honorary degree from Oxford.

The man Chamberlin portrayed was, therefore, more of a Priestley than a Burke: one of the leading scientists in England; a distinguished Fellow of the Royal Society; and a man whose work in the field of electricity represents, even today, his most "permanent and lasting contribution to scientific thought."[4] From the English point of view, his political career had not yet begun.

Franklin had observed his first electrical demonstration in Boston in 1746; the next seven years he spent retired from business conducting research into the phenomenon and communicating his findings to Peter Collinson, the London agent for the Library Company of Philadelphia. Because Collinson read Franklin's letters to the members of the Royal Society, Franklin's work immediately became known in England.[5] When he began his work, electricity was the least studied of the physical sciences. In antiquity and the Middle Ages, lightning was thought to be fire from heaven, and although by the mid-eighteenth century certain of Franklin's contemporaries had concluded that lightning was an electrical phenomenon, no one had proved it by experiment.[6]

This is what Franklin did, first by the invention of the lightning rod and second (though more famously) by his experiment with the kite in 1752.[7] Once

FIG. 10-1 Benjamin West (1738–1820), *Benjamin Franklin Drawing Electricity from the Sky,* c. 1816–17, oil on paper mounted on canvas, 13¼ x 10″ (33.5 x 25.5 cm.), Philadelphia, Philadelphia Museum of Art, Gift of Mr. and Mrs. Wharton Sinkler

FIG. 10-2 Detail of Benjamin Franklin's portrait

he had proved that lightning and electricity were identical, he was able to contribute fundamentally to the structure of electrical theory by premising that every body contains a normal quantity of single electrical fluid, which when electrified by friction or contact with an electrical body, gains or loses some of its normal quantity, thus becoming charged either positively or negatively. From here it was but a step to discover that positively charged bodies attract negative, but that positive repels positive and negative repels negative: in short, he explained the entire phenomenon of attraction and repulsion. To confirm the electrical nature of lightning and then discover the electrification of clouds were remarkable contributions to science, but Franklin also invented the lightning rod, a very practical application of the results of abstract research.[8] It is stunning to learn from his biographer Carl Van Doren that Franklin was the first man to use the following terms in print in English: armature, battery, charged, condense, conductor, discharge, electrical fire, electrical shock, electrician, electrified, Leyden bottle, negative, and positive.[9] Van Doren summed up Franklin's work in these words: "He had made one of the most dramatic guesses in the history of science, and he had verified his guess with a boy's plaything. He had applied his knowledge to making men's houses, barns, ships safe from an incalculable danger. With what seemed the simplest key he had unlocked one of the darkest and most terrifying doors in the unknown universe. Here was another hero of the human race, even as against the terrifying gods. Franklin, Kant said, was a new Prometheus who had stolen fire from heaven."[10]

Chamberlin began this portrait almost ten years after Franklin's conclusions about the nature of lightning and description of the lightning rod were first published in England by Edward Cave in a pamphlet of April 1751. When we compare it to Benjamin West's (1738–1820) portrait of Franklin conducting the experiment with a kite, in which the scientist is shown in the robe of a Promethean hero (fig. 10-1), the Chamberlin of 1762 seems a conventional, straightforward affair. Franklin is shown in the stock pose for portraying a man of letters in English art—seated at his desk but looking up from the pen and paper in his hands as though momentarily interrupted. In other portraits the interruption might be the subject's spouse, or even perhaps the muse of inspiration fluttering in. In Franklin's case his muse is shown to be his scientific instruments reacting to the effects of an electrical storm, glimpsed through the window.

Franklin himself was a figure, in Seller's apt phrase, "impressive in his lack of impressiveness."[11] Chamberlin gives us a plain man, with a mole on his left cheek, simply dressed, wearing a powdered wig (as he did until 1775), no spectacles (these did not appear until after 1776), and lights the portrait in the most ordinary, school-of-Thomas-Hudson, way. Some passages, particularly in the painting of the right hand and ruffles, the realistic and careful observation of the world, or the objects almost painfully described by the thin paint remind one of Joseph Wright of Derby (q.v.) about this date; but how one wishes, when Chamberlin comes to rendering the scientific instruments and the electrical storm in the background, that Wright had been in London in 1762 and available to paint Franklin's portrait.

Franklin is shown at work, making notes on some of his experiments. Three of these experiments are identifiable.

In a letter to Collinson written in September 1753, Franklin described the apparatus depicted in the upper left-hand corner (fig. 10-2). "In *September* 1752, I erected an iron rod to draw the lightning down into my house, in order to make some experiments on it, with two bells to give notice when the rod should be electrify'd: A contrivance obvious to every electrician."[12] The rods, which seem to be fastened to the floor and ceiling, must be connected to an

FIG. 10-3 Detail of Benjamin Franklin's portrait

FIG. 10-4 Model of a house with a lightning rod. Photograph: Harvard University

FIG. 10-5 Model of a steeple with a lightning rod. Photograph: Harvard University

external lightning rod somewhere out of our sight, and the clapper hanging between the bells will ring because it is excited by the same electrical charge as the bells, so that it will be repelled by each in turn. These bells had been described by Franklin even before he installed them in his own house. In August 1752 *The Gentleman's Magazine* recommended that lightning rods be used by "all gentlemen who take the ... pains of keeping meteorological journals. ... It is easy to annex two little bells to the wire of the [lightning rod] with a clapper between, which without further trouble will give notice when electrified."[13] Apparently before leaving Philadelphia for London Franklin forgot to disconnect the apparatus, and his wife Deborah wrote to him to complain that the mysterious ringings frightened her. Franklin replied from London on June 10, 1758: "If the ringing of the Bells frightens you, tie a Piece of Wire from one Bell to the other, and that will conduct the lightning without ringing or snapping, but silently. Tho' I think it best the Bells should be at Liberty to ring, that you may know when the Wire is electrify'd, and, if you are afraid, may keep at a Distance."[14]

The second experiment visible in Chamberlin's portrait takes place also in the upper left, slightly in front and to the right of the electrical bells. This was the electrification of two cork balls either positively or negatively so that they could be seen to repel each other. In April 1751, the same month and year that Franklin's discoveries were published in England, he and an unemployed Baptist minister named Ebenezer Kinnersley (1711–1778) drew up a series of lectures to demonstrate his discoveries. These were published in Philadelphia in 1752. One of the experiments to demonstrate that two electrically charged bodies repel each other reads:

> Suspend ... two Cork Balls from silk Threads, & electrify them; & they will immediately separate & fly asunder to a great Distance.—When there is more of the Electric Matter thrown on a Piece of common Matter than it can receive within its Substance; the rest forms an Atmosphere round it; which Atmosphere repels a like Atmosphere round another Body; so that the Bodies themselves seem to repel each other, as may be seen in those Cork Balls which being electrified, or having an electric Atmosphere given to each of them, they are thereby kept at a Distance, & cannot be brought to touch without Violence.[15]

The final experiment is perhaps the least obviously recognizable as an experiment. At first glance, what is happening outside the window seems perfectly straightforward: in the distance a storm is raging and lightning is destroying buildings whose owners have been so imprudent as to forgo the use of Franklin's lightning rod. The closest building, which stands intact, is of course equipped with just the kind of rod recommended by Franklin (the top pointed, not rounded). It is appropriate that the author of *Poor Richard* should include a cautionary lesson among the attributes illustrating his accomplishments as a scientist. But as Louise Todd Ambler pointed out in 1975, the background deserves a second look (fig. 10-3). Except in fanciful depictions of the destruction of Nineveh, lightning does not utterly level whole buildings. Indeed, the longer we look at the cityscape in Chamberlin's portrait, the clearer it becomes that the buildings are not meant to be taken for actual structures; they are, in fact, the toy models constructed under Franklin's direction to enable a lecturer to demonstrate the purpose and efficacy of the lightning rod. Several of these models still exist, preserved at Harvard University. Figure 10-4 is a profile of a house with a lightning rod running up its chimney, fixed onto a horizontal board. What happens during a lecture is this: the experimenter (Kinnersley or Franklin himself) shows that

FIG. 10-6 Model of Franklin's "Thunder House." Photograph: Harvard University

if he administers an electrical charge to the top of the lightning rod and does nothing to interrupt the passage of the charge to the ground, the house remains unharmed. But the profile of the house also contains at its center a small square of wood, within which is a wire that enables the experimenter to interrupt the charge of electricity before it has reached the ground. If he does this, the square of wood is dramatically and violently blown out of its place, thus showing what happens to buildings not protected by lightning rods. At the pointed tip of the rod is a thread on which a little ball can be screwed. The experimenter can perform the experiment with the pointed rod, as recommended by Franklin, and then with a rod ending in a ball, as advocated by his rival electrician Benjamin Wilson (q.v.) and endorsed by George III. Naturally, the second time around the experiment ends in the destruction of the house.[16] In the background of the Chamberlin portrait, a steeple with a rounded finial at its top is broken in two by a stroke of lightning, thus illustrating Franklin's point, as demonstrated by another toy model at Harvard, the steeple with lightning rod (fig. 10-5).[17]

The building collapsing into several pieces in the background of the Chamberlin portrait is probably meant to represent Franklin's "Thunder House" (fig. 10-6). This provided the most dramatic demonstration of the lecture. The "Thunder House" was a three-dimensional model of a house, made of mahogany, about ten inches high, with a separate roof and each of its four walls hinged. In the experiment, a small charge of dynamite is placed within the house, and the demonstration begins. First we are shown what happens when the house protected by lightning rods is struck by lightning (again, the experimenter administering an electrical charge). All is well. Next, the same charge is administered when the house is not protected, and the powder explodes, the house collapses, and the audience presumably runs out to buy lightning rods.[18]

1. For Ludwell see Archibald B. Shepperson, *John Paradise and Lucy Ludwell* (Richmond, 1942), pp. 18–33; Labaree and Willcox, eds., 1959–84, vol. 10, p. 107n, vol. 6, p. 532n.
2. Labaree and Willcox, eds., 1959–84, vol. 11, p. 89.
3. Ibid., vol. 10, p. xv; see engraving 1.
4. I. Bernard Cohen, ed., *Benjamin Franklin's Experiments: A New Edition of Franklin's Experiments and Observations on Electricity* (Cambridge, Mass., 1941), p. xi.
5. Franklin's first letter to Collinson is dated July 11, 1747. By January 1748 his work was being discussed by Sir William Watson at the Royal Society, and in 1750 articles on his experiments began to appear in England in *The Gentleman's Magazine*. For the history of

the publication of these letters as a book, *Observations on Electricity* (London, 1751), see Cohen, ed. (see note 4), pp. 138ff.
6. John Freke in England (1746), Jean Antoine Nollet in France (1748), and Johann Winkler in Germany.
7. The kite experiment was spectacular, but in Cohen's words, "an unnecessary step, one of little importance" (Cohen, ed., see note 4, pp. 76–77).
8. Ibid., pp. 69–70.
9. Van Doren, 1938, p. 173.
10. Ibid., p. 171.
11. Sellers, 1962, p. 1, see also pp. 2–3.
12. Cohen, ed. (see note 4), p. 268.
13. *The Gentleman's Magazine*, vol. 22 (1752), p. 383.

14. Labaree and Willcox, eds., 1959–84, vol. 5, pp. 69–71, vol. 8, p. 94.
15. Ebenezer Kinnersley, *A Course of Experiments on the Newly Discovered Electrical Fire* (Philadelphia, 1752). See Cohen (see note 4), p. 416.
16. I. Bernard Cohen, *Some Early Tools of American Science: An Account of the Early Scientific Instruments and Mineralogical and Biological Collections in Harvard University* (Cambridge, Mass., 1950), p. 161, fig. 17 following p. 154. See also David P. Wheatland, *The Apparatus of Science at Harvard 1765–1800* (Cambridge, Mass., 1968), pp. 146–48.
17. Cohen (see note 16), p. 161, fig. 18 following p. 154.
18. Ibid., p. 162, fig. 19 following p. 154.

INSCRIPTION: *L. 1786* [on cross member of stretcher (upside down) in red paint]; *Fleedham Liner* [carved on stretcher]; *The Property of Madame Van de Weyer 21 Arlington Street* [illegible] [on an old label attached to stretcher]; various inventory numbers carved or impressed in stretcher; and a Philadelphia exhibition label.

PROVENANCE: Commissioned by Col. Philip Ludwell III; by descent to his daughter Lucy Ludwell Paradise; bt. Joshua Bates; by descent to his daughter Mrs. Sylvain van de Weyer; her son, Col. Victor van de Weyer; his sale, Phillips, Son, and Neale, London, December 18, 1912, bt. Asher Wertheimer; Knoedler and Co.; George Palmer, New London, Connecticut; Rosenbach Galleries, New York, 1926; bt. Wharton Sinkler.

EXHIBITIONS: London, Society of Artists, 1793, no. 19 (as "Portrait of a Gentleman: half length"); Philadelphia, University of Pennsylvania Museum, *Benjamin Franklin/Winston Churchill, An Exhibition Celebrating the Bicentennial of the University of Pennsylvania Library,* May–June 1951, p. 37; Philadelphia, American Philosophical Society, *Exhibition of Portraits Marking the 250th Anniversary of the Birth of the Society's Founder, Benjamin Franklin,* January–April 1956, no. 3 (by Charles Coleman Sellers); Washington, D.C., National Portrait Gallery, Smithsonian Institution, *In the Minds and Hearts of the People, Prologue to the American Revolution, 1760–1774,* June–November 1974, p. 213, repro. p. 70 (by Lillian B. Miller, entry by Robert G. Stewart); Washington, D.C., National Portrait Gallery, Smithsonian Institution, *This New Man; A Discourse in Portraits,* September–December 1968, p. III (essay by Oscar Handlin); Philadelphia, Philadelphia Museum of Art, *The Art of Philadelphia Medicine,* September 15–December 7, 1965, no. 8.

LITERATURE: C. W. Bower, *The History of the Centennial-Celebration of the Inauguration of George Washington* (New York, 1902), p. 457, repro. opp. p. 444; *Times* (London), December 19, 1912, p. 9; Brad Stephens, *The Pictorial Life of Benjamin Franklin* (Philadelphia, 1923), unpaginated; John Clyde Oswald, *Benjamin Franklin in Oil and Bronze* (New York, 1926), pp. 16–18, repro. p. 17; Whitley, 1928, vol. 2, p. 83; New York, The Metropolitan Museum of Art, *Benjamin Franklin and His Circle,* May–September 1936, p. 14 (mezzotint by Fisher) (by R.T.H. Halsey, Joseph Downs, and Marshall Davidson); Van Doren, 1938, pp. 401–2, 431; *Transactions of the American Philosophical Society,* n.s., vol. 43, pt. I (March 1953), repro. opp. p. I (mezzotint by C. Turner); Labaree and Willcox, eds., 1959–84, vol. II, p. 89, vol. 10, pp. xv, 107n., repro. as frontispiece (mezzotint by Fisher); Sellers, 1962, pp. 57–60, 218–20, pl. p. 4; Ruth Davidson, "Museum Accessions," *Antiques,*

vol. 100, no. 5 (November 1971), pp. 682–83, repro. p. 682; Robert D. Crompton, "Franklin's House Off High Street in Philadelphia," *Antiques,* vol. 102, no. 4 (October 1972), p. 682 fig. 6 (as oil on paper mounted on panel); Sarah B. Sherrill, "Current and Coming," *Antiques,* vol. 106, no. I (July 1974), p. 25, repro. p. 24 (as oil on paper on panel); Cambridge, Massachusetts, Fogg Art Museum, Harvard University, *Benjamin Franklin: A Perspective,* April–September 1975, p. 72, no. 36 (mezzotint by Fisher repro. frontispiece) (catalogue by Louise Todd Ambler).

CONDITION NOTES: The original support is twill-weave, medium-weight linen (10 x 10 threads/cm.). The tacking margins have been removed. The painting has been lined with an aqueous adhesive and medium-weight linen. An off-white ground is present and is evident along the cut edges. The paint is in generally poor condition. Active cleavage is present in the proper right sleeve of the figure. Both fine and coarse webs of fracture crackle are present overall. A large loss (5 to 6″ in diameter) is located left of the figure's head. This loss has been filled with a grainy material and texturally is a poor match to an otherwise smooth paint surface. Under ultraviolet light, retouches are visible over the large loss and along the edges of the composition.

VERSIONS

1. Replica by Mason Chamberlin, *Benjamin Franklin,* oil on canvas, 50 x 40″ (127 x 101.6 cm.), destroyed.
 PROVENANCE: Ordered by Franklin as a gift to his son William, governor of New Jersey; destroyed by fire.
 LITERATURE: Sellers, 1962, p. 220, no. 2.

2. George Dunlop Leslie (1835–1921) after Mason Chamberlin, *Benjamin Franklin,* oil on canvas, 50 x 40″ (127 x 101.6 cm.), Cambridge, Massachusetts, Harvard University.
 PROVENANCE: Commissioned by Joshua Bates, who presented it to Harvard, 1856.

3. George Dunlop Leslie after Mason Chamberlin, *Benjamin Franklin,* oil on canvas, 50 x 40″ (127 x 101.6 cm.), New Haven, Connecticut, Yale University.
 PROVENANCE: John Milnes; Percy A. Rockefeller; Avery Rockefeller, who presented it to Yale University, 1926.

4. Unknown artist after Mason Chamberlin, *Benjamin Franklin,* late eighteenth century, opaque watercolor on ivory, 4¼ x 3⅜″ (10.8 x 9.2 cm.), Philadelphia, American Philosophical Society.
 LITERATURE: Sellers, 1962, p. 226.

5. S. Freeman after Mason Chamberlin, *Benjamin Franklin,* medium, dimensions, and location unknown. Photograph: London, Witt Library.

ENGRAVINGS

1. Edward Fisher (1730–1785) after Mason Chamberlin, *Benjamin Franklin,* 1762, mezzotint, 14⅞ x 10⅞″ (37.8 x 27.6 cm.).
 INSCRIPTION: *M: Chamberlin pinxt. E:Fisher fecit. B:Franklin of Philadelphia L.L.D.F.R.S. Sold by M Chamberlin in Stewart Street, Old Artillery Ground, Spittalfields. Price 5s.*
 LITERATURE: New York, The Metropolitan Museum of Art, *Benjamin Franklin and His Circle,* May–September 1936, p. 14; Sellers, 1962, pp. 220–21, pl. p. 4; Cambridge, Massachusetts, Fogg Art Museum, Harvard University, *Benjamin Franklin: A Perspective,* April–September 1975, frontispiece.

2. François Nicholas Martinet (b. 1731) after Edward Fisher, *Benjamin Franklin,* 1773, line engraving, 8⅛ x 5¼″ (20.6 x 13.3 cm.) (plate size).
 INSCRIPTION: *Dessiné et Gravé par F.AN. Martinet / Il a ravi le feu des Cieux / il fait fleurir les Arts en des Climats sauvages. / L'Amérique le place à la tête des Sages / La Grèce l'auroit mes au nombre de ses Dieux.*
 LITERATURE: Sellers, 1962, pp. 221–22, pl. p. 4.
 DESCRIPTION: Frontispiece to *Oeuvres de M. Franklin . . . traduites de l'anglais sur la quatrième edition par M. Barbeu Doubourg, avec des additions nouvelles et des figures en taille douce* (Paris, 1773).

3. John Lodge (d. 1796) after Edward Fisher, *Benjamin Franklin,* 1777, line engraving, 7 x 4¼″ (17.8 x 10.8 cm.).
 INSCRIPTION: *Ubi Libertas, ibi patria / BENJAMIN FRANKLIN, L.L.D. & F.R.S. / "Those who would give up Essential Liberty to purchase / a little Temporary Safety, deserve neither Liberty nor / Safety." Address of the Assembly of Pennsylvania, in 1755. Engraved from an Original Picture by Jnº Lodge. / Printed according to Act of Parliament, for J. Almon, in Piccadilly, London, 21st April 1777.*
 LITERATURE: Sellers, 1962, pp. 222–23, pl. p. 5.
 DESCRIPTION: Frontispiece to *The Remembrancer; or, Impartial Repository of Public Events. For the Year 1777* (London, 1778).

WORKS AFTER ENGRAVINGS

1. Artist unknown after Edward Fisher or the line engraving by John Lodge, bronze circular medal, diam. 1¾″ (4½ cm.).
 INSCRIPTION: *B. FRANKLIN OF PHILADELPHIA L.L.D.O.F.R.S.* [obverse].
 LITERATURE: Sellers, 1962, p. 223.
 DESCRIPTION: Head of Franklin, three-quarters to left, wearing a turbanlike cloth cap.

2. John Walker after Edward Fisher, line engraving, 8 x 5″ (20.3 x 12.7 cm.).

3. S. Freeman after Edward Fisher, line engraving, 9½ x 6¼″ (24 x 17 cm.).

4. See Sellers, 1962, pl. p. 5, for other early and late nineteenth-century prints loosely related to the Chamberlin painting or Fisher's engraving by S. Topham, John Romney, and W. J. Alais.

Growing up with little obvious natural talent, John Constable almost willed his genius into being; he was slow to come to more than ordinary proficiency in his art, yet in middle age painted landscapes as revolutionary as anything exhibited in Europe in their time. For most of his life he lived as an outsider, cut off from patronage and the approval of his colleagues, not selling a single picture to a stranger until he was thirty-eight years old, and waiting twenty-seven years for full membership in the Royal Academy. Nor was he allowed the luxury of indifference to fame. He courted conventional success and lived by middle-class, intensely conservative standards, sustained by his belief in his own originality. As Farington recorded in his diary entry for May 19, 1808, when Benjamin Robert Haydon (1786–1846) asked him "Why He was so anxious abt. what He was doing in Art," Constable replied, "Think what I am doing," meaning, Farington filled in, "how much greater the object & the effort."[1]

His father was a prosperous mill owner in East Bergholt, a village on the Essex-Suffolk border nestled in Dedham Vale, a valley two miles wide and six miles long, through which runs the river Stour. Constable would paint the villages and locks of the Stour Valley so often, and in such detail, that we know them, paradoxically, as well as we know imaginary villages in which novelists make us feel we have lived for a time—a Middlemarch, for example, or a Highbury.

Long before he could draw, Constable felt the need to visualize pictures of this cultivated landscape, threaded with canals built in the seventeenth century for the movement by barge of milled grain. In 1821 he wrote: "I associate my 'careless boyhood' to all that lies on the banks of the *Stour*. They made me a painter (& I am gratefull) that is I had often thought of pictures of them before I had ever touched a pencil."[2] Each day of his childhood drove deeper into him this love for "every stile and stump, and every lane in the village," every mood of the weather and effect of light. As late as 1833, long after he had ceased to visit his boyhood home, he described his mezzotint *Spring* like this: "One of those bright and animated days of the early year, when all nature bears so exhilarating an aspect; when at noon large garish clouds, surcharged with hail or sleet, sweep with their broad cool shadows the fields, woods, and hills."[3]

Two men, both from London, showed the miller's son what an artist's life might be. The first was Sir George Beaumont (1753–1827), to whom Constable was introduced in Suffolk. Beaumont allowed Constable to copy watercolor studies he owned by Thomas Girtin (1775–1802) and also his famous little Claude (1600–1682), *Hagar and the Angel*, now in the National Gallery in London. His other early mentor, John Thomas "Antiquity" Smith (1766–1833), whom Constable met on a year-long stay in London in 1796, passed on a more conservative, more fully eighteenth-century tradition of the picturesque style of landscape composition and also gave him lessons in etching as well as his first taste of the London art world of print and book dealers, collectors and Academicians.

Yielding to his father's wish, Constable spent the year 1797 clerking for the family concern in Suffolk. But in 1799 he moved to London, and on February 4 that year entered the Royal Academy schools as a probationer. There he made friends with older artists such as Joseph Farington (1747–1821) and Benjamin West (1738–1820), president of the academy, both of whom recognized in Constable's work a passionate devotion to nature and encouraged him with advice at once practical and idealistic. West, for example, counseled him to turn down the offer of a steady job as a drawing master on the grounds that such work would rob him of the chance to become a real

artist, or in Constable's words, it would be the "death-blow to all my prospects of perfection in the art I love."[4] Of his painting, West told him: "Always remember, sir, that light and shadow *never stand still,*" and "Your darks should look like the darks of silver, not of lead or of slate."[5]

From his first early exercises in the picturesque, Constable in the years from 1799 to 1808 groped from style to style, imitating now Claude, now Gainsborough (q.v.), now Girtin. Twice, under the patronage of his uncle David Pike Watts, he traveled to the Lake and Peak districts (1801, 1806) but found that mountain scenery failed to move him. Twice he tried his hand at large religious compositions, in altarpieces from the churches at St. Michael Brantham (1805) and St. James Nayland (1810), both in Suffolk, but the results were ludicrously inept. More successful were his portraits, painted during these years partly to gratify his parents' belief that he would always be able to survive by painting faces if his landscapes failed to sell. The conclusion to all these trial runs he foretold even before beginning them. To his painting partner in East Bergholt, the local glazier John Dunthorne (1770–1844), he wrote on May 29, 1802, "... 'there is no easy way of becoming a good painter.' For the last two years I have been running after pictures, and seeking the truth at second hand. I have not endeavoured to represent nature with the same elevation of mind with which I set out, but have rather tried to make my performances look like the work of other men.... I shall return to Bergholt, where I shall endeavour to get a pure and unaffected manner of representing the scenes that may employ me."[6]

In the years from 1809 to 1816 he turned within himself, narrowed his subject matter to encompass only the places and scenes he had known from his youth or had come to love. This meant in the first case, the Stour Valley; in the second, Salisbury, Wiltshire, which he first visited in 1811 and where lived his greatest friend, Archdeacon John Fisher (1788–1832), prebendary of Salisbury Cathedral. He stopped "running after pictures." Indeed, he seems to have tried to forget he had ever seen a picture before, seeking to record what he saw in front of him as it was at the moment he saw it, not with the objectivity of a topographer but with his own feelings and sensations as he stood before nature recorded intact. His art, in Lawrence Gowing's phrase, was to *realize* and not to *feign.*

How revolutionary this approach was has been discussed by Michael Kitson (1957), who points to such sketches from about 1811 as *Lock and Cottages on the Stour* (10 x 12″, London, Victoria and Albert Museum) as fundamentally different in approach from an eighteenth-century conception of landscape painting, in which feeling could be expressed only at the expense of naturalism (the later Gainsborough, for example) or naturalism sought only at the price of emotion (as in Paul Sandby [q.v.]). Now, with Constable, both naturalism and feeling were united in the same canvas. "Painting is but another word for feeling," he wrote to Fisher on October 23, 1821;[7] but he also said, elsewhere, "Painting should be *understood,* not looked on with blind wonder, nor considered only as a poetic aspiration, but as a pursuit, *legitimate, scientific,* and *mechanical.*"[8]

In an early masterpiece, *Boat-building near Flatford Mill* (1815, 20 x 24¼″, London, Victoria and Albert Museum), the artist chose an ordinary scene, a view of people at work in pretty but unremarkable surroundings. How different this is from the romanticism of either Gainsborough's peasants or Turner's (q.v.) *Hannibal* (1812, 57½ x 93½″, London, Tate Gallery). Henceforth, Constable wrote, "It is the business of a painter ... to make something out of nothing, in attempting which he must almost of necessity become poetical."[9] This is the first instance of an English artist claiming that beauty was independent of subject matter. No longer was he tied to the great

traditions of pastoral or heroic modes of landscape, although this hardly meant they were traditions Constable ignored. As early as the letter to Dunthorne of May 29, 1802, thinking of Turner's *Tenth Plague of Egypt* (1802, 56½ x 93″, London, Tate Gallery), Constable had written, "There is room enough for a natural painture. The great vice of the present day is *bravura*, an attempt at something beyond the truth. . . . *Fashion* always had, & will have its day—but *Truth* (in all things) only will last and can have just claims on posterity."[10]

In the years until about 1816 Constable gained the control over his medium that he needed before setting off to extend the very definition of what a finished picture could be. This great summation he unrolled in six canvases exhibited at the Royal Academy between 1819 and 1825, each about six feet by four and one-half feet, and each showing the progress of a barge on the canals of the Stour. The six are *The White Horse* (1819, New York, Frick Collection), *Stratford Mill* (1820, Great Britain, private collection), *The Hay Wain* (1821, London, National Gallery), *View on the Stour near Dedham* (1822, San Marino, California, Henry E. Huntington Library and Art Gallery), *The Lock* (1824, Gloucestershire, Sudeley Castle, Morrison Pictures Settlement), and *The Leaping Horse* (1825, London, Royal Academy). The problem he faced and solved in these pictures was one artists had pondered for at least a century: he had evolved an expressive and precise sketching style, which brilliantly caught effects of light, motion, texture, and time. But a sketch is limited, or in his words, "will not serve more than one state of mind & will not serve to drink at again & again—in a sketch there is nothing but one state of mind—that which you were in at the time."[11] The problem was twofold: how to translate the spontaneous brushstrokes of his spirited little sketches to a full-sized canvas and yet not lose the immediacy and freshness of the original moment of inspiration; and allied to this, how to translate scenes of working life in a tiny East Anglian village to a scale and a moral importance comparable to historical or classical landscapes of Claude, Gaspard Poussin (1615–1675), Richard Wilson, or Turner (q.q.v.).

The instrument he used to achieve the first of these aims was the full-sized sketch, what Kenneth Clark has called Constable's "supreme achievement."[12] These were apparently trial runs for his six-foot academy pictures, but painted with an unselfconscious freedom, which corresponded to everyone's idea of a sketch eight by twelve inches, but which in the early nineteenth century were unacceptable as "real" pictures. Besides blocking out the masses and working out the composition, he was free to minimize differences in tone and texture, background and foreground, and even to some extent differences of color. By doing so, he could explore the formal values of the scene in front of him, rather, if one is permitted such a comparison without making Constable sound more modern than he is, as Cézanne (1839–1906) would do with his Mount St. Victoire series in the 1890s.

These famous sketches seem to have been painted as exercises in self-referential painting: painting *as* painting rather than simply as a view of the real world. In the finished canvases, focus is clarified, texture to some extent returns, colors and outlines are rendered in a way much more true to their equivalents in nature.

The second of his aims, to have his academy machines accepted as the successors to the grand tradition of Roman and Bolognese landscape, simply meant the acceptance of things he knew to be real on a par with the idealized, and therefore imaginary, world. One way to effect this was to model the compositions of the academy pictures, however lowly their actual subject, on examples from the work of Claude and Rubens (1577–1640). Thus, paradoxically, when we stand in front of a canvas like *The Hay Wain*, however

accurate the fictive view in front of us may appear, it has been monumentalized, altered, shifted, falsified in its own way, so that the world in Constable's painting is denser, more intense, and more teeming than in reality: the buildings are larger, the river wider, the whole scene given a dignity and scale it simply does not possess when we stand in front of the spot itself.

Constable's life was one of deep frustration, of gratification delayed nearly beyond endurance. As he struggled for the acceptance of his art by his colleagues, so he defied the society in which he lived to marry the well-born granddaughter of the rector of East Bergholt, Maria Bicknell, in 1816. He placed his trust in what he knew to be real: the worth of his own art, his love for his wife, his devotion to his children, his friendship with John Fisher. In his most moving letter to Fisher, he thanks his friend for believing in him, for Fisher's trust "teaches me to value my own natural dignity of mind . . . above all things."[13] Like his painting, Constable was a man of inexhaustible richness and complexity. His letters are among the most revealing and eloquent ever written by an artist; his biography, by the artist C. R. Leslie (1794–1859), has been called the finest biography of a painter ever written.[14]

Constable's art was his life, and his canvases are but extensions, we sometimes feel (and indeed, he sometimes said),[15] of his own personality. This is most evident after his wife's death from tuberculosis in 1828, leaving him with seven children. Then, anxiety, tension, loneliness—qualities always liable to darken and trouble the spirit of paintings throughout his career—suddenly roll over Constable, so that works executed after 1828, such as the *Sketch for "Hadleigh Castle"* (1828–29, 48¼ x 65⅞″, London, Tate Gallery) with its wild, uncontrolled brushwork, become clear metaphors for loneliness and also endurance; or his *Cenotaph* (1836, 52 x 42¾″, London, National Gallery), his tribute to both Sir George Beaumont and Sir Joshua Reynolds (q.v.), a statement about the isolation of an artist's life, comparable in power to Cowper's most melancholy and gentle lines of poetry.

Constable first exhibited at the Royal Academy in 1802. He was elected an Associate at the age of forty-three in 1819, and a full Academician in 1829. His first real taste of fame came in 1824 when his *Hay Wain* was exhibited at the Paris Salon and won the gold medal. French artists, from Gericault (1791–1824)—who saw the picture in London in 1821—and Delacroix (1798–1863), who is said to have repainted the *Massacre at Chios* (1824, 164 x 139″, Paris, Louvre) after seeing *The Hay Wain* in Paris in 1824, were his most enthusiastic admirers. Delacroix, for example, sought Constable out in Sussex during the French artist's visit to England in 1825, and the dealers most anxious to possess Constable's paintings in the 1820s were primarily French.

Constable lived in London on the perimeters of Bloomsbury at Charlotte Street (1811–17) and Keppel Street, Russell Square (1817–22). From 1819 he took a house in Hampstead where his wife and children were sent in the summer for the air, and in 1827 he bought a house in Well Walk, Hampstead, where Maria died.

The number of locations associated with Constable are surprisingly few: besides Suffolk and Salisbury, he painted at Brighton, where he and his family spent time between 1824 and 1828, and in Hampstead, which after 1821 gradually replaced Suffolk as his contact with country scenery, and where he painted his famous studies of clouds, executed on the heath in 1821 and 1822.

1. Farington Diary, [1793–], May 19, 1808.

2. Constable to John Fisher, October 23, 1821, in Beckett, ed., 1962–68, vol. 6, p. 78.

3. See Wilton, 1979, p. 32.

4. Constable to John Dunthorne, May 29, 1802, in Leslie, 1951, p. 15.

5. Ibid., p. 14.

6. Ibid., p. 15.

7. Beckett, ed., 1962–68, vol. 6, p. 78.

8. Leslie, 1951, p. 273.

9. Constable to John Fisher, August 29, 1824, in Beckett, ed., 1962–68, vol. 6, p. 172.

10. Beckett, ed., 1962–68, vol. 2, p. 32.

11. Constable to John Fisher, November 2, 1823, in Beckett, ed., 1962–68, vol. 6, p. 142.

12. Kenneth Clark, *Landscape into Art* (London, 1949), p. 77.

13. February 1821, in Beckett, ed., 1962–68, vol. 6, p. 63.

14. Gowing, 1960, n.p.

15. "Now for some wise purpose is every bit of sunshine clouded over in me" (Constable to David Lucas, in Beckett, ed., 1962–68, vol. 4, p. 414), or "Can it therefore be wondered at that I paint continual storms? 'Tempest o'er tempest rolled'" (to C. R. Leslie, in Beckett, ed., vol. 3, p. 122); or, having added a ruin to the first engraving of *The Glebe Farm*, Constable remarked: "For, *not* to have a symbol . . . of myself . . . would be missing the opportunity" (Beckett, ed., vol. 4, p. 382).

SELECTED BIBLIOGRAPHY: John Constable, *Various Subjects of Landscape Characteristic of English Scenery, Principally Intended to Display the Phenomena of the Chair'oscuro of Nature: . . . From Pictures Painted by J. C. Engraved by D. Lucas* (London, 1833); Obituary, "Our Weekly Gossip on Literature and Art," *The Athenaeum*, April 8, 1837, p. 250; Leslie, 1843; Holmes, 1902; Windsor, 1903; Herbert W. Tompkins, *Constable* (London, 1907); C[osmo] M[onkhouse], *Dictionary of National Biography*, s.v. "Constable, John"; Whitley, 1928, *1800–1820*, passim; Whitley, 1930, passim; Shirley, 1930; Leslie, 1937; Key, 1948; Kurt Badt, *John Constable's Clouds*, trans. Stanley Godman (London, 1950; 2nd ed., 1960); Leslie, 1951; Jonathan Mayne, *Constable Sketches* (London, 1953); Comstock, 1956, pp. 282–88; Kitson, 1957; Gowing, 1960; Reynolds, 1960; Beckett, ed., 1962–68; Reynolds, 1965; Charles Rhyne, "Fresh Light on John Constable," *Apollo*, vol. 88 (March 1968), pp. 227–30; Louis Hawes, "Constable's Sky Sketches," *Journal of the Warburg and Courtauld Institutes*, vol. 32 (1969), pp. 344–65; Leslie Parris, Conal Shields, and Ian Fleming-Williams, eds., *John Constable: Further Documents and Correspondence* (London and Ipswich, 1975); Taylor, 1975; Reg Gadney, *Constable and His World* (London, 1976); Michael Kitson, "The Inspiration of John Constable," *Royal Society of Arts Journal*, vol. 124 (1976), pp. 738–53; Michael Kitson, "John Constable at the Tate," *The Burlington Magazine*, vol. 118, no. 877 (April 1976), pp. 248–52; Graham Reynolds, "John Constable: Struggle and Success," *Apollo*, vol. 103 (April 1976), pp. 322–24; Alastair Smart and Attfield Brooks, *Constable and His Country* (London, 1976); Leslie Parris and Ian Fleming-Williams, "Which Constable?" *The Burlington Magazine*, vol. 120, no. 906 (September 1978), pp. 566–78; John Walker, *John Constable* (London, 1979); Hoozee, 1979; Barrell, 1980, pp. 131–64; Parris, 1981; Reynolds, 1984.

SELECTED EXHIBITIONS: London, Leggatt's, *Collection of Captain Constable*, 1899; London, Tate Gallery, *Centenary Exhibition of Paintings and Watercolours by John Constable, R.A., 1776–1837*, 1937 (organized by Andrew Shirley and P. M. Turner); Boston, 1946; London, Guildhall Art Gallery (Corporation Art Gallery), *Exhibition of Paintings by John Constable 1776–1837*, July–August 1952; Manchester, City Art Gallery, *John Constable*, 1956 (introduction by R. B. Beckett); Philadelphia and Detroit, 1968 (nos. 124–30 and biography by Allen Staley); Washington, D.C., 1969; Paris, Palais des Beaux-Arts de la Ville de Paris, *La Peinture Romantique Anglais et les Preraphaelites*, January–April 1972 (entries by Michael Kitson); London, Tate Gallery, *Centenary Exhibition of Paintings and Water-Colours by John Constable R.A. (1776–1837)*, May–August 1973; Auckland, 1973–74; London, 1976; Cambridge, 1976; New York, 1983.

II JOHN CONSTABLE

SKETCH FOR "A BOAT PASSING A LOCK," 1822–24
Oil on canvas, 55½ x 48″ (141 x 122 cm.)
John H. McFadden Collection, M28-1-2

Constable first mentioned the picture that would be known as *The Lock* in a letter to John Fisher of October 31, 1822: "I have got an excellent subject for a six foot canvas, which I should certainly paint for next year . . . but I have neither time nor money to speculate with, & my children begin to swarm."[1] Family illness ("anxiety—watching—& nursing—& my own present indisposition")[2] kept him away from his easel from Christmas to February. But on February 21, 1823, he wrote to Fisher, "I have put a large upright landscape in hand, and I hope to get it ready for the Academy."[3]

This large upright was almost certainly the Philadelphia *Sketch for "A Boat Passing a Lock."* The subject is the opening of sluice gates to lower the level of water in the upper lock, where a barge waits before continuing its journey upstream. The site shown is Flatford on the Stour, with Dedham Church in the distance and Flatford Mill at the spectator's back. The painting's shape was originally horizontal, as were all Constable's other six-foot academy "set pieces" and as later versions of *The Lock* theme would also be (see horizontal versions 1 and 2). But Constable added to the canvas at the top and cut down (by how much we do not know) on the right. The change in shape presumably took place between the letter of October 1822 and the one of February 1823. No preliminary drawings for the Philadelphia Museum of Art full-sized sketch are known, and indeed, the many changes to the shape and the composition of the sketch suggest that the artist worked partly by instinct, drastically rearranging and reshaping as he worked. Staley has suggested that one reason the Philadelphia sketch might not have been developed further is that Constable made too many changes for the alterations not to be noticeable and so decided to start on a fresh canvas.[4] On the reverse of this canvas is a fragmentary sketch of a young girl (fig. 11-1). The differences between the full-sized sketch and the finished version (fig. 11-2), exhibited at the Royal Academy in 1824, bought by the draper James Morrison (1790–1857) and now at Sudeley Castle (henceforth: Morrison version), are instructive.

The Morrison version lacks the additions at the top (and bottom), thus indicating that Constable worked on an intact canvas, making no substantial changes in the composition. X-radiographs show that in the Philadelphia sketch the artist originally included crossbeams over the lock, used presumably to reinforce the sides of the lock (see fig. 11-3). These were painted out almost certainly for purely aesthetic reasons: to include them at close range meant blotting out large areas of tree, sky, and distance. These crossbeams are also omitted in the Morrison version. Constable's touch is surer in the Morrison picture and he brings his details to a high degree of finish: the sky is bright blue, the clouds fleecy white, the waistcoat of the navigator (or navvy) working the lock is bright red; the articulation of foreground, middle-ground, and distance is much clearer; the plants in the foreground are probably identifiable, which is not true of those in the Philadelphia sketch; and the complicated spatial structure of the lock itself, its intricate architecture, is the chief interest of the left half of the Morrison picture.

In the Philadelphia version the navvy has just put down his fishing rod to attend to his duties. This genre-like incident Constable abandoned in the finished painting for two reasons. First, by eliminating the narrative element, the artist could stabilize the scene, suppressing the particular to emphasize the timeless; and second, the fascinating shape of the wooden lock, which

FIG. 11-1 John Constable, Reverse of *Sketch for "A Boat Passing a Lock"*

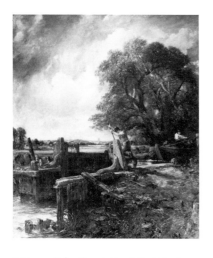

FIG. 11-2 John Constable, *A Boat Passing a Lock*, 1824, oil on canvas, 56 x 47½″ (142.2 x 120.6 cm.), Gloucestershire, Sudeley Castle, Trustees of the Walter Morrison Pictures Settlement

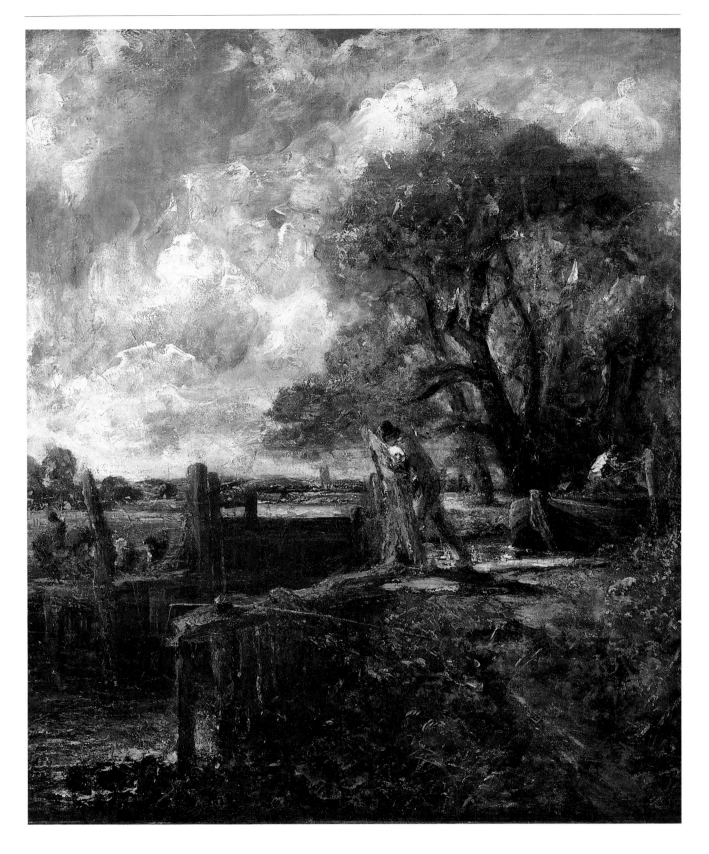

FIG. II-3 X-radiograph of *Sketch for "A Boat Passing a Lock,"* Philadelphia Museum of Art, Conservation Department, 1967

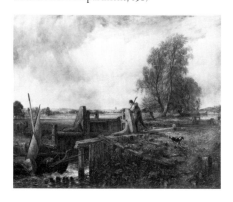

FIG. II-4 John Constable, *The Lock,* 1826, oil on canvas, 40 x 50″ (101.6 x 127 cm.), London, Royal Academy

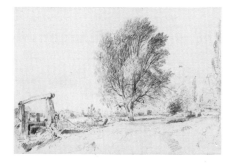

FIG. II-5 John Constable, *Flatford Lock,* 1827, pencil on paper, watermarked 1824, 8¾ x 12⅞″ (22.2 x 32.7 cm.), London, British Museum

draws the eye from left to right across the foreground of the picture, needed a stronger element than the slim fishing rod to connect it with the right foreground.

What we feel most in the Morrison picture is its freshness. Much more than in the Philadelphia sketch the artist caught the effect with heavy white impasto of water rushing out of the sluice gates at the lower left, so that we all but hear the sound of the creaking wooden gates and bubbling water foam. The artist might almost have intended the Morrison version to illustrate his remarks to Fisher in a letter of October 23, 1821: "The sound of water escaping from Mill dams . . . Willows, Old rotten Banks, slimy posts, & brickwork. I love such things. . . . As long as I do paint I shall never cease to paint such Places."[5] Twice Constable described his lock in similar language. To Fisher he wrote: "It is a lovely subject, of the canal kind, lively—& soothing—calm and exhilarating, fresh—& blowing,"[6] and again on April 13, 1825, speaking of the Morrison version which was back in his studio for Samuel William Reynolds (1774–1834) to engrave: "My Lock is now on my easil. It looks most beautifully silvery, windy & delicious—it is all health—& the absence of every thing stagnant, and is wonderfully got together after only this one year."[7]

The loss of time through illness meant that *The Lock* was not ready for the Royal Academy exhibition of 1823 but was sent to the 1824 exhibition instead. Even by September 30, 1823, the artist did not know what his large subject for the academy of 1824 would be,[8] and only on December 16, 1823, did he tell Fisher firmly that he would work on "my Lock."[9] On April 15, 1824, while preparing for the academy, Constable wrote to Fisher, "I was never more fully bent on any picture than on that on which you left me engaged upon. It is going to its audit with all its deficiencies in hand—my *friends* all tell me it is my best. Be that as it may I have done my best. It is a good subject and an admirable instance of the picturesque."[10]

On the opening day of the exhibition James Morrison bought *The Lock.* It was the most popular picture Constable had so far painted, if one excepts the French response to his *Hay Wain,* which would be acclaimed later in 1824 at the Paris Salon. *The Literary Gazette* compared Constable to Richard Wilson (q.v.);[11] the aged Fuseli (1741–1825), leaning on the porter's arm, visited the picture every Sunday morning.[12] On May 8, Constable wrote jubilantly to Fisher: "My picture is liked at the Academy. Indeed it forms a decided feature and its light cannot be put out, because it is the light of nature—the Mother of all that is valuable in poetry, painting or anything else."[13] Perhaps the most welcome praise came from the engraver S. W. Reynolds, who offered to engrave the landscape gratis, because "take it for all in all, since the days of Gainsborough and Wilson, no landscape has been painted with so much truth and originality, so much art, so little artifice."[14]

So deeply did Constable feel about his lock subject that he copied it in an upright format at least once (see upright version 2) and allowed John Dunthorne to copy it under his supervision (but which of the versions this is is not certain). Then in 1825 he undertook the same subject in a horizontal format for the dealer James Carpenter (b. c. 1760). He never gave this picture to Carpenter but submitted it instead as his diploma work to the Royal Academy (fig. II-4).

Recalling that the artist originally conceived of the Philadelphia version as a horizontal picture with crossbeams on the lock,[15] we might visualize his original intentions by looking to an earlier series, the *Mill at Dedham* (1818–19, 21 x 30½″, London, Tate Gallery).[16] In these views of a lock and mill the artist took a long view of the scene, from perhaps a quarter mile away, which enabled him to include the crossbeams over the lock but also forced him to show the mill buildings at the left. The artistic problem presented by the lock

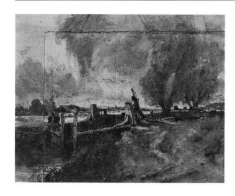

FIG. 11-6 John Constable, *The Lock*, c. 1826, pen and sepia wash on paper, 11¼ x 14½" (28 x 36.8 cm.), Cambridge, Fitzwilliam Museum

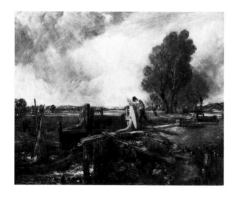

FIG. 11-7 John Constable, *The Lock*, c. 1826, oil on canvas, 40½ x 51⅛" (102.9 x 129.8 cm.), Melbourne, National Gallery of Victoria, Felton Bequest

series, begun with the Philadelphia sketch, was to depict a similar scene from close by.

In the fall of 1827 Constable revisited the site of Flatford Lock. At that time he executed a drawing on the spot showing the lock with crossbeams and willow tree (not the elm that appears in the Philadelphia and Morrison pictures). This drawing, on paper watermarked 1824, is now in the British Museum, and of all the lock paintings and sketches probably shows the site as it really was (fig. 11-5). Slightly earlier than the British Museum sketch is a pen and ink drawing in the Fitzwilliam Museum (fig. 11-6), which is preparatory to the diploma picture. In both the British Museum and Fitzwilliam sketches, Constable wrestled with the problem of depicting the scene as it appeared in reality. The only way to include the crossbeams without throwing off the composition seems to have been to take a longer view of the lock so that the beams would be below the horizon, and this long view could only be achieved by standing (theoretically) in a boat in the river. In what may be the unfinished preparatory oil sketch for the diploma picture, now in Melbourne (fig. 11-7), Constable once again painted in the crossbeams, as in the Philadelphia sketch for the Morrison picture; but once again he found they did not work and painted them out. In the diploma picture the artist was defeated by the problem, and the crossbeams do not appear. The other important difference in the Melbourne oil sketch and Royal Academy diploma picture is that the barge is traveling downstream, waiting for the navvy to raise the level of the water before the boat can enter the lock.

1. Beckett, ed., 1962–68, vol. 6, p. 100.
2. Constable to Fisher, February 1, 1823, ibid., p. 109.
3. Ibid., p. 112.
4. Philadelphia and Detroit, 1968, no. 128.
5. Beckett, ed., 1962–68, vol. 6, p. 77.
6. Ibid., p. 198.
7. Ibid., p. 200.
8. Ibid., p. 133.
9. Ibid., p. 146.
10. Ibid., p. 155.
11. Ibid., vol. 2, p. 340. See also Taylor, 1975, p. 207.
12. Beckett, ed., 1962–68, vol. 5, p. 61.
13. Ibid., vol. 6, p. 157.
14. Ibid., vol. 4, p. 266.
15. This was strictly accurate, but their absence was not particularly noticed by a Mrs. Godfrey of East Bergholt who in 1824 told Constable after seeing the Morrison picture at the academy that it "flattered the spot but did not belye nature." See Beckett, ed., 1962–68, vol. 1, p. 211.
16. Hoozee, 1979, no. 256, repro. Versions also in London, Victoria and Albert Museum, and Manchester, New Hampshire, Currier Gallery of Art.

PROVENANCE: Ernest Gambart, London; his sale, Christie's, May 4, 1861, lot 294, bt. E. A. Leatham, Misarden Park, Gloucestershire; his sale, Christie's, May 19, 1901, lot 121, bt. Vicars; Agnew; bt. John H. McFadden, June 14, 1901.

EXHIBITIONS: London, Thomas Agnew and Sons, *Seventh Annual Exhibition on Behalf of the Artist's General Benevolent Institution*, November–December 1901, no. 8; New York, 1917, no. 4, fig. 4; Pittsburgh, 1917, no. 1, repro.; Philadelphia, 1928, p. 22; Philadelphia, Philadelphia Museum of Art, *Diamond Jubilee Exhibition, Masterpieces of Painting*, November 4, 1950–February 11, 1951; Philadelphia and Detroit, 1968, no. 128; London, Royal Academy, *Royal Academy of Arts Bicentenary Exhibition 1768*, 1968–69, no. 94; New York, 1983, no. 21.

LITERATURE: *Catalogue of Oil Paintings by the Old Masters in the Possession of E. A. Leatham, Esq., Misarden Park, Gloucestershire* (1898), p. 5; Holmes, 1902, pp. 121, 247; Windsor, 1903, p. 203; Roberts, 1913, p. 541; McFadden, 1917, repro. p. 108; Roberts, 1917, pp. 3–5; Roberts, 1918, "Additions," p. 114; Roberts, 1919, p. 14, repro. p. 9; "Philadelphia's Diamond Jubilee," *The Connoisseur*, vol. 126 (October 1950), p. 130, repro. p. 131; "The Diamond Jubilee Exhibition," *Philadelphia Museum of Art Bulletin*, vol. 45, no. 224 (winter 1950), p. 81, repro. p. 79; Shirley, 1951, p. 73, repro. p. 74; R. B. Beckett, *John Constable and the Fishers:*

The Record of a Friendship (London, 1952), p. 121; Beckett, 1952, pp. 255, 256, p. 253 fig 8; Simpson, 1952, p. 39; Comstock, 1956, p. 282; Constable, 1964, pp. 131, 134, pl. 117; Reynolds, 1965, pp. 73, 142, pl. 41; Beckett, ed., 1962–68, vol. 2, pp. 279–80, vol. 6, pp. 100, 101, 112, 114; Washington, D.C., 1969, see no. 29; Staley, 1974, pp. 37–38; Taylor, 1975, pp. 207–8, n. 39, pl. 100; Cambridge, 1976, p. 108; London, 1976, p. 138; Alastair Smart and Attfield Brooks, *Constable and His Country* (London, 1976), p. 138; Walker, 1979, pl. 38; Hoozee, 1979, no. 404; Reynolds, 1984, vol. 1, p. 135.

CONDITION NOTES: The original support of medium-weight linen probably measured about 46 by 48½" to 49". It appears that at some time during the process of applying paint, the artist changed the shape of the design. From x-radiographs, this appears to have entailed flattening out the top tacking margin and adding a piece of fabric behind that margin, which allowed the design to be extended approximately 11¼" upward beyond the original top edge of the design. Of that painted addition, ¾" is now folded over as tacking margin. Probably at the same time a portion of the right edge was folded back to become a tacking margin. A faint evidence of cusping along the right edge in the x-radiograph suggests not much design is missing beyond that used for the right-hand tacking margin. Cusping in the x-radiograph suggests that the left edge has remained unchanged. Vertical lines of thinner paint can be seen in the x-radiograph running parallel to right and left edges 5½" in from the edges, probably indicating the inner edge of the original stretcher where the fabric rested on the edge as paint was applied to the fabric. A similar line parallel to the bottom edge suggests that the original design originally extended 1" below the present 1" addition, which appears to have been added at a later date and does not support original paint. In 1967 an old aqueous lining was removed and a slight overlap on the reverse was cut off where the top fabric joined the central fabric. A portrait sketch, visible in the x-radiograph, was revealed on the reverse (fig. 11-1). The painting was wax-resin lined at that time, retaining top and bottom additions and all tacking margins. The x-radiograph shows a 6 by 4" T-shaped tear at right above center and three other, smaller tears scattered across the original center portion of the design. That portion also sustained considerable paint loss in a horizontal line 1" below what was the original top edge. The top and right tacking margins, which bear original paint, are badly damaged and partially missing. The paint is in fairly good condition despite a history of active paint cleavage documented from 1955 until the wax-resin relining in 1967. The original profile of the paint varied from very high impasto to extremely thin applications, but the highest points of impasto have been markedly flattened by lining. The upper horizontal join is clearly visible through the paint texture, with the selvage of the central original support fabric especially prominent. The x-radiograph indicates artist's changes on both sides of the lock where vertical pilings and horizontal crossbeams have been painted out. A succession of partial cleanings (documented in 1944 and 1967) has left dark residues of varnish in the interstices of light tones, particularly noticeable in the sky. Ultraviolet light shows the 1967 retouchings, primarily along the horizontal joins in the support and in the water at lower left.

UPRIGHT VERSIONS
1. John Constable, *A Boat Passing a Lock,* 1824, oil on canvas, 56 x 47½" (142.2 x 120.6 cm.), Gloucestershire, Sudeley Castle, Trustees of the Walter Morrison Pictures Settlement (fig. 11-2).
PROVENANCE: Bt. from the Royal Academy exhibition, 1824, by James Morrison of Basildon Park; by descent.
EXHIBITIONS: London, Royal Academy, 1824, no. 180; London, British Institution, *Living Artists of the English School,* 1825, no. 129; London, 1976, no. 227.
LITERATURE: Holmes, 1902, p. 247; Beckett, 1952, p. 255, p. 254, fig. 15; Simpson, 1952, p. 39; Constable, 1964, pp. 131–32, pl. 115; Beckett, ed., 1962–68, vol. 4, p. 280; Hoozee, 1979, no. 405, p. 127 fig. XLIV; Reynolds, 1984, vol. 1, pp. 133–34.
ENGRAVING: S. W. Reynolds after John Constable (unfinished), *Canal Scene; The Opening of the Lock,* 1825, mezzotint, 15½ x 12⅞" (39.4 x 32.7 cm.).
INSCRIPTION: (3rd state) *Painted by John Constable R.A. / Engraved by S. W. Reynolds, Engraver to the King. A Canal Scene, the Opening of the Lock.*
LITERATURE: Alfred Whitman, *Samuel William Reynolds* (London, 1903), p. 99, no. 347; Holmes, 1902, p. 219, repro. opp. p. 132; Beckett, ed., 1962–68, vol. 4, pp. 267–68.

2. John Constable, *Landscape—A Barge Passing a Lock on the Stour,* 1825, oil on canvas, 55 x 48" (139.7 x 122 cm.), Hon. William Hamilton Collection, England.
PROVENANCE: Artist's sale, Fosters, May 16, 1838, lot 76, bt. Capt. Charles Birch, Matchley Abbey, Birmingham; his sale, Foster's, February 15, 1855, lot 18, bt. in; Foster's, February 28, 1856, lot 61; bt. William Holmes for W. Orme Foster, Apley Park, Bridgnorth; by descent to Maj. S. W. Foster; inherited by Maj. Gen. E. H. Goulburn; bequeathed to Hon. William Hamilton.
EXHIBITIONS: Possibly Brussels, *Exposition Nationale des Beaux-Arts,* 1833; Worcester, Worcester Institution, 1834, no. 141 (as "A Barge Passing a Lock on the Stour"); Birmingham, Society of Arts, 1838, no. 42; Manchester, *Art Treasures Exhibition,* 1857, no. 298 (lent by W. O. Foster); Wrexham, *Art Treasures Exhibition,* 1876, no. 283 (lent by W. O. Foster); London, 1976, no. 312.
LITERATURE: Beckett, 1952, pp. 255–56, p. 253 fig. 9; Simpson, 1952, p. 39; Constable, 1964, p. 133; Beckett, ed., 1962–68, vol. 2, p. 416; Hoozee, 1979, no. 457; Reynolds, 1984, vol. 1, p. 164.

ENGRAVING: David Lucas after John Constable, *The Lock,* begun 1832, published 1834, mezzotint, 27¼ x 20½" (69.2 x 52 cm.).

INSCRIPTION: (1st state) *PAINTED BY JOHN CONSTABLE ESQ.* ᴿ *R.A. / ENGRAVED BY DAVID LUCAS / London Published June 2, 1834 by F. G. Moon, 20, Threadneedle Street T, McLean, Haymarket & Hodgson, Boys & Graves, 6. Pall Mall / Messrs, Leggatt, Bros.* 3rd state dedicated to the president and members of the Royal Academy.

LITERATURE: Shirley, 1930, p. 198, no. 35, pl. XXXV; Constable, 1964, pp. 136–37.

3. After John Constable (John Dunthorne?), *The Lock,* oil on canvas, 51 x 46½" (129.5 x 118.1 cm.), New York art market, 1956.

PROVENANCE: Possibly Alfred Lucas (brother of David Lucas); bt. Henry G. Marquand, 1888.

LITERATURE: Constable, 1964, p. 133, pl. 116.

4. After John Constable, *The Lock,* oil on canvas, 46¾ x 55¾" (118.7 x 141.6 cm.), Omaha, Nebraska, Joslyn Art Museum.

PROVENANCE: Dr. Thompson, Sheffield, England; Francis Bartlett, Boston; by descent to Bartlett's son-in-law Herbert M. Sears; his sale, Parke-Bernet, October 17, 1942, lot 127, bt. M. Burman, San Francisco; Paul Drey Gallery, New York; bt. Joslyn Art Museum, 1946.

LITERATURE: Constable, 1964, p. 134.

5. Attributed to David Cox (q.v.) after John Constable, *The Lock on the Stour,* c. 1845, oil on canvas, 29¼ x 24¼" (74.3 x 61.6 cm.), Indianapolis, Indianapolis Museum of Art.

PROVENANCE: Cherámy Collection, Paris, to c. 1908; Julius Böhler, Munich; James William Fessler; The John Herron Museum (Indianapolis Museum of Art), 1953.

LITERATURE: Constable, 1964, p. 134, pl. 118.

6. After John Constable, *Sketch for "The Lock,"* oil on canvas, 36 x 28" (91.5 x 71 cm.), formerly Upperville, Virginia, Paul Mellon Collection.

EXHIBITIONS: New Haven, Yale University Art Gallery, 1965, no. 44; Washington, D.C., 1969, no. 29.

HORIZONTAL VERSIONS

1. John Constable, *The Lock,* 1826, oil on canvas, 40 x 50" (101.6 x 127 cm.), London, Royal Academy (fig. 11-4).

PROVENANCE: Commissioned by James Carpenter; presented by the artist as a diploma work to the Royal Academy, 1829.

EXHIBITIONS: London, British Institution, 1829, no. 38; London, Guildhall Art Gallery, 1952, no. 9; London, Royal Academy, *Treasures of the Royal Academy,* September–October 1963, no. 272; Auckland, 1973–74, no. 32; London, 1976, no. 262.

LITERATURE: Shirley, 1951, p. 72, repro. p. 72; Beckett, 1952, p. 256, p. 254 fig. 14; Constable, 1964, p. 138, pl. 119; Reynolds, 1965, pl. XII; Beckett, ed., 1962–68, vol. 2, p. 436; Hoozee, 1979, no. 472; Reynolds, 1984, vol. 1, p. 172.

2. John Constable, *The Lock,* c. 1826, oil on canvas, 40½ x 51⅛" (102.9 x 129.8 cm.), Melbourne, National Gallery of Victoria (fig. 11-7).

PROVENANCE: Private collection, Exeter; Arthur Tooth and Son, London, 1950, bt. National Gallery of Victoria.

EXHIBITION: Auckland, 1973–74, no. 33.

LITERATURE: Shirley, 1951, pp. 71–75, 132; Beckett, 1952, p. 256, p. 253 fig. 10; Constable, 1964, p. 138, pl. 120; Hoozee, 1979, no. 473; Reynolds, 1984, vol. 1, p. 172.

3. After John Constable, *The Lock,* oil on canvas, 33½ x 43½" (85 x 110.5 cm.), location unknown.

PROVENANCE: Mrs. Barfoot, Leicester, 1889; Sotheby's, March 20, 1968, lot 110.

4. After John Constable, *The Lock,* oil on canvas, 27 x 36" (68.6 x 91.4 cm.), New York, Morris Joseloff, 1952.

LITERATURE: Beckett, 1952, pp. 252–56; Hoozee, 1979, see under no. 272.

RELATED WORKS

1. John Constable, *Flatford Lock,* 1827, pencil on paper, watermarked 1824, 8¾ x 12⅞" (22.2 x 32.7 cm.), London, British Museum (fig. 11-5).

PROVENANCE: Bequest of Isabel Constable.

LITERATURE: Beckett, 1952, p. 256, p. 254 fig. 13; Constable, 1964, pp. 138–39, pl. 121; Hoozee, 1979, see under no. 472; Reynolds, 1984, vol. 1, p. 185.

2. John Constable, *The Lock,* c. 1826, pen and sepia wash on paper, 11¼ x 14½" (28 x 36.8 cm.), Cambridge, Fitzwilliam Museum (fig. 11-6).

PROVENANCE: Isabel Constable; Clifford Constable; J. Calm, 1899; J. P. Heseltine, 1902; Sotheby's, March 25, 1920 (lot unknown), bt. P. M. Turner; bequeathed to the Fitzwilliam Museum, 1950.

EXHIBITION: Cambridge, 1976, no. 27.

LITERATURE: Shirley, 1951, p. 73, repro. p. 73; Beckett, 1952, p. 256, p. 254 fig. 12; Constable, 1964, pp. 128ff., pl. 122; Hoozee, 1979, see under no. 472; Reynolds, 1984, vol. 1, pp. 172–73.

3. John Constable, *The Lock,* c. 1831–34, ink and sepia wash, 4½ x 5¾" (11.4 x 14.7 cm.), Cambridge, Fitzwilliam Museum.

INSCRIPTION: *A sketch by the late John Constable of the Lock. Diploma picture presented to the Royal Acadamy given to me by Mr. Constable. D. Lucas* [in the hand of David Lucas on the verso]; *David Lucas Esq, Hestamland* [in another hand]; and inscribed by Constable in pencil with notes for the arrangement of prints in *English Landscape Scenery.*

PROVENANCE: David Lucas; Theobald sale, Christie's, April 25–30, 1910, part of lot 1,097, bt. John Charrington and presented by him to the museum, 1910.

EXHIBITION: Cambridge, 1976, no. 31.

LITERATURE: Beckett, 1952, p. 256; Beckett, ed., 1962–68, vol. 4, p. 315; Constable, 1964, pl. 123; Hoozee, 1979, see under no. 472; Reynolds, 1984, vol. 1, p. 253.

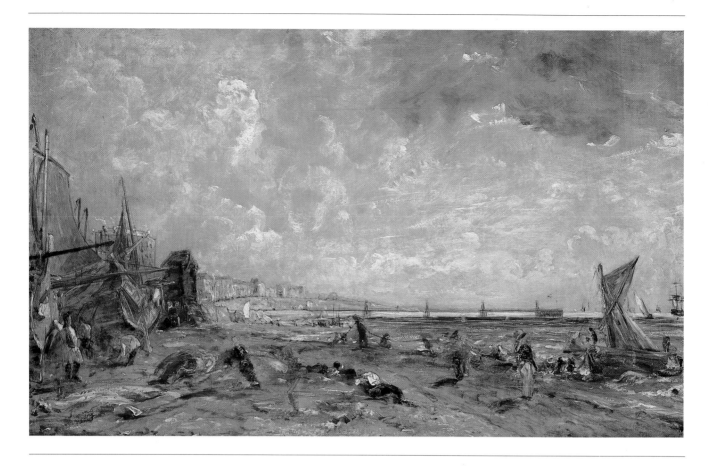

12 JOHN CONSTABLE

SKETCH FOR "THE MARINE PARADE AND CHAIN PIER, BRIGHTON,"
c. 1826–27
Oil on canvas, 23¾ x 38⅞″ (60.6 x 98.8 cm.)
W. P. Wilstach Collection, W96-1-5

Maria Bicknell had often spent time with her family in Brighton before her
marriage to John Constable in 1816. As early as November 12, 1814, her future
husband wrote to her there, "I never was at a bathing town, but I am told
they are amusing."[1] So, when Maria's health began seriously to deteriorate in
1824, it was to a resort she already knew, with frequent coach service to
London, that Constable took her. The family went there on May 13, 1824, but
the artist spent most of the summer in London, taking a week's holiday in
June and August. In 1825 the Constables spent September through November
in Brighton, and in 1826 were there in January. Their last stay was from May
to July 1828, just before Maria's final collapse and death in November of that
year.

Constable himself disliked Brighton, seeing in it the imposition of a
tawdry, urban world on the natural beauty of sea and sky. This is the theme of
a much-quoted letter to John Fisher of August 29, 1824, and may also be the
theme of his great Brighton "set piece," *The Chain Pier, Brighton,* exhibited at
the Royal Academy in 1827 and now in the Tate Gallery (fig. 12-1). The letter is
long, but deserves to be read more than once both to remind us how
distressing the new fashion for seaside life could be to the sensibilities of one
approaching it for the first time and also for Constable's comments on the
genre of the marine landscape:

> I am living here but I dislike the place.... Brighton is the receptacle of
> the fashion and offscouring of London. The magnificence of the sea, and
> its (to use your own beautifull expression) everlasting voice, is drowned

FIG. 12-1 John Constable, *Chain Pier, Brighton,* 1826–27, oil on canvas, 50 x 72″ (127 x 183 cm.), London, Tate Gallery

in the din & lost in the tumult of stage coaches—gigs—"flys" &c.—and the beach is only Piccadilly... by the sea-side. Ladies dressed & *undressed*—gentlemen in morning gowns & slippers on, or without them altogether about *knee deep* in the breakers—footmen—children—nursery maids, dogs, boys, fishermen—*preventive service men* (with hangers & pistols), rotten fish & those hideous amphibious animals the old bathing women, whose language both in oaths & voice resembles men—all are mixed up together in endless & indecent confusion. The genteeler part, the marine parade, is still more unnatural—with its trimmed and neat appearance & the dandy jetty or chain pier, with its long & elegant strides into the sea a full ¼ of a mile. In short there is nothing here for a painter but the breakers—& sky—which have been lovely indeed and always varying. The fishing boats are picturesque, but not so much so as the Hastings boats.... But these subjects are so hackneyed in the Exhibition, and are in fact so little capable of that beautifull sentiment that landscape is capable of or which rather belongs to landscape, that they have done a great deal of harm to the art—they form a class of art much easier than landscape & have in consequence almost supplanted it, and have drawn off many who would have encouraged the growth of a pastoral feel in their own minds—& paid others for pursuing it. But I am not complaining—I only meant to call to your recollection that we have Calcott & Collins—but not Wilson or Gainsborough.[2]

The Brighton Pier series is unusual in Constable's work because he was unsympathetic to the scene he was painting—indeed, as the last sentence of his letter to Fisher implies, to the whole genre of marine painting. To what degree, therefore, there exists an element of satire in the finished version, with its fishermen, bathers, sightseers, and even a "preventive service" man, with its boats, anchors, fish, dogs, hotels, flotsam, jetsam, and bathing machines—all of which draw our attention away from the sea and sky—is unclear. If satire is intended, such an edge is not the only way in which Constable's vision of Brighton stands apart from more conventional views by Turner (q.v.) and Augustus Callcott (1779–1844), and prefigures works of such Victorian artists as William Powell Frith (1819–1909), in whose *Life at the Seaside Ramsgate Sands* (1853, 30 x 60½″, Her Majesty Queen Elizabeth II), for example, seaside life is shown to have become as nightmarish as Paddington Station at the rush hour.

Why Constable undertook a perhaps antipathetic subject may be explained by John Fisher's complaint to him in a letter of November 13, 1824, that his pictures all looked the same, though Fisher was referring specifically to the time of day represented: "People are tired of mutton on top mutton at bottom mutton at the side dishes, though of the best flavour & smallest size."[3] When the picture was shown at the academy, Constable wrote to Dominic Colnaghi (April 6, 1827) that "Fisher rather likes my coast, or at least believes it to be a usefull change of subject."[4] Fisher himself took the greatest interest in the subject, predicting that it would become "the best sea-painting of the day,"[5] and it was he who connected it with the work of the more successful marine painters, telling his wife in a letter of April 11, 1827, that "it is most beautifully executed.... Turner, Calcott and Collins will not like it."[6]

The mention of these more successful artists introduces a second reason for Constable's undertaking the subject. Throughout the 1820s he tried repeatedly to secure election to the academy as a full Academician. As early as August 4, 1821, he wrote to Fisher, "I am going to pay my court to the world, if not for their sakes yet very much for my own."[7] It may be that in this change of direction he attempted to please his colleagues and also a public that

FIG. 12-2 J.M.W. Turner (q.v.), *The Marine Parade, Brighton*, c. 1828, oil on canvas, 28 x 53¾" (71 x 136 cm.), London, Tate Gallery

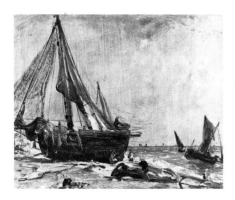

FIG. 12-3 John Constable, *Brighton Beach*, c. 1824–26, oil on canvas, 9½ x 11½" (24.2 x 29.2 cm.), Dunedin, New Zealand, Public Art Gallery

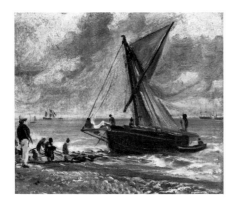

FIG. 12-4 John Constable, *Fishing Boats*, c. 1824–26, oil on canvas, 9½ x 11½" (24.2 x 29.2 cm.), private collection

had made these marine painters so successful. If so, the plan failed, for Constable was not elected a Royal Academician until 1829; *The Chain Pier* was criticized in the press and the picture was not sold during his lifetime.

Turner's views of Brighton Pier, at the Tate Gallery (fig. 12-2) and Petworth,[8] which are nearly contemporary with Constable's series, make an interesting comparison with Constable's *Chain Pier, Brighton* at the Tate (fig. 12-1). Where Turner turns Brighton into Cythera seen at sunset from a distance, Constable captures much of what must have been the raw vitality, the ugliness of seaside life, highlighting what we often feel to be Constable's moral strength as opposed to Turner's evasive, cosmetic approach to reality. Indeed, Constable shows Brighton as cold, damp, and windy—as we know he found it on several of his visits, such as the one in January 1826 when the weather was "dreadfull."[9] Yet the artist had also seen Brighton at its best, so his decision to depict the resort as wintry and squally was deliberate; earlier Brighton sketches of 1824 now in the Victoria and Albert Museum[10] were executed on the spot in fine weather and are among the most loving and sensitive studies ever to come from Constable's brush. The bold oil sketches connected with the early stages of the Brighton Pier series, c. 1824–26 (figs. 12-3 and 12-4), are also directly taken from nature. Yet in the later compositional sketch in Philadelphia and in the final painting (fig. 12-1), both executed in the Hampstead studio 1826–27, the vision, like the weather, has darkened. Whether Brighton was associated in his mind with Maria's worsening health and so symbolized for Constable the turmoil of his own life, or whether the transition from sketch to full-sized canvas implied for Constable the necessity for dramatic effects of light and movement—the "chia'oscuro" of nature of which he often spoke—must remain open for discussion.

Leslie Parris (1981) has worked out the chronology and development of the sketches for the Tate landscape. The earliest drawing, in the Victoria and Albert Museum (fig. 12-5), shows the topography of the scene after the completion of the new pier on November 25, 1823, and before the opening of the Royal Albion Hotel in August 1826, which is first visible in the Philadelphia sketch on the far left of the marine parade and reappears in the final painting. Certain elements in the drawing, such as the marine parade at the left, the pier, bathing machines, and a Turner-like repoussoir element in the left foreground (in the Victoria and Albert sketch a wooden hut, later the beached boats and fisherfolk), remain constant from drawing through compositional sketch to final painting. A reclining figure in the foreground of the Victoria and Albert drawing recurs in the Dunedin oil sketch (fig. 12-3) and in the Philadelphia sketch but disappears in the final painting. A standing male figure, who first appears looking out to sea directly in front of the bathing machines in the Victoria and Albert sketch, identified by Parris as one of the "preventive service" men, or customs officers, about whom Constable wrote to Fisher, is shown in more detail in the oil sketch in a private collection (fig. 12-4). The reason for his presence is here made clear, for he watches the beaching of a boat, perhaps from France. This incident, with several figures on the beach hauling the boat to shore by ropes, recurs in the Philadelphia sketch at the right, but differently in that the customs man seems to turn his back to the boat and to stand slightly down the beach from the place where the boat lands. In the Tate version, the boat has not yet been beached, and the customs man stands farther from the shore and away from us—almost in the same spot where he stands in the original Victoria and Albert sketch.

FIG. 12-5 John Constable, *Marine Parade and Chain Pier, Brighton,* 1825–26, pencil and pen on two pieces of paper, 4⅜ x 16¾" (11.1 x 42.5 cm.), London, Victoria and Albert Museum

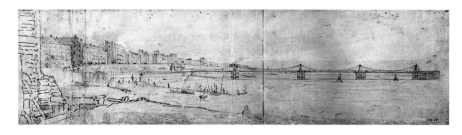

FIG. 12-6 John Constable, *Studies of Fishing Gear on the Beach at Brighton,* c. 1824, pen, pencil, and wash on paper, 7⅛ x 10⅜" (18.1 x 26.4 cm.), London, Victoria and Albert Museum

Other incidents Constable takes up and abandons from drawing to sketch to finished painting are the ladies with umbrellas and a sailor leaning against an upturned boat. Both first appear in the lively Dunedin sketch, and again are present in the Philadelphia sketch and the Tate canvas, but their positions in each are shifted slightly. The beached boat in the drawing formerly in the Heseltine collection (related work 3) appears in the Philadelphia sketch and again in the Tate picture.

Thus, in his Hampstead studio Constable seems to have worked from two sources: an accurate topographical drawing and several sketches made on the spot in Brighton (fig. 12-6). From there he arrived at a composition, hastily sketched in the Philadelphia picture, in which his interest is not in texture or color or even description, but in the assembly of the various elements: the beaching of the boat, the fisherfolk at the left, the ladies and the haulers. The beaching incident at the right was abandoned in the final picture possibly because it closed off the right side of the composition, whereas the final painting suggests the open expanse of sea stretching out from a too-crowded beach and shoreline on the left. The Tate landscape has been cut down by one-eighth of its length at the left. The engraving of the picture intact[11] shows that this impression of contrast between built-up land and open sea was even stronger in the original canvas.

The Philadelphia picture was at some point overpainted so that the two figures standing on the beach at the right-hand side of the picture, just to the left of the boat in the water, were removed. Likewise the sailor leaning on an upturned boat toward the left of the picture was in part overpainted. In 1957 these changes were removed and the figures restored.

1. Beckett, ed., 1962–68, vol. 2, p. 135.
2. Ibid., vol. 6, pp. 171–72.
3. Ibid., p. 180.
4. Ibid., vol. 4, p. 155.
5. Fisher to Constable, December 7, 1828, ibid., vol. 6, p. 241.
6. Ibid., p. 230.
7. Ibid., p. 71.
8. Butlin and Joll, 1977, nos. 286, 291.
9. Constable to Fisher, Beckett, ed., 1962–68, vol. 6, p. 212.
10. For illustrations of the 1824 Brighton sketches see Hoozee, 1979, nos. 409–15.
11. Frederick Smith after John Constable, *Brighton,* published 1829, line engraving, 7½ x 12¼" (19 x 31.1 cm.), London, British Museum. Published: Colnaghi, 1829 (London, 1976, no. 248, repro.).

PROVENANCE: Henry Reeve (b. 1813), by 1890; purchased for the W. P. Wilstach Collection, May 15, 1896.

EXHIBITIONS: London, Royal Academy, *Works by Old Masters and by Deceased Masters of the British School,* winter 1890, no. 55 (lent by Henry Reeve); Boston, 1946, no. 135; Columbia, South Carolina, Columbia Museum of Art, *10th Anniversary Exhibition,* March–May 1960; Phoenix, Arizona, Phoenix Art Museum, *English Landscape Painters,* December–January 1960–61.

LITERATURE: Wilstach, 1897 (suppl.), no. 182; Wilstach, 1908, no. 66; Wilstach, 1922, pp. 25–26, no. 63, repro. opp. p. 26; *The Pennsylvania Museum Bulletin,* vol. 33, no. 177 (March 1938), repro.; Leslie, 1951, pp. 415–16; Mary Chamot, "The Constable Room at the Tate," *The Connoisseur,* vol. 137 (May 1956), p. 262; Comstock, 1956, p. 282, p. 283 fig. 1; Gowing, 1960, pl. 12 with text; Reynolds, 1965, p. 149; Taylor, 1975, pl. 116, p. 209 n. 45; London, 1976, p. 149 no. 247, p. 139 no. 232; Hoozee, 1979, no. 476; Parris, 1981, p. 124, p. 125 fig. 6; Reynolds, 1984, vol. 1, p. 179.

CONDITION NOTES: The original support is medium-weight (12 x 12 threads/cm.) linen. The tacking margins have been removed. The painting was lined in 1938 with an aqueous adhesive and twill-weave, medium-weight linen. A very thin, off-white ground can be seen along the cut edges. Additionally, a light brown imprimatura is present overall and visible through the thinnest areas of paint application. The paint is in good condition overall. Minor scratches in the immediate foreground are the only damages present. An irregular web of narrow-aperture fracture crackle extends over the surface. The x-radiograph reveals three minor losses in the sky.

VERSION: John Constable, *Chain Pier, Brighton,* 1826–27, oil on canvas, 50 x 72" (127 x 183 cm.), London, Tate Gallery (fig. 12-1).

PROVENANCE: Artist's sale, Foster and Sons, May 16, 1838, lot 68, bt. Tiffin; bt. Rev. T. Sheepshanks, 1838; by descent to Lt. Col. A. C. Sheepshanks; bt. Agnew, 1948; H.A.C. Gregory, 1948; Sotheby's, July 20, 1949, lot 136, bt. in; bt. Tate Gallery through Agnew, 1950.

EXHIBITIONS: London, Royal Academy, 1827, no. 186; London, British Institution, 1828, no. 64; London, Royal Academy, *Old Masters,* 1888, no. 48; Leeds, Municipal Art Gallery, *Loan Collection of Works by "Old Masters,"* 1889, no. 540; London, Thomas Agnew and Sons, *English Landscapes,* 1926, no. 5; London, Royal Academy, *British Art,* 1934, no. 633; Leeds, City Art Gallery, *Masterpieces from the Collections of Yorkshire and Durham,* 1936, no. 40; London, Tate Gallery, *Centenary Exhibition of Paintings and Water-Colours by John Constable, R. A., 1776–1837,* May 4–August 31, 1937, no. 43; London, Royal Academy, *Bicentenary Exhibition,* 1968–69, no. 74; London, 1976, no. 247.

LITERATURE: Holmes, 1902, p. 248; Whitley, 1930, pp. 132–33, 142–43; Leslie, 1937, pp. 219, 221, 224, 229–30, 233, p. 221 pl. 106; Leslie, 1951, pp. 162, 163, 170; Mary Chamot, "The Constable Room at the Tate," *The Connoisseur,* vol. 137 (May 1956), pp. 262–63; Reynolds, 1965, pp. 102–5; Beckett, ed., 1962–68, vol. 2, p. 437, vol. 4, p. 155, vol. 5, pp. 230–31, 241; Hoozee, 1979, no. 477; Parris, 1981, no. 32, pp. 122–27, with additional bibliography; Reynolds, 1984, vol. 1, pp. 177–78.

RELATED WORKS

1. John Constable, *Marine Parade and Chain Pier, Brighton,* 1825–26, pencil and pen on two pieces of paper, 4⅜ x 16¾" (11.1 x 42.5 cm.), London, Victoria and Albert Museum (fig. 12-5).

EXHIBITION: London, 1976, no. 245.

LITERATURE: Reynolds, 1960, p. 177, no. 289, pl. 225; Mary Chamot, "The Constable Room at the Tate," *The Connoisseur,* vol. 137 (May 1956), p. 262; Hoozee, 1979, no. 477; Parris, 1981, p. 124 fig. 1, p. 126 n. 2; Reynolds, 1984, vol. 1, p. 178.

2. John Constable, *Studies of Fishing Gear on the Beach at Brighton,* c. 1824, pen, pencil, and wash on paper, 7⅛ x 10⅜" (18.1 x 26.4 cm.), London, Victoria and Albert Museum (fig. 12-6).

EXHIBITION: London, 1976, no. 231.

LITERATURE: Reynolds, 1960, no. 273 and 273a (recto and verso); Hoozee, 1979, no. 477; Parris, 1981, p. 124; Reynolds, 1984, vol. 1, p. 142.

3. John Constable, *Study of a Fishing Boat,* c. 1825–26, pencil on paper, 7 x 10¼" (17.8 x 25.4 cm.), private collection.

PROVENANCE: Possibly Capt. Constable; possibly his sale, Christie's, July 11, 1887, lot 3; J. P. Heseltine; his sale, Sotheby's, March 25, 1920, lot 117, bt. Gooden and Fox for Lord Leverhulme; Leverhulme sale, Anderson Galleries, New York, March 2, 1926, lot 81, bt. B. J. Klar; Sotheby's, New York, June 3, 1981, lot 197.

LITERATURE: Parris, 1981, pp. 124, 126 n. 4, p. 125 fig. 3; Reynolds, 1984, vol. 1, p. 142.

4. John Constable, *Brighton Beach,* c. 1824–26, oil on canvas, 9½ x 11½" (24.2 x 29.2 cm.), Dunedin, New Zealand, Public Art Gallery (fig. 12-3).

PROVENANCE: Isabel Constable; Christie's, June 17, 1892, lot 255, bt. Dowdeswell; Leggatt; P. L. Halstead, 1931; presented to the gallery, 1943.

EXHIBITIONS: Auckland, 1973–74, no. 30; London, 1976, no. 232.

LITERATURE: Hoozee, 1979, no. 425; Parris, 1981, pp. 124, 126, n. 5, p. 125 fig. 4; Reynolds, 1984, vol. 1, p. 147.

5. John Constable, *Fishing Boats,* c. 1824–26, oil on canvas, 9½ x 11½" (24.2 x 29.2 cm.), private collection (fig. 12-4).

PROVENANCE: Isabel Constable sale, June 17, 1892, lot 254, bt. Dowdeswell; Chéramy Collection; sale, Galerie Georges Petit, Paris, May 5–7, 1908, lot 19.

LITERATURE: London, 1976, p. 149; Hoozee, 1979, no. 426; Parris, 1981, p. 124, p. 125 fig. 5, p. 127 n. 6; Reynolds, 1984, vol. 1, p. 147.

6. Attributed to John Constable, *Marine Parade and Chain Pier, Brighton,* oil on paper on canvas, 13 x 24⅛" (33 x 61 cm.), Philadelphia, John G. Johnson Collection at the Philadelphia Museum of Art.

PROVENANCE: The French Gallery; bt. John G. Johnson, 1893.

LITERATURE: Hoozee, 1979, no. 693; Parris, 1981, pp. 124, 127 n. 8, p. 125 fig. 7; Reynolds, 1984, vol. 1, pp. 178–79.

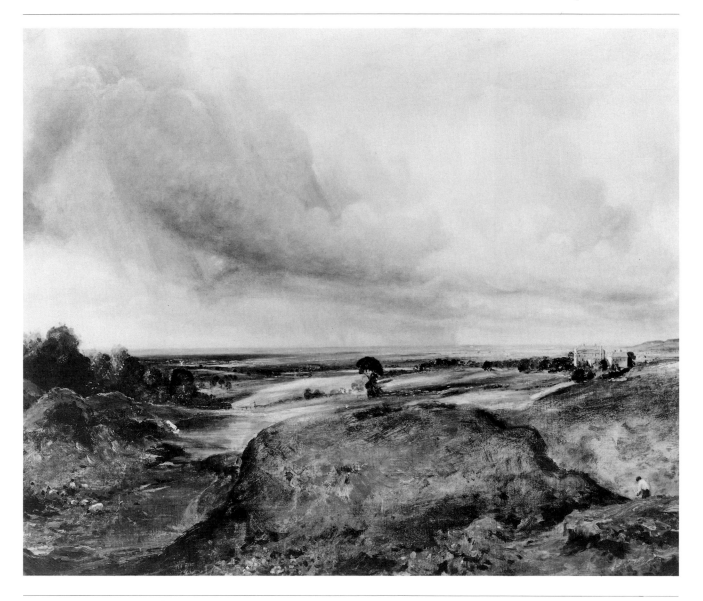

13 JOHN CONSTABLE AND STUDIO

BRANCH HILL POND, HAMPSTEAD HEATH, after 1825
Oil on canvas, 23 x 29½″ (58.4 x 75 cm.)
John H. McFadden Collection, M28-1-3

Constable first took his family to Hampstead in the summer of 1819, when he
rented Albion cottage, Upper Heath. On November 2, 1819, Farington noted
that Constable had "brought two pictures, studies on Hampstead Heath,
which he had painted," one of which showed Branch Hill Pond;[1] he returned
to the theme often until 1836.

Constable painted two basic types of views over Branch Hill Pond in
Hampstead. One, which Parris, following Reynolds, calls type A, includes a
steep bank of hill protruding sharply from the right foreground;[2] type B, to
which the Philadelphia picture and the primary versions in Richmond, Virginia
(fig. 13-1), Winterthur (fig. 13-2), and London at the Tate Gallery (fig. 13-3)
belong, shows the pond from higher up and farther away. The two finished
primary versions of *Branch Hill Pond* in Richmond and Winterthur (figs. 13-1
and 13-2) are almost identical because the latter seems to have been copied
from the former for the French dealer Claude Schroth in 1824. In both we find
a shepherd with his flock on the left, bathers in the pond, a cow drinking, and
just beyond the pond, a man leaning over a fence looking out to the windmill
in the far distance. In both Constable shows men, with a dog, and carts and
horses at work in the foreground, excavating sand.

FIG. 13-1 John Constable, *Branch Hill Pond, Hampstead Heath*, 1825, oil on canvas, 24¼ x 30¾" (61.6 x 78.1 cm.), Richmond, Virginia, Virginia Museum of Fine Arts

FIG. 13-2 John Constable, *Branch Hill Pond, Hampstead Heath*, 1824, oil on canvas, 23⅝ x 30¼" (60 x 77 cm.), Winterthur, Oskar Reinhart Collection

FIG. 13-3 John Constable, *Branch Hill Pond, Hampstead Heath*, c. 1825, oil on canvas, 21⅛ x 30¼" (53.6 x 76.8 cm.), London, Tate Gallery

The Tate sketch (fig. 13-3) is unfinished because, as the inscription states, Constable was pleased with the effect of the sky and feared spoiling it. Nevertheless, the shepherd and flock, bathers, and one cart and horse are retained at the right.

On August 1, 1825, Constable described the scene represented in the version of *Branch Hill Pond* then on view at the Royal Academy (version 1) to its prospective purchaser, Francis Darby, as "A scene on Hampstead Heath, with broken foreground and sand carts, Windsor Castle in the extreme distance on the right of the shower. The fresh greens in the distance (which you are pleased to admire) are the feilds about Harrow, and the villages of Hendon, Kilburn, &c."[3] The view is toward the west, southwest, taken from the end of Judges' Walk, on the Flagstaff and Whitestone pond side.

At first glance, the Philadelphia picture appears all but empty in comparison to the Winterthur and Richmond versions, and indeed two of the major motifs in those versions—the bathers in the pond and the excavation of sand in the foreground with horses and carts—are not present in the Philadelphia picture. Other elements are, however, included—although they are tentatively dabbed in: the shepherd and flocks to the left, the cow drinking at the pond, the man leaning over the fence in the middle distance behind the pond, and the tiny white windmill in the distance. The house called the Salt Box in the right middle distance is rendered in precise detail. In addition, the central cloud formation—the storm clouds seen to sweep toward the foreground—are nearly identical in the Winterthur, the Richmond, and the Philadelphia versions, whereas in the Tate version they are very different. On the basis of the sky and background alone, one might feel comfortable with a secure attribution to Constable's hand.

Yet the projecting hill in the foreground of the Philadelphia picture is either so unfinished that it is unintelligible as a form, or a later hand has finished an unfinished canvas by Constable but misunderstood the structure of the landscape. In fact, the hillock should have a rather steep side, falling off from the top as in the other two versions. Likewise, the line of the hill running down to the right is surely too crude to be by Constable's hand. The area in front of the Salt Box would seem also to be unfinished in the picture, lacking the definition in the Richmond and Winterthur versions, which shows that it too has a steep side and crest, with a road (up which the second cart is toiling) at the bottom. The whole foreground of the Philadelphia landscape is unfinished or finished by a painter who did not understand the artist's original intention. The man wearing a white blouse in the foreground at the right reminds one of similar figures in the landscapes of Richard Wilson (q.v.) but lacks the vigor of a peasant painted by Constable.

Both the Winterthur and Richmond pictures are painted on a red ground and are rather more colorful than the Philadelphia version, which has a blanched, even tonality, perhaps consistent with an unfinished canvas. The cloud formations, although identical to those in the other two pictures, have less feeling of sweep and are in general less airy than those in the other two versions.

1. Farington Diary, [1793], November 2, 1819. See also Reynolds, 1960, no. 171.
2. For versions of type A, see Reynolds, 1960, pp. 118–19; Parris, 1981, p. 114, no. 29.
3. Beckett, ed., 1962–68, vol. 4, p. 97.

PROVENANCE: Hugh Constable; bt. dealer Joseph Cahn, May 20, 1899; Leggatt, 1899; bt. Agnew, October 2, 1899; bt. from Agnew, February 3, 1900.

EXHIBITIONS: London, Leggatt Gallery, *Pictures and Water-Colour Drawings by John Constable, R.A.,* November 1899, no. 1 (as "Hampstead, Stormy Noon"); New York, 1917, no. 3; Pittsburgh, 1917, no. 3.

LITERATURE: Roberts, 1917, p. 7; Roberts, 1919, pp. 14, 17, repro. p. 13; Hans Tietze, ed., *Masterpieces of European Painting in America* (London, 1939), p. 236; Davies, 1959, p. 27; A. D. Chegodaev, *Constable* (in Russian) (Moscow, 1968), pl. 125; William S. Talbot, "John Constable: Branch Hill Pond, Hampstead Heath," *Bulletin of the Cleveland Museum of Art,* vol. 61, no. 3 (March 1974), pp. 108, 110, p. 109 fig. 13, p. 115 n. 9; Hoozee, 1979, no. 690; Reynolds, 1984, vol. 1, p. 159.

CONDITION NOTES: The original support is lightweight (20 x 20 threads/cm.) linen. The tacking margins have been removed. The painting is lined with an aged aqueous adhesive and medium-weight linen. The painting is mounted on a stretcher measuring 24 x 30¼" (61 x 78.1 cm). An off-white ground is present and evident along the cut edges and through the areas of thinnest paint application. The paint is in good condition. Much of the original profile of the brushwork has been retained. Generally paste-vehicular mixtures of paint were applied, followed by thinner, washlike applications of rich vehicular mixtures of paint. The highlights of the foliage are comprised of thinner, more transparent application of paint allowing some of the ground color to show through. In the foreground there is a single application of green in a very opaque, paste-vehicular paint.

VERSIONS

1. John Constable, *Branch Hill Pond, Hampstead Heath,* 1825, oil on canvas, 24¼ x 30¼" (61.6 x 78.1 cm.), Richmond, Virginia, Virginia Museum of Fine Arts (fig. 13-1).
PROVENANCE: Bt. from the artist by Francis Darby, Coalbrookdale, 1825; Alfred Darby; from whom bt. Agnew, 1908?; Sir J. Beecham, Bart.; Christie's, May 3, 1917, lot 8, bt. Agnew; M. Knoedler and Co., 1918; Chester Johnson; Mrs. F. E. Weyerhauser; Newhouse and Co., New York; A. D. Williams; presented to the museum by Mrs. A. D. Williams, 1949.
EXHIBITIONS: London, Royal Academy, 1825, no. 115 (as "Landscape"); Auckland, 1973–74, no. 28; London, 1976, no. 239.
LITERATURE: Comstock, 1956, p. 285; Beckett, ed., 1962–68, vol. 4, p. 97; *European Art in the Virginia Museum of Fine Arts* (Richmond, 1966), no. 121; Hoozee, 1979, no. 441; John Walker, *John Constable* (London, 1979), p. 120; Parris, 1981, pp. 114, 117–18.

2. John Constable, *Branch Hill Pond, Hampstead Heath,* 1824, oil on canvas, 23⅝ x 30¼" (60 x 77 cm.), Winterthur, Oskar Reinhart Collection (fig. 13-2).
PROVENANCE: Ordered by Claude Schroth, a French dealer, May 22, 1824; Mrs. Gibbons, 1855; Rev. B. Gibbons; Sir Robert Witt; Sir Joseph Beecham; his sale, Christie's, May 3, 1917, lot 10 (as "exhibited in Paris"); Agnew, 1932.
EXHIBITION: London, Royal Academy, winter 1890, no. 39 (lent by Rev. B. Gibbons).
LITERATURE: Reynolds, 1960, p. 148, no. 247; Beckett, ed., 1962–68, vol. 2, p. 314, vol. 6, p. 187; Graham Reynolds, "Constable at Work," *Apollo,* vol. 96 (July 1972), p. 12; Rudolf Koella, *Collection Oskar Reinhart* (Paris, 1975), no. 44, repro.; London, 1976, p. 144; Hoozee, 1979, p. 439; Parris, 1981, pp. 114, 117–18, p. 118 fig. 2; Reynolds, 1984, vol. 1, pp. 158–59.
ENGRAVING: David Lucas after John Constable, *Hampstead Heath: With Bathers,* before 1845, mezzotint, 9⅝ x 11½" (24.4 x 29.2 cm.).
INSCRIPTION: *John Constable, R.A. David Lucas / Hampstead Heath / Bohn's publication, 1855.*
PUBLISHED: *Bohn's English Landscape Scenery* (1855), no. 13 (as "Branch Hill Pond").
LITERATURE: Shirley, 1930, no. 51, p. 217, pl. LI; Wilton, 1979, p. 110, repro. p. 11.

3. John Constable, *Branch Hill Pond, Hampstead Heath,* c. 1825, oil on canvas, 21⅛ x 30¼" (53.6 x 76.8 cm.), London, Tate Gallery (fig. 13-3).
INSCRIPTION: *Constable told Purton that the sky so satisfied & pleased him, that he would never touch the canvas again for fear of spoiling it* [in the hand of Edwin W. Field on the stretcher, with details of provenance].
PROVENANCE: Probably artist's sale, Foster and Sons, May 16, 1838, lot 44, bt. William Purton; Edwin W. Field, July 1866; bequeathed to the National Gallery by Miss Susan Field, 1927.
LITERATURE: Comstock, 1956, p. 285; Davies, 1959, pp. 25–27, no. 4,237; London, 1976, p. 144; Hoozee, 1979, no. 529; Parris, 1981, no. 30, pp. 117–18, repro. p. 119; Reynolds, 1984, vol. 1, p. 159.

4. Circle of John Constable, *Branch Hill Pond, Hampstead Heath,* oil on canvas, 14 x 18" (35.5 x 45.7 cm.), Hampstead, Fenton House.
PROVENANCE: Lady Binning, Hampstead, by 1950.
LITERATURE: Gordon Nares, "Fenton House, Hampstead: A Home of Lady Binning," *Country Life,* March 24, 1950, p. 806.

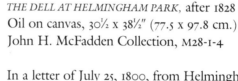

14 IMITATOR OF JOHN CONSTABLE

THE DELL AT HELMINGHAM PARK, after 1828
Oil on canvas, 30½ x 38½" (77.5 x 97.8 cm.)
John H. McFadden Collection, M28-1-4

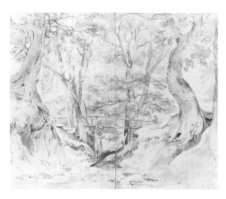

FIG. 14-1 John Constable, *The Dell at
Helmingham Park,* 1800, pencil, pen, and wash
on paper, 21 x 26⅛" (53.3 x 66.4 cm.), The
Clonterbrook Trustees

In a letter of July 25, 1800, from Helmingham Park in Suffolk, about twenty
miles north of East Bergholt, John Constable wrote to John Dunthorne:
"Here I am quite alone among the oaks and solitude of Helmingham
Park. . . . I am left at liberty to wander where I please during the day. There are
abundance of fine trees of all sorts; though the place on the whole affords
good objects rather than fine scenery; but I can hardly judge yet what I may
have to show you. I have made one or two drawings that may be usefull."[1]
One of the drawings to which Constable referred is a study dated July 23,
1800, now belonging to the Clonterbrook Trustees (fig. 14-1) and one of
Constable's most important early works on paper. On it all painted versions of
the scene are based. It depicts a water course running through the park at
Helmingham Hall, the seat of the Tollemache family, and in particular
Constable's early patron and lifelong friend the Countess of Dysart, wife of
Wilbraham, 6th Earl of Dysart, who in 1807 would commission from
Constable a number of portraits and copies after Reynolds (q.v.).

 A year before this letter to Dunthorne, Constable had written on August
18, 1799, to John Thomas "Antiquity" Smith while sketching in Ipswich, "I
fancy I see Gainsborough in every hedge and hollow tree."[2] The composition
of the Clonterbrook drawing may remind us of Gainsborough (q.v.) in its
dense, lush foliage and the motif of the rustic bridge. When a fine, smaller,
finished version of *The Dell at Helmingham* was exhibited at the British
Institution in 1833 (fig. 14-2), the critic of the *Morning Post* at once made this
association, writing that it had been painted in a "bygone style" with "all the
richness of truth of Gainsborough's best efforts without his tameness." The
same critic went on to compare the "brilliance and variety of colour [to] many
of the landscapes of Rubens."[3] Even more sensibly he might have pointed to
Constable's overriding debt to the landscapes of Jacob van Ruisdael
(1628?–1682).

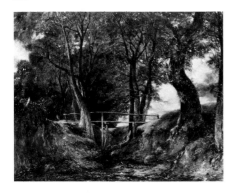

FIG. 14-2 John Constable, *The Dell at Helmingham Park*, 1825–26, retouched 1833, oil on canvas, 27⅞ x 36″ (70.8 x 91.4 cm.), Philadelphia, John G. Johnson Collection at the Philadelphia Museum of Art

FIG. 14-3 John Constable, *The Dell at Helmingham Park*, c. 1823–26, oil on canvas, 28 x 36¼″ (71.1 x 92.1 cm.), Anthony W. Bacon Collection, on loan to Birmingham, City Art Gallery

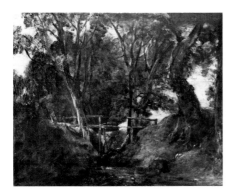

FIG. 14-4 John Constable, *The Dell at Helmingham Park*, c. 1825–26, oil on canvas, 40½ x 50¾″ (102.9 x 128.9 cm.), Paris, Louvre

The first painted version of *The Dell at Helmingham Park* dates from about 1823 (fig. 14-3), when Constable wrote to Fisher on July 10 recording Sir George Beaumont's satisfaction "with a large wood I have just toned."[4] The sketch in the Louvre, probably begun by c. 1825–26 (fig. 14-4), may have been preparatory to the canvas ordered by James Carpenter in 1826 (fig. 14-5). Of this, Constable wrote to Fisher on May 24, 1830, "My Wood is liked [at the Royal Academy] but I suffer for want of that little completion which you always feel the regret of—and you are quite right. I have filled my head with certain notions of *freshness—sparkle*—brightness—till it has influenced my practice in no small degree, & is in fact taking the place of truth so invidious is manner, in all things—it is a species of self worship—which should always be combated—& we have nature (another word for moral feeling) always in our reach to do it with—if we will have the resolution to look at her."[5]

In all versions of the subject the trees blot out the light, darkening the image and producing a sense of claustrophobia. In its emptiness and bosky gloom, *Helmingham Dell* prefigures such moving valedictory late works as the *Cenotaph*.[6] However, Constable painted (at least) the Johnson Collection version before his wife Maria's death in 1828,[7] so we cannot necessarily correlate the overcast mood of the picture with Constable's later sense of helplessness and depression.

This version is an imitation, never touched by Constable's hand, and probably painted with the intention to deceive. It is hard to know what the painter was looking at when he painted the bridge from a nonexistent spot much higher up than the riverbed where Constable must have stood to draw the Clonterbrook sketch. The trees here are structurally misunderstood, bending into shapes in which, as the Clonterbrook drawing shows, they did not grow. The nervous flicking brushwork of the Johnson Collection (fig. 14-2) or Kansas City (fig. 14-5) versions, which constantly define form and texture, is here rendered in meaningless scratches. The house to the left behind the trees is a feature not present either in reality or in any of the genuine versions of the picture.

1. Beckett, ed., 1962–68, vol. 2, p. 25.
2. Ibid., vol. 2, p. 16.
3. Ibid., vol. 3, p. 90; Taylor, 1975, p. 211.
4. Beckett, ed., 1962–68, vol. 6, p. 125.
5. Ibid., p. 258.
6. *Cenotaph to the Memory of Sir Joshua Reynolds, Erected in the Grounds of Coleorton Hall, Leicestershire, by the Late Sir George Beaumont, Bart.*, exhibited 1836, oil on canvas, 52 x 42¼″, London, National Gallery.
7. However, note that Constable retouched this version in 1833.

PROVENANCE: Sir Henry Thompson, by 1873; Mrs. Joseph, London, perhaps by 1910; Agnew; bt. John H. McFadden, October 12, 1916.

EXHIBITIONS: London, Royal Academy, *Works of the Old Masters,* winter 1873 (lent by Sir Henry Thompson); London, *International Exhibition,* 1874, no. 190 (lent by Thompson); London, *Japan Exhibition,* 1910, no. 58 (lent by Mrs. Joseph) or no. 46 (as "Helmingham Park," lent by F. W. Fox Graves); New York, 1917, no. 2; Pittsburgh, 1917, no. 2; Philadelphia, 1928, p. 21; Boston, 1946, no. 144.

LITERATURE: Roberts, 1917, pp. 9–10; Roberts, 1918, "Additions," p. 114, p. 111 fig. 4; Roberts, 1919, p. 14, repro. p. 10; Siple, 1928, p. 255; Comstock, 1956, p. 282, p. 284 fig. 3; Beckett, 1961, p. 13, p. 12 fig. 7; Beckett, ed., 1962–68, vol. 4, p. 107; Taylor, 1975, pls. 127, 130; Hoozee, 1979, no. 699.

CONDITION NOTES: The original support consists of a single piece of medium-weight (14 x 14 threads/cm.) linen. The tacking margins have been removed, however weave cusping in the support suggests that the present format is close to the original size. The painting is lined with an aged aqueous adhesive onto a medium-weight, twill-weave linen. A tan, moderately thick and evenly applied ground is evident through the thinnest areas of paint application. The ground is in exceptionally good condition, clean, unabraded, and with little or no development of fracture crackle. The paint is in very good condition. A very narrow-aperture traction crackle is present at left of center in the brown tones of the foliage. The original relief of the paint profile varies from thick to thin areas and has been partially flattened by lining. The original fabric's weave texture has been emphasized by lining, as well. A natural resin coating has been partially removed.

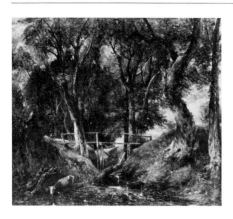

FIG. 14-5 John Constable, *The Dell at Helmingham Park*, 1826, oil on canvas, 44⅝ x 51½" (113.3 x 130.8 cm.), Kansas City, Missouri, William Rockhill Nelson Gallery of Art, Atkins Museum of Fine Arts

VERSIONS

1. John Constable, *The Dell at Helmingham Park*, 1825–26, retouched 1833, oil on canvas, 27⅞ x 36" (70.8 x 91.4 cm.), Philadelphia, John G. Johnson Collection at the Philadelphia Museum of Art (fig. 14-2).

PROVENANCE: Painted for James Pulham; after his death, 1830, repurchased by the artist and given in 1833 to Robert Ludgate (d. 1833) in exchange for several pictures; his sale, Christie's, June 29, 1833 (not catalogued), bt. Charles Scovell; by descent to J. Scovell; sold by him, Christie's, June 8, 1883, lot 243, bt. Fielder; John G. Johnson, by 1914.

EXHIBITIONS: London, British Institution, 1833, no. 156; Boston, 1946, no. 141; London, 1976, no. 295.

LITERATURE: Whitley, 1930, pp. 255–56; Beckett, 1961, pp. 4, 5, 9, 10, 13, p. 12 fig. 8; Beckett, ed., 1962–68, vol. 2, p. 381, vol. 3, pp. 5, 86, 88–90, vol. 4, pp. 92–93, 104–5, 107 n., 141, vol. 5, p. 164; Hoozee, 1979, no. 548, repro. p. 142; John Walker, *John Constable* (London, 1979), p. 144, pl. 49; Wilton, 1979, p. 34; Reynolds, 1984, vol. 1, pp. 174–75, 247.

ENGRAVING: David Lucas after John Constable, *A Dell, Helmingham Park, Suffolk*, first issued 1830, mezzotint, 6⅞ x 8¾" (15.4 x 22.2 cm.), London, British Museum.

INSCRIPTION: *Painted by John Constable, R.A. Engraved by David Lucas* / *A DELL HELMINGHAM PARK. SUFFOLK* / *London Published by M^r Constable 35 Charlotte St. Fitzroy Square 1830.*

LITERATURE: Shirley, 1930, p. 171, no. 12, pl. XII; Beckett, 1961, p. 13; Wilton, 1979, p. 34, pl. 5.

2. John Constable, *The Dell at Helmingham Park*, 1826, oil on canvas, 44⅝ x 51½" (113.3 x 130.8 cm.), Kansas City, Missouri, William Rockhill Nelson Gallery of Art, Atkins Museum of Fine Arts (fig. 14-5).

PROVENANCE: Painted for James Carpenter but retained by the artist until his death in 1837; artist's sale, Foster and Sons, May 16, 1838, lot 73, bt. Allnutt; John M. Keiller, 1887; Butterworth.

EXHIBITIONS: London, Royal Academy, 1830, no. 19; London, Royal Academy, 1887, no. 151 (lent by Keiller).

LITERATURE: Comstock, 1956, p. 284 fig. 3b; Beckett, 1961, pp. 5, 6, 9, p. 2 fig. 1; Beckett, ed., 1962–68, vol. 4, pp. 106–7, 141, vol. 6, p. 258; Taylor, 1975, p. 211, pl. 127; Hoozee, 1979, no. 530; Reynolds, 1984, vol. 1, pp. 217–18.

3. John Constable, *The Dell at Helmingham Park*, c. 1823–26, oil on canvas, 28 x 36¼" (71.1 x 92.1 cm.), Anthony W. Bacon Collection, on loan to Birmingham, City Art Gallery (fig. 14-3).

PROVENANCE: T. W. Bacon; Anthony W. Bacon.

EXHIBITIONS: London, Burlington Fine Arts Club, *Exhibition of English Paintings and Drawings circa 1780–1830,* 1933–34, no. 15; London, Guildhall Art Gallery, *John Constable, 1776–1837,* 1952, no. 43; Auckland, 1973–74, no. 37.

LITERATURE: Key, 1948, repro. p. 107; Leslie, 1951, p. 185; Beckett, 1961, pp. 4, 13 n. 5, p. 11 fig. 5; Beckett, ed., 1962–68, vol. 2, p. 185, vol. 4, p. 107 n.; Hoozee, 1979, no. 475; Reynolds, 1984, vol. 1, p. 218.

4. John Constable, *The Dell at Helmingham Park*, c. 1825–26, oil on canvas, 40½ x 50¼" (102.9 x 128.9 cm.), Paris, Louvre (fig. 14-4).

PROVENANCE: P. M. Turner; presented to the Louvre.

EXHIBITIONS: London, Tate Gallery, *Centenary Exhibition of Paintings and Water-Colours by John Constable, R.A., 1776–1837,* May 4–August 31, 1937, no. 35.

LITERATURE: Leslie, 1951, p. 104; Beckett, 1961, pp. 4, 13 n. 7, p. 11 fig. 6; Beckett, ed., 1962–68, vol. 2, p. 104, vol. 4, p. 106; Hoozee, 1979, no. 474; Reynolds, 1984, vol. 1, p. 218.

DESCRIPTION: No deer, cattle, but figures (a woman with a red dress and child) to left of the bridge.

5. Imitator of John Constable, *The Dell at Helmingham Park*, oil on canvas, 25½ x 30½" (64.7 x 77.5 cm.), New York, Acquavella Galleries, 1960.

LITERATURE: *The Connoisseur*, vol. 146 (October 1960), repro. p. LIX (as "The Rustic Bridge").

6. John Constable?, *The Dell at Helmingham Park*, oil on canvas, 27¼ x 35½" (69.2 x 90.2 cm.), location unknown.

PROVENANCE: John Graham; his sale, Christie's, May 5, 1894, lot 44, bt. Gooden.

LITERATURE: Beckett, ed., 1962–68, vol. 4, p. 107 n.

7. A version, no dimensions stated, was exhibited at the International Exhibition, London, 1862, no. 255 (lent by H. McConnel, Esq.).

RELATED WORK: John Constable, *The Dell at Helmingham Park*, 1800, pencil, pen, and wash on paper, 21 x 26⅛" (53.3 x 66.4 cm.), The Clonterbrook Trustees (fig. 14-1).

INSCRIPTION: *July 23 Afternoon.*

PROVENANCE: Possibly C. R. Leslie, by 1843.

EXHIBITION: London, 1976, no. 21.

LITERATURE: Leslie, 1951, p. 11; Beckett, ed., 1962–68, vol. 2, p. 25; Ian Fleming-Williams, *Constable Landscape Watercolours and Drawings* (London, 1976), p. 19; Hoozee, 1979, see no. 475.

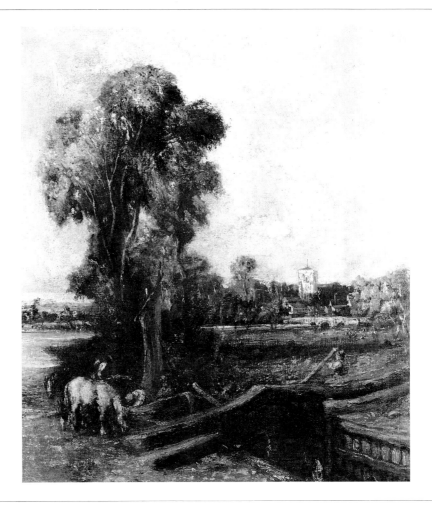

15 IMITATOR OF JOHN CONSTABLE

LANDSCAPE: THE LOCK, nineteenth century
Oil on canvas, 35¼ x 30⅝" (89.5 x 77.8 cm.)
The George W. Elkins Collection, E24-4-4

PROVENANCE: A. Andrews; his sale,
Christie's, April 14–17, 1888, lot 154, bt. Fraser;
William H. Fuller, New York; his sale,
American Art Association at Chickering Hall,
February 25, 1898, lot 30, possibly T. J.
Blakeslee; his sale, American Art Association,
New York, April 13–14, 1899, lot 159 (as "On
the River Stour, *Suffolk,* 25 x 36", purchased
from William H. Fuller, esq."); G. W. Elkins.

EXHIBITIONS: London, Grosvenor Gallery, *A
Century of British Art, 1737–1837,* winter 1887–88,
no. 135 (lent by A. Andrews); Philadelphia,
Union League Club, 1899 (lent by Elkins);
Philadelphia, 1928, p. 17.

LITERATURE: Elkins, 1925, no. 6; "The
George W. Elkins Collection," *Pennsylvania
Museum Bulletin,* vol. 31, no. 168 (November
1935), p. 5.

CONDITION NOTES: The original support is
medium-weight (12 x 12 threads/cm.) linen. The
tacking margins have been removed. The
painting has been lined with an aqueous
adhesive and medium-weight linen. A light-tan-
colored ground is present and evident along
the cut edges. The paint is in generally poor
condition. An extensive, irregular web of
wide-aperture traction crackle extends over the
entire surface. Extensive pinpoint losses to
both ground and paint are present overall and
follow the weave pattern of the support. The
brushwork profile has been severely flattened
by lining. Under ultraviolet light, retouching is
visible over much of the left-hand portion of
the sky and in the treetop.

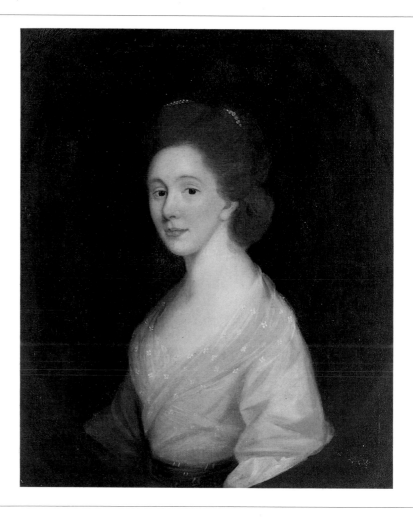

16 STYLE OF FRANCIS COTES

PORTRAIT OF A LADY, nineteenth century? after the style of the 1750s
Oil on canvas, 30⅜ x 25¼" (77.1 x 64.1 cm.)
Gift of Mrs. Henry W. Breyer, 74-98-2

This portrait in a feigned oval came to the Philadelphia Museum of Art in 1974
as the work of Francis Cotes (1726–1770). There is no known provenance
beyond the name of the donor. The portrait is certainly not by Cotes, or
necessarily of the eighteenth century, but it is loosely connected in composition
and style with a Cotes such as *Mrs. Chalmers of Pittencreiff* (29½ x 24¼",
Sotheby's, December 17, 1975, lot 111). It is thus based on Cotes's earliest
portrait style in oils, c. 1757–60. During the first half of his career Cotes
worked almost exclusively in pastels. His draftsmanship was firm and vigorous,
and he was able to evoke exquisite, luminous effects of color by laying on his
homemade pastels in a way that allowed one color to show through and
between another. A pastelist had to make his own crayons, and some
knowledge of chemistry (his father was an apothecary) must account for the
strength and brilliance of Cotes's colors in comparison with those of his
contemporaries. The artist's first successful oils are dated 1757. By 1759 he had
produced his delightful portrait of Paul Sandby (q.v.) (49½ x 39½", London,
Tate Gallery). In the following year, 1760, Cotes exhibited publicly for the first
time at the Society of Artists (four pastels and two oils). During this decade he

exhibited regularly at the Society of Artists and became a founding member of the Royal Academy, where he showed eighteen portraits in the first two exhibitions. Occasionally, as in his late *Lady Stanhope and Lady Effingham as Diana and Her Companion* (c. 1767–70, 94½ x 60″, the Earl of Mexborough Collection), he succeeded brilliantly in combining the grand manner with his own pretty, rather than sensuous, feeling for light and color.[1]

Edward Mead Johnson (letter of January 17, 1980) knows of no known work or school piece of which this picture is a copy, and so it is likely that this is a pastiche of an English picture, attributed (or called) Cotes until recently because we had no clear picture of Cotes's style, making attributions to him harder to disprove than those to better-known artists such as Wright or Romney (q.q.v.). In addition, Cotes left no letters, account or sitters' books, or progeny to help authenticate portraits attributed to him.

1. Edward Mead Johnson, *Francis Cotes* (Oxford, 1976), p. 92 no. 250, fig. 86.

CONDITION NOTES: The original support is medium-weight (10 x 10 threads/cm.) linen. The tacking margins have been removed. The painting is lined with an aqueous adhesive and medium-weight linen. An off-white ground is present and is visible along the cut edges. The paint is in fair condition. Abrasion is extensive overall and is most evident in the mid-tones of the figure's face and dress. A fine web of fracture crackle is developing at each of the four corners. The painted oval format appears to be original to the design.

The son of a blacksmith, David Cox was born in Deritend, a poor suburb of Birmingham, on April 29, 1783. Although he was almost entirely self-taught, and spent thirty-two years of his life in the provinces, he can be ranked as the best of the secondary landscape painters of the English school, not the equal of Turner or Constable (q.q.v.) or Richard Parkes Bonington (1802–1828), but perhaps greater than Samuel Prout (1783–1852), Peter de Wint (1784–1849), or Thomas Shotter Boys (1803–1874).

Cox's first employment was as a decorator of snuffboxes and buckles for the Birmingham toy trade; later his father apprenticed him to a locket- and miniature-maker named Fieldler. Released from his articles by his employer's sudden death in 1800, at seventeen Cox joined the Birmingham Theatre as a colorgrinder for the scene painter James DeMaria. By the time he left the company four years later, Cox had risen to become scene painter in his own right. In 1804 he went to London, hoping to work for Astley's Circus in Lambeth. This job fell through, but he kept up his association with the theater for the next few years, designing sets for the companies in Surrey and Swansea.

The young Cox had an energy and will to better himself worthy of a hero out of Dickens. In Birmingham he had worked in the theater during the day and attended art school at night under the artist Joseph Barber (1758–1811). In London he bought Pond's engravings after old master landscapes, subscribed to Turner's *Liber Studiorum,* and took several lessons in watercolor from John Varley (1778–1842), who at just this period was also teaching the young Linnell (q.v.) and William Mulready (1786–1863). When and how he made the transition from artisan to artist is hard to pinpoint, but the change had taken place by the end of his second year in London, 1806. He began his career as a watercolorist by painting views of London and the Thames, selling his studies to London booksellers at two guineas a dozen. By 1806, with two sketching tours of North Wales behind him, he had established himself as a landscape watercolorist, working at odd jobs available in the art world's Grub Street: giving private drawing lessons, selling his work cheap, and even publishing his own manual for students, *A Treatise on Landscape Painting* (1813–14), illustrated with his own soft-ground etchings.

After his marriage to Mary Agg in 1808 he lived in Dulwich, where his son David was born in 1809 (d. 1885). In 1814 he moved to Farnham to teach drawing at the military academy there, but left after a short stay because the job required his residence but not his family's at the academy. The same year he moved to Hereford, where until 1826 Cox supported his family by teaching at Miss Croucher's Academy for Girls two days a week at a salary of a hundred pounds a year. This he supplemented by giving private lessons, taking in boarders, and exhibiting and selling his work through the Old Water Colour Society, which he had joined in 1813. He also published another technical treatise on landscape painting in 1816.

Throughout this period Cox paid annual visits to London and so kept up with developments in landscape painting, following the careers of Turner and Constable and witnessing the dramatic unfolding of Bonington's brief, sublime achievement. By 1827, partly because his son wished to become a painter and needed to live in the capital, Cox moved to London, to 9 Foxley Road, Kennington Common. For the next fourteen years his art developed along its own lines, in a career marked by few outward stylistic changes. Trips to Belgium and Holland (1826), and to France (1829 and 1832), as well as the example of Bonington led to a brief interest in architectural views in the late 1820s; a tour of Derbyshire and the lakes made less of an impression on him

than a visit to Ulverston Sands, Lancashire, which led to some of his most famous and often-repeated themes.

In 1839 came a dramatic change of direction when Cox, at fifty-six, resolved to learn to paint seriously in oils. He contacted the twenty-seven-year-old William Müller (1812–1845), just back from Egypt, and took several lessons. By 1841 he had developed a proficiency and a pleasure in handling oil paints, which led him to retire from London and teaching, to buy a house at Harborne, near Birmingham, and to devote the next eighteen years, until his death in 1859, to painting in oils—although he never gave up working in, and exhibiting, his watercolors. The year 1844 marked the first of his extended visits to the Welsh town of Bettws y Coed, a name as inseparable from his work as the Stour Valley is from Constable's. Most critics have seen the years from 1844 to 1856 as his best period, corresponding with the years when he visited Bettws y Coed annually.

Simplicity and solidity are the words to describe Cox's landscapes in oil. In fine weather he worked out-of-doors, but all his exhibited works in oil seem to have been painted in the studio. He was sensitive to his materials and chose pigments that he believed would last, painting in pure colors and rarely using glazes except in his foregrounds. The typical Cox brushstroke is a glancing, sidelong touch, with the brush slightly drawn on its side to suggest the movement of the wind ruffling shrubs, trees, or clouds. His pictures are empty of even the slightest element of narrative, such as we find in Morland, Shayer (q.q.v.), or Bonington. They are simply descriptions, in Ruskin's words, of "the looseness, coolness, and moisture of . . . herbage, the rustling crumpled freshness of . . . broad-leaved weeds, the play of pleasant light across . . . deep heathered moor or plashing sand."[1]

Cox is the painter of sudden showers, blustering clouds, late March weather in the open country or seaside. De Wint and John Sell Cotman (1782–1842) emphasize the beauty of the more stable aspects of landscape, the shady groves, gentle hills, or weathered buildings of rural England. Cox's gift lies in his ability to capture the changing conditions of English weather—an effect achieved by his broken, flickering brushstrokes. Above all, Cox is a deeply romantic artist. His figures often stand in isolation, either looming large or seeming small against vast expanses of sea, sand, or moorland, pushing against wind or rain and making headway only with difficulty.

For more than forty years, from 1813 to the year of his death, Cox exhibited at the Old Water Colour Society a total of 849 works. Two drawings by the young Cox were accepted for exhibition at the Royal Academy in 1805, but he exhibited only twelve pictures in all there—nine between 1805 and 1829, and three in 1843 and 1844.

1. Ruskin, 1903–12, vol. 3, p. 195.

BIBLIOGRAPHY: David Cox, *A Series of Progressive Lessons Intended to Elucidate the Art of Painting in Water Colours* (London, 1811); David Cox, *A Treatise on Landscape Painting and Effect in Water Colours . . .* (London, 1813–14) (repr. with foreword by A. L. Baldry in *The Studio,* special issue [fall 1922]); David Cox, *Progressive Lessons on Landscape for Young Beginners . . .* (London, 1816); David Cox, *The Young Artist's Companion . . .* (London, 1819–20); Obituary, *The Art Journal,* 1859, p. 211; "Exhibition of the Works of David Cox, at the French Gallery," *Dublin University Magazine,* vol. 53 (1859), pp. 747–49; Solly, 1873; Redgrave, 1878, pp. 102–3; Frederick Wedmore, "David Cox," *The Gentleman's Magazine,* vol. 242 (1878), pp. 330–41; Hall, 1881; C[osmo] M[onkhouse], *Dictionary of National Biography,* s.v. "Cox, David"; Birmingham, 1890; Gilbert Richard Redgrave, *David Cox and Peter de Wint,* Illustrated Biographies of the Great Artists (London, 1891); Baldry, 1903; Ruskin, 1903–12, vol. 3, pp. 193, 195, 603; Alexander J. Finberg, *Drawings of David Cox* (London and New York, 1906); H. M. Cundall, "David Cox as a Drawing Master," *The Art Journal,* 1909, pp. 177–80; Roe, 1924; A. P. Oppé, *The Water-Colours of Turner, Cox, and de Wint* (London and New York, 1925); Birmingham, Birmingham Museum and Art Gallery, *Catalogue of the Permanent Collection of Works by*

David Cox (Birmingham, 1926); Basil Long, "David Cox (1783–1859)," *The Old Water-Colour Society's Club Tenth Annual Volume, 1932–33* (London, 1933), pp. 1–19; Roe, 1946; Trenchard Cox, *David Cox* (London, 1947); Cyril G. E. Bunt, *David Cox: Painter of Nature's Moods* (Leigh-on-Sea, 1949); Trenchard Cox, *David Cox, 1783–1859* (Birmingham, 1955); Christopher Neve, "Cox's Weather: A Barometer of Taste," *Country Life*, September 30, 1976, pp. 884–85; Thomas B. Brumbaugh, "David Cox in American Collections," *The Connoisseur*, vol. 197 (February 1978), pp. 83–88.

EXHIBITIONS: London (Hampstead), Rooms of the Conversazione Society, *David Cox*, 1858; London, The Gallery, 120 Pall Mall (French Gallery), *Exhibition of Pictures, Sketches & Water-colour Drawings: The Works of David Cox*, 1859; London, Burlington Fine Arts Club, *Drawings and Sketches by the Late David Cox and the Late Peter de Wint, Lent by John Henderson*, 1873; Liverpool, Liverpool Art Club, *Catalogue of the Loan Collection of the Works of the Late David Cox*, 1875 (preface by William Hall); Swansea, Glynn Vivian Art Gallery, *David Cox (1783–1859)*, summer 1953; Birmingham, Birmingham Museum and Art Gallery, *Centenary Exhibition of the Works of David Cox, 1783–1859*, June–July 1959 (catalogue and introductory notes by John Rowlands); London, Walker's Gallery, *Drawings by David Cox, 1783–1859: Purchased from the Artist's Grand-daughter in 1904*, 1960; Philadelphia and Detroit, 1968, pp. 213–14, nos. 135–36 (entries by Allen Staley); Paris, Petit Palais, *La Peinture romantique Anglaise et les préraphaélites*, 1972, pp. 74ff., nos. 75–79 (entries by Mary Anne Stevens); London, Tate Gallery, *Landscape in Britain, c. 1750–1850*, 1973, pp. 106–9, nos. 255–59 (by Leslie Parris); London, Anthony Reed, New York, Davis and Long, *David Cox, Drawings and Paintings,* September–November 1976 (by Anthony Reed); New York, Davis and Langdale, London, Anthony Reed, *David Cox, 1783–1859*, April 29–August 12, 1983; Birmingham, Birmingham Museums and Art Gallery, London, Victoria and Albert Museum, *David Cox, 1783–1859*, July 26, 1983–January 8, 1984 (by Stephen Wildman).

17 DAVID COX

GOING TO THE HAYFIELD, 1849
Oil on canvas, 28 x 36″ (71 x 91.5 cm.)
Inscribed lower right: *David Cox 1849*
John H. McFadden Collection, M28-1-5

Speaking to William Hall about one of the 1849 versions of *Going to the Hayfield* (version 5), David Cox said: "I want to show a proper hay-making day—bright and sunny, of course, but with a brisk, drying wind sweeping across the fields, and making the fleecy clouds speed along the sky."[1] *The Hayfield* was one of Cox's favorite and most often repeated subjects; the image of the mounted farmer slowly making his way to the distant haymaking seems to have exerted a peculiar spell over the artist. So many versions exist in oil and watercolor that it is almost meaningless to count them, a task in any case made all the more difficult by Cox's use of the same title to cover all the variations on the theme. Thus, certain identification of Cox's pictures in exhibition or sales catalogues where dimensions are not given is extremely difficult. However, according to Solly, there are no exact replicas;[2] and each version known to the author differs in slight details—the direction of the path, the inclusion of rustics, fences, and trees, and their placement.

The composition of *Going to the Hayfield* dates from at least 1813, when the subject with the essential composition was published as plate 16 in Cox's *Treatise on Landscape Painting*. A watercolor entitled *Going to the Hayfield* was exhibited in 1838 at the galleries of the Society of Painters in Water Colour,[3] and a watercolor (14 x 19½″) said in the sales catalogue to be dated 1839 passed through Christie's on May 1, 1908 (lot 41). An oil dated 1843 was lent by James Langton to the Cox exhibition at Liverpool in 1875 and may be the version exhibited at the Royal Academy in 1844 (no. 296).[4] A version securely dated 1848 exists, but the following year, 1849, was the year Cox apparently gave over to painting repetitions of the subject.

Solly records four pictures with this title painted in 1849, for Messrs. Butler, Briscoe, Bullock, and Roberts.[5] The versions painted for the first three gentlemen are known (although their present locations are unrecorded). For different reasons—either because we know their dimensions or have a photograph or a description—the first three can be ruled out as the Philadelphia picture. However, dimensions, description, and location of Mr. Roberts's picture are not known. It is possible that the Philadelphia picture may originally have belonged to him, but two facts must make us wary of a firm statement: first, Solly also records a version of *Going to the Hayfield* (14 x 8″) that belonged to Roberts and was sold by him in 1867 (version 8). It is possible, however, that Roberts owned two versions of the composition,

FIG. 17-1 David Cox, *Going to the Hayfield*, 1853, oil on canvas, 11 x 14½″ (27.9 x 36.8 cm.), Birmingham, Birmingham City Art Gallery

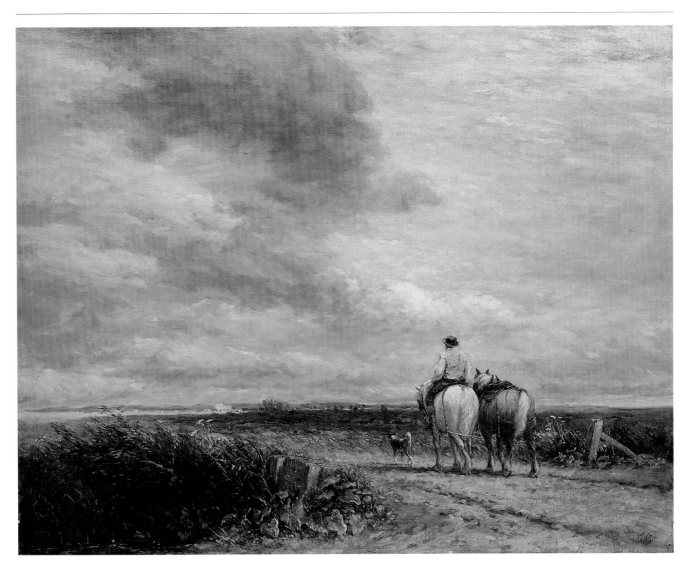

as did Edwin Bullock, who possessed both a large 1849 version (version 7) and a small version dated 1853 (fig. 17-1). Another reason to be wary of Solly's information is that there were more than four versions of the subject painted in 1849.

On July 12, 1849, Cox wrote to Roberts: "I have nearly finished my picture for the Birmingham exhibition [version 5] and have got on very well with one ('Kit Cat') for Liverpool."[6] If Cox was using the term "Kit-Cat" in the same sense of proportions as John Linnell (q.v.) had,[7] the latter landscape measured twenty-eight by thirty-six inches, hence we might identify it with version 6. This version, measuring the same as the Philadelphia painting, was said by Solly to have been painted on the wrong side of the canvas. Again, this seems to be true of the Philadelphia oil.

In addition to the six versions dated 1849 we can count at least thirteen other versions in oil. The watercolors would certainly double this number. Clearly Cox was painting some of these versions for dealers, and all his biographers stress the immense popularity of his work in Birmingham; apparently patrons signed blank canvases with their own names to reserve for themselves pictures Cox had not yet begun.

Philadelphia's *Going to the Hayfield* is particularly haunting, as it includes only the figures of the rider, horses, and dog. Without the genre details—the women with pitchforks or children at fences—the image becomes more potent, the sense of loneliness and silence stressed, the emptiness of the landscape underscored.

1. Hall, 1881, p. 140.
2. Solly, 1873, p. 187.
3. Ibid., p. 88.
4. Reviewed by *The Art-Union*, vol. 67, suppl. (June 1, 1844), p. 160.
5. Solly, 1873, p. 218.
6. Ibid., p. 177.
7. Firestone, 1973, p. 131 n. 5.

INSCRIPTION: ———87 DAVID COX / GOING TO THE HAYFIELD / *This important work possesses in an eminent* [degree] *characteristic of this esteemed artist.* / *The next lot of work in oil, and possessing in an eminent degree the* [?] *characteristic of this esteemed artist, perfect fidelity to nature* [on an old sales catalogue entry attached to the stretcher].

PROVENANCE: Spencer Brunton; Agnew; bt. John H. McFadden, February 19, 1900.

EXHIBITIONS: New York, 1917, no. 5; Pittsburgh, 1917, no. 4.

LITERATURE: Roberts, 1917, p. 11.

CONDITION NOTES: The original support is medium-weight (18 x 18 threads/cm.) linen. The painting is unlined. An off-white ground extends partially onto the tacking margins. The reverse of the painting carries a similar ground and lead-white, oil-paint layer, which also partially extends onto the reverse of the tacking margins. The paint is in good condition. A fine net of fracture crackle is beginning to appear, radiating from each corner. Two long scratches (2 to 3″) appear in the sky at right. Microscopic analysis of cross-sections removed from the front and back of the painting indicate that a second painting exists on the reverse under the lead-white oil layer. A single retouch on one of the scratches in the sky is evident under ultraviolet light.

VERSIONS
1. David Cox, *Going to the Hayfield*, 1843, oil on canvas, dimensions and location unknown.
 PROVENANCE: Charles Langton, 1875.
 EXHIBITION: Liverpool, Liverpool Art Club, *Loan Collection of the Works of the Late David Cox*, 1875, no. 13.

2. David Cox, *Going to the Hayfield*, 1844, oil on canvas, dimensions and location unknown.
 EXHIBITION: London, Royal Academy, 1844, no. 296.
 LITERATURE: "The Royal Academy," *The Art-Union*, vol. 67, suppl. (June 1, 1844), p. 160; Solly, 1873, pp. 124–25.

3. David Cox, *Going to the Hayfield*, 1847, oil on canvas, dimensions and location unknown.
 PROVENANCE: Purchased from the artist by James Bagnall; his sale, Christie's, June 1, 1872, lot 39 (said to be dated 1849); bt. Agnew.
 LITERATURE: Solly, 1873, pp. 148, 199; Hall, 1881, pp. 257–58, possibly refers to this version.
 DESCRIPTION: Boy and dog on road in foreground; possibly identical with version 9.

4. David Cox, *Going to the Hayfield*, signed and dated 1848, oil on canvas, 23 x 33″ (58.4 x 83.8 cm.), London, Midland Bank.
 PROVENANCE: Edward Hermon, M.P., Wyford Court, Henley; Christie's, May 13, 1882, lot 55; bt. Agnew; Sir Charles Tennant; Hon. Colin Tennant; Sotheby's, June 27, 1973, lot 66; bt. Agnew; bt. Midland Bank, 1974.
 EXHIBITION: Glasgow, *International Exhibition*, 1901, no. 124.

5. David Cox, *Going to the Hayfield*, 1849, oil on canvas, 28 x 34″ (71.1 x 86.4 cm.), location unknown.
 PROVENANCE: E. A. Butler, Birmingham; bt. S. Mayou of Edgbaston, 1859; bt. Frederick Nettlefold, 1872.
 EXHIBITIONS: Birmingham, Society of Artists, 1849; Liverpool, Liverpool Art Club, *Loan Collection of the Works of the Late David Cox*, 1875, no. 29; Manchester, *Jubilee Exhibition*, 1887, no. 830 (lent by F. Nettlefold).
 LITERATURE: Solly, 1873, pp. xii, 177, 197, 218, repro. opp. p. 189; Hall, 1881, pp. 140–41, 254, 258.
 DESCRIPTION: Trees on right and two country women.

6. David Cox, *Going to the Hayfield*, 1849, oil on canvas, 28 x 36″ (71.1 x 91.4 cm.), location unknown.
 PROVENANCE: Bt. from the artist by Briscoe; his sale, 1859, bt. W. Holmes; Hall; Howard Fletcher, 1859; bt. Page, 1861; with Thomas Page, 1873.
 EXHIBITION: Liverpool, Liverpool Art Club, *Loan Collection of the Works of the Late David Cox*, 1875, no. 1.
 LITERATURE: Solly, 1873, pp. 196, 218; Hall, 1881, p. 227; *The Birmingham Daily Post*, November 15, 1875.
 DESCRIPTION: Trees on right. Solly states that this version is painted on the wrong side of the canvas.

7. David Cox, *Going to the Hayfield*, 1849, oil on canvas, 20 x 30″ (50.8 x 76.2 cm.), location unknown.
 PROVENANCE: Edwin Bullock, Harborne, Birmingham; his sale, Christie's, May 21, 1870, lot 284; bt. Agnew.
 LITERATURE: Solly, 1873, pp. 205–6, 218.

8. David Cox, *Going to the Hayfield*, 1849, oil on canvas?, possibly 14 x 8″ (36 x 20 cm.), location unknown.
 PROVENANCE: Bt. from the artist by William Roberts; sold by him, 1867.
 LITERATURE: Solly, 1873, pp. 203, 218.

9. David Cox, *Going to the Hayfield*, 1849, oil on canvas, 23½ x 34½″ (59.7 x 87.6 cm.), location unknown.
 PROVENANCE: Tom Nickalls; his sale, Christie's, June 4, 1909, lot 14; bt. Henry.
 EXHIBITION: East Lowestoft, *Victorian Era*, 1897, no. 36 (lent by Tom Nickalls).

FIG. 17-2 David Cox, *Way to the Hayfield*, oil on canvas, 13½ x 17½" (34.3 x 44.4 cm.), Preston, Harris Museum and Art Gallery

10. David Cox, *Going to the Hayfield,* 1849, oil on canvas, dimensions and location unknown.

PROVENANCE: Sale, Diff. Properties [Horton Lee and Lee], Christie's, June 8, 1883, lot 266, bt. in, and again, same vendor, Christie's, May 17, 1884, lot 100, bt. in.

LITERATURE: C[osmo] M[onkhouse], *Dictionary of National Biography,* s.v. "Cox, David."

11. David Cox, *Going to the Hayfield,* c. 1850, oil on canvas, 11¾ x 15¾" (29.8 x 40 cm.), location unknown.

LITERATURE: Solly, 1873, p. 210.

12. David Cox, *Going to the Hayfield,* 1852, oil on canvas, 19 x 28½" (48.3 x 72.4 cm.), location unknown.

PROVENANCE: Painted for Thomas Walsh, Jr.; bt. Agnew, 1872.

LITERATURE: Solly, 1873, p. 200.

13. David Cox, *Going to the Hayfield (A Breezy Day),* 1852, oil on canvas, 18½ x 28" (47 x 71.1 cm.), Bury, Bury Art Gallery.

INSCRIPTION: *David Cox 1852.*

PROVENANCE: Thomas Webster; Thomas Wrigley, by whose family it was presented to the gallery, 1901.

EXHIBITION: Manchester, Royal Manchester Institution, *Art Treasures Exhibition,* 1878, no. 82.

LITERATURE: Baldry, 1903, no 10 (repro.); *Catalogue of the Thomas Wrigley Gift to the Bury Art Gallery* (Bury, 1901), no. 17.

DESCRIPTION: Road runs toward the right; peasant woman walks by the mounted man's side.

14. David Cox, *Going to the Hayfield,* 1852, oil on canvas, 10½ x 14" (26.7 x 35.5 cm.), Bath, Victoria Art Gallery.

PROVENANCE: Frederick J. Nettlefold, 1887; Thomas James Barratt; his sale, May 11, 1916, lot 45; bt. Cremetti for F. J. Nettlefold, who presented it to the gallery, 1948.

LITERATURE: Joseph Grego, "The Art Collection at 'Bell-Moor,' the House of Mr. Thomas J. Barratt," *Magazine of Art,* vol. 22 (1898), pt. 1, pp. 133, 138, pt. 3, p. 261.

DESCRIPTION: Two women following wagon to hayfield.

15. David Cox, *Going to the Hayfield,* c. 1852, oil on canvas, 23¼ x 47½" (59 x 120.6 cm.), John C. Neve Collection, 1959.

PROVENANCE: James Orrock, by 1888; Sir Joseph Beecham; Henry Beecham; John C. Neve, 1925.

EXHIBITIONS: Glasgow, *Glasgow International Exhibition,* Fine Art Section, 1888, no. 56 (lent by James Orrock); Birmingham, Birmingham Museum and Art Gallery, *Centenary Exhibition of the Works of David Cox, 1783–1859,* June–July 1959, no. 116.

DESCRIPTION: Unfinished.

16. David Cox, *Going to the Hayfield,* 1853, oil on canvas, 11 x 14½" (27.9 x 36.8 cm.), Birmingham, Birmingham City Art Gallery (fig. 17-1).

PROVENANCE: Edwin Bullock; his sale, Christie's, May 21, 1870, lot 282; bt. White; Joseph H. Nettlefold; bequeathed to the gallery, 1882.

EXHIBITIONS: Liverpool, Liverpool Art Club, *Loan Collection of the Works of the Late David Cox,* 1875, no. 28; Birmingham, 1890, no. 105; Birmingham, Birmingham Museum and Art Gallery, *Centenary Exhibition of the Works of David Cox, 1783–1859,* June–July 1959, no. 118.

LITERATURE: Solly, 1873, pp. 206, 277; Baldry, 1903, no. 14 (repro.); Roe, 1924, p. 95; Roe, 1946, pl. 39.

DESCRIPTION: Woman with pitchfork and little boy; fence to left.

17. David Cox, *Going to the Hayfield,* 1854, oil on canvas, 28 x 42½" (71.1 x 107.9 cm.), location unknown.

PROVENANCE: Bequeathed by the artist to his son David Cox, Jr; his sale, Christie's, May 3, 1873, lot 138 (with a sketch on the back); bt. Permain.

LITERATURE: Solly, 1873, p. 208.

18. David Cox, *Going to the Hayfield,* 1855, oil on canvas, 43 x 30½" (109.2 x 77.5 cm.), Birmingham, Birmingham City Art Gallery.

PROVENANCE: Nettlefold Bequest.

LITERATURE: Birmingham, 1890, no. 89.

DESCRIPTION: Man on foot with basket.

19. David Cox, *Way to the Hayfield,* date unknown, oil on canvas, 13½ x 17½" (34.3 x 44.4 cm.), Preston, Harris Museum and Art Gallery (fig. 17-2).

EXHIBITIONS: Glasgow, *International Exhibition,* 1901, no. 339; London, *Japan Exhibition,* 1910, no. 67.

DESCRIPTION: Road to right; woman and child in middle distance.

Breath [breadth] must be attended to, if you paint but a muscle give breath [*sic*]. . . . Trifles in nature must be overlooked that we may have our feelings raised by seeing the whole picture at a glance, not knowing how or why we are so charmed."[1] These words of John Crome's in a letter of January 1816 to his pupil James Stark (q.v.) might serve as an introduction to his work. Born in the year of the foundation of the Royal Academy, 1768, Crome was the son of an innkeeper and weaver in Conisford Street (today King Street), Norwich. He had no formal schooling and as an artist was essentially self-taught, beginning work about 1781 as an errand boy, then on August 1, 1783, as an apprentice to a sign and coach painter named Francis Whisler. There he worked until the expiration of his articles in August 1790.

His next fifteen years are poorly documented. Crome set up as a painter on his own shortly after 1790, the date of his earliest sketch in oil. He must have spent these years laboriously acquiring the technical skill to carry out his art, but by 1792 evidently he was selling enough of his work to marry and start the family that was to total eleven children. During these years Crome met a local patron of the arts, the master weaver Thomas Harvey of Catton House (1748–1819), who can be said to have formed Crome by commissioning pictures and also by affording him access to the Gainsboroughs, Wilsons, and Hobbemas in his own collection. Through Harvey, the young man also met and became friendly with two artists from London. The portrait painter William Beechey (q.v.), whom Crome met in 1789, transmitted to the young man his knowledge of Joshua Reynolds's (q.v.) complex technique of scumbles and glazes and taught him how to paint on a dark, wet ground in a broad and monumental style.[2] Another portrait painter, John Opie (q.v.), Crome met in 1798. Opie was an artist of raw energy, an intellectual yet also an untutored provincial like Crome. He may have communicated to the younger man something even more important than Reynolds's technique: direct knowledge of the theories set forth in Reynolds's Discourses, on which Opie would in part base his own Royal Academy lectures on painting in 1807. Thus, indirectly through Reynolds, the landscape painter learned to think in terms of grandeur and ideal beauty, to conceive of the nobility of the art of painting, its high seriousness. This sets him apart from all other artists of the Norwich School. Crome learned to despise what he called "trifles" in nature.

At Catton House, Crome copied several pictures by Richard Wilson (q.v.), the artist who practiced in landscape the theories Reynolds applied primarily to portraiture and history painting. From Wilson, Crome learned to paint luminous skies—not the skies of Wilson's ideal Italianate world but those above the flat, marshy, and windswept countryside around Norwich. Crome never attempted to paint more than the simple scenery around him, always infused with his profound love for nature. When the painter John Burnet (1784–1868) met him with his pupils on the banks of the river Yare, he heard Crome cry out triumphantly, "This is our Academy!"[3] And to his eldest son, the painter John Bernay Crome (1793–1842), he is supposed to have said on his deathbed, "If your subject is only a pig sty—dignify it!"[4]

By dignity Crome meant breadth and monumentality, qualities he could find in an oak, a blacksmith's shop, or a burdock. Like Wilson he achieved breadth by suppressing details, conceiving of a picture as one harmonious design in which color, tone, and texture are subordinated to the general effect. To Stark he wrote in 1816 that a picture should form "one grand plan of light and shade."[5]

Our eye takes in a Crome all at once, very unlike our response to Constable (q.v.), where the eye is led typically through the fictive space from a foreground motif to a building beyond and finally into the distance. A Crome isolates one vivid pictorial motif, so that the picture is carried almost entirely by the

composition. In a landscape by Crome there is an extraordinary lack of incident. Even where figures in his pictures draw water or sharpen tools, they function as no more than tones within the landscape. His art is an art of elimination, not accretion. Of all artists, Crome requires from us a patient and subtle eye.

Under the influence first of Wilson, then, around 1806, of Gainsborough (q.v.), and finally, after 1810, of Hobbema (1638–1709), Crome celebrated the English countryside. Maturing as he did during the Napoleonic Wars when travel on the Continent was impossible, he sold his paintings to those who appreciated him for his depiction of a beloved homeland. Allan Cunningham, the first writer to appraise Crome, betrayed this nationalistic element in the English response to his work: "All about him is sterling English; he has no foreign airs or put-on graces; he studied and understood the woody scenery of his native land with the skill of a botanist, and the eye of a poet."[6]

In the first decade of the nineteenth century, Crome worked as a teacher of drawing to children of well-to-do families around Norwich—the Gurneys of Earlham Hall, the Dawson Turners in Yarmouth, and the Jerninghams at Costessey. He also traveled with the Gurney family to Cumberland in 1802 and 1806 and with the painter Robert Ladbrooke (1770–1842) to Wales in 1804. By 1803, when Crome was thirty-five, he was still primarily a local drawing master and had never exhibited a picture. In that year he helped to found the Norwich Society, a group of local drawing masters and amateurs who banded together to exhibit in Norwich, hoping to sell their work locally and so bypass the London marketplace. Among the men who exhibited in the shows, held from 1805 onward, were John Sell Cotman (1782–1842), Ladbrooke, John Thirtle (1777–1839), and Robert Dixon (1780–1815). A second generation of artists—the pupils and children of the first—including Stark and George Vincent (1796–1831?), would constitute the Norwich School of painters. Crome exhibited a total of 289 pictures at the Norwich Society exhibitions held in Sir Benjamin Wrenche's Court from 1805 until his death on April 22, 1821, aged fifty-three. He also kept an eye on London, showing at the Royal Academy thirteen pictures beginning in 1806. Six of his pictures were shown at the British Institution between 1818 and 1824.

Crome's life was successful and externally uneventful. A calm, well-liked and convivial local, he stuck close to Norwich apart from occasional trips to London, a sketching trip to Derbyshire in 1811, and a journey in October–November 1814 to Paris to see paintings and sculpture accumulated by Napoleon on view at the Louvre. The paintings that resulted from this trip abroad, *The Boulevard des Italiens, Paris* (1814–15, 21½ x 34⅜") and *The Fishmarket at Boulogne* (20¾ x 34", both R. Q. Gurney Collection), were late masterpieces quite unlike anything that went before or after in Crome's oeuvre, remarkable for their colorful view of teeming Continental life.

1. ADD. MS., no. 43830, 73, British Museum, London; quoted by Goldberg, 1978, vol. 1, p. 17.
2. Cunningham, 1838, p. 25.
3. John Burnet, *Landscape Painting in Oil-Colours Explained in Letters on the Theory and Practice of the Art* (London, 1849), p. 52.
4. Mallalieu, 1974, p. 14.
5. Crome to Stark, Norwich, January 1816, ADD. MS., no. 43830, 73, British Museum, London; quoted by Goldberg, 1978, vol. 1, p. 17.
6. Cunningham, 1838, p. 27.

BIBLIOGRAPHY: Reeve MS., no. 167, c. 6, British Museum Print Room, London; John Crome, *Etchings of Views of Norfolk, by the Late John Crome . . . Together with a Biographical Memoir by Dawson Turner* (Norwich, 1838); Cunningham, 1838, pp. 23–28; Wooderspoon, 1876; Cunningham, 1879, vol. 3, pp. 164–78; Mary M. Heaton, "John Crome," *The Portfolio*, vol. 10 (1879), pp. 33–36, 48–51; Elise Paget, "Old Crome," *The Magazine of Art*, April 1882, pp. 221–26; Binyon, 1897; Dickes, 1905, pp. 13–149; Theobald, 1906; Cundall, 1920; Collins Baker, 1921; S. C. Kaines Smith, *Crome, with a Note on the Norwich School* (London, 1923); Mottram, 1931; Hawcroft, 1959, pp. 232–37; Goldberg, 1960, pp. 214–17; Norman L. Goldberg, "On John Crome and Connoisseurship: The Present Day Problem," *The Connoisseur*, vol. 154 (November 1963), pp. 194–200; Derek Clifford, *Watercolours of the Norwich School* (London, 1965); Clifford and Clifford, 1968; Mallalieu, 1974, pp. 9ff.; Goldberg, 1978; Day, 1979, pp. 7–29; Hemingway, 1979, pp. 10–46; Miklós Rajnai, *The Norwich School of Painters* (Norwich, 1979), unpaginated.

EXHIBITIONS: Norwich, Sir Benjamin Wrenche's Court, *Crome Memorial Exhibition*, 1821; London, Royal Academy, *Works by the Old Masters: The Norwich School*, winter 1878; Norwich, 1921; Manchester, 1961; Jacksonville, 1967; Norwich and London, 1968.

18 JOHN CROME

THE BLACKSMITH'S SHOP NEAR HINGHAM, NORFOLK, c. 1808
Oil on canvas, 60⅛ x 48″ (154 x 121.9 cm.)
John H. McFadden Collection, M28-1-6

Crome's early masterpiece *The Blacksmith's Shop near Hingham* shows the tumbledown shack thrown up against the side of a thatched cottage used by the blacksmith for the villages of Hingham and Hardingham, each about twelve miles southwest of Norwich. Other paintings by Crome on the blacksmith-shop theme were exhibited under the name of either village. In this painting, to the left, the smithy sharpens a tool at a grindstone; family members and perhaps assistants mill around the shop. The dense, full foliage of the trees, and the blue, silver-clouded sky indicate a scene in midsummer; the whole breathes an air of intense stillness on a warm afternoon in the deep country. In the foreground two ducks float on a pond. Crome used the motif of the shop in picturesque dilapidation set against a verdant landscape to create one whole and harmonious melding of shapes, tones, and textures.

The scale of the picture indicates that from the first Crome conceived it as an exhibition picture, perhaps with the Royal Academy exhibition in mind, where it appeared in 1808. Two watercolors are related to it. The first, in the Norwich Castle Museum (fig. 18-1), shows the blacksmith's shop from a different angle; it is presumably one of the watercolors exhibited at the Norwich Society in 1807 (no. 19 or 100), and may be assumed to have preceded the Philadelphia oil. The Doncaster watercolor (fig. 18-2), which is nearly identical in composition with the Philadelphia picture, has been thought by Goldberg (1978, vol. 1, p. 255) to have been executed in preparation for the Philadelphia oil, and is perhaps also one of the watercolors "from nature" exhibited at the Norwich Society in 1807 (no. 19 or 100).

Nearly all commentators on Crome agree on the importance of *The Blacksmith's Shop,* with the exception of Binyon (1897, pp. 20–21), who thought it "not a very characteristic or significant work." Beginning with Hawcroft (1959, p. 234), scholars have seen *The Blacksmith's Shop* primarily in terms of Crome's response to Gainsborough's (q.v.) *Cottage Door* (fig. 18-3), which belonged (until its sale in 1807) to Crome's patron Thomas Harvey of Catton, and which Crome is known to have copied.[1] The Crome is, of course, an essay in the picturesque very much in the spirit of *The Cottage Door;* and in 1806 Crome had exhibited at the Norwich Society (no. 221) a "Sketch, from Nature, in the Style of Gainsborough."

There are, however, important differences between the intentions of Gainsborough and Crome—so that the Norwich artist can be said to have been influenced only superficially by Gainsborough in comparison to his less obvious but much more profound debt to Richard Wilson (q.v.). Gainsborough's cottage and its inhabitants are idealized visions living out a pastoral idyll, creations of a rococo sensibility. Gainsborough's lighting and composition have a theatricality and artificiality very different from Crome's deadpan description. Crome is utterly without sentimentality, and the problems that interest him are largely artistic ones: Crome's work is about the resolution of formal problems.

In style and technique *The Blacksmith's Shop* should be compared to the Tate Gallery's *Moonrise on the Yare* (c. 1806, 28 x 43¾″). Both are painted on coarsely woven canvas on a monochrome ground of dark red or ocher, with liquid, runny paint handled with great broadness and freedom. The undercoat

FIG. 18-1 John Crome, *The Blacksmith's Shop,* c. 1806–7, pencil and watercolor, 21¼ x 17½″ (54.1 x 44.3 cm.), Norwich, Norwich Castle Museum (Norfolk Museums Service)

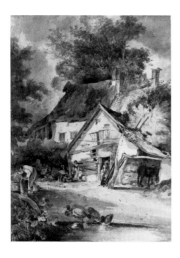

FIG. 18-2 John Crome, *The Blacksmith's Shop,* c. 1806–7, watercolor, 15¼ x 11½″ (38.7 x 29.2 cm.), Doncaster, Museum and Art Gallery

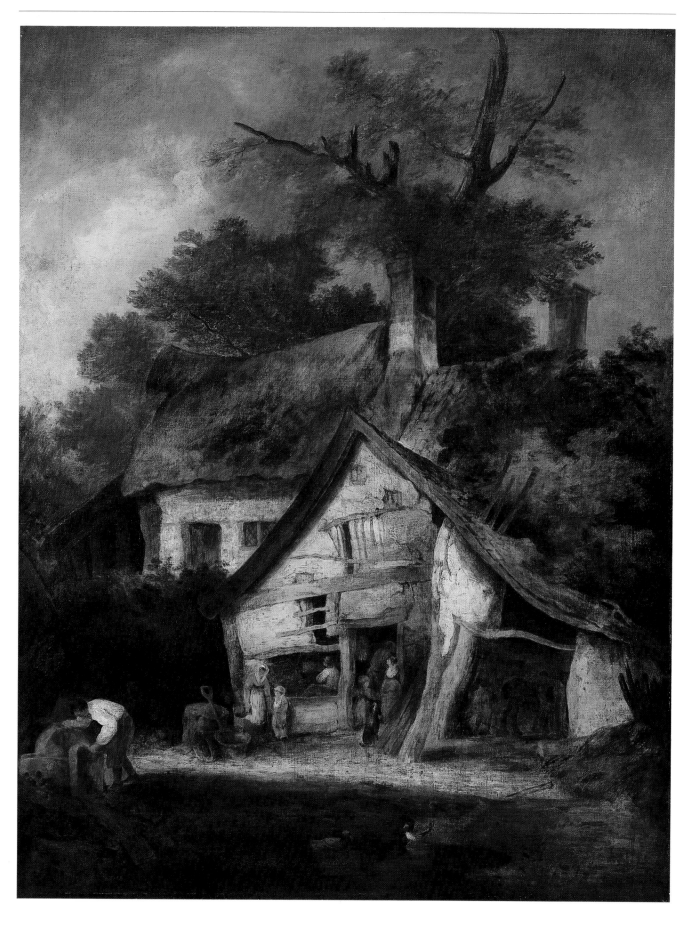

was allowed to dry, after which the next layer of color was applied. Some bitumen was used to give the picture a mellow tone.

In addition to the influence of Gainsborough, Crome clearly responded in *The Blacksmith's Shop* to the return of John Sell Cotman (1782–1842) to Norwich late in 1806. Comparing the watercolors of *The Blacksmith's Shop* to Cotman's *Old Houses at Gorleston* (fig. 18-4), one perceives that Cotman's interest in the simplified patterns made by the planes and the angles of timbers is reflected in a similar treatment of architecture in *The Blacksmith's Shop*, where, like Cotman, Crome's primary interest is in subtlety of texture and tone, the definition of shape through the modulation and control of color.

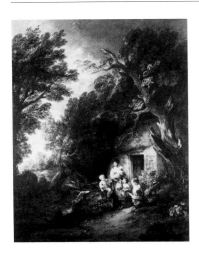

FIG. 18-3 Thomas Gainsborough (q.v.), *The Cottage Door*, 1780, oil on canvas, 58 x 47" (147.3 x 119.4 cm.), San Marino, California, Henry E. Huntington Library and Art Gallery

FIG. 18-4 John Sell Cotman (1782–1842), *Old Houses at Gorleston*, c. 1815–23, oil on canvas, 18 x 14" (45.5 x 35.3 cm.), Norwich, Norwich Castle Museum (Norfolk Museums Service)

1. Dawson Turner, *Outlines in Lithography from a Small Collection of Pictures* (privately published, 1840), p. 23.

PROVENANCE: By descent to John Crome's sons Frederick J. Crome, 1821, and John B. Crome, to 1834; the latter's sale, Norwich, September 5, 1834, lot 57 (as "the Blacksmith's Shop, one of the best pictures in the style of Gainsborough"); James N. Sherrington, to 1848; by descent to Mrs. J. N. Sherrington (later Mrs. Caleb Rose); apparently sold privately to Louis Huth, but resold by Huth on speculation at Sherrington sale, Christie's, May 1, 1858, lot 26, bt. in; W. W. Pearse, to 1871; his sale, 1872?, bt. Myers; Agnew; bt. John H. McFadden, May 9, 1896.

EXHIBITIONS: London, Royal Academy, 1808, no. 591; Norwich, Sir Benjamin Wrenche's Court, *Crome Memorial Exhibition*, 1821, no. 61; London, Thomas Agnew and Sons, 1896, no. 20; Philadelphia, The Pennsylvania Academy of the Fine Arts, *John Howard McFadden Collection of Paintings by English Artists of the Eighteenth Century*, 1916; New York, 1917, no. 6, fig. 6; Pittsburgh, 1917, no. 6; Washington, D.C., National Gallery of Art, 1922; Philadelphia, 1928, p. 22; London, Thomas Agnew and Sons, *Crome and Cotman*, July 1–26, 1958, no. 46; Norwich and London, 1968, no. 39.

LITERATURE: Reeve MS., no. 167, c. 6, fol. 18, British Museum Print Room, London; "John Crome and His Works," *Norwich Mercury*, November 1858; Wooderspoon, 1876, p. 20; Binyon, 1897, pp. 20–21; Dickes, 1905, p. 63; Theobald, 1906, pp. 13–14; Roberts, 1917, pp. 13–14, repro. opp. p. 13; Cundall, 1920, pp. 13–14, pl. XXII; Collins Baker, 1921, p. 59 n. 2, pp. 83, 86, 98, 101, 106, 118, 122, 186, 195, 197; Mottram, 1931, p. 116; Hawcroft, 1959, p. 234 fig. 7; Goldberg, 1960, pp. 214–15, p. 215 fig. 3; Manchester, 1961, pp. 5, 32 (notes for no. 34); Clifford, 1965, p. ix; Jacksonville, 1967, pp. 25–26, 47, 73; Clifford and Clifford, 1968, pp. 53–54, 131, 197 no. P37, 201, 263, 266, 268, 272, 274–76, pl. 86; Norwich and London, 1968, introduction (unpaginated), pl. 2; Staley, 1974, p. 37; Goldberg, 1978, vol. 1, pp. 13, 21, 24–25, 33, 51–54, 52 n. 48, 70, 77 n. 24, 90, 131, 135, 141, 186–87 no. 34, 189, 254–55 (under no. 175), 297, vol. 2, fig. 34; Day, 1979, p. 17; Hemingway, 1979, p. 15; Kathryn Moore Heleniak, *William Mulready* (New Haven and London, 1980), p. 67, fig. 65.

CONDITION NOTES: The original support consists of two pieces of medium-weight (10 x 10 threads/cm.), butt-joined linen, with the join running horizontally near mid-image. The tacking margins have been removed. The painting has been strip lined along all four edges with pieces of unsized medium-weight, double-thread linen attached with a synthetic adhesive. Two additional aqueous linings remain attached to the painting. An off-white ground is present and evident along the cut-off tacking margins. The oil medium is pastelike in consistency and low in overall profile. The paint layer is in only fair condition overall. Much of the original texture has been flattened by lining. The surface has been appreciably darkened by the application of a bituminous surface coating, possibly original. Abrasion has occurred locally over much of the surface. Under ultraviolet light, retouching is evident along the horizontal join in the fabric support and along the cut-off tacking margins.

RELATED WORKS
1. John Crome, *The Blacksmith's Shop*, c. 1806–7, pencil and watercolor, 21¼ x 17½" (54.1 x 44.3 cm.), Norwich, Norwich Castle Museum (fig. 18-1).
PROVENANCE: James N. Sherrington; by descent to his widow, Mrs. Caleb Rose; her sale, Christie's, March 30, 1908, lot 25; bt. Sherrington; presented to the museum by P. M. Turner, 1942.
MAJOR EXHIBITIONS: Norwich, Norwich Society, 1807?, no. 19 or 100 (as "A Blacksmith's Shop, from Nature"); Manchester, 1961, no. 35; Norwich and London, 1968, no. 63, pl. 16.
LITERATURE: Dickes, 1905, p. 61; Collins Baker, 1921, pp. 76, 115, 122, 180; Hawcroft, 1959, pp. 234–35, p. 235 fig. 9; Clifford and Clifford, 1968, pp. 130–31, no. D44, pl. 38; Goldberg, 1978, vol. 1, p. 186, no. 175, vol. 2, fig. 175.

2. John Crome, *The Blacksmith's Shop*, c. 1806–7, watercolor, 15¼ x 11½" (38.7 x 29.2 cm.), Doncaster, Museum and Art Gallery (fig. 18-2).
PROVENANCE: W. W. Spelman; Waterhouse family; Miss Ethel Colman; bequeathed to the National Art Collections Fund, presented to Doncaster, 1949.
EXHIBITIONS: Norwich, Norwich Society, 1807?, no. 19 or 100 (as "A Blacksmith's Shop, from Nature"); Norwich, 1921, no. 83; Sheffield, Graves Art Gallery, *Pictures from Yorkshire Galleries*, 1952; Manchester, 1961, no. 34; Norwich and London, 1968, no. 60; Jacksonville, 1967, no. 16, p. 85 pl. 16.
LITERATURE: Collins Baker, 1921, p. 122, pl. IX; Hawcroft, 1959, p. 234; Clifford, 1965, pp. ix, 20, pl. 10b; Goldberg, 1978, vol. 1, pp. 186–87, 255, no. 176, vol. 2, fig. 176; Hardie, 1966, vol. 2, p. 63; Clifford and Clifford, 1968, pp. 62, 125 no. D36, pl. 37.

3. Attributed to Samuel Prout after John Crome, *Figures by a Cottage Door*, watercolor, 22¾ x 17" (57 x 43 cm.), location unknown.
PROVENANCE: Sotheby's, New York, November 2, 1967, lot 65.

4. Walter M. Aikmann after John Crome, carved boxwood, dimensions unknown, Philadelphia, Mrs John K. van Renaessler Collection.
LITERATURE: Goldberg, 1978, vol. 1, p. 186.

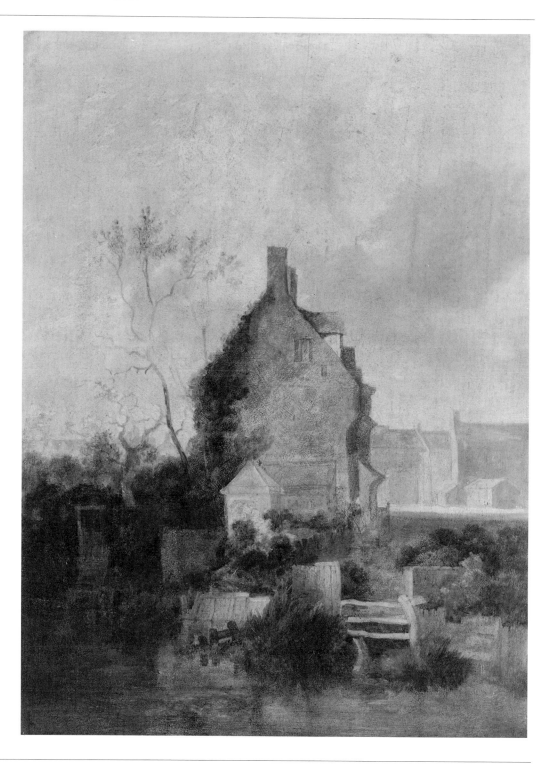

19 JOHN CROME *ST. MARTIN'S RIVER NEAR FULLER'S HOLE, NORWICH*, c. 1813–14
 Oil on panel, 20⅛ x 15¼″ (51.3 x 38.7 cm.)
 The William L. Elkins Collection, E24-3-27

Crome's *St. Martin's River near Fuller's Hole* is known in three almost identical
versions; two of these, at the Norwich Castle Museum (fig. 19-1) and in the
collection of Hon. James Bruce, in Scotland (version 1), are certainly by his
hand and are among Crome's most sensitive and delicate essays in the
picturesque. The other version, in the Philadelphia Museum of Art, has been
accepted and rejected alternately by scholars since it was first published by
Dickes in 1905. Dickes believed in the picture and dated it to 1816. Collins
Baker, in 1921, accepted it as a work of about 1813, and reiterated the

FIG. 19-1 John Crome, *St. Martin's Gate,*
c. 1812, oil on panel, 20 x 15" (50.8 x 38.1 cm.),
Norwich, Norwich Castle Museum
(Norfolk Museums Service)

attribution in 1946.[1] The Cliffords, however, writing in 1968 and basing their
judgment on a photograph, rejected the attribution, calling the Philadelphia
version "an early simplified copy of the original at [the Norwich Castle
Museum]."[2] Goldberg reintroduced the picture into Crome's canon, but did
so in language so tentative that he left a great deal of room for counter-
argument. He described it as a "repetitious paraphrase" of the Norwich *St.
Martin's Gate,* and "either an experimental effort or a painting Crome left
unfinished."[3] Calling attention to what he believed to be severe rubbing of the
canvas, he lamented that later restorations had left "little of the virtue of the
original, which in this case is scarcely nothing, and now it is a ghost of a
shadow of what was once there." He also admitted that "a brush foreign to
that of Crome has touched the surface," but on the basis of an examination of
the brushstrokes through a magnifying glass, and close study of the picture in
1950, 1963, and 1965, concluded that the picture was after all by Crome.[4]
Goldberg was apparently unaware of the nineteenth-century inscription on the
reverse of the painting concerning attribution to Crome. Since Goldberg's book
appeared, two other scholars have given their opinions: Andrew Hemingway
and Miklós Rajnai have both doubted the authenticity of the picture.[5]

In support of Goldberg's view, there is a delicacy of effect, a lightness of
touch, to suggest Crome's hand or the hand of someone close to him. Yet by
1810 John Crome was accomplished in the rendering of the structure of tree
trunks and branches—so that these feathery, brushed-in trees look very different
from trees in other works securely attributed to him. In the versions at Norwich
and in Scotland, the buildings are formed by the juxtaposition of rectangles,
squares, and triangles realized through the sensitive tempering of tone and
color. By contrast, here they are drawn with the brush and conceived in terms
of outline. The treatment of the architecture suggests that the artist had no
profound knowledge of the structure of buildings, particularly apparent in the
rendering of the background architecture.

What is clear from a technical examination of this painting is that it is an
unfinished picture, and in relatively good condition, not rubbed as Goldberg
believed. Under a microscope the pattern of brushstrokes and the uneven
particles of pigment are seen to be identical to those in Crome's *Blacksmith's
Shop* (no. 18). The high quality of the picture would suggest that this is an
unfinished landscape by Crome himself.

The inscription on the reverse states that the picture was in the collection
of Lord Stafford (1758–1833), one of the most important connoisseurs and
patrons in pre-Victorian England. Stafford's seat was Costessey Park, also the
home of Lady Jerningham, whom we know to have been a pupil of Crome.[6]

The theme of St. Martin's River is one that occupied Crome during the
middle period of his exhibiting career. In 1807 he showed at the Norwich
Gallery a pencil drawing of the subject and the following year exhibited his
first oil (possibly the version in the Norwich Castle Museum). In 1810, 1811,
1812, 1815, and 1816 Crome returned to the theme, exhibiting in all ten pictures
and drawings with St. Martin's in the title. Precisely what all these views show
is not certain. Attempts by Dickes, Cotman and Hawcroft, and the Cliffords
to identify the site in the Philadelphia, the Balmano Castle, Scotland, and the
Norwich pictures as Fuller's Hole or Hall, a structure formerly just outside
St. Martin's Gate in Norwich, have not been successful, for Fuller's Hall was
quite different in appearance. Hawcroft, in the catalogue for the 1968
exhibition in Norwich and London, dismissed the idea that the site here can be
identified, a view endorsed by Goldberg.[7] St. Martin's in the title of a picture
by Crome probably means simply a view or scene near the river Wensum in
St. Martin's parish, Norwich.

1. See Goldberg, 1978, vol. 1, pp. 54–55.
2. Clifford and Clifford, 1968, p. 212 (copy [a]).
3. Goldberg, 1978, vol. 1, p. 206.
4. Ibid., p. 55.
5. Hemingway after a visit to the Philadelphia Museum of Art, January 1979, and in conversation with the author, April 1981. Rajnai in conversation with the author, April 1981.
6. Clifford and Clifford, 1968, p. 78.
7. Goldberg, 1978, vol. 1, p. 190.

INSCRIPTION: *November 12, 1885: I hearby certify that I have known this picture a view on St. Martin's River / near Fullers hole for thirty years & the late Lord Stafford always told me it was by Crome. There were many others of his in the Hall* [signed] *C. E. Britcher / The Carver* [?] [on an old label on the reverse].

PROVENANCE: Lord Stafford, Costessey Park, Norfolk; Mrs. Steward, Rackheath Park, Norwich; her sale, Christie's, December 8, 1888, lot 131; bt. Agnew; James Price; his sale, Christie's, June 15, 1895, lot 27; bt. Agnew; John G. Johnson; William L. Elkins.

EXHIBITION: Elkins, 1925, no. 13.

LITERATURE: Elkins, 1887–1900, vol. 2, no. 59, repro.; Dickes, 1905, p. 110; Collins Baker, 1921, pp. 19, 27, 79–80, 111, 113, 161, 191, 195; Elkins, 1925, no. 13; Goldberg, 1960, p. 214; Clifford and Clifford, 1968, p. 212 (copy [a]); Goldberg, 1978, vol. 1, pp. 33, 49, 55, 206 no. 73, 297, vol. 2, fig. 73.

CONDITION NOTES: The original support is a single piece of ¼″ tangentially cut mahogany. The planar, uncradled panel has two vertical cracks between 2 to 3″ in length, which extend into the support from the top edge. These cracks have been mended from the reverse with linen patches. Staining on the reverse of the panel indicates that additional support members were attached at some point. A white ground can be seen along the panel's edges. The paint is generally in good condition. There is fracture crackle coincident with splits in the panel support extending down from the top edge. There are local areas of abrasion in the tree limbs on the left side of the design. Underdrawing is evident, through thinly applied paint, especially in the architectural elements. The image appears to be uncleaned; accumulated grime in the paint interstices tends to accentuate the vertical grain lines in the sky.

VERSIONS
1. John Crome, *St. Martin's Gate*, c. 1810, oil on panel, 20 x 16½″ (50.8 x 41.9 cm.), Balmano Castle, Scotland, Hon. James Bruce.
 PROVENANCE: Mrs. Temple Silver, by 1878; her sale, Christie's, April 4, 1912 (as "On the Back River, Norwich"), bt. Agnew (according to Goldberg [1978, vol. 1, p. 189], however, no Christie's sale April 4, 1912, and no Temple Silver sale listed in *Art Prices Current*); W. B. Patterson; Misses Margaret and Lilly Coats, to 1920; by descent to Miss Lilly Coats; her sale, Christie's, July 23, 1954, lot 31; bt. Lord Glentanar; by whom presented to Hon. James Bruce, 1954.

EXHIBITIONS: Possibly Norwich, Norwich Society of Arts, 1810, no. 29 or 34; London, Royal Academy, 1878, no. 20; London, 1958, no. 27; Norwich and London, 1968, no. 40.
 LITERATURE: Dickes, 1905, p. 60; Cundall, 1920, pl. XVI; Collins Baker, 1921, pp. 27, 41–42, 161–62, pl. XXI opp. p. 40; Denys Sutton, *Christie's Since the War, 1945–58* (London, 1959), p. 52, fig. 80; Clifford and Clifford, 1968, p. 212 (version [a]); Goldberg, 1978, vol. 1, pp. 54–55, 189–90, no. 41.

2. John Crome, *St. Martin's Gate*, c. 1812, oil on panel, 20 x 15″ (50.8 x 38.1 cm.), Norwich, Norwich Castle Museum (fig. 19-1).
 PROVENANCE: Possibly Samuel Coleman, by 1821; Rev. H. J. Coleman, by 1875 and still in his possession 1885; G. N. Stevens sale, Christie's, June 12, 1912, lot 78, bt. Agnew (according to Goldberg [1978, vol. 1, pp. 196–97] but no Christie's sale June 12, 1912); Miss Faith Moore, by 1912; Buchanan sale (Moore Collection), Christie's, June 26, 1936, lot 67; bt. Gooden and Fox; bt. Ernest E. Cook; bequeathed to the Norwich Museums, 1955.

EXHIBITIONS: Possibly Norwich, Norwich Society, 1807; possibly Norwich, Sir Benjamin Wrenche's Court, *Crome Memorial Exhibition*, 1821, no. 66 (as "River Wensum," dated 1819); Norwich, Saint Andrew's Hall, *Art Loan Exhibition*, 1878, no. 98; London, Royal Academy, 1878, no. 13; Norwich, 1921, no. 45; Brussels, *Retrospective of British Art*, 1929, no. 54; London, Burlington House, *Exhibition of British Art*, 1934, no. 617; Brussels, *Universal International Exhibition*, 1935, no. 1,104; London, 1958, no. 22; Manchester, 1961, no. 8; London, Royal Academy, *Primitives to Picasso*, 1962, no. 183; Norwich and London, 1968, no. 30.
 LITERATURE: Dickes, 1905, p. 60; Collins Baker, 1921, pp. 27, 41, 42, 55, 80, 86, 93, 117, 118, 161, 193, pl. XIII; Mottram, 1931, pp. 117, 132; Clifford and Clifford, 1968, pp. 211–12, no. P61, pl. 101; Goldberg, 1978, vol. 1, pp. 196–97 no. 54.

3. After John Crome, *St. Martin's Gate*, oil on panel, 21 x 15¼″ (53.3 x 38.7 cm.), location unknown.
 PROVENANCE: With Agnew, 1933.
 LITERATURE: Clifford and Clifford, 1968, p. 212 (copy [b]).

20 AFTER AN ETCHING
 BY JOHN CROME

WOODY LANDSCAPE AT COLNEY, third quarter of the nineteenth century?
Oil on canvas, 22½ x 17″ (57.2 x 43.2 cm.)
John H. McFadden Collection, M28-1-7

Accepted by Collins Baker (1921) as "probably genuine," *Woody Landscape at Colney* was called "a fine example" of Crome's work by Goldberg in 1960. The Cliffords (1968, p. 176) doubted the picture, and Goldberg (1978) nailed it as a pastiche in oil of the third state of the etching *At Colney* by Crome (fig. 20-1). Goldberg went on to attribute the picture to the painter Joseph Paul (1804–1887), "the high priest of professional copiers and forgers,"[1] who specialized in faking Cromes and Constables (q.v.) as well as Canalettos. The picture is clearly a forgery of Crome's work, but the attribution to Joseph Paul must remain speculation.

FIG. 20-1 John Crome, *At Colney,* c. 1812–13, soft-ground etching, 3rd state, 8½ x 6½″ (21.6 x 16.8 cm.), London, British Museum Print Room

1. Goldberg, 1978, vol. 1, p. 101.

PROVENANCE: Gillot Collection;
S. Addington, his sale, Christie's, May 22, 1886, lot 66 (as "An Upright Landscape with fine trees"); bt. Agnew; Fisk Collection?; S. S. Joseph, by 1889; Agnew, c. 1913; bt. John H. McFadden, October 18, 1916.

EXHIBITIONS: London, Grosvenor Gallery, 1889, no. 80 (as "A Woody Landscape" lent by S. S. Joseph); New York, 1917, no. 7; Pittsburgh, 1917, no. 7.

LITERATURE: Roberts, 1917, pp. 15–16, repro. opp. p. 15; Roberts, 1918, "Additions," pp. 108, 114, 117; Cundall, 1920, p. 14, pl. XXIII; Collins Baker, 1921, pp. 56, 97, 110, 127, 135, 181; Goldberg, 1960, p. 214; Clifford and Clifford, 1968, p. 176 (E1[c]); Goldberg, 1978, vol. 1, p. 276; Day, 1979, p. 26.

CONDITION NOTES: The original support is medium-weight linen (12 x 12 threads/cm). The tacking margins have been removed. The painting is lined with an aqueous adhesive and medium-weight fabric. An off-white ground is evident along the cut edges. The paint is in poor condition. An extensive network of

fracture crackle, with associated cupping, and traction crackle, exists over the entire paint surface. Severe abrasion has occurred in the sky and in the central portion of the foreground tree. Some moating from lining is evident in the areas of highest relief in the paint texture. The upper-left corner of the sky can be seen in both visible and ultraviolet light to have been heavily retouched.

VERSIONS

1. After John Crome, *Woody Landscape at Colney,* oil on canvas, 29 x 24″ (73.7 x 61 cm.), formerly Norwich, J. R. Nutman.
 LITERATURE: Collins Baker, 1921, pp. 127, 194; Goldberg, 1978, vol. 1, p. 276.

2. After John Crome, *Woody Landscape at Colney,* oil on canvas, 30 x 29″ (76.2 x 73.7 cm.), location unknown.
 PROVENANCE: Anonymous sale [Leggatt], Christie's, March 30, 1903, lot 94, bt. in?
 LITERATURE: Collins Baker, 1921, p. 127; Goldberg, 1978, vol. 1, p. 276.
 DESCRIPTION: Possibly the Nutman picture (version 1).

3. After John Crome, *Fine Trees, Landscape,* oil on canvas, 22 x 17″ (55.9 x 43.2 cm.), location unknown. Photograph: London, Witt Library.
 LITERATURE: Collins Baker, 1921, p. 127.

4. After John Crome, *Landscape,* medium, dimensions, and location unknown. Photograph: London, Witt Library.
 PROVENANCE: Iden Gallery, Rye.
 LITERATURE: Clifford and Clifford, 1968, p. 176 (E1[a]).

5. After John Crome, *Landscape,* oil on canvas, 16 x 12″ (40.6 x 30.5 cm.), Lady Mackintosh of Halifax Collection.
 PROVENANCE: A U.S. dealer.
 LITERATURE: Clifford and Clifford, 1968, p. 176 (E1[b]).

RELATED WORK: John Crome, *At Colney,* c. 1812–13, soft-ground etching, 3rd state (of four), 8½ x 6½″ (21.6 x 16.8 cm.), London, British Museum Print Room (fig. 20-1).
 LITERATURE: Theobald, 1906, no. 1; Clifford and Clifford, 1968, p. 163; Goldberg, 1978, vol. 1, p. 276.

21 CIRCLE OF JOHN CROME

OLD MILL ON THE YARE, c. 1806
Oil on canvas, 25 x 30⅛″ (63.7 x 76.6 cm.)
The George W. Elkins Collection, E24-4-9

Accepted by Collins Baker and (on the basis of a photograph) by the Cliffords, the attribution to Crome was first challenged (also on the basis of a photograph) by Hawcroft in 1969.[1] Goldberg, having accepted the picture in 1960, confirmed his belief in it in 1978 as a work "wholly compatible with work of 1806 or thereabouts," citing the "broad composition, free and thin handling, precise draftsmanship, and careful brushwork and finish."[2] Goldberg cited Rembrandt's (1606–1669) *Mill* (34½ x 41½″, Washington, D.C., National Gallery of Art) from the Orleans Collection, which was on public exhibition in London for six months beginning December 28, 1798, as a source for the motif of the solitary windmill here.[3]

In conversation with the author in April 1981, Miklós Rajnai rejected the painting as a work by Crome. The dry, mingy drawing of the weirs and sheds, the awkwardly drawn sails of the windmill, the flat, unvaried texture and lack of technical complexity argue against an attribution to Crome. On the other hand, the Crome-like conception of the shadowed left side of the landscape, the bold chiaroscuro and the broad moonlight effects in the sky and water place the work very close to the circle immediately around Crome, perhaps that of a relation or pupil.

The sky is carefully painted in around the windmill, but then the chimneys on top of the building at the left are painted in after the sky.

The catalogue of the Marquand sale in 1903 states that the picture was in the Dawson Turner Collection in 1852, but that picture, *Moonrise on the Yare,* is today in the Tate Gallery (c. 1806, 28 x 43¾″).

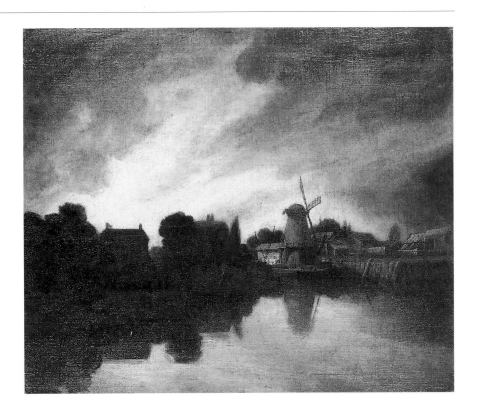

1. Francis Hawcroft, "Review of *John Crome,* by Derek Clifford and Timothy Clifford," *The Burlington Magazine,* vol. III, no. 801 (December 1969), p. 765.
2. Goldberg, 1978, vol. I, p. 180.
3. Ibid., p. 48.

PROVENANCE: Henry E. Marquand; his sale, American Art Association, Mendelsohn Hall (Fortieth Street, east of Broadway), New York, January 23, 1903, lot 33; bt. M. Knoedler and Co.; George W. Elkins.

LITERATURE: Collins Baker, 1921, pp. 147, 182, 192, 195; Elkins, 1925, no. 12; Elkins, 1935, p. 7; Goldberg, 1960, p. 214; Clifford and Clifford, 1968, pp. 181–82, no. P8 pl. 59b; Francis W. Hawcroft, "Review of *John Crome,* by Derek Clifford and Timothy Clifford," *The Burlington Magazine,* vol. III, no. 801 (December 1969), pp. 765–66; Goldberg, 1978, vol. I, p. 180 no. 24, pp. 48, 297, vol. 2, fig 24.

CONDITION NOTES: The original support is medium-weight (10 x 10 threads/cm.) linen. The tacking margins have been removed. Weave cusping in the support on all four sides suggests that very little of the original is missing. The painting is lined with an aged, medium-weight linen and an aqueous adhesive A white ground is visible along the cut edges. The paint is in only fair condition. The original variable profile of the paint has been flattened somewhat by lining. A fine web of narrow-aperture traction crackle is present throughout and seems to be associated with the brown tones of the foliage. A narrow-aperture fracture crackle is present in the areas of highest relief, generally the highlights, of the sky. Losses are restricted to the edges of the composition. The paint interstices are filled with residues of a toned surface coating, possibly applied by the artist.

Nathaniel Dance was born on May 18, 1735, the year before his architect father George Dance (1700–1768) was appointed surveyor to the city of London.[1] Nathaniel and his brother George (1741–1825), who became a successful architect, both attended Merchant Taylors's School in London. In 1748 Nathaniel became the pupil of the painter of history and conversation pieces Francis Hayman (1708–1776), whose version of the rococo, nurtured among the clique of artists and engravers who congregated at Slaughter's Coffee House in St. Martin's Lane in the 1730s, and 1740s, was somewhat like Hogarth's (q.v.)—naturalistic, decorative, the opposite of the grand style—but without Hogarth's feel for the handling of paint or his delight in color.[2]

In May 1754 Nathaniel traveled to Rome, where he was to remain, first as a student and then as a practicing artist, for twelve years. The first five of these years are blank to us, but they were probably spent in an academy of art where Dance would have received a grounding, rare for an Englishman at this date, in Continental academic technique. His first dated Roman canvas portrays *Pietro Nardini and an Unknown Man* (1759, 38½ x 28″, Conte Busiri Vici d'Arcevia) and shows that by 1759 he possessed a command of the rudiments of his art—draftsmanship, knowledge of anatomy and materials—far superior to anything Hayman was capable of teaching him. However, the slightly awkward way in which his marionette-like figures exist in space and relate (or fail to relate) to each other still owes much to Hayman, and even a year later, in 1760, in the Philadelphia *Conversation Piece* (no. 22), he was still borrowing motifs and poses from his old teacher. Unlike his contemporary Gainsborough (q.v.), who started as a painter of conversation pieces under the influence of Hayman and who also matured into a painter of full-length portraits in the grand manner, Dance never quite shook off the intimate, awkward naiveté of the illustrators and decorators in the St. Martin's Lane set.

In 1762 Dance entered into a partnership with the greatest Italian portrait painter of the eighteenth century, Pompeo Batoni (1708–1787). What he learned from Batoni was to paint with a lighter, less opaque palette, which resulted in paintings much less dense and murky than the example of his work owned by the Philadelphia Museum of Art. By 1764 Dance had received his first royal commission, for a portrait of Edward Augustus, Duke of York (94¾ x 58½″, Her Majesty Queen Elizabeth II), and in the following year he was elected to the Accademia di San Luca, the Roman precursor to and model for the Royal Academy.

Although he is now known mainly as a portrait painter, during his Roman years Dance executed several history pictures drawn from classical texts. He is thus considered one of the first neo-classical artists, even though many of these canvases have now disappeared. The most famous was *The Death of Virginia* (location unknown), shown at the Society of Artists' first exhibition in 1761, where it attracted the attention of George III.

With the advantages of Italian academic training, close contact with Batoni, ambition to paint history pictures and, above all, access to aristocrats who were apparently willing to commission such pictures, Dance returned to England in the spring of 1766, arguably the most promising young artist of his generation. For about ten years he seemed to fulfill his early promise. He established a studio at 13 Tavistock Row in Covent Garden, where he made a reputation for himself both as a painter of portraits and of historical paintings. How quickly he rose to the top of his profession can be judged by his exhibiting full-length portraits of George III and Queen Charlotte (Uppark, National Trust) at the first Royal Academy exhibition of 1769 (nos. 30, 31) and by the king's actually commissioning his *Timon of Athens* (48 x 54″, Her Majesty Queen Elizabeth II) in 1767—the first neo-classical picture to enter the Royal Collection.

Dance was the youngest of the founding members of the Royal Academy in 1768. Between 1769 and 1772 he exhibited sixteen portraits and one history picture there, and in the years 1774 and 1776, two history pieces each. Then, in 1776, at the age of forty-one, having become financially independent through an inheritance, he stopped exhibiting professionally and dismantled his studio, although he continued to serve on committees and on the council of the Royal Academy until his resignation in 1790. Until his old age he still painted and drew portraits of friends as well as exhibiting landscapes at the annual Royal Academy exhibitions as a non-member.

Late in his Roman period Dance had fallen in love with the Swiss artist Angelica Kauffmann (1741–1807), who in 1766 followed him to England, where they planned to be married. But almost on the moment of her arrival, Angelica broke his heart by forsaking him to pursue a much greater catch, Joshua Reynolds (q.v.). Not until 1783 did Dance marry, and then to a rich widow, Mrs. Harriet Dummer. He became a Member of Parliament, representing, at different times, East Grinstead and Great Bedwyn. In 1800 he changed his name to Nathaniel Dance-Holland, after his wife's distant cousin Charlotte Holland, and later the same year he was created a baronet. He died aged seventy-six in 1811, leaving a fortune of two hundred thousand pounds.

1. For Dance, see Kenwood, 1977.
2. Girouard, 1966, "Slaughter's," pp. 58–61.

BIBLIOGRAPHY: Basil C. Skinner, "Some Aspects of the Work of Nathaniel Dance in Rome," *The Burlington Magazine*, vol. 101, nos. 678/79 (September/October 1959), pp. 346–49; David Goodreau, "Nathaniel Dance: An Unpublished Letter," *The Burlington Magazine*, vol. 114, no. 835 (October 1972), pp. 712–15.

EXHIBITION: Kenwood, 1977.

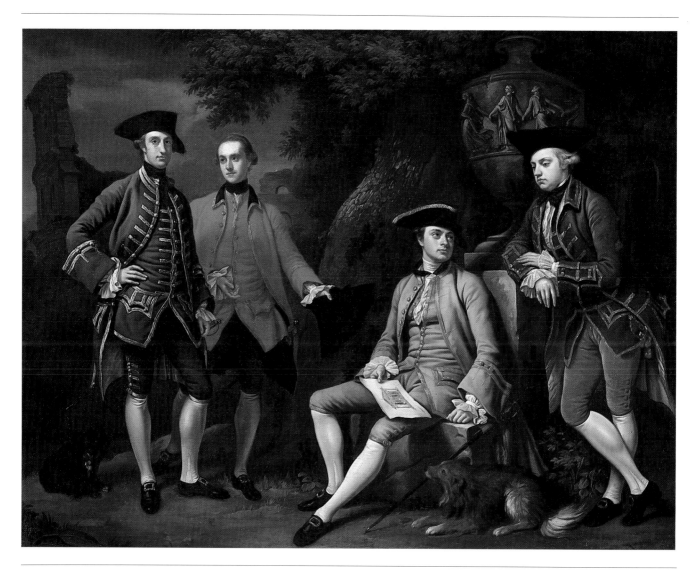

22 NATHANIEL DANCE

A CONVERSATION PIECE: JAMES GRANT OF GRANT, JOHN MYTTON,
HON. THOMAS ROBINSON, AND THOMAS WYNN, 1760–61
Oil on canvas, 37⅞ x 48½″ (96.2 x 123 cm.)
Gift of John H. McFadden, Jr., 46-36-1

A conversation piece is an informal group portrait in which the sitters are
shown full length to a scale much smaller than life. A direct outgrowth of
Dutch seventeenth-century domestic portraiture, and particularly the interiors
of Metsu (1629–1667) and ter Borch (1617–1681), the genre became fashionable
in England in the late 1720s and 1730s.[1] Dance was in part responsible for its
revival in the 1760s, but with the difference that he specialized in showing
English gentlemen at ease on the Grand Tour in Rome.[2] Although Dance's
name was soon to become identified with this kind of souvenir of Italy, the
present painting was his first attempt at the genre. A slightly later example
with which this picture might be compared shows *Charles, Lord Hope, and His
Brother James, Later 3rd Earl of Hopetoun, with Their Tutor William Rouett*
(1762, 38 x 28½″, Hopetoun House).[3] After his return to England in 1766,
Dance never painted another conversation piece.

 This picture is one of four almost identical canvases (see figs. 22-1 and
22-2)[4] painted in 1760–61 for each of the four sitters. They are, from left to
right, James Grant of Grant (1738–1811) dressed in a blue suit with silver trim;
John Mytton (d. 1784) in a red coat with gold trim and black trousers; Hon.

FIG. 22-1 Nathaniel Dance, *A Conversation
Piece*, 1760, oil on canvas, 38 x 48½″ (96.5 x 123.2
cm.), Cullen, Banffshire, the Earl of Seafield
Collection

FIG. 22-2 Nathaniel Dance, *A Conversation
Piece*, 1760, oil on canvas, 38¼ x 48½″ (97.2 x
123.2 cm.), New Haven, Yale Center for British
Art

FIG. 22-3 Plate 51 of Giacomo Leoni's edition
of *The Architecture of A. Palladio*, vol. 4
(London, 1721), showing the elevation discussed
by the sitters

Thomas Robinson (1738–1786) in mauve with gold trim; and Thomas Wynn
(1736–1807) in a green coat with gold trim and red trousers. They are shown
in an imaginary landscape, with the ruins of the Colosseum behind them at
the left, and at the right a large classical urn decorated with dancing female
figures derived from a Hellenistic relief known as the Borghese Dancers
(marble, 28 x 74″, Paris, Louvre). Just as the four dancers visible to the viewer
on this urn are frozen in their sinuous frieze, so the four sitters are artfully
arranged into a subtle and rhythmic composition. Only Grant looks out at us;
Mytton turns his head toward Grant but gestures with both hands toward the
seated Robinson who, in turn, shows Wynn an elevation of the Temple of
Jupiter Stator (fig. 22-3). We are thus invited to enter the picture at the left,
but our eyes are drawn by Mytton's gesture forward again by the diagonal of
his left arm to the engraving of the Temple of Jupiter. Wynn closes off the
composition at the right.

That the men should be seen to be discussing this particular building is
hardly fortuitous, since its columns were in the process of being restored the
year the portraits were painted, as mentioned in a letter from Nathaniel's
younger brother, the architect George Dance the Younger (1741–1825), who
also studied in Rome, to their father on October 4, 1760: "The three famous
Columns of the Temple of Jupiter in the Campo Vaccino being in a very
ruinous condition, The Campidoglio have employed Workmen to repair &
preserve them, to perform which they have raised a Scaffold quite up to the
Architrave. I have not let slip this opportunity of measuring them, & have
sav'd up money to get them modelled."[5]

Thomas Robinson was a keen amateur architect and later a member of
the Society of Dilettanti (elected 1763), as were Wynn (elected 1764) and
Mytton (elected 1764), but we do not know for certain whether they availed
themselves of the opportunity to climb the scaffolding. One resident of Rome
who did so was Giovanni Battista Piranesi (1720–1778), who in that year drew
and measured the columns in order to correct inaccuracies in Antoine
Desgodetz's *Les Edifices antiques de Rome* (Paris, 1682, pp. 126–32).[6] But in this
painting we are a long way from Piranesi's obsessions with the antique.
Although two of the poses distantly echo famous classical statues—the Apollo
Belvedere pose struck by Mytton and a rather drowsy Farnese Hercules by
Wynn—Dance has used antiquity as a prop and a backdrop against which to
paste his visiting English noblemen. Far from responding to antiquity either
with a sense of passionate moral earnestness, as Reynolds (q.v.) had done, or
awe, as Henry Fuseli (1741–1825) was soon to do, Dance and his patrons here
trivialize the classical past. David Goodreau has pointed out that the whole
right half of the composition is derived from Francis Hayman's pretty rococo
portrait group *Margaret Tyers and Her Husband* (fig. 22-4),[7] which at this date
Dance could only have utilized from memory. Still, the picture has great
charm and is an important document of the Grand Tour, serving, as it might,
to symbolize generations of eighteenth-century English travelers to Rome.
Fortunately, a great deal is known about the movements of all four sitters on
their tour, the circumstances of their meeting, traveling to Rome, and
commissioning their portraits.

Robinson set out for Italy on October 20, 1758, arriving in Turin on
November 21. There he settled down for a year's study of the Italian language
under the guidance of a Signor Borra, who "for near Eight months...never
hardly missed spending two or three hours in the afternoon with me."[8] In his
frequent correspondence with his father, Sir Thomas Robinson, later 1st Lord
Grantham, Robinson did not mention his future traveling companions until a
letter from Turin dated March 30, 1759: "Mr. Grant is perhaps the only

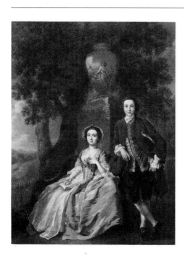

FIG. 22-4 Francis Hayman (1708–1776), *Margaret Tyers and Her Husband George Rogers*, 1750s, oil on canvas, 30⅛ x 27⅛" (90.5 x 70.3 cm.), New Haven, Yale Center for British Art

person . . . I should like to undertake the journey thro' Italy with. Mr. Mytton & a younger son of Sir John Wynne's are just arrived."[9] These three were spending the winter in Geneva, and since Robinson had been to Westminster School with Grant and Mytton,[10] it was natural for him to travel to Switzerland in June of 1759 to meet them.[11] As a result of this trip, he modified his traveling plans. This he explained to his father in a letter from Turin of August 18, 1759:

> I have now settled something in regard to my progress into Italy & my manner of taking it. Nothing was fixed upon that head in Switzerland, as Mr. Wynne & Mr. Grant were of different Sentiments; the former being desirous of spending his Winter at Venice & the latter preferring Rome. I therefore thought proper on my return to this place to provide against all cases & make sure of an agreeable companion as far as Rome, & finding that my old Acquaintance Mr. Mytton was in the same Case, made Overtures to him & settled that we should go to Rome together at all Events; if our Geneva friends should separate, we agreed to take in the one that was to go our way, and if they intended both to go to Rome we determined to let them go some time before or after us as might be most agreeable to us all, for we propose meeting at last & being pretty much of the same turn in regard to our Love of Virtue, hope our Society at Rome will not be disagreeable. I heard the other day that Mr. Wynne was come over to our Plan. Mr. Mytton was my School-fellow at Westminster & was afterwards at Clare Hall [Cambridge] & at both these places was always one of my intimate Friends. I could not have met with a man more agreable to my Choice, as he is of a most worthy Character, a good Scholar & has a cultivated understanding.[12]

Robinson's father replied with his approval of the plan (and of Mytton), and by October 14 the four friends were reunited in Turin.[13] By October 30, decisions had been reached. Robinson wrote from Turin: "I shall set out with Mr. Mytton only, as ye other Gentlemen propose going another Road; it would besides be very impossible for so large a party to travel together with Ease or Convenience."[14]

So these two left Turin and traveled to Rome, stopping at Parma on November 6 and arriving in Rome on November 25. They lost no time in establishing themselves there, hiring a *cicerone* to show them the city. Wynn and Grant were expected any day. Thus, Robinson wrote to his father in December 1759, "I have ye happiness to be attended by ye best antiquarian in Rome, the Abbate Venuti, who as soon as Mr. Grant & Mr. Wynn arrive will begin to go about with us, which will be in a very few days."[15]

After leaving Turin around November 1, Grant and Wynn visited Parma, Bologna, and Florence on their way south, but whether they stopped in Rome in December to rejoin their friends as planned or continued directly to Naples we do not know. The next certain sighting of the pair is on January 1, as they entered Naples.[16] Grant's slightly dry account of this stay survives; in it he described their ascent of Mount Vesuvius and a collection of Priapuses at Portici. They remained in Naples until February 1760, arriving (or returning) to Rome on the tenth.[17] These dates are relevant because the first version of this conversation piece was probably commissioned about this time, with the sittings commencing sometime in the following two months, when the four were together in Rome. This is likely because by April 15, Robinson and Mytton had left for Naples, not to return until June 20, and by the beginning of July, Grant had departed for home.

Nowhere in their letters do Robinson or Grant refer to the conversation piece by Dance, but on the day after his return from Naples, June 21, 1760, Robinson, in a letter to his father, brought up the subject of having his portrait painted. Here he compared the merits of the two leading portrait painters of the city, Batoni (1708–1787) and Mengs ("Mr. Menx") (1728–1779).[18] By August of that year he had decided on Mengs (that portrait is today at Newby Hall, North Yorkshire), but added: "It is with pleasure also I can inform you that many students of our own Nation give great hopes of their future skill, & will some day be the means of justifying us against the Reproach of having produced no Great Painters, the true reason of which I find to be, that till twenty years ago we never sent any to study here."[19] And although he did not mention him by name, Dance must have been one of the promising artists referred to, as he was painting Robinson's portrait at just that time. Even before this letter was written, the four friends had begun to disperse. Grant had left Rome by July 12, 1760, when the Scottish Catholic agent in Rome, Abbé Peter Grant (d. 1784), wrote to him in Munich.[20] Grant returned with Wynn to England by November of the same year. We do not know when Mytton left Rome, but Robinson had departed by September 1760 for a nine-month return journey that included visits to Florence, Turin, Venice, and Munich. On June 13, 1761, almost four years after he had left London, Robinson was able to write to his father from their house in Whitehall, "I arrived two hours ago."

As we have seen, the commission to paint this work must have been given before July 1760. We can assume that the first version of the picture is that which belonged to James Grant of Grant and is today in the collection of the Earl of Seafield (fig. 22-1). The artist and dealer in antiquities Thomas Jenkins (1722–1798), writing from Rome to James Grant in England on November 19, 1760, noted that "according to your directions left with me . . . the Conversation Picture by Mr. Dance I have now by me and I have paid for. . . . All your other things shall be forwarded as soon as possible."[21] This means that by November 1760, a second version was far enough advanced for a third version to be copied from it, as the first version had already left the studio. The next month, on December 17, 1760, Nathaniel Dance wrote to his father:

> I have not yet quite freed myself from the disagreeable task of copying the Conversation Picture, tho' I believe it will not now be long before I shall. It has taken me up a good deal of time, as I was obliged to make 4 Copies, & tho I shall not acquire any great improvement from it or be paid much for my trouble yet I cou'd not refuse doing it, as it was the means of making me acquainted with my LORD GREY [George Henry, 5th Earl of Stamford, whose portrait Dance painted, together with that of Sir Henry Mainwaring, 4th Bart., in 1760; 35 x 28″, England, private collection] and the other Gentlemen who have given me Commissions for Pictures besides. . . . I am convinc'd these gentlemen will do me all the service that lyes in their power; I hear already that Mr. Robinson has recommended me to the DUKE of MARLBOROUGH, and other gentlemen who are coming to ROME, & he has me very much at heart. My good friend Mr. Crispin introduc'd one to the acquaintance of these Gentlemen.[22]

But the commission dragged on. Almost a year later, on October 14, 1761, he wrote to his father that he was delayed in finishing his "Aeneas Discovering Venus" because "I have been interrupted by those four copies of the Conversation Piece."[23]

Dance's hope that this dull commission would lead to better things was justified, for Robinson recommended him to his cousin William Weddell, whose portrait (with his servant Janson and Rev. William Palgrave) Dance painted on Weddell's Grand Tour in 1765 (38¼ x 52¾", Upton House, Bearsted Collection, National Trust); Grant commissioned a history picture (*Nisus and Euryalus,* location unknown) from him; and Sir Henry Mainwaring commissioned his portrait in addition to the history painting *The Meeting of Aeneas and Achates with Venus* (c. 1761, location unknown).

With the exception of Mytton, who remains a shadowy figure, it is possible to say something about the characters and personalities of each of the men in Dance's *Conversation Piece.* The one who comes most vividly to life is Robinson, not only because of his interesting and affectionate letters home, but because his acquaintance Mr. Crispin, writing to a Mr. Porter from Rome on July 3, 1760, described the twenty-two year old in glowing terms:

> Mr. Robinson, after making the most of Rome, followed the several Branches of Virtu, but without neglecting the much more essential knowledge that conversation & the best acquaintance here could help him to gather. . . . His person is rather tall, & tho' there may be some perhaps of a genteeler make, will not pass unnoticed, his colour has the freshness of Sir Thomas's [his father], he is short sighted, without any blemish or other defect in his Eyes, his Voice is remarkably good, but to rise now to better things, he has a most uncommon Elocution, a command in speaking that belongs not to his years, while his manner is made to convince not to offend. . . . The learned esteem him a good Scholar, & Cardinal Passionier who shews him uncommon attention & Civility, has confessed himself very much flattered by a Sapphick Ode that Mr. Robinson lately presented him with. . . . He is quick at an Essay of Humour, Capable of any longer work, rises above Mediocrity as a Poet, remarkable for strength of Memory, listened to already at Rome on matters of Taste, understanding well Architecture, drawing himself very neatly, making a daily progress in Musick. . . . The men seek his Company & the Ladies like it, his heart seems to be most happily tempered, there's warmth of feeling in it.[24]

It is interesting, in the light of this description, to notice how the portrait group is composed around Robinson and how the poses and gestures of the others seem to defer to him. Then, too, his poor eyesight (and possibly, despite Crispin's disclaimer, slightly crossed eyes) may be responsible for his apparently spontaneous glance up toward Wynn. He certainly fulfilled Crispin's expectations for a distinguished life, serving as ambassador to the court of Spain between 1771 and 1779, and secretary of state for foreign affairs in the administration of Lord Shelburne (1737–1805). In 1780 he married Lady Mary Jemima Yorke (1756–1830), whose portrait by Romney (q.v.) is in the Philadelphia Museum of Art (*Lady Grantham,* no. 87).

The personality of the lanky Scotsman James Grant of Grant emerges in a volume containing his diary and accounts while on the Grand Tour, which is preserved among the Seafield manuscripts in the Scottish Record Office.[25] Here he methodically collected his letters of introduction and credit, a list of currency exchanges from scots to sterling, a carefully laid-out itinerary, and an elaborate compilation of the names and birth and death dates of major artists and architects together with their principal achievements. This is followed by a long (and dull) compilation of the principal events in the histories of the towns through which he was to pass and a daily diary in which he jotted

down the bare facts about the sights and pictures he had seen each day or the inns in which he had dined. Most of this is straightforward reporting: if he liked a picture it was "very fine," if he enjoyed his stay, the city was "excessively agreeable." In short, he was a methodical and conscientious sightseer. Grant returned to England and married Jane Duff at Bath on January 4, 1763. He became Member of Parliament for Elgin and Florres from 1761 to 1776 and succeeded his father as 7th Baronet and chief of the Clan Grant in 1773, residing mainly at Castle Grant until his death in 1811. He had seven sons and seven daughters.[26]

In some ways the most colorful of the four sitters is the man standing at the right. He has been correctly identified by John Fleming (1962, p. 370) as Thomas Wynn, who succeeded as 3rd Baronet in 1773 and was created Baron Newborough in 1776 in recognition of his work as a colonel of the Caernarvon militia and a builder of military defenses in Wales. He served as Member of Parliament for county Caernarvon from 1761–1774, and in 1766, at age thirty, he married as his first wife a daughter of the Earl of Egmont, Lady Catherine Perceval (d. 1782), whose half-brother, the Prime Minister Spencer Perceval, was assassinated in the House of Parliament in 1812. Very little is known about Wynn's life and personality during the years he was on the Grand Tour, for no papers from this period survive. It is therefore irresistible, although perhaps unfair, to infer something about his character as a young man from the events of his later life, for he is known to us principally as the first husband of the notorious Maria Stella, Lady Newborough (1773–1843), whose autobiography catalogued, with what degree of accuracy we cannot say, his more flamboyant shortcomings. Chief of these, in the eyes of his wife, was the manner in which he secured her hand—by purchasing her, when he was fifty years old and she but thirteen, from her father, the former jailer of the town of Faenza in Italy, for fifteen thousand francesconi (four thousand pounds).

Maria Stella Chiappini, the teen-age Lady Newborough, was brought to Wales and accepted by English society as the mistress of her husband's great house Glynllivon; there she lived with Lord Newborough for twenty-one years until his death in 1807. Nevertheless, when she came to write her life story, she described him as a man with offensive breath, discolored teeth, frightful fits of anger, befuddled by "the fumes of wine [which] upset his weak mind." She also described their first meeting when, "at the sight of him I gave a wild cry, and, falling at his knees, with sobs implored him ... to think of my youth.... [but] He did nothing but laugh at my pitiful simplicity."[27]

If we know rather too much about Wynn, the opposite is true of Mytton. He married Rebecca Pigot and lived at Halston in Shropshire until 1784 and possessed "a small but excellent collection of pictures."[28] This collection was sold to pay for his grandson "Mad Jack" Mytton's debts by the auctioneer Mr. Gimblett beginning April 13, 1831.[29] Earl de Grey, son of another sitter, Thomas Robinson, went to that sale and recorded the following anecdote: "One year when I was upon duty with my regiment at York, a collection of pictures was upon sale which I believe had belonged to a Mr. Mitten [Mytton], the person dressed in red in this picture. The auctioneer sent me a catalogue as my family name was in it, and I went to see it. As far as I could judge without having the two pictures together, it was a precise duplicate of this. It was advertised as a work of Hogarth, and the name of my father and Mr. Mitten were the same as we have always believed them to be, the others were different, though I do not recollect who they were."[30]

Earl de Grey's description suggests that the Mytton version was inscribed with the names of the sitters and, as one of the four versions (version 3) is so inscribed, we may presume that this was the one that belonged to Mytton.

The Philadelphia version was sold in 1923 with the contents of Brocket Hall, a house that came into the possession of the descendants of Thomas Robinson upon the marriage of the de Grey heiress Anne Robinson, a direct descendant of Thomas Robinson, to the 6th Lord Cowper. It is therefore probable that the Philadelphia picture is the version originally owned by Thomas Robinson. However, a version of the picture believed by the family to descend from Robinson is still in the possession of Lady Lucas, who is also Robinson's direct descendant; but as this is the inscribed version, we can only conclude that the Robinson family acquired Mytton's version and sold Robinson's version.

1. Edwards, 1977, p. 252.

2. Kenwood, 1977, introduction.

3. Ford, 1955, p. 376; Kenwood, 1977, fig. 1.

4. In each of the four versions the turning of the dancers on the urn is different. In the Seafield and the Yale versions (figs. 22-1 and 22-2), the seated Robinson wears a ring on the little finger of his left hand.

5. Dance Family MS., box 1, MS.72.034 (42).8/.88:92D, Royal Institute of British Architects, London.

6. Dorothy Stroud, *George Dance, Architect, 1741–1825* (London, 1971), p. 65.

7. Kenwood, 1977, no. 5.

8. Thomas Robinson to his father, Turin, September 26, 1759, Lucas MS. 12305, Bedfordshire County Record Office, Bedford.

9. Lucas MS. 12361.

10. Thomas Robinson to his brother Fritz Robinson, Turin, October 15, 1759, Lucas MS. 12307.

11. Thomas Robinson to his father, Bern, June 30, 1759, Lucas MS. 12299.

12. Lucas MS. 12303.

13. Thomas Robinson to his father, Turin, October 14, 1759, Lucas MS. 12306.

14. Lucas MS. 12308.

15. Lucas MS. 12311.

16. Volume containing James Grant of Grant's diary and accounts while on the Grand Tour, Seafield MS. GD248/39/1, Scottish Record Office, Edinburgh.

17. Thomas Robinson to his father, February 10, 1760, Lucas MS. 12318: "I expect Mr. Grant and Wynne home today."

18. Thomas Robinson to his father, Rome, June 21, 1760, Lucas MS. 12322; and August 9, 1760, Lucas MS. 12325.

19. Thomas Robinson to his father, Rome, August 9, 1760, Lucas MS. 12325.

20. Edinburgh, Scottish Record Office, Seafield MS. GD 248/99/3.

21. Seafield MS. GD 48/177/1/83.

22. London, Royal Institute of British Architects, Dance Family MS., box 1, MS. 72.034 (42).8/.88:92D.

23. Ibid.

24. Lucas MS. 12347.

25. Seafield MS. GD 248/39/1.

26. For the life of Sir James Grant of Grant, see Archibald Kennedy [the Earl of Cassillis], *The Rulers of Strathspey: A History of the Lairds of Grant and Earls of Seafield* (Inverness, 1911), pp. 147–50.

27. Maria Stella Wynn [Baroness Newborough], *The Memoirs of Maria Stella (Lady Newborough),* trans. Harriet M. Capes (London, 1914), pp. 60–97. See also Ralph Payne-Gallwey, *The Mystery of Maria Stella Lady Newborough* (London, 1907).

28. Charles James Apperley [Nimrod], *Memoirs of the Life of the Late John Mytton, Esq. of Halston, Shropshire,* 2nd ed. (London, 1837), p. 7.

29. *Salopian Journal,* April 13, 1831, p. 1.

30. Earl de Grey, "History of the Rebuilding of Wrest House," April 1846, typescript, Lucas MS. CRT 190/45 2, Bedfordshire Record Office, Bedford. Earl de Grey believed that the version in his collection (the Philadelphia version) was by Batoni.

INSCRIPTION: [illegible] *R / Lobby* [on the stretcher, incised in script]; *LORD WALTER T. KERR C.C.B. / 72* [stenciled]; *No 1 R* [illegible] *H* [written in faint script on top of stretcher]; *No 40069 / McF Picture 39 / 15581* [on inventory stickers]; *421 R* [stenciled in black]; *(6963) / 15581* [incised]; *BATONI No. 40069* [inscribed in pencil in modern hand on frame].

PROVENANCE: Probably Hon. Thomas Robinson, 2nd Baron Grantham, for whom painted; his son, Thomas, 2nd Earl de Grey, 5th Baron Lucas of Crudwell, and 3rd Baron Grantham; by descent to Auberon Thomas Herbert, 8th Baron Lucas and 11th Baron Dingwall; his aunt Lady Amabel Cowper; her husband, Admiral of the Fleet Lord Walter Talbot Kerr, G.C.B., of Brocket Hall, Hatfield, Hertfordshire; sale Messrs. Foster, contents of Brocket Hall, March 8, 1923, lot 284 (as by Batoni); Arthur Tooth, London, and M. Knoedler and Co., New York; bt. John McFadden, Jr., February 8, 1928 (as by Batoni).

EXHIBITIONS: Philadelphia, University Museum, Detroit, The Detroit Institute of Arts, *The Ruins of Rome,* 1960–61, no. 35; Philadelphia, John Wanamaker Store, *Exposition Britannia,* 1963; Storrs, Connecticut, William Benton Museum of Art, University of Connecticut, *The Academy of Europe: Rome in the 18th Century,* 1973, no. 109; Kenwood, 1977, no. 5.

LITERATURE: "In the Sale Room—Brocket Hall Sale," *The Connoisseur,* vol. 66 (May 1923), p. 40; Sacheverell Sitwell, *Conversation Pieces: A Survey of English Domestic Portraits and Their Painters* (London, 1936), pp. 74, 105, pl. 88 (notes by Michael Sevier); Brinsley Ford, "A Portrait Group by Gavin Hamilton: With Some Notes on Portraits of Englishmen in Rome," *The Burlington Magazine,* vol. 97, no. 633 (December 1955), p. 375; Basil C. Skinner, "A Note on Four British Artists in Rome," *The Burlington Magazine,* vol. 99, no. 652 (July 1957), p. 238; Basil Skinner, "Some Aspects of the Work of Nathaniel Dance in Rome," *The Burlington Magazine,* vol. 101, nos. 678/79 (September/October 1959), p. 349; David Sellin, "Nathaniel Dance, A Conversation Piece," *Philadelphia Museum of Art Bulletin,* vol. 56, no. 268 (winter 1961), pp. 61–63; Robert C. Smith, "The Ruins of Rome," *Expedition: The Bulletin of the University Museum of the University of Pennsylvania,* vol. 3, no. 2 (winter 1961), pp. 29–30; Fleming, 1962, p. 370; Andrea Busiri Vici, "Ritratti di N. Dance tra Ruderi e Salotti," *Capitolium,* vol. 40 (July/August 1965), repro. p. 387; Mario Praz, *Conversation Pieces: A Survey of the Informal Group Portrait in Europe and America* (London, 1971), p. 254, pl. 294 (version 1); Kenwood, 1972, introduction; David Goodreau, "Pictorial Sources of the Neo-Classical Style: London or Rome?," *Studies in Eighteenth Century Culture,* vol. 4 (1975), pp. 247–70; Edwards, 1977, p. 261, pl. IV p. 256; Haskell and Penny, 1981, p. 195; New Haven, 1981, p. 45.

CONDITION NOTES: The original support is lightweight (10 x 10 threads/cm.) linen. Several tears, now mended, are evident in the support. A single, large, diagonal tear, approximately 7″ in length, is present at shoulder height in the figure at the extreme right. Draws are present at all four corners. The tacking margins are missing. The painting appeared relined and retouched before conservation in 1967 (per Siegl). The aged aqueous lining was retained and repaired along its torn tacking folds. A white ground is visible along the cut edges. The paint is in fair to good condition. The profile of the original, moderate to low relief brush marking has a "blistered" appearance. Areas of black or dark brown paint appear generally abraded. The most severe abrasion has occurred in the hat on the figure at the far left and to the walking stick and dog next to the figure second from the right. The painting was cleaned in 1967. Under ultraviolet light, retouching is seen to be generally restricted to areas of deepest abrasion, areas adjacent to tear mends, various pinpoint losses overall, and losses along the cut edges.

VERSIONS

1. Nathaniel Dance, *A Conversation Piece,* 1760, oil on canvas, 38 x 48½″ (96.5 x 123.2 cm.), Cullen, Banffshire, the Earl of Seafield Collection (fig. 22-1).

PROVENANCE: James Grant of Grant; by descent to present owner.

LITERATURE: Mario Praz, *Conversation Pieces: A Survey of the Informal Group Portrait in Europe and America* (London, 1971), p. 254, pl. 294.

2. Nathaniel Dance, *A Conversation Piece,* 1760, oil on canvas, 38¼ x 48½″ (97.2 x 123.2 cm.), New Haven, Yale Center for British Art (fig. 22-2).

INSCRIPTION: *No. 40/H Th* [?] [on an old label on the stretcher, possibly in an eighteenth- or early nineteenth-century hand]; *667RZ* [stenciled]; 4 red wax custom seals.

PROVENANCE: Possibly Thomas Wynn, later 1st Lord Newborough, for whom painted; H. St. George Gray, 1926; his sale, Christie's, June 11, 1926, lot 48 (as by Batoni), bt. Parsons; Arthur Tooth and Sons, by 1936; Julius Weitzner, New York; Agnew, 1959; Senator A. McGuire; Christie's, June 20, 1969, lot 113; bt. Baskett and Day for Paul Mellon and subsequently presented to the Yale Center for British Art.

EXHIBITIONS: New Haven, Yale Center for British Art, *The Pursuit of Happiness, A View of Life in Georgian England,* 1977, no. 35 (by Edward J. Nymen, Nancy Pressly, and J. H. Plumb); New Haven, 1981, no. 54.

3. Nathaniel Dance, *A Conversation Piece,* 1760, oil on canvas, 38 x 48½″ (96.5 x 123.2 cm.), Lady Lucas Collection.

INSCRIPTION: The names of the sitters on the front of the canvas; *HAR/F/348* [on an inventory sticker].

PROVENANCE: Possibly John Mytton, and if so by descent to his grandson "Mad Jack" Mytton; sold by the auctioneer Mr. Gimblett with the contents of Halston Hall, Shropshire, April 14, 1831 (as by Hogarth); acquired by the descendants of Thomas Robinson, 2nd Baron Grantham; by descent to Auberon Thomas Herbert, 8th Baron Lucas and 11th Baron Dingwall.

EXHIBITION: Bristol, Bristol Art Gallery, *Art Treasures of the West Country,* 1937, no. 95.

Robert Dowling was born in Australia in 1827 and moved to London in the 1850s. He is not noted in Bryan's *Dictionary of Painters and Engravers,* nor did he merit an obituary in *The Art Journal*. His specialties were genre, oriental scenes, portraits, and history pictures. Much of what we know about Dowling is gleaned from the Royal Academy exhibition catalogues. His first London address, given in the catalogue of 1859, was 56 Upper Charlotte Street, and in 1860 he had moved to 7 Lidlington Place near Euston Square. Between 1869 and 1872 he lived in Horbury Crescent, Kensington, and between 1875 and 1882 at 27 Coleherne Road.

From 1859 to 1882 Dowling exhibited sixteen works at the Royal Academy. His first, number 962 in the 1859 exhibition, was entitled *Breakfasting Out*. *The Art Journal* failed to describe the subject but called the drawing and painting "unexceptionable" and opined that although Dowling's name was new to the reviewer "his manner of Art is sound, and bears with it a prospect of distinction."[1] In 1864 Dowling exhibited at the academy a portrait of the Prince of Wales (no. 338), commissioned by the Tasmanian government. He also exhibited five works at the British Institution between 1859 and 1867, regularly showed at the Royal Society of British Artists, and late in his life, from 1880 to 1884, exhibited at the Royal Society of Artists in Birmingham.

In 1879 Dowling's *Moses on Mount Nebo* was shown at the London Stereoscopic Company on Regent Street. *The Art Journal* noted that the picture was "painted from the very spot on which the prophet stands,"[2] implying that Dowling, like William Holman Hunt (1827–1910), had actually traveled to the Near East in order to ensure accuracy in his landscape settings. The National Gallery of Australia at Melbourne holds his *Sheik and His Son Entering Cairo on Their Return from a Pilgrimage to Mecca* (1874, 96 x 54").

Dowling died in 1886. His studio sale was held in London in 1887; thus presumably he never returned to Australia.

1. "The Royal Academy Exhibition," *The Art Journal,* 1859, p. 171.
2. "Mr. Dowling's *Moses on Mount Nebo,*" *The Art Journal,* 1879, p. 142.

BIBLIOGRAPHY: "The Royal Academy Exhibition," *The Art Journal,* 1859, p. 171;

"Mr. Dowling's *Moses on Mount Nebo,*" *The Art Journal,* 1879, p. 142; London, Puttick and Simpson, *Catalogue of the Contents of an Artist's Studio* [Dowling studio sale], July 18, 1887; Melbourne, National Gallery of Australia, *Illustrated Catalogue of the National Gallery,* 1911.

23 ROBERT DOWLING *DANIEL IN THE LION'S DEN,* 1882
Oil on canvas, 72 x 50½" (182.6 x 128.2 cm.)
Gift of the Richard and Susan Levy Art Foundation, 68-181-1

Daniel in the Lion's Den was sold at Sotheby's in 1966 and entered the Philadelphia Museum of Art as by the French artist and illustrator Gustave Doré (1832–1883). When the relining was removed in 1969 an inscription was discovered identifying Dowling as the artist. A comparison between this and Doré's own *Daniel in the Lion's Den,* executed for the Doré Bible, first published in 1866 (fig. 23-1), shows how easily the attribution to Doré could have arisen. In compositional elements, the Dowling comes closest to Doré's *Christ Healing the Man Possessed by the Devil* (fig. 23-2). Doré had exhibited

regularly in London in the Egyptian Hall from 1868, and consequently
Dowling would have known his work first-hand. Also, Dowling must have
known the work of Sir Edwin Landseer (1803–1873), an artist resident in
London, and the present picture may echo one of Landseer's most famous
paintings, *Mr. Van Amburgh* (1839, 44½ x 68½", Her Majesty Queen
Elizabeth II). In addition, *Daniel in the Lion's Den* may be reminiscent of the
famous Landseer lions sculpted for Trafalgar Square (unveiled 1867).

A tradition of English religious painting stretches back at least as far as
Macklin's Bible gallery of 1800. In the group of pictures sold at the Macklin
sale of 1802 was one by William Hamilton (1751–1801), *Daniel's Vision*
(fig. 23-3),[1] which, although there is no question of its being a direct source
for the Dowling, does show how the Australian-born artist was working
within an accepted formula for the representation of the theme. Dowling,

FIG. 23-1 Gustave Doré (1832–1883), *Daniel in the Lion's Den,* 1866, wood engraving, 13½ x 11" (34.3 x 27.9 cm.)

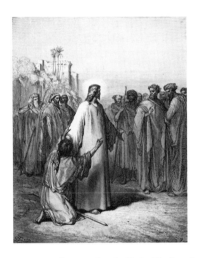

FIG. 23-2 Gustave Doré, *Christ Healing the Man Possessed by the Devil,* 1866, wood engraving, 13½ x 11" (34.3 x 27.9 cm.)

FIG. 23-3 William Hamilton (1751–1801), *Daniel's Vision,* before 1796, oil on canvas, 58 x 40" (147.3 x 101.6 cm.), England, private collection

however, shows a young and bearded Christlike figure appearing to the kneeling Daniel in place of Hamilton's angel. Obviously, the representation of Christ is technically wrong in a subject from the Old Testament.

The relevant biblical passage is from the Book of Daniel, chapter 6, verses 16–24:

> Then the king commanded, and they brought Daniel, and cast *him* into the den of lions. *Now* the king spake and said unto Daniel, Thy God whom thou servest continually, he will deliver thee. And a stone was brought, and laid upon the mouth of the den; and the king sealed it with his own signet, and with the signet of his lords; that the purpose might not be changed concerning Daniel.... Then the king arose very early in the morning, and went in haste unto the den of lions. And when he came to the den, he cried with a lamentable voice unto Daniel: *and* the king spake and said to Daniel, O Daniel, servant of the living God, is thy God, whom thou servest continually, able to deliver thee from the lions? Then said Daniel unto the king, O king, live for ever. My God hath sent his angel, and hath shut the lions' mouths, that they have not hurt me: forasmuch as before him innocency was found in me; and also before thee, O king, have I done no hurt. Then was the king exceeding glad for him, and commanded that they should take Daniel up out of the den. So Daniel was taken up out of the den, and no manner of hurt was found upon him, because he believed in his God. And the king commanded, and they brought those men which had accused Daniel, and they cast *them* into the den of lions, them, their children, and their wives; and the lions had the mastery of them, and brake all their bones in pieces or ever they came at the bottom of the den.

1. Engraved by F. Bartolozzi, published October 22, 1796, in volume 5 of Macklin's Bible (1800).

INSCRIPTION: *DANIEL IN THE DEN OF LIONS BY DOWLING / 27 COLEHERNE ROAD / WEST B[ROMPTON] / 1882* [on the reverse of the canvas].

PROVENANCE: The Convent of the Sacred Heart, Hove, possibly as early as 1905; sold to a local dealer, Amos, 1966; Sotheby's, December 7, 1966, pt. 1, lot 97 (as by Doré); Brook Street Gallery, London; Richard Feigen Gallery, New York; Dr. and Mrs. Richard W. Levy.

CONDITION NOTES: The original support is medium-weight (12 x 12 threads/cm.) linen. The tacking margins have been removed. Two tears exist in the support; one 8" tear runs horizontally to the left of the figure of Daniel and a 5" tear extends vertically to the left of the figure's knee. The painting was lined with a wax-resin adhesive and lightweight linen (Siegl, 1970). A white ground is present and is evident along the cut edges. The paint is in only fair condition. Local areas of traction crackle are evident around the figure's head and an irregular web of narrow-aperture fracture crackle extends overall. Small losses associated with the tears and tacking edge abrasions are present. The painting was cleaned in 1970. Severe blanching has occurred around the figure of Daniel. Under ultraviolet light, local areas of retouching are visible in the figure of Daniel, in the lion at the left of Daniel, and coincident with the tear repairs.

William Maw Egley was a rarity among English painters in leaving almost no trace of his life or personality on the London art world. When in 1916 he died in his ninetieth year in Chiswick, the London *Times* carried a two-sentence obituary, but among the art magazines not even *The Art Journal* took notice of the event.

Egley was born in 1826, the son of William Egley (1798–1870), a miniature painter distinguished enough to merit an entry in the *Dictionary of National Biography*. Of William Maw Egley's training we know little, although he recorded in his diary, preserved in the library of the Victoria and Albert Museum, that by the age of fifteen he was working as his father's assistant.[1] By 1844, at eighteen, he had received commissions in his own right from both the Countess of Chesterfield and from the Count d'Orsay.

Egley's early work, from 1843 to 1855, is composed of scenes from English history, Molière, and Shakespeare. In 1851 he described himself as a "historical painter."[2] Two years later, on March 13, 1853, the *Times*, reviewing his *Queen Katharine of Aragon and Anne Boleyn* (location unknown), then on exhibition at the National Institution of Fine Arts in the Portland Gallery, grouped him with the early Pre-Raphaelites—and indeed, at this period he was working with bright colors on a white ground in a meticulous, glossy style somewhat reminiscent of the early Arthur Hughes (1832–1915).

By 1855 Egley had entered his second period, to last until 1862, in which he concentrated on charming scenes from modern life, such as *The Talking Oak* (1857, 30 x 25″, Detroit, The Detroit Institute of Arts) and *Omnibus Life in London* (1859, oil on panel, 17⅞ x 16½″, London, Tate Gallery), influenced perhaps by the paintings of his close friend William Powell Frith (1819–1909), for whom he painted backgrounds.[3] In his final phase, Egley exhibited eighteenth-century costume pieces in the style of Marcus Stone (1840–1921).

Egley's catalogue, also in the Victoria and Albert Museum Library, reveals him to have been a slow and methodical worker—obsessive, too, in recording the dates he began and finished paintings, to whom he sold them, and the sequence, date, and whereabouts of all preliminary drawings and oil sketches. His diary in eight volumes is, sadly, without interest either for the historian of Victorian art or society, unless Egley's fascination with mesmerism, phrenology, seances, and religion throws light on the mid-Victorian fad for the occult.

He exhibited eighteen works at the British Institution between 1844 and 1867, and thirty-four works at the Royal Academy between 1843 and 1898. A sketching society he founded in 1873, the Scratch Club, was composed entirely of his female pupils. He lived off the Bayswater Road in Connaught Terrace (1846–53), Hereford Road (1857–77), Bassett Road, Notting Hill (1878–98), and finally in Chiswick.

1. Diary, 1844–63, vol. 1, p. 10, 86.FF.14-MS. Eng., Library of the Victoria and Albert Museum, London.
2. Ibid., p. 386.
3. William Powell Frith, *My Autobiography and Reminiscences* (London, 1887), vol. 2, p. 53.

BIBLIOGRAPHY: William Maw Egley, "Catalogue of Pictures, Drawings, and Designs by W. Maw Egley. B. 1826: October 2," vol. 1, 1840–67, vol. 2, 1868–1903, 86.BB.1-4 MS. Eng. (1903), Library of the Victoria and Albert Museum, London; William Maw Egley, Diary, 1844–63, 8 vols., 86.JJ.25-40, Library of the Victoria and Albert Museum, London; "Notes [and Letters] on W. Egley and W. M. Egley," 86.FF.14-MS. Eng., Library of the Victoria and Albert Museum, London; Obituary, *Times* (London), February 22, 1916, p. 11; David Fincham, "Three Painters of the Victorian Scene," *Apollo*, vol. 23 (May 1936), pp. 241–44; Graham Reynolds, *Painters of the Victorian Scene* (London, 1953), p. 96; Graham Reynolds, *Victorian Painting* (London, 1966); Christopher Wood, *The Dictionary of Victorian Painters* (London, 1971), p. 43; Christopher Wood, *Victorian Panorama* (London, 1976), p. 68; Christopher Wood, *The Dictionary of Victorian Painters*, 2nd ed. (London, 1978), p. 142.

24 WILLIAM MAW EGLEY
25

JUST AS THE TWIG IS BENT, 1861 (May 23–October 8)
Oil on canvas, 24¼ x 18¼″ (62.2 x 47 cm.)
Inscribed lower left: *W. Maw Egley. 1861*
Purchased: Katherine Levin Farrell Fund, 70-3-1

THE TREE'S INCLINED, 1861 (February 2–August 8)
Oil on canvas, 24¼ x 18¼″ (62.2 x 47 cm.)
Inscribed lower right: *W. Maw Egley. 1861*
Purchased: Katherine Levin Farrell Fund, 70-3-2

The titles of these two paintings, *Just as the Twig Is Bent* and *The Tree's Inclined,* are taken from Alexander Pope's *Moral Essays,* Epistle 1, to Lord Cobham: "'Tis education forms the common mind: Just as the twig is bent, the tree's inclined." They constitute a before-and-after series in the English tradition stretching back to Hogarth's (q.v.) "Marriage à la Mode" and Augustus Leopold Egg's (1816–1863) mid-century masterpieces *Past and Present* (figs. 25-1–3).

 In Egley's first scene the date is about 1850 when we meet the cast: a dark-haired older sister seated at the desk to the left, her prettier younger sister, a blonde, in the foreground, and a little boy showing off his military costume, strutting in front of them. Both sisters are smitten by the boy, but he shows a preference for the younger girl, who looks up at him adoringly, while the elder child nibbles her pen and furrows her brow in a pet of jealousy. In

FIG. 25-1 Augustus Leopold Egg (1816–1863), *Past and Present, No. 1* (The husband learns of his wife's infidelity), 1858, oil on canvas, 25 x 30″ (63.5 x 76.2 cm.), London, Tate Gallery

FIG. 25-2 Augustus Leopold Egg, *Past and Present, No. 2* (Five years later, the daughters grieve their father's death), 1858, oil on canvas, 25 x 30″ (63.5 x 76.2 cm.), London, Tate Gallery

FIG. 25-3 Augustus Leopold Egg, *Past and Present, No. 3* (The demise of the unfaithful wife), 1858, oil on canvas, 25 x 30″ (63.5 x 76.2 cm.), London, Tate Gallery

the companion, *The Tree's Inclined,* the time is ten years later, the present, about 1860. All three children have grown up—and nothing has changed; the dark-haired sister, now over twenty and a prune, is seen in the convex mirror on the wall fairly gnawing her fan. The source of her vexation, of course, is the fanning of Fanny by her still ardent suitor, now a real soldier, perhaps back from the Crimea. Thus, human nature and human situations remain the same from childhood through adult life.

This, of course, is not Pope's point; and if the quotation seems inappropriate as a title for the illustration of the progress of a Victorian flirtation, then the primary visual reference—which is to Egg's powerful series illustrating the consequences of Victorian marital infidelity, *Past and Present*—is still more disconcerting. Egley has lifted the external formula from Egg's series, trivialized the subject, and turned high tragedy into children's pantomime.

When the pictures were exhibited in 1861, *The Art Journal* complained that the pair constituted "an obtrusive production, rudely outlined, and totally deficient in textural differences." Yet both pictures are wonderfully accurate illustrations of mid-Victorian furnishings and fashions. The restless patterns of the wallpapers, the fabrics, and the carpets, the polished hardness of the furniture, and the obsessive neatness of the children's dress—all evoke the claustrophobic atmosphere of a middle-class Victorian home.

Accuracy was Egley's strong suit. According to his catalogue, he discarded the first version of *Just as the Twig Is Bent* (now called *Military Predilections,* fig. 25-4) when he realized that he had painted the children in fashions of the 1860s, whereas if the companion piece was to show the same children ten years later (that is, in 1860) it was necessary to show them in the first scene in clothes typical of 1850. The artist's description of the pictures in his catalogue is hardly concerned with the narrative element at all, but rather with minute descriptions of the clothing worn by his models, the sisters Selina (dark hair) and Marie Georgiana Bagge[1] (ages twelve and ten respectively). Of the blonde girl, he wrote: "She is dressed in a white muslin frock with excessively full tucked skirt, low bodice, and short sleeves tied with scarlet silk bows, and with a broad sash to match. The skirt barely reaching the knees displays her snow-white stiffly starched trousers trimmed with deep borders of rich needlework, which are so long as to fall across the instep. The feet are dressed in lustrous, white, open-work silk stockings and brilliantly glittering patent leather shoes and sandals." This is not the place to quote his similar, intricate descriptions of the clothing in both pictures—or of the military costumes worn by the boy, posed for by Henry Tristram Dudgeon.

The two paintings were sold to the picture dealer James Law of Manchester, secretary to the Art Union of Great Britain, a national lottery, which offered at a shilling per share the chance for the subscriber to win an original work of art. In 1862 Law offered *Just as the Twig Is Bent, The Tree's Inclined* as first prize of a possible 1,150 prizes, including 300 paintings. The winning ticket was drawn on June 28, 1862, but the winner's name is not known.[2]

FIG. 25-4 William Maw Egley, *Military Predilections*, 1861, oil on canvas, 24 x 18" (61 x 45.7 cm.), Bath, Holburne of Menstrie Museum

1. In *The Tree's Inclined* the younger girl was painted from Lucy Elizabeth Foley.
2. See *The Lynn Advertizer*, June 7, 1862, for the announcement of Egley's pictures as first prize. See also "Art in Scotland and the Provinces," *The Art Journal*, 1862, p. 173, for the Art Union lottery.

PROVENANCE OF NOS. 24 AND 25: Sold by the artist to James G. Law, a picture dealer, 46 Prince's Street, Manchester, for the Art Union of Great Britain, May 14, 1862; Mrs. Robert Frank, London.

EXHIBITIONS FOR NOS. 24 AND 25: Manchester, Royal Institution, 1861, no. 14; London, Crystal Palace, 1862.

LITERATURE FOR NOS. 24 AND 25: "Manchester Royal Institution, Exhibition of Pictures and Sculpture," *The Art Journal*, 1861, p. 367; *The Lynn Advertizer*, June 7, 1862; William Maw Egley, "Catalogue of Pictures . . . ," vol. 1 (1840–67), pp. 184, 188–91, no. 359, 86.BB.1-4 MS. Eng., Library of the Victoria and Albert Museum, London; *Bulletin of the Philadelphia Museum of Art,* vol. 65, no. 304 (July–September 1970), pp. 61, 68, repro. p. 69.

CONDITION NOTES FOR NO. 24: The original support is medium-weight (14 x 14 threads/cm.) linen. Stretcher creases have formed on top, bottom, and left sides. The painting is lined with a wax-resin adhesive and medium-weight linen. A white ground has been thickly and evenly applied and extends onto the tacking margins. The paint is in good condition. Traction crackle is present in scattered areas of the green curtains on each side behind the figures. Fracture crackle radiating from each corner is associated with a slight cupping. Under ultraviolet light, retouching is evident on the two foreground figures, the adjacent background, and the highlight areas of the curtains.

CONDITION NOTES FOR NO. 25: The original support is medium-weight (14 x 14 threads/cm.) linen. The painting is lined with a wax-resin adhesive and medium-weight linen. A white ground has been thickly and evenly applied and extends onto the tacking margins. The paint is in good condition. Minor abrasions are evident in the curtain shadows in the background. Paint and ground have a coarse web of fracture crackle with associated cupping running throughout. Retouching is restricted largely to the area of the female figure and is visible under ultraviolet light.

PREPARATORY SKETCHES FOR NO. 24:
1. William Maw Egley, *Just as the Twig Is Bent*, 1861 (May 2–6), pencil sketch, dimensions and location unknown.
 LITERATURE: William Maw Egley, "Catalogue of Pictures . . . ," vol. 1 (1840–67), p. 190, Library of the Victoria and Albert Museum, London.

2. William Maw Egley, *Just as the Twig Is Bent*, 1861 (May 16–17), oil sketch, 7 x 5¼" (17.8 x 13.3 cm.), location unknown.
 PROVENANCE: Sold by the artist to Thomas Wallis, dealer, January 1, 1874; Mrs. W.A.H. King, 15 Thurloe Square, London, 1940.
 EXHIBITION: London, Wallis's Gallery, 129 Pall Mall.
 LITERATURE: William Maw Egley, "Catalogue of Pictures . . . ," vol. 1 (1840–67), p. 187, no. 353, p. 189, Library of the Victoria and Albert Museum, London (notes that the figure of the younger girl in the sketch is entirely changed in the finished picture).

PREPARATORY SKETCH FOR NO. 25: William Maw Egley, *The Tree's Inclined* (title altered by the artist to "A Little Flirtation"), 1861 (January 28–29), retouched 1900 (July 23), oil on canvas, 7 x 5¼" (17.8 x 13.3 cm.), location unknown.
 LITERATURE: William Maw Egley, "Catalogue of Pictures . . . ," vol. 1 (1840–67), p. 183, no. 349, Library of the Victoria and Albert Museum, London.

RELATED WORK FOR NO. 24: William Maw Egley, *Military Predilections*, 1861 (February 25–April 9), retouched 1862 (February), oil on canvas, 24 x 18" (61 x 45.7 cm.), Bath, Holburne of Menstrie Museum (fig. 25-4).
 EXHIBITIONS: London, Royal Academy, 1861, no. 505; London, Crystal Palace, 1863.
 LITERATURE: William Maw Egley, "Catalogue of Pictures . . . ," vol. 1 (1840–67), pp. 183–85, no. 351, Library of the Victoria and Albert Museum, London.
 PREPARATORY SKETCH: William Maw Egley, *Military Predilections,* 1860 (January 17–20), medium, dimensions, and location unknown.

Born in 1727, the first year of George II's reign, in Sudbury, a village in the flat, empty county of Suffolk, Thomas Gainsborough was the fifth son of a successful wool merchant and shroud manufacturer. His (sometime) friend and first biographer Philip Thicknesse (1719–1792) described Gainsborough's country childhood: "During his *Boy-hood*, though he had no Idea of becoming a Painter then, yet there was not a Picturesque clump of Trees, . . . nor hedge row, stone, or post, at the corner of the Lanes, for some miles round about the place of his nativity, that he had not so perfectly in his *mind's eye*, that had he known he *could use* a pencil, he could have perfectly delineated."[1]

Sent to London at the age of thirteen to lodge at the house of a silversmith, Gainsborough became the pupil or assistant of the French engraver Hubert François Bourguignon, known as Gravelot (1699–1773), who worked in England from 1732 to 1755. As a student of François Boucher (1703–1770), teaching draftsmanship at the St. Martin's Lane Academy, Gravelot was, in part, responsible for the dissemination of the French rococo style in England. Among the lively group of artists who made up the academy in St. Martin's Lane, Gainsborough is particularly associated with the painter of slightly wooden but charming conversation pieces Francis Hayman (1708–1776), although there is no evidence that as a boy he ever actually became Hayman's pupil. By the time Gainsborough set up on his own in a studio in Hatton Garden, Holborn, around 1746, he had picked up from the clique at St. Martin's Lane a bias toward informality, wit, and naturalism in painting, as against the prevailing taste for the staid and aristocratic Palladianism of Lord Burlington and his followers.[2]

To support himself, Gainsborough copied and repaired Dutch landscapes, which, with the rise of a taste for collecting among the middle classes, began in the 1740s to be sold in great numbers both in auction houses and through dealers.[3] We might characterize Gainsborough's first style, which he developed away from London on his return to Sudbury in 1748, as a reworking of Ruisdael (1628/9–1682) and Wynants (c. 1625–1684) in the silvery colors and linear rhythms of the French rococo. Sometimes naturalism and artifice are even developed separately within the same picture, as in his famous *Mr. and Mrs. Andrews* (1748, 27½ x 46¾", London, National Gallery), where a realistic, nearly topographical landscape is set off by the dainty, silly, Haymanesque dolls whose portraits form the picture's subject.

In 1752, with a wife (Margaret Burr, d. 1798), whom he had married in 1746, and two small daughters to support, Gainsborough moved to Ipswich, a seaport ten miles from Sudbury, where a larger population meant more portrait commissions. There he lived for seven years, until October 1759, when he moved again to trawl the yet more abundant waters of Bath.

But long before the move to Bath, he began to alter and develop his style to meet the demands of more sophisticated clients. In landscape this meant turning away from the relative realism of the Sudbury period toward a more fanciful, artificial vision of nature. As John Hayes has pointed out, this may have been a response to the tremendous popularity at this period of Francesco Zuccarelli's (1702–1788) decorative landscape concoctions, on which the provincial artist may have wanted to capitalize.[4] In his portraits Gainsborough began in the 1750s to abandon the small-scale, informal, and slightly old-fashioned conversation piece to experiment with full-length formal portraiture to the scale of life, as, for example, in his *Mrs. Philip Thicknesse* of 1760 (77½ x 53", Cincinnati, Cincinnati Art Museum). The sitter's body is obviously drawn from a wooden doll or lay-figure; but the portrait is carried by the brilliant handling of paint in every inch of her dress. It might have been of this picture as well as of any other that Reynolds (q.v.) was thinking when

in his eulogy to Gainsborough in his Fourteenth Discourse he spoke of "all those odd scratches and marks, which, on a close examination, are so observable in Gainsborough's pictures, and which even to experienced painters appear rather the effect of accident than design; this chaos, this uncouth and shapeless appearance, by a kind of magick, at a certain distance assumes form, and all the parts seem to drop into their proper places."[5]

Behind these changes in style lay a sure sense of what the market required and how the artist could provide it. Mrs. Thicknesse's husband wrote that of all the men he knew, Gainsborough "possessed least of that worldly knowledge, to enable him to make his own way into the notice of the GREAT WORLD";[6] but the fact remains that he did make his way in that world, and with tremendous success, too. For he was actually very willing to adapt himself to the demands of his patrons, and, unlike Reynolds, fully accepted the reality of what the British public was willing to hang on their walls. This he explained to William Jackson of Exeter (1730–1803), the organist of Exeter Cathedral and a friend: "[In my profession] a Man may do great things and starve in a Garret if he does not conquer his Passions and conform to the *Common Eye* in chusing that branch which *they* will encourage & pay for."[7]

The Bath period, from 1759 until his move to London late in 1774, although in some ways one in which Gainsborough made professional compromises in order to attract clients, is nonetheless the time when he painted his most appealing portraits and some of his most ravishing landscapes. His exposure to the Rubenses and Van Dycks in West Country houses (Bowood, Wilton, Longleat) and the romantic, rolling countryside around Bath are partly responsible for an ever more apparent attempt on his part to form his own grand manner in emulation of the classical masters of the seventeenth century, in such pictures as *The Harvest Wagon* (1767, 47½ x 57″, Birmingham, Barber Institute of Fine Arts) and *The Blue Boy* (1770, 70 x 48″, San Marino, California, Henry E. Huntington Library and Art Gallery).[8] Then, too, public competition with Reynolds, in the form of a series of full-length portraits sent to the Society of Artists exhibition every year from 1761 to 1768, kept him aware of developments in the capital in the decade in which Reynolds was virtually inventing the English grand manner. Because he exhibited annually in London and was known to the beau monde who flocked to Bath, Gainsborough became in these years one of the best-known artists in England. When the Royal Academy was established in 1768, he was among the original forty founding members.

We know something about the way Gainsborough worked from two descriptions: one from the miniature-painter Ozias Humphry (1742–1810), who lived with Gainsborough's close friends the Linleys in Bath from 1760 to 1764; the other from his daughter Margaret. According to Humphry "[His portraits]... as well as his landscapes, were frequently wrought by candle-light, and generally with great force and likeness. But his painting room—even by day a kind of darkened twilight—had scarcely any light, and I have seen him, whilst his subjects have been sitting to him, when neither they nor the pictures were scarcely discernible."[9]

He used fine-woven canvas, primed with light gray or yellow paint so that he started a portrait on a smooth surface. By working with "paint so thin and liquid that his palette ran over unless he kept it on the level," as one of his daughters recalled,[10] he allowed the gray or yellow ground to be seen through his surface paints, resulting, as in his *Mary, Countess Howe* (c. 1763–64, 96 x 60″, Kenwood, The Iveagh Bequest), in an effect of *couleur changeant*.

Gainsborough painted with brushes up to several feet long, allowing him to control the brushstrokes with great delicacy and precision. Particularly in

the 1770s, he seems to have attempted to make his oil paints look like the soft, dry strokes of pastels.[11] He also made certain that his pictures were properly framed, and, when he could, saw that they were hung to their best advantage. Thus he offered this advice to David Garrick in 1772: "If you let your Portrait hang up so high, only to consult your Room . . . it never can look without a hardness of Countenance and the Painting flat, it was calculated for breast high and will never have its Effect or likeness otherwise."[12]

The rule at the Royal Academy that full-length canvases should be hung above the line (which in the eighteenth century was above the top of the doorways[13]) meant that Gainsborough's delicate colors and elaborate scumbles (the rubbing of a light and opaque color over a darker one) and glazes (laying a darker color over a lighter) were completely lost to the public; lost, that is, unless he chose to compete with other artists by jazzing up his portraits for the exhibition, then toning them down later. Gainsborough, who preferred in art "the mild Evening gleam and the quiet middle time" to the "Glare and Noise" of exhibition portraits[14] put up with a number of Royal Academy exhibitions, but did not exhibit from 1773 to 1776. He resumed exhibiting in 1777 but ceased altogether after a row with the authorities in the spring of 1784 over the hanging of his portrait group *The Three Eldest Princesses* (originally 100 x 70½", Her Majesty Queen Elizabeth II). To the hanging committee he wrote: "[Mr. Gainsborough] has painted the Picture of the Princesses, in so tender a light, that notwithstanding he approves . . . of the established Line for strong Effects, he cannot possibly consent to have it placed higher than five feet & a half, because the likenesses & Work of the Picture will not be seen any higher."[15]

Still, the committee thwarted him; Gainsborough resigned and for the rest of his life he exhibited in his own studio at Schomberg House, Pall Mall. But if he jumped, it was only after carefully looking around him. After an economically thin period during his last year in Bath and first few years in London (1774–76), he received his first royal commission in 1777. Thereafter he became the court painter in fact although not in title, because Reynolds was Principal Portrait Painter to the king. He had invested in government securities in the 1770s, and his daughters were by then grown, so he was freer after 1777 to consult his own preferences in art and in life.

From the later 1770s Gainsborough began a new period in his career, characterized by experiments not so much in technique as in technology and subject matter. The herald of the change was his work with Benjamin West (1738–1820) and Giovanni Battista Cipriani (1727–1785) on the decoration of Johann Christian Bach's and Karl Friedrich Abel's concert room, which opened on February 1, 1775.[16] Gainsborough's contribution was a *Comic Muse* painted on some kind of transparent material, possibly glass, and lit from behind to illuminate the room. Then, when Philipp de Loutherbourg (1740–1812), the artist and stage designer for Garrick at Drury Lane, unveiled his celebrated Eidophusikon in 1781, an exhibition of moving pictures painted on transparent material and lit from behind, Gainsborough attended performances every evening. In the 1780s he built his own Exhibition Box, a kind of slide viewer with a place for candles and a slot in which to place one of a set of landscapes the artist painted on squares of glass.[17]

Viewing his works thematically, we find Gainsborough's only sea pieces in the 1780s (the most successful seascapes before Turner's [q.v.] in the late 1790s); the first attempt to paint picturesque scenery in his mountain and lakeland landscapes of 1783 (which, in turn, were influential in creating a taste for the picturesque in the next decades); and his only mythological painting (*Diana and Actaeon*, 1784–85, 62¼ x 74", Her Majesty Queen Elizabeth II). In the early 1780s he painted his first "fancy pictures," on which much of his

reputation in the nineteenth century was based.[18] These were sentimentalized portraits of rustics or beggar children in a landscape setting, painted on the scale of life under the influence of Murillo's famous *The Good Shepherd,* a painting that, as Ellis Waterhouse has shown, Gainsborough had copied in 1780.[19] Fancy pictures were something quite new—not only in English painting but in the whole history of art. Neither portraiture, nor genre, nor history, nor religious paintings, and yet a combination of all four, these boys and girls, housemaids and woodsmen, were painted life-sized and with the surface brilliance usually reserved for portraits of duchesses, which moved the viewer by appealing to his emotions—perhaps the first nonreligious and apolitical pictures to attempt this.

In the last decade of his life Gainsborough painted a series of portraits that are among the handful of overwhelming masterpieces in the history of art, comparable to the greatest portraits of Titian or Van Dyck. In *The Morning Walk* (1785, 93 x 70½″, London, National Gallery), a dense, moody, fleeting vision of a young couple (Mr. and Mrs. William Hallet) walking in a park, all the colors and textures of nature seem to merge and yet to remain separate, as though Gainsborough saw and weighed but valued equally light and air, trees and plants, animals, youth, and physical beauty.

Part of this near-mystical vision of life as embodied in the late paintings can be glimpsed throughout his career and explained by his devotion to his art. Sir Joshua Reynolds, searching for words to describe Gainsborough's genius, was reduced to the simple observation that it was "the love which he had to his art; to which, indeed, his whole mind appears to have been devoted...[for] his regret at losing life, was principally the regret of leaving his art."[20]

Gainsborough employed only one studio assistant, his nephew Gainsborough Dupont (1754–1797), whom he apprenticed at seventeen, in 1772. He never employed a drapery painter but finished every part of the canvas himself. That he did so underlines the difference between his attitude toward his art and Reynolds's. To Sir Joshua, the greatest journalist in the history of art, a portrait was a representation of a sitter's face, his station in life, and his politics, though not necessarily in that order. The idea, the theory, of the picture could in many cases be more important than what was actually on the canvas—so the hand that finished the secondary parts was not important. But for Gainsborough, Beauty was paramount, and he approached his canvas first as a poet and then as a craftsman, making of a blank canvas an object of supreme beauty. For Gainsborough, a lover of music and an amateur musician, it was as unthinkable that a lace, a bow, a set of pearls should be finished by another painter as it would be to hire another cellist to play his part in a string quartet.

Gainsborough died of cancer on August 2, 1788, aged sixty-two. His recent biographer John Hayes has called him "one of the most loveable persons who ever lived"; and no one who has looked thoughtfully at his pictures or read his letters will disagree. Indeed, in an essay of this length one can only recommend to the reader those letters, among the most delightful literary productions of the eighteenth century.

1. Thicknesse, 1788, pp. 5–6.
2. Girouard, 1966, "Slaughter's," pp. 58–61.
3. Hayes, 1966, pp. 188–97, esp. p. 190.
4. Nottingham, 1962, introduction.
5. Wark, ed., 1959, pp. 257–58.
6. Thicknesse, 1788, p. 32.
7. Woodall, ed., 1963, no. 58, pp. 117–19.
8. Hayes, 1963, pp. 89–97.
9. Humphry's unpublished autobiographical memoir (Royal Academy, London), quoted by Whitley, 1915, p. 391.
10. Whitley, 1915, p. 247.
11. Possibly to attract the customers who might otherwise patronize Francis Cotes (1726–1770) and Jean Étienne Liotard (1702–1789), who enjoyed considerable popularity working in pastel.
12. Woodall, ed., 1963, no. 34, pp. 75–77.
13. Whitley, 1915, p. 216.
14. Gainsborough to David Garrick, 1772, in Woodall, ed., 1963, no. 34, pp. 75–77.
15. Woodall, ed., 1963, no. 3, p. 29.
16. Whitley, 1915, p. 114.
17. Jonathan Mayne, "Thomas Gainsborough's Exhibition Box," *Victoria and Albert Museum Bulletin,* vol. 1, no. 3 (July 1965), pp. 17–24; Hayes, 1982, vol. 1, pp. 140–41, figs. 171–72.
18. Ellis K. Waterhouse, "Gainsborough's 'Fancy Pictures,'" *The Burlington Magazine,* vol. 88, no. 519 (June 1946), pp. 134–41.
19. Waterhouse, 1958, p. 125. Gainsborough had painted after a copy of Murillo (1617/8–1682) by Jean Grimou (1680–1740), not *The Good Shepherd* in the Lane Collection or the Prado.
20. Wark, ed., 1959, pp. 250, 252 (Fourteenth Discourse).

BIBLIOGRAPHY: Thicknesse, 1788; William Jackson (of Exeter), *The Four Ages Together with Essays on Various Subjects* (London, 1798), pp. 147–61, 179–84; Fulcher, 1856; Cunningham, 1879, vol. 1, pp. 258–81; Armstrong, 1898; Armstrong, 1904; William B. Boulton, *Thomas Gainsborough: His Life, Work, Friends, and Sitters* (London, 1905); Whitley, 1915; Whitley, 1928; Mary Woodall, *Gainsborough's Landscape Drawings* (London, 1939); Ellis K. Waterhouse, "Gainsborough's 'Fancy Pictures,'" *The Burlington Magazine,* vol. 88, no. 519 (June 1946), pp. 134–41; Oliver Millar, *Thomas Gainsborough* (London, 1949); Mary Woodall, *Thomas Gainsborough: His Life and Work* (London and New York, 1949); Waterhouse, 1953, "Gainsborough"; Waterhouse, 1953, pp. 180–91; Waterhouse, 1958; Robert R. Wark, "Thicknesse and Gainsborough: Some New Documents," *The Art Bulletin,* vol. 40 (December 1958), pp. 331–34; Wark, ed., 1959, pp. 247–61 (Fourteenth Discourse); John Hayes, "Gainsborough's Early Landscapes," *Apollo,* n.s., vol. 76 (November 1962), pp. 667–72; Hayes, 1963, pp. 89–97; Woodall, ed., 1963; John Hayes, "Gainsborough's Later Landscapes," *Apollo,* n.s., vol. 80 (July 1964), pp. 20–26; Emilie Buchwald, "Gainsborough's 'Prospect, Animated Prospect,'" in *Studies in Criticism and Aesthetics, 1600–1800, Essays in Honor of Samuel Monk,* ed. Howard Anderson and John S. Shea (Minneapolis, 1967), pp. 358–79; John Hayes, "Gainsborough's 'Richmond Water-Walk,'" *The Burlington Magazine,* vol. 111, no. 790 (January 1969), pp. 28–31; Hayes, 1970; John Hayes, "Gainsborough and the Gaspardesque," *The Burlington Magazine,* vol. 112, no. 806 (May 1970), pp. 308–11; John Hayes, *Gainsborough as Printmaker* (London, 1971); Hayes, 1975; Michael I. Wilson, "Gainsborough, Bath and Music," *Apollo,* n.s., vol. 105 (February 1977), pp. 107–10; Pointon, 1979; Jack Lindsay, *Thomas Gainsborough: His Life and Art* (London, 1981); Hayes, 1982.

EXHIBITIONS: London, Schomberg House, 1814; London, British Institution, 1814; London, Grosvenor Gallery, *Exhibition of the Works of Thomas Gainsborough, R.A.,* 1885; Ipswich, Ipswich Museum, *Bicentenary Memorial Exhibition of Thomas Gainsborough, R.A.,* 1927 (notes by P. M. Turner); Cincinnati, Cincinnati Art Museum, *Exhibition of Paintings and Drawings by Thomas Gainsborough, R.A.,* May 1–May 31, 1931 (preface by Walter H. Siple); London, 45 Park Lane, *Gainsborough Exhibition in Aid of the Royal Northern Hospital,* 1936; London, Arts Council of Great Britain, *Thomas Gainsborough: An Exhibition of Paintings,* 1949 (introduction by Mary Woodall); Bath, Victoria Art Gallery, *An Exhibition of Paintings and Drawings by Thomas Gainsborough, 1727–1788,* 1951 (by Mary Woodall); London, Tate Gallery, *Thomas Gainsborough, 1727–1788: An Exhibition of Paintings Arranged by the Arts Council of Great Britain,* 1953 (by Ellis K. Waterhouse); Nottingham, 1962; London, Kenwood, The Iveagh Bequest, *Gainsborough and His Musical Friends,* 1977 (by Lindsay Stainton); London, 1980–81; Paris, 1981.

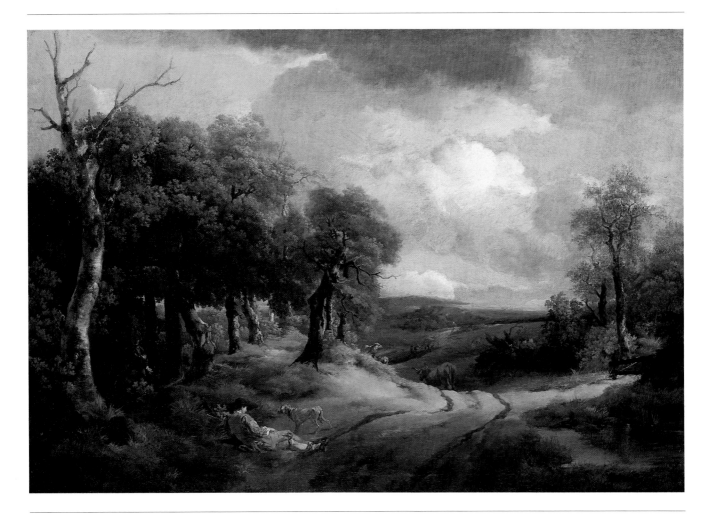

26 THOMAS GAINSBOROUGH

REST BY THE WAY, 1747
Oil on canvas, 40⅛ x 58″ (101.9 x 147.3 cm.)
Inscribed lower left: *Gainsbro:1747*
W. P. Wilstach Collection, W95-1-4

Painted in 1747, *Rest by the Way* is a superb example of Gainsborough's early landscape style and, as one of the few paintings from any period of his career that is signed and dated, is a linchpin for evaluating the artist's early development. The composition appears to be artless but is actually quite complex, although the elements themselves are simple: a dark wood of beech trees at the left; a pool of water opposite; a rutted path sloping downhill in the center and winding away into the distance in the background at the right; the whole scene permeated with the feel of a day in early spring, soon after a shower of rain, when the light in the blue sky is made fitful by swiftly scudding clouds.

But these components are arranged with the precision of an architect's plans. In each of the picture's receding planes, Gainsborough has placed figures and animals, thus providing a scale with which the viewer can measure the distance his eye travels. The abrupt transitions from plane to plane are softened by the device of placing those animals—the back of the ox disappearing, the sheep grazing—just at the point where the eye has to jump from a foreground plane to one beyond it. The balance of the picture is preserved not by placing masses of equal volume against each other but by contrasting mass and darkness against emptiness and light and dividing these two distinct areas by the winding road in which the ox serves as a kind of fulcrum in the center.

FIG. 26-1 Thomas Gainsborough, *River Scene with Figures and a Dog Barking at a Swallow*, 1746–47, oil on canvas, 30 x 59½" (76.2 x 151 cm.), Edinburgh, National Gallery of Scotland

Rest by the Way is organized on Dutch seventeenth-century principles of landscape design, and it would be possible to point to any number of works by Jacob van Ruisdael (1628/9–1682) or Nicolaes Berchem (1620–1683) that its composition resembles;[1] but the soft roll of the terrain, the feathery clouds, the way in which clear gray light dapples the scene, and the delicate, silvery grays and greens in which the picture is painted, all look to the Continental rococo style. Within Gainsborough's oeuvre, we can compare this painting to the *River Scene with Figures and a Dog Barking at a Swallow* (fig. 26-1), in which the exquisitely painted figures bend and posture with all the bravura of figures by Francesco Guardi (1712–1793).

There is also a subject in *Rest by the Way*—or perhaps it is more accurate to say a nonsubject. A traveler has stopped to rest by the side of a road on a spring day, still holding his dog by a leash in his right hand and a staff in his left. His pose, reclining on the ground with legs crossed, once again recalls any number of such figures in Dutch pictures. Behind him another man emerges from a wood, his left hand clutching something we cannot make out—a walking stick or, more sinister, the hilt of a sword; his right hand reaching into his breast pocket for something we cannot see—a pinch of snuff...or a pistol. Disconcertingly, this second man, whose distinct physiognomy suggests a portrait, stares not at the traveler but straight out at us, as if to acknowledge that since the party of travelers we can see disappearing into the far distance has passed beyond earshot, we, the spectators, are the only witnesses to what is about (or not about) to happen; we, that is, and the traveler's faithful dog, who has also seen the intruder, and who has bristled, turned, and will in one moment break the stillness with a warning bark. In a split second our traveler will turn, but what will happen next Gainsborough does not tell us. Will the stranger in the wood turn out to be a harmless poacher? Or is he a highwayman intent upon robbing or killing the unarmed traveler? In terms of Gainsborough's own art, the narrative here seems to be unique. And not only unique, but contrary to his stated views on the function of the human figure in landscape, written to William Jackson on August 23, 1767: "Do you really think that a regular Composition in the Landskip way should ever be fill'd with History, or any figures but such as fill a place (I won't say stop a Gap) or to create a little business for the Eye to be drawn from the Trees in order to return to them with more glee."[2]

Hayes points out that x-radiographs of this painting reveal a building with a gabled roof originally behind the trees to the right, but otherwise there are no pentimenti.[3]

1. Particularly Ruisdael's *Forest* (67⅜ x 76⅛", Paris, Louvre, on deposit at Douai, Musée de la Chartreuse). See John Hayes's discussion in the catalogue of the Gainsborough exhibition held at the Tate Gallery (London, 1980–81, no. 80).

2. Woodall, ed., 1963, no. 49, p. 99.

3. Hayes, 1982, vol. 2, no. 22, fig. 22b.

PROVENANCE: Frederick Perkins; George Perkins; his sale, Christie's, June 14, 1890, lot 51, bt. Charles Fairfax Murray; bt. the Pennsylvania Museum of Art (Philadelphia Museum of Art) for the W. P. Wilstach Collection, November 16, 1895.

EXHIBITIONS: London, 1980–81, no. 80; Philadelphia, Philadelphia Museum of Art, *One Hundred Years of Acquisitions,* May 7–July 3, 1983.

LITERATURE: Fulcher, 1856, p. 208; Wilstach, 1897, no. 187; Wilstach, 1900, no. 60, repro. opp. p. 48; Wilstach, 1906, no. 112, repro.; Wilstach, 1922, p. 51, no. 124, repro. opp. p. 52; Waterhouse, 1958, pp. 12, 107, no. 831, pl. 23 (as "Road through a Wood with a Boy Resting and Dog"); Nottingham, 1962, pp. 671–72, fig. 5; Elizabeth Ripley, *Gainsborough* (London, 1964), repro. p. 9; Giuseppe Gatt, *Gainsborough* (London, 1968), p. 18, pls. 2–3; Hayes, 1970, pp. 133–34; Staley, 1974, p. 36; John Ingamells, "Gainsborough at the Tate Gallery," *The Burlington Magazine,* vol. 122, no. 932 (November 1980), pp. 779–80, fig. 91; Jack Lindsay, *Thomas Gainsborough: His Life and Art* (London, 1981), p. 22; Hayes, 1982, vol. 1, pp. 46, 48–51, 65, pls. 58, 60 (details), vol. 2, pp. 312, 324, 349–50, no. 22, figs. 22, 22a (detail), 22b (x-radiograph detail).

CONDITION NOTES: The original support is medium-weight (12 x 12 threads/cm.) linen. The tacking margins have been removed. The painting has an aged lining with an aqueous adhesive and medium-weight support. A white ground is evident through the thinnest areas of paint and along the cut edges. The paint is in very good condition. The profile relief varies from moderate to low and has been well preserved, along with the original brush marking. Minor, local abrasion is present in the largest tree on the right. Patches of narrow-aperture traction crackle are present throughout the blue areas of the sky. Viewing with low-powered magnification confirms indications with infrared reflectography that the greenery of the tree clump at the left extended higher at one time. Similarly, x-radiographs suggest a gabled roof line existed at one time behind the trees at the right. Under ultraviolet light, retouching is seen to be restricted to small losses throughout the sky, in the foliage, and along the edges.

ENGRAVING: Charles Courtry (1846–1897) after Thomas Gainsborough, *Rest by the Way,* second half of the nineteenth century, etching. Published: A. Salmon and Ardail, Paris.

27 THOMAS GAINSBOROUGH

*LANDSCAPE WITH RUSTIC LOVERS, TWO COWS, AND A MAN
ON A DISTANT BRIDGE,* c. 1755–59
Oil on canvas, 25¼ x 30″ (64.1 x 76.2 cm.)
Gift of Mr. and Mrs. Wharton Sinkler, 64-103-1

Landscape with Rustic Lovers is one of a pair of landscapes said by Fulcher to
have been painted for Gainsborough's old associate at the St. Martin's Lane
Academy, Francis Hayman (1708–1776). Its pendant, *Wooded Landscape with
Peasants in a Country Wagon* (fig. 27-1), shows rustics seated in a horse-drawn
cart on a winding road, with a distant church spire and, to the right, a
milkmaid and cattle on a hillock.[1] Both are fantasy landscapes, but in the
Philadelphia picture the feathery trees, rushing stream, ruined castle, and hazy
mountains—even the overall blue tonality—belong to a tradition of pastoral
imagery popular in France in the paintings of Watteau (1684–1721) and
Boucher (1703–1770) and beginning to become fashionable in England in the
landscapes of Zuccarelli (1702–1788). Populating this ethereal world are a pair
of lovers lazing away the afternoon under the shade of a tree, two cows
grazing nearby, and a man leaning on the railings of a distant bridge. We
might be in countryside painted by Fragonard (1732–1806) were it not for
the split trunk of a fallen tree in the foreground to remind us that all things

FIG. 27-1 Thomas Gainsborough, *Wooded Landscape with Peasants in a Country Wagon*, c. 1756–57, oil on canvas, 25 x 30" (63.5 x 76.2 cm.), Newcastle, Australia, private collection

pass away, and, more prosaically, that Gainsborough had arrived at this style after an earlier, prolonged study of landscapes of the seventeenth-century Dutch school.

Waterhouse (1958, p. 109) dated *Rustic Lovers* and its pendant to 1755–59. Hayes (1982, vol. 2, nos. 68, 79), while agreeing with Waterhouse on the dating of its companion (c. 1756–57), assigned a date to the *Rustic Lovers* of 1762–63: that is, to the early Bath period. To this author's eye, the styles of both the pendant and the Philadelphia work seem compatible with a date in the later 1750s. The *Peasants in a Country Wagon* has about it a naturalism absent from the *Rustic Lovers*, but could not the contrast in the treatment of the countryside in the two landscapes have been intentional? Hayes sees *Rustic Lovers* as a "lyrical masterpiece," but surely this is an exaggeration. For all its apparent lightness, here one feels that Gainsborough was not as comfortable with the rococo style in landscape as he was with his figures. Unlike, for example, the foliage in the famous *Mountainous Wooded Landscape with Horse Drinking* (57½ x 62", Worcester, Massachusetts, Worcester Art Museum; Hayes, 1982, vol. 2, no. 80), which Hayes dated to c. 1763, the trees and foliage in *Rustic Lovers* are painstakingly worked over, so that the picture lacks, on the one hand, the freshness of the style of the early or mid-1750s, or, on the other, the lyricism Gainsborough so fully absorbed in the 1760s at Bath in response to the classical landscapes of the seventeenth century by Rubens (1577–1640) or Gaspard Dughet (1615–1675) seen in West Country houses. I would argue that *Rustic Lovers* is a more transitional picture than Hayes allowed and endorse dating to the late 1750s.

1. Hayes, 1982, vol. 2, no. 68, repro. p. 405.

PROVENANCE: Francis Hayman?, who is said to have commissioned the picture; John Heywood, 1814; John Heywood Hawkins, 1844; C.H.T. Hawkins; Christie's, May 11, 1896, lot 12, bt. Colnaghi; Henry Joseph Pfungst, 1898, his sale, Christie's, June 15, 1917, lot 88, bt. A. Wertheimer; D. H. Farr, Philadelphia, 1928; Mr. and Mrs. Wharton Sinkler.

EXHIBITIONS: London, British Institution, 1814, no. 66; London, British Institution, 1844, no. 158 or 163; London, British Institution, 1859, no. 155; Leeds, *National Exhibition of Works of Art*, 1868, no. 1,031; Glasgow, Glasgow Art Gallery, *Loan Exhibition of Pictures of French and British Artists of the Eighteenth Century*, 1902, no. 90; London, 1980–81, no. 109; Paris, 1981, no. 40.

LITERATURE: Fulcher, 1856, pp. 174, 207; Roberts, 1897, vol. 2, p. 276; Armstrong, 1898, p. 207, pl. XXV opp. p. 100; Arthur B. Chamberlain, *Thomas Gainsborough* (London and New York, 1903), pp. 158–60, repro. p. 59; Armstrong, 1904, p. 288; Waterhouse, 1958, p. 109, no. 856, pl. 54; Hayes, 1982, vol. 1, pp. 35, 120, 271, vol. 2, pp. 417–19, no. 79, fig. 79.

CONDITION NOTES: The original support is lightweight (18 x 18 threads/cm.) linen. The painting is lined with an aged aqueous adhesive and medium-weight linen. An off-white ground has been thickly and evenly applied and extends partially onto the tacking margins. The ground is also visible through the thinnest areas of paint. The paint is in good condition. Much of the original brushwork and the moderate to low relief of the paint profile have been retained. Paint consistency varies from thick, direct applications of a paste-vehicular mixture to thin washes of a rich-vehicular medium. A fine web of fracture crackle with slight, associated cupping is present overall and is most obvious in the sky area. Local areas of traction crackle are evident in the foreground foliage and extend into the lower portions of the sky. Under ultraviolet light, retouching is seen to be restricted to losses along the tacking folds.

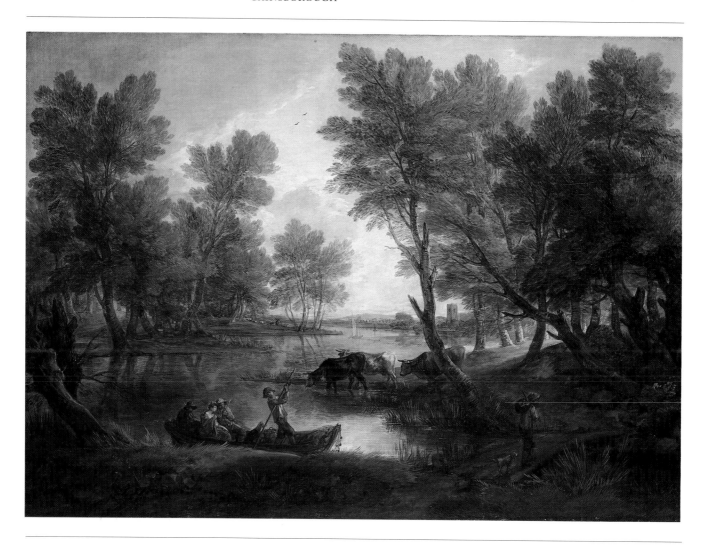

28 THOMAS GAINSBOROUGH

VIEW NEAR KING'S BROMLEY-ON-TRENT, STAFFORDSHIRE, 1768–70
Oil on canvas, 47 x 66⅛″ (119.4 x 168.1 cm.)
The William L. Elkins Collection, E24-3-6

Hayes (1963) discussed this river scene in terms of Gainsborough's response in
the later 1760s to Rubens's (1577–1640) mature landscapes, comparing it to the
Flemish artist's panoramic *Park of a Castle* (c. 1631, oil on panel, 20½ x 38¼″,
Vienna, Kunsthistorisches Museum). His long analysis of the complex
composition emphasizes the movement laterally across the picture: "The eye is
led from the foreground tree stumps on the left through the main subject of
the picnic-party to the rustic crossing over the bridge, and back again in a
further plane through the diagonals of the tree trunks on the right and the
group of cattle drinking. There is a tremendous sense of recession in the
landscape, and the eye is finally lost in the sketchily painted background,
where dragged white brushstrokes envelope the distance in a kind of haze."[1]
Hayes connected this composition with a landscape by Lucas van Leyden
(1489/94–1533) at Stourhead, Wiltshire (fig. 28-1), which was well known in the
eighteenth century.

 This criticism accords well with the traditional view that Gainsborough's
later landscapes are entirely imaginary—a view stemming from Gainsborough
himself, who, in a letter to Lord Hardwicke of c. 1764, gracefully declined a
commission to paint a view of Lord Hardwicke's country seat with these
words: "But with respect to *real Views* from Nature in this Country he has
never seen any Place that affords a Subject equal to the poorest imitations of
Gaspar or Claude. Paul Sandby [q.v.] is the only Man of Genius, he believes,

who has employ'd his Pencil that way." [2] Yet, as Hayes and Pointon (1979) have written elsewhere, Gainsborough certainly sketched from nature, and his close friend William Jackson wrote that "he never chose to paint anything from invention, when he could have the objects themselves." [3]

This is indeed a sophisticated exercise in Flemish and Dutch landscape composition. But it is more. Since its sale at Christie's in 1894, this painting has been called "View near King's Bromley, on Trent, Staffordshire." And a visit to the village of King's Bromley confirms that Gainsborough has painted a view of the tower of All Saints Church as it appears from the river bank at a distance of about one half mile along the south bank, upstream. Since then the shoreline has changed somewhat, and the trees, of course, have disappeared, while others—birches, alders, and cedars—far more numerous, have replaced them; but the square tower of All Saints, set back about two hundred yards from the river, is easily recognizable, except that it is now crowned by four Victorian gothic pinnacles, added in 1870.

Any doubts that this is a real view vanish on examination of the provenance of the picture. It belonged to John Newton-Lane, a descendant of Samuel Newton, who owned the manor King's Bromley in the eighteenth century. The spot from which Gainsborough stood to see All Saints in this position is in the north terrace of the manor park. That the terrain has not changed much in the last one hundred years is evident from a description of the manor park in a local history: "The park...extends to the banks of the Trent, and formerly used to contain deer....The Trent pursues its winding course on the north side of the house, the river walk leading from the north terrace along well-wooded grounds, which in summer present a most picturesque appearance. The river Trent, now, as in olden time, affords ample sport." [4] In the eighteenth century (but no longer) this was a popular place for pike and salmon fishing, and it is still used for bathing.

This is not to say that Gainsborough has painted a straightforward topographical view. The footbridge, if it ever existed, is no longer there, and may well have been included in homage to a similar motif in Rubens's *Park of a Castle*. The sailing ships in the distance are fictive, because the Trent at this point is too narrow and shallow to permit the sport. Then, too, the pleasure party in the fishing boat is presumably an arcadian touch, removing the scene from the particular and giving it a timeless, old masterish tone. Waterhouse may have hit the nail on the head when he referred to these figures as having a "slightly rarified quality of beauty, a sort of less modish Watteau quality," [5] for the mood of the picture is one of gentle melancholy, recalling Gainsborough's remarks to the artist and actor Prince Hoare (1775–1834) criticizing Reynolds's (q.v.) Fourth Discourse, in which he recommended that Sir Joshua "come *down to Watteau* at once (who was a very fine Painter taking away the french conceit)." [6] What emerges from this identification of the scene is that Gainsborough's achievement in transforming a very pretty local scene into a timeless, arcadian dream is able to stand comparison with Rubens and Watteau (1684–1721).

On a more mundane level, this also presupposes that Gainsborough visited Staffordshire, which has not hitherto been recorded. We do know that in the late 1760s Gainsborough was writing to his attorney, James Unwin, whose family lived in nearby Derbyshire. Unfortunately, we know nothing about the person who presumably commissioned the picture, Samuel Newton (d. 1771). The obvious supposition, that Gainsborough was invited to the manor at King's Bromley to paint members of the Newton family, is not tenable, as no portraits have come down to us. Until we have more information about Gainsborough's movements and patrons in these years, the mystery must remain unsolved.

FIG. 28-1 Lucas van Leyden (1489/94–1533), *Landscape*, oil on panel, 21 x 34″ (53.3 x 86.4 cm.), Wiltshire, Stourhead

1. Hayes, 1963, p. 92.

2. Woodall, ed., 1963, no. 42, pp. 87–91. But Pointon (1979, p. 444) remarks that despite this disavowal, Gainsborough spent much of his time during his Suffolk years (at least) painting "real views from Nature." See Emilie Buchwald, "Gainsborough's 'Prospect, Animated Prospect,'" in *Studies in Criticism and Aesthetics, 1660–1800, Essays in Honor of Samuel Holt Monk,* ed. Howard Anderson and John S. Shea (Minneapolis, 1967), p. 367.

3. John Hayes, "Gainsborough and the Gaspardesque," *The Burlington Magazine,* vol. 112, no. 806 (May 1970), p. 308. See William Jackson, *The Four Ages* (London, 1798), pp. 167–68.

4. Alfred Williams, *Sketches in and around Litchfield and Rugeley, Comprising a Descriptive and Historical Account of All the Towns and Villages in the District, Together with the Principal County Seats. As Well as of All the Churches in the Locality* (Litchfield and Rugeley, 1892), p. 179.

5. Waterhouse, 1958, p. 30.

6. Woodall, ed., 1963, no. 46, p. 95.

PROVENANCE: Samuel Newton (d. 1771); by descent to John Newton Lane; bt. from him by William Delafield, 1854; his sale, Christie's, April 30, 1870, lot 88, bt. Agnew for Richard Hemming; his sale, Christie's, April 28, 1894, lot 82, bt. Agnew; William L. Elkins, 1894.

EXHIBITIONS: London, British Institution, 1854, no. 146; Philadelphia, 1928, p. 17; Worcester, Massachusetts, Worcester Art Museum, *Condition: Excellent, A Special Exhibition of Paintings Notable for Their State of Preservation,* March 22–April 22, 1951, no. 14; Ottawa, National Gallery of Canada, *British Painting in the Eighteenth Century,* 1957–58, no. 16, repro. p. 107; London, Royal Academy, *Bicentenary Exhibition,* 1968–69, no. 144.

LITERATURE: J. P. Neale, *Views of the Seats of Noblemen and Gentlemen,* 2nd series (London, 1828), vol. 4, unpaginated; *Jones's Views of the Seats, Mansions, Castles, etc. of Noblemen and Gentlemen* (London, 1829), vol. 2, unpaginated; Fulcher, 1856, p. 208; Elkins, 1887–1900, vol. 2, no. 62, repro.; Roberts, 1897, vol. 2, pp. 226–27; Armstrong, 1898, p. 205; Armstrong, 1904, p. 284; A. E. Fletcher, *Thomas Gainsborough R.A.* (London, 1904), p. 220; Elkins, 1925, no. 19; Waterhouse, 1958, pp. 30, 117, no. 945, pl. 122; Hayes, 1963, p. 92, fig. 7, p. 94; Hayes, 1970, p. 168; Herrmann, 1973, p. 97, pl. 90; Staley, 1974, p. 36, repro. p. 36; Hayes, 1975, p. 213, no. 63, pl. 74; Paulson, 1975, p. 247; Ellis K. Waterhouse, *The Dictionary of British 18th Century Painters in Oils and Crayons* (Woodbridge, Suffolk, 1981), repro. p. 138; Hayes, 1982, vol. 1, pp. 96, 110, 112, 120, 123 n. 37, 238, vol. 2, pp. 437–38, no. 94, fig. 94.

CONDITION NOTES: The original support is medium-weight (14 x 14 threads/cm.) linen. The painting is lined with an aged aqueous adhesive and medium-weight linen. A light-brown ground is present and extends unevenly onto the tacking margins. The paint is in excellent condition. Considerable brush marking and low paint profile have been preserved. Local areas of very fine irregular web traction crackle exist in the darkest sections of the background foliage. Under ultraviolet light, only minimal retouching is evident, generally in the area of the sky to the left.

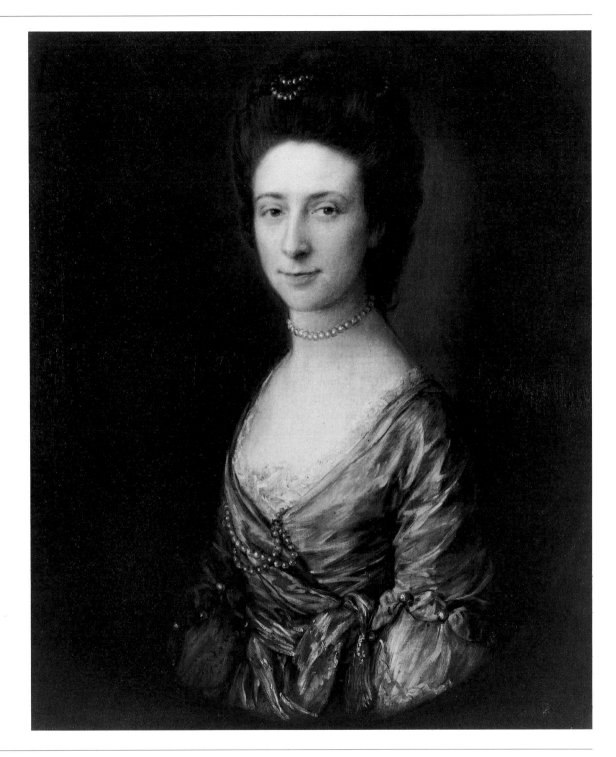

29 THOMAS GAINSBOROUGH

MRS. CLEMENT TUDWAY, 1773
Oil on canvas, 30⅛ x 25⅛″ (76.5 x 64 cm.)
The George W. Elkins Collection, E24-4-12

On June 7, 1762, Elizabeth Hill (1739–1828), younger daughter of Sir Rowland
Hill, married Clement Tudway (1734–1815), Member of Parliament for Wells in
the county of Somerset, bringing him a dowry of six thousand pounds.[1] In his
twenty-nine years in Parliament, from 1761 to 1790, Clement Tudway
consistently voted independently, although during that time he was called to
speak only once before the house, in 1773. In his own time, he was called "The
Father of the House of Commons";[2] a full political biography of him appears
in *The History of Parliament, The House of Commons, 1754–90*.[3] In addition to

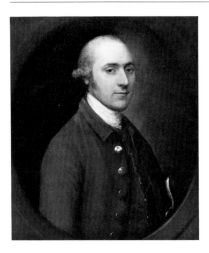

FIG. 29-1 Thomas Gainsborough, *Clement Tudway*, 1773, oil on canvas, 30¼ x 25¼" (77 x 64.1 cm.), Raleigh, North Carolina Museum of Art

his political activities, he managed the family's extensive sugar plantations in Antigua, as well as their many properties in and around Wells.

According to the *Sherbourne, Dorchester and Taunton Journal* of February 21, 1828, Mrs. Tudway died on February 13 of that year. She was buried on February 22 in St. Cuthbert's Wells. The few papers of hers that survive show her to have been a modest, gentle, and religious woman, who was devoted to her husband. In one letter to her nephew John Paine Tudway (1775–1835), dated May 11, 1821, she wrote that "at the time of my beloved Husband's decease I was so overwhelmed with grief and consequent illness, that I was unable to attend to any worldly matters. I never was anxious for great abundance, and my dear husband knew my retired disposition—not ambitious of entering into high style of life, much less so now."[4]

In her will she asked that her coffin be borne by six of her laborers and made bequests to her housekeeper, waiting woman, gardener, footman, housemaid, dairymaid, and coachman. She directed that her body be buried "without parade or unnecessary expense." Charities that benefited from her one-hundred-pound bequests were the British and Foreign Bible Society and the Church Missionary Society. In 1821 she had endowed a charity in St. Cuthbert's Wells for poor lying-in women who were not obtaining relief from any other source.[5]

Mrs. Tudway's portrait forms a pair with her husband's, which is today in the North Carolina Museum of Art, Raleigh (fig. 29-1). In the mid-1760s Gainsborough had painted Clement's father, Charles (1713–1774), and mother, Hannah Tudway, in full-length portraits, today in the Courtauld Institute Galleries, London, and the Baltimore Museum of Art (each 89 x 60½").

Until now, the exact date of Gainsborough's portraits of Mr. and Mrs. Clement Tudway has been given only as "late Bath period." In the Somerset Record Office, however, among Clement Tudway's bills is a receipt from Gainsborough for the two works: "Bath July 2[d]. 1773 / Rev.[d] of Clem: Tudway Esq. the sum of / seventy Pounds sixteen Shillings, in full for / two ¾ Portraits (Viz. Himself & Mrs. Tudway) / and two Frames Burnish'd Gold, / Case & ec.–/ Thos Gainsborough / £70: 16."[6]

In the Philadelphia picture, a feigned oval, Mrs. Tudway is about thirty-three years old; a plain woman, with a long nose and a sweet, shy smile, she is dressed in a blue dress with pearls at her breast, throat, and in her unpowdered hair.

1. Tudway MS., DD/SAS/SE3, Somerset Record Office, Taunton.
2. *The Gentleman's Magazine*, vol. 85 (1815), p. 184.
3. Edited by Sir Lewis Namier and John Brooke (London and New York, 1964), vol. 3, p. 566.
4. Tudway MS., DD/TD/44/6.
5. Ibid.
6. Ibid., DD/TD/2/72–74.

PROVENANCE: Clement Tudway; his nephew John Paine Tudway; R. C. Tudway (d. 1855); Charles Clement Tudway, who sold it c. 1909; Scott and Fowles, New York; George W. Elkins.

LITERATURE: Elkins, 1925, no. 16; Elkins, 1935, p. 9; Benson, 1937, p. 20, repro. p. 20; Waterhouse, 1958, p. 93, no. 679.

CONDITION NOTES: The original support is medium-weight (20 x 20 threads/cm.) linen. The tacking margins have been removed. Weave cusping on both sides and along the bottom of the support suggests that very little of the original support is missing. The painting is lined with twill-weave, medium-weight linen and a fairly recent aqueous glue adhesive. An off-white ground is evident along the cut edges as well as through the thinnest applications of paint. The paint is in good condition. Original brush marking and moderate to low relief of the paint profile are well preserved. A fine, irregular web of fracture crackle is present overall, along with a small stress crack related to an old stretcher-member crease along the top edge. Minor abrasion is present in the mid-tones of the figure's face and dress. Under ultraviolet light, retouching can be seen along the tacking folds and over two large spots, one at the proper right sleeve and the other to the left of the face, in the background.

RELATED WORK: Thomas Gainsborough, *Clement Tudway*, 1773, oil on canvas, 30¼ x 25¼" (77 x 64.1 cm.), Raleigh, North Carolina Museum of Art (fig. 29-1).
PROVENANCE: Charles Clement Tudway; Mrs. Lillian Emerson Boscowitz, New York; gift of Mrs. Boscowitz to the museum, 1960.
LITERATURE: Waterhouse, 1958, p. 93, no. 678; Raleigh, North Carolina Museum of Art, *Catalogue of Paintings, Vol. II: British Paintings to 1900* (Raleigh, 1969), no. 74, repro. p. 21.

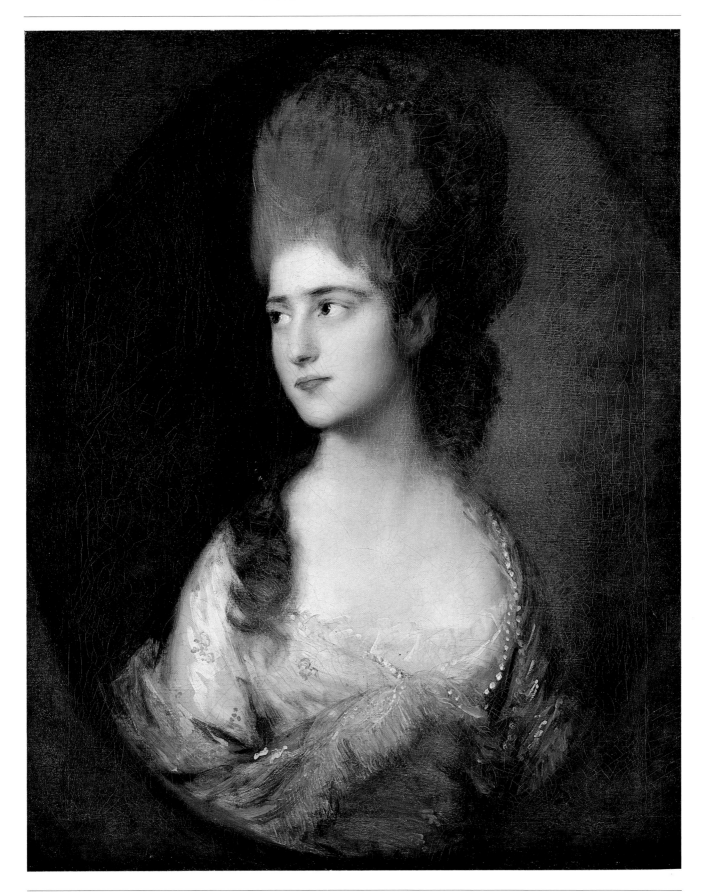

80 THOMAS GAINSBOROUGH

MISS ELIZABETH LINLEY, AFTERWARDS MRS. RICHARD BRINSLEY SHERIDAN, c. 1775
Oil on canvas, 30 x 25″ (76.2 x 63.5 cm.)
The George W. Elkins Collection, E24-4-13

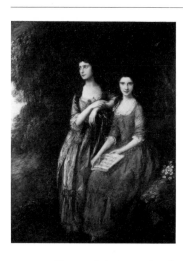

FIG. 30-1 Thomas Gainsborough, *Elizabeth and Mary Linley*, 1772, oil on canvas, 77¾ x 60" (197.5 x 152.4 cm.), London, Dulwich College Picture Gallery

"She is really beautiful; her complexion a clear, lovely, animated brown, with a blooming colour on her cheeks; her nose, that most elegant of shapes, Grecian; fine luxurious, easy-sitting hair, a charming forehead, pretty mouth, and most bewitching eyes. With all this her carriage is modest and unassuming, and her countenance indicates diffidence, and a strong desire of pleasing,—a desire in which she can never be disappointed."[1] So Fanny Burney described the sitter in this portrait in her diary for April 1773. That Fanny should have been curious to meet the beautiful Mrs. Sheridan is not hard to understand: she was meeting not only the most celebrated English soprano of the decade but a woman who, in her private life, had staged one of the most romantic elopements of the eighteenth century with a man who was to become famous both as a playwright and as a politician, Richard Brinsley Sheridan (1751–1816).

Elizabeth Linley (Betsy to her parents, Eliza to her friends) was born in Bath on September 7, 1754, the eldest of the surviving children of Thomas Linley (1732–1795), concert master at the Bath Assembly Rooms and, after 1774, manager (and later co-owner) of the Drury Lane Theatre in London. Like all her brothers and sisters, Eliza was naturally musical; others played instruments and composed under their father's instruction; she was trained as a vocalist. By the age of twelve, in 1766, she had begun to perform at Bath. The following year she and her younger brother Tom (1756–1778), a prodigy who was to become a close friend of Mozart in Florence, made their singing debut at Covent Garden in "The Fairy Favour," a masque performed by children for the four-year-old Prince of Wales on his first visit to the theater. Thereafter, her father refused to allow her to sing in the opera, preferring to have her make her reputation in the more respectable world of concerts and oratorios.[2]

But Eliza was formed for the world, and no amount of protection from her father could keep the world away. In 1770 she met Sheridan, the penniless son of an Irish actor and theater manager. Eventually, after a courtship enlivened by her betrothal to the man of her father's choice, a duel fought between Sheridan and his rival, Eliza's flight to a convent in Lille, Sheridan's pursuit, and their secret (and invalid) marriage at Calais in the spring of 1772, they were married in St. Marylebone's Church on April 13, 1773.

In the month of her marriage she sang for George III and his family at Buckingham House, after which the king told her father that he "never in his life heard so fine a voice as his daughter's,"[3] and Horace Walpole, who was present at another royal concert, observed that the king ogled Miss Linley "as much as he dares to do in so holy a place as an oratorio, and at so devout a service as Alexander's Feast."[4] That April, Fanny Burney observed that London "has rung of no other name this month. . . . The applause and admiration she has met with, can only be compared to what is given Mr. Garrick. The whole town seems distracted about her. Every other diversion is forsaken. Miss Linley alone engrosses all eyes, ears, hearts."[5]

After their marriage, Sheridan refused to permit his wife to sing in public, although he did arrange private soirees at which she was the star attraction. According to the *Morning Post* for February 4, 1774, Sheridan took a house in Orchard Street off Oxford Street, "where he purposes . . . to give concerts twice a week to the Nobility."[6] And, again according to Fanny, "the highest circles of society were attracted to them by the talents, beauty and fashion of Mrs. Sheridan. Entrance to them was sought not only by all the votaries of taste and admirers of musical excellence, but by the leaders of the *ton* and their followers and slaves."[7]

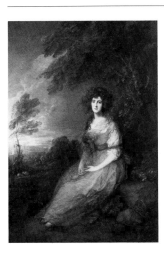

FIG. 30-2 Thomas Gainsborough, *Mrs. Richard Brinsley Sheridan*, c. 1785–86, oil on canvas, 86½ x 60½″ (220 x 154 cm.), Washington, D.C., National Gallery of Art, Andrew W. Mellon Collection

There are many contemporary descriptions of the quality of Eliza's voice, but none more eloquent than that of Gainsborough's friend William Jackson: "Her voice . . . was remarkably sweet and her scale just and perfect. . . . Her genius and sense gave a consequence to her performance which no fool with the voice of an angel could ever attain; and to these qualifications was added the most beautiful person, expressive of the soul within. As a singer she is perished for ever, as a woman she still exists in a picture painted by Gainsborough."[8]

Within a few years of Eliza's triumphant debut in London, her husband had become the best-known playwright in England. In January 1775 his comedy *The Rivals* opened, followed in 1776 by *The Duenna,* and in May 1777 by *The School for Scandal.* Sheridan was a member of the literary circle that met at the Turk's Head in Gerrard Street, and included Dr. Johnson (1709–1784), Garrick (1717–1779), and Sir Joshua Reynolds (q.v.). His eloquence made him the brightest light in the Devonshire House set (the Whig opposition to the policies of William Pitt and the king). There are hints early on that Eliza was not at home in these literary and political circles. James Northcote tells a story of the time Eliza and her husband were invited to dine at Sir Joshua Reynolds's house and the artist suggested that she sing for his guests after supper. When she declined, an angry Sir Joshua asked Northcote: "What reason could they think I had to invite them to dinner, unless it was to hear her sing, for she cannot talk?"[9] In 1775 Eliza gave birth to a son, Tom (d. 1817), but even by then her marriage to Sheridan had begun to deteriorate. Eliza endured with patience his long affair with the Duchess of Devonshire's sister Harriet, Lady Duncannon. But then, in 1790, Eliza fell in love with a much younger man, Lord Edward Fitzgerald (1763–1798). By him she bore one child on March 30, 1792. She did not long survive her confinement, dying of tuberculosis, after a reconciliation with Sheridan, on June 28, 1792.[10]

Although she was painted several times by other artists, notably Reynolds in his *Saint Cecilia* (exhibited R.A. 1775, no. 232, 56¼ x 45½″, Waddesdon Manor, National Trust) and as the Madonna in his *Nativity* window for New College, Oxford (1779), Eliza Linley is as much associated with Gainsborough's portraits of her as Lady Hamilton is with Romney's (q.v.) of her. Gainsborough must have known Eliza as a child at Bath, for the artist's circle of friends always included composers and musicians. In his biography of Gainsborough, Thicknesse tells a story that conveys the spontaneity of Gainsborough's enchantment with the young Eliza in the first years of her professional career: "After returning from the Concert at Bath, near twenty years ago, where we had been charmed by Miss Linley's voice, I went home to supper with my friend, who sent his servant for a bit of clay from the small beer barrel, with which he first modelled, and then coloured her head, and that too in a quarter of an hour, in such a manner that I protest it appeared to me even superior to his paintings!"[11]

The clay bust has disappeared, but a portrait he began in 1768 showing Eliza and her brother Tom still survives (28 x 25″, Williamstown, Massachusetts, Sterling and Francine Clark Art Institute).[12] Thereafter he painted her several times, both before and after her marriage—most spectacularly in two full-length portraits, one of 1772 at Dulwich College Picture Gallery (fig. 30-1), the other from c. 1785–86 in the National Gallery of Art in Washington, D.C. (fig. 30-2). In the earlier picture she stands to the left of her sister Mary (1758–1787), later the first wife of Richard Tickell (see no. 97), who is seated by her side; the turn of Eliza's head, her glance, even the arrangement of her hair (although it is unpowdered and "dressed") is so close

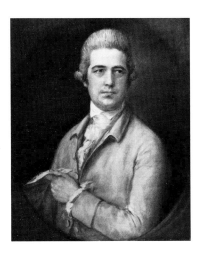

FIG. 30-3 Thomas Gainsborough, *Thomas Linley, Sr.,* 1760s, oil on canvas, 30⅛ x 25″ (76.5 x 63.5 cm.), London, Dulwich College Picture Gallery

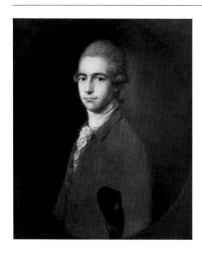

FIG. 30-4 Thomas Gainsborough, *Thomas Linley, Jr.,* c. 1773–74, oil on canvas, 29⅞ x 25″ (75.9 x 63.5 cm.), London, Dulwich College Picture Gallery

to the Philadelphia portrait that the latter could be called simply a variation on the head in the Dulwich picture, though we should date the Philadelphia portrait after the Dulwich full length, to c. 1775, when Eliza, age twenty-one, was newly married and at the height of her fame and beauty. Here sophistication is mingled with innocence, and even slightly with insipidity—perhaps unavoidable in a girl so young and so pretty. In the light of the subsequent history of her life, the Washington, D.C., portrait makes an interesting comparison to the earlier pictures. In it she is a mature woman, touched by melancholy, composed: a woman who has had a life and a destiny. Although the picture may have been begun earlier, its style is that of the eighties, all vibrating lights and fleeting shadow, her hair windblown—nature defined in terms of light and dark, cloud and shadow, forest and open space. It is as though in the Dulwich and Philadelphia portraits the sitter has not yet been touched by life, and this accounts, in part, for the steady, cool light enveloping and revealing Eliza while keeping her slightly removed from contact with the viewer.

The size and feigned oval format of the Philadelphia painting match two portraits by Gainsborough at Dulwich, one of her father, Thomas Linley, dated by Waterhouse to the late 1760s (fig. 30-3), and the other of her brother Thomas, Jr., of about 1773–74 (fig. 30-4). It is possible that Gainsborough began a series of family portraits, starting with the most musical Linleys, but that this project was never completed. We know nothing of the history of the Philadelphia picture before 1883; hence the supposition is impossible to prove.

1. Annie Raine Ellis, ed., *The Early Diary of Frances Burney, 1768–1778* (London, 1889), vol. 1, p. 203.
2. For Eliza, see Margot Bor and Lamond Clelland, *Still the Lark: A Biography of Elizabeth Linley* (London, 1962); Kenwood, 1977, no. 6.
3. For Thomas Linley, Sr., see R. F[arquharson] S[harp], *Dictionary of National Biography,* s.v. "Linley, Thomas, the Elder."
4. Horace Walpole, *Letters Addressed to the Countess of Ossory from the Year 1769 to 1797* (London, 1848), vol. 1, p. 56 (March 16, 1773).
5. Clementina Black, *The Linley's of Bath* (London, 1971; 1st ed. 1911; rev. ed. 1926), p. 94; Ellis, ed. (see note 1), vol. 1, pp. 199–202.
6. Bor and Clelland (see note 2), p. 74.
7. Ibid.
8. Quoted by Whitley, 1915, p. 201.
9. Northcote, 1818, pt. 2, p. 85.
10. For the Sheridan marriage see William Le Fanu, ed., *Betsy Sheridan's Journal* (London, 1960). For her love affair with Fitzgerald, see Bor and Clelland (note 2), pp. 154–56.
11. Thicknesse, 1788, p. 39.
12. Waterhouse, 1958, p. 103, no. 801 (as "A Beggar Boy and Girl").

PROVENANCE: George Mowser, Worthing, Sussex, by 1883; his daughter; anon. [Miss Mowser] sale, Christie's, May 23, 1903, lot 64; bt. Charles J. Wertheimer; Scott and Fowles, New York; William L. Elkins, after 1908.

EXHIBITIONS: London, Burlington House, 1907, no. 91; Berlin, Königliche Akademie der Künste, *Ausstellung aelterer englischer Kunst,* January 26–February 23, 1908, no. 49.

LITERATURE: Ronald Sutherland Gower, *Thomas Gainsborough* (London, 1903), pp. 114, 126, repro. between pp. 62–63; Armstrong, 1904, p. 272; A. E. Fletcher, *Thomas Gainsborough, R.A.* (London, 1904), p. 200, repro. opp. p. 168; "Pictures of 1908," *Pall Mall Magazine Extra,* special issue (1908), repro. within William Orpen's portrait of Charles Wertheimer, p. 69; James Grieg and Mortimer Mempes, *Gainsborough* (London, 1909), pp. 97, 176; M. H. Spielmann, *British Portrait Painting* (London, 1910), p. 90; Whitley, 1915, pp. 202–3; Elkins, 1925, no. 17; Siple, 1928, p. 255; Hinks and Royde-Smith, 1930, pp. 170–71; Elkins, 1935, p. 9, repro. (cover); "Memorials in the Museum," *The Philadelphia Museum Bulletin,* vol. 34, no. 182 (May 1939), repro. p. 15; *The Philadelphia Museum Bulletin,* vol. 37, no. 193 (March 1942), repro. p. 30; Waterhouse, 1953, "Gainsborough," p. 69; Waterhouse, 1958, p. 79, no. 449.

CONDITION NOTES: The original support is single-thread (20 x 20 threads/cm.) linen. The tacking margins have been removed. A small puncture has occurred in the middle of the figure's chest. The painting is lined with an aged aqueous adhesive and medium-weight linen over a previous aqueous lining. A white ground has been thickly applied. The paint is in poor condition. Abrasion has occurred throughout much of the background and in the figure's hair and bodice. Much of the original paint profile has been flattened by lining. Under ultraviolet light, retouching coincident with the abraded areas described above can be seen.

ENGRAVING: After Thomas Gainsborough, *Miss Elizabeth Linley,* after 1903, line engraving, ¾″ (1.9 cm.) diam.

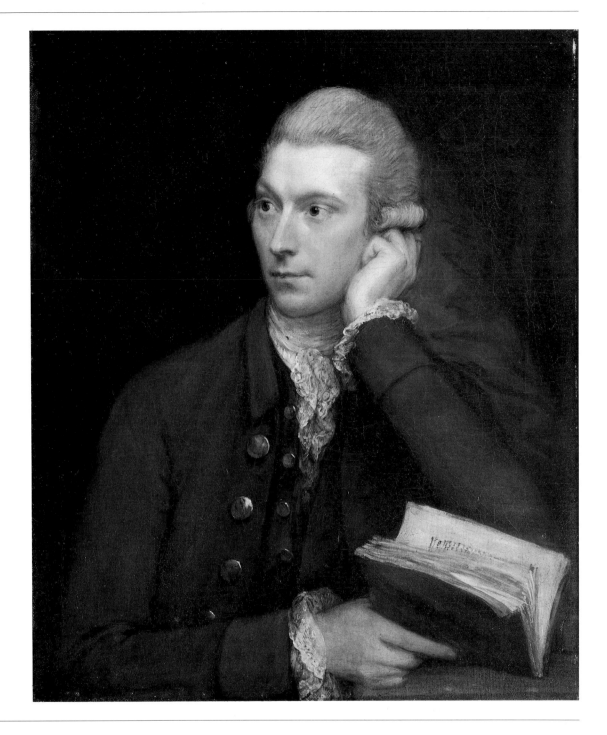

31 THOMAS GAINSBOROUGH

JOHN PALMER, C. 1775
Oil on canvas, 30 x 25⅛″ (76.2 x 63.8 cm.)
The William L. Elkins Collection, E24-3-28

John Palmer (1742–1818) is remembered in the history of the English stage as the manager of the Bath Theatre in Orchard Street, which, under him, attracted the greatest stars of the eighteenth-century stage. Among the performers who first appeared there were John Henderson (1747–1785), Mrs. Siddons (1755–1831), and Mrs. Abington (1737–1815). Palmer persuaded King George III to grant letters patent to his theater, making it the Theatre Royal, Bath—the first provincial theater to be so honored, and a distinction it shared only with Covent Garden and Drury Lane.[1] But this was only the first phase in his remarkable career. In his work for the theater, traveling up and down

the country in search of actors, Palmer hit upon a simple but brilliant idea for improving communications between English cities. Through his invention he revolutionized the English mails.

Before Palmer, the mail was carried in a one-horse diligence, or "machine." If this arrived at all (robbery of the mails was common) it was slow, taking two days to complete the journey between London and Bath. By suggesting that the mail be carried in a coach drawn by two horses, which were to be changed every six miles, he proposed to increase the speed of the mails to eight or nine miles an hour, thus cutting the London/Bath route to sixteen hours. Palmer's coaches were to carry no passengers outside the coach and to be protected by shotgun-carrying guards whose presence would dampen any attempt to interfere with their progress. The coach was to leave London punctually at 8:00 in the evening—not between 12:00 and 3:00 A.M. as before—and was not permitted to wait for government letters when these happened to be late.[2]

In October 1782, Pitt's government agreed to try Palmer's plan, and on Monday, August 2, 1784, the first mail coach left London for Bath. Within a few years, London was united to York, Chester, Glasgow, and Liverpool by an efficient mail system, and by 1788, 320 towns that formerly had received the post three times a week had it daily—an improvement that, if not quite akin to the invention of the telephone, was of vast importance for every aspect of English life, as it allowed the provinces to keep up with political and commercial developments in the capital. So awesome was the reputation of Palmer's improved mail coaches, that, as an old man Lord Chancellor Campbell (1779–1861) recalled that in his youth travelers were warned to make their wills before departure as "instances were offered . . . of passengers who had died suddenly of apoplexy from rapidity of motion."[3]

Palmer well knew the value of his invention. As a result of its success he was appointed comptroller general of the Post Office, in which capacity he proceeded to reorganize that department of the government. By oral agreement he was to have received for life 2½ percent of the increased revenue of the Post Office, and on this commitment the government reneged. Not surprisingly, Palmer created a furor, and found himself dismissed from office. Eventually, in 1808, he won his claim for recompense, but by this time he had distinguished himself in yet another career. He was twice elected mayor of Bath (in 1796 and 1809) and was returned as Member of Parliament for that city four times (in 1801, 1802, 1806, and 1807). He died in Brighton in 1818.[4]

Palmer himself is a fascinating figure. Born into an old Bath family, he was educated for the church at Marlborough Grammar School but instead entered the countinghouse of his father's brewery, before devoting himself to the theatrical side of the family business. A hot-headed enthusiast, a man of great enterprise, perseverance, and physical endurance, he was a close friend of Gainsborough. The Philadelphia portrait shows him about age thirty-three, while he was still living and working in Bath, and before he became involved in the reform of the mails. Gainsborough's portrait suggests an intelligent and thoughtful man, showing Palmer looking up from a book held in his right hand. With his left hand propped at his cheek, he turns to his right, an expression of keen intelligence on his face. He is dressed in a green coat against a red background.

1. Belville S. Penley, *The Bath Stage* (London, 1892), pp. 33–37; R. E. Peach, *Historic Houses in Bath and Their Associations* (London and Bath, 1884), pp. 115–19.

2. Herbert Joyce, *The History of the Post Office, from Its Establishment Down to 1836* (London, 1893), pp. 208–80.

3. Jerom Murch, *Biographical Sketches of Bath Celebrities Ancient and Modern* (London and Bath, 1893), p. 112.

4. Ibid., pp. 113-14.

INSCRIPTION: *HILL/LINER/BATH* [impressed into the stretcher].

PROVENANCE: Edmund Palmer, the sitter's son; his son Col. Palmer; Christie's, July 18, 1874, lot 56, bt. Agnew; James Price; his sale, Christie's, June 15, 1895, lot 74, bt. Agnew; William L. Elkins.

EXHIBITION: Philadelphia, 1928, p. 17.

LITERATURE: George Scharf, annotated sales catalogue, Christie's, July 18, 1874, p. 3, lot 56, National Portrait Gallery Library, London (contains a pencil drawing of the portrait); Elkins, 1887–1900, vol. 2, p. 61, repro.; Jerom Murch, *Biographical Sketches of Bath Celebrities Ancient and Modern* (London and Bath, 1893), p. 116; Mrs. Arthur Bell [N. D'Anvers], *Thomas Gainsborough: A Record of His Life and Works* (London, 1897), repro. between pp. 104–5; Roberts, 1897, vol. 2, p. 256; G[eorge] A[therton] A[itkin], *Dictionary of National Biography,* s.v. "Palmer, John"; Armstrong, 1898, p. 200; Armstrong, 1904, p. 275 (mistakenly cited as John G. Johnson Collection, Philadelphia); Elkins, 1925, no. 18; Waterhouse, 1953, "Gainsborough," p. 82; Waterhouse, 1958, p. 84, no. 533.

CONDITION NOTES: The original support is medium-weight (12 x 12 threads/cm.) linen. The tacking margins have been removed. Weave cusping is evident in the support along all four edges. The painting is lined with an aged aqueous adhesive and medium-weight linen. There is a small, repaired puncture in the original and lining fabrics at the right of the sitter's mouth. A white ground is evident along the cut edges. The paint is in very good condition. Considerable brush marking remains overall. The oil paint mixture is rich vehicular in consistency and its profile is low in relief. A wide irregular net of fracture crackle is present. Under ultraviolet light, only minor retouching is evident in local areas of loss and in the small puncture noted above.

32 THOMAS GAINSBOROUGH

LADY RODNEY, c. 1781–82
Oil on canvas, 50¼ x 39⅞" (127.6 x 101.5 cm.)
John H. McFadden Collection, M28-1-8

Roberts (1917), following *The Athenaeum* of February 22, 1890, and Christie's catalogue of June 3, 1893, identified the sitter in this portrait as Henrietta Lady Rodney (c. 1739–1829), wife of the naval hero Admiral Sir George Brydges Rodney, Lord Rodney (c. 1719–1793). In fact, however, as Waterhouse (1958) has shown, she is Anne, second of the five daughters of Rt. Hon. Thomas Harley (1730–1804), alderman of the city of London, lord mayor of London in 1768, and brother of the Earl of Oxford. She was born on May 13, 1758, and died in 1840. On April 10, 1781, she married Lord Rodney's eldest son, George (1753–1802), at which time her father presented her with a great house, Berrington, in Herefordshire (National Trust). Her husband, a captain of a company in the third regiment of foot guards, a lieutenant colonel in the army, and a Member of Parliament for Northampton, succeeded to the title on the death of his father in 1793. They had eleven sons and one daughter.[1]

That George and Anne should have married was the dearest wish of their fathers. Admiral Rodney wrote to his son George on September 26, 1780, from the frigate *Sandwich* off New York: "When you see Mr. Harley who is very [near?close?] acquaintance remember me to him, and my dear Geo. if your heart is touched by either of his daughters indulge the flame she is of a great and noble family."[2] George took the hint and set to work at once. On February 12, 1781, again from the *Sandwich,* moored off Saint Eustatius in the West Indies, Rodney wrote to his wife: "My son has acquainted me with his attachment, and Mr. Harley has written me a very flattering letter upon the occasion. You may be sure I will do every thing in my power to make him happy";[3] and two days later, on February 14, he wrote to George that he would be sending back a convoy from the West Indies with spoils amounting to one million pounds, and concluded: "My love attends your intended consort that every happiness may attend you is the sincerest prayer of him who will ever prove himself, my dear Geo. Your most affection[ate] friend and father."[4] Then, on October 12, 1781, Rodney wrote (perhaps a bit too effusively) to Thomas Harley: "My dear Sir, Nothing could have given me greater pleasure than the letter you honour'd me with, I have not a doubt but my son will prove himself such a son in law, as your great partiality for him can desire; I shall always look upon myself as highly Honour'd by the noble alliance and will do everything in my power towards the making my son and Miss Harley happy. There is nothing that can be pointed out but I shall be ready at a moments warning to comply with. My sons happiness is nearer my heart than anything in this life, his happiness will greatly contribute to mine, his virtue and affection demands all my attention and he shall have it. . . . I dispatch with all the haste possible to England, a letter of attorney to empower him to receive the pension H[is] M[ajesty] has so graciously bestowed upon my family."[5]

This is one of a pair of portraits commissioned by Alderman Harley of two of his daughters. The pendant shows the eldest daughter, Martha (1757–1788), who on November 30, 1779, married George Drummond of Stanmore (d. 1789), a senior partner of Drummonds's Bank (fig. 32-1). Both sisters are dressed in modified Van Dyck costume: identical low-cut blue silk gowns with white muslin sleeves, edged with gold and trimmed at the bust and waist with pearls. Both sisters wear their hair in powder. But there are important differences as well. Anne is shown standing with the train of her dress held with her right arm to her waist, while in her left she draws a gauze scarf to her bosom, a pose reminiscent of a portrait now attributed to the

FIG. 32-1 Thomas Gainsborough, *Martha Harley (Mrs. George Drummond),* oil on canvas, 49½ x 39½" (125.7 x 100.3 cm.), South Africa, Natalie Labia Collection

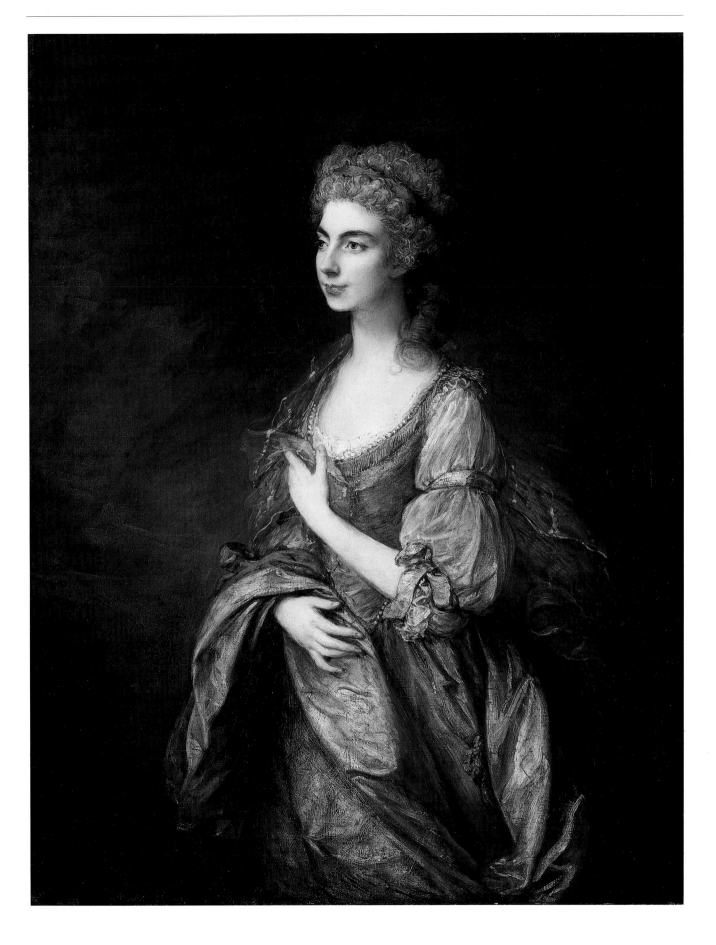

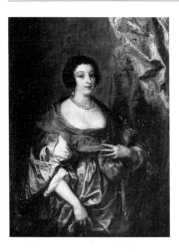

FIG. 32-2 Studio of Anthony Van Dyck (1599–1641), *Lady Penelope Naunton,* oil on canvas, 45⅝ x 35⅝″ (116 x 90.6 cm.), London, Dulwich Picture Gallery

studio of Van Dyck, *Lady Penelope Naunton* (fig. 32-2). Her sister Martha is seated, looking out at us, a drawing in her right hand, sketchbooks, a pen, and fragments of sculpture at her side, to reveal that she had her artistic side.

Waterhouse dated both portraits to 1779/80, at the time of Martha's marriage, but this may be several years too early. It is possible, although unprovable, that the picture of Anne was commissioned about the time of her marriage to George Rodney on April 10, 1781, the traditional time for young women to sit in the eighteenth century. If so, Anne's gesture and pose may also help us to date the portrait more precisely. The first of her many children, George, was born on June 18, 1782, so she became pregnant in September 1781. If we assume that she was enceinte while sitting to Gainsborough, her otherwise meaningless, slightly stiff gestures become significant and graceful. She rests her right hand on her belly, while her left hand touches her breast, a motion by which she gently and subtly alludes to her condition, while at the same time cleverly concealing with the train of her gown her burgeoning waist. Roberts (1917) called attention to her "dreamy eyes" and "enigmatical smile," which he interpreted as manifestations of an exotic sensuality, but which may instead reveal contentment at her approaching motherhood.

Alderman Harley commissioned a third family picture from Gainsborough, a full-length portrait of his daughter's new father-in-law, his friend Admiral Lord Rodney (90 x 58″, Dalmeny, Lord Rosebery Collection). Waterhouse dated it to 1783–86, and, in any case, it must have been after the admiral's return from his victory at the Battle of Dominica in the West Indies on April 12, 1782.[6]

1. Sir Egerton Brydges, ed., *Collins's Peerage of England* (London, 1812), vol. 7, p. 568.
2. Quoted in a letter from Christopher Harley to the author, January 8, 1980.
3. Godfrey Basil Mundy, *The Life and Correspondence of the Late Admiral Lord Rodney* (London, 1830), vol. 2, p. 26.
4. Quoted in a letter from Christopher Harley to the author, January 8, 1980.
5. Ibid.
6. Waterhouse, 1958, p. 87, no. 583.

PROVENANCE: Commissioned by the sitter's father, Alderman Harley; by descent to the sitter's son, George, 3rd Baron Rodney, Berrington, Herefordshire; bt. Rt. Hon. Lord Revelstoke, c. 1880; his sale, Christie's, June 3, 1893, lot 41, bt. Agnew; bt. John H. McFadden, June 5, 1893.

EXHIBITIONS: London, Royal Academy, *Exhibition of Old Masters,* 1890, no. 156; London, Thomas Agnew and Sons, *Twenty Masterpieces of the English School,* November–December 1897, no. 5; New York, 1917, no. 9, fig. 9; Pittsburgh, 1917, no. 8; Philadelphia, 1928, p. 21, repro. p. 18.

LITERATURE: "Fine Arts," *The Athenaeum,* no. 3252 (February 22, 1890), p. 249; Roberts, 1897, vol. 2, p. 213; Armstrong, 1898, p. 201; Armstrong, 1904, p. 278; Roberts, 1913, p. 539; Roberts, 1917, pp. vi, 17, repro. opp. p. 17 (as "Henrietta Lady Rodney"); McFadden, 1917, repro. p. 109; Roberts, 1918, "Portraits," pp. 125, 128, repro. p. 127; Siple, 1928, p. 255, repro. p. 246; *The Philadelphia Museum Bulletin,* vol. 37, no. 193 (March 1942), repro. p. 28; Waterhouse, 1958, p. 87, no. 584; Staley, 1974, p. 35, repro. p. 34.

CONDITION NOTES: The original support is medium-weight (20 x 20 threads/cm.) linen. The tacking margins have been removed. The painting is lined with an aged aqueous adhesive and medium-weight linen. A small puncture near the proper left arm has been repaired with a local patch, which is evident on the reverse of the lining. A white ground has been evenly and thickly applied and can be seen along the cut edges. The paint is in good condition overall. Much of the original profile has been retained along with considerable brush marking. The dark brown of the background is cracked with bitumenlike traction crackle of extemely wide aperture along the right side. Under ultraviolet light, retouching can be seen primarily in the areas of traction crackle and along the edges of the cut-off tacking margins.

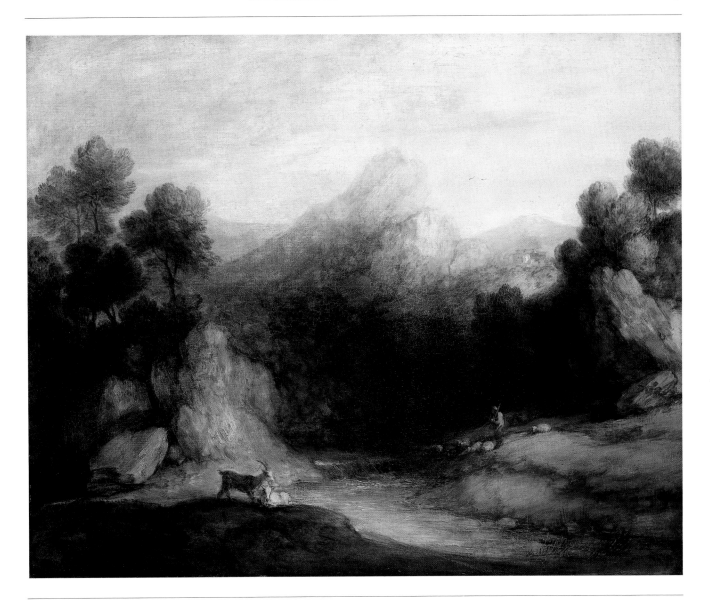

33 THOMAS GAINSBOROUGH

A PASTORAL LANDSCAPE (ROCKY MOUNTAIN VALLEY
WITH SHEPHERD, SHEEP, AND GOATS), c. 1783
Oil on canvas, 40⅜ x 50⅜" (102.5 x 127.9 cm.)
John H. McFadden Collection, M28-1-9

Both Waterhouse and Woodall have pointed out that the "Rocky Landscape"
exhibited at the Royal Academy in 1783 (no. 34) could be either of two
pictures: this painting or a landscape formerly in the collection of the Duke of
Sutherland and now in the National Gallery of Scotland (fig. 33-1). In both,
the artist depicts a wild mountainous landscape with sheep and shepherds; a
mountain stream running from left to right diagonally through the scene; and,
incongruously, an Italianate hill town, rising up in the middle distance.

Two contemporary descriptions of the picture exhibited in 1783 only
partially resolve the problem. Horace Walpole, in his notes on the Royal
Academy for that year, remarked that the mountain landscape was "too
green,"[1] and that in it, sheep were approaching the water to drink. This would
seem at first glance to refer to the Philadelphia picture. Here, the shepherd
actually stands by the sheep as they drink from the stream, whereas in the
Edinburgh picture the sheep are nowhere near the water or their shepherd.
Then, too, the Philadelphia picture's overall tonality is a yellowish-green,
although its colors are now far from fresh. It is hard to understand how

FIG. 33-1 Thomas Gainsborough, *Rocky Wooded Landscape with Dell and Weir*, 1783, oil on canvas, 45¾ x 56½" (116.2 x 143.5 cm.), Edinburgh, National Gallery of Scotland

Walpole could have called the vivid blue-purple tonality of the Edinburgh landscape green. On the other hand, Bate-Dudley's review of the academy exhibition for April 30, 1783, in the *Morning Herald,* quoted by Whitley, seems to refer unmistakably to the Edinburgh picture: "A precipice is the principal object in the foreground, with several figures, sheep, &c., descending to a rivulet that gushes through a cranny in the earth."[2] While the foreground of the Philadelphia picture could conceivably be called a precipice, the word is far more appropriate for the Edinburgh landscape, as is the description of the stream gushing forth from a cranny in the earth. But what finally indicates that it was probably the Edinburgh picture that was exhibited at the Royal Academy in 1783 is the use of the phrase "several figures," for there are three in that picture, whereas the Philadelphia landscape has only one.

In 1783 Gainsborough wrote to his friend William Pearce (1751–1842), chief clerk of the Admiralty, describing a trip he was about to undertake with his friend the Ipswich attorney Samuel Kilderbee to the Lake Country, "to show you that your Grays and Dr. Brownes were tawdry fan-Painters. I purpose to mount all the Lakes at the next Exhibition, in the great stile."[3] By Gray and Brown, he was referring to the poet Thomas Gray's (1716–1771) journal of a visit to the Lakes in 1769, published in 1775,[4] and Dr. John Brown, vicar of Newcastle, who published *A Description of the Lake at Keswick . . . in Cumberland* in 1771 extolling the beauties of the Lake Country.[5] Brown's publication played a part in arousing interest in the Lake District at just the time when William Gilpin (1724–1804) was formulating his theory of the picturesque. Gilpin was born in Cumberland, and as a result of his travels throughout Britain in the 1760s and 1770s formed a theory in which he defined a category of aesthetic appreciation in landscape that was neither the beautiful nor the sublime.[6] For a landscape to be picturesque, it should be rough, irregular, with varieties of texture and color. A landscape that lacked these qualities—say, the flat countryside around Sudbury and Ipswich—might be beautiful, but it was not picturesque. Gilpin's *Essay on Picturesque Beauty* was not published until 1792, although it had been written sixteen years earlier; and it is unlikely that Gainsborough, who was far from being an intellectual or literary man, would have read the book. Yet his comments to Paine about the works of Brown and Gray show that he was acquainted with these theories, which were certainly discussed by his friends. The rocky mountain series of the 1780s is but the expression in paint of the changing response to English scenery, for only at the end of the century is English landscape appreciated with the same reverence the mid-century Englishman reserved for the Roman Campagna.

There is no way to know whether the Philadelphia landscape either preceded or followed the trip to Cumberland in 1783, although if the trip was undertaken in the spring or summer (when the Lake District is usually visited), the Edinburgh picture, exhibited at the academy in the spring, was, paradoxically, painted before that visit. It is thus possible that the Philadelphia picture, as well as other mountain landscapes from this time, such as the *Rocky Mountain Scene* painted on glass for Gainsborough's Exhibition Box (c. 1781–82, transparency on glass, 11 x 13¼", London, Victoria and Albert Museum), were all composed in Gainsborough's imagination. To explain this anomaly, we must turn to two contemporary descriptions of Gainsborough's method of composition. The first is by Reynolds (q.v.) and occurs in his Fourteenth Discourse: "From the fields he brought into his painting-room, stumps of trees, weeds, and animals of various kinds; and designed them, not from memory, but immediately from the objects. He even framed a kind of model of landskips, on his table; composed of broken stones, dried herbs, and pieces of looking glass, which he magnified and improved into rocks, trees, and water."[7] Then there is the reminiscence of an "Amateur of Painting,"

quoted by Whitley, who "more than once sat by him of an evening and [saw] him make models—or rather thoughts—for landscape scenery on a little old-fashioned folding oak table...[on which] he would place cork or coal for his foregrounds; make middle grounds of sand and clay, bushes of mosses and lichens, and set up distant woods of broccoli."[8]

As John Hayes has pointed out, Gainsborough was not really sensitive to mountain scenery[9] and there is little of the sense of awe, scale, horror, or immensity felt by Brown in the mountain series. Indeed, their beauty lies in the unnatural perfection of their compositions, the strange and delicate colors, which somehow convey a sense of the gloomy, moisture-laden atmosphere of mountainous terrain. One critic who might be expected to have appreciated these direct precursors to Turner's (q.v.) landscapes is John Ruskin (1812–1900). In the first volume of *Modern Painters* he wrote about another Gainsborough landscape, *A Romantic Landscape with Sheep at a Fountain* (c. 1783, 60½ x 73½", London, Royal Academy).[10] Worth quoting here because it might have been written about the Philadelphia picture, it says eloquently both what is remarkable about these mountain landscapes and where they fail.

Nothing can be more attractively luminous or aërial than the distance of the Gainsborough, nothing more bold or inventive than the forms of its crags and the diffusion of the broad distant light upon them, where a vulgar artist would have thrown them into dark contrast. But it will be found that the light of the distance is brought out by a violent exaggeration of the gloom in the valley; that the forms of the green trees which bear the chief light are careless and ineffective; that the markings of the crags are equally hasty; and that no object in the foreground has realization enough to enable the eye to rest upon it.[11]

1. Quoted in Whitley, 1928, vol. 2, p. 382.
2. Whitley, 1915, p. 204.
3. Woodall, ed., 1963, no. 64, p. 125.
4. Thomas Gray, *The Poems of Mr. Gray to Which Are Prefixed Memoirs of His Life and Writings by W. Mason* (York, 1775).
5. John Brown, *A Description of the Lake at Keswick (and the Adjacent Country) in Cumberland Communicated in a Letter to a Friend by a Late Popular Writer* (Kendal, 1771).
6. Barbier, 1963, pp. 98–108.
7. Wark, ed., 1959, p. 250.
8. Quoted by Whitley, 1915, p. 369.
9. John Hayes, "Gainsborough's Later Landscapes," *Apollo*, n.s., vol. 80 (July 1964), p. 23.
10. Hayes, 1982, vol. 2, p. 503, no. 138 (as "Rocky Wooded Landscape with Shepherd, Figure and Dog, Goat and Sheep at a Fountain, and Distant Village and Mountains").
11. Ruskin, 1903–12, vol. 3, p. 190.

INSCRIPTION *Fleedham / Liner* [inscribed on the stretcher].

PROVENANCE: Charles Frederick Huth of Oakhurst, Tunbridge Wells; his sale, Christie's, March 19, 1904, lot 53, bt. Agnew; bt. John H. McFadden, November 7, 1904.

EXHIBITIONS: London, Agnew, 1904, no. 10; New York, The Metropolitan Museum of Art, *Portraits and Landscapes of the British School Lent by John H. McFadden*, June–October 1907, no. 8, repro.; New York, 1917, no. 8, fig. 8; Pittsburgh, 1917, no. 9.

LITERATURE: A. E. Fletcher, *Thomas Gainsborough, R.A.* (London, 1904), p. 221; Roberts, 1917, p. 19, repro. opp. p. 19; Philadelphia, 1928, p. 20; Hinks and Royde-Smith, 1930, pp. 155–56?; Waterhouse, 1958, pp. 31, 119, no. 968, pl. 258; Woodall, ed., 1963, p. 28; Giuseppe Gatt, *Gainsborough* (London, 1968), p. 38, pls. 62–63; Paulson, 1975, pl. 154; Staley, 1974, p. 36; Hayes, 1982, vol. 1, p. 140, vol. 2, p. 511, no. 143, p. 510 fig. 143.

CONDITION NOTES: The original support is medium-weight (8 x 8 threads/cm.) linen. The tacking margins have been removed. The painting was lined with a wax-resin adhesive and medium-weight linen in 1968 and a previous aqueous adhesive lining was retained. The old discolored varnish and retouchings were not removed. A white ground is visible along the cut edges and in the traction crackle in the paint film. The paint is in generally good condition. A wide-aperture traction crackle appears to be associated with the dark brown tones of the foliage. Considerable brush marking is evident. A moderate relief of the paint profile is present and appears to be flattened by lining at its highest points. Under ultraviolet light, retouching is evident along the cut-off edges, over small losses in the sky, and within the apertures of the traction crackle.

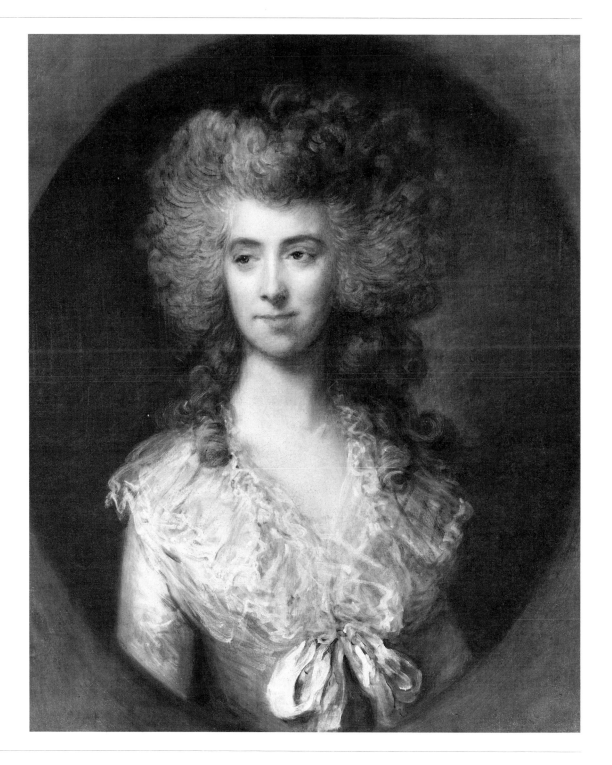

34 THOMAS GAINSBOROUGH

PORTRAIT OF A LADY IN A BLUE DRESS, c. 1783–85
Oil on canvas, 30¼ x 25″ (76.8 x 63.5 cm.)
Bequest of George D. Widener, 72-50-1

This painting came to the Museum in 1972 as a portrait by Thomas
Gainsborough of the 1780s; and on the basis of a photograph, both Ellis
Waterhouse and John Hayes have accepted the attribution. Neither the
identity of the sitter nor the provenance of the portrait is known.

 The pose, format, dress, and style of the Philadelphia picture could be
compared to a portrait of *Mrs. Thomas Samuel Joliffe* in the Cleveland Museum
of Art (fig. 34-1). The Cleveland picture is attibuted not to Gainsborough, but

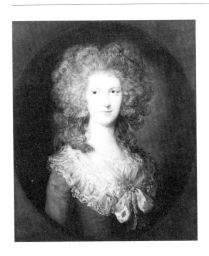

to his nephew, Gainsborough Dupont (1754–1794), son of Thomas's sister Sarah, and his uncle's studio assistant from 1772 to 1788. It is instructive to compare the two portraits. The treatment of the face, trimming, and bow in the Philadelphia portrait is feathery and suggestive, whereas in the Dupont, the sitter's dress is described tightly and accurately. The whole effect of the Philadelphia picture, though superficially akin to the Cleveland portrait, is sketchier, freer, more assured.

FIG. 34-1 Gainsborough Dupont (1754–1794), *Mrs. Thomas Samuel Joliffe*, oil on canvas, 30¼ x 25⅝″ (77 x 64 cm.), Cleveland, The Cleveland Museum of Art, John L. Severance Collection

INSCRIPTION: Two twentieth-century storage or inventory labels, one numbered *29685* [on the reverse].

LITERATURE: *Bulletin of the Philadelphia Museum of Art*, vol. 67, no. 308 (October–December 1972), repro. p. 6; *La Chronique des Arts, Supplément à la "Gazette des Beaux-Arts,"* no. 1,249 (February 1973), p. 133, fig. 475.

CONDITION NOTES: The original support is medium weight (14 x 14 threads/cm.) linen. The tacking margins have been removed. The painting is lined with an aqueous adhesive and open-weave, medium-weight linen. The lining fabric is primed with an aqueous ground front and back and carries a white-lead oil layer of paint on its reverse. A white ground is visible along the cut edges. The paint is in good condition. Considerable brush marking is evident throughout. Traction crackle is present in the area of the bodice. The highest points of relief have been flattened by lining. In ultraviolet and normal light, retouching is evident in the traction crackle noted above. A large area under the lower lip and across the chin has been filled and overpainted, suggesting an old tear in the support. The lips appear to have been overpainted.

John Watson Gordon's father, Capt. John Watson, R.N., was a sailor who
had fought at Gibraltar under Commodore Keppel. John was born in
Edinburgh in 1778, grew up in Stockbridge in Raeburn Place and then Ann
Street. Encouraged by the success of his uncle, the portrait painter George
Watson (1767–1837), later first president of the Royal Scottish Academy
(1826–37), he entered the Trustees' Academy, a school for drawing founded in
Edinburgh in 1798 by John Graham (1754–1817). There the pupils, who
included David Wilkie (1785–1841) and David Roberts (1796–1864), learned to
work from life, an innovation in the teaching of art in Scotland at this date.
Graham's advice to his students "never to paint on your principal work
without you have nature before you"[1] was beginning to be echoed, in more
grammatical form, throughout the British Isles at the beginning of the
nineteenth century and would bear fruit in the works of the new generation of
landscape painters, Crome, Constable (q.q.v.), and John Varley (1778–1842).

But John Watson was not a landscape painter—neither was he at first a
portrait painter. His first pictures exhibited at the Associated Society of
Artists, Edinburgh, were large-scale histories—*The Battle of Bannockburn*
(1809, location unknown) and *Lord Lindsay Forcing Queen Mary to Sign Her
Resignation* (1809, location unknown)—and he continued to show subject
pictures such as the *Shipwrecked Sailor Boy* (1812, location unknown). As late as
1827 he exhibited *Return from a Foray* (39½ x 49¾", Edinburgh, National
Gallery of Scotland) and worked as one of the illustrators of Cadell's edition
of the Waverley Novels (1829–33) which, as the Irwins point out, can be
regarded as a nineteenth-century successor to Boydell's Shakespeare Gallery.[2]
By 1821 he had begun to concentrate exclusively on portraits. William Hall,
who in 1855 accompanied the English landscape painter David Cox (q.v.) to
Edinburgh, where Watson Gordon painted his portrait, described a dinner
with the Scots artist: "The dining-room contained a number of Sir John's
works, mostly figure and subject pictures, which it was conjectured had been
exhibited but not sold. The artist had commenced his career by painting
pictures of this description, but want of success compelled him to turn his
attention to portraiture."[3]

Watson was a friend and student of Sir Henry Raeburn (q.v.), and when
the old man died in 1823, he inherited his place as the first portrait painter in
the city. In 1826 he added the Gordon to his name in order to distinguish
himself from an uncle and two cousins also practicing in Edinburgh.

At first glance Watson Gordon's paintings look like Raeburn's, but they
are much more than mere imitations. Unlike his master, he always drew
studies of his subjects' heads and hands in pencil before painting, and this
means that his finished portraits are closer in technique to those of Sir Thomas
Lawrence (q.v.).[4] His method of applying color was to lay down the various
pigments side by side like a mosaic, not onto twill canvas but onto the
smoother, less absorbent surface of Scotch sheeting.[5] And unlike Raeburn he
did not blend his separate tints to achieve an overall warmth of tonality.
However, even his combination of vigorous draftsmanship and relatively
strong color could not make his usual Scots sitter a lively thing to look at; and

the conservatism innate among his patrons meant that his compositions were rarely inventive. In the light of this technique, however, it is worth speculating about which French artists noticed his works when they were exhibited at the Paris International Exhibition of 1855 and were praised by Théophile Gautier.[6]

Watson Gordon became a member of the Royal Scottish Academy in 1829. He first exhibited at the Royal Academy in 1817 and again in 1820 and 1825 under the name John Watson; then, between 1827 and 1864 he sent 124 portraits to the Royal Academy. He was elected an Associate Royal Academician in 1841 and Academician in 1851. In 1850 Queen Victoria knighted Watson Gordon and appointed him Queen's Limner for Scotland, and he was also elected third president of the Royal Scottish Academy to replace Sir William Allan (1782–1850). He died of a stroke on June 1, 1864.

1. Quoted in Irwin and Irwin, 1975, p. 97.
2. Ibid., p. 206.
3. Hall, 1881, p. 172.
4. Irwin and Irwin, 1975, p. 309.
5. Hall, 1881, p. 171.
6. Théophile Gautier, *Les Beaux-Arts en Europe 1855* (Paris, 1855), p. 87.

BIBLIOGRAPHY: "The Royal Academy," *The Illustrated London News,* vol. 18, no. 474 (March 15, 1851), p. 219; Hall, 1881, pp. 166–72; Cumberland Hill, *Historic Memorials and Reminiscences of Stockbridge, the Dean, and Water of Leith, with Notes Anecdotal, Descriptive, and Biographical* (Edinburgh, 1887), pp. 100ff.; Irwin and Irwin, 1975, pp. 95, 97, 187, 204–6, 308–10.

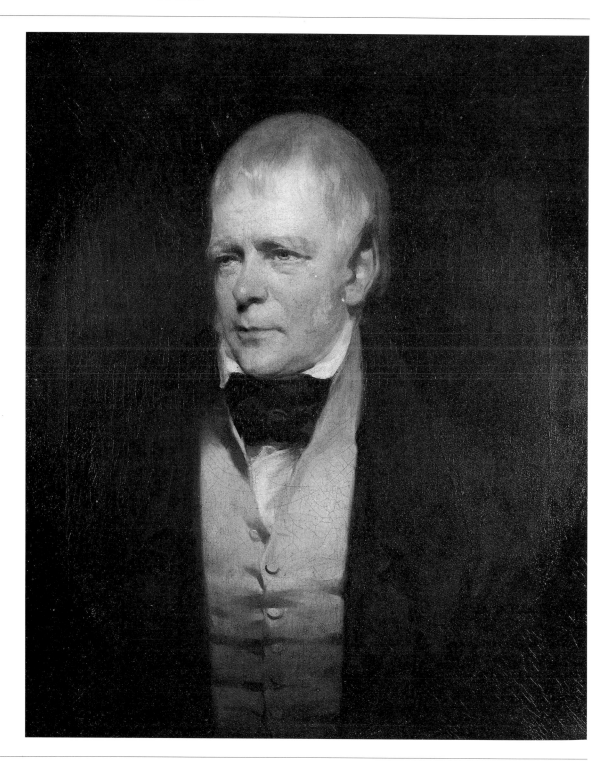

35 SIR JOHN WATSON GORDON

SIR WALTER SCOTT, c. 1831–35
Oil on canvas, 30 x 25″ (76.2 x 63.5 cm.)
John H. McFadden Collection, M28-1-42

Watson Gordon painted four different types of portraits of Sir Walter Scott. He first portrayed the writer in 1820 in a portrait for the Marchioness of Abercorn (partly destroyed, England, private collection). Ten years later, in 1830 (February–March), he painted a three-quarter-length portrait of Sir Walter leaning on his walking stick with his staghound Bran at his side (fig. 35-1).[1] This was executed for the publisher Robert Cadell, whose edition of the Waverley Novels (1829–33) Watson Gordon, along with other artists, was then illustrating. Besides the prime version at Dunecht, three other

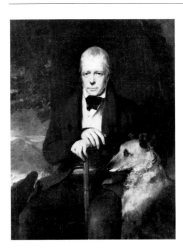

FIG. 35-1 Sir John Watson Gordon, *Sir Walter Scott*, 1830, oil on canvas, 50 x 40" (127 x 101.6 cm.), Dunecht, Aberdeenshire, Rt. Hon. Viscount Cowdray Collection

versions by Watson Gordon are known.[2] A third type was painted after Scott's death.[3] It is a cabinet portrait showing Sir Walter in his study in Castle Street, Edinburgh (39 x 29½", Edinburgh, Scottish National Portrait Gallery).

The Philadelphia picture is a version of a fourth portrait type, head and shoulders turned toward his right. The prime version here is an unfinished portrait in the Scottish National Portrait Gallery (fig. 35-2). Russell related the Philadelphia picture to this prime version, but pointed out that it is also very close to the version on panel (formerly Arthur Kay, see version 3), which was engraved in 1835.

The fourth type seems not to have been executed from life, but is rather a variant by Watson Gordon on the second type, the prime version of which is at Dunecht. Using the journal of Robert Cadell's conversations with Sir Walter Scott, Russell reconstructed the history of the Dunecht portrait. On January 16, 1830, Cadell first approached Sir Walter to ask him to sit for his portrait for use as the frontispiece of Cadell's edition of the Waverley Novels, but Sir Walter "growled at this more than I looked for," saying that he could not spare the time for sittings and proposing that Cadell should use Lawrence's (q.v.) portrait of him instead.[4]

On February 7, Watson Gordon paid a visit to the sculptor Lawrence MacDonald's (1799–1878) studio for the purpose of seeing "Sir Walter's Bust to ground portrait upon." On the eighteenth, Cadell noted "Mr. Watson Gordon called & asked me to look down with him & see the progress he had made with his Portrait of Sir Walter from the bust."[5] On March 4, 1830, Watson Gordon finally got his one and only sitting from Sir Walter, forcing the painter to work mainly from the bust lent to him by MacDonald and from his own acquaintance with Scott. If Scott refused to sit for the Dunecht portrait, it is almost certain that he did not sit for the much less important Philadelphia type; likewise, if the painter could execute the Dunecht portrait from a model, he was capable of adapting that type to the smaller, head-and-shoulders format of the Philadelphia portrait without troubling an ill and tired Sir Walter for further sittings.

The author of *Ivanhoe* (1819), *The Bride of Lammermoor* (1818), *Kenilworth* (1821), and *Quentin Durward* (1823) was in 1830 the most famous Scotsman of all—his books loved and he himself honored throughout Great Britain and the Continent. In 1826, at the age of fifty-five, a rich man living as the laird of Abbotsford, he had been stricken penniless by the failure of the publishing house of his partner Archibald Constable. His personal liability was for debts in excess of £100,000. Characteristically, feeling "neither dishonoured nor broken," he resolved to repay every penny through his own labors. The last six years of his life, 1826–32, were years of nearly unrelenting toil; beginning each morning at seven, he sat down to reduce, with every page he wrote, the mountain of debt oppressing him. His work was made harder to bear after the death of his wife, Charlotte, in May 1826, and as his health deteriorated.[6]

While at work on his novel *Woodstock*, on February 15, 1830, he suffered a slight paralytic stroke; he quickly recovered but had a second seizure in November of the same year. Scott was to die on September 21, 1832, of apoplexy; thus the man we see in Watson Gordon's portrait is a stricken warrior, courageous, but already shaken with palsy.

FIG. 35-2 Sir John Watson Gordon, *Sir Walter Scott*, c. 1830, oil on canvas, 30 x 24" (76.2 x 61 cm.), Edinburgh, Scottish National Portrait Gallery

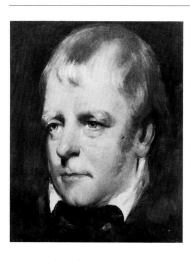

FIG. 35-3 Sir John Watson Gordon, *Sir Walter Scott,* oil on panel, 13 x 11″ (33 x 28 cm.), Edinburgh, Scottish National Portrait Gallery

1. *Catalogue of Pictures and Drawings in the Collection of the Viscount Cowdray* (London, 1971), no. 125, pl. 64.

2. They are Edinburgh, Edinburgh Speculative Society; formerly A. H. Wigan; and Manchester, City Art Gallery.

3. F. G. Kitton, "Some Portraits of Sir Walter Scott," *The Magazine of Art,* vol. 19 (1896), p. 4.

4. Francis Russell, "Catalogue of Portraits of Sir Walter Scott," p. 175A (MS. in the possession of Francis Russell, London), quoting "Journal of Robert Cadell's Conversations with Sir Walter Scott," MS. ACC 5188, box 1, National Library of Scotland, Edinburgh.

5. Ibid., p. 175B, (box 2).

6. John Buchan, *Sir Walter Scott* (1932; 8th ed., London, 1961).

PROVENANCE: F. W. Arkwright; his sale, Christie's, May 16, 1885, lot 75, bt. Gladwell; James Duncan of Benmore; his sale, Christie's, May 26, 1906, lot 127, bt. Holbrook Gaskell; his sale, Christie's, June 24, 1909, lot 33, bt. Agnew; bt. John H. McFadden, September 5, 1910.

EXHIBITIONS: New York, 1917, p. v, no. 10, fig. 10; Pittsburgh, 1917, no. 10; Philadelphia, 1928, p. 22.

LITERATURE: Roberts, 1918, "Portraits," p. 137, repro. p. 136; Francis Russell, "Catalogue of Portraits of Sir Walter Scott," p. 184, no. 54 (MS. in the possession of Francis Russell, London); Roberts, 1913, p. 540; Roberts, 1917, pp. vii, 83–84, repro. opp. p. 83.

CONDITION NOTES: The original support is medium-weight (20 x 20 threads/cm.) linen. The painting is lined with an aqueous adhesive and double-thread, medium-weight linen. An off-white ground is present and partially extends onto the tacking margins. The paint is generally in good condition. An irregular net of narrow-aperture fracture crackle is present overall and most prominent in the waistcoat, which also shows evidence of minor traction crackle. A slight cupping is associated with this crackle. Small losses are present and restricted to the areas along the tacking margins. Under ultraviolet light, retouching is visible in the right lapel, the upper right corner, and the bottom left corner background.

VERSIONS

1. Sir John Watson Gordon, *Sir Walter Scott,* c. 1830, oil on canvas, 30 x 24″ (76.2 x 61 cm.), Edinburgh, Scottish National Portrait Gallery (fig. 35-2).

PROVENANCE: Presented to the National Gallery of Scotland by the artist's brother, William G. Watson, 1885, and transferred 1898.

LITERATURE: Francis Russell, "Catalogue of Portraits of Sir Walter Scott," p. 181, no. 51 (MS. in the possession of Francis Russell, London).

DESCRIPTION: Prime version. Unfinished. Head completed, clothes sketched in gray. Russell MS., p. 181, considers this the prime version, datable to spring or early summer 1830.

2. Sir John Watson Gordon, *Sir Walter Scott,* 1831, oil on canvas, 30 x 24″ (76.2 x 61 cm.), formerly, the Earl of Minto.

INSCRIPTION: *J. Watson Gordon Pint 1831*

PROVENANCE: Acquired by the 2nd Earl of Minto (d. 1854); by descent; Parke-Bernet, New York, October 14, 1943, lot 54, repro.

LITERATURE: Russell MS., p. 182, no. 52.

3. Sir John Watson Gordon, *Sir Walter Scott,* oil on panel, 8½ x 7⅛″ (21.6 x 18.1 cm.), location unknown.

INSCRIPTION: *John Watson Gordon Pinxt Edinburgh*

PROVENANCE: Probably painted for Blackie and Son, publishers; Blackie family; Arthur Kay; his sale, Christie's, May 11–12, 1943, lot 88; Wheeler and Son, 1950.

LITERATURE: Russell MS., p. 183, no. 53.

ENGRAVING: S. Freeman after Sir John Watson Gordon. Published by Blackie and Son in Robert Chambers, *A Biographical Dictionary of Eminent Scotsmen,* vol. 4 (Glasgow, 1835).

4. Sir John Watson Gordon, *Sir Walter Scott,* oil on panel, 13 x 11″ (33 x 28 cm.), Edinburgh, Scottish National Portrait Gallery (fig. 35-3).

PROVENANCE: Purchased from Leggatt, 1939 (as by David Wilkie).

LITERATURE: Russell MS., p. 185, no. 55.

5. Sir John Watson Gordon, *Sir Walter Scott,* c. 1830–31, oil on canvas, 30 x 24″ (76.2 x 61 cm.), Keir, Scotland, Lt. Col. William Stirling of Keir.

PROVENANCE: William Stirling (later Sir William Stirling Maxwell), by 1857.

LITERATURE: Russell MS., p. 186, no. 56.

6. Sir John Watson Gordon, *Sir Walter Scott,* possibly c. 1850–51, oil on canvas, 30 x 24″ (76.2 x 61 cm.), Scotland, Christopher Scott of Gala.

PROVENANCE: Scott of Gala.

LITERATURE: Russell MS., p. 187, no. 57. Russell MS., pp. 188–89, gives details of another version of Watson Gordon's portraits of Sir Walter Scott, which cannot be securely identified as any of the above-listed versions.

Headstrong, impulsive, handsome, and vain, George Henry Harlow scorned the opinions of his contemporaries, trusting instead entirely to his own genius. Like his contemporary Byron he died young, but unlike the poet, the work he left behind has hardly made his name immortal. As a portraitist he ranks as the best of Sir Thomas Lawrence's (q.v.) pupils; as a history painter he has rightly been forgotten. Born in St. James's Street, London, on June 10, 1787, five months after the death of his father, Harlow became a child prodigy, fussed over by his mother and five sisters, who instilled in him a tragic conviction of his own brilliance. Around 1800 he was sent to study for one year with the Antwerp-born landscape painter Hendrick Frans de Cort (1742–1810) and then for another year with the history and portrait painter Samuel Drummond (1765–1844), an Associate Royal Academician. Both teachers were competent artists, but naturally his mother tried to place her son with the most successful artist of the age, Sir Thomas Lawrence, who had himself impressed the great Sir Joshua Reynolds (q.v.) when not much older than Harlow, and who might have been expected to cultivate the boy's talent and guide his career. But Lawrence's studio was not easy to enter. In 1802, possibly as a result of the intercession of his friend Lady Elizabeth Foster, later Duchess of Devonshire (1759–1824), Lawrence did accept the fifteen-year-old boy, but according to the editor of *The Literary Gazette* charged his mother one hundred guineas a year merely for "free access to his house at nine o'clock in the morning, [and the right] to copy his pictures till four o'clock in the afternoon." The price did not include "instruction of any kind."[1] In practice, Harlow also seems to have prepared Lawrence's pictures in dead color and advanced copies for him to work upon.

There he remained, learning from art, not nature, for eighteen months, until he could imitate the superficial characteristics of his master's style, his brilliant coloring, glamorous compositions, and lively facial expressions. Unfortunately, he failed to absorb the very rudiments of Lawrence's art, his understanding of anatomy, draftsmanship, and perspective.

But Harlow had no idea that these deficiencies would prevent his becoming Lawrence's natural heir. Accordingly, he never studied or (as far as we know) drew at the Royal Academy, and, romantic and immature as he was, loudly asserted his distrust of all academic rules and principles. At the same time, his character and personality grew increasingly obnoxious to his contemporaries. Like the young Lawrence, he was good-looking and naturally talented; but unlike his master, proud and pompous. He dressed ostentatiously, preening and strutting about London, flaunting his sense of superiority, until, according to his entry in the *Dictionary of National Biography,* in artistic circles he became known as "Clarissa Harlowe." Twice he tried to gain admission to the Royal Academy as an Associate; after the second attempt, in 1816, when Henry Fuseli (1741–1825) cast the only vote in his favor, a friend asked the Swiss artist how he could have voted for such a person. Fuseli replied, "I voted for the talent, and not for the man."[2]

After eighteen months with Lawrence, in 1804, he exhibited for the first time at the Royal Academy a portrait of Dr. John Thornton (1768–1837), the botanist. Harlow was a gifted portraitist, but like his friend Benjamin Robert Haydon (1786–1846)—or for that matter, most English artists—his ambition was to succeed as a historical painter. His first effort in the genre was *Queen Elizabeth Striking the Earl of Essex* (exhibited R.A. 1807, no. 304, location unknown). Around 1813 he painted *Hubert and Prince Arthur* (110 x 74″, Stratford-upon-Avon, Royal Shakespeare Theatre Memorial Gallery), followed by *The Entrance of Bolingbroke into London* (exhibited British Institution 1815,

no. 131, 52 x 44″, location unknown), and *The Court for the Trial of Queen Katharine (Trial Scene from Henry VIII)* (oil on panel, 63 x 86″, Gloucestershire, Sudeley Castle, The Walter Morrison Pictures Settlement). This last painting, containing portraits of members of the Kemble family appearing in Shakespearean roles, was reviewed in the periodical *Annals of the Fine Arts* for 1818: "He appears completely to have mastered the difficulties of colour; all the seductive beauties of this branch of his art seem completely open to him; yet he must cultivate drawing, arrangement, composition, expression and other essential qualities; in all of which, except the expression of portraiture, he is at present deficient. He must beware of glare and tinsel . . . and superabundant decoration."[3] A more malicious critic in the *Morning Herald* counted the number of heads in the picture, tried to match them to the legs, and concluded: "It is a fact that among [the figures] are two legs which nobody seems to claim."[4]

Whether as a result of such reviews, or through a belated process of maturation enabling him to see that draftsmanship and the study of the antique were after all the basis of art, or simply because the end of the Napoleonic Wars in 1815 had once again made travel abroad possible, Harlow left England for Rome in June 1818. There, anticipating the triumph of Lawrence of the following year, he was lionized by Italian artists, particularly Canova (1757–1822), made an Academician of Merit in the Accademia di San Luca (an honor he shared with Benjamin West [1738–1820], Henry Fuseli, John Flaxman [1755–1826], and soon, Lawrence), and invited to deposit his portrait in the Gallery of Self Portraits of the Uffizi. He also worked diligently at copying old masters and produced at least one historical picture, *The Presentation of the Cardinal's Hat to Wolsey* (26 x 30″, Rome, Accademia di San Luca).

He returned to England on January 13, 1819, but almost at once he sickened, and on February 4 died, of the mumps, at 83 Dean Street, Soho. He was buried under the altar of St. James's Church, Piccadilly, on February 16, age thirty-two.

Harlow's theatrical history pictures are ambitious failures; broadly conceived, but with sprawling compositions, awkward gestures, slapdash painting, they look forward to the much more successful theatrical extravaganzas of Daniel Maclise (1806–1870) in the 1830s. His portraits of men are, in general, more successful than those of women or children, and in those of the painters James Northcote (1746–1831) (exhibited R.A. 1816, no. 40, oil on panel, 20⅛ x 15⅛″, London, National Portrait Gallery) and Henry Fuseli (exhibited R.A. 1817, no. 365, oil on panel, 21 x 16⅛″, New Haven, Yale Center for British Art) there are a restraint and a success at characterization rarely found in his commissioned works. His women and children, true precursors of Victorian "keepsake" pictures, can be repellent. Haydon classed Harlow with William Owen (1769–1825), Martin Archer Shee (1769–1850), and John Jackson (1778–1831), as one of the "tip-toe school" of portrait painters.

1. "The Late George Henry Harlow," *Annals of the Fine Arts,* vol. 4, no. 13 (1820), p. 339. Goldring (1951), p. 310, names the Duchess of Devonshire as Harlow's early protectress, but presumably he is referring to Lady Elizabeth, who was sitting to Lawrence at least by 1804.
2. Knowles, 1831, vol. 1, p. 318.
3. "Exhibition at the Royal Academy," *Annals of the Fine Arts,* vol. 2, no. 4 (1818), pp. 69–70.
4. See Whitley, 1928, *1800–1820,* p. 273.

BIBLIOGRAPHY: "The Late Mr. Harlowe," *Annals of the Fine Arts,* vol. 4, no. 12 (1820), pp. 158–59; "George Henry Harlow," *The Literary Gazette and Journal of the Belles Lettres,* no. 113 (March 20, 1819), pp. 187–88, no. 114 (March 27, 1819), pp. 201–4; "Exhibition of the Paintings and Drawings of the Late Mr. G. H. Harlow, at No. 87 Pallmall," *Annals of the Fine Arts,* vol. 4, no. 13 (1820), pp. 320–23; "The Late George Henry Harlow," *Annals of the Fine Arts,* vol. 4, no. 13 (1820), pp. 338–45; Smith, 1828, vol. 2, pp. 408–14; "Memoir of the Late George Henry Harlow," *Library of the Fine Arts,* vol. 2, no. 10 (1831), pp. 245–53; Knowles, 1831, vol. 1, pp. 314–18; William Jerdan, *The Autobiography of William Jerdan with His Literary, Political, and Social Reminiscences and Correspondence During the Last Fifty Years,* 4 vols. (London, 1852–53), vol. 3, pp. 55–56; Cook, 1869, pp. 295–315; L[ionel] C[ust], *Dictionary of National Biography,* s.v. "Harlow, George Henry"; Whitley, 1928, *1800–1820,* pp. 272–74; Goldring, 1951, pp. 309–10; Boase, 1959, p. 15.

EXHIBITION: London, 87 Pall Mall, *Exhibition of Paintings and Drawings of the Late Mr. G. H. Harlow,* 1820?.

36 GEORGE HENRY HARLOW
37

THE MISSES LEADER, 1813–14
Oil on canvas, 94¼ x 58″ (239.4 x 147.3 cm.)
John H. McFadden Collection, M28-1-10

THE LEADER CHILDREN, 1813–14
Oil on canvas, 94½ x 58¼″ (240 x 147.9 cm.)
John H. McFadden Collection, M28-1-11

The Misses Leader and *The Leader Children* are portraits of the six children of William Leader (d. 1828), a wealthy coachbuilder, distiller, and glass manufacturer, who became Member of Parliament for Camelford Borough in Cornwall (1812–18) and Winchelsea (1820–26). The Leader family lived in Surrey on an estate at Putney Hill, and in London in their town house in Queen's Square, Westminster.

Leader's youngest son, John Temple Leader (1810–1903), the baby riding the donkey in the picture of the younger children, described these portraits in his autobiography.

> Harlow, the vainest of men, the favorite pupil of Sir Thomas Lawrence, and a much admired portrait painter, was a frequent visitor at the Putney Hill Villa. He painted two large pictures with life size figures, one of my eldest sister Mary, who became afterwards [April 23, 1816] the wife of Edward Lowther Crofton [and after his death, before 1823, married a Mr. Losack] a captain in the Royal Navy, leaning on her harp, of my second sister Fanny [d. 1844] afterwards [November 7, 1815] the wife of Sir Peregrine Palmer Acland of Fairfield and of St. Audries, Somersetshire, sitting near with a music book on her knee and looking up at her sister.
>
> The other picture (also painted by Harlow) of me, then a fair blue-eyed merry little child, held by my sister Anne [d. 1882, married September 19, 1826, Rev. Henry Dashwood] sitting on a donkey led by my elder brother William, [1802–1826] with my youngest sister Jane (afterwards [May 11, 1824] the wife of the Rev. Alexander Fownes Luttrell, Rector of East Quantoxhead Somersetshire) . . . walking near. These two pictures are still [1899] at the Upper House (or Holmwood) Putney Hill.
>
> My father refused to let the picture with the donkey in it be sent to the Royal Academy Exhibition, as he said laughingly it would be called a family picture.[1]

Roberts confused the eldest sister Mary (with the harp) with Anne (on the donkey) but correctly identified Jane, Fanny, John, and William.[2]

Except for their identities, we know nothing about the lives of any of the children except John, who, because of the early death of his elder brother William inherited his father's fortune, the estate at Putney Hill, and the two pictures. He became the liberal Member of Parliament for Bridgwater (1835–37), and then Westminster (1837–47); he was a well-known host, connoisseur, and historian, the friend of the adventurer Edward John Trelawny (1792–1881), the poet Richard Monckton Milnes (1809–1885), and Louis Bonaparte (1808–1873), afterward Napoleon III. After 1844 Temple Leader lived abroad, mainly in Florence, where he bought and restored several palaces and villas, including the castle at Vincigliata, where both Queen Victoria and Gladstone visited him in 1888. When he died in 1903 his fortune, house, and pictures passed to his youngest sister Jane's grandson, Lord Westbury.[3]

One circumstance of the commission that John Temple Leader does not record, but that is mentioned by all Harlow's early biographers, is that

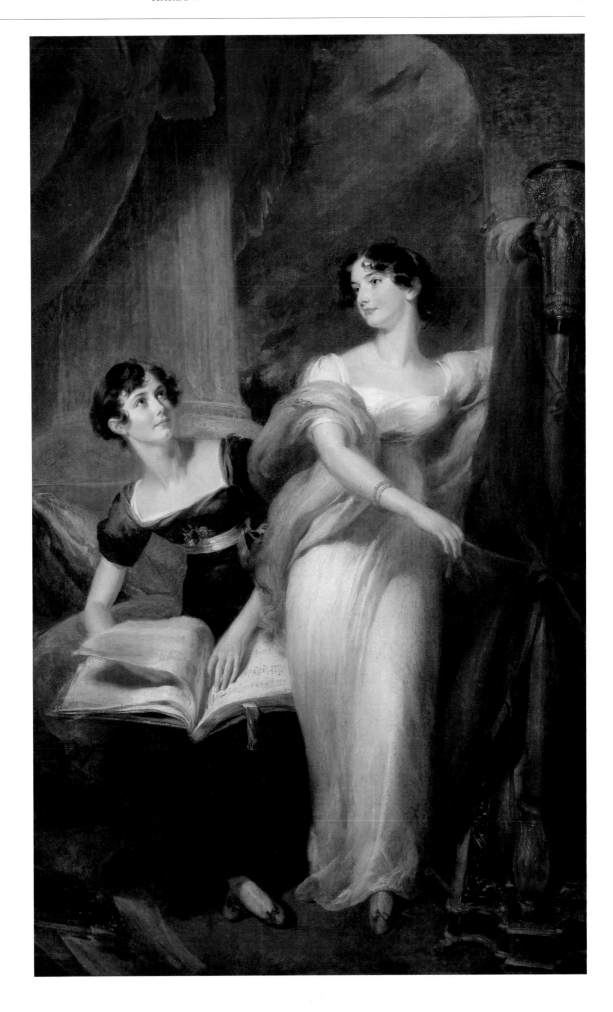

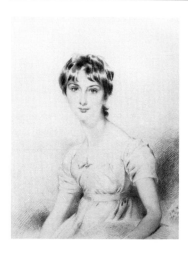

FIG. 36-1 George Henry Harlow, *Mrs. Henry Dashwood,* pencil and chalk on paper, 8¼ x 7⅞" (22.2 x 19 cm.), Hon. Richard Bethell Collection (in 1927). Photograph: Witt Library, London

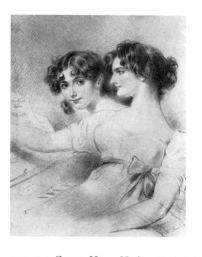

FIG. 36-2 George Henry Harlow, *Lady Acland and Mrs. Losack,* pencil and chalk with color added, on paper, 8¼ x 7⅞" (22.2 x 19 cm.), Hon. Richard Bethell Collection (in 1927). Photograph: Witt Library, London

William Leader originally commissioned from Harlow a large theatrical-history picture, *Hubert and Prince Arthur,* from Shakespeare's *King John,* act 4, scene 1 (112 x 75", Stratford-upon-Avon, Royal Shakespeare Theatre Memorial Gallery) at a price of one hundred guineas. According to Cook, who repeats an anecdote that originally appeared in full in Cunningham, "The patron...was less pleased with the vigour and glow of colour of the work than were the critics, and was not sorry to exchange the picture for portraits of his children. This was sufficiently galling to the painter's pride, but he was not rich enough to resent such conduct. He could not afford to close all dealing with his patron, as he would greatly have preferred to do."[4] However, this story was refuted in a letter from Alaric Watts to Allan Cunningham: "You are entirely in error in your assertion that Mr. Leader liked Harlow's first historical effort so little that he exchanged it for portraits of his daughters. On the contrary, he liked it so much that, not content with paying him a higher price than he demanded for his performance, he gave him no less than three commissions for pictures of a similar size—two family full-length groups and a portrait of Mrs. Siddons as Lady Macbeth."[5]

Hubert and Prince Arthur was exhibited at the British Institution in 1815 (no. 33). This fact led Roberts to date both groups of the Leader children to c. 1816–17, that is, immediately after the exhibition of *Hubert and Arthur.* But this does not allow for the possibility that, as suggested by Watts, the Shakespeare picture was painted several years earlier, and not exhibited immediately, which seems to be the case.

The Leader pictures must have been painted in 1813–14, when John was, as he recorded, about three years old, and before Fanny (the second daughter, with the music book) married in November 1815. A portrait drawing of Anne (the third sister, riding the donkey) labeled under her married name, Mrs. Henry Dashwood (fig. 36-1), belonged to John's great-grandnephew Hon. Richard Bethell in 1927. This drawing is inscribed "G.H.H. Sepber 1813." A pendant showing Fanny (Lady Acland) and Mary (Mrs. Lowther Crofton, later Mrs. Losack) sitting at the piano is inscribed "G. H. Harlow" (fig. 36-2).

Another confirmation of the dates of the Leader pictures is provided by Harlow's addresses as listed in the catalogues of the British Institution. In 1812 and 1815 addresses in London are given. In the intervening years, there is no address for 1813 because Harlow did not exhibit; but in 1814 the artist is listed as "G.H. Harlowe, Putney Hill."[6] This suggests that Harlow actually was living at the Leader family home while working on the two portrait groups, and perhaps, too, while working on *Hubert and Arthur.* Certainly he was more to the Leaders than merely a portrait painter, because in 1813 he was attending dances with the Leader girls, as we know from a humorous sketch he made during one of these parties (fig. 36-3).[7]

The Leader Children is loosely related to Thomas Lawrence's (q.v.) *Pattison Boys* (begun 1811, exhibited R.A. 1817, no. 44, 50 x 44", Polesden Lacy, National Trust), in which two little boys are seen to lead a donkey from left to right across the picture.[8] But *The Pattison Boys* is a relatively small picture, and in it the children are deporting themselves with a decorum very different from the high spirits that apparently prevailed in the Leader household. Here the note is one of boisterous anarchy. The composition is a slightly tipsy triangle formed by the head of John at the apex, and the feet of William and Jane at the base. But by placing the older sister Anne slightly behind and out of the triangle at the top, and failing to provide perspective to anchor the children in a rational space, Harlow creates the impression that in one minute all five figures will pick up momentum and come toppling down on us. William, as the leader, does provide some direction as he turns to the left, but he is paying

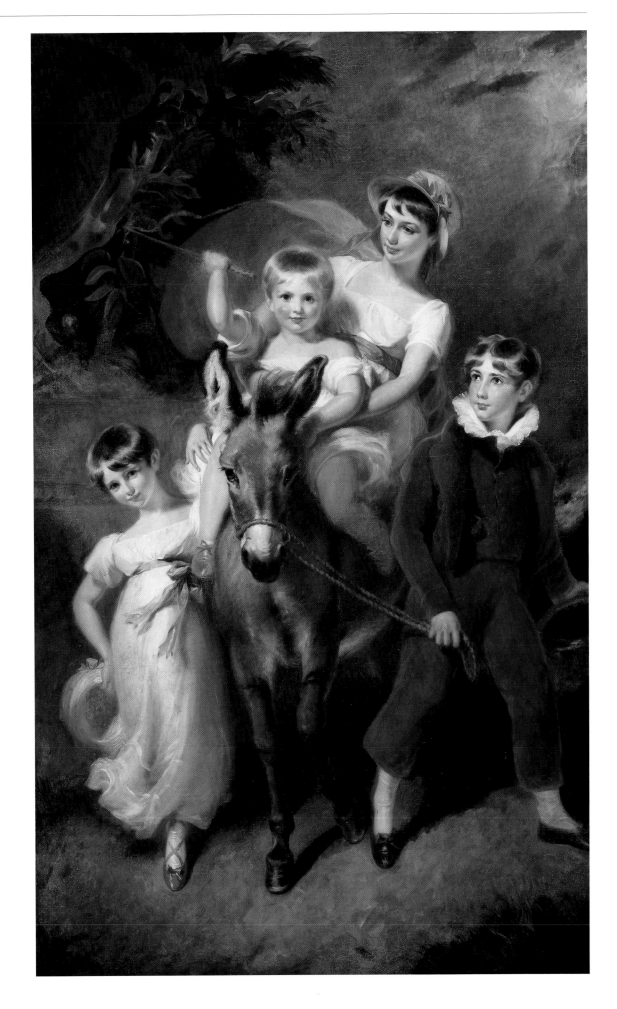

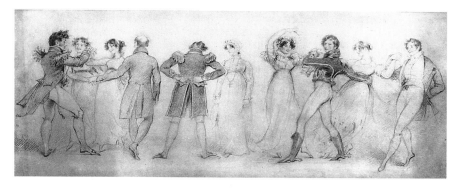

FIG. 36-3 George Henry Harlow, *Christmas Night at the Lower House, Putney Hill,* 1813, pencil on paper, 8½ x 21⅛" (21.6 x 55 cm.), Hon. Richard Bethell Collection

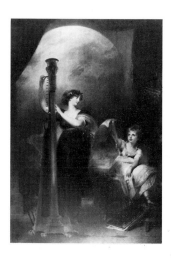

FIG. 36-4 Sir Thomas Lawrence (q.v.), *Caroline, Princess of Wales, and Princess Charlotte,* 1802, oil on canvas, 119 x 80" (302.3 x 203.2 cm.), Her Majesty Queen Elizabeth II

far too little attention to what baby John is doing with his riding crop, and indeed, only the sublime, quizzical expression on the donkey's face provides a note of dignity and restraint to hold the whole precarious pyramid together. Staley has suggested that the composition recalls the traditional *Flight into Egypt,* but if so, the echo here is very faint.[9]

To understand just how exuberantly vulgar the pendant group showing Fanny and Mary Leader is, we must look to the picture on which its composition is based, Lawrence's *Caroline, Princess of Wales, and Princess Charlotte,* exhibited at the Royal Academy in 1802 (no. 72) (fig. 36-4), where the poses and composition are almost identical to Harlow's, but in reverse.[10] Harlow or his patron seems not to have understood that what was an appropriate pose or scale for the portrait of a future queen of England, which, though privately commissioned, ultimately would hang in a quasi-public state room, and which would have a partly political function, was not necessarily appropriate for portraits of two middle-class teen-age girls from Putney Hill. What we have here is flattery gone out of control, a disparity between the real and the ideal that Reynolds, Romney, or Lawrence (q.q.v.) would never have attempted. Yet, for all its gross anatomical infelicities (Fanny's lap, for example, or Mary's left hand) there is an endearing swagger and naiveté about the picture. Then too, the heads of the two girls are beautifully painted: the only real note in a wonderfully blowsy and overblown extravaganza.

Mary Leader stands by a pedal harp not yet loosed from its protective covering. The angle from which we see the instrument prevents our seeing how it is strung at the top. There were several different ways in fashion during this period, the purpose being to devise a satisfactory way of tuning the instrument to handle chromatic notes (to allow the player to change keys by tightening or loosening the necessary strings by means of a pedal mechanism). One cannot see a pedal in the picture, although probably one is intended at the base of the instrument just next to Mary's foot. The harp was popular in English upper-class circles for domestic music-making from at least as early as the last third or fourth quarter of the eighteenth century. As Lawrence's 1806 portrait of the Princess of Wales with her harp illustrates, the fashion for the instrument reached the highest level of society, not only in England and Germany, but in French court circles, for Marie Antoinette played it well.[11] Whether the music Fanny Leader holds represents a specific piece is not certain, although it may be possible to suggest that this is a vocal composition, showing that Fanny was a singer and Mary a harpist.

Readers of *Mansfield Park,* published in 1814, the year in which Harlow's double portrait was painted, will recall that for Jane Austen the harp incarnated the glittering but ultimately disruptive world of London fashion. At least, her antiheroine, the fascinating Mary Crawford (foil to the

country-bred heroine Fanny Price), arrives at Mansfield Park during harvest time with her harp and is astonished that she can find no farmer with a horse and cart free to transport the instrument at short notice from Northampton.[12] And a few pages later Jane Austen describes the bewitching effect Mary's playing has on Edmund Bertram: "A young woman, pretty, lively, with a harp as elegant as herself; and both placed near a window, cut down to the ground, and opening on a little lawn, surrounded by shrubs in the rich foliage of summer, was enough to catch any man's heart."[13]

1. Temple Leader, 1899, pp. 17–18.
2. Roberts, 1917, pp. 21–22.
3. S[idney] L[ee], *Dictionary of National Biography,* s.v. "Leader, John Temple."
4. Cook, 1869, pp. 305–6, relying on Cunningham, 1830–33, vol. 5, pp. 282–83. The anecdote was first told in the *Annals of the Fine Arts,* vol. 4, no. 13 (1820), p. 341.
5. Quoted in Cunningham, 1879, vol. 2, p. 318.
6. Graves, 1908, p. 244.
7. Temple Leader, 1899, p. 19, repro. pp. 28–29.
8. Garlick, 1954, p. 53, pl. 76.
9. Staley, 1974, p. 36.
10. Millar, 1969, vol. 1, p. 61, no. 874, vol. 2, pl. 187.
11. Information kindly provided by Prof. Richard D. Leppert. The standard source on the subject of the harp is Roslyn Rensch, *The Harp: Its History, Technique and Repertoire* (London, 1969).
12. Jane Austen, *Mansfield Park* (1814; London, 1971), pp. 70–71.
13. Ibid., p. 79.

INSCRIPTION FOR NOS. 36 AND 37: [a copy of typewritten letter from Lord Westbury pasted onto stretcher]

21st September 1913
30 Hill Street W

My dear McFadden:—
The portraits in the two pictures by Harlow are those of my great uncle John Temple Leader, who was a contemporary at Oxford of Mr. Gladstone, and sometime Member of Parliament for Westminster, and his Brother and four Sisters.

He (Mr. John Temple Leader) is the baby held on the donkey by his Sister Ann (afterwards Mrs. Dashwood); the donkey is being led by his elder brother who died before his father, and the other figure is that of his sister Jane (my godmother, who became Fownes-Luttrel).

The other picture represents his sister Fanny (who became Lady Peregrine Acland) and his sister Mary who married 1) Captain Edward Lowtear Crofton R. N. and 2) Captain Woodley Losack.

Believe me, yours sincerely,
Westbury.

INSCRIPTION FOR NO. 36: *13444/2 W.O./608/13/9/13 B. 68/692* [on a label on the stretcher]; *MAISON POTTIER (FONDÉE EN 1802) / CH. POTTIER / EMBALLEUR—PACKER / 14, RUE GAJLLON / PARIS* [on another label].

INSCRIPTION FOR NO. 37: *12945 [?] 693 W. O. 608 13/9/13 400 [1?]* [on four paper labels on the stretcher].

PROVENANCE OF NOS. 36 AND 37: Commissioned by William Leader, Putney Hill, Surrey; bequeathed to his son, John Temple Leader; who bequeathed them to his great-nephew Richard Luttrel Bethell, 3rd Lord Westbury, 1903; who sold them to John H. McFadden, 1913.

EXHIBITIONS FOR NO. 36: New York, 1917, no. 11; Pittsburgh, 1917, no. 11; Philadelphia, 1928, p. 20.

EXHIBITIONS FOR NO. 37: New York, 1917, no. 12; Pittsburgh, 1917, no. 12; Philadelphia, 1928, p. 20.

LITERATURE FOR NO. 36: "George Henry Harlow," *The Literary Gazette and Journal of the Belles Lettres,* no. 114 (March 27, 1819), p. 201; "Exhibition of the Paintings and Drawings of the Late Mr. G. H. Harlow, at No. 87 Pall Mall," *Annals of the Fine Arts,* vol. 4, no. 13 (1820), p. 341; Cunningham, 1830–33, vol. 5, pp. 282–83; Cook, 1869, p. 306; Cunningham, 1879, vol. 2, p. 318; Temple Leader, 1899, pp. 17–18, repro. p. 16; S[idney] L[ee], *Dictionary of National Biography,* s.v. "Leader, John Temple"; Roberts, 1917, pp. vii, 21–22, repro. opp. p. 21; Roberts, 1918, "Portraits," p. 134; *The Pennsylvania Museum Bulletin,* vol. 31, no. 169 (January 1936), repro. p. 10 (detail); Boase, 1959, p. 15, pl. 6b; Staley, 1974, pp. 35–36.

LITERATURE FOR NO. 37: *Annals of the Fine Arts,* vol. 4, no. 13 (1820), p. 341; Cunningham, 1830–33, vol. 5, pp. 282–83; Cook, 1869, p. 306; Temple Leader, 1899, pp. 17–18, repro. opp. p. 18; S[idney] L[ee], *Dictionary of National Biography,* s.v. "Leader, John Temple"; Roberts, 1917, pp. vii, 23–24, repro. opp. p. 23; Boase, 1959, p. 15; Staley, 1974, p. 37, pl. iv.

CONDITION NOTES FOR NO. 36: The original support is twill-weave, medium-weight (12 x 12 threads/cm.) linen. The tacking margins have been removed. A crease extends the length of the left side, ½" from the edge. The painting was relined with an aqueous adhesive and medium-weight linen in 1943. An off-white ground is visible along the cut edges and within the apertures of traction crackle. The paint is in fair condition. A very wide traction crackle is present in the lower area of the dress of the figure on the right. The background above and to the right of this figure is extremely abraded. The paint texture profile has been flattened by lining. A pentimento is evident in the proper right arm of the figure on the right: the arm now appears in a less extended configuration. Under ultraviolet light, retouching is visible in the areas of background abrasion and within the traction crackle.

CONDITION NOTES FOR NO. 37: The original support is raw-weave, medium-weight (12 x 12 threads/cm.) linen. The tacking margins have been removed. Weave cusping in the support is evident along all four edges. The painting is lined with an aqueous adhesive and medium-weight linen. A thin, evenly applied off-white ground is visible through the apertures of a traction crackle in the paint. The paint is generally in good condition. A web of traction crackle extends throughout the background around the figures. A single, large circular loss (2 to 3") is present in the area of the white dress. This area was reported in 1944 to have an active cleavage problem, which now has been stabilized. Local areas of abrasion are evident in the sky at the right. Retouches are evident under ultraviolet light and are coincident with the traction crackle in the immediate foreground, along the edges, and over the large loss.

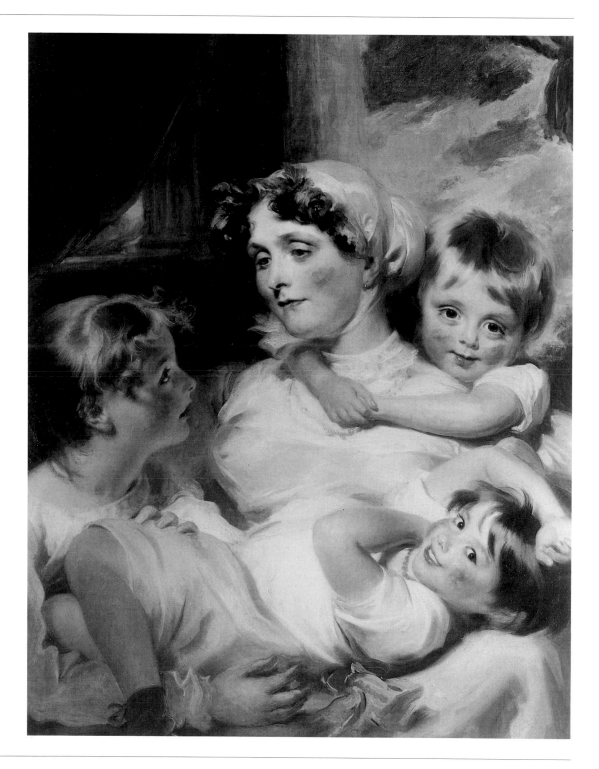

38 GEORGE HENRY HARLOW

MOTHER AND CHILDREN, c. 1816
Oil on canvas, 36 x 28¼″ (91.5 x 71.8 cm.)
John H. McFadden Collection, M28-1-12

Harlow based this composition on Reynolds's (q.v.) famous portrait of *Lady Cockburn and Her Three Eldest Sons* of 1773 (fig. 38-1), which he could have known either through the engraving by C. Wilkin of 1791, or, more likely, when the original was lent by Sir James Cockburn to the British Institution in 1813 (no. 128).[1] There are, of course, differences in the two pictures: in the Harlow the sitters are seen close to and with space around them; the positions of the arms have been altered; and the mother is shown in three-quarter view rather than in profile. The exotic notes of the Reynolds—the parrot and the

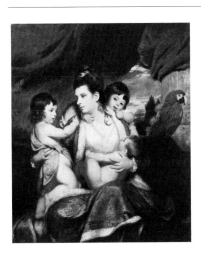

FIG. 38-1 Sir Joshua Reynolds, *Lady Cockburn and Her Three Eldest Sons,* 1773, oil on canvas, 55¾ x 44½" (141.6 x 113 cm.), National Gallery, London

ermine trimmings—are absent, for this mother, dressed in simple white muslin and wearing a white cap, is an altogether more ordinary creature than the glamorous Lady Cockburn. We might almost believe that *these* children are shown with their nanny, and that she has spent the day with them, her nerves frayed by the experience; the aristocratic Lady Cockburn, by contrast, has permitted her children the run of her lap and neck at the request of the painter, and in the interests of high art. As Edgar Wind has demonstrated, the figures in the Reynolds, and hence those in the Harlow, derive from the traditional symbol for Charity, a mother surrounded by her children.[2] But whereas behind the Reynolds we feel the intellectual conceit, behind the Harlow we see only a mother worn out by her offspring.

Despite the example of Reynolds's superbly satisfying composition, the composition here teeters just on the edge of chaos, with visual activity going on everywhere at once, from the tumbling, swooning, flirting children, the color pitched as high throughout as the vivid red on mother's cheek. Mother, in fact, performs the same artistic (and in some ways physical) function as the donkey in Harlow's *Leader Children* (no. 37), for the unexpected look of suffering on her face puts, as it were, a brake on the picture, stopping us short by showing her to be emotionally removed from her children's antics. Only her eldest daughter, at the left, seems to show any awareness that her mother's feelings are at odds with the jovial mood of the rest of the portrait.

The identity of this woman and her children is not known. Attempts to identify her as one of the Kemble family of actors,[3] or with one of the Hopwood family of engravers,[4] are not based on concrete evidence. In 1816 Harlow exhibited a portrait group of *Mrs. Weddell and Children* at the Royal Academy (no. 178). As this was the only picture Harlow exhibited publicly that could conceivably be our portrait group, Roberts (1917) identified our sitter as Mrs. Weddell and suggested that she may have been a member of the family of that name who lived at Newby Hall in Yorkshire. But the name Weddell of Newby had ceased to be used by this date, and any attempt to associate our sitter with the sitter in the 1816 portrait is pure speculation.[5] Until further research is done on Harlow, the title of the picture must revert to that under which the picture was sold in 1897, *Mother and Children.*[6]

Harlow was fond of the format of the head-and-shoulder portrait group seen close to. We can compare *Mother and Children* to his *Proposal* (36¾ x 28", New York, Sotheby Parke Bernet, January 12, 1974, lot 138), in which three pretty girls tumble over one another with the same vivacity as the children in this painting.

1. Davies, 1959, pp. 84–85.

2. Wind, 1938, "Charity," p. 328.

3. The picture was called *The Kemble Family* only while it was in the Quilter collection (1897–1909). The 1911 catalogue of that collection bore the disclaimer that "the exact identities are not quite clear." Harlow was a friend of the Kembles and painted members of the family on several occasions, but there is no evidence that the woman in this picture is a Kemble. The only possible candidate is Maria Theresa De Camp Kemble (1774–1830), wife of Charles Kemble (1775–1854), whose children were John (1807–1857), Adelaide, later Sartoris (1814–1879), and Fanny (1809–1893). These birthdates might almost coincide if the portrait was executed c. 1816 when Adelaide was two and John eight: but the eldest child here seems to be a girl.

4. So called in the Christie's sale catalogue, 1909. Harlow painted a *Miss Caroline Hopwood* (30⅛ x 25¼", D. Douglas, 1924–26. Photograph: Witt Library, London), who, although much younger than the woman here, has a face and hairstyle similar to hers. But Miss Hopwood presumably changed her name before she had children.

5. There is a family called Weddall of Burlby and Selby listed in *Burke's Landed Gentry* (London, 1972), pp. 941–43, from which the most likely candidate for the sitter in the 1816 portrait comes. This was Nancy Routh, who married George Lyon Weddall (1780–1820) in 1803. However, neither the birth, death, nor marriage dates of Mrs. Weddall or her children are given. There is no tradition that Harlow painted any members of his family among the descendants of George Lyon Weddall (letter from Maj. D.J.W. Sayer to the author, November 21, 1979).

6. When this painting was sold at Christie's on July 9, 1909, lot 91, the provenance was given as "J. Graham, Esq. 1894," but this is wrong. The picture bought at the Dunbar sale on May 5, 1894, lot 67, was not in the Graham sale of the previous day, May 4, although the numbering of the catalogues for the two sales was continuous.

PROVENANCE: Duncan Dunbar, London; his sale, Christie's, May 5, 1894, lot 67 (as "Mother and Children"), bt. Lesser; Sir W. Cuthbert Quilter, Bart., London, 1897, his sale, Christie's, July 9, 1909, lot 91 (as "Portrait of Mrs. Hopwood and Family," 36 x 27½"), bt. M. Knoedler and Co.; John H. McFadden, by 1913.

EXHIBITIONS: Possibly London, Royal Academy, 1816, no. 178 (as "Mrs. Weddell and Children"); London, Burlington Fine Arts Club, *Pictures, Decorative Furniture, and Other Works of Art*, 1904, no. 37 (as "Portrait Group of the Kemble Family," lent by Sir Cuthbert Quilter, Bart.); New York, 1917, no. 13, fig. 13; Pittsburgh, 1917, no. 13 (as "Mrs. Weddell and Children"); Philadelphia, 1928, p. 21 (as "Mrs. Weddell and Her Children").

LITERATURE: F. G. Stephens, "The Collection of Mr. W. Cuthbert Quilter, M.P., V.—Various Masters," *The Magazine of Art*, vol. 20 (November 1896–April 1897), p. 70, repro. p. 69 (as "The Kemble Family"); *Sir Cuthbert Quilter's Pictures: London Collection* (London, 1911), p. 29, repro. opp. p. 29; Roberts, 1913, p. 541; Roberts, 1917, pp. vii, 25, repro. opp. p. 25; Roberts, 1918, "Portraits," p. 134, repro. p. 137; Sir Charles Holmes, "The Heirs of Lawrence—1825–1835," *The Burlington Magazine*, vol. 69, no. 404 (November 1936), p. 195, pl. II A; Wind, 1938, "Charity," p. 328, repro. between pp. 328–29, pl. 59e; Fiske Kimball, "They Like What They Know as Philadelphia Show Proves," *Art News*, vol. 45, no. 6 (August 1946), pp. 30, 51, repro. p. 30.

CONDITION NOTES: The original support is medium-weight (20 x 20 threads/cm.) linen. The tacking margins have been removed. The painting is lined with an aged aqueous adhesive and medium-weight linen. A white ground is evident along the cut edges. The paint is in excellent condition overall. Brush marking is well preserved as is the original relief. Several pentimenti in the children's hands, arms, and legs are visible in normal light. A pronounced bituminous traction crackle is present in the deepest shadow areas around the figures' heads.

Born in Bartholomew Close near Smithfield Market in London on
November 10, 1697, William Hogarth spent the formative years of his
childhood in the shadow of the Fleet Prison where his father, a Latin scholar
and author from the North Country whose attempt to keep a coffeehouse in
London ended in financial ruin, had been committed for debt "within the
rules" from 1708 to 1712. Like Charles Dickens, the experience of seeing his
father in debtor's prison seared the young Hogarth's heart; no other artist
painted prisons—the Fleet, Newgate, Bridewell, or the madhouse Bedlam—so
frequently or with such ferocious realism; like Dickens, Hogarth's early
poverty contributed to later unrelenting efforts to achieve financial security
through popular success; and like Dickens, Hogarth's greatest theme is the
teeming, various life within the city of London.

After 1708 Hogarth's mother was reduced to selling homemade tonics;
thus any education the boy had received probably terminated about the age of
eleven when he was needed around the house or to bring in extra money. In
these years he felt the first stirrings of artistic impulse in his love both for
theatrical performances and for drawing pictures: "I had naturally a good eye
[and] shews of all sort gave me uncommon pleasure when an Infant and
mimickry common to all children was remarkable in me. an early access to a
neighbouring Painter drew my attention from play [and] evry oppertunity was
employed in attempt at drawing."[1]

In 1714, the year George I ascended the throne, William was apprenticed
to a silversmith, Ellis Gamble of Blue Cross Street in Leicester Fields, who
taught him how to engrave onto metal small heraldic designs, ornaments, and
beasts. But as an engraver of silverplate William was bored: "The Narrowness
of this business I determind [should be followed] no larger [longer] than
necessity obliged me to it."[2] By 1720 he had set up on his own as an engraver
of shop cards and bookplates. At the same time he was among the first
subscribers to a new academy of art run by Louis Chéron (1660–c. 1715) and
John Vanderbank (1694–1739) off St. Martin's Lane, where his fellow pupils
included Joseph Highmore (1692–1780), Arthur Pond (c. 1705–1758), and
William Kent (1685–1748). What he learned there was not, apparently, the
traditional academic method of drawing from casts, from life, and copying old
masters; rather, Hogarth developed a system of "visual mnemonics," the fixing
of images in the mind to be drawn later in the studio: "Instead of burthening
the memory with musty rules, or tiring the eyes with copying dry and
damaged pictures, I have ever found studying from nature, the shortest and
safest way of attaining knowledge in my art."[3]

By 1723 Hogarth was no longer a tradesman but had taken up political
and social caricature and book illustration. Two early successes in these fields
were the engraving of 1724 entitled *Masquerades and Operas* or *The Bad Taste of
the Town* (in which he lampooned Lord Burlington and the fashion for
imported Italian entertainment) and twelve large illustrations from 1726 to
Samuel Butler's Don Quixote-like novel *Hudibras*. After the collapse of the
first academy in St. Martin's Lane, he attended the private art school in
Covent Garden founded in 1724 by a man whom he idolized, Sir James
Thornhill (1675/6–1734), a mural painter trained by the baroque artist Antonio
Verrio (1639–1707). In 1729 Hogarth eloped with Thornhill's daughter Jane,
and years later, in 1757, he succeeded his father-in-law at court as Sergeant
Painter to King George II. We can, like Waterhouse,[4] view Hogarth's
intermittent but lifelong attempts to secure royal patronage, his noble but
flawed stabs at historical painting—in St. Bartholomew's Hospital (1735),
Lincoln's Inn Hall (1748), and St. Mary Redcliffe in Bristol (1755–56)—as
aspects of an ambition to follow step by step the pattern of Thornhill's success.

The first step, taken in 1728 with Thornhill's encouragement, when he was thirty-one, was to shift from engraving to painting. Among his earliest works is one masterpiece, a theatrical conversation showing a scene from John Gay's *Beggar's Opera,* which opened to enormous acclaim in 1728 (six versions, one from 1729–32, 22½ x 29⅞", London, Tate Gallery). Hogarth recorded a dramatic moment during an actual performance, underscoring the journalistic element in some versions by showing the proscenium arch within which the actors play their parts; in addition, melding real life with art, he depicted Lavinia Fenton, the actress playing Polly Peachum, in the act of turning to her real-life lover the Duke of Bolton, who appears in the picture as part of the audience on the stage. But brilliant as his *Beggar's Opera* was, it was not a success Hogarth repeated for several years. With a young wife to support, he concentrated for the next three years on commissions for small-scale conversation pieces in the manner of the successful French artist Philip Mercier (1689/91–1760). Ronald Paulson estimated that Hogarth painted at least two dozen of these groups between 1728 and 1731,[5] and although (in John Ireland's paraphrase of Hogarth's own words) Hogarth regarded the work as a "kind of drudgery,"[6] the strides he made in his technique, draftsmanship, and composition during this time indicate ceaseless hard work. Vertue could write around 1730 that "Mr Hogarths paintings gain every day so many admirers that happy are they that can get a picture of his painting."[7] Yet in many cases the sitters seem to have presented too little of a challenge to the young man. Indeed, he rarely responded at this stage to his sitters as individuals, and as a painter of conversations in the early 1730s he may be consigned to the level of a charming but very limited minor master.

This he certainly knew. After about 1731 he began to turn clients away in order to try his hand at a genre of his own invention, the "moder[n] moral Subject[,] a Field unbroke up in any Country or any age."[8] In his three great narrative cycles of the 1730s and 1740s, "A Harlot's Progress" (1732), "A Rake's Progress" (1732–34), and "Marriage à la Mode" (1743), he developed themes and narrative techniques first explored in *The Beggar's Opera.* These famous cycles showing the descent to ruin, disease, and death of, variously, a whore, a libertine, and a young couple married for convenience are fictional tales of life in eighteenth-century London. In each we follow the adventures of one or more characters invented by Hogarth as they unfold from one canvas or engraving to another, structured in the same manner as a story in literature, with the equivalents of an introduction, development, subplot, climax, and denouement. They are completely theatrical in the sense that performers use gesture, pose, costume, props, and lighting to further or explicate a narrative line; and yet, as in *The Beggar's Opera* Hogarth used portraits of real people—the composer George Frederick Handel (1685–1759), the singer Giovanni Carestini (1705–1760)—side by side with those of invented characters to create a sense that what the viewer sees is a story as real as any found in the streets or salons of contemporary London. The artist wrote succinctly of his own role as narrator or author: "Subjects I consider'd as writers do[;] my Picture was my Stage and men and women my actors who were by Mean[s] of certain Actions and express[ions] to Exhibit a dumb shew."[9]

Not every cycle, however, was a success. "The Industrious and Idle Apprentice" ("Industry and Idleness") (1747) and "The Stages of Cruelty" (1751) are little more than crude clichés badly drawn and engraved. "The Election Cycle" of 1753–54 (London, Sir John Soane Museum) is beautifully painted but refers to abuses and issues in English politics so specific to the 1750s that they belong to a slightly baser tradition of political caricature, culminating in the prints of James Gillray (1757–1815) and Thomas Rowlandson (1756–1827) later in the century.

By achieving some financial security through the sale of the engravings of the "Harlot's Progress" and "Rake's Progress"—a success he insured by working tirelessly for the passage of the Copyright Act of 1735, which protected artists from the pirating of their designs—Hogarth also achieved freedom from the need to court the patronage of the rich. At the same time he abandoned temporarily both the conversation piece and the progress: "I . . . entertain'd some notions of succeeding in what is call[ed] the grand stile of History [so that] without having done any-thing of the kind before[,] Painted the staire case at St Bartholomew Hospital gratis."[10] These paintings, *The Pool of Bethesda* (1736, 164 x 243″) and *The Good Samaritan* (1737, 164 x 243″), launched his attempt to preserve by a single thread the moribund tradition of both history and religious painting in England. But however admirable the ambition, the resultant paintings have always been deemed only fairly successful, their scale not quite commensurate with Hogarth's ability to organize space, gesture, and dramatic expression in a dignified and rational way. Vertue was the first to pronounce them "more than cou[l]d be expected of [Hogarth],"[11] and yet they exerted by their very existence a vital influence on later generations of history painters, notably Benjamin West (1738–1820).

Having curtailed his work as a painter of conversations in the early 1730s, Hogarth returned to the field of portraiture with renewed vigor in the 1740s, this time concentrating on single or double portraits. The reason, we are told, was his resentment against the huge success of the French portrait painter Jean Baptiste van Loo (1684–1745), who arrived in England in December 1737 for a stay of five years.

One example of Hogarth's work as a portrait painter must serve to sum up a dozen works of the deepest feeling, quality, and originality. This is his famous full-length portrait of *Captain Thomas·Coram* (94 x 58″, London, Thomas Coram Foundation for Children) of 1740. Coram (c. 1668–1751) was a wealthy ship's captain who founded London's first hospital for orphans in 1739. Hogarth was a member of the board of governors of the Foundling Hospital, and for them he painted the portrait as a gift. In England there were few precedents in art for public images of such men. People like Coram were only beginning to want to be painted in the 1730s and 1740s, and so far had confined their patronage to the modest (and private) format of the conversation piece or bust-length portrait. Hogarth, therefore, was forced to rely on an aristocratic formula, basing Coram's pose on a French source, Rigaud's portrait of the banker Samuel Bernard engraved by Drevet in 1729.[12] But Hogarth transformed Bernard's pose into one suitable for a simple man by omitting the windblown swag of drapery and the classicizing robe worn by the banker, while retaining elements such as the globe, the ships, and the seal of the royal charter of the Foundling Hospital, which were truly pertinent to Coram's achievement. And so the sitter appears without a wig, dressed in a plain suit and stockings and wearing a rough red coat without embroidery. His face, which still strikes us as a brilliantly accurate likeness, suggests a mixture of kindliness and hardiness.

Hogarth has been called the father of English painting because he is the first artist to have painted pictures in genres we now take for granted—middle-class portraits, modern moral subjects, scenes from Shakespeare (*Falstaff,* 1728, 19½ x 23″, London, The Iveagh Bequest; *The Tempest,* c. 1735, 31½ x 40″, Wakesfield, Nostell Priory Collection; and *David Garrick as Richard III,* 1745, 75 x 98½″, Liverpool, Walker Art Gallery), and a passage from Milton (*Satan, Sin, and Death,* 1735–40, 24¾ x 29⅜″, London, Tate Gallery). In addition, he was the founder of the famous St. Martin's Lane Academy, which he took over after the demise of Thornhill's academy in Covent Garden in 1734 and ran until the 1750s. With Hogarth's example before them, the St.

Martin's Lane group—Gravelot (1699–1773), Roubiliac (1705?–1762), Francis Hayman (1708–1776), and the young Gainsborough (q.v.)—stood for all that was anticlassical, unstuffy, fresh, and elegant in English art.[13] Perhaps paradoxically, Hogarth resisted a movement in the 1750s to form a Royal Academy, objecting partly to the stratification of artists into ranks and partly to dependence on royal patronage which, he thought, could serve only to benefit the House of Hanover.[14] Furthermore, Hogarth was against teaching too many boys to become artists, for only a few could hope to make a living by their brush: "Great painting requires the genius of a Shakespeare or a Swift; it is better to be a successful tradesman or manufacturer than a mediocre painter condemned to starvation."[15] Hogarth was old by the time the age of the public art exhibition began to dawn. The only one in which he exhibited was in that of the Society of Artists at Spring Gardens in 1761 when he contributed seven paintings.

Finally, it is not possible to write about Hogarth's achievement without mentioning his *Analysis of Beauty,* a book of 1753 that has been called the first systematic anti-academic treatise. This was yet another volley at Burlington and Kent and their promotion of the rules and decorum of Palladian classicism. Hogarth stood for a freer, more informal style of painting, a style more or less identical with the rococo. In the *Analysis* he speaks of "the line of beauty," a concept that means not only a specific, undulating S shape but a way of looking at form as inseparable from movement in space and, by implication, of growth. He therefore argues for a connection between absolute beauty and organic, living things: a profoundly anticlassical conception, which in certain ways anticipated Ruskin's (1819–1900) defense of the Gothic almost a century later. Hogarth's quarrels with pro-academy factions in London and the attacks heaped upon his *Analysis* helped to estrange him from his fellow artists toward the end of his otherwise successful and fruitful life. He died in 1764.

1. William Hogarth, *The Analysis of Beauty with the Rejected Passages from the Manuscript Drafts and Autobiographical Notes,* ed. Joseph Burke (Oxford, 1955), p. 204.
2. Ibid., p. 205.
3. Ireland, 1798, p. 13.
4. Waterhouse, 1978, p. 168.
5. Paulson, 1971, vol. I, p. 213.
6. Ireland, 1798, p. 26.
7. Vertue, 1934, p. 41.
8. Burke, ed. (see note 1), p. 216.
9. Ibid., p. 209.
10. Ibid., p. 216.
11. Vertue, 1934, p. 78.
12. Antal, 1962, pls. 66a and b.
13. Girouard, 1966, "Slaughter's," pp. 58–61.
14. Kitson, 1968, p. 92.
15. Ibid., p. 68.

BIBLIOGRAPHY: Jean André Rouquet, *Lettres de Monsieur** à un de ses amis à Paris, pour expliquer les estampes de Monsieur Hogarth* (London, 1746); William Hogarth, *The Analysis of Beauty* (London, 1753); John Trusler, *Hogarth Moralized* (London, 1768); Walpole, 1771, vol. 4, pp. 68–89; John Nichols, ed.,

Biographical Anecdotes of William Hogarth; with a Catalogue of His Works (3rd ed., 1785; facsimile repr. London, 1971); Ireland, 1791; Ireland, 1794–99; Ireland, 1798; Nichols and Steevens, 1808; Walpole, 1828, vol. 4, pp. 126–75; Nichols, 1833; Trusler, 1833; Cunningham, 1879, vol. I, pp. 44–151; Walpole, 1888, pp. 1–26; Dobson, 1907; Roberts, 1920; Vertue, 1934; Wind, 1938, "Attitudes"; Joseph Burke, "Hogarth and Reynolds," *The William Henry Charlton Memorial Lecture, November 1941* (Oxford and London, 1943); Joseph Burke, "A Classical Aspect of Hogarth's Theory of Art," *Journal of the Warburg and Courtauld Institutes,* vol. 6 (1943), pp. 151–53; Beckett, 1948; A. P. Oppé, *The Drawings of William Hogarth* (London, 1948); Beckett, 1949; Forrest, 1952; Hilde Kurz, "Italian Models of Hogarth's Picture Stories," *Journal of the Warburg and Courtauld Institutes,* vol. 15 (1952), pp. 136–68; Frederick Antal, "The Moral Purpose of Hogarth's Art," *Journal of the Warburg and Courtauld Institutes,* vol. 15 (1952), pp. 169–97; Lawrence Gowing, "Hogarth, Hayman, and the Vauxhall Decorations," *The Burlington Magazine,* vol. 95, no. 598 (January 1953), pp. 4–19; William Hogarth, *The Analysis of*

Beauty with the Rejected Passages from the Manuscript Drafts and Autobiographial Notes, ed. Joseph Burke (Oxford, 1955); George Vertue, "The Note-Books of George Vertue Relating to Artists and Collections in England," *The Walpole Society, 1951–1952* [Vertue Note Books, vol. 6], vol. 30 (1955); Antal, 1962; David Kunzle, "Plagiaries-by-Memory of the 'Rake's Progress,'" *Journal of the Warburg and Courtauld Institutes,* vol. 29 (1966), pp. 311–48; Baldini and Mandel, 1967; Kitson, 1968; Ronald Paulson, *Hogarth's Graphic Works,* 2 vols. (1965; rev. ed. New Haven and London, 1970); Paulson, 1971; Edwards, 1972; Ronald Paulson, *The Art of Hogarth* (London, 1975); Lindsay, 1977; Webster, 1979.

EXHIBITIONS: London, British Institution, *Pictures by the Late William Hogarth, Richard Wilson, Thomas Gainsborough, and J. Zoffani,* 1814; London, British Institution, *William Hogarth,* 1817; London, 1951; Manchester, City Art Gallery, *William Hogarth, 1697–1764,* October–November 1954; London, Guildhall Art Gallery (Corporation Art Gallery), *An Exhibition of Paintings and Drawings by Hogarth the Londoner,* June–July 1957; London, 1971–72.

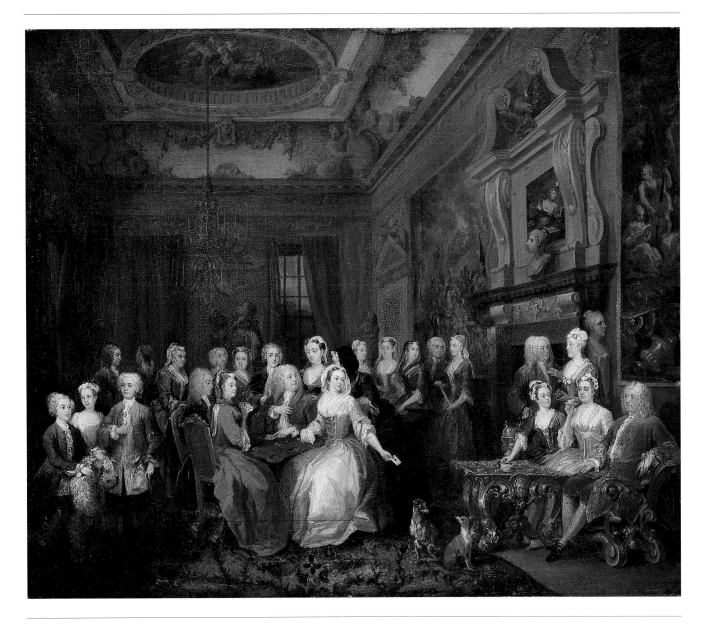

39 WILLIAM HOGARTH

THE ASSEMBLY AT WANSTEAD HOUSE, 1728–31
Oil on canvas, 25½ x 30″ (64.7 x 76.2 cm.)
John H. McFadden Collection, M28-1-13

In January 1730 George Vertue wrote, "The daily success of Mr Hogarth in
painting small family peices & Conversations with so much Air &
agreeableness Causes him to be much followd, & esteemd."[1] At this time
Hogarth had been active as a painter for only about two years, having begun,
as far as we know, to paint conversations only after his marriage to Jane
Thornhill on March 23, 1729.[2] Originally an engraver, caricaturist, and
illustrator, Hogarth was inspired by exceptional events that stirred his
imagination for his first oil paintings. The scene from *The Beggar's Opera,* for
example, represents the artist's response to the success of the 1728 theatrical
season, a play written, produced, and acted by his friends. The *Committee of
the House of Commons (the Goals Committee)* of 1729 (20⅛ x 27″, copy, London,
National Portrait Gallery) depicted—one wants to say recorded—a
parliamentary inquiry into abuses by the warden of the Fleet debtor's prison,
and was a subject of personal interest to Hogarth, whose own father had
suffered in the Fleet from 1708 to 1712. To take commissions for portraits of
men and families not connected in any way with the artist was, therefore, an

important change of direction, and in some ways it is odd that Hogarth should have made such a success in this line. Horace Walpole pointed out that of all branches of art, portrait painting was "the most ill-suited employment imaginable to a man whose turn certainly was not flattery, nor his talent adapted to look on vanity without a sneer."[3]

Odder still, his work as a portrait painter brought him into contact with the very type of patron he most despised, the connoisseur, the Englishman who not only imported into his country what Hogarth considered second-rate Italian pictures but who also patronized painters, designers, and architects influenced by the neo-Palladian doctrines of Lord Burlington. Of the men who sold such pictures, the artist wrote, "it is their Interest to depreciate every *English* Work, as hurtful to their Trade, of continually importing Ship Loads of dead *Christs, Holy Families, Madona's* [*sic*], and other dismal Dark Subjects, neither entertaining nor ornamental; on which they scrawl the terrible cramp Names of some Italian Masters, and fix on us poor *Englishmen*, the Character of *Universal Dupes.*"[4] And to Mrs. Piozzi he declared, "The connoisseurs and I are at war you know."[5]

The most conspicuous of these early patrons was Richard Child, Viscount Castlemaine (1680–1750), who commissioned *The Assembly at Wanstead House* in August 1728. Child was the son of the banker Sir Josiah Child (1630–1699), director of the East India Company. On the death of Richard's older brother he inherited his father's fortune and Jacobean house at Wanstead in Essex, eight miles northeast of London. Child, although possessing what one writer has labeled "almost revolting wealth,"[6] was still the son of a banker, and his ambitions lay more in the direction of social advancement than toward the attainment of political power. With the death of Queen Anne in 1714 and the ascendency to the throne of the House of Hanover, all the power and most of the wealth in England was to be concentrated in the hands of the Whig supporters of the Hanoverian cause. Tories were driven from office, and Child, briefly a Tory, changed his allegiance to the Whigs.[7] In return for his loyalty, or rather his lack of it, he was created Viscount Castlemaine in the Irish peerage in April 1718, and subsequently, in March 1731, by an act of Parliament, became Earl Tylney of Castlemaine. But already by 1715, three years before being raised to the peerage, Child had begun to build the traditional appendage to prestige and political power in England, a great country house.[8]

For his architect he chose Colen Campbell (1676–1729), a young Scotsman who had arrived in London around 1712. As in the case of his patronage of Hogarth, we do not know how Child came to employ Campbell, and the fact that his architect was almost unknown can be seen either as an indication of the patron's enlightened taste or of his blind good luck in taking up an untried young professional. Campbell was the architect who was to be largely responsible for the revival of the Palladian style in England, and the house he built for Child, Wanstead, is of the first importance to historians of architecture in England in the eighteenth century.

The chronology of the building of Wanstead can quickly be summarized. Dated 1713 is a first drawing with a plan for the main floor and an elevation of the west facade.[9] In 1715 Campbell published the first volume of his *Vitruvius Britannicus* with both an unexecuted elevation for Wanstead and the design for the house as it was eventually built.[10] By 1722 the exterior, sheathed in Portland stone, was complete, but work was carried on at Wanstead until Campbell's death in 1729. The finished house measured 260 feet long by 70 feet deep, with 58 bedrooms and at least 365 windows. According to Phillips, the cost was £360,000,[11] and in John Steegman's phrase, Wanstead's "vastness

FIG. 39-1 Detail of *The Assembly at Wanstead House* showing the term with William Kent's features

FIG. 39-2 Detail of *The Assembly at Wanstead House* showing Lord Castlemaine

was remarkable even in an age of vast houses." [12] Still, although of a scale to match Chatsworth or Blenheim, Wanstead remained a suburban estate only a few miles from London, suitable for a man whose wealth came not from the land but from business interests in the city.

If it is ironic that Castlemaine employed Hogarth of all artists to record the appearance of an Italianate, Palladian pile, it is more ironic still that the furniture and decorations in the house, although executed under the supervision of Campbell, were carried out by Campbell's associate William Kent (1685–1748). Kent, Burlington's protégé, executed the ceiling decoration of the great hall (*The Four Times of Day: Morning, Noon, Evening, and Night*), a work Walpole called "proof of his incapacity" as an artist[13] and he is said to have painted other rooms as well as to have designed some of the furniture there.[14] Hogarth, who resented Kent's easy success with the aristocracy and court and had burlesqued his altarpiece at St. Clement Danes in London in a print published in October 1725, wrote after Kent's death: "Never was there a more wretched dauber."[15]

With this trio of connoisseur, architect, and hack artist, we have assembled a group who, to Hogarth, can only have been an anathema. As Walpole noted, Hogarth was not good at flattery, and although his portraits of the Child family are straightforward enough, his rendering of the room in which they stand has been seen by Marks as a reflection of Hogarth's true feelings about the taste of Lord Castlemaine.

Plate 23 of Campbell's *Vitruvius Britannicus* is a plan of Wanstead. From it we can surmise that Hogarth shows us the ballroom (formerly the library and two adjacent chambers), 75 feet long by 25 feet wide, on the east side of the house. The artist stood facing south so that we see the two great windows on the south (front) side of the house. A door to the left of the fireplace leads to the central part of the house. But as many writers, including Cornforth, Webster, and Marks, have pointed out, it would be a mistake to regard the room we see as a portrait of a real space with real furniture. No piece of furniture matching the ornate, gilded chairs and tables has come to light, nor do they seem to be based on actual designs by William Kent. Rather, we may assume that Hogarth, as would be consistent with his own stated working methods, painted the room and furniture from memory in his studio. Perhaps, as Marks believes, he exaggerated the pompous baroque trappings of the ballroom, but this may be the result of his attempt to re-create a strong general impression when back in his studio and not (at this stage in his career) a way of deliberately satirizing the taste of an influential patron. Marks also pointed out that the carved term of the fireplace (fig. 39-1) behind Lord Castlemaine resembles the engraving of Kent after a portrait by William Aikman (1682–1731) and suggested that the inclusion of Kent's features petrified in wood or stone is Hogarth's gibe at Kent's petrified taste—but again, the painting was a commission for a private client and was never engraved, so Hogarth's subtle satire, if satire it was, would have been wasted. We must beware of treating *The Assembly at Wanstead House* as though it were a trial run for "The Rake's Progress."

The scene is the ballroom of Wanstead House. The time is late afternoon; the Child family has gathered for tea drinking and card playing, while a servant, having already drawn one curtain on the sinking sun, now lights the chandeliers. The occasion depicted has never been identified, but the reason for the gathering of the Child family is not difficult to discover. On April 22, 1703, Richard Child married Dorothy, daughter of John and Dorothy Glynne (d. 1743/4) and together they had five children. Child commissioned this

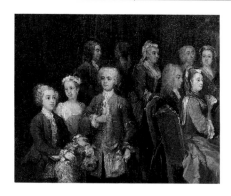

FIG. 39-3 Detail of *The Assembly at Wanstead House* showing younger children

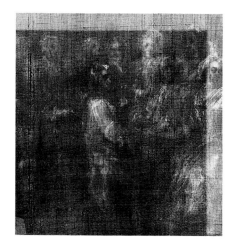

FIG. 39-4 Detail of x-radiograph of *The Assembly at Wanstead House* showing Lady Castlemaine, Philadelphia Museum of Art, Conservation Department, 1981

picture on August 28, 1729,[16] thus it is possible that it records the celebrations for the twenty-fifth wedding anniversary of Lord and Lady Castlemaine of the previous year.

At the far right Lord Castlemaine, dressed in rich red velvets, is seated on a gilded and carved X-framed chair (fig. 39-2). His daughter is next to him, raising a china teacup (still without a handle at this date) and a saucer. Next to them sits another daughter, offering to pour her father tea. At the other end of the room stand their three younger children, the youngest son astride a poodle at the left, the youngest daughter, Emma (in 1735 to marry Sir Robert Long), in the center, and John, the second son but first surviving male (1712–1784), on the right (fig. 39-3). John inherited the estate and title on February 19, 1733/4, when his older brother Richard, who may be the heavy-set young man seated at the card table in the center, died of smallpox. The lady in the exact center of the composition has been identified by Marks as Lady Castlemaine, and x-radiographs show that her face was originally much coarser and older (fig. 39-4). A close look at the features of the daughter sitting next to Lord Castlemaine and a three-way comparison among her, the lady in the center as seen in the x-radiographs, and the two little boys on the left of the composition show that they all bear a close family resemblance. We know from Vertue that Hogarth was known for his attention to "an exact immitation of Natural likeness";[17] hence it is reasonable to suppose that this lady is the children's mother. Moreover, once we have noted the thick, ugly eyebrows of Dorothy Glynne Child, we can look through the assembled company and point to those relatives who are obviously related to the Castlemaines through the Glynne connection.

If this is indeed the celebration of a wedding anniversary, several other motifs first discussed at length by Marks can be re-examined and explained as allusions to the devotion of the couple for each other. Lady Castlemaine shows her husband the ace of spades, the winning card, and so an allusion to their winning partnership. In front of them a pair of whippets flirt in a charming motif that parodies, in a favorite device of Hogarth's, the emotions of their human owners.[18] Over the fireplace are two works of art alluding to classical examples of wifely fidelity, a painting by Godfried Schalcken (1634–1706), *Portia Destroying Herself*, in which the wife of Brutus swallows live coals at the news of her husband's death;[19] and below stands a bust of Julia, the faithful wife of Pompey (see fig. 39-1).[20]

Behind the Castlemaines hangs a fragment of a tapestry identified as *Telemachus Detained by Calypso*, woven by the Leyniers factory in Brussels and bought by "Milord Chartelman" between 1724 and 1728.[21] As Marks has pointed out, the glimpse we get shows the left-hand side of the tapestry, a group of music-making nymphs who by their introduction into this particular scene allude to the assembly as a garden of love, a *fête galante*. And, of course, Telemachus is the dutiful son of the faithful Penelope and wise Odysseus, themselves examples from Greek mythology of marital fidelity. On the other side of the fireplace is another tapestry, *Alexander at the Battle of Granicus*, after Charles Lebrun (1619–1690), and above in the painted ceiling we have the merest suggestion of an Olympian scene (fig. 39-5), probably a reflection of a ceiling painting actually at Wanstead, and if so, perhaps an allusion to Lord Castlemaine as a contemporary Jupiter.

Hogarth has included twenty-five portraits and the figure of a servant in a canvas only 25½ by 30 inches. Undoubtedly the commission necessitated a visit to Wanstead, where the artist may have painted several of the principal figures, and then perhaps a number of visits by the sitters to Hogarth's studio in Covent Garden over the next few years. The great number of portraits and the

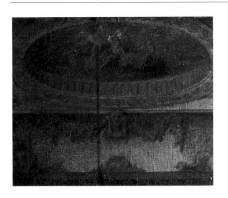

FIG. 39-5 Detail of *The Assembly at Wanstead House* showing ceiling painting

drudgery of fitting them all into the composition probably accounts for Hogarth's long delay in completing the work, for by January 1, 1731, it was still unfinished. The composition is, however, cleverly thought out. Three groups of principal figures are in the foreground plane. These consist of members of the immediate family and their closest relations, perhaps the brothers and sisters of Lord and Lady Castlemaine. Behind them, like a chorus in an opera, stand more distant relations and friends—one, at least, identifiable as a widow in mourning, who, because her face is cut off, may herself have died before Hogarth could paint her. The total effect is in some ways monotonous (Jonathan Richardson wrote of this kind of conversation piece that the faces look like "a great many single grapes scattered on a table");[22] but given the problem, Hogarth makes a staid gathering relatively lively and elegant; and it was because of this ability that his early reputation was made.

As early as 1730 the poet Joseph Mitchell could write in his "Poetical Epistle to Mr. Hogarth," certainly in reference to this picture, that "Large Families obey your hand; Assemblies rise at your Command."[23] But whatever the merits and the limitations of *The Assembly at Wanstead House,* it should be repeated that Hogarth was only beginning to work in this genre. A comparison between this painting and a composition executed around 1730, *The Wollaston Family* (40⅜ x 49¼", Leicester, Museums and Art Gallery), shows that very soon Hogarth advanced perceptibly in his ability to break up a frieze-like composition into one that works in different planes of the picture surface.

In the later 1740s Hogarth sketched a series of paintings that he intended as a sequel to "Marriage à la Mode," to be called "The Happy Marriage." One of these sketches, *The Country Dance,* Hogarth had engraved and used as an illustration for his *Analysis of Beauty* of 1753, plate II. John Ireland described this composition as *The Wanstead Assembly* and wrote that it contained portraits of the first Earl Tylney (Castlemaine) and his countess.[24] He dated it 1728. *The Country Dance* has, therefore, occasionally been confused with the picture in Philadelphia.

This entry is based largely on Arthur Marks's 1981 article in the *Philadelphia Museum of Art Bulletin*, vol. 77, no. 332 (spring 1981), pp. 2–15.

1. Vertue, 1934, pp. 40–41.

2. In Hogarth's own words: "Then maried and turnd Painter of Portraits in small conversation Peices and great success" (William Hogarth, *The Analysis of Beauty with the Rejected Passages from the Manuscript Drafts and Autobiographical Notes,* ed. Joseph Burke [Oxford, 1955], pp. 215–16).

3. Quoted by Nichols and Steevens, 1808–17, vol. 1 (1808), pp. 19–20.

4. Quoted by Paulson, 1971, vol. 1, p. 373; *St. James's Evening Post*, June 7–9, 1737.

5. Hesther Lynch Piozzi, *Anecdotes of the Late Samuel Johnson*, ed. Arthur Sherbo (London and New York, 1974), p. 106; quoted in Joseph Burke, "Hogarth and Reynolds," *The William Henry Charlton Memorial Lecture, November 1941* (Oxford and London, 1943), p. 6.

6. Winifred V. Phillips, *Wanstead through the Ages,* 2nd rev. ed. (London, 1949), p. 29.

7. For Child, see the *Complete Peerage,* 1910–, vol. 2 (1913), p. 92; Romney Sedgwick, *The History of Parliament: The House of Commons 1715–1754* (London, 1970), vol. 1, p. 549.

8. Mark Girouard, *Life in the English Country House: A Social and Architectural History* (New Haven and London, 1978), p. 2.

9. John Harris, *Colen Campbell, Catalogue of the Drawings Collection of the Royal Institute of British Architects* (Farnborough, 1973), p. 16, no. 31.

10. Colen Campbell, *Vitruvius Britannicus, or the British Architect* (London, 1715), vol. 1, pls. 21–27.

11. Phillips (see note 6), p. 30.

12. John Steegman, *The Artist and the Country House* (London and New York, 1949), p. 37.

13. Quoted by Arthur S. Marks, "Assembly at Wanstead House," *Philadelphia Museum of Art Bulletin,* vol. 77, no. 332 (spring 1981), p. 8.

14. Ibid., p. 15, n. 25.

15. Engraving, 11⅛ x 7″. See Kitson, 1968, pp. 86–87.

16. Hogarth's "Account taken January first 1731 of all ye Pictures that Remain unfinish'd," ADD. MS., 27 995 f.1., British Museum, London.

17. Vertue, 1934, p. 41.

18. As, for example, in *The Marriage Contract,* the first scene in "Marriage à la Mode."

19. Cornelis Hofstede de Groot, *A Catalogue Raisonné of the Works of the Most Eminent Dutch Painters of the Seventeenth Century,* 8 vols. (London, 1908–27), vol. 4 (1913), p. 335, no. 89. Sold at the Wanstead sale, June 20, 1822, lot 167.

20. The bust of Julia appears again in the oil sketch of *"A Rake's Progress"* (c. 1733, 24¼ x 29¼″, Oxford, Ashmolean Museum). See Paulson, 1971, vol. 1, p. 374.

21. See Heinrich Göbel, *Tapestries of the Lowlands,* trans. Robert West (New York, 1924), pl. 295, for the "Story of Telemachus" woven in Brussels by the Reydams-Leyniers-Konzern factory about 1725. Hogarth alters the figures on the left of the tapestry so drastically that it is probable he painted the tapestry from memory. See also Marthe Crick-Kuntziger, "The Tapestries in the Palace of Liege," *The Burlington Magazine,* vol. 50, no. 289 (April 1927), p. 177. Both sources cited originally by Marks.

22. Jonathan Richardson, "The Theory of Painting," in *The Works of Jonathan Richardson* (Strawberry Hill, 1792), p. 55.

23. Quoted by Vertue, 1934, p. 48.

24. Ireland, 1791, vol. 1, p. lxxv.

PROVENANCE: Commissioned by Richard Child, Viscount Castlemaine; by descent to Hon. William Pole-Wellesley, later 4th Earl of Mornington, 1814–22; sold by him at the Wanstead House sale, June 20, 1822, lot 171; Sir Robert Peel, 1862; Frederick Davies, 1885; Lord Tweedmouth, 1896–1905; C. Morland Agnew, 1906; bt. John H. McFadden, September 5, 1910.

EXHIBITIONS: London, British Institution, 1814, no. 121; London, *International Exhibition,* 1862, no. 86; London, Royal Academy, 1885, no. 28; London, Royal Academy, 1896, no. 19; London, Royal Academy, 1906, no. 20; Manchester, City Museum and Art Gallery, 1909, no. 59; New York, 1917, no. 14, fig. 14; Pittsburgh, 1917, no. 14; Detroit, The Detroit Institute of Art, *English Conversation Pieces of the Eighteenth Century,* January–February 1948, no. 13, repro. p. 17; London, 1951, p. 6, no. 24; Montreal, Montreal Museum of Fine Arts, Ottawa, National Gallery of Canada, Toronto, Art Gallery of Toronto, Toledo, Toledo Museum of Art, *British Painting in the Eighteenth Century,* 1957–58, no. 29, repro.; Richmond, Virginia, Virginia Museum of Fine Arts, *William Hogarth,* January 30–March 5, 1967, no. 8 repro. p. 16; London, 1971–72, no. 29.

LITERATURE: Ireland, 1791, vol. 1, p. lxxv (confused with *The Country Dance);* Ireland, 1798, p. 23; Pilkington, 1805, p. 248; Nichols and Steevens, 1808–17, vol. 1 (1808), pp. 16, 45, vol. 2 (1810), pp. iv, 86, vol. 3 (1817), p. 172; Walpole, 1828, vol. 4, p. 150; Nichols, 1833, pp. 122, 350, 376, and mistakenly on p. 370; Trusler, 1833, vol. 1, pp. 2–3; Cunningham, 1879, vol. 1, p. 67; Dobson, 1907, pp. 21, 198, 310, and mistakenly on p. 196; Roberts, 1913, p. 537; William Roberts, "Two Conversation Pieces of Hogarth," *Art in America,* vol. 1, no. 2 (April 1913), pp. 104–9, fig. 22; Roberts, 1917, pp. 27–28, repro. opp. p. 27; Roberts, 1918, "Portraits," pp. 125–26, repro. p. 126; Roberts,

1920, p. 1; Philadelphia, 1928, p. 20; *The Pennsylvania Museum Bulletin,* vol. 24, no. 125 (February 1929), pp. 2, 19; *The Pennsylvania Museum Bulletin,* vol. 25, no. 129 (November 1929), pp. 7–9, repro. p. 6; Fiske Kimball, "Wanstead House, Essex.–1," *Country Life,* December 2, 1933, pp. 606–7, repro. p. 605; Frederick Antal, "Hogarth and His Borrowings," *The Art Bulletin,* vol. 29 (March 1947), p. 43 n. 26; Beckett, 1948, pp. 160–62, p. 161 fig. 1; Edgar P. Richardson, "Conversation for the Eye," *Art News,* vol. 47, no. 1 (March 1948), p. 35, repro. p. 35; Beckett, 1949, pp. 8, 46, pl. 32; Winifred V. Phillips, *Wanstead through the Ages,* 2nd rev. ed. (London, 1949), pp. 34, 36; Helen Comstock, "Paintings as Documents, I, English Interiors as Seen in Conversation Pieces," *Antiques,* vol. 58, no. 5 (November 1950), pp. 366–67, repro. p. 367; Ralph Edwards, "Hogarth's Tea-Tables," *The Burlington Magazine,* vol. 93, no. 582 (September 1951), p. 304; John Gloag, *Georgian Grace: A Social History of Design from 1660 to 1830* (London and New York, 1956), pp. 93, 100, 103, pl. 25; Antal, 1962, p. 36, 225–26 n. 26, pl. 28a; Baldini and Mandel, 1967, no. 37, pl. VII–VIII; Edward Croft-Murray, *Decorative Painting in England, 1537–1837* (Feltham, Middlesex, 1970), vol. 2, p. 249; Paulson, 1971, vol. 1, pp. 212–13, 218, 225, p. 221 pl. 80; Edwards, 1972, pp. 14–16, 21, p. 15 fig. 1 (detail); M.J.H. Liversidge, "An Elusive Minor Master: J. F. Nollekens and the Conversation Piece," *Apollo,* vol. 95 (January 1972), pp. 34, 41 n. 5, p. 34 fig. 2; Staley, 1974, p. 35; John Cornforth, "Painters and Georgian Interiors," *Country Life,* January 27, 1977, pp. 174–75; Lindsay, 1977, p. 54; William Gaunt, *The World of William Hogarth* (London, 1978), repro. between pp. 22–23, no. 3; Waterhouse, 1978, p. 170; Potter, 1979, p. 135; Webster, 1979, pp. 20–21, 34, repro. p. 34; Arthur S. Marks, "Assembly at Wanstead House," *Philadelphia Museum of Art Bulletin,* vol. 77, no. 332 (spring 1981), pp. 2–15.

CONDITION NOTES: The original support is medium-weight (10 x 10 threads/cm.) linen. The tacking margins have been removed. A series of parallel creases run vertically down the left-hand side of the painting. The painting is lined with an aqueous adhesive and lightweight linen. An off-white ground can be seen along the cut edges. The paint is generally in fair condition. A pronounced traction crackle has formed over much of the design. The x-radiograph reveals an extensive network of especially wide traction crackle in the foreground. A fine web of fracture crackle extends over the surface, with associated cupping. Losses are located primarily along the tacking edges and at the edges of cupped paint. Ultraviolet light examination reveals local retouching overall as well as considerable overpainting (probably bituminous) in the lower left corner.

40 WILLIAM HOGARTH

CONVERSATION PIECE WITH SIR ANDREW FOUNTAINE, c. 1730–35
Oil on canvas, 18¾ x 23" (47.6 x 58.4 cm.)
John H. McFadden Collection, M28-1-14

This is one of two conversation pieces showing almost the same group of
sitters gathered together in a garden. Sometime before 1817 the Philadelphia
version was altered by the painting out of the figure of the gentleman who
reclines at the feet of the two ladies in the other version (version 1, henceforth
Langford version, fig. 40-1). In the following discussion of the composition
and of the identity of the sitters, we will refer to the x-radiograph of the
Philadelphia picture in which this figure appears (fig. 40-2).

The composition of both versions was formed originally by two groups
of three figures each, divided by a couloir, or inverted pyramid in the center.
To the left sit two young women at a circular tripod table, probably made at
the end of the seventeenth century,[1] on which stand a wicker flask, some fruit,
and a glass. The woman to our left in a brown dress wearing a pearl necklace
looks through a magnifying glass at the picture the gentlemen at the right are
discussing and points out its merits to her companion with the index finger of
her right hand. Her friend holds a round object in her right hand, possibly an
extra lens to insert into the magnifier to increase its power. She is dressed in a
blue frock with a white muslin apron and head covering.

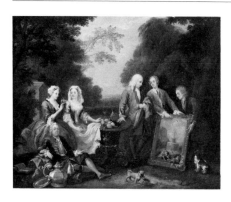

FIG. 40-1 Attributed to William Hogarth, *Conversation Piece with Sir Andrew Fountaine,* c. 1742–50, oil on canvas, 18¼ x 22¾" (46.3 x 57.8 cm.), London art market, 1980 (Langford version)

At the other side of the table, to our right, three men are grouped around a picture. In this fictive painting a tiny, winged Pegasus can be seen in the sky soaring away from a cluster of half-clothed women reclining by the basin of an overflowing fountain. The scene is therefore meant to be Parnassus, the domain of the Muses, where Pegasus by stamping his hoof caused a fountain to gush forth from the earth. Gazing at this fictive Parnassus is an older man, his full-bottomed wig touching his shoulders, dressed in an eighteenth-century gentleman's suit of dun color; he also wears a peach-colored mantle tucked into his left elbow and passed around his middle to spread out behind him—a device used in baroque portraiture to enhance the dignity and stature of a sitter and employed in many early portraits by Hogarth such as his *Woodes Rogers Family* (1729, 16½ x 22", Greenwich, National Maritime Museum). This gentleman places his left hand within his buttoned coat, a dignified gesture underlying his position as the most important figure in the group and the one around whom the conversation piece revolves. Next to him, a younger man with thick eyebrows and a double chin, wearing a short tiewig powdered gray and a red, embroidered coat, helps to support the picture with his left hand while pointing to it with his right. At the far right, closing his eyes and bowing slightly, supporting the carved and gilded frame of the fictive picture with both hands, is an older man in a plain brown suit, his hair undressed.

The conversation takes place on a spring or summer's day in an (almost certainly imaginary) garden or park. The sitters are surrounded by willow and orange trees and have supplied themselves with agreeable things in life—food, a flask and a silver flagon for wine, books, pictures, and their pets (a spaniel and a mischievous pug in the foreground, a dog that perhaps belonged to the artist).

In the Langford version, an older gentleman lies propped up by one elbow at the feet of the two ladies. He is a slightly comical-looking fellow, richly dressed in blue satin trimmed with gold, but posed in the attitude of a river god, or more ridiculously, of one of the Muses by the fountain. X-radiographs (fig. 40-2) of the Philadelphia picture also show him in approximately the same position as the figure in the Langford version, and yet different in certain important respects. Here his head is turned toward the left so that he is looking out of the picture instead of toward the right-hand group; his face is very different from that of the man in the Langford conversation: he may be much younger and wears not a short wig but a shoulder-length one. This figure has been painted over crudely, but in such a way that the silver tankard has not been disturbed.

In addition, the face of the woman seated second from the left has been worked over. The short brushstrokes that under a microscope can be seen to model all the faces in the Philadelphia picture by following the contours of the face to define form are, however, also visible in this woman's face. They have been lightly painted over, not to change the face but to make it appear brighter, fresher. The lips, for example, have been given a vermilion tinge and the face delicately heightened with a thin wash of pink in brushstrokes that do not follow the form. We can conclude that the face was originally painted by the same hand that executed the faces in the rest of the canvas, but that at a later date this one face was lightly repainted. Furthermore, the woman at the far left shows in the x-radiograph numerous pentimenti around the head, shoulders, and arms—but these are the original artist's mistakes and corrections, not the hand of a later restorer.

Judged purely on the basis of style and quality, the Philadelphia picture would seem to be the first version by Hogarth himself. The Langford picture is a close copy after it, perhaps also by Hogarth, but not necessarily of the

FIG. 40-2 X-radiograph of *Conversation Piece with Sir Andrew Fountaine,* Philadelphia Museum of Art, Conservation Department, 1985, showing reclining figure

same date. In the Philadelphia picture the handling of the paint is tighter, crisper, and more vigorous than in the other version. The faces are more sharply drawn, the textures and the folds of the clothing (except in the one area of obvious repainting in the lower left-hand corner) thoughtfully observed and rendered. A comparison of the faces of the three men in the Philadelphia and the Langford versions reveals that in the former the underlying bone structure has been made clear, whereas in the latter, it is absent, giving the faces a bland and flaccid quality. A side-by-side comparison between the Philadelphia Fountaine conversation piece and Hogarth's *Assembly at Wanstead House* (no. 39) shows that at this date, about 1730, the slight tightness of handling and the miniature-like quality of the heads is consistent with Hogarth's early portrait style. That the Langford version is a replica is also indicated by the omission from it of the braid and trim on the red coat of the younger man pointing to the picture.

The Philadelphia picture has an impeccable provenance. Until 1909 it was at Narford Hall, the family home of the Fountaine family, whose ancestor Sir Andrew Fountaine is presumed to have commissioned it. The Langford picture's provenance is almost, but not quite, as good. It was published for the first time in 1799 by Samuel Ireland in the collection of Abraham Langford of Highgate (d. 1818), who is presumed to have inherited it from his father, also Abraham Langford. It has been claimed, but cannot be proved, that Langford, Sr., inherited it from his partner in business, the auctioneer Christopher Cock[2] and, if so, that Cock was responsible for commissioning this version. Lending support to this theory is the mention in a list of unfinished pictures compiled by Hogarth in January 1731 of "A Conversation of six fig: Mr. Cock Nov[ber]. 1728."[3]

The history of the various conflicting identifications of the sitters is complicated and would be tedious to relate: few writers seem able to agree on who is depicted in the two versions, and the hitherto unsuspected figure revealed by the recent x-radiograph of the Philadelphia picture means that until now historians have been forced to conjecture. An appendix to this entry outlines the conflicting theories about the sitters. What follows is an attempt to explain a picture that will be argued about for many years to come.

The older man around whom the composition revolves must be Sir Andrew Fountaine (1676–1753), resembling as this figure does the marble portrait of Sir Andrew by Roubiliac (1705?–1762) at Wilton House and at Narford Hall and corresponding to the age Sir Andrew would have been around 1730, that is, fifty-four. The picture at which Sir Andrew Fountaine looks is, of course, a play on his name and a flattering allusion to his role as patron of the arts symbolized by the Muses and perhaps even to his creation of a new Parnassus at his country seat, Narford Hall. This picture has never been identified and may well be an invention of Hogarth's;[4] however, an interesting precedent for the motif of the Parnassian fountain exists in an object still in the possession of the Fountaine family at Narford Hall. This is a silver charger by a late seventeenth-century German silversmith, engraved with the subject of the *Visit of Minerva to the Muses on Mount Parnassus.* On it, the number and distribution of the figures is slightly different from those in the Parnassus in Hogarth's picture, but the fountain, double-tiered and flowing with water, is identical. It is therefore reasonable to suppose that Hogarth invented the composition himself, but under instructions from Sir Andrew, who was able to describe the charger to him. The subject of the German plate is also a play on words, but with implications beyond simply the name of Fountaine: the Electress of Hanover, Sophia, presented it to Sir Andrew to commemorate his role in the delegation of gentlemen who brought to Hanover the news of the Act of Succession in 1701.[5]

Sir Andrew Fountaine came from an old Norfolk family. His father, also Andrew Fountaine (d. 1706/7), purchased Narford Hall in 1666–67 and rebuilt the house in the Queen Anne style in 1704. His son was educated at Eton, then at Christ Church, Oxford, where he shone as the most brilliant classical scholar of the celebrated Dr. Henry Aldrich (1647–1710), receiving his B.A. in 1696 and M.A. in 1700. Andrew Fountaine was chosen to deliver an address of welcome in Latin to King William III, and for this reason was knighted by the king at Hampton Court on December 30, 1699, at age twenty-three. In the summer of 1701 he was sent to Hanover with Lord Macclesfield (1659–1701) to present the Electress Dowager Sophia with a copy of the Act of Succession, for which, as we have seen, he was rewarded with the silver charger. On this mission he also journeyed through Germany and Italy, buying curiosities and antiquities as he traveled.[6] Upon his return to England, Fountaine began to advise the earls of Pembroke and Devonshire on matters of collecting,[7] and in 1707 accompanied the Earl of Pembroke to Ireland as Usher of the Black Rod, where Fountaine met and patronized Jonathan Swift.[8]

He succeeded to Narford in 1706/7 and in the same year embarked for a stay in Paris, Rome, and Florence. In the last city he became the close friend of the Medici prince Cosimo III. By the time of his return to England about 1717, Fountaine's collection of coins and medals, majolica, watches, and armor was unrivaled in England. Later he was to serve the Hanoverian royal family as vice chamberlain to Princess Caroline (1725); as proxy for Prince William, later Duke of Cumberland, at the prince's installation at the revival of the Order of the Bath; and finally as Warden of the Mint (1727–53). His real claim to the attention of historians, however, is his incredible activity as a collector.

His collection, although it included prints and paintings, consisted primarily of objects, and particularly of Renaissance earthenware. In his taste for sixteenth-century virtu, Fountaine was almost alone in his generation, for the eighteenth-century collector tended to concentrate on antiquities or Italian pictures. However, the inaccessibility of the collection in the family home in Norfolk until its dispersal by auction in 1884 (objects) and 1894 (paintings) has led to the neglect by historians of Fountaine's considerable position as a collector and arbiter of taste in the first half of the eighteenth century.

According to Jonathan Richardson the younger, Fountaine was "one of the keenest *virtuosi* in *Europe,* and out-*Italianed* the *Italians* themselves."[9] He also patronized living artists. His portrait was drawn by Carlo Maratta (1625–1713), and he purchased two religious subjects from the same artist (England, private collection). He invited Pellegrini (1675–1741) to Narford to paint the salon with the *Loves of the Gods.* As we have seen, he also patronized Hogarth. A comment in a letter from a Dr. Clarke (probably George Clarke, 1661–1736) to Mrs. Clayton dated April 22, 1732, suggests that it was Fountaine who, as Warden of the Mint, introduced John Conduitt (1688–1737), Master of the Mint, to Hogarth, and that it was thus indirectly through Fountaine that the artist received Conduitt's commission to paint his famous early masterpiece *A Scene from "The Indian Emperor"* (1732–35, 51½ x 57¾", Melbury House, Lady Teresa Agnew Collection): "Mr. Conduit came into the country with Sir Andrew Fountaine for two days in Easter Week but I did not see him. I am told he is going to have a conversation piece drawn by Hogarth of the young people of Quality that acted in his house."[10]

We know, too, that Fountaine took an interest in other contemporary English artists and on one occasion, in 1722, was present during a visit to the St. Martin's Lane Academy by the Prince of Wales, later George II.[11] Vertue tells a story about Gravelot (1699–1773), who, sitting one day in Slaughter's Coffee House, held forth "with great vehemence and Freedom for and against

whom he pleas(ed) . . . mentioning Sr. Andr Fountain he said amongst other
remarkables that he never imployed or encouraged Ingenious men or persons
of merrit only stupid silly blockheads or bunglers in Art." Whereupon the
French painter Jean François Clermont (1717–1807), much employed by Sir
Andrew, "gave him a stout box on the face, telling him he deserv'd that justly.
and should have more if he liked it."[12]

The tradition that the auctioneer Christopher Cock appears somewhere in
the Langford and Philadelphia versions is so persistent that it cannot be
dismissed lightly. The motif of the younger man in red showing a picture to
his client, Sir Andrew, makes him the logical candidate for Christopher Cock,
although it should be stressed that this figure was identified by a
nineteenth-century member of the Fountaine family as Capt. William Price,
Sir Andrew's nephew by marriage—an identification accepted by Mary
Webster in her 1979 monograph. We know very little about Christopher Cock.
He died on December 10, 1748, but the date of his birth is not known
precisely. His father, John Cock (d. 1714), was a printseller and picture dealer
in London, and Vertue mentions that "young Cock" was involved in the sale
of Sir George Hungerford's pictures in March 1716/7.[13] This epithet "young"
might suggest a birth date somewhere near or before 1700, and in any case the
next time we hear Cock's name mentioned as an auctioneer is in connection
with the dispersion of Elihu Yale's (1649–1721) vast horde of paintings,
pictures, and objects in 1721. This sale comprised ten thousand articles sold in
thirty-six hundred lots in a marathon of seven sales, most lasting six days each,
spread over a period of two years from December 1721 to April 1723. These
sales established Cock as the foremost auctioneer of his time. In 1725 he moved
to rooms in the Great Piazza, Covent Garden, and so was a neighbor of both
Thornhill (whose sale he conducted in February 1734) and Hogarth. Lugt
records numerous sales conducted by Cock between 1726 and 1748, and one
historian calls him "the forgotten father of the auctioneering profession in
the first of London's auction offices."[14] The man in brown to the right can
only be a servant either of Fountaine or Cock, as no man distinguished
enough to have his portrait painted would deign to appear in so menial and
obsequious a pose.

Another consistent tradition names Captain Price as a sitter. Price was
married to Elizabeth Clent, the daughter of Sir Andrew's sister Elizabeth
Clent (d. 1740). Captain and Mrs. Price were Sir Andrew's heirs, and their son
Brigg Price inherited both Narford and Sir Andrew's vast collections,
assuming the name and arms of Fountaine in 1769. The idea put forward by
Webster that the man in red is actually wearing a military uniform, and that
his gesture in pointing to a picture of a fountain refers to his marriage into the
Fountaine family is most attractive, and, like most of the other theories,
cannot be disproved, only made less likely if we are forced to account for
Christopher Cock's presence somewhere in the canvas. It is possible, however,
that Captain Price *did* once appear in the picture as the man now painted out
of the Philadelphia version. Certainly he is younger than the equivalent man in
the Langford version, and the ease with which he reclines on the ground may
perhaps indicate his status as a gentleman and Sir Andrew's social equal. Why
he should be painted out is not known, but it may be of some significance
that he is not buried beside his wife and children at Narford.[15]

If these identifications are correct, we should follow the lead of the
Fountaine family catalogue in identifying the woman in brown as Mrs. Cock[16]
and the woman in blue as Elizabeth Price (1706–1746)—identifications that
make sense only if the husbands of these two women also appear, or appeared,
in the picture.

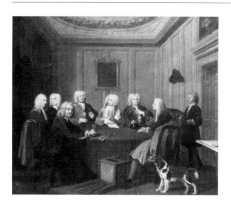

FIG. 40-3 William Hogarth, *A Club of Gentlemen*, c. 1728–31, oil on canvas, 18½ x 23″ (47 x 58.4 cm.), New Haven, Yale Center for British Art, Paul Mellon Collection

We are now left with the fellow who reposes in the Langford version at the feet of the women. Since 1799 he has been called John Rich (1692–1761), the pantomimist and owner of the theater in Lincoln's Inn Fields where John Gay's *Beggar's Opera* was first performed. Rich is also the man who built the first Covent Garden Theatre in 1731. He lived on a grand scale, loving wine and women and filling his house in Bloomsbury Square with friends.[17] We know him to have been a business associate and close friend of Cock and also a friend and patron of Hogarth, who devoted a satirical print to him in 1732, *Rich's Triumphal Entry into Covent Garden,* and who was a fellow member of the famous Beefsteak Club, founded by Rich in 1735. Ostentatious, corpulent, a good mimic and humorist, as Lun the Harlequin, Rich was the foremost pantomimist of his age, a clown of genius.

In the conversation piece Rich is at least fifty, indicating that this version dates from at least 1742. When the Langford version was engraved in 1799 for Samuel Ireland's book on Hogarth it was called a "Garden Scene at Cowley, [Middlesex on the Thames near Uxbridge] the home of Thomas [*sic*] Rich." John Rich did own a house at Cowley, but bought it in 1742.[18] As Cock died in 1748, the tradition that the conversation shows Rich and Cock together at Cowley must date from the 1740s. Samuel Ireland gives the date of "about 1750" to the Langford version, noting that Rich appears to be a full twenty years older in it than in a Hogarth reproduced by Ireland as the *Rich Family,* which dates from about 1730.[19]

On the face of it, the Hogarth manuscript summary of commissions unfinished as of January 1, 1731, listing one conversation ordered by Cock for "A Conversation of six fig: Mr. Cock Nov^ber. 1728" would seem to be describing the Langford picture. The question is, Was this conversation finished at once, or was the fulfillment of the commission delayed? We may be able to suggest a tentative answer by examining two other commissions from Cock.

The first is another conversation, *A Club of Gentlemen* (fig. 40-3). This was said by Nichols and Steevens (1808–17, vol. 3, p. 181) to show Rich, Cock, Pope, Steele, and Gay—identifications that cannot be verified. *A Club of Gentlemen* is almost identical in size to the Langford Fountaine family and for stylistic reasons must be dated about 1730 or slightly before. It is not, however, the conversation mentioned in Hogarth's 1731 list because it contains more than six figures. *A Club of Gentlemen* descended (through Cock?) to the Langford family, as did their version of the Fountaine family, so since the eighteenth century the two pictures have been considered pendants. Yet the very different proportions of the figures in the two pictures and their uncomplementary compositions argue that the pictures were not *painted* as pendants. Indeed, the much more sophisticated composition of the Fountaine family, the very different mood, would suggest that they were not painted at the same time. One hypothesis is that *A Club of Gentlemen* was painted in the late 1720s and a pendant to it commissioned at the same time. This is the pendant that was not finished in the list of 1731. Then, for reasons we do not know, the execution of the commission was delayed, and when the artist came to fulfill his obligations he satisfied his friend and client Cock with a repetition of a scene in which Cock and Cock's wife already appeared, the *Conversation Piece with Sir Andrew Fountaine;* but as Captain Price was perhaps not a close friend of Cock, Hogarth substituted for his figure that of the good friend of both Cock and Hogarth, John Rich.

It is suggestive that still another picture commissioned by Cock from Hogarth, *An Auction of Pictures,* was left unfinished (19 x 29½″, Lt. Col. H.M.C. Jones-Mortimer Collection).[20] Again, this is a picture of the early 1730s and is said to show Cock's auction rooms at Covent Garden. Like several

pictures associated by tradition with Cock, the question of who and what is actually depicted is uncertain, and the reason it was left unfinished is not known. It is interesting, however, to compare the woman in brown in both versions of the *Conversation Piece with Sir Andrew Fountaine* with the woman sitting in the foreground of *An Auction of Pictures*. The pose, gesture, and clothes at any rate do seem to be similar. Can it be that Mrs. Cock was also meant to appear in *An Auction of Pictures*?

Finally, if the Philadelphia and Langford conversations do indeed represent Sir Andrew Fountaine and Christopher Cock, there is an irony in Hogarth's painting them at all, for as the leading connoisseur and art dealer of their day, they may be supposed to have represented everything most enraging to Hogarth, who never ceased to bewail the damage done to the cause of the development of a native English school of painting by dealers and patrons. In the *St. James's Evening Post* of June 7–9, 1737, Hogarth wrote a satirical sketch of a dealer with his victim:

> "Mr. Bubbleman," says the honest buyer, "that Grand Venus (as you are pleased to call it) has not Beauty enough for the Character of an English Cook-Maid." Upon which the Quack answers with a Confident Air, "O L—d, Sir, I find you are no *Connoisseur*—That Picture, I assure you, is in *Alesso Baldovinetto's* second and best Manner, boldly painted, and truly sublime; the *Contour* gracious; the Air of the Head in the high Greek Taste, and a most divine Idea it is"—Then spitting on an obscure Place, and rubbing it with a dirty Handkerchief, takes a Skip to t'other End of the Room, and screams out in Raptures—"There's an amazing Touch! A Man shou'd have this picture a Twelve-month in his Collection, before he can discover half its Beauties."[21]

APPENDIX
Identifications of sitters in the Philadelphia version (no. 40)

Nichols and Steevens (1808–17, vol. 3 [1817], pp. 171–73) are the first to identify the sitters in the Philadelphia picture as Fountaine and Price, but do not commit themselves further. By this date the reclining figure had been painted out, and the ages of the two remaining important men would indicate that Price is the figure in red.

Nichols (1833, p. 370) identifies "one of the gentlemen" as William Price. This must be the figure in red.

MS. catalogue compiled by a later Andrew Fountaine (d. 1874) (still at Narford, Norfolk) identifies the figures as follows:
 Central figure: Christopher Cock ("Mr. Coxe")
 Man in red: Price
 Lady in blue: Mrs. Price
 Lady in brown: Mrs. Cock ("Mrs. Coxe").
The MS. states that the picture celebrates the marriage of Price to an heiress of the Fountaine family.

Identification of sitters in the Langford version (version 1)

Samuel Ireland (1794–99, vol. 2 [1799], pp. 67–70) dates the picture to about 1750 and identifies the figures as follows:
 Reclining man: Thomas Rich (a slip for John Rich)
 Man in center with his hand on the table: Christopher Cock
 Man in red: Hogarth
 Man at far right: a servant
 Lady with her hand on the table: Mrs. Rich
 Lady with magnifying glass: Mrs. Cock.

Nichols and Steevens (1808–17, vol. 2 [1810], pp. 287–88) repeat Samuel Ireland.

Nichols and Steevens (1808–17, vol. 3 [1817], pp. 172–81) cite Abraham Langford as their source for repeating Ireland, but with reservations.

Nichols (1833, p. 370) identifies the figures as follows:
 Reclining man: Mr. Rich
 "Other portraits": Mr. Cock, Hogarth
 Ladies: Mrs. Rich and Mrs. Cock.

Roberts (1913), Beckett (1948), Antal (1962), Gowing (London, 1971–72), Lindsay (1977), and Jarrett (1976) name the central figure as Sir Andrew Fountaine and the figure in red Mr. Cock, although Antal, Gowing, Lindsay, and Jarrett add the erroneous information that Cock was Sir Andrew's son-in-law.

Roberts (1917) calls the central figure Andrew Fountaine, the figure in red Mr. Price, and the man in brown Christopher Cock.

Webster (1979) identifies the figures as follows:
 Central figure: Andrew Fountaine
 Man in red: Mr. Price
 Man at far right: a servant
 Ladies: Mrs. Price and Mrs. Clent.

1. Edwards, 1972, p. 16.

2. When the Langford version was sold at Bonham's in 1974, the catalogue stated that Langford, Sr., was Cock's legatee. However, an examination of the wills in the Public Record Office, London, 1748–53, has failed to turn up Christopher Cock's will.

3. ADD. MS., 27 995 f.1., British Museum, London.

4. The iconography of Parnassus and Mount Helicon, both the abodes of the Muses in Greek mythology, includes the story of Pegasus striking his hoof to create a spring of water. In Medieval and Renaissance art the tendency is to represent a natural spring and not a manmade fountain. The fountain in Hogarth's picture corresponds more closely to representations of the *Fons Amoris*, the fountain of love, and is unusual in a Parnassus grouping.

5. Ranghild Hatton, *George I: Elector and King* (London, 1978), p. 75.

6. For Sir Andrew Fountaine, see his entry in the *Dictionary of National Biography* and the series of articles on his collection by J. C. Robinson, published in the *Times* (London) on April 18, May 19, and June 2, 1884. See also Walter Langley Edward Parsons, *Salle, The Story of a Norfolk Parish: Its Church, Manors and People* (Norwich, 1937).

7. Adolf Michaelis, *Ancient Marbles in Great Britian* (Cambridge, 1882), p. 57.

8. Jonathan Swift, *The Journal to Stella* (1710), ed. George A. Aitken (London, 1901), passim.

9. Jonathan Richardson, Jr., *Richardsoniana: or, Occasional Reflections on the Moral Nature of Man* (London, 1776), pp. 331–32.

10. Whitley Papers, British Museum, London.

11. Whitley, 1928, vol. 1, p. 18; Paulson, 1971, vol. 1, p. 107, quoting Vertue, 1934, p. 11.

12. Vertue, 1934, p. 91.

13. See Ronald Parkinson, "The First Kings of Epithets," *The Connoisseur*, vol. 197 (April 1978), p. 273.

14. Peter Ash, "The Great Yale Auction," *Estates Gazette*, vol. 179 (August 26, 1961), pp. 507–9.

15. An alternative to Captain Price for this reclining figure is Price's father-in-law, Colonel Clent (d. 1735), the father of Elizabeth Price. Clent had married Sir Andrew Fountaine's sister Elizabeth, and was thus Sir Andrew's brother-in-law. They were also close friends, for Clent had accompanied Sir Andrew to Italy earlier in the century and was painted with Sir Andrew in a conversation piece by the Italian artist Pignotti, set in the Tribuna in Florence (Narford Hall, Norfolk). If Clent were present, one of the women would be his wife, the other his daughter. As the painting now exists this is impossible, because the women are about the same age, not mother and daughter. However, the face of the woman in blue shows evidence in the x-radiograph of repainting, so it cannot be ruled out that she was originally an older woman.

16. Mrs. Cock was described by Samuel Ireland, 1794–99, vol. 2 (1799), as "famed at that time for her knowledge in the polite arts nor less so for her taste in literature."

17. Paul Sawyer, "John Rich: A Biographical Sketch," *The Theatre Annual*, vol. 15 (1957–58), pp. 55–68. Rich also owned the earliest version of Hogarth's *Beggar's Opera*. As late as the 1750s Hogarth was visiting Rich at his country house at Cowley. See Paulson, 1971, vol. 2, p. 184.

18. Sawyer (see note 17), pp. 57–58. It should be noted, however, that when Rich's second wife, Amy, died in 1737 she was buried at Hillingdon near Cowley, indicating that she had some connection with this part of Middlesex before the purchase of a house at Cowley by Rich in 1742.

19. This must be the picture mentioned in Hogarth's MS. list of 1731 as a "Family Piece Consisting of four figures for / Mr. Rich / half Payment Rec^d 1728," ADD. MS., 27 995 f.1., British Museum, London. Cock and Rich are also traditionally said to be depicted in Hogarth's *Beggar's Opera* of 1728, but if so their portraits have never been identified with certainty.

20. Paulson, 1971, vol. 1, pl. 73.

21. Paulson, 1971, vol. 1, pp. 372–73.

PROVENANCE: Sir Andrew Fountaine; by descent in the Fountaine family, Narford Hall, Norfolk, until 1909; Robert Langton Douglas, 1909; John H. McFadden, before 1913.

EXHIBITIONS: London, British Institution, 1817, no. 54 (as "The Family of Sir Andrew Fountaine," lent by A. Fountaine); London, South Kensington Museum, *National Portrait Exhibition*, 1867, no. 355 (lent by A. Fountaine); London, Burlington House, 1880, no. 46 (lent by A. C. Fountaine); New York, 1917, no. 15; Pittsburgh, 1917, no. 15; London, 1951, no. 22; London, 1971–72, no. 37; Richmond, Virginia Museum of Fine Arts, *William Hogarth*, January 30–March 5, 1967, no. 11.

LITERATURE: Nichols and Steevens, 1808–17, vol. 3 (1817), pp. 171–73; Walpole, 1828, vol. 4, p. 151; Nichols, 1833, p. 370; Waagen, 1854–57, vol. 3, p. 431; John Murray, ed., *Murray's Handbook for Essex, Suffolk, Norfolk, and Cambridgeshire* (London, 1870), p. 278; Walpole, 1888, p. 16; Dobson, 1907, p. 211; Roberts, 1913, p. 537; William Roberts, "Two Conversation Pieces of Hogarth," *Art in America*, vol. 1, no. 2 (April 1913), pp. 104–9, fig. 23; Roberts, 1917, pp. 29–30, repro. opp. p. 29; McFadden, 1917, repro. p. 112; Roberts, 1918, "Portraits," p. 126, repro. p. 128; Roberts, 1920, p. 1; Philadelphia, 1928, p. 20; *The Pennsylvania Museum Bulletin*, vol. 25, no. 129 (November 1929), p. 9, repro. p. 6; Beckett, 1948, pp. 162, 164, p. 164 fig. 3; Beckett, 1949, p. 43, pl. 24; John Gloag, *The English Tradition in Design* (London, 1959), pl. 17; Antal, 1962,

pp. 36, 225–26 n. 26, pl. 30c; Baldini and Mandel, 1967, no. 25, pl. VI; Mario Praz, *Conversation Pieces* (London, 1971), pp. 28, 29 fig. 2; Paulson, 1971, vol. 1, pp. 218, 529 n. 21, pl. 78; Edwards, 1972, p. 16, fig. 8; John Ingamells, "An Existence à la Watteau, Aspects of Rococo Painting in England—I," *Country Life,* February 7, 1974, p. 258, fig. 6; Staley, 1974, p. 35, fig. 2; Jarrett, 1976, p. 83, repro. between pp. 96–97 pl. 10a; Lindsay, 1977, pp. 54–55; Ronald Parkinson, "The First Kings of Epithets," *The Connoisseur,* vol. 197 (April 1978), p. 273, repro. p. 272 no. 5; Webster, 1979, pp. 26, 40–41, repro. pp. 40–41; Denys Sutton, "Aspects of British Collecting, Part 1, No. III—Augustan Virtuosi," *Apollo,* n.s., vol. 114 (November 1981), pp. 320–21, p. 321 fig. 15 and cover (detail); Ellis K. Waterhouse, *The Dictionary of British 18th Century Painters in Oils and Crayons* (Woodbridge, Suffolk, 1981), repro. p. 176.

CONDITION NOTES: The original support is medium-weight (20 x 20 threads/cm.) linen. The tacking margins have been removed. The painting is lined with an aqueous adhesive and medium-weight linen. The lining has aged to an extremely weakened state. A light gray ground is evident along the cut edges. The paint is in very good condition. The original moderate-to-low relief of the paint profile has been preserved along with much of the original brush marking. A fine web of narrow-aperture fracture crackle with slight, associated cupping is present overall. Small losses are present but are restricted to the extreme edges of the composition. Under ultraviolet light retouching to the foliage above the female figures and along the edge of the frame of the Pegasus painting can be seen. There is evidence of light retouching on the face of the woman seated second from the left, while an x-radiograph reveals numerous pentimenti around the head, shoulders and arms of the woman at the far left. An x-radiograph (fig. 40-2) reveals a reclining figure, which has been painted out.

VERSIONS
1. Attributed to William Hogarth, *Conversation Piece with Sir Andrew Fountaine,* c. 1742–50, oil on canvas, 18¼ x 22¾" (46.3 x 57.8 cm.), London art market, 1980 (fig. 40-1).
PROVENANCE: Christopher Cock ?; Abraham Langford, Sr.; his son Abraham Langford, Jr. (d. 1818), by 1799; by descent to Mrs. Langford Sainsbury, 1947; James Hamilton, Esq., Northern Ireland, 1961; Mr. and Mrs. Fielding Marshall Collection; Bonham's, March 28, 1974, lot 59 (as "Garden Scene at Cowley"); Sabin Galleries, London.
LITERATURE: Ireland, 1794–99, vol. 1 (1794), p. 278; Ireland, 1794–99, vol. 2 (1799), pp. xiv, 67–70 (Skelton line engraving repro. opp. p. 68); Nichols and Steevens, 1808–17, vol. 2 (1810), pp. 287–88 (Cook engraving repro. opp. p. 287); Nichols and Steevens, 1808–17, vol. 3 (1817), pp. 172–81; Nichols, 1833, pp. 370–71; Dobson, 1907, p. 211 (as "Garden Scene at Cowley"); Beckett, 1948, pp. 162, 164; Beckett, 1949, p. 42; Antal, 1962, pp. 225–26 n. 26; Baldini and Mandel, 1967, no. 25; Paulson, 1971, vol. 1, p. 218.
ENGRAVINGS AFTER VERSION 1
Skelton after William Hogarth, *Garden Scene at Cowley,* 1799, line engraving, 11 x 13¼" (27.9 x 33.6 cm.).
INSCRIPTION: *Hogarth Pinxt Skelton sculpᵗ Garden Scene at Cowley the residence of the late Thoˢ Rich Esq / Dedicated to Abrᵐ Langford Esqʼ by his very obedᵗ & obliged Servᵗ / Samʼ Ireland / Pub for S. Ireland May 1 1799.*
LITERATURE: Ireland, 1794–99, vol. 2 (1799), repro. opp. p. 68; Nichols, 1833, p. 285 (as "A Scene at Mr. Rich's Villa at Cowley").

T. Cook after William Hogarth, *Garden Scene at Mr. Rich's Villa at Cowley,* 1809, engraving, 9 x 11" (22.8 x 27.9 cm.).
INSCRIPTION: *GARDEN SCENE AT MR. RICH'S VILLA AT COWLEY / From an Original Painting in the Possession of Abrᵐ Langford Esqʳ. / Hogarth Pinx. T. Cook Sc. / Published by Longman, Hurst, Rees & Orme Nov 1, 1809.*
LITERATURE: Nichols and Steevens, 1808–17, vol. 2 (1810), repro. opp. p. 287.

W. C. Edwards after a drawing in crayon by Armstrong, 1847, aquatint. Published: C. Muskett, Norwich. Photograph: London, National Portrait Gallery.

WORK RELATED TO VERSION 1
William Hogarth, *A Club of Gentlemen,* c. 1728–31, oil on canvas, 18½ x 23" (47 x 58.4 cm.), New Haven, Yale Center for British Art, Paul Mellon Collection (fig. 40-3).
PROVENANCE: Same as version 1, above, to 1960; Arthur Tooth and Sons, 1960; Mr. and Mrs. Paul Mellon.
LITERATURE: Nichols and Steevens, 1808–17, vol. 3 (1817), p. 181 n. 1: "This painting is the companion to [version 1]"; Nichols, 1833, p. 371; Beckett, 1949, p. 41, pl. 20; Paulson, 1971, vol. 1, pp. 230–34, pl. 92.

2. Charles Fullwood after William Hogarth, *Conversation Piece with Sir Andrew Fountaine,* 1909, oil on canvas, 18 x 23" (45.7 x 58.4 cm.), England, private collection.
PROVENANCE: Probably commissioned by R. Langton Douglas to replace the Philadelphia version at Narford Hall in 1909.

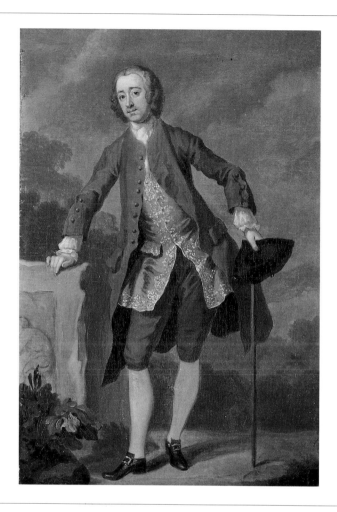

41 AFTER WILLIAM HOGARTH

GUSTAVUS HAMILTON, 2ND VISCOUNT BOYNE, C. 1740
Oil on canvas, 21 x 14⅝" (53.3 x 37.2 cm.)
John D. McIlhenny Collection, 43-40-49

Gustavus Hamilton (1710–1746) was the eldest son of Hon. Frederick
Hamilton and grandson of Gustavus, 1st Viscount Boyne, whom he succeeded
in 1723. He was educated at Westminster School and was a Member of
Parliament for Newport, Isle of Wight, from 1736 to 1741. Hamilton was also a
member of the Irish Privy Council and Commissioner of Revenue for Ireland
and Scotland (1737–46). He died on April 20, 1746. Lord Boyne was a
founder-member in 1734 of the Society of Dilettanti, a group of Englishmen
who had made the Grand Tour and who met in London to discuss, and to
exert their influence on, matters of taste. Among Boyne's fellow members was
his particular friend, the notorious rake Francis Dashwood, Baron le
Despencer (1708–1781).

 We do not know when Boyne commissioned his portrait, but it was
probably between 1735 and 1740. About 1740 he gave Hogarth a further
commission, to paint him in the act of rescuing a fellow traveler from a thief
who has attacked them by night in front of a tavern (*A Night Encounter,*
c. 1740, 28 x 36", Salop, the Viscount Boyne Collection). This commission led
Dashwood to commission from Hogarth a facetious and half-blasphemous
portrait of Sir Francis as a hermit meditating on a crucifix composed of the

nude body of a magdalen (*Sir Francis Dashwood at His Devotions*, 1750s, 48 x 35″, Salop, the Viscount Boyne Collection). The Philadelphia portrait of Boyne[1] is a copy of the prime version, which is in the collection of the Viscount Boyne (fig. 41-1). There are at least twelve (and probably more) versions of this composition.

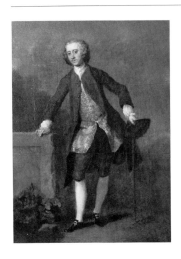

FIG. 41-1 William Hogarth, *Gustavus Hamilton, 2nd Viscount Boyne*, c. 1740, oil on canvas, 22 x 16″ (55.9 x 40.6 cm.), Burwarton House, Salop, the Viscount Boyne Collection

1. A Royal Academy exhibition label for 1887 is pasted on the stretcher, but the picture is not listed in the catalogue for the Royal Academy winter exhibition, 1887.

INSCRIPTION: *No 1825* [an inventory number stenciled on the canvas]; and a Royal Academy exhibition label for 1887.

PROVENANCE: Mr. Bellamy; Thomas Dimsdale; Mr. Woodburn, 1833; Martin Colnaghi, 1891; M. Knoedler and Co.; John D. McIlhenny, 1912.

EXHIBITIONS: London, Royal Academy, 1887?; London, Royal Academy, 1891, no. 5; Philadelphia, Pennsylvania Museum of Art, *John D. McIlhenny Collection*, 1926; New York, M. Knoedler and Co., *Hogarth and His Tradition*, November 1935; Northampton, Massachusetts, Smith College Museum of Art, *Paintings, Watercolors, Drawings, and Prints by William Hogarth*, October 19–November 19, 1944; Milwaukee, Milwaukee Art Institute, *Three Centuries of British Art*, 1946; Northampton, Massachusetts, Smith College Museum of Art, *The Art of Eighteenth-Century England*, January 11–26, 1947, no. 56; Baltimore, Baltimore Museum of Art, *Age of Elegance: The Rococo and Its Effect*, April–June 1959, no. 348.

LITERATURE: Nichols, 1833, p. 384; Dobson, 1907, p. 207 (provenance confused with that of the version in the National Gallery of Ireland); Arthur Edwin Bye, "John D. McIlhenny Memorial Exhibition—Paintings," *The Pennsylvania Museum Bulletin*, vol. 21, no. 100 (February 1926), p. 92; Janet Rosenwald, "Knoedler Holds Loan Exhibition of Hogarth's Art," *Art News*, vol. 34, no. 7 (November 16, 1935), repro. p. 4; *Parnassus*, vol. 7 (November 1935), repro. p. 13; Marceau, 1944, p. 55, repro. p. 56; *Art News*, vol. 43, no. 18 (January 1–14, 1945), repro. p. 17; Milwaukee, Milwaukee Art Institute, *Gallery Notes*, vol. 19, no. 2 (November 1946), repro. (cover); Beckett, 1948, pp. 172–73; Beckett, 1949, p. 48; *The Baltimore Museum of Art News*, vol. 22 (May 1959), repro. p. 11; Baldini and Mandel, 1967, no. 101.

CONDITION NOTES: The original support is medium-weight (12 x 12 threads/cm.) linen. The format of the painting has been enlarged with the addition of a 1″ wide strip of fabric along the top edge. The tacking margins have been removed. The painting is lined with an aqueous adhesive and lightweight linen. An off-white ground is evident along the cut edges. The paint is in only fair condition. An irregular web of narrow-aperture fracture crackle with slight, associated cupping is present overall. Small losses are evident along the cut-off edges and in the proper left leg of the figure. Minor local abrasions are present along the outer edge of the proper left sleeve and in local areas of the background. Under both visible and ultraviolet light, retouching to the hat, collar, and sky to the left of the figure's head is apparent. The added support strip along the top is entirely overpainted.

VERSIONS

1. William Hogarth, *Gustavus Hamilton, 2nd Viscount Boyne,* c. 1740, oil on canvas, 22 x 16″ (55.9 x 40.6 cm.), Burwarton House, Salop, the Viscount Boyne Collection (fig. 41-1).

PROVENANCE: Commissioned by the sitter and thence by family descent.

EXHIBITION: London, South Kensington, *National Portrait Exhibition,* 1868, no. 801.

LITERATURE: Ireland, 1794–99, vol. 1 (1794) pp. xv, 133–34, etching repro. opp. p. 133; Beckett, 1948, pp. 172–73; Beckett, 1949, p. 48, pl. 79; Baldini and Mandel, 1967, no. 101; Paulson, 1971, vol. 1, pp. 426–27, p. 427 pl. 158; Webster, 1979, presumably no. 81, p. 183, repro.

ENGRAVINGS AFTER VERSION 1

Michael Ford after William Hogarth, 1747, mezzotint, 19½ x 14″ (49.5 x 35.5 cm.).

INSCRIPTION: *W. Hogarth Pinx. Ford fecit. The R^t Hon^{ble} Gustavus Lord Vis^{ct} Boyne, Baron of Stackallen, one of his Majesty's Most Hon^{ble} Privy Council, one of the Com^{rs} of the Revenue of Ireland, & To the R^t Hon^{ble}, the Earl of Kildare this Plate is Humbly dedicated by his Lordship's most obedient humble serv^t Mich. Ford. / Published and sold by Mich. Ford, Painter and Print seller on Cork Hill.. Price 5^s. 5^d.*

Samuel Ireland after William Hogarth, 1794, etching, 9⅛ x 6⅛″ (23.2 x 15.5 cm.).

LITERATURE: Ireland, 1794–99, vol. 1 (1794), repro. opp. p. 133.

T. Cook after William Hogarth, 1809, line engraving, 7¾ x 5½″ (19.7 x 14 cm.).

INSCRIPTION: *Hogarth pinx^t. T. Cook Sculp. / Gustavus Lord Viscount Boyne &c. / Published by Longman Hurst, Rees & Orme, Aug. 1, 1809.*

LITERATURE: Nichols and Steevens, 1808–17, vol. 2 (1810), repro. opp. p. 301.

Andrew Miller after William Hogarth, mezzotint, 19½ x 14½″ (49.5 x 36.8 cm.).

2. Copy after William Hogarth, *Gustavus Hamilton, 2nd Viscount Boyne,* c. 1740, oil on canvas, 21 x 13¾″ (53.3 x 33.6 cm.), formerly Burwarton House, Salop, the Viscount Boyne Collection.

PROVENANCE: Sold by the Viscount Boyne, Burwarton sale (Knight Frank and Rutley Auctioneers), July 17, 1956, lot 212.

3. Copy after William Hogarth, *Gustavus Hamilton, 2nd Viscount Boyne,* c. 1740, oil on canvas, 36 x 28″ (91.4 x 71.1 cm.), formerly Burwarton House, Salop, the Viscount Boyne Collection.

EXHIBITION: London, South Kensington Museum, *National Portrait Exhibition,* 1868, no. 839.

4. Copy after William Hogarth, *Gustavus Hamilton, 2nd Viscount Boyne,* oil on canvas, 20 x 14½″ (50.8 x 36.8 cm.), Dublin, National Gallery of Ireland.

PROVENANCE: Willett Collection; presented by Mrs. Noseda, 1873.

LITERATURE: *Catalogue of Pictures . . . in the National Gallery and National Portrait Gallery of Ireland* (Dublin, 1890 and 1914), no. 127; Dobson, 1907, p. 207 (provenance confused with that of the Philadelphia version); Beckett, 1949, p. 48; Baldini and Mandel, 1967, no. 101.

5. Copy after William Hogarth, *Gustavus Hamilton, 2nd Viscount Boyne,* oil on canvas, 20 x 14⅞″ (50.8 x 37.8 cm.), Edinburgh, National Gallery of Scotland.

PROVENANCE: Scott Moncrieff Wellwood, Pitliver House, Fife; Christie's, May 16, 1918, lot 37; Arthur Tooth and Sons, bt. the National Gallery of Scotland, 1925.

LITERATURE: Beckett, 1949, p. 48.

6. Copy after William Hogarth, *Gustavus Hamilton, 2nd Viscount Boyne,* oil on canvas, 19¾ x 14½″ (50.2 x 36.8 cm.), location unknown.

PROVENANCE: Sidney Sabin, Esq., 1953.

EXHIBITIONS: London, Sabin Galleries, *English Portraits, 1700–1800,* November 1956, no. 16; London, 1971–72, no. 97.

LITERATURE: *Illustrated London News,* no. 1,229 (November 10, 1956), p. 804.

7. Copy after William Hogarth, *The Earl of Mornington,* oil on canvas, 19¾ x 13¾″ (50.2 x 34.9 cm.), location unknown.

PROVENANCE: Sir Herbert Hughes-Stanton; Robert Dunthorne and Son, London; Mackinnon Collection; Hon. Mrs. Nellie Ionides; Sotheby's, May 29, 1963, lot 114; Christie's, New York, January 11, 1979, lot 217 (as "Portrait of Garrett Colley Wellesley, 2nd Lord Mornington, as Sir Charles Grandison" by Francis Hayman).

EXHIBITION: London, Royal Academy, 1912, no. 149 (as "The Earl of Mornington" by William Hogarth).

8. Copy after William Hogarth, *Gustavus Hamilton, 2nd Viscount Boyne,* oil on canvas, 19½ x 14″ (49.5 x 35.5 cm.), presumably Burwarton House, Salop, the Viscount Boyne Collection.

PROVENANCE: Viscount Bangor, Castle Ward; Christie's May 8, 1964, lot 10, bt. Lord Boyne.

9. Copy after William Hogarth, *Gustavus Hamilton, 2nd Viscount Boyne,* oil on canvas, 19½ x 14″ (49.5 x 35.5 cm.), location unknown.

PROVENANCE: H.T.W. Clements, Killadoon.

10. Copy after William Hogarth, *Gustavus Hamilton, 2nd Viscount Boyne,* oil on canvas, 19 x 14″ (48.2 x 35.5 cm.), location unknown.

PROVENANCE: Christie's, November 4, 1960, lot 134, bt. Newton.

11. Copy after William Hogarth, *Portrait of Richard Wellesley, 1st Lord Mornington,* oil on canvas, 29½ x 24¼″ (74.9 x 61.6 cm.), Duke of Wellington Collection.

EXHIBITION: London, Guildhall Art Gallery, 1957, no. 15.

12. Copy after William Hogarth, *Viscount Boyne,* medium, dimensions, and location unknown.

PROVENANCE: Sir Oliver Lambert ?; sold, Alain Chawner, The Stable Galleries, Charleston Rectory, Ardee, County Louth, Ireland, July 3–5, 1974.

EXHIBITION: London, National Portrait Gallery, *Exhibitions of Paintings from Irish Collections,* 1956, no. 57.

LITERATURE: *Apollo,* n.s., vol. 99 (June 1974), repro. p. 204; *Country Life,* June 13, 1974, repro. suppl. p. 86.

13. Copy after William Hogarth, *Gustavus Hamilton, 2nd Viscount Boyne,* oil on canvas, 20 x 14¾″ (50.8 x 37.5 cm.), location unknown.

PROVENANCE: Alan Mackinnon; Sotheby's, March 20, 1963, lot 142, bt. Ellis.

14. Copy after William Hogarth, *Gustavus Hamilton, 2nd Viscount Boyne,* oil on canvas, 20¼ x 14½″ (51.4 x 36.8 cm.), location unknown.

PROVENANCE: Sotheby's, December 9, 1981, lot 159.

John Hoppner's antecedents are mysterious. His German mother worked as an attendant at the royal palace and it was rumored that his real father was the future George III, who in the year of Hoppner's birth was twenty years old and still unmarried.[1] If this story, current in the artist's lifetime[2] and never denied by him, were true, many otherwise remarkable circumstances surrounding his upbringing and early career are explained. He was born on April 4, 1758, in Whitechapel, a part of London far from the court at St. James's where his mother presumably lived as well as worked. As the boy grew older he was brought up in the palace to become a chorister in the Chapel Royal. Walton, the king's librarian, was given charge of Hoppner's education, and, according to the life of the painter written by his granddaughter, the general belief that he was the king's natural son "became almost a certainty owing to his [the king's] affection for him, the interest he took in his studies, visiting the Library constantly to note his progress; the *carte blanche* accorded for all his whims and expenses; and also the warm attachment of the Prince of Wales, the Dukes of Kent and Clarence, whose constant companion he was."[3] Of Mrs. Hoppner's husband, said to have come to England in the entourage of George II as a surgeon, we know nothing.

On March 6, 1775, on the same day as Gainsborough Dupont (1754–1794), Hoppner entered the Royal Academy schools, thus becoming one of the first generation of artists in England to undergo formal academic training. In 1778 he won the silver medal for drawing from life and in 1780 began to exhibit regularly at the Royal Academy.

In 1784, three years after marrying Phoebe Wright (see no. 44), he moved to a house and studio at 18 Charles Street, St. James's Square, where he remained for the rest of his life. Marrying this particular young woman may have been a miscalculation for an ambitious young man. She was the daughter of Patience Wright, the American-born wax modeler, ardent patriot in the American cause, and—said her contemporaries—a spy for Benjamin Franklin. Not unnaturally, this woman was anathema to George III; when Hoppner married her daughter without his permission, the king never patronized him again.[4] Queen Charlotte, however, ordered the artist to Windsor in 1784 to paint the portraits for her three youngest daughters, Sophia, Amelia, and Mary (exhibited R.A. 1785, nos. 220–22, Her Majesty Queen Elizabeth II, Windsor Castle), resulting in three portraits as sensitive as anything Hoppner was later to achieve, owing their intimacy and naturalness to the example of Reynolds's (q.v.) portraits of children and adolescents. Then, as Mrs. Papendiek, the queen's Assistant Keeper of the Wardrobe tells us, Hoppner's friend Mr. Gifford (tutor to Lord Belgrave, later editor of the *Quarterly Review*) introduced him to Lord Grosvenor, who in turn "took him by the hand," ensuring that "the Prince of Wales, the Duke of York, all the Whig nobility, and most of the leading people of the day, sat to him."[5]

It must have seemed to Hoppner, and to all London, that the natural successor to Reynolds had appeared, that nothing could prevent his progress to the highest rank of English portrait painting. But in 1787 there arrived in London a sixteen-year-old prodigy from Bath to overturn all Hoppner's expectations and calculations. This was Thomas Lawrence (q.v.), who, in 1789, was to paint the queen, and in 1792 to replace Reynolds as Painter in Ordinary to His Majesty. In truth, George III disliked Hoppner's style, as he had disliked Reynolds's, complaining that both men painted trees in shades of yellow and red.[6] And when Hoppner, a Whig, was appointed portrait painter to the Prince of Wales in 1789, the king seized on the young Lawrence to carry the Tory banner for the court at Windsor against the Whigs at Carlton House.

The political differences between father and son were carried over into the field of patronage, so that the rivalry between Hoppner and Lawrence in the 1790s and 1800s seemed to some observers to revive that between Reynolds and Romney (q.v.), which had divided London earlier in the century.[7] Ironically, the Prince of Wales and his set, the most glamorous and loose-living court in Europe, were saddled with the heavy-handed productions of Hoppner, while the intensely moral, stultifyingly dull court assembled around the king and his family was associated with the more glossy, theatrical portraits of Lawrence. A visit to Paris in March 1802, in the company of Turner (q.v.) and Henry Fuseli (1741–1825) did little to infuse life into Hoppner's style. This situation was not to be altered until after Hoppner's death in 1810, by which time George III had long been out of his mind, and beyond patronizing anyone. Soon after, in 1814, Sir Charles Steward introduced Lawrence to the Prince Regent, thus initiating one of the most fruitful associations between a royal patron and an English artist.

The rivalry between the two men was openly acknowledged by the vastly more successful and talented Lawrence, who, almost consciously attempting to reenact the final reconciliation between Gainsborough (q.v.) and Reynolds, tried to extend his hand to Hoppner as the latter lay dying at Charles Street.[8] That Hoppner to the last refused to take the hand gives us a gauge by which we can measure the difference between his character and that of the more placable Gainsborough.

According to the poet Samuel Rogers (1763–1855), Hoppner had "an awful temper,—the most spiteful person I ever knew!"[9] Martin Archer Shee (1769–1850), future president of the Royal Academy, wrote that "his sarcasm was powerful and sometimes unsparing."[10] We know that he possessed a vein of cynicism about his work, for he once told a young artist who was visiting his studio, "You don't suppose I can always afford to paint good ones? If I did how could I keep the pot boiling?"[11] And he can hardly have endeared himself to his colleagues by the reviews of Royal Academy exhibitions that he began to publish in the *Morning Post* by 1785. These were conspicuous for the lavish praise of their author's own work and the scathing criticisms of the efforts of his contemporaries, especially Benjamin West (1738–1820).[12] His literary activities probably went far toward alienating him from his colleagues at the academy, and he had to wait until 1793 (the year after Lawrence) to be elected an Associate and 1795 (a year after Lawrence), to full Academician.

Hoppner was a friend of the lovable and discriminating Thomas Gainsborough, who on one occasion presented him with a landscape drawing, the memento of one of their sketching expeditions into the countryside together.[13] Hoppner's own style of landscape drawing is remarkably close to Gainsborough's; and for that matter, the men were alike in some ways, for Shee tells us that Hoppner was a man of taste not only in literature but in music: he played the pianoforte and sang with great feeling. Even more endearing to Gainsborough, perhaps, there were "few . . . more competent either by vivacity of remark or quickness of repartee to 'set the table in a roar.'" He adds that Hoppner rarely approached "the depths of philosophy or the dissertations of argument [but] he skimmed lightly over general topics and seldom failed to produce something new in form or substance."[14]

In all, Hoppner sent 168 paintings to the Royal Academy between 1780 and 1809. Most were portraits. At his best, in the 1780s, his painting reminds one of Reynolds at his most subtle and gentle. His colors, like Reynolds's, were rich, creamy, and mellow. In the use of wax and bitumen he even tried to copy Sir Joshua's palette, sometimes with the same disastrous results for the future condition of the painting.[15] His more formal portraits are straightforward and dull, or put another way, never showy or meretricious— reminding us, as Waterhouse remarked, first of Reynolds, then of Romney, then of Raeburn (q.v.).[16]

1. After the king's marriage in 1762 such a liaison would have been out of the question. J. Sewell, "Gainsborough's 'Blue Boy,'" *Notes and Queries,* 4th ser., vol 11 (June 14, 1873), pp. 485–86 (June 21, 1873), pp. 505–6.
2. Pasquin, 1796, p. 91.
3. Mrs. Cromarty's MS. life of Hoppner, quoted by McKay and Roberts, 1909, p. xv.
4. According to the artist's son Belgrave Hoppner, cited by McKay and Roberts, 1909, pp. xiii–xiv.
5. Whitley, 1928, vol. 2, p. 43.
6. McKay and Roberts, 1909, p. xix.
7. Cunningham, 1879, vol. 2, p. 289.
8. Williams, 1831, vol. 1, p. 304. "To the last, I found that his soreness to me . . . would have prevented the good I wish'd, and turn'd it on me as Evil!" (Lawrence to Joseph Farington in 1810, quoted by McKay and Roberts, 1909, p. xxi).
9. Samuel Rogers, *Recollections of the Table-Talk of Samuel Rogers* (London, 1856), p. 208.

10. Whitley, 1928, *1800–1820*, p. 159.
11. Ibid., p. 160.
12. Whitley, 1928, vol. 2, pp. 39, 50–51. Several of Hoppner's longer essays and reviews are collected in Frank Rutter, ed., *Essays on Art by John Hoppner* (London, 1908).
13. Hayes, 1970, vol. 1, pp. 80, 249–50, no. 610, vol. 2, pl. 359.
14. Whitley, 1928, *1800–1820*, p. 159.
15. Redgrave and Redgrave, 1947, pp. 60–61.
16. Waterhouse, 1953, p. 226.

BIBLIOGRAPHY: Andrew W. Tuer, ed., *Bygone Beauties: A Selected Series of Ten Portraits of Ladies of Rank and Fashion from Paintings by John Hoppner, R.A., Engraved by Charles Wilkin, Annotated by W. Tuer, F.S.A.* (London, 1803); Cunningham, 1879, vol. 2, pp. 287–97; H.P.K. Skipton, *John Hoppner* (London, 1905); Frank Rutter, ed., *Essays on Art by John Hoppner* (London, 1908); McKay and Roberts, 1909; McKay and Roberts, 1914; Whitley, 1928, passim; Whitley, 1928, *1800–1820*, passim; Redgrave and Redgrave, 1947, pp. 60–61; Waterhouse, 1953, pp. 226–27.

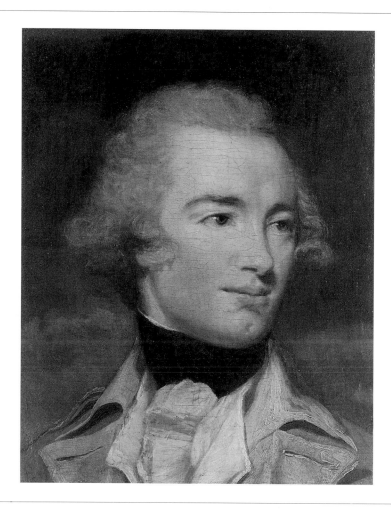

42 ATTRIBUTED TO JOHN HOPPNER

PORTRAIT OF AN OFFICER, C. 1795–1800
Oil on canvas, 15¾ x 13″ (40 x 33 cm.)
Bequest of Helen S. Fennessy, in memory of her stepfather, Horace
Trumbauer, 74-161-2

An x-radiograph of *Portrait of an Officer* suggests that the face has been almost
entirely repainted to make a young and handsome man out of an older, more
individual, and also less good-looking one (fig. 42-1). The face here has been
cut out of a larger canvas and set into the present canvas, which measures 15¾
by 13 inches. We do not know how large the original canvas may have been
but one guess is that this portrait was cut from a very much larger group
portrait, repainted, and set into the present canvas for sale. Hoppner is not,
however, known to have painted large, military group portraits.

PROVENANCE: Hoppner's sale, Christie's,
May 31, 1823, lot 305, bt. William Havell;
Christie's, May 24, 1858, lot 309, bt.
Rowbotham; Mrs. Mary K. Holly, New York;
Anderson Galleries, New York, October 19,
1927.

CONDITION NOTES: The original support is
twill-weave, medium weight (10 x 10
threads/cm.) linen. The absence of weave
cusping and the sharply cut edges in the
x-radiograph suggest that this painting has
been cut down to its present size from a larger
format. A strip of plain-weave linen about ⅞″
wide has been added around all four edges of

the original fabric and both have been lined
with an aqueous adhesive. Evidence of a thinly
applied white ground is present along the cut
edges of the painting. Both ground and paint
have developed a fracture crackle with slight
cupping running horizontally across the image,
suggesting that the painting may have been
rolled at some time. The brushwork profile has
been flattened by lining. Surface grime has
accumulated in the paint interstices, which
accentuates the twill pattern of the support. A
heavy, discolored varnish masks the extensive
repainting of the design suggested by
x-radiography, infrared reflectography, and
examination with a low-powered microscope.

FIG. 42-1 X-radiograph of *Portrait of an
Officer,* Philadelphia Museum of Art,
Conservation Department

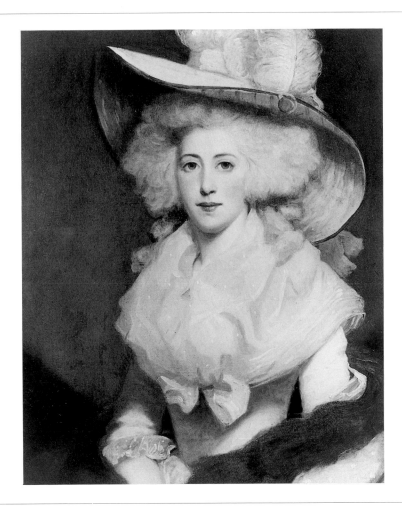

43 AFTER JOHN HOPPNER

SUSANNA GYLL, nineteenth century? after the style of c. 1779
Oil on canvas, 30⅛ x 25⅛″ (76.8 x 63.8 cm.)
The George W. Elkins Collection, E24-4-16

According to McKay and Roberts, this is a portrait of Susanna Gyll, third daughter of William Gyll, Esq., of Wyrardisbury House, near Wraysbury (not far from Windsor), Buckinghamshire.[1] She was born in 1756 and married for the first time on February 11, 1779, Thomas Chudleigh Sanders, of the East India Company, a resident of Charlwood Surrey, who died in 1816. Her second husband, whom she married on June 10, 1819, was William Bailey of Tonbridge Castle, Kent. She died in 1833, leaving one child, Harriet, who married Rev. George Dinely Goodyer, rector of Otterden, Faversham, Kent. Hoppner also painted Mrs. Gyll, the wife of Mrs. Sander's step-brother William Gyll.[2]

In this painting the sitter is wearing a blue dress cut low with a white fichu and feather boa and a large blue "Gainsborough" hat. The style of the dress and the age of the sitter, and the date of her marriage, all point to a date of the original portrait, now untraced (fig. 43-1), of about 1779—that is, before Hoppner began to exhibit at the Royal Academy.

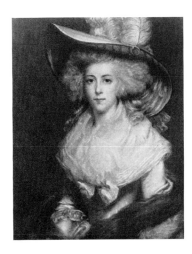

FIG. 43-1 John Hoppner, *Miss S. Gyll,*
medium, dimensions, and location unknown.
Photograph: National Portrait Gallery Library,
London

1. McKay and Roberts, 1909, p. 229.
2. Ibid., p. 114.

INSCRIPTION: *Portrait—Susanna daughter /
William Gyll of Wysadsbury / Scott and Fowles
Co. / E. FACON WATSON / ARTIST AND PICTURE
RESTORER / NO 201 PICCADILLY / OPPOSITE ST.
JAMES'S HALL / LONDON* [on the stretcher];
*Susanna Daughter of William Gyll of
Wysadsbury. Married 4 Feb. 1779 Thomas Cheadle
Sanders Esq re / Died 7 Sept. 1833 aged 77* [in an
old hand directly on the stretcher].

PROVENANCE: Anonymous sale [Dr. E.
Carter], Christie's, July 5, 1907, lot 76, bt.
Agnew; Galerie Sedelmeyer, 1908; Scott and
Fowles Co., New York; T. J. Blakeslee, New
York (not in Blakeslee sale of 1916); George W.
Elkins.

EXHIBITIONS: London, Thomas Agnew and
Sons, 1908, no. 12; Paris, Galerie Sedelmeyer,
1908, no. 18; Philadelphia, 1928, p. 17.

LITERATURE: McKay and Roberts, 1909,
p. 229, under Sanders; Elkins, 1925, no. 23;
Elkins, 1935, p. 11, repro. p. 4; *The Philadelphia
Museum Bulletin,* vol. 33, no. 178 (May 1938),
p. 12.

CONDITION NOTES: The original support is
twill-weave, medium-weight (10 x 10
threads/cm.) linen. The tacking margins have
been removed. The painting is lined with an
aqueous adhesive and lightweight linen. An
off-white ground is present. The paint is in fair
condition. It is cracked overall with a very fine
web of fracture crackle. The surface has been
extensively abraded; this is most evident in the
shadow areas of the shawl and the hat brim.
The texture of the paint surface has been
altered by weave enhancement from the lining
process. Retouching is visible under ultraviolet
light along the bottom edge of the
composition.

VERSION: John Hoppner, *Miss S. Gyll,*
medium, dimensions, and location unknown.
An unmarked photograph of what appears to
be the first version of the Philadelphia picture
is in the photograph files of the National
Portrait Gallery Library, London (fig. 43-1).
ENGRAVING: Norman Hirst after John
Hoppner, *Miss Gyll,* mezzotint, 16⅝ x 13½"
(42 x 34 cm.).
EXHIBITION: London, Royal Academy,
1908, no. 1,491.

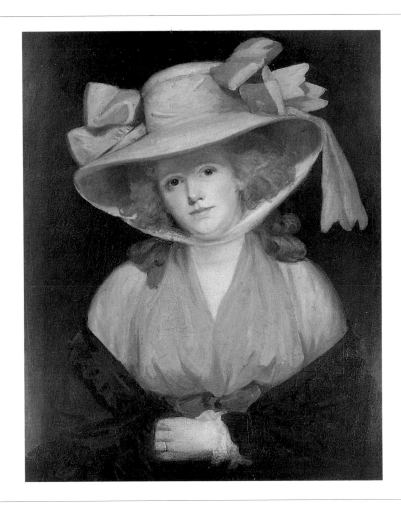

44 AFTER JOHN HOPPNER

MRS. HOPPNER, second half of the nineteenth century?
after the style of c. 1783–84
Oil on canvas, 30¼ x 24⅞″ (76.8 x 63.2 cm.)
John H. McFadden Collection, M28-1-15

The pose and style of this portrait should be compared to Hoppner's *Marchioness of Hertford* (fig. 44-1), exhibited at the Royal Academy in 1784 (no. 64). Or again, the portrait could be compared to Hoppner's *Sophia Western,* engraved in 1784 by J. R. Smith. In the latter picture the sitter is Hoppner's wife, confirming the identification of our portrait, which was indicated first by McKay and Roberts in 1914.[1] But our picture is probably a copy of an unrecorded picture, or perhaps an adaptation after the print of *Sophia Western.*

Phoebe Wright (1761–1827) was born in America and came to London with her mother and brother in 1772. Hoppner may have met her through her brother Joseph Wright, who was a fellow pupil at the Royal Academy schools. Their mother, Patience Wright (1725–1784), was a sort of American Madame Tussaud, celebrated for her life-sized portraits in wax (with real hair and clothes) of contemporary celebrities, and for her outspoken loyalty to the American cause.[2] Hoppner married Phoebe on July 8, 1781, and seems to have moved into his mother-in-law's house at Cockspur Street, Haymarket[3]—an establishment rumored to be a hotbed of spies and traitors. Among the guests who at one time or another accepted Mrs. Wright's hospitality were Garrick, Benjamin West (1738–1820), and Benjamin Franklin.

According to his son Belgrave Hoppner, Hoppner's marriage to the daughter of so notorious a republican, and without the king's consent, played into the hands of his enemy, the malicious Benjamin West, who intrigued

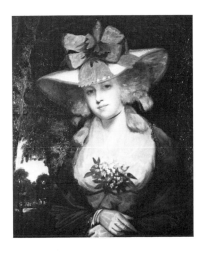

FIG. 44-1 John Hoppner, *Marchioness of Hertford,* 1784, oil on canvas, 29½ x 24½″ (74.9 x 62.2 cm.), San Marino, California, Henry E. Huntington Library and Art Gallery

against the Hoppners, persuading the king to disown his young protégé and to cut off his royal stipend.[4] Even though we have only the word of the artist's loyal descendant Mrs. Cromarty for it, the marriage seems to have been happy—largely because Mrs. Hoppner was content to efface herself for her husband: "She made all his clothes herself, even coats and waistcoats, washed and ironed, and, lest she should be a means of incurring expense, refused all society on the plea of distaste for it; whereas, Mr. Hoppner did not exercise so great a self-denial."[5] They had five children. Mrs. Papendiek described Phoebe as "a spirited, handsome woman."[6]

1. McKay and Roberts, 1914, p. 125. At Agnew's this portrait was described as "Miss Palmer, née Gasciogne."
2. Richard D. Altick, *The Shows of London* (Cambridge, Mass., and London, 1978), p. 54; Sellers, 1962, pp. 84–94. See also Philip Thicknesse, *The New Prose Bath Guide for the Year 1778* (London and Bath, 1778), pp. 50–53, for a biography of Patience Wright.
3. Graves, 1905–6, vol. 4, p. 153.
4. McKay and Roberts, 1909, pp. xiii–xiv. See also Whitley, 1928, vol. 2, p. 42.
5. McKay and Roberts, 1909, p. xviii.
6. Whitley, 1928, vol. 2, p. 43.

PROVENANCE: Leonard Clow; Agnew; bt. John H. McFadden, September 9, 1910.

EXHIBITIONS: New York, 1917, no. 16; Pittsburgh, 1917, no. 16; Philadelphia, 1928, p. 20.

LITERATURE: Roberts, 1913, p. 541; McKay and Roberts, 1914, p. 125; Roberts, 1917, p. 31, repro. opp. p. 31; Roberts, 1918, "Portraits," p. 137, repro. p. 136.

CONDITION NOTES: The original support is medium-weight linen (10 x 10 threads/cm.). The tacking margins have been removed. An off-white ground is evident along the cut edges as well as through areas of thinnest application of paint. The paint is in only fair to good condition. The original moderate to low relief of the paint profile has been flattened somewhat by lining. The darkest areas of brown in the background, in the shawl, and in the figure's hair have traction crackle of particularly wide aperture. An irregular web of wide-aperture fracture crackle is especially prominent in the face and bodice. Abrasion to the mid-tone of the face and hand is evident. Pentimenti related to the shape of the bow on the hat are visible in normal light. Under ultraviolet light, retouching is evident within the apertures of the traction crackle in the shawl, over areas of abrasion in the shadow areas in the hair and to a singular, large patch along the left edge.

Born in the Baltic coast town of Lübeck, Germany, in 1646, Gottfried Kniller (later Kneller) was the son of the chief surveyor of the city, the architect Zachary Kniller. Though he was sent to study mathematics at Leyden University around 1662, his predilection for drawing led his father to place him in the studio of Ferdinand Bol (1616–1680) in Amsterdam, where, perhaps, he also took instruction from the aged Rembrandt (1606–1669). According to Buckeridge, he left these Dutch masters because with them "exact design and true proportion were wanting"[1] and traveled to Italy, to Rome, in 1672. Here, Vertue tells us, he "studyd continually with great application Geometry Perspective & Anatomy. & from the most celebrated Paintings of Raphael, Titian, Paulo Veronese...he formd to himself a firm true & Noble Manner of designing Chiefly Historical Subjects."[2] He also entered the studios both of Carlo Maratta (1625–1713) and Bernini (1598–1680). A long sojourn in Venice and commissions from noble families there led him away from history and genre toward portraiture.

He returned to Germany in 1674, and by 1676 he had made his way to London bearing letters of introduction to the Hamburg-born merchant John Banckes, who lodged Kneller in his own house, commissioned portraits from him, and introduced him to James Vernon, secretary to the illegitimate son of King Charles II, James Scott, Duke of Monmouth (1649–1685).

In England in the later 1670s the grand tradition of court portraiture initiated by Van Dyck (1599–1641) was carried on in the glorious painting of Sir Peter Lely (q.v.), Principal Painter to the king. In 1678 the Duke of Monmouth asked Charles to sit to Kneller for his portrait and this the king consented to do provided Kneller would work side by side with Lely. Kneller, it was said, amazed the king by striking off a finished likeness in the time it took Lely to lay in the broad outlines of his picture, and as Kneller at that time was "Young full of Fire & Ambition. a fine & handsom well turnd Gentleman that gave a certain grace to all his Actions,"[3] his success at court was from then assured. This portrait of the king, Vertue tells us, "gained Kneller a great deal of Reputation. & Many people of [quality] Immediately sat to him. & further recommended him." He adds that "by his daily Practice & observations of the Works of Vandyke. Rubens. & the excellent Beauties of Nature that he had to Copy continually here...made & Form'd to himself a most glorious & Noble stile of Painting."[4]

In 1684 Charles sent Kneller to France to draw the portrait of Louis XIV, the first instance of Kneller's talents being put to diplomatic use. William III, his greatest patron, took the painter with him to the Low Countries in 1697, commissioning from him the portrait of the elector of Bavaria with whom William was seeking an alliance at this time. The following year William commissioned a full-length portrait of *Peter the Great, Czar of Russia*, who was then visiting England (1698, 95 x 57¼", Her Majesty Queen Elizabeth II, London, Kensington Palace). In all, Kneller painted ten reigning sovereigns and served six English kings and queens—Charles II, James II, William and Mary, Anne, and George I. He was knighted by William in 1692 and granted a baronetcy by George I in 1715. He lived first in the Grand Piazza, Covent Garden, until 1697; then in Great Queen Street, Lincoln's Inn Fields, until his death in 1723.

In 1709 Christopher Wren designed a country house for him, Whitton, near Hounslow in Middlesex, and from 1712 to 1718 he served as the governor of the first academy to be founded in England, located near his own house in Great Queen Street. No wonder Vertue said of him, simply: "He has been the Morning star for all other Portrait Painters in his Time to follow."[5]

Kneller's work might be divided broadly into two periods. The first, from 1676 to c. 1699, saw the establishment of a forceful and naturalistic style, formed by the study of Van Dyck and Lely and influenced by such contemporaries as Willem Wissing (1653–1687) and John Riley (1646–1691), who shared with Kneller the title of Principal Painter to the king until his death in 1691. A brilliant example of this early style is Kneller's self-portrait in the National Portrait Gallery, London, in which the lovely feeling for the handling of paint, brushed on with confidence and verve, seems to match the self-assured, handsome face of the sitter. After his trip with William III to the Low Countries in 1697, there emerges a second style, influenced by his exposure to Rubens (1577–1640), in which the creamy colors are laid on with more dash and with a lighter, almost rococo touch. The apogee of this style is perhaps his equestrian portrait of William III at Hampton Court (1701, 68½ x 65¾", Her Majesty Queen Elizabeth II).

Kneller ran a notoriously large studio—so large that a great number of lifeless and dead-handed Knellers exist. Horace Walpole complained that "where he offered one picture to fame, he sacrificed twenty to lucre."[6] But this is true largely after about 1693, when the sheer number of his clients made it impossible for him to do more than draw their heads. We know that in June 1693 Kneller was seeing fourteen sitters in one day, but Stewart points out that some of these sitters would be made to return to sit ten or twelve times.[7]

Thus, more than most artists, Kneller must be judged by his best works—*The Hampton Court Beauties* (begun c. 1690), full-length portraits of the ladies of the court painted for Mary II in imitation of Lely's *Windsor Beauties* (1662–65), or *Michael Alphonsus Shen Fu-Tsung (The Chinese Convert)* (1687, 83½ x 58", Her Majesty Queen Elizabeth II, London, Kensington Palace), surely the most powerful full-length portrait to have been painted in England between the death of Van Dyck and the emergence of Reynolds (q.v.).

Kneller's most famous works, the ones by which we can best measure his achievement, are the forty portraits of the members of the Whig drinking society, the Kit-Cat Club, painted between 1697 and about 1715 (London, National Portrait Gallery). For them, Kneller invented a new format, the Kit-Cat, measuring thirty-six by twenty-eight inches and showing the head and one or both of the hands. The problem set for the painter was formidable—the commission demanded liveliness and variety when the full-bottomed wigs worn by all the sitters tended to promote heaviness and uniformity. But looking at the portraits today we are struck by the variety of pose and by the way each personality is swiftly explored through the limited vocabulary of gesture and expression—all painted in creamy, supple oils against summary but lovely backgrounds ultimately looking back to Titian (c. 1487/90–1576) for inspiration.

Looking at these portraits we see how little, really, the succeeding generation of painters, including Thomas Hudson (1701–1779), advanced on Kneller, and why the next English painter to challenge him, Joshua Reynolds, could tell Northcote that in his own youth "had any person attempted to compare Vandyke with him, he would have been laughed at as an idiot."[8]

1. Bainbrigg Buckeridge, "An Essay Towards an English School of Painters," in Roger de Piles, *The Art of Painting,* 3rd ed. (London, 1754), p. 394.
2. Vertue, 1932, p. 119.
3. Ibid., p. 120.
4. Ibid.
5. Ibid., p. 121.
6. Walpole, 1888, p. 202.
7. Stewart, 1964, p. 198.
8. Fletcher, ed., 1901, p. 211.

BIBLIOGRAPHY: Bainbrigg Buckeridge, "An Essay Towards an English School of Painters," in Roger de Piles, *The Art of Painting,* 3rd ed. (London, 1754), pp. 393–98; W. A. Ackermann, *Der Porträtmaler Sir Godfrey Kneller im Verhältniss zur Kunstbildung seiner Zeit* (Lübeck, 1845); John Pye, *Patronage of British Art: An Historical Sketch* (London, 1845), pp. 19–20; Walpole, 1888, vol. 2, pp. 202–13, 259–60; L[ionel] C[ust], *Dictionary of National Biography,* s.v. "Kneller, Sir Godfrey"; C. H. Collins Baker, *Lely and the Stuart Portrait Painters: A Study of English Portraiture before and after Van Dyck,* 2 vols. (London, 1912), vol. 2, pp. 75–94; C. H. Collins Baker, *Lely and Kneller* (London, 1922); Vertue, 1932, pp. 119–23 (see also *Walpole Society* [Vertue Note Books, vols. 1–6], vols. 18 [1930], 22 [1934], 24 [1936], 26 [1938], 29 [1947], 30 [1955]); Lord Killanin [Michael Morris], *Sir Godfrey Kneller and His Times, 1646–1723* (London and New York, 1948); Waterhouse, 1953, pp. 97–100; Margaret Whinney and Oliver Millar, *English Art, 1625–1714* (Oxford, 1957), pp. 192–98; Millar, 1963, vol. 1, pp. 141–50; Stewart, 1964, pp. 192–98; J. Douglas Stewart, "William III and Sir Godfrey Kneller," *Journal of the Warburg and Courtauld Institutes,* vol. 33 (1970), pp. 330–36; J. D. Stewart, "Records of Payment to Sir Godfrey Kneller and His Contemporaries," *The Burlington Magazine,* vol. 113, no. 814 (January 1971), pp. 30–33; J. Douglas Stewart, *Sir Godfrey Kneller and the English Baroque Portrait* (Oxford, 1983).

EXHIBITION: London, National Portrait Gallery, *Sir Godfrey Kneller,* 1971–72 (by J. Douglas Stewart).

45 SIR GODFREY KNELLER *PORTRAIT OF A SOLDIER*, C. 1690–95
 Oil on canvas, 49½ x 39½″ (125.7 x 100.3 cm.)
 The William L. Elkins Collection, E24-3-97

 The soldier in this portrait is posed in ceremonial armor, with his general's
 baton in his left hand, a sword at his hip, and a splendid swath of symbolic
 drapery over his shoulder and arm. His identity is not known, but the long,
 pale face is similar to that of Frederick Herman, Duke of Schomberg
 (1615–1690), the German-born general who accompanied William, Prince of
 Orange, to England in 1688 and who was killed at the battle of the Boyne in
 July 1690. Kneller painted an equestrian portrait of Schomberg (see fig. 45-1)

and it is by comparing the face in *Portrait of a Soldier* with this that our tentative identification has been made.

J. Douglas Stewart, on the basis of a photograph, suggested a date of c. 1690–95 for our portrait;[1] that is, when Kneller was at the height of his powers, having assimilated the influence of Van Dyck (1599–1641) and Lely (q.v.), but having retained his own elegant yet vigorous and realistic style.

A double portrait at Dulwich Picture Gallery, *Two Children, Perhaps of the Howard Family* (formerly called *Lord Carlisle and His Sister*, 50⅛ x 40½") by Kneller, also bears a label on the reverse inscribed, like this portrait, with the name Hon^ble Mary Howard.[2] An Hon. Mary Howard was born in 1865, but nothing is known at the present of her life. The Dulwich picture was presented by Charles Fairfax Murray in 1911; as Murray was a picture dealer, it may be that our canvas also passed through his hands.

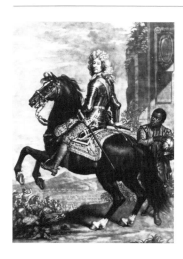

FIG. 45-1 John Smith after Sir Godfrey Kneller, *Frederick, 1st Duke of Schomberg,* c. 1689, mezzotint, 15 x 10¼" (37.5 x 25.6 cm.), London, National Portrait Gallery

1. J. Douglas Stewart, *Sir Godfrey Kneller and the English Baroque Portrait* (Oxford, 1983), p. 136, no. 788A.
2. Peter Murray, *Dulwich Picture Gallery: A Catalogue* (London, 1980), p. 73, no. 570.

INSCRIPTION: *HON^BLE MARY HOWARD* [on a label on the stretcher in a hand dating from the second half of the nineteenth century]; *Go with the House* [in script].

PROVENANCE: Hon. Mary Howard; Charles Fairfax Murray?; William L. Elkins.

LITERATURE: J. Douglas Stewart, *Sir Godfrey Kneller and the English Baroque Portrait* (Oxford, 1983), p. 136, no. 788A.

CONDITION NOTES: The original support is medium-weight (12 x 12 threads/cm.) linen. The tacking margins have been removed. The painting is lined with an aqueous adhesive and medium-weight linen. The present lining is brittle and weak, with planar distortions. A thin white ground is visible along the cut edges. The paint is in good condition overall. A narrow-aperture traction crackle has formed in the darkest areas of the background. A fine irregular web of fracture crackle is present overall. There are small losses along the edges, consistent with damage from rabbet abrasion.

Philip László was born in Hungary but became a naturalized English subject in 1914. To call him the last of the society portrait painters in a line extending back to Van Dyck (1599–1641) through John Singer Sargent (1856–1925), Lawrence, and Reynolds (q.q.v.) would hardly do him justice: compared to him they were provincials, painting mainly the faces of a narrow circle of English aristocrats. To list De László's sitters, by contrast, is to name virtually every important figure in politics, industry, religion, and society between 1895 and 1937—not only in England, but in western Europe, central Europe, and the United States. His sitters included most of the members of the royal houses of England, Spain, the Balkan States, Austria-Hungary, and Sweden; popes Leo XIII and Pius XI; presidents Theodore Roosevelt, Harding, Coolidge, and Hoover; Kaiser Wilhelm II; Mussolini; and such celebrities as Comte Robert de Montesquiou and Elinor Glyn. By the end of his life he had been awarded twenty-two orders and seventeen medals, including the Legion of Honor and the Victorian Order. In 1912 Emperor Franz Joseph ennobled the painter, permitting him to add "De" to his original name.

He was born poor in Budapest in 1869. His father, a small business holder, he described as "hard and selfish . . . [a] tyrant . . . who never respected his wife or children." He adored his mother, who, although she "had not much time to give to the spiritual and intellectual upbringing of her children,"[1] encouraged his early leanings toward art, born after seeing an exhibition in Budapest of Mihály Munkácsy's (1844–1900) then famous machine *Christ before Pilate* (1881, 48⅞ x 85⅞", Budapest, Hungarian National Gallery).

In 1880, at the age of eleven, Philip was apprenticed to a painter of theatrical scenery but left after a few months. There followed a series of jobs from which he was either dismissed or left: scene painter at the Royal Opera House, apprentice to a majolica and porcelain painter, to a sign painter, and finally assistant to a fashionable photographer, Sándor Strelisky, for whom he hand-tinted portrait photographs with watercolors. From Strelisky's he began to attend the School of Arts and Crafts on a part-time basis, eventually gaining admission to the life classes held by Prof. Karl Lotz (1833–1904), the leading mural painter in Hungary. In 1888 his picture *The Goose Girl* was accepted for exhibition at the Academy of Arts in Budapest and bought by the agents of Franz Joseph for the royal collection. The following year he was awarded a Hungarian state scholarship to study abroad—first at the Royal Bavarian Academy in Munich (1890, 1891–92) and then at the Académie Julian in Paris under Jules Joseph Lefebvre (1836–1911) and Benjamin Constant (1845–1902) (from autumn 1890 to summer 1891).

De László's ideal as a student was to emulate the paintings of Dagnan-Bouveret (1852–1929); but the Hungarian lacked the poetic spirit of the French artist, painting instead old-fashioned but technically accomplished narrative paintings such as *The Hofbräuhaus* (1891, 32 x 50", Budapest, Hungarian National Gallery) in which the humor consists in the reactions of prim English tourists to lusty carryings-on in a Munich beer cellar.

It is difficult to connect these early realistic, narrative pictures with the dazzling portraits for which De László is famous. One can only surmise that several early royal commissions revealed to the young man a hitherto unsuspected talent for outrageous flattery. What was required was a kind of nonchalant glamour, achieved through the controlled application of sloppy pigments with brushy brushwork. The end product never suggests an artist laboriously drawing and working up the portrait (as indeed, he hadn't) but an afternoon's sitting to a fellow guest, who happened to paint, at a country house party.

His first royal commission, in 1894, was to paint Prince Ferdinand and Princess Marie-Louise of Bulgaria in their Ruritanian castle at Sofia. These portraits were quickly followed by his early masterpiece *The Archimandrite Gregorious* (1894, National Gallery of Bulgaria). With the success of these first commissions, the crowned heads of most of the other Balkan States summoned De László to their courts; when he finally decided to move from Vienna to London in 1907 at the age of thirty-eight, he did so partly because there were no more prominent people in central Europe left for him to paint.

His first visit to England had been in 1898, and he returned in 1900 to marry a well-connected Irish beauty, Lucy Guinness. In that year, De László painted Pope Leo XIII and received a commission from Queen Victoria for a portrait of Field Marshal Sir George White (1835–1912). No doubt De László noted the success in England of his fellow countryman Sir Joseph Edgar Boehm (1834–1890), former Sculptor in Ordinary to the queen, and the immense popularity (and potential competition) of Sargent. De László's success in England after 1907 can be grasped only by the recitation of a tedious list of famous sitters who trooped to his studio on Campden Hill in Kensington, or, like Kaiser Wilhelm, summoned him to their courts.

Although De László had exhibited in London at the invitation of Auguste Rodin (1840–1917) at the International Society of Art in 1904, and would eventually be elected to replace Walter Sickert (1860–1942) as president of the Royal Society of British Artists (in 1930), he was never really accepted by English art institutions and seldom exhibited at the Royal Academy. He preferred instead one-man shows at his dealers, first Dowdeswell, then ascending through Agnew, French, and Knoedler, to (his apotheosis) Wildenstein in the year of his death, 1937.

In 1914 he became a British subject, but Scotland Yard nevertheless arrested him in 1917 on suspicion of collaboration with the Austro-Hungarian enemy. He was interned at Holloway from 1917 to 1919 and branded by the press as "the traitor painter." Emerging from this experience scarred but whole after the war, he slowly built up his ruined practice, until by 1926 he was again the leading portrait painter in Europe and again patronized by the English court. De László was outgoing and friendly, as smooth as butter, a real courtier; physically he was small, with a trim mustache and a passion for spotless clothes.

His paintings can be most easily compared with those of Romney (q.v.), although they are less intelligent and rarely betray even a hint of Romney's weariness with his profession. His women are slim, long-necked, graceful; their jewels drip from their ears and necks; they look out with straight-backed serenity while smooth, juicy swirls of thick paint envelop them. The brush is used not to define form or texture but to create a surface excitement as a foil to the absolute self-assurance of the sitters. Except in rare cases (such as the portrait of the artist's terrifying mother, *Mother Dear*, 36 x 28″, private collection), character is never the point. Like Leighton (q.v.) and Sargent he was also a competent landscape painter working in oils on a small scale. All his landscapes date from after 1902.

1. Owen Rutter, *Portrait of a Painter: The Authorized Life of Philip De László* (London, 1939), p. 17.

BIBLIOGRAPHY: Guido Menasci, "Artisti Contemporanei: F. E. Laszlò," *Emporium*, vol. 22, no. 131 (November 1905), pp. 322–36; Gabriel von Térey, "A Hungarian Portrait Painter: Philip A. László, *The Studio*, vol. 40 (1907), pp. 254–67; A. L. Baldry, "Some Recent Portraits by Philip A. László," *The Studio*, vol. 53 (1911), pp. 261–69; O. von Schleinitz, *Ph. A. von László* (Bielefeld and Leipzig, 1913); A. L. Baldry, "Some Paintings and Drawings by Mr. P.A. De Laszlo," *The Studio*, vol. 81 (1921), pp. 45–57; P. A. De László, *Selections from the Work of P. A. de László to Which Is Prefixed an Essay on László's Art by Comte Robert De Montesquiou*, ed. Oakley Williams (London, 1921); [Philip] De László, *Painting a Portrait* (London and New York, 1934); Owen Rutter, *Portrait of a Painter: The Authorized Life of Philip De László* (London, 1939); Derek Clifford, *The Paintings of P.A. De László* (London, 1969).

EXHIBITIONS: London, Fine Arts Society, 1907; London, Dowdeswell Galleries, *Portraits by Philip A. László*, June–July, 1908; London, Thomas Agnew and Sons, *Exhibition of Portraits by Philip A. László, M.V.O., Exhibited on Behalf of the Artists' General Benevolent Institution*, May–June 1911; London, Thomas Agnew and Sons, *Catalogue of Portraits by Philip A. De László, M.V.O., Exhibited on Behalf of the Artists' General Benevolent Institution*, June–July 1913; London, The French Gallery, *A Series of Portraits and Studies by Philip A. de László, M.V.O.*, June 1923; London, The French Gallery, *A Series of Portraits and Studies by Philip A. de László, M.V.O.*, June 1924; London, The French Gallery, *A Series of Portraits and Studies by Philip A. de László, M.V.O.*, June 1927; London, The French Gallery, *A Series of Portraits and Studies by Philip A. de László, M.V.O.*, May–June 1929; London, M. Knoedler, *Portraits by Philip A. de László, M.V.O.*, June–July 1933; New York, Knoedler Galleries, *Portraits by Philip A. De László, M.V.O.*, October 1933; London, M. Knoedler, *Royal Portraits by Philip A. de László, M.V.O.*, November–December 1934; London, Wildenstein, *Exhibition of Paintings by Philip A. de László, M.V.O.*, November–December 1937 (foreword by A. L. Baldry).

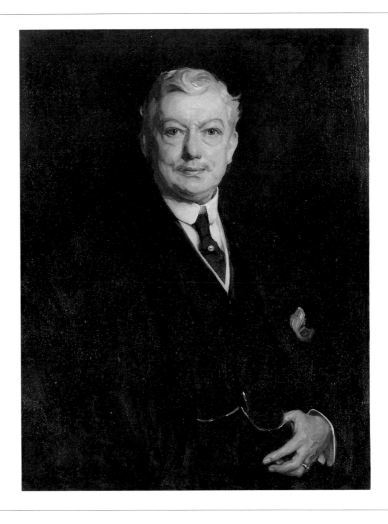

46 PHILIP A. DE LÁSZLÓ

JOHN H. MCFADDEN, 1916
Oil on canvas, 35¾ x 27½" (91 x 70 cm.)
Inscribed lower left: *Laszlo London 1916.XI.I*
Gift of Mr. and Mrs. John H. McFadden, Jr., 56-13-1

The date of De László's portrait of John McFadden (1851–1921) is 1916, when
Agnew was the artist's dealer and agent. Lockett Agnew, in particular,
arranged commissions for De László, and without doubt it was he who was
responsible for De László's painting McFadden—one of the last groups of
portraits he executed before his arrest as an enemy alien in September 1917.
McFadden may have wanted the portrait specifically as a frontispiece to
William Roberts's catalogue of his collection of English pictures, published in
1917. For a biography of the collector John H. McFadden, who left his
collection intact to the city of Philadelphia, now in the Philadelphia Museum
of Art, see the Introduction to the present catalogue.[1]

1. Information on John H. McFadden is preserved in a scrapbook of newspaper clippings in the collection of John H. McFadden's grandson, John Brinton, London.

LITERATURE: Roberts, 1917, repro. (frontispiece).

CONDITION NOTES: The original support is medium-weight (16 x 16 threads/cm.) linen. The painting is unlined. A white, evenly applied ground extends uniformly onto the tacking margins. The paint is in excellent condition. The paint profile varies in relief from very thick to very thin applications. No crackle is evident at this time. The paint appears never to have been cleaned and carries a single, probably original, layer of now-discolored, natural-resin varnish.

VERSION: Copy after Philip A. De László, *John H. McFadden,* oil on canvas, 36 x 28" (91.4 x 71.1 cm.), London, Mr. and Mrs. John Brinton Collection.

Thomas Lawrence's father (1724–1797) seems to resemble a character out of the pages of Dickens—gregarious, feckless, a failure, a dreamer of new schemes to keep his wife and five surviving children afloat in the world. He was also devoted to poetry and music, and when Fanny Burney stayed at the inn he managed at Devizes, The Black Bear, on April 8, 1780, she reported that the Lawrence home was "full of books, as well as paintings, drawings, and music." She also described the youngest of the Lawrence children, Tom (b. May 4, 1769, at Bristol) as "a most lovely boy of ten years of age, who seems to be not merely the wonder of their family, but of the times, for his astonishing skill in drawing," a boy whom Sir Joshua Reynolds (q.v.) had already pronounced "the most promising genius he had ever met with." [1] Fanny would have met the prodigy as a matter of course, for like a pet monkey, Tom was one of the attractions of his father's establishment, produced with the refreshments to recite passages from Milton and Shakespeare and to draw the portraits of the artists, actors, and aristocrats who stopped at Devizes on their way from London to Bath. Early on he became accustomed to the society of the talented and powerful.

By 1780 Tom's father was declared bankrupt; his one remaining asset was his boy's talent, and on this he proceeded to capitalize, moving the family first to Oxford, then to Weymouth, to work the market for cheap pastel portraits. Early in 1781 the Lawrences had reached Bath. Twelve-year-old Tom apparently supported the family, although now his father took up innkeeping again and his brothers and sisters were old enough to have jobs of their own.

Bath was in many ways an ideal choice for the cultivation of so promising an artistic talent. There were, of course, plenty of clients to sit for their portraits in pastel, but the city also possessed an atmosphere of sophistication and culture, of bookshops and printsellers, the theater, concerts, and private art collections (at Corsham Court, and, farther afield, at Wilton) to educate a young man. Lawrence, Sr., despite his love for poetry, held the bizarre opinion that "Genius must be its own instructor, reading will but lead my boy astray," [2] although he did allow him to take lessons in pastel from William Hoare and possibly from the young Thomas Barker of Bath (q.v.). When Hoare offered to send Tom to Italy with his own son Prince, Mr. Lawrence refused, and this decision, however much it may have constricted the child's artistic development, probably did his career no harm: as Cunningham recorded, George III "had an aversion to all artists who claimed fame from having studied abroad; and Lawrence was wholly of home manufacture." [3]

In 1784 Lawrence's copy on glass of a copy of Raphael's *Transfiguration* won him a medal from the Society of Arts, and two years later, in 1786, he painted his first picture in oils, a *Christ Bearing the Cross,* eight feet high (location unknown). In September of that year, at age seventeen, he visited London to weigh his chances for success as a portrait painter in the capital. Bearing in mind that Romney, Reynolds, and Gainsborough (q.q.v.) were still alive and at the height of their powers, it is astonishing that he felt able to report in a letter to his mother that "excepting Sir Joshua, for the painting of a head, I would risk my reputation with any painter in London." [4] More to the point, he was very nearly right.

By the summer of the next year, 1787, Lawrence had set up a studio near Sir Joshua's at 4 Leicester Fields, sent seven portrait heads to the Royal Academy, and enrolled as a student there, although he only stayed for three months. Two years later, in 1789, he sent to the academy his first full-length oil portrait of *Viscountess Cremorne* (95 x 57″, England, private collection), an accomplished essay in the manner of Sir Joshua, which led to a summons on September 27, 1789, to Windsor, to paint Queen Charlotte. This first royal commission resulted in a portrait (95 x 58″, London, National Gallery) of such

dignity and originality that Sir Joshua, half-blind, and near the end of his life, generously warned the boy that in him, "the world will expect to see accomplished all that I have failed to achieve."[5]

From this time on, Lawrence began to work exclusively in oils. He was rightly seen as the heir apparent to Reynolds, although it is worth stressing that he was never Reynolds's pupil and that in the sheer sensuous pleasure he had in the medium of oil paint, he is more truly the successor to Gainsborough. A discussion of two portraits he exhibited in 1790 at the Royal Academy (nos. 100 and 171) may help to characterize the nature of his genius.

Queen Charlotte was a tired, dowdy lady of forty-six, who, by the artist's own testimony, looked like "an old grey parrot."[6] He contrived to make her glamorous without resorting to rhetoric. And, more than glamorous, to be seen as a woman who, with the king only recently recovered from a severe bout of madness, and the Prince of Wales in moral disrepute, embodied all the dignity and the right to leadership of the royal family: the person in whom resided at that moment in the history of England whatever was left of the nation's trust in the monarchy. Gray-haired and bare-headed, she sits in a simple chair on a low dais—ordinary props that in Lawrence's hands somehow manage to imply a throne just as in this context the wonderful autumnal view of Eton College in the distance symbolizes all England. But Reynolds had been capable of this much. Lawrence did something more: he painted her pale blue silk dress and huge jewels with a voluptuous delight in color and texture so ravishing to the eye that the intellectual level of the portrait is put out of the spectator's mind until he has had time to drink in these sumptuous details.

The other portrait of the 1790 academy, *Miss Farren* (94 x 57½", New York, The Metropolitan Museum of Art), shows a famous actress, authentically glamorous (she was engaged to marry the Earl of Derby) posed in a landscape setting. The picture is a study in contradiction and psychology. By taking Miss Farren out of the world in which she was naturally at home, that is, in the city, at night, in the artificial light of the theater, and placing her in the countryside on a bright, fresh spring morning, he already turns the tables on us, juxtaposing high artifice with nature. For Eliza Farren is not playing the role of country maiden in the picture: she is made up, dressed to the teeth, swathed in silk and furs, with a huge fur muff hanging by her side. What is more, her pose is anything but natural and simple; rather, she turns half away from us, while keeping her gaze level with ours, a half smile on her face, an expression and pose full of ambiguity—or, in the words of the critic for *The Diary* for 1790, "arch, careless, spirited, elegant and engaging."[7]

Scholarly work has yet to be done on the politics behind royal appointments throughout the eighteenth century, but what happened to Lawrence in the next few years, although he was unquestionably the rising genius of his generation, was partly the result of the king's desire to promote his own artist in opposition to his son's favorite, John Hoppner (q.v.), and by doing so to assert the royal role as patron of the Royal Academy. Through the king's direct intervention, the twenty-one-year-old was voted an Associate of the academy in November 1791, and in February 1794, at twenty-five, he defeated Hoppner in his election to full Academician.

Within three days of Reynolds's funeral, in a letter dated February 26, 1792, Lawrence was made his successor as Painter in Ordinary to His Majesty.[8] Immediately, the Society of Dilettanti, whose portrait painter Reynolds also had been, followed suit.

Lawrence's career was made. Establishing a studio first in Piccadilly in 1794 and later, in 1813, at 65 Russell Square, he was swept up in the stream of fashionable life to record the civilization in England during the period of the

Napoleonic Wars and their aftermath, from 1790 to 1830. Indeed, our conception of this time we owe in part to Lawrence: there is in his best portraits, whether of men or of women, a quality of scintillation, of urgency, a sense of people living out extraordinary destinies at a time when England's fate did, in fact, hang on the outcome of battles and revolutions, and on the personalities of a few men like Wellington and Napoleon. And although Lawrence tried his hand at history painting (*Satan Calling His Legions,* exhibited R.A. 1797, no. 170, 170 x 107″, London, Royal Academy) he quickly saw that his talent lay in portraiture; he may even have glimpsed that contemporary events and personalities were in real life more dramatic, and cast on a more heroic scale, than the great set pieces of history or literature.

Ironically for a painter so associated with the Regency period, Lawrence was not to meet and paint the Prince Regent, later George IV, until 1814. The reasons were simple: Lawrence was the king's artist and therefore unacceptable to the prince or to his political and social circle; he was also the friend of the prince's estranged wife, Caroline, and, more damaging, had been suspected (although cleared) of being one of her lovers during the "Delicate Investigation" into her morals in 1806. But by the second decade of the century, with Hoppner dead, the only artist in Great Britain who came close to Lawrence in eminence was Raeburn (q.v.), who lived in Edinburgh, and whom George IV was not to meet until 1822, when he did single out Raeburn for high honors.

The regent proved to be a gracious friend and generous patron to Lawrence. In 1814 he commissioned him to paint the portraits of the sovereigns and generals assembled at Vienna for peace negotiations, and, to add greater status to the king's servant, conferred a knighthood on the artist on April 22, 1815. But Napoleon's Hundred Days, and the battle of Waterloo, prevented this trip, so it was not until September 1818 that the artist left England for Aix-la-Chapelle, his second trip abroad (the first had been in May 1814 to Paris for a few weeks). The twenty-four portraits resulting from this commission, eventually placed in the Waterloo Chamber at Windsor Castle, are Lawrence's masterpieces, a rare instance of an artist, his sitters, and times perfectly matched, for as Benjamin Robert Haydon said, "Lawrence was suited to the age and the age to Lawrence."[9] Wellington, Blücher, Alexander of Russia, Archduke Charles of Austria, and above all Pope Pius VII, whom he painted in Rome in the summer of 1819, honored and befriended Lawrence to the extent that he has justly been compared with Rubens (1577–1640), as an artist and ambassador. It was inevitable that on his return to England on March 30, 1820, he was greeted with the news of his election to the presidency of the Royal Academy, and by the end of his life he had been elected to most of the academies of Europe.

Posterity has been less kind to Lawrence. Because his portraits have a surface brilliance, an unnatural, overpolished quality, which has been described as Regency Mannerism, Lawrence has been accused of a kind of moral insincerity in his work. And it is true that he couldn't be unsophisticated, a shortcoming most obvious in his portraits of children, such as *Sarah Barrett Moulton* (1794, 57½ x 39¼″, San Marino, California, Henry E. Huntington Library and Art Gallery), in which the sitter's coy seductiveness could fairly be described as shameless. But Lawrence was never a virtuoso technician who, like John Everett Millais (1829–1896), exploited his own talents for profit. Far from dashing off a portrait in a few hours, he worked slowly, first drawing the sitter's face in detail on the canvas, then filling in the color, and unlike Reynolds, painting every inch of the drapery, including that on repetitions, by himself. In fact, as Michael Levey has stressed, he seems to have lived for his art and been obsessed with painting. What ruined him financially was not the

pursuit of pleasure of society, but his collection of old master drawings, one of the finest ever assembled by a private collector.

How little we could guess from his portraits that the artist's favorite author was Jane Austen. But behind the painter was a man more like one of her characters than any of his own clients. Garlick summarized Farington's opinion of his best friend thus: "Essentially Lawrence was a temperamental man, dependent on the advice and affection of a few friends and by no means the suave courtier which later, in Society, he appeared to be."[10]

1. Burney, 1854, vol. 1, p. 263.
2. Cunningham, 1879, vol. 3, pp. 19–20.
3. Ibid., vol. 3, p. 31.
4. Williams, 1831, vol. 1, p. 83.
5. Quoted in London, 1979–80, p. 16.
6. Layard, ed., 1913, p. 227.
7. Quoted in Goldring, 1951, p. 86.
8. Ibid., p. 91.
9. Quoted in Garlick, 1954, p. 14.
10. Ibid., p. 6.

BIBLIOGRAPHY: Williams, 1831; Cunningham, 1879, vol. 3, pp. 17–106; Gower, 1882; Gower, 1900; Oswald G. Knapp, ed., *An Artist's Love Story Told in the Letters of Sir Thomas Lawrence, Mrs. Siddons, and Her Daughters* (London and New York, 1904); Armstrong, 1913; Layard, ed., 1913; Goldring, 1951; Garlick, 1954; Garlick, 1964.

EXHIBITIONS: London, British Institution, *Lawrence Memorial Exhibition,* 1830; London, British Institution, *Exhibition of Reynolds, West, and Lawrence,* 1833; London, Royal Academy of Arts, *A Special Selection of Works by Sir Thomas Lawrence, P.R.A.,* winter 1904; Brighton, Brighton Art Gallery, *Sir Thomas Lawrence, P.R.A.,* 1951 (introduction by Derek Rogers); Bristol, City Art Gallery, *Exhibition of Works by Sir Thomas Lawrence P.R.A.,* July–August 1951 (by Kenneth Garlick); London, Thomas Agnew and Sons, *Loan Exhibition of Paintings by Sir Thomas Lawrence, P.R.A., in Aid of the Association of the Friends of the Bristol Art Gallery,* May–June, 1951 (introduction by Kenneth Garlick); Columbus, Ohio, The Columbus Gallery of Fine Arts, *Sir Thomas Lawrence as Painter and Collector,* October 7–November 13, 1955; Worcester, Massachusetts, Worcester Art Museum, *Sir Thomas Lawrence, Regency Painter: A Loan Exhibition of His Portraits,* April 27–June 6, 1960; London, Royal Academy, *Sir Thomas Lawrence, PRA, 1769–1830,* 1961 (by Kenneth Garlick); London, 1979–80.

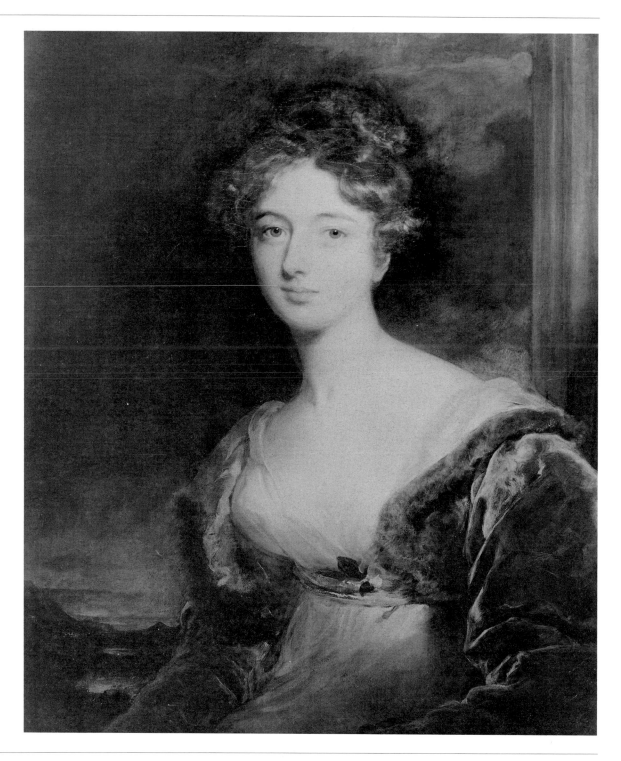

47 SIR THOMAS LAWRENCE *MRS. JAMES FRASER OF CASTLE FRASER*, C. 1817
 Oil on canvas, 30⅛ x 25″ (76.5 x 63.5 cm.)
 The George W. Elkins Collection, E24-4-17

This portrait was painted in 1817 at the time of Jane Hay's marriage to Col.
Charles Fraser of Castle Fraser (1792–1871), County Aberdeen, Scotland. She
was the fourth daughter of Sir John Hay, 5th Baronet, and bore her husband
four sons and five daughters.
 Jane Fraser (d. 1861) is seated, looking out directly at the spectator, who
sees her from a viewpoint slightly below. Her dress is in the Empire style, its
high waist defined by a gold sash just below her bosom. She wears a red velvet

coat with ballooning, mutton-chop sleeves and a fur-trimmed collar turned down around her shoulders to reveal a yellow silk lining. She is posed on a balcony or terrace, with one fluted pillar behind her to our right. In the distance below, Scottish lochs and mountains are seen in the moonlight, silhouetted against a dark and turbulent sky. The landscape here is a precursor to that in the background of Lawrence's *Charles William Lambton* (1825, 54 x 44″, Lord Lambton Collection) with its rocks and river seen from above at night.

INSCRIPTION: [C]*astle Fraser / Mackenzie Frazer* [on an old label, partially effaced, on the stretcher].

PROVENANCE: By descent to the sitter's grandson Col. Frederick Mackenzie Fraser of Castle Fraser, 1894; M. Knoedler and Co., New York; George W. Elkins, 1914.

EXHIBITION: London, Grafton Galleries, *Fair Women*, summer 1894, no. 83.

LITERATURE: Gower, 1900, p. 128; Armstrong, 1913, p. 132; Elkins, 1925, no. 24; Elkins, 1935, p. 11, repro. p. 6; *Philadelphia Museum of Art Bulletin*, vol. 34, no. 182 (May 1939), repro. p. 15; Garlick, 1954, pp. 37, 88; Garlick, 1964, pp. 82–83.

CONDITION NOTES: The original support is twill-weave, medium-weight (10 x 10 threads/cm.) linen. The tacking margins have been removed. The painting is lined with an aged aqueous adhesive and medium-weight linen. A thick, evenly applied white ground can be seen along the cut edges. The paint is in good condition. An irregular web of fracture crackle with slight, associated cupping is present overall. The original profile and brush marking are well preserved. Pentimenti in the figure's proper left shoulder and neckline are apparent in normal light. Under ultraviolet light, retouches are evident and limited to losses along the cut edges and a small area to the left of the figure's face.

48 SIR THOMAS LAWRENCE

MISS HARRIOTT WEST, AFTERWARDS MRS. WILLIAM WOODGATE, c. 1824–25
Oil on canvas, 30¼ x 25⅛″ (76.8 x 63.8 cm.)
John H. McFadden Collection, M28-1-16

Harriott West (1804–1879) was the daughter of Lt. Col. Sir James West of the Royal Artillery. In 1825 she married William Woodgate of Swaylands (1799–1866), partner in the firm of solicitors Currie, Williams, and Woodgate of Lincoln's Inn, and deputy lieutenant of Kent. The artist shows Miss West standing in a landscape with her right hand at her watch, which is attached to the blue sash around her waist. The sitter wears a long-sleeved white dress and on her left hand wears a ring, perhaps an engagement ring. According to Rev. G. Woodgate, historian of the Woodgate family, Miss West was often late in keeping her appointments for sittings with the artist. "One day she came in late, slightly flushed and holding a watch in her hand. Her colour, her pose were so exquisite as she advanced to make her excuses and beg the artist's forgiveness, that he readily replied, 'Certainly madam, if you will allow me to paint you in your present attitude.'"[1] In a letter of February 29, 1908, T. W. Jex-Blake, dean of Wells Cathedral, repeated the story and added that the portrait was a wedding present from the sitter to her future husband.[2] The portrait is therefore to be dated c. 1824–25.

A contemporary description of the sitter was given by Frances Woodgate, William's cousin, at the time of their engagement, on September 24, 1824: "William Woodgate and his *Bride elect* are staying at South Park. We went over on Saturday to be *introduced*. Had we not heard she was beautiful, we should certainly have considered her a *very pretty* young woman, but her having been so much extolled has been rather disadvantageous to her. She is much taller than we expected to see her, I think she is about my height, exceedingly thin & pale; she has beautiful dark eyes and hair and a very pretty mouth and set of teeth. . . . I have no doubt we shall find her very agreable; she appears exceedingly pleasing and good-tempered."[3]

In the poor reproduction of our portrait in the Woodgate history the picture appears to have been much extended, but this is an illusion produced by the process of reproduction, for the painting has not been cut down.[4] Pentimenti on the front of the sitter's dress show that the artist changed the position of the pink bow.

1. Woodgate and Woodgate, 1910, p. 119.
2. Photocopy in the Accession Files, Philadelphia Museum of Art.
3. Woodgate and Woodgate, 1910, p. 449.
4. Ibid., repro. opp. p. 384.

PROVENANCE: By descent to the sitter's daughter-in-law, Mrs. Ernest Woodgate of Rochester; sold as the property of a gentleman [F.C.H. Barrett], Christie's, February 23, 1907, lot 82; Colnaghi and Agnew, London; bt. from Agnew, by John H. McFadden, December 12, 1907.

EXHIBITIONS: London, Thomas Agnew and Sons, *Annual Exhibition for the Artist's General Benevolent Institution*, 1907, no. 19; New York, 1917, no. 17, fig. 17; Pittsburgh, 1917, no. 17; Philadelphia, 1928, p. 22.

LITERATURE: Woodgate and Woodgate, 1910, pp. 119, 383, repro. opp. p. 384; Armstrong, 1913, pp. 169–70 (wrongly identified as the wife of William Woodgate of Somerhill); Gowans Art Books, *Masterpieces of Lawrence* (London and Glasgow, 1913), repro. p. 60; Roberts, 1913, p. 541; Roberts, 1917, pp. vii, 33–34, repro. opp. p. 33; Roberts, 1918, "Portraits," p. 134, repro. p. 134; Garlick, 1954, pp. 62, 88; Garlick, 1964, pp. 195–96.

CONDITION NOTES: The original support is twill-weave, medium-weight (10 x 10 threads/cm.) linen. The painting was lined with an aqueous adhesive in 1943. In 1964 Siegl retained the aqueous lining and added a second lining of medium-weight linen with wax-resin adhesive. An off-white ground is present and extends onto the tacking margins. The paint is in good condition and the texture of the brush marking has been preserved. The paint consistency is extremely vehicular and rich. A fine network of traction crackle is evident in the red scarf. A pentimento of the scarf's position is evident in paint texture in this area. Pinpoint losses in paint and ground exist overall. Active cleavage noted by Siegl in 1964 now appears stable. Retouching is visible in normal and ultraviolet light along all four edges.

ENGRAVING: Norman Hirst, 1908, mezzotint.

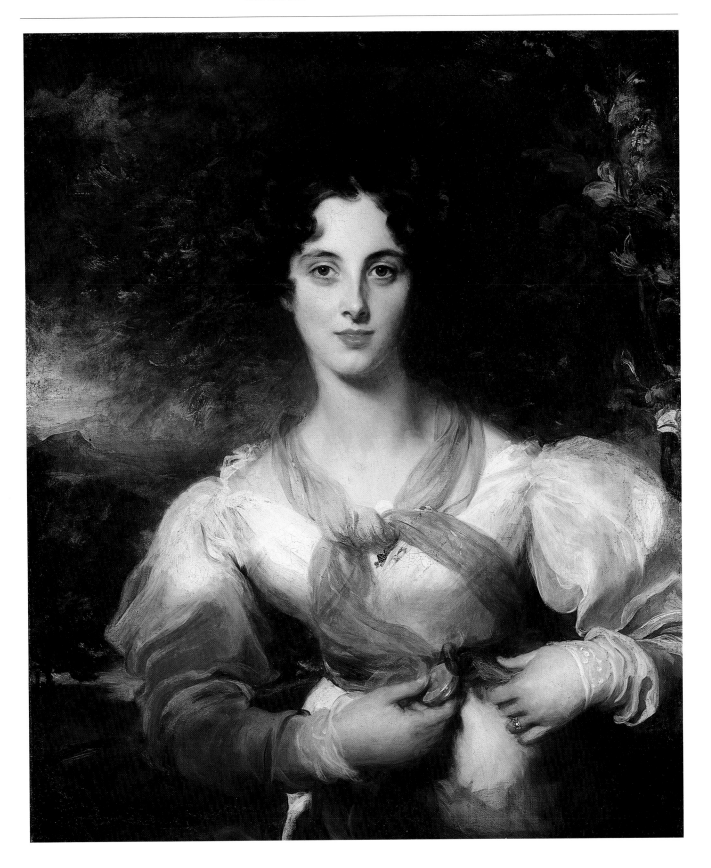

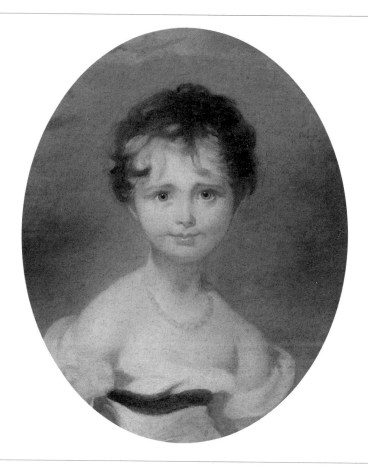

49 AFTER SIR THOMAS LAWRENCE

LADY EMILY COWPER, LATER LADY ASHLEY AND COUNTESS OF SHAFTESBURY
Oil on canvas, 21⅛ x 16⅞″ (53.5 x 42.8 cm.) (oval)
Bequest of Lisa Norris Elkins, 50-92-8

Emily Caroline Catherine Frances (1810–1872), first daughter of the 5th Lord Cowper, married on June 10, 1830, Anthony Ashley-Cooper, 7th Earl of Shaftesbury (1801–1885), the great evangelical philanthropist, who is commemorated by the statue of Eros in Piccadilly Circus. Lawrence painted Lady Emily at the age of about three. Just before her marriage, Thomas Creevy described her, on March 3, 1829, as "the leading favorite of the town *so far.* She is very inferior to her fame for looks, but is very natural, lively, and appears a good natured young person."[1]

1. Herbert Maxwell, ed., *The Creevy Papers: A Selection from the Correspondence and Diaries of the Late Thomas Creevy, M.P.* (London, 1903), vol. 2, p. 198.

INSCRIPTION: *No. 5791* [on the reverse]; *Xavier Manelle* [?] *B* [on the stretcher].

CONDITION NOTES: The original support is a rectangular piece of medium-weight (16 x 16 threads/cm.) linen matted into an oval format. The tacking margins have been removed. The painting is lined with an aqueous adhesive and medium-weight linen. An off-white ground is visible along the cut edges. The paint is in fair condition. Traction crackle has formed within the oval, unmatted portion. Drying characteristics of the brown paint suggest the presence of bitumen in the artist's palette. Under ultraviolet light, retouches are coincident with the traction crackle overall.

VERSIONS
1. Sir Thomas Lawrence, *Lady Emily Cowper,* 1814, oil on canvas, 30 x 25″ (76.2 x 63.5 cm.) (oval), the Earl of Shaftesbury.
 EXHIBITIONS: London, Royal Academy, 1814, no. 271; London, British Institution, 1830, no. 22; London, *International Exhibition,* 1862, no. 228.
 LITERATURE: Cunningham, 1879, vol. 3, p. 58; Gower, 1900, pp. 120, 158, repro. opp. p. 54; Armstrong, 1913, p. 124; Garlick, 1954, p. 33; Garlick, 1964, pp. 60–61.
 ENGRAVINGS AFTER VERSION I
T. Wright after Sir Thomas Lawrence, *The Rosebud,* 1830.
J. R. Jackson after Sir Thomas Lawrence, *Lady Emily Cowper,* 1844.

2. After Sir Thomas Lawrence, *Lady Emily Cowper,* oil on canvas, 19¼ x 11⅔″ (50 x 29.6 cm.) (oval), location unknown.
 PROVENANCE: Fischer (auctioneer), Lucerne, August 27–28, 1929, lot 95.

3. Emily Sturt after Sir Thomas Lawrence, *Lady Emily Cowper,* 1833, oil on canvas, 20 x 17″ (50.8 x 43.2 cm.) (oval), location unknown.
 PROVENANCE: Christie's, July 24, 1980, lot 35.

4. After Sir Thomas Lawrence, *Lady Emily Cowper,* oil on canvas, 23¼ x 19½″ (59 x 49.5 cm.) (oval), Mobile, Alabama, Daniel T. McCall, Jr. Collection.
 PROVENANCE: Felix Goulet; Mrs. J. C. Bush, Mobile, Alabama, 1937; by descent to her son J. C. Bush; bt. Daniel T. McCall, Jr.

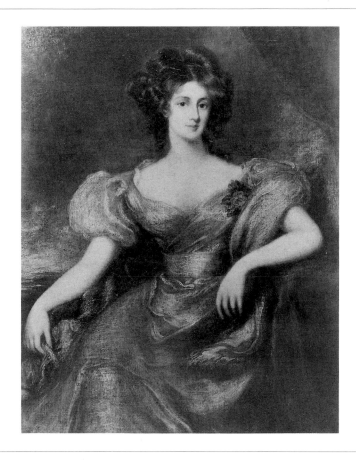

50 FREE COPY AFTER *LADY HARRIET CLIVE, LATER BARONESS WINDSOR,* nineteenth century
 SIR THOMAS LAWRENCE Oil on canvas, 49½ x 40½" (125.7 x 102.9 cm.)
 Walter Lippincott Collection, 23-59-17

Lady Harriet Clive (1779–1869), second daughter of the Earl of Plymouth, married Hon. Robert Clive in 1819. She was created Baroness Windsor in 1855. The portrait came to the museum as a portrait of Elizabeth Grantham. The correct identity of the sitter and the whereabouts of the original are due to Kenneth Garlick (March 1965).

LITERATURE: "The Walter Lippincott Collection," *The Pennsylvania Museum Bulletin,* vol. 19, no. 80 (November 1923), p. 26, repro. p. 27.

CONDITION NOTES: The original support is medium-weight linen. The tacking margins have been removed. The painting is lined with a wax-resin adhesive and medium-weight linen. An off-white ground is visible along the cut edges. The paint is in only good to fair condition. Traction crackle is especially prominent in the brown tones of the figure's hair. An irregular net of wide-aperture fracture crackle with slight, associated cupping is present overall. Some local abrasion is evident in the mid- and shadow tones of the figure's face. Small losses, consistent with losses along the edges of cupped and raised paint, are present overall. Under ultraviolet light, retouching is visible over the abraded areas in the face and hair and over a large area in the lower left corner.

VERSION: Sir Thomas Lawrence, *Lady Harriet Clive,* begun c. 1823, oil on canvas, 56 x 44" (142 x 112 cm.), Oakley Park, the Earl of Plymouth Collection.

EXHIBITIONS: Paris, *Cent Portraits de Femmes,* 1909, no. 25; Rome, *International Fine Arts Exhibition, British Section,* 1911, no. 48.

LITERATURE: Gower, 1882, p. 119; Gower, 1900, p. 118; Armstrong, 1913, p. 122; Garlick, 1954, p. 32; Garlick, 1964, pp. 55–56.

ENGRAVINGS
Samuel Cousins after Sir Thomas Lawrence, *Lady Harriet Clive,* 1840, mezzotint, 16⅛ x 12¾" (41 x 32.4 cm.).
R. J. Lane after Sir Thomas Lawrence, *Lady Harriet Clive,* 1832, lithograph (half length).

LITERATURE: Gower, 1900, p. 118; Garlick, 1954, p. 32.

Frederic Leighton was born in 1830 in Scarborough, Yorkshire, the son of Frederic Septimus Leighton (1800–1892), a doctor who had given up his practice to cultivate musical and artistic tastes and, for the sake of his wife's health, to travel on the Continent. Like the James family, the Leightons wandered across Europe's capitals and spas, and like Henry James, the young Frederic Leighton blossomed into the complete cosmopolite—learning to speak fluently German, French, Italian, and (later) Spanish. By the age of eleven he was taking drawing lessons from Francesco Meli in Rome (1841), and at fifteen entered the Accademia di Belle Arti in Florence for the year 1845–46. When the American sculptor Hiram Powers (1805–1873) advised his father to take his son's gift for art seriously, the Leightons moved in 1846 to Frankfort, where Frederic entered the Städelsches Kunstinstitut. There he stayed until 1850, although the revolutions of 1848 forced the family to spend long periods in Brussels and Paris. Back in Frankfort in 1850, his master was Edward von Steinle (1810–1886), a religious painter of the Nazarene school, working in the flat, precise, and archaizing style first promulgated by Peter von Cornelius (1783–1867), Johann Friedrich Overbeck (1789–1869), and Philipp Veit (1793–1877) in Rome.

The next ten years saw Leighton coming to terms with his identity as an Englishman trained in the rigorous academic traditions of the Continent. From 1852 to 1855 he lived in Rome, visiting England in the summers, but surrounded at Rome by a circle composed of the artists George Heming Mason (1818–1872) and Giovanni Costa (1833–1903), the socialite and former opera singer Adelaide Sartoris (1814–1879), the poet Robert Browning (1812–1889), and a smattering of glamorous international society.

While in Rome he worked on two large-scale history pictures. The first, which harked back to the theatrical history paintings of the Boydell Shakespeare Gallery, was the lushly romantic *Reconciliation of the Montagues and the Capulets over the Dead Bodies of Romeo and Juliet* (1853–55, 70 x 91″, Decatur, Georgia, Agnes Scott College). This he sent to the Exposition Universelle in Paris in 1855. For his English debut he submitted to the Royal Academy an altogether more austere and Germanic painting, his monumental processional picture *Cimabue's Celebrated Madonna Is Carried in Procession through the Streets of Florence* (1853–55, 87½ x 205″, Her Majesty Queen Elizabeth II). Queen Victoria, at the instigation of Prince Albert, bought the canvas off the walls of the academy, and in so doing assured Leighton's success in London. Even before its exhibition, in 1854, William Makepeace Thackeray (1811–1863), who had met Leighton in Rome, observed to the young Pre-Raphaelite John Everett Millais (1829–1896), at that time the most technically brilliant English artist of his generation: "There's a young fellow in Rome called Leighton who is making prodigious strides in his art.... If I'm not mistaken that young man will one day be President of the Royal Academy."[1] After the exhibition of *Cimabue's Madonna,* Dante Gabriel Rossetti (1828–1882), another member of the original Pre-Raphaelite Brotherhood, wrote to the poet William Allingham (1824–1889) describing Leighton's picture—which he admired—but added that Leighton would be used by the Royal Academicians against the Pre-Raphaelite insurgents: "The R.A.'s have been gasping for six years for someone to back against [William Holman] Hunt and Millais, and here they have him."[2]

Leighton was not quite the success they or he had hoped. He did not return at once to England but spent the years 1855–58 in Paris, mixing with such painters as the Englishman Edward Poynter (1836–1919), the American James Abbott McNeill Whistler (1834–1903), the French sculptor Jules Dalou (1838–1902), and meeting Ingres (1780–1867), Ary Scheffer (1795–1858), and Corot (1796–1875). Throughout this period he sent his work to the Royal

Academy. The press actually panned his 1856 offering, *The Triumph of Music* (c. 1855–56, 80 x 110″, location unknown), and were not again wholly enthusiastic about his pictures until the exhibition of 1859 when he showed studies of the Roman model Nanna Risi. In this year he finally moved permanently to England but still had to wait five more years, until 1864, for election as associate member of the Royal Academy. Full membership came in 1868, and ten years later, at the age of forty-eight, Leighton succeeded Sir Francis Grant (1803–1878) as president.

Perhaps only Sir Thomas Lawrence (q.v.), and before him Sir Joshua Reynolds (q.v.), so fully deserved the honor. Leighton seems consciously to have tried his hand at almost every branch of the fine arts, working in the 1860s as a book illustrator of taut dramatic power in his woodcuts to George Eliot's *Romola* (1863) or Dalziel's *Bible Gallery* (1863–64); or, at the other end of the scale, undertaking the mural decorations for St. Michael's, Lyndhurst (*The Wise and Foolish Virgins*, 1862–64, fresco, 8 x 24′), and later the monumental frescoes for the South Kensington Museum (*The Arts of Industry as Applied to War*, 1878–80, and *The Arts of Industry as Applied to Peace*, 1883–86, each 16 x 35′). As a sculptor he introduced the style of Rodin (1840–1917) into England with his *Athlete Struggling with a Python* (1874–77, height 69″, London, Tate Gallery), a bronze that would herald a whole new spirit of naturalistic sculpture in England, which would become known as the New Sculpture. Leighton was primarily a history painter, but he was also a genre painter of great sweetness, a landscape artist whose small oil sketches from nature have been compared to those of Corot (1796–1875), and a portrait painter, on occasion, of real penetration.

By 1864 in his *Orpheus and Eurydice* (50 x 43″, London, Leighton House) he had painted his first classically inspired picture. From this time he was in the forefront of the neo-classical revival in England of the 1860s, a revival that, under the influence of Whistler and Albert Moore (1841–1893), shaded off into the aesthetic movement of the 1870s. But because, like John Frederick Lewis (1805–1876) or William Holman Hunt (1827–1910), Leighton was a compulsive traveler in the Near East, his pictures, even when they have a classical theme, as in the *Syracusan Bride* (1865–66, 53 x 167″, James Lamantia Collection) or the *Daphnephoria* (1874?, 89 x 204″, Port Sunlight, Lady Lever Art Gallery), possess a brash, almost vulgar vitality—a sense of bold form and feverish color surely absorbed from the bazaars and deserts of Africa and the East.

Still, his oeuvre on the whole must be described as hit and miss. Sometimes, as in his 1860 portrait of *May Sartoris* (59⅞ x 35½″, Fort Worth, Texas, Kimbell Art Museum), his portraits are among the most original and tenderly felt of the whole Victorian period. There is also splendor in his great machines, particularly *Captive Andromache* (c. 1888, 77 x 160″, Manchester, City Art Gallery). But at other times his peculiar ideal of female beauty, or his over-theatrical representation of extreme emotions, strikes the modern viewer as bizarre. As examples of his failures we might list *Phryne at Eleusis* (c. 1880, 86 x 46″, location unknown) or *The Last Watch of Hero* (c. 1887, 62 x 35½″, Manchester, City Art Gallery).

In his role as Royal Academician and patron Leighton also made a lasting contribution to English painting. He instituted the famous winter exhibitions of old masters at the Royal Academy and enticed into the academy true artists such as Alfred Gilbert (1854–1934), G. F. Watts (1817–1904), Edward Burne-Jones (1833–1898), and John Singer Sargent (1856–1925); as a private patron he encouraged the early work of such men as Aubrey Beardsley (1872–1898), Gilbert, Costa, and George Mason (1818–1872); as a collector of works by French artists such as Corot and Ingres he was in advance of most English collectors of his generation; and his house in Holland Park, built

between 1864 and 1866 by George Aitchison (1825–1910), with its Arab Hall and splendid drawing rooms hung round with his own and other artists' works, was one of the wonders of Victorian London. There Leighton received the artistic world, from members of the royal family interested in the arts, to musicians, painters, poets, and journalists at his popular Sunday receptions and his musical evenings.

Leighton never married. Having ascertained that he had no children to whom he could pass the title,[3] Queen Victoria raised him to the peerage as Lord Leighton of Stretton, three weeks before he died, on January 25, 1896.

1. Quoted by Ormond, 1975, p. 22, from J. Comyns Carr, *Some Eminent Victorians* (London, 1908), p. 95.
2. Dated May 11, 1855; Oswald Doughty and John Robert Wahl, eds., *Letters of Dante Gabriel Rossetti,* vol. 1 (Oxford, 1965), p. 252.
3. Lord Salisbury to Queen Victoria, December 16, 1891, RA A68/89, Royal Archives, Windsor Castle.

BIBLIOGRAPHY: Pattison, 1882; Mrs. Andrew Lang, "Sir F. Leighton, President of the Royal Academy, His Life and Work, Art Annual," *The Art Journal,* 1884; Rhys, 1895; Frederic Leighton, *Addresses Delivered to Students of the Royal Academy,* 2nd ed. (London and New York, 1897); Rhys, 1898; W[alter] A[rmstrong], *Dictionary of National Biography,* suppl., s.v. "Leighton, Frederic"; Corkran, 1904; Barrington, 1906; Staley, 1906; Ormond, 1975.

EXHIBITIONS: London, Royal Academy, *Works by the Late Lord Leighton of Stretton, President of the Royal Academy,* winter 1897; Manchester, City Art Gallery, Minneapolis, Minneapolis Institute of Arts, Brooklyn, Brooklyn Museum, *Victorian High Renaissance,* September 1978–April 1979 (entries by Leonée and Richard Ormond).

51 SIR FREDERIC LEIGHTON

A ROMAN LADY (LA NANNA), 1859
Oil on canvas, 31½ x 20½" (80 x 52 cm.)
Purchased: The Henry Clifford Memorial Fund, 1976-34-1

To his mother in England Frederic Leighton wrote from Rome on February 24, 1859, "I am just about to despatch to the Royal Academy some studies from a very handsome model, 'La Nanna.' I have shown them to a good many people, artists and 'Philistines,' and they seem to be universally admired. Let us hope they will be well hung in the Exhibition."[1]

The studies he mentions all show the famous Roman beauty Anna, or Nanna, Risi. In addition to this portrait, the largest of the group and the only one showing the model full face in three-quarter length, Leighton painted a half-length profile of her against a background of peacock feathers, *Pavonia* (fig. 51-1), which was bought by the Prince of Wales (later Edward VII) on February 24, 1859—the very day Leighton was writing to his mother in the letter quoted above. A replica of *Pavonia* (23½ x 20") painted for George de Monbrison, is now in Leighton House, and a small study, now untraced, called *Sunny Hours,* was purchased in Rome by Lady Hoare. Still another variant of *Pavonia* (21 x 16½") showing the model with her back to us and head in three-quarter profile, was purchased from the artist in 1859 by George Payne, Esq., and descended to his granddaughter, who sold it at Sotheby's, New York (October 28, 1982, lot 78).

Leighton had been living in Paris since the success at the Royal Academy in 1855 of his *Cimabue's Celebrated Madonna Is Carried in Procession through the Streets of Florence* (1853–55, 87½ x 205", Her Majesty Queen Elizabeth II) and had gone to Rome in October 1858 to prepare for the Royal Academy

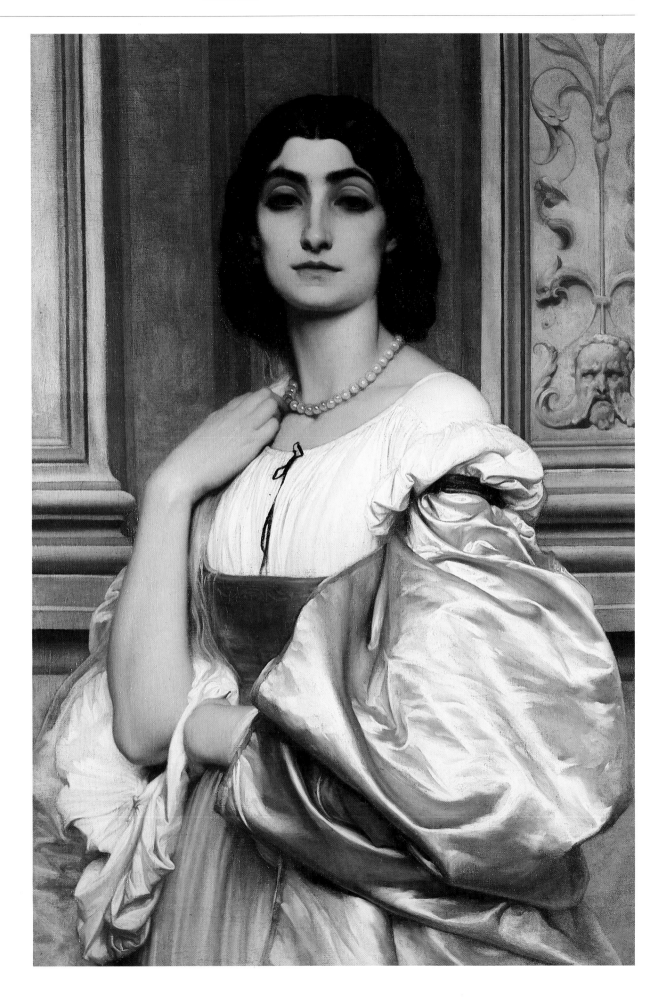

FIG. 51-1 Sir Frederic Leighton, *Pavonia*, 1859, oil on canvas, 22¼ x 19¾" (57.8 x 50.2 cm.), Her Majesty Queen Elizabeth II

exhibition the following spring. In the autumn of that year he met Nanna, the wife of a cobbler in Trastevere and a professional model. One of his Roman notebooks, now preserved in the Royal Academy Library (XIX), records that she sat to him in November (20–21), December (1–6, 12–17) 1858; and January (7–12), February (3–4, 16, 25, 27), March (21–22), and April (6–7) 1859. Leighton was far from alone among the artists resident in Rome in the 1850s in responding to her extraordinary looks, as has been described elsewhere,[2] but it is worth noting that both the French sculptor Jean Baptiste Clésinger (1814–1883) in a marble portrait bust (untraced) exhibited at the Paris Salon of 1859 (bronze dated 1858) and Léon Bonnat (1834–1923), the French painter, had already been inspired by her. The year after Leighton's studies of her, in 1860, Nanna would meet the German artist Anselm Feuerbach (1829–1880) whose numerous portraits of her are among the most striking manifestations of mid-century German romanticism (fig. 51-2).

At the Royal Academy, the Nanna series was a success. The critics, who had been lukewarm or even hostile to Leighton since the triumph of *Cimabue's Madonna* in 1855, outdid themselves in their praise:

> Mr. Leighton, after a temporary eclipse, again struggles to light. His heads of Italian women this year are worthy of a young old master,—so rapt, anything more feeling, commanding or coldly beautiful we have not seen for many a day.... Mr. Leighton has admirably caught the Italian complexion in all its tints, down even to the languid sepia tint under the eyes, as in his full-face model, who might be a Vittoria Corombona, so feeling and passionate she looks. This is real painting, and we cannot but think that a painter who can paint what he sees so powerfully will soon be able to surpass that processional picture of his [*Cimabue's Madonna*] about which there was such a primitive charm and saintliness. It is a pity if such a spring has no summer.[3]

In May 1861 Leighton wrote to his father that he would exhibit the three studies of Nanna at the great International Exhibition of 1862 in Paris, but he never did so.[4]

In this painting the model is posed like a portrait by Pontormo (1494–1556), with her right hand to her shoulder, proudly erect, against an engaged pillar painted with Mannerist grotesques. Her dress, a peasant costume of white blouse and red bodice made sumptuous by ballooning sleeves of dove-gray silk, evokes, as do the pearls at her throat, the sensuous descriptions of fabrics and jewels we associate with Paolo Veronese (c. 1528–1588). Her great hooded eyes, salient cheekbones, and enigmatic half smile are all painted in the softest sfumato, evoking Leonardo's mysterious female faces. As is known from contemporary descriptions of Nanna, she was a tall, statuesque woman, and a woman of passionate temper. Something of her immense solidity and insistent physical presence Leighton communicates in his portrait of her, although his use of Nanna to evoke the style of various Renaissance artists does slightly distance the viewer from the model; *The Athenaeum*'s phrase, in describing the portrait as "coldly beautiful," seems apt.

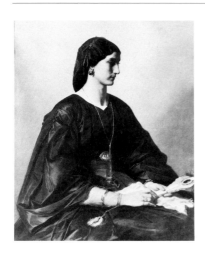

FIG. 51-2 Anselm Feuerbach (1829–1880), *Nanna,* 1861, oil on canvas, 46⅛ x 38⅛″ (118.4 x 97 cm.), Stuttgart, Staatsgalerie

1. Barrington, 1906, vol. 2, p. 39.
2. Richard G. Dorment, "'A Roman Lady' by Frederick Leighton," *Bulletin of the Philadelphia Museum of Art,* vol. 73, no. 317 (June 1977), pp. 2–11.
3. "Royal Academy," *The Athenaeum,* May 7, 1859, p. 618.
4. Barrington, 1906, vol. 2, p. 62.

PROVENANCE: Benjamin Godfrey Windus; his sale, July 19, 1862, lot 51, bt. Agnew; possibly the picture of a "Roman Lady" sold by Col. Holdsworth, Christie's, April 30, 1881, lot 65, bt. Garrett; William Graham, his sale, Christie's, April 2, 8, 1886, lot 74, bt. McLean; Edwin Lawrence, M.P.; Sotheby's, Belgravia, March 9, 1976, lot 46, bt. Agnew, for the Philadelphia Museum of Art.

EXHIBITIONS: London, Royal Academy, 1859, no. 281; London, Royal Academy, 1897, no. 59; Manchester, City Art Gallery, Minneapolis, Minneapolis Institute of Arts, Brooklyn, Brooklyn Museum, *Victorian High Renaissance,* September 1978–April 1979, no. 39, repro. p. 102.

LITERATURE: "Royal Academy," *The Athenaeum,* May 7, 1859, p. 618; "The Royal Academy Exhibition," *The Art Journal,* 1859, p. 166; Pattison, 1882, p. 10, see repro. p. 12; Rhys, 1895, pp. xvii, 55, 66; Rhys, 1898, pp. 14, 84, see p. 72; Corkran, 1904, pp. 38, 202, see p. 36; Barrington, 1906, vol. 2, pp. 38–41, 48, 62, 382; Staley, 1906, pp. 55–56, 232, 260–61; Ormond, 1975, pp. 41–42, 49–50, 60, 152 no. 45, pl. 59; Richard G. Dorment, "'A Roman Lady' by Frederick Leighton," *Bulletin of the Philadelphia Museum of Art,* vol. 73, no. 317 (June 1977), pp. 2–11.

CONDITION NOTES: The original support is medium-weight (12 x 12 threads/cm.) linen. The tacking margins have been removed. Two small repaired tears, 1 to 2″ long, are visible below the proper right forearm. The painting was lined in 1976 with a wax-resin adhesive and a plain-weave, glass-fiber composite fabric. An off-white ground is visible along the cut-off edges. The paint is in fairly good condition. Only a minor alteration of the brushwork profile is evident. There are pinpoint losses overall, which generally coincide with the edges of fracture crackle. An irregular net of very narrow aperture fracture crackle exists overall. Minor abrasion is visible in the shadow areas of the figure's dress. Under ultraviolet light, pinpoint retouches are visible overall.

Pieter Van der Faes, nicknamed Lely or Lily, was born on September 14, 1618, while his father was on military duty in the town of Soest, Westphalia, for the elector of Brandenberg. His family, however, came from The Hague, where they owned property in the fashionable quarter of the city. By 1637 Pieter was a pupil in the Haarlem studio of Frans Pieters de Grebber (c. 1573–1649) and came to England sometime between 1641 and 1643. He arrived in London at a propitious moment for a young and ambitious artist. Van Dyck (b. 1599) died in 1641; Cornelius Johnson (1593–1661) left for Holland in 1643; and the most brilliant English-born painter of the seventeenth century, William Dobson (b. 1610), died after a short career attached to the exiled court of Charles I at Oxford, in 1646.

Graham states that at first Lely "pursu'd the natural bent of his *Genius* in Landtschapes with *Small Figures* and *Historical Compositions;* but finding the practice of *Painting, after the Life* generally more encouraged, he apply'd himself to *Portraits* with such success, as in a little time to surpass all his CONTEMPORARIES in EUROPE."[1] The style Lely brought with him, and the direction his art might have taken had he not given himself over to portraiture, can be seen in his *Sleeping Nymphs by a Fountain* of the early 1650s (50¼ x 57″), in the Dulwich Picture Gallery. Here we see how his work developed out of small-scale mythological scenes painted by such Dutch masters as Cornelis van Poelenburgh (1586–1667), and also how Lely's feeling for the sensual use of paint to describe voluptuous flesh would ultimately make him the ideal recorder of the profligate court of Charles II.

His first royal portrait group was commissioned in 1647 when he painted *Charles I (1600–1649) with His Second Son James, Duke of York (Later James II, 1633–1701)* (49¾ x 57¼″, Syon House, Duke of Northumberland) at Hampton Court where Charles, in custody, was still allowed to see his children.

After the king's execution, and throughout the Commonwealth, Lely flourished—even painting Cromwell himself in 1654, the same year in which one contemporary, James Waynwright, described Lely in a letter to Mr. Bradshaw as "the best artist in England."[2] Lely's maturity, however, dates from the Restoration in 1660. He is the painter of those lovely Restoration wantons—Barbara Villiers, Countess of Castlemaine and Duchess of Cleveland, Nell Gwyn, or Louise de Kéroualle, Duchess of Portsmouth. Charles's mistresses are all shown with their hair and chemises disheveled, their eyes half-closed, their bosoms heaving—images that are hard to separate into individual portraits but that collectively conjure up the world of Rochester and Pepys. When Pope described a portrait of the Duchess of Cleveland as having "the Sleepy Eye that spoke the melting soul," he might have been describing any of Lely's beauties. Contemporaries complained that Lely's sitters looked exactly alike: "Sir Peter Lilly when he had painted the Dutchess of Clevelands picture, he put something of Clevelands face as her Languishing Eyes into every one Picture, so that all his pictures had an Air one of another, all the Eyes were Sleepy alike. So that Mr. Walker ye Painter swore Lilly's Pictures was all Brothers and sisters."[3]

However superficial from a psychological point of view Lely's works may be, they seduce with their clear, gorgeous colors, assured handling of paint, and the artist's ability to create a sense of volume around the sitter. Although he does not have Van Dyck's rare refinement or elegance, he is still that artist's true successor, and as a colorist he may be called the finest artist to have painted in England before the advent of Gainsborough (q.v.).

Working out of a house and studio in the Grand Piazza, Covent Garden, Lely inevitably ran a large studio, probably painting only the heads of most of his sitters, while assistants worked on the figures and drapery. In 1661 Charles II granted him a pension as Principal Painter to the king, and in 1662 Lely was granted naturalization. He was knighted in January 1680 and died later the same year, on November 30.

1. Richard Graham, "A Short Account of the Most Eminent Painters . . . down to the Present Times . . . ," in C. A. DuFresnoy, *De Arte Graphica: The Art of Painting* (London, 1695), p. 343.
2. See Margaret Whinney and Oliver Millar, *English Art, 1625–1714* (Oxford, 1957), p. 172.
3. ADD. MS. (Anon.), 22950, fol. 41, British Museum, London; quoted by Oliver Millar, in London, National Portrait Gallery, *Sir Peter Lely, 1618–80,* November 17, 1978–March 18, 1979, p. 63.

BIBLIOGRAPHY: Richard Graham, "A Short Account of the Most Eminent Painters . . . down to the Present Times . . . ," in C. A. DuFresnoy, *De Arte Graphica: The Art of Painting* (London, 1695), pp. 343–44; [Bainbrigg Buckeridge], "An Essay Towards an English School of Painters," in Roger de Piles, *The Art of Painting* (London, 1706), pp. 444–47; Walpole, 1888, vol. 2, pp. 91–101; C. H. Collins Baker, *Lely and the Stuart Portrait Painters: A Study of English Portraiture before and after Van Dyck* (London, 1912), vol. 1, pp. 138–76, vol. 2, pp. 122–49; C. H. Collins Baker, *Lely and Kneller* (London and New York, 1922), pp. 1–64; R. B. Beckett, *Lely* (London, 1951); Margaret Whinney and Oliver Millar, *English Art, 1625–1714* (Oxford, 1957), pp. 169–77; Waterhouse, 1978, pp. 92–100.

EXHIBITION: London, National Portrait Gallery, *Sir Peter Lely, 1618–80,* November 17, 1978–March 18, 1979 (by Oliver Millar).

52 SIR PETER LELY

JAMES BUTLER, 12TH EARL AND 1ST DUKE OF ORMONDE, 1647
Oil on canvas, 47⅞ x 36½" (121.6 x 92.7 cm.)
Arthur H. Lea Bequest, F38-1-3

This portrait entered the Philadelphia Museum of Art as a work by the English-born portrait painter William Dobson (1610–1646), whose entire period of activity took place between 1642 and 1646, mainly at the court of Charles I in Oxford. However, both Malcolm Rogers and Sir Oliver Millar have attributed this portrait to Peter Lely, dating it to the very late 1640s. Millar confirms that it represents James Butler, Duke of Ormonde.

Stylistically, it bears all the attributes of Lely's early period. The lively facial expression, strong draftsmanship, and assured modeling, as well as the uncertain placement of the figure in the canvas, and the sense of gentleness and slight melancholy on the face of the sitter are characteristic. It also has the restraint and simplicity typical of early Lely but very different from Dobson's more baroque sense of composition.

We might compare this painting with a portrait of Ormonde by Justus van Egmont (1601–1674) (fig. 52-1), inscribed "1648 Paryiis." Clearly the same man is represented in both, with mustache and short beard, cleft chin and scoop nose.

The Duke of Ormonde (1610–1688), head of the great Anglo-Norman family of Butler, was one of the most heroic and devoted followers of the royalist cause, serving both Charles I and Charles II. He twice served as lord lieutenant of Ireland and was given the Order of the Garter in April 1661. Ormonde's travels in the later 1640s help us to date the portrait. He arrived in England from Ireland on August 2, 1647, and went at once to Hampton Court where Charles I was being detained. In the month of August he took lodging at nearby Kingston, but when his wife arrived in England in September he moved to London. There he remained until Christmas 1647. By the beginning of March 1648 he had escaped to Paris, and by September of that year was back in Ireland. After the execution of the king and Cromwell's defeat of Ormonde's royalist forces in Ireland, he retired to Paris in 1649.[1]

If the portrait was painted from life, it was executed between August and December 1647, at just the period when Lely was painting Charles I and the Duke of York at Hampton Court.

FIG. 52-1 Justus Van Egmont (1601–1674), *James Butler, 12th Earl and Later 1st Duke of Ormonde*, 1648, oil on canvas, 25½ x 24½" (64.8 x 62.2 cm.), Buckingham, Claydon House, Sir Ralph Verney Collection

1. Winifred Gardner [Lady Burghclere], *The Life of James, First Duke of Ormonde, 1610–1688*, vol. 1 (London, 1912), pp. 327ff.

INSCRIPTION: *13 MAG. 13 / RI* [?] *DOGANA DI FIRENZE* [two circular twentieth-century customs stamps on the stretcher]; *Via Sete* [?] *N.1 / FIRENZE 1007* [on three similar stickers]; *1042* [painted onto the lining canvas]; *569F / 235* [?] [stenciled on the stretcher]; *James Butler* [in penciled script].

CONDITION NOTES: The original support is medium-weight (10 x 10 threads/cm.) linen. A puncture in the support is present in the middle of the sky at the left of the figure. Weave cusping in the support is evident on all four sides. The painting was relined in 1985 with a linen/fiberglass support and wax-resin adhesive. An off-white ground is present, which partially extends onto the tacking margins. The paint is in poor condition. Areas of active cleavage above the head of the figure and along the left edge of the painting were consolidated with the relining. An irregular net of fracture crackle with associated cupping is evident overall. Small losses are present at the edges of the cupped paint over much of the surface of the painting. Abrasions are present along all four edges, probably caused by the frame's rabbet. Heavy natural resin varnishes and retouching were removed in 1985. X-radiographs and infrared reflectography show pentimenti in the proper left hand, indicating a change in position.

In 1803 the eleven-year-old John Linnell, the son of a frame maker in Bloomsbury, met the artist William Varley (1785–1856) on a view day in Christie's auction rooms. Varley took him home to meet his two brothers, both painters of landscape in watercolors, John (1778–1842) and Cornelius (1781–1873); each was to influence Linnell in a very different way.

John Varley took on Linnell as a pupil in 1804, enabling him to give up the drudgery of copying the paintings of George Morland (q.v.) to be sold by his father, substituting instead the famous dictum (which would be repeated later in the century with admiration by John Ruskin [1819–1900] and the Pre-Raphaelites) "go to nature for everything!"[1] In practice this meant sketching expeditions on the Thames at Millbank and Twickenham with Varley and his other disciples William Henry Hunt (1790–1864), William Collins (1788–1847), and William Mulready (1786–1863). Among them, Linnell particularly idolized the Irish-born Mulready, six years older than he, who since the age of fourteen had been studying in Royal Academy schools. Linnell was never primarily a watercolorist like John Varley; in his early years, he imitated instead Mulready's luminous, Dutch-inspired genre paintings, as for example, his *Kensington Gravel Pits* (1811–12, 28 x 42″, London, Tate Gallery).[2]

Against this clique of young men largely committed to seeing the world unblinkered by academic rules, Linnell balanced a year of informal instruction from the very personification of academic rigidity, the president of the Royal Academy, Benjamin West (1738–1820). In November 1805, at the age of thirteen, he enrolled at the Royal Academy schools, where he learned not only to draw from casts and from life but also to appreciate the masters of the Italian Renaissance. In the evenings he went to the academy at 8 Adelphi Terrace where Dr. Thomas Monro (1759–1833) paid students to copy sketches by Gainsborough (q.v.), Thomas Girtin (1775–1802), and Turner (q.v.).

From 1807 he began to exhibit at the Royal Academy, then abruptly stopped from 1812 until 1820, while he submitted pictures to the Water Colour Society, which during this period admitted paintings in oil to its exhibitions. He also went on sketching expeditions, notably to Wales (1813), Windsor Forest (1815), and Scotland (1817). All this time he saved his money to marry Mary Palmer in 1817. In 1824, with four children, they moved from 6 Cirencester Place (now Westbourne Green, Paddington) to Collins Farm at North End in Hampstead.

From about 1821, when he once again began to exhibit at the Royal Academy, to 1847, Linnell concentrated exclusively on portraiture, the most lucrative and steady work for a painter in the first half of the nineteenth, as in the eighteenth, century. In 1818, urged by his wife to experiment in painting miniatures on ivory, Linnell made a success of this too. In 1818 he was introduced to William Blake (q.v.), who became a close friend and intimate of the family. To help Blake financially, Linnell commissioned a duplicate set of his *Book of Job* (1820) and then his illustrations to *The Divine Comedy* (begun 1825).

Linnell lived in Hampstead until 1828, the year after Blake's death, when he moved to Bayswater; there, in 1830, he had a house built for his family at 38 Porchester Terrace. Each year for twenty years (1821–41) he stood for membership to the Royal Academy, where his friends Mulready and Collins had long since become Academicians. Each year he was turned down. He blamed this on the jealous machinations of John Constable (q.v.), but, in fact, the electors seem to have objected to Linnell's bohemian life style and eccentric religious opinions.

Family life at Porchester Terrace may have been arduous but hardly strikes us as unusual today: the family ground their own corn, kneaded and baked their own bread, and brewed their own beer, living, it seems, as close to a

self-sufficient life as was possible in London. Linnell's religious views, however, do need some explanation. As early as 1811, William and John Varley's brother Cornelius introduced him to the Dissenting minister John Martin (1741–1820) of the Keppel Street Baptist Church near Bedford Square in Bloomsbury. In 1812, age twenty, Linnell was converted and carried his fundamentalist convictions to the extreme of refusing to be married in a church, *always* working on the Sabbath, and, later, briefly joining the fundamentalist sect the Plymouth Brethren.

Evidence of Linnell's deep involvement with the Scriptures may be found in his later religious paintings, and throughout his life he was close to, but never quite part of, a visionary element that had been developing in English painting since the end of the eighteenth century. In addition to his friendship with Blake, he was a figure deeply respected as an artist by Samuel Palmer (1805–1881)—who became his son-in-law in 1837—and the painters of idyllic pastoral landscapes who called themselves the Ancients—Palmer, George Richmond (1809–1896), Edward Calvert (1799–1883), Henry Walter (1786–1849), and Francis Oliver Finch (1802–1862). Later, in the late 1840s and 1850s, his own religious pictures have an intensity and a reverence for the grandeur of created things that link them to the Ancients and to the Pre-Raphaelites in landscape painting, and yet rarely transcend topographic and atmospheric description, however lurid the dawns and sunsets, to convince us that we are in the presence of a unique artistic vision. This is because in order to live on the spiritual plane of a Blake or a Palmer, the artist needed some detachment from the world, and Linnell arguably may have been the most worldly artist of his time. His biographer, Alfred T. Story, did justice to the undoubted sincerity of Linnell's vision, while drawing attention to his limitations: "He was guided by the desire to give delight and induce thankfulness. He aimed at being true; and though he threw as much poetry into his subjects as he could, he never overstepped the bounds of fidelity. In all this he was guided not only by the higher motives of sincerity and truth, but also by a shrewd business tact which told him that people would be most likely to buy that which gave them pleasure."[3] This business tact became legendary. Story estimated Linnell's fortune after his death at around two hundred thousand pounds.[4] It is a measure of how drastically the Victorian art market differed from the Georgian that a good part of his hoard he made not from work as a portrait painter but from landscapes painted during the last twenty years of his life.

Before 1847 Linnell exhibited only some dozen landscapes, while he turned out innumerable portraits. After that date, he reversed this pattern, giving up portraiture altogether to concentrate on landscapes. In 1851 he moved his family to Redstone Wood (Redhill) in Surrey, where he was to paint some of his most famous works, such as *Reapers, Noonday Rest* (1865, 37 x 55″, London, Tate Gallery) and *Harvest Home, Sunset: The Last Load* (1853, 35¾ x 58″, London, Tate Gallery). He worked first for a barrister-turned-picture-dealer named Ralph Thomas, later the dealer for the young John Everett Millais (1829–1896); after 1853 the firm of Thomas Agnew in Manchester sold Linnell's landscapes fresh from the easel to Midland industrialists; finally in the late 1850s and 1860s he worked for the Belgian dealer Ernest Gambart (1814–1902), who sold his landscapes to the same clients who bought paintings by William Holman Hunt (1827–1910) and later Alma-Tadema (q.v.).[5]

The demand for Linnell's work was so heavy that he undoubtedly hurried his productions, and some works of the 1850s and 1860s have a fuzzy, woolly surface finish. He often painted several versions of the same composition with details added or suppressed in accordance with the instructions of the dealer.

A good candidate for one of Lytton Strachey's *Eminent Victorians,* Linnell was a great compromiser in his art. Tight-fisted, tyrannical, and domineering at home, he ruled over his wife and children like an Old Testament prophet. And yet he generously encouraged younger artists, recognizing the talent of the young Millais and William Holman Hunt. In 1881, the year before Linnell's death, Hunt visited him at Redhill. As he walked into the room, the feeble, white-bearded old man struggled to hold up a Bible high with one hand, half rising from his chair to exhort Hunt to look after his immortal soul:[6] a memorable last glimpse of this survivor from the earliest years of the nineteenth-century landscape.

1. Story, 1892, vol. 1, p. 25.
2. Kathryn Moore Heleniak, *William Mulready* (London and New Haven, 1980), pp. 10–11.
3. Story, 1892, vol. 1, p. 307.
4. Ibid, vol. 2, p. 234.
5. Firestone, 1973, pp. 124–31.
6. Story, 1892, vol. 2, p. 232.

BIBLIOGRAPHY: MS. record of paintings, 1976-1-31-7, "Landscapes and Other Pictures Not Portraits Painted by John Linnell Sr. from 1807. The First Exhibited To—," British Museum, London; John Linnell, "Dialogue upon Art, Collector and Painter," *The Bouquet,* no. 33 (1854), n.p.; Dafforne, 1859, pp. 105–7; F. G. Stephens, "John Linnell," *The Portfolio,* vol. 3 (1872), pp. 45–48; F. G. Stephens, "John Linnell, Painter and Engraver," *The Art Journal,* 1882, pp. 261–64, 293–96; F. G. Stephens, "The Aims, Studies, and Progress of John Linnell, Painter and Engraver," *The Art Journal,* 1883, pp. 37–40; Story, 1892; Alfred T. Story, "John Linnell's Country," *The Art Journal,* 1892, pp. 301–5; C[osmo] M[onkhouse], *Dictionary of National Biography,* s.v. "Linnell, John"; Evan R. Firestone, "John Linnell, English Painter: Works, Patrons and Dealers" (Ph.D. diss., University of Wisconsin, 1971); Firestone 1973; Evan R. Firestone, "John Linnell: The Eve of the Deluge," *The Bulletin of the Cleveland Museum of Art,* vol. 62, no. 4 (April 1975), pp. 131–39.

EXHIBITIONS: London, Royal Academy, *Works by Old Masters and by Deceased Masters of the English School, Including a Special Selection from the Works of John Linnell and Dante Gabriel Rossetti,* winter 1882–83; London, P. and D. Colnaghi, *A Loan Exhibition of Drawings, Watercolours, and Paintings by John Linnell and His Circle,* January 10–February 2, 1973; Cambridge, Fitzwilliam Museum, New Haven, Yale Center for British Art, *John Linnell: A Centennial Exhibition,* October 5, 1982–March 20, 1983 (by Katharine Crouan).

53 JOHN LINNELL

THE STORM (THE REFUGE), 1853
Oil on canvas, 35½ x 57½" (90.2 x 146.1 cm.)
Inscribed lower right: *J. Linnell, 1853*
John H. McFadden Collection, M28-1-17

The Storm is a view of the Surrey hills near Linnell's home at Redhill. A storm
has just broken in the distance; a flash of lightning striking the steeple of a
church lights up the darkening sky, blanching the green fields in the center
distance. In the foreground a family—father, mother, two children, and their
dog—run across toward the right. The father, in a farmer's smock, shields his
eyes from the light while the mother, perhaps carrying an infant in her arms,
presses on ahead. We can sense the panic of the dog, frightened by the sound
of thunder and the flickering lightning. The whole wonderfully conveys the
atmosphere of a summer storm in the countryside: the queasy effects of
unnatural light and dark, the sense of leaves quivering and turning in the
wind, and the onset of sudden rain. What is not clear is where the family is to
take shelter: Linnell's title for the landscape, *The Refuge,* would seem to refer
to a blasted tree trunk in the lower right corner in which the family will find
cover. There also seem to be manmade steps covered in grass or moss leading
into it and out of the picture to the right. The refuge is surrounded by light
red flowers growing from the trees.

Linnell, as a radical Dissenter, passionately objected to the external
paraphernalia of organized religion—going so far as to insist on a civil
ceremony in his own marriage in 1817 and making a point of working on
Sundays. He particularly balked at the clergy and church coming between man
and the word of God, which could be found entirely in the Scriptures.[1]

The lightning striking the church steeple may be merely an observation of
a natural occurrence; or it can be read as God's judgment on conventional
religions for the distortion of His word. The refuge at the right may be read

FIG. 53-1 John Linnell, *Storm (The Refuge),* pen and ink on paper, 3⅝ x 5½" (9.1 x 14 cm.), London, British Museum

as the refuge from God's wrath offered by nature. If we choose to see the landscape as in some way allegorical, the theme fits well with biblical subjects treated by Linnell throughout the late 1840s and 1850s, many of which concern God's retribution for man's disobedience. An example is *The Eve of the Deluge* (1847–48, 57 x 88", Cleveland, Cleveland Museum of Art). Yet many landscape/storm subjects painted by Linnell at this date, such as *Harvest Home, Sunset: The Last Load* (1853, 35¾ x 58", London, Tate Gallery), seem on the face of it to be without underlying meanings.

Stylistically, *The Storm* reflects Linnell's study of Titian's (c. 1487/90–1576) landscapes, in particular the presumed copy after Titian, *The Coming Storm* (46 x 38¾"), now in the collection of Her Majesty Queen Elizabeth II at Hampton Court but then belonging to R. R. Reinagle. Around 1822 Linnell made a copy of this picture, and this copy hung during his lifetime in the library of his house at Redhill. The storm theme, the grandeur of the landscape, the concern with capturing fleeting effects of light all look toward the Titian.

Linnell kept a *Liber Veritatis,* a two-volume sketchbook in which he drew rough pen-and-ink sketches of his works in oil, adding notations on measurements, exhibitions, and sales, and listing all the versions he had made. This painting is found there (fig. 53-1) with information on two other versions, one of which was sold at Parke-Bernet in 1966. According to this record of paintings, *The Storm* was exhibited at the British Institution in 1854 (no. 165). There it was noticed and praised by the critics for *The Art Journal* and *The Athenaeum. The Art Journal* (1854, p. 62) reported: "The sky of this work presents a thunderstorm, described with all the effective power of which the artist is master, and so true that the spectator feels wet through as soon as he sees it. The material is of the commonest kind; this is immaterial, but there is a green tree near the centre utterly fatal to the effect." Linnell noted in his record of paintings that he retouched the two versions of this picture for the dealer Benjamin Flatow in 1859, and perhaps this included an adjustment to the color of the tree in the center.

1. The sect to which he briefly belonged, the Plymouth Brethren, recognized no clergy or members as distinct from the laity and emphasized biblical prophecy and the Second Coming of Christ.

PROVENANCE: Joseph Fenton, Bamford Hall, Rochdale; Christie's, May 5, 1879, lot 178 (as "The Storm"), bt. Agnew; Thomas Agnew, Fairhope Eccles, near Manchester; by descent to Mrs. Thomas Agnew, her sale, Christie's, June 16, 1906, lot 101, bt. Agnew; Scott and Fowles; Agnew; bt. John H. McFadden from Agnew, July 25, 1910.

EXHIBITIONS: London, British Institution, 1854, no. 165 (as "The Refuge"); New York, 1917, no. 18; Pittsburgh, 1917, no. 18.

LITERATURE: "The British Institution Exhibition—1854," *The Art Journal,* 1854, p. 62; "The Arts—British Institution," *The Athenaeum,* February 11, 1854, pp. 187–88; Dafforne, 1859, p. 107; Story, 1892, vol. 2, p. 272; Roberts, 1917, p. 35, repro. opp. p. 35.

CONDITION NOTES: The original support is medium-weight (12 x 12 threads/cm.) linen. The tacking margins have been removed. The

painting is lined with an aged aqueous adhesive and medium-weight support. A slight undulation in the lining support, consistent with a severely cupped paint film, is evident from the reverse. Two ground layers of moderate thickness are present overall and are evident in microscopic cross section. The lower is off-white and the upper is white, both appearing to contain oil and lead white. The paint is in good condition. Paste to rich vehicular mixtures have been used. Much of the original brush marking has been preserved. The most severe areas of loss consist of flake losses in the lower left corner. The brown tones appear to contain a resinous or bituminous type of pigment and have suffered some abrasion, especially in the foreground foliage. The painting was cleaned in 1984 and relined with a double fabric (support linen and twill-weave polyester) and synthetic resin adhesives. Under ultraviolet light, retouching is restricted to the areas of loss in the lower left corner and to small damages in the sky, right of center. Infrared light reveals sketching done with pencil under some areas of the foreground.

VERSIONS
1. John Linnell, *The Refuge—Storm,* 1853, retouched 1859, oil on canvas, 26 x 37" (66 x 94 cm.), location unknown.

INSCRIPTION: signed and dated *53.9*
PROVENANCE: Benjamin Flatow, 1859; Parke-Bernet, New York, April 7, 1966, lot 65, and again, May 28, 1981, lot 32.
LITERATURE: MS. record of paintings, 1976-1-31-7 (53), p. 120, British Museum, London.
DESCRIPTION: Identical to the Philadelphia composition but with a donkey in the left foreground.

2. John Linnell, *The Refuge—Storm,* 1853, retouched 1859, oil on canvas, 26 x 37" (66 x 94 cm.), location unknown.
PROVENANCE: Benjamin Flatow, 1859.
LITERATURE: MS. record of paintings, 1976-1-31-7 (53), p. 120, British Museum, London.

RELATED WORK: John Linnell, *Storm (The Refuge),* pen and ink on paper, 3⅝ x 5½" (9.1 x 14 cm.), London, British Museum (fig. 53-1).
INSCRIPTION: *B-Gall / 54 Storm / The Refuge / Small drawing of this / Two kitcats also nearly the same / these two K* [itcats]*—retouched all over—for Flatow 1859*
LITERATURE: MS. record of paintings, 1976-1-31-7 (53), p. 120, British Museum, London.

Born in London in 1740, in the parish of St. Saviour, Southwark, William Marlow is known to have trained from 1754 to 1759 in the Covent Garden studio of the topographical and marine artist Samuel Scott (c. 1702–1772), and then to have studied at the St. Martin's Lane Academy. Between 1762 and 1765 he traveled around England and Wales as a landscape and country-house painter, exhibiting views of these places alongside those of Paul Sandby (q.v.) at the Incorporated Society of Artists at Spring Gardens in 1762, 1763, 1764, and 1765. From 1765 to 1766, through the patronage of the Duchess of Northumberland, he traveled on the Continent—to Paris, Avignon, Lyons, Nîmes, Florence, Rome, Naples, and Venice.[1]

After his return to England, Marlow began to exhibit at the Incorporated Society of Artists works based on sketches made on his Continental travels. Because no other English artist had thought to work the rich mine of the Grand Tour souvenir landscape, Marlow's success in a field hitherto dominated by the Venetian *vedute* painters was remarkable. By 1769 young Thomas Jones (1742–1803) could list Marlow with Francesco Zuccarelli (1702–1788) and Gainsborough (q.v.) as one among those artists "in full possession of Landscape business."[2] In 1771 two works by Marlow were sold as Canalettos (1697–1768), with Horace Walpole wryly commenting that although Marlow was the better painter, "the purchasers did not mean to be so well cheated."[3] In 1775 Marlow was prosperous enough to retain a London studio at Newport Street off Leicester Fields and to rent a country house in Twickenham. Between 1783 and 1788 he exhibited nothing, and by 1785 he had given up his London practice to live in semi-retirement in Twickenham. Nevertheless, between 1788 and 1796 (and once again in 1807) Marlow sent twenty-five pictures to the Royal Academy. He never attempted to become an Academician.[4]

The little we know of Marlow as a man we learn from Joseph Farington (1747–1821), who described him as shy and gouty, and reckoned his property at one hundred pounds a year. Marlow was a friend of Sir Joshua Reynolds (q.v.), a high recommendation for any man's character, and, according to gossip, lived in Twickenham with the family of a butcher named Curtis, whose wife was rumored to have been Marlow's mistress, and several of whose six or seven children (Farington had heard) looked "very like Marlow."[5]

In the 1790s, when war with France halted Continental travel, the demand for Marlow's landscapes lessened. Farington recorded in his diary entry for January 31, 1794: "Marlows Pictures fall in value; Wilsons rise."[6] In response to this situation, the artist turned out a few etchings but spent most of his last years tinkering with telescopes in Twickenham, where he died on June 14, 1813.

Marlow's views show no particular originality; they are accomplished exercises in the manner of Canaletto, or more accurately, of Canaletto's nephew Bernardo Bellotto (1720–1780), perhaps filtered through the impression made on Marlow by the coastal scenes of Claude Joseph Vernet (1714–1789). The clean outlines and assured draftsmanship, the strong contrasts of light and dark, the general absence of poetry or feeling in the conception or handling contribute to a sense of finiteness in these pictures. They satisfy completely without transcending the limitations of topographical tradition in landscape.

1. Walpole, 1937, p. 103. For the date of
Marlow's return to London see M.J.H.
Liversidge, "Six Etchings by William Marlow,"
The Burlington Magazine, vol. 122, no. 929
(August 1980), pp. 549–53.

2. Thomas Jones, "Memoirs of Thomas Jones,"
The Walpole Society, 1946–1948, vol. 32 (1951),
pp. 19–20.

3. Walpole to Sir Horace Mann, April 26, 1771.
See Mrs. Paget Toynbee, ed., *The Letters of
Horace Walpole* (Oxford, 1904), vol. 8, p. 29.

4. Marlow's exhibiting history is as follows:
Society of Artists, 1762–65, 1767–78, 1780–83,
and 1790; Free Society, 1782; Royal Academy,
1788–96, and 1807.

5. Farington Diary, [1793], June 23, 1808. For
other observations on Marlow, see Farington
Diary, [1793], July 31, 1796.

6. Ibid, January 31, 1794.

BIBLIOGRAPHY: C[osmo] M[onkhouse],
Dictionary of National Biography, s.v. "Marlow,
William"; Farington Diary, [1793], February 10,
1813; Whitley, 1928, vol. 1, p. 206; Constable,
1953, pp. 142–43; Waterhouse, 1953, p. 178;
Hardie, 1966–68, vol. 1, pp. 170–71; Herrmann,
1973, pp. 63–66; M.J.H. Liversidge, "Six
Etchings by William Marlow," *The Burlington
Magazine,* vol. 122, no. 929 (August 1980),
pp. 549–53.

EXHIBITIONS: London, Guildhall Art Gallery
(Corporation Art Gallery), *An Exhibition of
Paintings and Drawings by William Marlow
1740–1813,* June–July 1956 (introductory notes by
J. L. Howgego); London, Somerset House,
(organized by the National Maritime Museum),
*London and the Thames: Paintings of Three
Centuries,* July–October 1977, nos. 36–39 (by
Harley Preston).

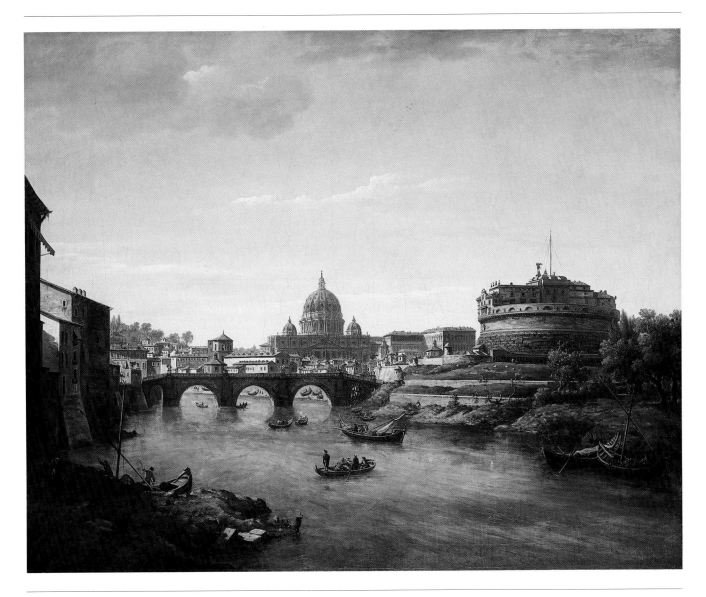

WILLIAM MARLOW

VIEW OF ROME FROM THE TIBER, C. 1775
Oil on canvas, 40 x 50⅛" (101.6 x 127.3 cm.)
Inscribed lower center on stone at water's edge: *W. Marlow*
Gift of Jay Cooke, 55-2-4

FIG. 54-1 William Marlow, *St. Peter's and the Castel S. Angelo,* 1765–66, pen and ink on paper, 8¼ x 13" (21 x 33 cm.), Paul Oppé Collection

View of Rome from the Tiber is one of five views of the Castel S. Angelo and the Church of St. Peter's seen from the Lungotevere (see versions 1 and 2). Each differs slightly from the others in such details as the reflection of the bridge in the water and the disposition of the boats and figures in the foreground; but the scenes are all alike in the distance from which the artist viewed his subject. A sketch in the Paul Oppé Collection (fig. 54-1) is identical to the scene in the Philadelphia painting in all important respects. The pen sketch contains color notes and is inscribed *Roma,* and so can be dated to 1765–66, when Marlow was in the city. The Philadelphia view would therefore seem to be based on the Oppé drawing. However, Kroenig (1972) has shown that Marlow's view of the Castel S. Angelo in Philadelphia is closely related to an engraving by Giovanni Battista Piranesi (1720–1778) dated to c. 1754 (fig. 54-2), and though the foreground and river traffic in the two views are not similar, the viewpoint and the angle of the buildings at the left are very close. However, one should be wary of treating any of these early views of the Tiber as though they were photographic records, for some degree of artistic caprice was acceptable, and few renderings of the scene agree in all the details.

FIG. 54-2 Giovanni Battista Piranesi
(1720–1778), *Hadrian's Tomb and St. Peter's*,
c. 1754, engraving, 14⅞ x 22⅞" (37.7 x 58.1 cm.)

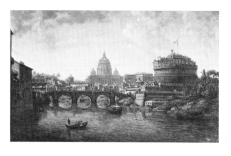

FIG. 54-3 William Marlow, *Rome from the Tiber*,
oil on canvas, 32½ x 53" (82.5 x 134.6 cm.),
London, Department of the Environment

In Marlow's version 1 (fig. 54-3) the walls of the fortifications of the Castel S. Angelo slightly above water level are very different from those rendered in either the Philadelphia picture or the Oppé drawing in having square apertures for cannons. A comparison with views of the castle painted by Gaspar van Wittel (1653–1736) from the same viewpoint shows that both the Philadelphia view and the view in the Oppé drawing match van Wittel's delineation of the castle fortifications in not showing these apertures.[1] Likewise these openings for cannons are never shown in views of the castle by Antonio Joli (1700–1777) listed by Kroenig.[2] But in Piranesi's engraving of c. 1754 (eleven years before Marlow's drawing in the Oppé Collection) these square apertures *are* shown; perhaps they could be covered over at certain times.

Another vexing detail is the existence or absence of a wooden scaffolding under the arch farthest to the right of the Ponte S. Angelo (or perhaps it is a wooden gate to prevent passage under the arch by land). The Philadelphia picture and version 1 show this wooden gate, as does the Piranesi engraving and another engraved view of the scene by Giuseppe Vasi (1710–1782) dated 1754 (7⅛ x 12⅛").[3] In the Oppé drawing, and in most later views of the Ponte S. Angelo listed by Kroenig, this scaffolding does not appear.

Determining the date of any undocumented view by Marlow is difficult. He began to exhibit Italian views at the Society of Artists beginning in 1767. Paintings entitled *A View of Rome* were shown there in 1769 (no. 92), 1775 (no. 166), 1777 (no. 59), and 1780 (no. 180). At the Royal Academy in 1788 Marlow exhibited *Castel St. Angelo, etc., Rome* (no. 440). Michael Liversidge, who is preparing a catalogue of Marlow's work, suggested in a letter to the author, June 22, 1981, that the version now owned by the Department of the Environment (fig. 54-3) may have been the *View of Rome* exhibited at the Society of Artists in 1769. The Philadelphia picture, he suggests, was the *View of Rome* shown at the Society of Artists in 1775 and, in any case, would seem to be a picture dating from the mid-1770s.[4] In the Witt Library, London, are photographs of four views of the Castel S. Angelo attributed to Marlow, all of which can be rejected.[5]

1. See Giuliano Briganti, *Gaspar van Wittel, e l'origine della veduta settecentesca* (Rome, 1966), pp. 197–98, nos. 75–80.
2. Kroenig, 1972, fig. 27.
3. Ibid., fig. 28. However, the Vasi and Piranesi, though they are of the same date, differ in Vasi's exclusion of apertures for cannons.
4. Farington Diary, [1793], January 31, 1794, noted that Sir Watkins Williams Wynne "bid in a very spirited manner for Pictures at the sale of John Hunters Pictures [January 29, 1794]. Marlows, St. Angelo & the Companion, (a pair), sold for 20 guineas." At the Hunter sale a view of the Castel S. Angelo (lot 61) with a view of Lyons was sold to a Mr. Bowles. This

may be the picture now in Philadelphia, but no firm proof exists.
 A Marlow entitled *Castle and Bridge of St. Angelo* was exhibited at the Suffolk Street Gallery, 1833, no. 333 (lent by L. Dulacher); but again, there is no evidence to connect this view with the picture in Philadelphia.
5. They are as follows: (a) Attributed to William Marlow (perhaps Gaspar van Wittel or a follower), *Rome from the Tiber*, dimensions unknown, Oakley Park, the Earl of Plymouth; (b) Attributed to William Marlow, *Rome from the Tiber,* oil on canvas, 29 x 34" (73.6 x 86.4 cm.), formerly with John Mitchell and Son, London (*The Connoisseur*, vol. 181 [November 1972], p. 40); (c) Follower of William Marlow

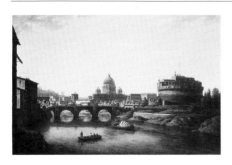

FIG. 54-4 William Marlow, *Rome from the Tiber,* oil on canvas, 25½ x 38½" (64.8 x 97.8 cm.), United States, private collection

(here attributed to Antonio Joli), *Rome from the Tiber,* dimensions unknown, with Leggatt, 1946; (d) Follower of William Marlow (here attributed to Antonio Joli), *Rome from the Tiber,* oil on canvas, 55½ x 73" (141 x 185.4 cm.), with Leggatt, 1926.

PROVENANCE: Laurence Currie, Coombe Warren, Kingston Hill, Surrey; his sale, Christie's, December 17, 1926, lot 157, bt. Pawsey and Payne; M. Knoedler; bt. Jay Cooke, September 1928.

EXHIBITION: Possibly London, Society of Artists, 1775, no. 166 (as "A View of Rome").

LITERATURE: Kroenig, 1972, p. 188 and nn. 60, 100, fig. 51; Staley, 1974, p. 36.

CONDITION NOTES: The original support is medium-weight (14 x 14 threads/cm.) linen. The tacking margins have been removed. The painting is lined with an aged aqueous adhesive and medium-weight linen. An off-white evenly applied ground is present and evident along the cut edges. The paint is in good condition. The surface was partially cleaned in the area of the sky in 1967. A large area of loss exists in the water in the lower right corner. Several pentimenti of the river shoreline and the figures along it are visible in normal light in the lower-left quadrant. Under ultraviolet light, retouching can be seen over losses along the cut edges and the loss in the water, lower right.

VERSIONS
1. William Marlow, *Rome from the Tiber,* oil on canvas, 32½ x 53" (82.5 x 134.6 cm.), London, Department of the Environment (fig. 54-3).
INSCRIPTION: *W. Marlow*
EXHIBITION: Possibly Society of Artists, 1769, no. 92 (as "A View of Rome").

2. William Marlow, *Rome from the Tiber,* oil on canvas, 35 x 40" (88.9 x 101.6 cm.), formerly with Agnew. Photograph: London, Witt Library.

3. William Marlow, *Rome from the Tiber,* oil on canvas, 35½ x 49" (90.2 x 124.5 cm.), London, Department of the Environment.
INSCRIPTION: *W. Marlow*
PROVENANCE: Purchased from Agnew, 1954.

4. William Marlow, *Rome from the Tiber,* oil on canvas, 25½ x 38½" (64.8 x 97.8 cm.), United States, private collection (fig. 54-4).
PROVENANCE: Hazlitt, Gooden and Fox, 1975.
DESCRIPTION: Signed.

RELATED WORKS
1. William Marlow, *St. Peter's and the Castel S. Angelo,* 1765–66, pen and ink on paper, 8¼ x 13" (21 x 33 cm.), Paul Oppé Collection (fig. 54-1).
INSCRIPTION: *Roma* [and with color notes].
PROVENANCE: Acquired by Paul Oppé, 1924.
EXHIBITIONS: London, Guildhall Art Gallery, 1956, no. 75; London, Royal Academy, *The Paul Oppé Collection,* 1958, no. 2; London, Kenwood, The Iveagh Bequest, *British Artists in Rome, 1700–1800,* June 8–August 27, 1974, no. 127.

2. William Marlow, *View of Rome from the Tiber, with Castel S. Angelo,* watercolor on paper, 14½ x 21½" (36.8 x 54.6 cm.), location unknown.
PROVENANCE: Phillips, March 23, 1981, lot 98.
DESCRIPTION: Signed.

Born in Seagrave, Leicestershire, in 1768, the same year as John Crome and Thomas Lawrence (q.q.v.), Ben Marshall started his career as a provincial schoolmaster. We can only guess, because none of his early work survives, that an innate talent for drawing gained him the attention of a local Member of Parliament, William Pochin (1731–1798), who sent him at the age of twenty-three to London. There Marshall studied with Lemuel Francis Abbott (1760–1803), a painter specializing in small-scale, full-length portraits distantly derived from the conversation pieces of Arthur Devis (1711–1787). Marshall began to train as a portrait painter but apparently found his true métier in 1793 when he saw Sawrey Gilpin's (1733–1807) *Death of the Fox* at the Royal Academy (146 x 80″, S. C. Whitbread Collection). Of the most important sporting painters of his generation, Marshall ranks with James Ward (1769–1859) and Jacques Laurent Agasse (1767–1849); indeed most historians place him second only to George Stubbs (q.v.) as the greatest English horse painter of all.

Success in London came quickly. *Curricle, with a Huntsman* (34 x 39¾″, Her Majesty Queen Elizabeth II) was executed for the Prince of Wales in 1794, and in 1796, when he was twenty-nine, he was received by George III and Queen Charlotte. In February of the same year he contributed his first picture to be engraved in the *Sporting Magazine*. This led to an association that would last—with Marshall as both illustrator of and commentator on sporting subjects—for thirty years. In 1801 he was successful enough to take on his first apprentice, John Ferneley (1782–1860), who stayed with him until 1804, and secure enough to contribute his first picture to the Royal Academy. His relationship with the academy, however, like that of so many of the most talented English painters before and after him, was unhappy: although he contributed in all thirteen pictures to its walls, he was reported by the *Sporting Magazine* to have "held the Academy and all connected with it in a kind of contempt."[1] Marshall was never elected to any rank of Royal Academician.

The period after Ferneley's departure from his studio in 1804 to 1820 saw a succession of masterpieces from Marshall's brush. He grew into something much more than a consummate painter of hunting and racing horses: he became a portraitist of unusual humanity and sensitivity—amused by his ungainly human subjects and yet treating these dim, gruff jockeys and trainers with the respect only absolute realism affords in art. Part of the power of a masterpiece like *Anticipation with Bourbon* (1817, 40 x 50″, England, private collection) lies in the contrast between the brutish, seedy human beings, and the serene, graceful horses. All this is done with a minimum of comment and little attempt to manipulate the spectator through such artistic devices as compositional subtlety, rhythmic spacing of the figures, or the prettiness of the palette—all integral to the much more stylized and artificial art of George Stubbs.

Moreover, Marshall was a gifted landscape painter; his backgrounds beautifully convey the mist-laden atmosphere of wintry East Anglia, the soggy, muddy ground near a race course, or the bare, vast skies near Newmarket. This was recognized by his contemporaries. On March 28, 1804, Farington recorded in his diary that "[Sir Francis] Bourgeois [Royal Academician, 1756–1811] spoke of Marshall, a Horsepainter as having extraordinary ability and that Gilpin had said that in managing His back grounds He had done that which Stubbs & Himself never could venture upon."[2]

Marshall achieved his effects, which rely on a richness of surface texture very different from the smooth, thin finish of a Stubbs, by permitting his ground to dry, then rubbing the surface with a pumice stone and water to

create texture, and finally by painting the surface in impasto.[3] He sketched each figure separately from life, then combined the sketches in the studio into a group composition on a full-sized canvas. This device resulted in slightly haphazard compositions, which have, however, the advantage of creating a sense of naiveté and immediacy very sympathetic to a twentieth-century sensibility.

In 1819 a coach in which Marshall was a passenger overturned, crushing the artist's spine. He continued to paint, but his work henceforth is feeble in comparison to what went before, probably due to sheer loss of manual control. He lived through a second tragedy when in 1834 his youngest daughter Elizabeth's dress caught fire and she was burned alive before his eyes.

Between 1795 and 1810 Marshall lived in Beaumont Street, Marylebone. In 1812 he moved to Newmarket in Norfolk, the great racing center, then finally settled at Bethnal Green in London in 1825, dying on July 24, 1835. His son Lambert Marshall (1809–1870) was also a painter.

1. *Sporting Magazine,* n.s., vol. 7 (1844), p. 448, quoted by Walter Shaw Sparrow, *George Stubbs and Ben Marshall*, vol. 2, *The Sport of Our Fathers* (London and New York, 1929), p. 50 n.
2. Farington Diary, [1793], March 28, 1804.
3. London, Hayward Gallery (etc.), *British Sporting Painting, 1650–1850,* December 1974–May 1975, p. 86.

BIBLIOGRAPHY: Obituary, *The Gentleman's Magazine,* n.s., vol. 4 (1835), p. 331; Obituary, *Sporting Magazine,* n.s., vol. 11 (1835), pp. 297–99; Gilbey, 1900, pp. 85–96; C[ampbell] D[odgson], *Dictionary of National Biography,* suppl., s.v. "Marshall, Benjamin"; Sparrow, 1922, pp. 169–80; Walter Shaw Sparrow, *George Stubbs and Ben Marshall,* vol. 2, *The Sport of Our Fathers* (London and New York, 1929), pp. 45–80; Sparrow, 1931, pp. 90–109; Sparrow, 1935; Guy Paget, "Ben Marshall and John Ferneley," *Apollo,* vol. 40 (August 1944), pp. 30–37; Guy Paget, *Sporting Pictures of England* (London, 1945), pp. 18–20; Walker, 1972, pp. 95–97; Judy Egerton, "Solitary Sportsmen: The Shooting Paintings of Ben Marshall (1768–1835)," *Country Life,* July 24, 1975, pp. 190–91; Noakes, 1978; Judy Egerton, *British Sporting and Animal Paintings, 1655–1867* (London, 1980), pp. 191–207, nos. 203–18.

EXHIBITIONS: Leicester, Leicester Museum and Art Gallery, *Ben Marshall, 1768–1835 / John Leech 1817–1864,* October 7–November 5, 1967; London, Hayward Gallery, Leicester, Leicestershire Museum and Art Gallery, Liverpool, Walker Art Gallery (Arts Council of Great Britain), *British Sporting Painting, 1650–1850,* December 1974–May 1975 (paintings catalogue by Mary Webster and Lionel Lambourne, introduction by Oliver Millar).

55 BENJAMIN MARSHALL

*THE FAVORITE CHESTNUT HUNTER OF LADY FRANCES STEPHENS,
NÉE LADY FRANCES PIERREPONT,* 1799
Oil on canvas, 24⅝ x 29½″ (62.5 x 75 cm.)
Inscribed lower right: *B. Marshall pt. 1799*
Gift of Mr. and Mrs. Charles H. Norris, Jr., 1977-44-1

Frances Augusta Pierrepont (c. 1782–1847) was the only daughter of Charles,
1st Earl Manvers (1737–1816), whose seat was at Thoresby Park, Ollerton,
Nottingham. She married, first, in October 1802, Adm. William Bentinck
(d. 1813) and, second, on July 30, 1821, Henry William Stephens. She died at
Bishopsteighton, East Devon, on February 10, 1847, leaving two sons and
one daughter.

INSCRIPTION: *The favourite hunter of Lady
Frances Stephens, daughter of the first Lord
Manvers, painted for the family by Ben Marshall
1799* [on a handwritten label on the stretcher].

PROVENANCE: Painted for Lady Frances
Pierrepont, 1799; M. Knoedler and Co., New
York, 1929; Harris Hammond sale,
Parke-Bernet, April 10, 1943, lot 369; Arthur
Ackermann and Son, New York; Parke-Bernet,
New York, anonymous properties, May 18,
1972, lot 154; Christie's, June 21, 1974, lot 8;
Richard Green, London; Mr. and Mrs. Charles
Norris, Jr.

EXHIBITION: Philadelphia, Philadelphia
Museum of Art, *Gifts to Mark a Century,*
February 18–March 20, 1977, no. 108.

LITERATURE: Noakes, 1978, p. 32 no. 25,
pp. 72, 77, 78.

CONDITION NOTES: The original support is
twill-weave, medium-weight (12 x 12
threads/cm.) linen. The tacking margins have
been removed. Weave cusping in the support is
evident along all four sides, suggesting that the
present size is nearly the same as it was
originally. The painting is lined with an aged
aqueous adhesive and medium-weight linen. A
white ground has been thickly and evenly
applied. The paint is in good condition. The
paint has been applied in paste-vehicular
mixtures. Thin washes of a rich vehicular
consistency have been applied over this. An
irregular web of narrow-aperture fracture
crackle has formed. The overall relief of the
paint profile is low and much of the original
brush marking is intact. Under ultraviolet
light, retouching to the widest apertures of
fracture crackle in the sky area is visible. Some
local areas of retouching, possibly over abraded
paint, are evident in the sky along the left-
hand edge.

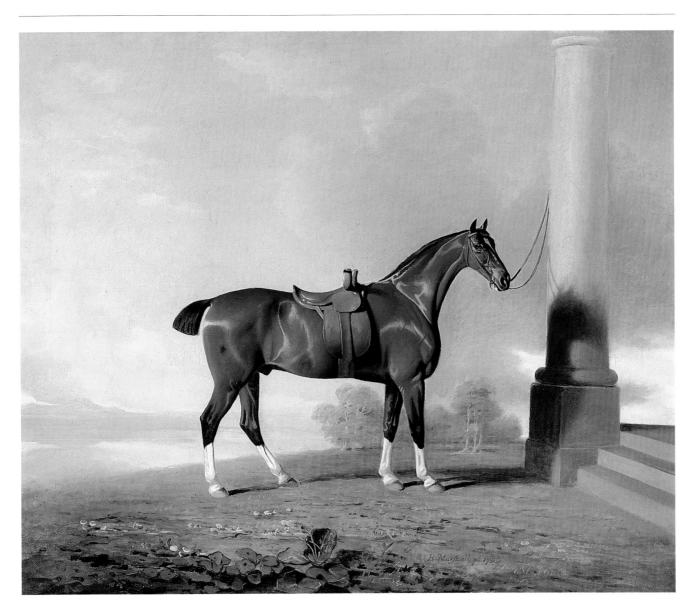

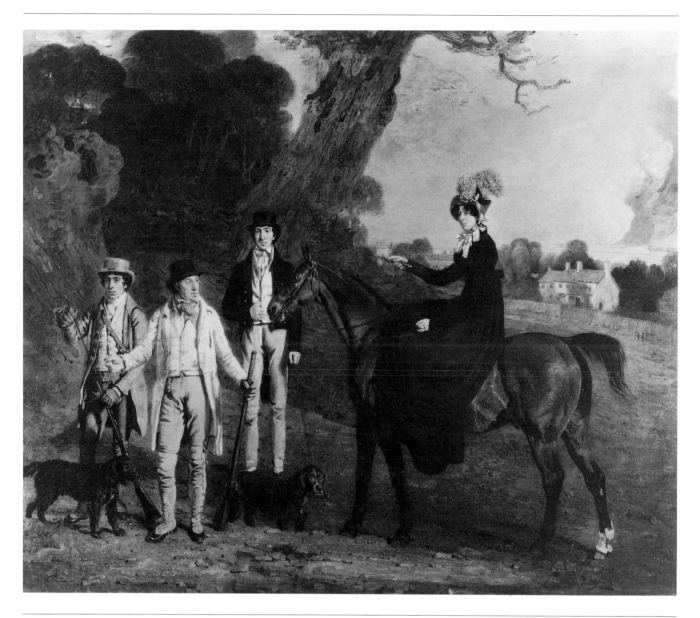

56 BENJAMIN MARSHALL *THE WESTON FAMILY,* 1818
 Oil on canvas, 39⅞ x 50¼" (101.3 x 127.5 cm.)
 Inscribed lower right: *B. Marshall 1818*
 Gift of Diana Kendall, Alexandra Dewey, Linda Jones, and Sheila Neville,
 in memory of their grandfather, George D. Widener, 1978-40-1

This painting was exhibited at the Royal Academy in 1819 (no. 241) as
"Portraits of a Family at Little Thurlow, Suffolk." Sparrow (1931) first
identified the sitters as the Weston family, presumably relying on information
supplied by the dealer in whose possession the picture was in 1930. No
inscription or label on the picture confirms this identification.

Little Thurlow is a small village on the river Stour, about ten miles from
Newmarket, where Marshall lived from 1812 to 1825. The view shown in the
picture is still recognizable, although the artist has used a certain amount of
artistic license—the land, for example, does not slope as much as it does in the
picture. The white building on the right-hand side still stands, although
somewhat altered; in Marshall's time it was the rectory, but no longer. The
church at Little Thurlow appears in the distance just to the left of the
woman's right hand; the building between the rectory and the church is
shown on nineteenth-century tithe maps, but no longer exists.

The main family in Little Thurlow was not the Westons but the Soames, who lived in Little Thurlow Hall (burned down 1809, rebuilt 1840s). There is no mention in the Little Thurlow parish records or tithe maps and schedules of a Weston or Western family after the date of the picture, 1818. This fact originally cast some doubt on the identification of the family as the Westons. However, a stone slab on the floor of Little Thurlow Church is inscribed: "IN MEMORY OF WILL[IAM] WESTON [SON OF] WILLI[AM] [AND REB]ECCA WEST[ON] WHO D[IED] JUNE 181[?] IN THE [?] [YEAR] OF HIS AGE." The Suffolk Record Office preserves the bishop's transcripts of the Little Thurlow parish registers covering the period ending c. 1837. A search of these reveals the following record of burial: "21 June 1817 William Weston of Little Thurlow buried, aged 23."

It therefore seems probable that the people in the picture are William and Rebecca Weston and two of their sons. If so, a number of possibilities present themselves. The most straightforward identification of the sitters simply assumes that the Westons had three sons, one of whom, William, died in 1817, a year before Marshall painted the surviving members of the family. But we cannot rule out the possibility that the Westons had only two sons and that the picture, though inscribed 1818, was painted—or at least the portraits were sketched—before William's death in 1817. And it is just as conceivable that the painting was begun and finished in 1818 and the portrait of the older boy in the rear, in black, is a posthumous portrait of William. This may be the reason for his slight remove from the other members of the family, and why, unlike his father and brother, he is not shown as a participant in the shoot, but carries a walking stick. If the portrait is posthumous, Mrs. Weston is in mourning and her vague gesture toward the older boy refers to her loss.

No obituaries of the Westons appear in *The Gentleman's Magazine;* nor are the Westons recorded in the local will or marriage indexes, indicating that they were not in Little Thurlow for very long. They may even have rented the rectory, whose rector, Thomas Crick (d. 1818), was also vicar of Mildenhall, a much larger parish about twenty miles away, where he probably lived most of the time. From their costume and bearing we can assume that the Westons were not quite gentlefolk: one might confidently place Mr. Weston as a prosperous East Anglian farmer whose sport, as shown here, was not fox hunting but partridge or duck shooting along the Stour.

Marshall's working method, making sketches (often in oil) from life, then working out the composition in the studio, accounts for something of the stiff, unintegrated quality of the group. Apart from Mr. Weston, in a white jacket, yellow cravat, and gloves, with buckskin trousers, who looks toward his wife—all in black but with yellow gloves—none of the sitters is seen to relate to the others; rather, they stare unfocused into space, or like Rebecca Weston astride her cob, gesture in one direction while looking in another.

PROVENANCE: Presumably Weston family; Howard Young Galleries, New York, 1930; bt. Knoedler Galleries, bt. George D. Widener, November 1930.

EXHIBITION: London, Royal Academy, 1819, no. 241 (as "Portraits of a Family at Little Thurlow, Suffolk").

LITERATURE: Gilbey, 1900, p. 94; *International Studio,* vol. 97 (December 1930), repro. p. 38; Sparrow, 1931, p. 93, repro. opp. p. 96; Sparrow, 1935, p. 67, repro. p. 63; Sitwell, 1936, pp. 83, 110, pl. 113; Tancred Borenius, *English Painting in the XVIII*th *Century* (London, 1938), pl. 94; Walker, 1972, pp. 83–84; *Bulletin of the Philadelphia Museum of Art,* vol. 74, no. 323 (December 1978), repro. p. 2; Noakes, 1978, pp. 14, 46 no. 144.

CONDITION NOTES: The original support is twill-weave, medium-weight (10 x 10 threads/cm.) linen. The tacking margins have been removed. The painting is lined with an aqueous adhesive and medium-weight linen. The ground is off-white, as seen along the cut edges. The paint is in good condition overall. Local areas of traction crackle are associated with the brown tones, indicating the use of bitumen in the artist's palette. A coarse web of irregular fracture crackle with slight cupping extends over the surface. This is most obvious in the sky behind the woman. Under ultraviolet light, retouching can be seen primarily in the woman's face, the horse, and the dog at center.

Henry Robert Morland (1716–1797), a failed portrait painter and picture dealer, himself the son of a mediocre artist, bred his son George from infancy to the family profession. An early biographer corroborates other accounts of George's upbringing: "[He] was confined from day to day, and from year to year, in an attic apartment, where he was incessantly employed in copying drawings or pictures, or making drawings from casts."[1] Dawe adds that "from an over anxious regard to his morals" the boy was not permitted to study at the Royal Academy,[2] but Morland the elder may simply have had little regard for the future commercial value either of classical academic training or its concomitant, the painting of history pictures. As a friend of Reynolds (q.v.), Benjamin West (1738–1820), and Henry Fuseli (1741–1825), Henry Robert Morland well knew that the prosperous middle class was not yet ready to purchase ennobling history pieces but eagerly bought up mild landscapes and instructive genre scenes. Young George was made to study and copy pictures by the Dutch masters and shipwrecks by Joseph Vernet (1714–1789), while he himself chose to study Stubbs's (q.v.) *Anatomy of the Horse* and later copied fancy pictures by Gainsborough (q.v.). By 1775 he had achieved such a degree of competence that his father entered his twelve-year-old son's work in the exhibition at the Free Society of Artists as by "Master George Morland, ten years old," capitalizing on the vogue for "discovering" untutored geniuses, popularized by the writings of Rousseau and exemplified a few years later by the brief fashion for "the Cornish Wonder" John Opie (q.v.).[3]

At fourteen, in 1777, George was exhibiting at the Society of Artists and at the same time bound apprentice to his father. There he stayed, in near incarceration, until 1784, exhibiting continually at the Royal Academy and the Free Society of Artists. In 1784 his apprenticeship expired. There followed several years of experiment and indecision. He drew from the model on three occasions in 1784 at the (forbidden) Royal Academy, traveled to Margate and Calais with a patroness to seek work as a portrait painter in 1785, married the sister of the engraver William Ward (1766–1826) in 1786, and saw the birth of a still-born son in 1787. His earliest dated work, from about 1786–87, is *St. Valentine's Day* (18 x 13½", London, Victoria and Albert Museum), part of a series of paintings on the "Progress of Love" executed in collaboration with Francis Wheatley (q.v.), whose success as a painter of sentimental genre no doubt influenced Morland's decision to take up this most lucrative and fashionable branch of painting.

The period from 1786 to 1790 constitutes the first brief phase of Morland's career when he established himself as a painter of moral and domestic genre (*The Squire's Door*, c. 1790, 15¼ x 12⅞", New Haven, Yale Center for British Art) and English *fêtes galantes* (*St. James's Park*, 16 x 19", Upperville, Virginia, Paul Mellon Collection, and *A Tea Garden*, 16 x 19⅞", London, Tate Gallery, both 1789). He also took up the tradition of the moralizing progress in emulation of Hogarth (q.v.), beginning in 1786 with a series of six pictures called "Laetitia" or "A Harlot's Progress," showing the path of a young girl from innocence to vice, and finally (and here Morland is very much of his own time and very unlike Hogarth) to repentance. His Continental reputation was established in the late 1780s through prints after his subjects of children at play such as *Blind Man's Buff* (1789, 27½ x 20½", Detroit, The Detroit Institute of Arts) or *Juvenile Navigators* (1789, 24 x 30", location unknown).

This period as a genre painter lasted only four years. Around 1790, possibly because he sensed that the commercial appeal of the cult of sensibility had drawn to a close and a new fashion for the picturesque had dawned, he began to paint landscapes and rustic low-life subjects, beginning in 1791 with the exhibition of *Inside of a Stable* (58½ x 80¼", London, Tate Gallery) at the Royal Academy to huge critical acclaim. From this year until his death in 1804

his stock in trade was the depiction of tumbledown farmyards, harmless gypsies, happy peasants, bumbling farmers, picturesque smugglers and fishermen, and shipwrecks in the style of the highly popular Swiss painter Philipp de Loutherbourg (1740–1812). As David Winter has shown, even within the relatively short span of a decade's work on such subjects there are two distinct periods: works painted from about 1790 to 1794, which constitute Morland's "best period," having a freshness and vitality absent from the later works; and works painted after 1794, when drink, debt, and poor health led him to turn out carelessly executed parodies of his own earlier style.

Morland's methods of painting and distribution were revolutionary. As an oil painter, he worked with the best available materials but without sketches or even preconceived compositions, inventing as he worked, so that the finished product, often the labor of only a few hours, had the spontaneity and bravura of a Continental oil sketch. He copied as much as he could from life, bringing donkeys, pigs, and straw into his studio, or waylaying passers-by to pose when the color of their cloaks suited his artistic purpose.[4]

With a chronic dislike of patrons ("Oh d——n *Lords,* I paint for no *Lords*")[5] he fell into the clutches of a series of middlemen who hung around his studio, paying him a few pounds' drinking money for a picture painted in Camden Town or Paddington, then selling it immediately for double the price to dealers or engravers in Bond Street and Covent Garden. This system, which presumed an unlimited demand for Morland's productions brought about by the vogue for the picturesque and the craze for English prints in England or France and Germany, changed the relationship between English painters and their clients. For the first time the painter could, in theory, paint the subjects *he* chose, in the size and colors he selected, and expect to sell the picture at once to a dealer. The burden of finding a purchaser then fell to the businessman.[6] Furthermore, under this system the necessity to exhibit at a public institution was eliminated, and thus it was the owners of Morland's paintings who submitted them to the Royal Academy and the Society of Artists, not Morland himself.

But this system hardly meant complete freedom for the artist. Because his works were meant for engraving, a publisher would buy only images appealing to the broadest (or lowest) public taste. Morland and his like were confined to inoffensive, undemanding subjects with particular preference given to scenes of moral edification, children at play, or views of peasant and farming life. Likewise, pictures could be smaller because their purchasers came from the middle and merchant classes and lived in smaller houses than patrons of a generation before. Finally, complexity of technique or surface finish were not necessarily considerations in a painting whose value lay largely in its quick and successful translation into black and white by an artisan, often unknown to the artist.

Morland himself is an unforgettable character. His father's severity left him unable to submit to authority or discipline of any kind. Dawe tells us that "he seemed to pride himself in doing every thing which his parents had represented to him as pernicious, and the more he could throw off his juvenile fears the more he thought himself a man."[7] In practice this led to behavior so extreme that he takes his place alongside the Prince of Wales, William Beckford, and Lady Hamilton as one of the great comic figures of the late eighteenth century. To begin with, he was drunk at all times; he rarely washed or changed his clothes. Morland usually dressed up like a jockey or groom, in costumes described by Hassell as "whimsical," "eccentric," "ridiculous," "finical, fantastical, and grotesque."[8] These get-ups gained in their visual effect if, like Hassell, one met the painter in Paddington, on a summer's morning, carrying a baby pig in his arms.[9] He lived in squalor but surrounded himself

with food and wine in a studio filled with friends, wrestling, boxing, or pelting passing coachmen with blobs of paint. At the bottom of his garden at Winchester Row in Paddington in the early 1790s, Morland maintained a menagerie of horses, foxes, goats, dogs, squirrels, guinea pigs, and dormice.[10]

All this seems to have fascinated his contemporaries, but after about 1794 it began to affect his health and interfere with his work. Near the end of Morland's life Collins described him as "besotted and squalid; cadaverous hanging cheeks, a pinched nose, contracted nostrils, bleard and bloodshot eyes, a bloated frame, swelled legs, a palsied hand, and a tremulous voice."[11] Morland died in a sponging house in Eyre Street Hill, Cold Bath Fields, in October 1804, age forty-one.

To briefly sum up his whereabouts in London during a short life: he lived in North London, near or in Camden Town from the time of his marriage until about 1791 when he moved to the rural village of Paddington; in 1792 he fled with his wife to Enderby in Leicester but returned to live in Charlotte Street, Fitzroy Square, Bloomsbury. By 1794 he had begun a life of constant peregrination to avoid his creditors. He had visited the Isle of Wight on and off since at least 1789 and spent several months there in 1799. On December 30, 1799, he was arrested for debt and committed for two years to King's Bench Prison where, under the "rules," he lived in a furnished house while working to pay off his bills.

1. Blagdon, 1806, p. 4.
2. Dawe, 1904, p. 4.
3. For a summary of Morland's development see Dawe, 1904, pp. 4–6; Winter, 1977, passim.
4. Dawe, 1904, p. 40.
5. Blagdon, 1806, p. 8.
6. See David Thomas's essay in London, Arts Council of Great Britain, *George Morland: An Exhibition of Paintings and Drawings*, 1954, pp. 5–6; Burke, 1976, pp. 390–91.
7. Dawe, 1904, p. 17.
8. Hassell, 1806, p. 9.
9. Ibid., p. 21.
10. Dawe, 1904, pp. 58–59.
11. Collins, 1805, vol. 2, p. 133.

(London, 1902); Dawe, 1904; Martin Hardie, "George Morland I: The Man and the Painter," *The Connoisseur*, vol. 9 (July 1904), pp. 156–63; Martin Hardie, "George Morland II: The Engravings," *The Connoisseur*, vol. 9 (August 1904), pp. 199–207; Williamson, 1904; J. T. Herbert Baily, "George Morland," *The Connoisseur*, extra number, no. 1 (1906); Gilbey and Cuming, 1907; Williamson, 1907; David Henry Wilson, *George Morland* (London and New York, 1907); Francis Buckley, *George Morland's Sketch Books and Their Publishers* (Uppermill, 1931); Sparrow, 1931, pp. 61–70; Burke, 1976, pp. 390–91; Winter, 1977; Barrell, 1980, pp. 89–129.

BIBLIOGRAPHY: John Raphael Smith, *A Descriptive Catalogue of Thirty-Six Pictures Painted by George Morland . . . to Be Engraved by Subscription by and under the Direction of J[ohn] R[aphael] Smith* (London, [1792]); Collins, 1805; Blagdon, 1806; Hassell, 1806; Dawe, 1807; "Memoir of George Morland," *Arnold's Library of the Fine Arts and Journal of Literature and Science*, n.s., vol. 1, no. 3 (January 1833), pp. 161–71; Richardson, 1895; Ralph Richardson, *George Morland's Pictures, Their Present Possessors, with Details of the Collections* (London, 1897); Nettleship, 1898; Julia Frankau, *An Eighteenth Century Artist and Engraver John Raphael Smith: His Life and Works*, 2 vols.

EXHIBITIONS: London, Messrs. Orme and Co., 14 Old Bond Street, *The Morland Gallery*, 1792; London, Messrs. Orme and Co., 14 Old Bond Street, *The Morland Gallery*, 1793; London, Mrs. Macklin's Morland Gallery, *A Collection of 95 Paintings by Morland Owned by Charles Chatfield*, 1805–7; London, J. and W. Vokins Gallery, *Loan Collection of an Exhibition of Pictures by George Morland and Engravings from His Works*, 1884; London, Victoria and Albert Museum, *Catalogue of an Exhibition of Paintings by George Morland Held at the Victoria and Albert Museum, South Kensington*, 1904; London, Arts Council of Great Britain, *George Morland: An Exhibition of Paintings and Drawings*, 1954 (by David Thomas); Reading, Museum and Art Gallery, *George Morland, 1763–1804: Paintings, Drawings and Engravings*, 1975.

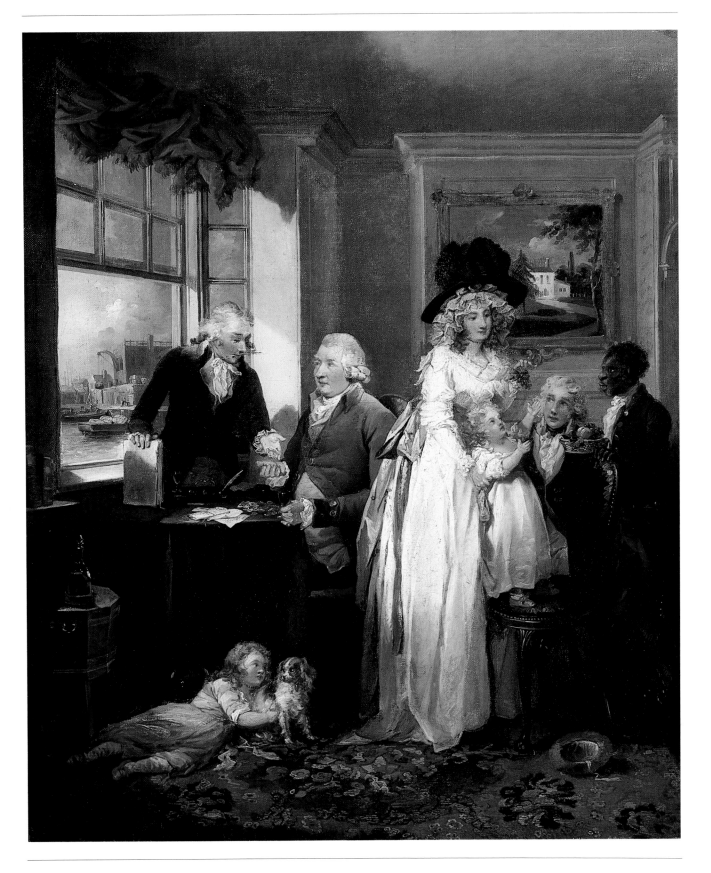

57 GEORGE MORLAND

FRUITS OF EARLY INDUSTRY AND ECONOMY, 1789
Oil on canvas, 30¼ x 25⅛″ (76.8 x 63.8 cm.)
John H. McFadden Collection, M28-1-19

FIG. 57-1 George Morland, *Effects of Youthful Extravagance and Idleness,* 1789, oil on canvas, 29¼ x 24¼" (74 x 62 cm.), location unknown, Sotheby's, March 12, 1969, lot 43

William Collins, in his 1805 biography of George Morland, discussed the origin of the pair of moralizing genre subjects known as the *Fruits of Early Industry and Economy* and the *Effects of Youthful Extravagance and Idleness* (fig. 57-1): his solicitor, Mr. Wedd, in order to free Morland from "the apprehension of a prison [for debt] . . . procured for him the benefit of the rules of the Board of the Green Cloth [by which the debtor lived outside the prison on parole until he paid his creditors]. Within the precincts of this privileged spot, he had very genteel lodgings, in Buckingham Court, Charing Cross. . . . Here he, amongst many others, painted a pair of pictures, one of which would have been a credit to any master of the most celebrated schools of antiquity. The subject of these pictures was given him by the author [Collins], with several others, during his abode at Warren Place, Camden Town; and the fortunate purchaser was, we believe, a Mr. Simpson, drawing–master, who had two prints engraved after them."[1]

When these prints were published in 1789, they were inscribed with trite verses hammering home the moral by S. Collings, presumably the caricaturist S. Collings who exhibited at the Royal Academy between 1784 and 1789.

Fruits of Early Industry and Economy is the finer of the pair. A prosperous businessman is seated at a table covered with his account books and money. A young man, presumably his son, acts as steward (the ledger in his right hand is inscribed "True Steward").[2] The merchant's pretty daughter, with her husband, dangles grapes offered by a black servant (or slave) in front of the younger of her two sons. The other grandchild plays with his pet spaniel and eats another of the fruits of early industry (an apple). The dockyards and warehouses glimpsed through the open window reveal the source of all this prosperity, and a framed view of the family's suburban villa hanging on the wall tells us more about the extent of the family possessions. Mahogany chairs, a floral carpet, and what may have seemed to Morland the ultimate symbol of human felicity, a full wine cooler on a breezy summer's day, complete this picture of bourgeois domestic satisfaction.

Thus the moral: Hard work tends toward the happiness not only of the hard worker but also of future generations as well. The pendant, the *Effects of Youthful Extravagance and Idleness,* in which a family starving in a garret all look to the father as the source of their misery, restates in the negative this theme of paternal responsibility for the happiness of one's dependents. This very theme must have been close to Morland's heart. His own father had been declared bankrupt in January 1762,[3] and as a result his son was forced to turn out paintings to pay the family bills. Morland himself painted both pictures while living under house arrest for debt in conditions presumably only a cut above those of the father in the *Effects of Youthful Extravagance.* Still, the question of how seriously we are to take either picture as a straightforward statement of moral right and wrong is complicated.

Iconographically and even stylistically, both pictures derive ultimately from the example of Hogarth's (q.v.) moral series, and in particular from "Marriage à la Mode," from which Morland borrowed heavily. In the *Fruits of Early Industry and Economy,* the entire left-hand side of the picture is taken from the first scene in "Marriage à la Mode," *The Marriage Contract.*[4] The content and many aspects of the composition of the *Effects of Youthful Extravagance* echo scenes in both "The Rake's Progress" and "The Idle Apprentice." Hogarth's paintings and prints were, of course, satirical, and any knowledgeable buyer of paintings and prints in the later eighteenth century when confronted with Morland's neo-Hogarthian pair of domestic genre scenes would at least entertain the possibility that an element of social caricature exists.

FIG. 57-2 Francis Wheatley (1747–1801), *Family Group with a Black Servant,* early 1770s, oil on canvas, 40 x 50″ (102 x 127 cm.), London, Tate Gallery

FIG. 57-3 Johann Zoffany (1733–1810), *Bradshaw Family,* 1769, oil on canvas, 52 x 69″ (132 x 175 cm.), London, Tate Gallery

Reading the *Fruits of Early Industry* unironically, one feels a smugness and a self-satisfaction most odd for a man of Morland's anarchistic, dissolute temperament, and for a man who spent his whole life scorning the very values supposedly celebrated by the picture. And although it is true that the artist is described by an early biographer as never having read a newspaper, and perhaps never having possessed a book in his life,[5] this does not mean that he was indifferent to current social controversies. In 1790, the year after the *Fruits* and *Effects* series, he exhibited at the Society of Artists another series, called *African Hospitality* and *Slave Trade,* in which native kindness to shipwrecked British sailors is contrasted to the treatment of black natives by English slave traders.[6] Both subjects were suggested by William Collins, who also provided the subjects for the *Fruits* and *Effects* pair, and were politically radical in their sympathy for William Wilberforce and the abolitionist movement. The slave series may be one of the earliest attempts to treat critically the subject of slavery in painting.[7] In the light of this second series, the black servant in the *Fruits of Early Industry* could be seen as one of the fruits referred to in the title and as a portion of the businessman's property. If we go even further and suggest that the black servant was from a class of men whose labor permitted this family to augment their wealth, we may also suggest that he presents the family with a distinct scowl along with their grapes and peaches.

Perhaps even more to the point, we should remember that Morland had started his independent career only three years before painting the *Fruits of Early Industry* in an apparently unsuccessful attempt to become a portrait painter. We might therefore view the *Fruits of Early Industry* as a parody of the typical English conversation piece of the 1770s. By comparison, for example, to Francis Wheatley's (1747–1801) *Family Group with a Black Servant,* early 1770s (fig. 57-2), which itself depends on Johann Zoffany's (1733–1810) *Bradshaw Family,* 1769 (fig. 57-3),[8] the Morland looks like a parody of these two family groups because it exuberantly spells out what is naturally not referred to in either the Wheatley or the Zoffany: the trade, the gold, the account books, and the slaves on which the family's prosperity rests.

However, *Fruits of Early Industry* and its pendant come at the very end of a long and nearly played-out tradition of moralizing genre scenes. There was no need for Morland to show us *how* the protagonist made his fortune or met his fate as Hogarth felt obliged to do in a series like "Idleness and Industry" (published 1747).[9] The lesson had been too well learned by the public. There is a perfunctoriness and routineness here because Morland knows his public has heard the message before in the bland and optimistic works of Bigg, Wheatley (q.q.v.), Edward Penny (1714–1791), and John Mortimer (1741–1779). Winter concluded that Morland's intentions were closer to those of this later generation of artists than to the satires of Hogarth, and that the *Fruits of Early Industry* is a straightforward paean to the middle-class values of thrift and diligence. In support of this thesis, let us view the *Fruits of Early Industry* in an international context—comparing it to the works of Morland's French contemporaries, Louis Léopold Boilly (1761–1845) and Marguerite Gérard (1761–1837). Then Morland seems to fit perfectly into a fashion for reworking the Dutch domestic genre tradition in a post-rococo idiom. Perhaps the truth is that Morland was here a satirist despite himself, and that while working within a bland and inoffensive tradition, he allowed his true feelings about English middle-class family prosperity to come through.

1. Collins, 1805, vol. 2, pp. 48–49.
2. The merchant in the *Fruits of Early Industry* is reused in reverse in Morland's *Tea Garden* (1789, 16 x 19⅞", London, Tate Gallery) as the figure of the grandfather at the left, and the clerk/son in the former is seen with a teapot in the latter. See Winter, 1977, p. 51.
3. "Gazette, January 23–26, 1762," Whitley Papers, British Museum, London.
4. Winter, 1977, p. 40.
5. Dawe, 1904, p. 15.
6. Respectively, 34¾ x 48½", Great Britain, private collection and location unknown. According to Winter (1977, p. 170) copies sold Christie's, June 20, 1969, lot 61.
7. Engraved by J. R. Smith in 1791. See Winter, 1977, pp. 46, 66, 169–70. Winter points out that Wilberforce founded his committee for abolition in 1787, and Parliament considered the question in 1788.
8. Mary Webster, *Francis Wheatley* (London, 1970), p. 24 figs. 28, 29.
9. Winter, 1977, p. 40.

PROVENANCE: Mr. Simpson, 1789; Mr. Thompson, Great Newport Street, London, 1807; Townley sale, Christie's, February 25, 1809, lot 109, bt. in; Sgt. Pulling; Christie's, May 10, 1873, lot 91, bt. Agnew; H.W.F. Bolekow; his sale, Christie's June 9, 1877, lot 82, bt. Vokins; Charles Seely; his sale, Christie's, May 29, 1886, lot 114, bt. Donaldson; Romer Williams; Agnew; bt. John H. McFadden, October 9, 1913.

EXHIBITIONS: Pittsburgh, 1917, no. 20; New York, 1917, no. 20; Philadelphia, 1928, p. 20.

LITERATURE: Collins, 1805, vol. 2, p. 49; Richardson, 1895, p. 8; Roberts, 1897, vol. 1, p. 280; Dawe, 1904, pp. 39, 41, 124; Martin Hardie, "George Morland I: The Man and the Painter," *The Connoisseur*, vol. 9 (July 1904), p. 160; Williamson, 1904, p. 115; J. T. Herbert Baily, "George Morland," *The Connoisseur*, extra number, no. 1 (1906), pp. 49, 126; Gilbey and Cuming, 1907, pp. 79, 223; David Henry Wilson, *George Morland* (London and New York, 1907), pp. 76, 183, 195, repro. opp. p. 48; Roberts, 1917, pp. 39–40, repro. opp. p. 39; Sparrow, 1922, p. 149; John Gloag, *The English Tradition in Design* (London, 1959), pl. 31; Antal, 1962, p. 182; Staley, 1974, p. 38; Winter, 1977, pp. 39–42, 48, 51, p. 170 no. P30, p. 225 fig. 21; Denys Sutton, "The World of Sacheverell Sitwell, Part II, Chapter IX, Castles and Conversations," *Apollo*, n.s., vol. 112 (October 1980), p. 264 fig. 14.

CONDITION NOTES: The original support is medium-weight (10 x 10 threads/cm.) linen. The tacking margins have been removed. A tear along the top edge was repaired in 1943. Weave cusping is evident along the top edge and sides. The painting is lined with an aqueous adhesive and medium-weight linen. A thickly and evenly applied white ground is visible along the cut edges. The paint is in good condition. A fine traction crackle is present in the dark tones of the seated man and a fine web of fracture crackle is present in the whites and highlights of the figures. Local areas of abrasion are present and are most obvious in the standing female figure. Under ultraviolet light, retouchings are visible in the figures, in scattered areas of background adjacent to them, and along the edges. Infrared reflectography reveals a direct and thin application of paint with very little change in detail. The painting was cleaned in 1943.

ENGRAVINGS
1. William Ward after George Morland, *Fruits of Early Industry and Economy*, November 1, 1789, mezzotint, 20¼ x 15¾" (51.4 x 40 cm.). Published: T. Simpson, St. Paul's Churchyard, London.

INSCRIPTION: *Lo here, what ease, what elegance you see; / The just reward of youthful Industry! / The happy Grandsire looks thro'all his race, / Where well earn'd plenty brightens every face, / The beauteous daughter school'd in virtues lore, / Now gives th'example she received before, / While her fond Husband train'd to fair renown, / Sees future laurels his brave offspring crown.*

2. William Ward after George Morland, *Fruits of Early Industry and Economy*, March 1794, mezzotint, 23⅜ x 18¾" (59.4 x 47.6 cm.). Published: Darling and Thompson, Great Newport Street, London.

DESCRIPTION: Costumes brought up to date.

3. The same as nos. 1 and 2, reissued 1804.

LITERATURE: Collins, 1805, vol. 2, p. 49; Richardson, 1895, pp. 40, 136, 147; Ralph Richardson, *George Morland's Pictures, Their Present Possessors, with Details of the Collections* (London, 1897), p. 22; Nettleship, 1898, p. 83; Dawe, 1904, pp. 170, 171; Williamson, 1904, p. 134; Gilbey and Cuming, 1907, pp. 249, 275.

RELATED WORK: George Morland, *Effects of Youthful Extravagance and Idleness*, 1789, oil on canvas, 29¼ x 24¼" (74 x 62 cm.), location unknown (fig. 57-1).

PROVENANCE: Mr. Simpson, 1789; Mr. Thompson, Great Newport Street, 1807; Christie's, February 25, 1809, lot 109, bt. in; Lt. Col. Packe, his sale, June 18, 1881, lot 34, bt. Vokins; Sir Walter Gilbey, Bart.; his sale, Christie's, June 11, 1915, lot 347, bt. Agnew; Barnet Lewis sale, Christie's, March 3, 1930, lot 131, bt. [Earl of] Effingham; S. B. Joel sale, Christie's, May 31, 1935, lot 23, bt. McConnal; P. H. Ford, his sale, Christie's, October 24, 1958, lot 54; Eric Saunders, his sale, Sotheby's, November 24, 1965, lot 68; P. M. Knatchbull-Hugesson; Sotheby's, March 12, 1969, lot 43.

ENGRAVING: William Ward after George Morland, *Effects of Youthful Extravagance and Idleness*, July 1, 1789, mezzotint, 20¼ x 15¾" (51.4 x 40 cm.). Published: T. Simpson, St. Paul's Churchyard, London.

INSCRIPTION: *What misery in a narrow scale confined! / The mournful work of one degenerate mind; / See fair fidelity that might have blest / A fond- a victim to a faithless breast; / The gloomy prospect of her opening day / See beauty, blooming to the world a prey, / While the lost son, depresst, his youthful fire / Looks sad conviction to the conscious sire! / —S. Collins.*

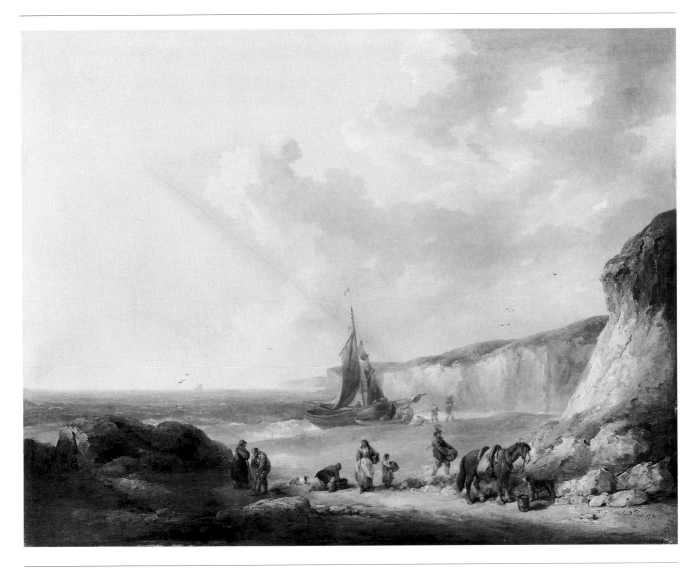

58 GEORGE MORLAND

COAST SCENE WITH SMUGGLERS, 1790
Oil on canvas laid on board, 38¼ x 50½" (97.1 x 128.3 cm.)
Inscribed lower right: *G. Morland pinx'1790*
Gift of Mrs. Edward Browning, 47-99-1

Morland's association with the Isle of Wight lasted nearly the whole of his
working career, from his first visit in 1789, when he stayed at Eglantine
Cottage, Shanklin,[1] to his last visit in April 1799, when he fled to Cowes with
his wife to escape his creditors in London.[2] From 1790 he began to exhibit
views of the beach and cliffs there, populated by the colorful inhabitants—the
smugglers and fishermen who became Morland's friends. In 1792 J. R. Smith
described a smuggling scene by Morland as having "the General air . . . of
Vernet."[3] Although Morland certainly sketched the topography and citizens
of the Isle of Wight from life,[4] the finished paintings were always executed
in the studio, and consequently were filtered through the prism of
Vernet's (1714–1789) conventions and mannerisms. Morland's coast scenes
are superficially lively and fresh but lack the wet, salty immediacy of
Gainsborough's (q.v.) sea pieces such as *Fisherman Setting Out* (1781,
39 x 49", Mrs. Robert Mellon Bruce Collection) or *Coast Scene: Selling Fish*
(1781, 39½ x 50", London, Westminister Trustees).[5]

 What we see in Morland's picture are cognac smugglers at work during a
time when smuggling carried the capital penalty. What these men were
smuggling was understood at the time of the picture's exhibition, for in 1792

J. R. Smith wrote of the smuggling scene that such men "laugh at the prohibitions of Government, and run every hazard to supply their fellow-subjects with the *unadulterated spirits* of other nations."[6] One of Morland's biographers objected to the artist's failure to distinguish "the honest and harmless fisherman... from the smuggler and depredator,"[7] but the line between smuggler and fisherman was, at this time, a thin one.

A smaller version of *Coast Scene,* more coarsely and roughly drawn, appeared at Sotheby's in 1968.[8] The scene, which was identified in the catalogue as a view at Shanklin, Isle of Wight, is topographically identical to the Philadelphia picture, with the same boats and nearly the same cloud formations. The three central figures in the foreground (the kneeling man and the woman and child to his right) are in both pictures, but the two men with pitchforks at the left in the Philadelphia picture, the dogs, horse, barrel, and man carrying a barrel on the right, are absent from the smaller version.

1. Gilbey and Cuming, 1907, p. 83.
2. Dawe, 1904, p. 83.
3. John Raphael Smith, *A Descriptive Catalogue of Thirty-Six Pictures Painted by George Morland... to be Engraved by Subscription by and under the Direction of J[ohn] R[aphael] Smith* (London, [1792]), p. 11.
4. Hassell (1806, p. 38) described meeting Morland at Shanklin, when the artist "drew from his pocket a sketch-book, filled with the most exquisite treasures."
5. Waterhouse, 1966, nos. 954, 955, pls. 224, 225.
6. Smith (see note 3), p. 11.
7. Dawe, 1904, pp. 103–4.
8. April 3, 1968, lot 53.

INSCRIPTION: *The Rv^d R.A. Dashwood of / Smugglers landing a / Cargo / Geo. Morland 1896 / Nov. [p?] 53; Rebacked & restored October 1940 by Harrie M[?] Hosmer / Upper Darby* [on the reverse].

PROVENANCE: Rev. R. L. Dashwood, The Mount, Yarmouth, Isle of Wight; M. Knoedler and Co.; Mrs. Edward Browning, Philadelphia.

LITERATURE: Winter, 1977, p. 254 fig. 73, p. 175 no. P64.

CONDITION NOTES: The original support is medium-weight (14 x 14 threads/cm.) linen. The tacking margins have been removed. Weave cusping is evident on all four sides of the support. Stretcher creases are apparent on all four sides and diagonally across each corner. The painting is lined with a ¼" thick panel of plywood and an aqueous adhesive. A stretcher, not original, has been added to the reverse. A white ground has been thickly applied. The paint is in only fair condition. Much of the original relief of the paint profile has been flattened. The paint is heavily retouched in the sky. The areas of overpaint correspond to the losses at each corner associated with the diagonal stretcher creases. A fine web of fracture crackle extends from each corner inward. Traction crackle is present in local areas of the foreground sand and rock. Ultraviolet light examination shows small retouches in the foreground. Infrared reflectography reveals that the background coastline was painted first and then the boat and the figures were added.

RELATED WORK: George Morland, *A Beach Scene at Shanklin, Isle of Wight,* oil on canvas, 16½ x 22½" (41.9 x 57.1 cm.), location unknown.
 PROVENANCE: Sotheby's, April 3, 1968, lot 53.

59 GEORGE MORLAND

FARMYARD, 1790−91
Oil on canvas, 28 x 36″ (70.5 x 92 cm.)
Inscribed center right on fence: *G Morland*
Gift of Mrs. Gordon A. Hardwick and Mrs. W. Newbold Ely, in memory of
Mr. and Mrs. Roland L. Taylor, 44-9-1

The Farmyard shows Morland at the height of his powers, in the early 1790s,
after the huge success of *Inside of a Stable* (58½ x 80¼″, London, Tate Gallery)
at the Royal Academy in 1790 and before drink and the drudgery of churning
out formula farmyard scenes took the life out of his painting. Particularly
beautifully painted here are the sow and piglets in the foreground and the
donkey giving suck to her foal. Although Morland's textures are slightly
uniform—the leaves and straw, for example, are hardly differentiated—he
nevertheless conveys the atmosphere of a soft afternoon in high summer, the
stillness interrupted by barnyard grunts and shufflings, and the feeling of
endless time for the farmer and his lady to gossip or flirt the afternoon away.

INSCRIPTION: *L.29 16. 21 / Exh. 29.16.21* [on reverse, a loan label for the Baltimore Museum of Art].

PROVENANCE: Thomas James Barratt, Bellmoor, Hampstead Heath, London, before 1916; his sale, Christie's, May 11, 1916, lot 74; bt. Sir Joseph Beecham, Bart.; Mrs. W. Cox, Christie's, May 14, 1926, lot 61; bt. Urquhart; The French Gallery.

EXHIBITIONS: London, Royal Academy, 1903, no. 17; Baltimore, Baltimore Museum of Art, on extended loan, 1929; Philadelphia, Cosmopolitan Club, 1944.

LITERATURE: Joseph Grego, "The Art Collection at 'Bell-Moor,' The House of Mr. Thomas J. Barratt—I," *The Magazine of Art,* vol. 21 (1898), p. 133, pt. 2, p. 195, repro. p. 193, pt. 3, p. 265; Williamson, 1904, pp. 108, 110; Gilbey and Cuming, 1907, repro. opp. p. 118; Williamson, 1907, p. 137; Winter, 1977, p. 178 no. P79, p. 234 fig. 38.

CONDITION NOTES: The original support is medium-weight (16 x 16 threads/cm.) linen. The tacking margins have been removed. A crease with an associated planar distortion runs horizontally through the tree branches above the figures. The painting was lined in 1962 with a wax-resin adhesive and medium-weight linen. A previous aqueous adhesive lining was retained. The ground is off-white. The paint is in good condition. Slight flattening of the texture of brush marking has occurred. Fracture crackle has formed only in the highlight areas of the figures and farmyard animals. Losses are small and occur along the cut edges. The painting was cleaned fairly completely in 1962. Ultraviolet light examination reveals retouching in the unfilled losses along the edges. Infrared reflectography shows little change in detail and extremely thinly applied paint in the tree above the couple.

60 GEORGE MORLAND

THE HAPPY COTTAGERS (THE COTTAGE DOOR), c. 1790–92
Oil on canvas, 14½ x 18½" (37.1 x 46.1 cm.)
John H. McFadden Collection, M28-1-20

This painting is a reduction of the first version of *The Happy Cottagers,* almost twice this size, exhibited at the Society of Artists in 1790 as "The Cottage Door" (no. 207). The Philadelphia picture was painted around 1790–92 during Morland's best period, when from around 1790 to 1794 he first concentrated on rustic and farming subjects.

In both pictures a bonneted and tidy-looking peasant woman sits outside her tumbledown but picturesque cottage, knitting. Her little girl stands by her chair pulling a toy wagon filled with straw. An older woman, perhaps the grandmother, turns her back to the spectator, disappearing into the cottage with a load of firewood under her arm. In the foreground one naughty-looking boy wheels his friend or brother in a wooden barrow. This boy with the barrow is Welsh, indicated by the leeks he wears in his hat. This custom, like the wearing of a shamrock on St. Patrick's Day, took place on March 1, St. David's Day, in honor of the patron saint of Wales. In the eighteenth century this date coincided with Queen Charlotte's birthday, an event referred to in scene four of Hogarth's (q.v.) "Rake's Progress" where the rake is carried in a

sedan chair to attend the festivities in honor of the queen at court and is
accosted by a Welsh bailiff wearing the traditional leeks. The motif of the child
being wheeled in the barrow in this painting echoes the sedan-chair motif in
the Hogarth.

In the first and larger version we see a longer view of the scene, with the
whole cottage visible, a group of pigs, a duck pond in the right foreground,
and beyond a fence and field. The Philadelphia version is, however, more than
a close-up view of the earlier, more panoramic picture. In a broader context, it
develops out of Gainsborough's (q.v.) cottage subjects of the later 1780s such
as *The Cottage Door* of 1788 (77 x 62″, Los Angeles, University of Southern
California), and Horace Walpole, commenting on the version of
The Happy Cottagers exhibited in 1790, wrote that it was "as good as
Gainsborough, but with more harmony & better finished."[1] In a sense,
Morland afforded the public a more intimate and detailed depiction of what
was only glimpsed from further away in the Gainsborough. In Morland's
Happy Cottagers this closer look at the peasantry may well have reassured a
middle-class purchaser of the picture or print after it. Everyone looks well fed
and happy; both the adult women are busy with domestic chores. The "moral"
of the picture, if there is one, is very close to the ostensible morals of
Morland's genre subjects of the late 1780s, that industry results in the
happiness of all society.

1. "Notes by Horace Walpole, Fourth Earl of Orford, on the Exhibitions of the Society of Artists and the Free Society of Artists, 1760–1791. Transcribed and Edited by Hugh Gatty," *The Walpole Society, 1938–1939*, vol. 27 (1939), p. 72.

PROVENANCE: Mrs. Joseph, London; Agnew; bt. John H. McFadden, October 12, 1916.

EXHIBITION: Pittsburgh, 1917, no. 19 (as "The Cottager's Family").

LITERATURE: Roberts, 1917, p. 41, repro. opp. p. 41; Roberts, 1918, "Additions," p. 117, repro. p. 115 fig. 6; Winter, 1977, p. 174 no. P55.

CONDITION NOTES: The original support is medium-weight (16 x 16 threads/cm.) linen. The tacking margins have been removed. The painting is lined with an aqueous adhesive and medium-weight fabric. An off-white ground can be seen along the cut edges. The paint is generally in good condition with much of the original brush-marking texture retained. Traction crackle is restricted to the dark brown areas of foliage along the right-hand edge of the composition. A fine web of fracture crackle extends over the surface of the painting. Several pentimenti are evident in the design texture and are visible with infrared reflectography. Changes were made in the barrow, the brim of the mother's hat, and the left sleeve of the female figure in the doorway.

VERSION: George Morland, *The Happy Cottagers*, 1790, oil on canvas, 32 x 42" (81.3 x 106.7 cm.), Miami Beach, Florida, Bass Museum of Art.
PROVENANCE: Col. Charles Stuart; Mrs. Hargreaves; Christie's, February 23, 1907, lot 80; Frank T. Sabin, 1911; M. Knoedler and Co.; Richard D. Bass.

EXHIBITION: London, Society of Artists, 1790, no. 207 [Graves, 1907, p. 174, as no. 202] (as "The Cottage Door").
LITERATURE: Hassell, 1806, pp. 106–10; A. L. Gowan, *The Masterpieces of Morland* (London, 1911), repro. p. 42; Winter, 1977, pp. 82–84, p. 172 no. P42, p. 238 fig. 45.
ENGRAVING: Joseph Grozer after George Morland, *The Happy Cottagers*, 1793, mezzotint, 17⅝ x 22⅛" (44.8 x 56.2 cm.). Published: B. B. Evans in the Poultry, London.
LITERATURE: Hassell, 1806, pp. 170–71; Richardson, 1895, pp. 132–51; Dawe, 1904, pp. 145, 171.

COPIES AFTER VERSION
1. After George Morland, *The Happy Cottagers*, pigment on an oval papier-mâché tea tray, 18 x 24" (45.7 x 61 cm.), Kastrup, Denmark, Risvad. Photograph: London, Witt Library.

2. After George Morland, *The Happy Cottagers*, oil on canvas?, 20 x 25" (50.8 x 63.5 cm.), W. Burrough Hill Collection. Photograph: London, Witt Library.

RELATED WORKS
1. George Morland, *Studies of Rustics, a Cart and a Wheelbarrow*, 1791, pencil, 16½ x 21" (41.9 x 53.3 cm.), location unknown.
INSCRIPTION: *1791* [and signed].
PROVENANCE: Sotheby's, July 19, 1973, lot 170.
DESCRIPTION: The boy wheeling a barrow here appears in both authentic versions of *The Happy Cottagers* and in Morland's *Horses in a Stable*, dated 1791 (London, Victoria and Albert Museum).

2. John Baldrey after George Morland, *A Boy Wheeling a Barrow*, 1792, soft-ground etching, 18⅜ x 18½" (46.7 x 47 cm.).
INSCRIPTION: *G Morland 1791; J. Baldrey fecit., London. Publish'd Jan y 1 1792, by Jnᵒ Harris, No. 28 Gerrard Street, Soho.*

61 GEORGE MORLAND

THE STAGECOACH, 1791
Oil on canvas, 34½ x 46½" (87.6 x 118.1 cm.)
Inscribed lower left on rock: *G. Morland Pinx. October 3*[?]. *1791*
John H. McFadden Collection, M28-1-18

At the Morland Gallery in 1792 (no. 23), Morland exhibited a painting entitled
"The Manchester and Derby Stagecoach." In the following year, again at the
Morland Gallery (no. 73) a picture was described in the catalogue as "A
large-Well-finished Landscape, with a Stage Coach, &c. View from Nature."
Whether either of these pictures was identical with *The Stagecoach* is uncertain.
Morland is said to have been fascinated by stagecoaches and to have lived near
the route of the stage to Highgate, Hampstead, and Barnet, so that he could
converse with the drivers and ride in the box-seat next to them.[1]

The picture has been repainted on two occasions and was restored to its
original state in 1967. The first restoration took place before it was purchased
by McFadden in 1900. Labels on the back of the horizontal stretcher cross
member are inscribed "to be cleaned up" with the date May 31, 1882,
suggesting that the painting may have been cleaned at that time; or it may
have been cleaned when it was in the possession of the dealer Agnew at some
time between 1888 and 1900. (Henceforth we will designate this the first
restoration.) A second restoration took place in the twentieth century,
probably before 1928. In 1967 the repaint was removed, so that what we see
today is presumably close to the picture that left Morland's studio.

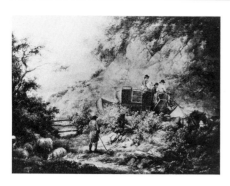

FIG. 61-1 Photograph of *The Stagecoach,* early twentieth century

In it, a stagecoach moves off to the right, carrying three figures—the driver with his whip, a companion, and a boy with his dog just behind them. Two vagabonds are in the foreground, one asleep under a hedge, the other standing with his back to us, watching the coach go by. To the left stands a cow with her calf lying by her. The entire right half of the background is taken up with the face of an overhanging cliff, giving way at the left to a vista of mountains and sky. The composition is divided horizontally and in depth by three gentle arcs spanning left to right across the picture. The lowest, dividing the vagabonds from the stagecoach, is formed by the top of the stone wall and moves along the hedge up, then down, to the lower right. The second arc is formed by the hill in the middle distance joining the curve of the top of the stage. The topmost arc starts with the curve of the highest and farthest mountain in the left background.

Some idea of what the picture looked like when McFadden purchased it in 1900 is preserved in a discolored and faded photograph dating from the early part of this century (fig. 61-1). There are major differences between the photograph and the painting we see today. From left to right, the two cows to the left of the standing man are seen in the old photograph to have been painted out and replaced by a flock of sheep. During the second restoration these sheep were, in turn, painted over and replaced by a few boulders, but so crudely that the positions of the sheep, whether facing left or right, are easily perceived in the photograph of the picture as it was before its final restoration in 1967 (see fig. 61-2). The 1967 restoration also revealed a stone wall in the original paint surface, which had been covered over by a wooden fence. Thus, to summarize: the cow and the calf are original, while the sheep, fence, and boulders (fig. 61-2) were later additions. Technical examination shows that the crackle system is consistent between the cows and the original foliage paint layers.[2] The sheep paint layer is on top of the cow and foliage paint layers and covers some of the original crackle. The sheep layer has developed an extensive traction crackle system, which is, for the most part, independent of the crackle system in the original paint layers.

The probable sequence of retouching is, therefore, as follows: the original cow and calf were painted out and replaced with four sheep. The fence was probably painted over the stone wall at this time. After a time, during which the sheep area suffered extensive traction crackle, they were painted out and covered with rocks. Finally, concerning the painting technique of the cow, examination under high magnification shows that fingerprints can be seen where the artist manipulated the paint while still wet.

Another area of repaint occurs in the face of the young man seated on the coach roof. Examination with the binocular microscope shows that the young man was originally painted in profile, as we see him now. There are no paint layers, except the ground, underneath the face. In the old photograph (fig. 61-1) he is shown to have been altered to a much younger man looking over his right shoulder at the standing man in the red coat. Between the first restoration and the second, a restorer changed the hat worn by the standing vagabond from a low, slouched hat pulled down, giving him an air of wretchedness and despondency (fig. 61-1), to a tall, gentleman's hat, not dissimilar to those worn by the men riding on the stagecoach (fig. 61-2).

Finally, at the time of the 1967 restoration a fragmentary signature and date were found on the rock in the lower left. At that time, the extended tree limb visible in the first restoration was removed, as a later invention dating from the time of the introduction of the sheep and the alteration in the boy's head. There is nothing to indicate that these changes were anything more than pure interpretive whimsy on the part of the restorer.

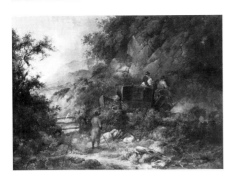

FIG. 61-2 Photograph of *The Stagecoach,* before restoration in 1967

All this simply means that the original painting by Morland was deemed by a later, nineteenth-century owner or dealer not to have been sweet enough for commercial consumption. What should be a scene of some social tension—two down-and-outs living rough under a hedge watching the stage and its passengers clattering by—was transformed into a scene of mere picturesque interest, a coaching picture in the manner of an artist such as Robert Pollard (1755–1838).

If it is correct to surmise that a restorer consciously or unconsciously sweetened a slightly harsher scene showing the reality of eighteenth-century life, this picture lends substance to John Barrell's thesis that Morland's engravers almost always prettified, and therefore emasculated, Morland's paintings in order to render prints after them more attractive to a complacent middle-class public.[3] Here we are not seeing the work of an early engraver whose livelihood depended on the palatability of his wares but of a twentieth-century restorer who perhaps inadvertently altered the scene to make it fit in with a nineteenth- and twentieth-century preconception of Morland's work as entirely sentimental and idealized. For Barrell maintains that although much of Morland's oeuvre is indeed trivial in subject matter, the artist was unable to keep social tensions in the England of his time out of his paintings.

Morland shows us the Manchester stagecoach rather than the Manchester mail coach. The distinction is of some importance, for the stagecoach was operated by a private coaching system, whereas the mail coach was operated for the post office for the purpose of carrying mail as well as passengers. Mail coaches were always painted maroon and black with the stars of the Orders of the Garter, Bath, Thistle, and St. Patrick on the side and the names of the towns at the end of the route. The protrusion at the rear of the coach is an open-topped basket for carrying luggage. The design of the coach is contemporary with the date of the painting. It is not possible to be more precise, as the undercarriage is not shown, but the date of the vehicle is 1785–1835.[4]

1. Gilbey and Cuming, 1907, p. 65.
2. The technical discussion follows the examination report on the painting made by Marigene Butler and Laurence Pace dated April 3, 1981, Conservation Department, Philadelphia Museum of Art. Any doubts that figs. 61-1 and 61-2 show the same painting are dispelled by the fact that the photographs show the severe tear in the lower left center of the painting.
3. Barrell, 1980, pp. 89–129.
4. Information in this paragraph kindly supplied by P. R. Mann, assistant keeper, Road Transport Collection, the Science Museum, South Kensington, in a letter to the author dated August 7, 1980. See also David Mountfield, *The Coaching Age* (London, 1976).

INSCRIPTION: *1882 / May 31ˢᵗ NO 1 / H.B. Arnaud Esqʳᵉ; A Roadside Scene with coach, peasants & dog in the foreground signed. / By G. MORLAND* [on a label on the back of the horizontal stretcher cross member]; *H.B.A.*—[illegible] / *Landscape & figs / Morland / To be cleaned up* [on an identical label probably in the same hand]; and a Royal Academy exhibition label for 1888 with the name of the artist and lender (Arnaud) and with the title *Old Coaching days Sussex; The Manchester Coach* [in different ink along the edge of the label].

PROVENANCE: By descent to Henry Bruce Arnaud (b. 1824), Christ Church, Oxford and Inner Temple; Agnew, after 1888; bt. John H. McFadden, February 19, 1900.

EXHIBITIONS: London, The Morland Gallery, 1792, no. 23?, or London, The Morland Gallery, 1793, no. 73?; London, Royal Academy, *Old Masters' Exhibition,* 1888, no. 2 (as "Old Coaching Days"); Port Sunlight, Hulme Hall, *Art Exhibition to Celebrate the Coronation of Their Majesties King Edward VII and Queen Alexandra,* 1902, no. 162 (as "The Manchester Coach," lent by John H. McFadden); New York, 1917, no. 21.

LITERATURE: Williamson, 1904, pp. 105, 107; Williamson, 1907, p. 149; Roberts, 1917, p. 37, repro. opp. p. 37; Winter, 1977, p. 182 no. P107.

CONDITION NOTES: The original support is medium-weight (10 x 10 threads/cm.) linen. The tacking margins have been removed. A slight weave cusping is evident on all four sides of the painting. A tear exists, in the shape of an inverted V, approximately 16″ in length, centered between the cow and figure in the red coat on the left. The painting has been lined with an aqueous adhesive and medium-weight linen (before 1928, according to Siegl). A white ground is present and is evident along the cut edges. The paint is generally in poor condition; extensive abrasion has occurred throughout the foliage in the foreground, especially in the lower left-hand corner. This area has been heavily interfered with; two earlier restorations overpainted much of the area occupied by cow and calf. The overpaints were removed so far as was possible in 1967 (Siegl). Losses have occurred along the cut edges and along the tear. A fine web of traction crackle extends over most of the surface of the painting. Retouchings are evident under ultraviolet light; these are most prominent in the lower left corner to the cow and calf, to some of the traction crackle overall, and in the area of the coach.

62 GEORGE MORLAND

SHIPWRECK, 1793
Oil on canvas, 38⅛ x 57″ (97.5 x 144.8 cm.)
Inscribed lower center: *G. Morland*
The William L. Elkins Collection, E24-3-98

What we see in *Shipwreck* is not the moment when a large seagoing ship is wrecked, for that has already taken place in the right background, but the destruction against a rocky coast of a smaller sailing craft, perhaps a rescue boat or a lifeboat. Stimulated perhaps by his observation of such a scene during his visits to the Isle of Wight, Morland treated the theme of the shipwreck from around 1790 until the end of his life. Horrific tales of maritime disasters and paintings depicting these events were popular in English and French painting after the middle of the eighteenth century.[1] Morland, who as a youth is known to have studied prints after Joseph Vernet (1714–1789), must have known of Vernet's specialty, his shipwrecks exhibited regularly at the Salon between 1766 and 1789. In addition, the shipwrecks of Philipp de Loutherbourg (1740–1812), the primary exponent of the genre in England in the 1770s and 1780s, were known to him.

Morland's shipwrecks are slightly tame in their attempt to thrill us with this calamity so dreaded by the eighteenth-century public. Nevertheless, his work forms a prelude to the far more successful shipwrecks of Turner (q.v.) a decade or so later. *Shipwreck* should be compared to Morland's *The Wreck—A Seascape,* in which the composition is repeated with a few variations.[2]

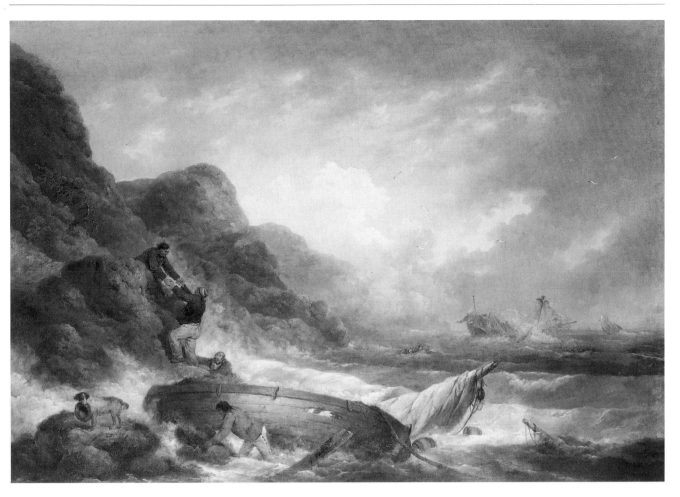

1. T.S.R. Boase, "Shipwrecks in English Romantic Painting," *Journal of the Warburg and Courtauld Institutes,* vol. 22, nos. 3–4 (July–December 1959), pp. 332–46.
2. Oil on canvas, 57 x 39″, Charteris sale, London, June 14, 1915. Photograph: London, Witt Library.

PROVENANCE: William L. Elkins, by 1900.

LITERATURE: Elkins, 1887–1900, vol. 2, no. 65, repro. (as "Marine View"); Winter, 1977, p. 191 no. P156.

CONDITION NOTES: The original support is medium-weight (10 x 10 threads/cm.) linen. The tacking margins have been removed. The painting is lined with an aged aqueous adhesive and medium-weight linen. An off-white ground can be seen along the cut edges. The paint is generally in only fair condition. Traction crackle is visible in the green shoreline rocks in the foreground. The image is extremely abraded; this is most evident throughout the mid-tones of the ocean, the foreground figures, and the sky. There are small areas of discolored paint throughout the sky, perhaps where a foreign material splashed onto the surface. Under ultraviolet light, minor local retouches are visible along the bottom edge.

63 AFTER GEORGE MORLAND

GATHERING WOOD
Oil on canvas, 15¼ x 12½" (38.7 x 30.2 cm.)
Inscribed lower right: *G. Morland 1795*
The William L. Elkins Collection, E24-3-44

FIG. 63-1 George Morland, *Gathering Sticks,*
1791, oil on canvas, 15¼ x 11¾" (39 x 30 cm.),
location unknown. Photograph: Sotheby Parke
Bernet

PROVENANCE: William L. Elkins, by 1900.

LITERATURE: Elkins, 1887–1900, vol. 2,
no. 66, repro. (as "Landscape").

CONDITION NOTES: The original support is
medium-weight (10 x 12 threads/cm.) linen.
The painting is unlined. A small patch has
been applied on the reverse, lower left. An
off-white ground is evident along the tacking
margins. There is active cleavage of both
ground and paint along the bottom edge. The
paint is in generally poor condition. An
extensive network of both fracture and traction
crackle, with severe associated cupping, is
present overall. Under ultraviolet light,
retouching is visible along all of the tacking
margin edges.

VERSION: George Morland, *Gathering Sticks,*
1791, oil on canvas, 15¼ x 11¾" (39 x 30 cm.),
location unknown (fig. 63-1).
 INSCRIPTION: *1791.*
 PROVENANCE: Sir Walter Gilbey; his sale,
Christie's, June 11, 1915, lot 348, bt. Dewar;
Sotheby Parke Bernet, March 6, 1975, lot 78.
 EXHIBITION: London, Messrs. Orme and
Co., 14 Old Bond Street, *The Morland Gallery,*
1792.

LITERATURE: John Raphael Smith, *A
Descriptive Catalogue of Thirty-Six Pictures
Painted by George Morland . . . to Be Engraved by
Subscription by and under the Direction of J[ohn]
R[aphael] Smith* (London, [1792]), p. 24; Ralph
Richardson, *George Morland's Pictures, Their
Present Possessors, with Details of the Collections*
(London, 1897), p. 22; Nettleship, 1898,
pp. 74–75, repro. in unpaginated plates; Gilbey
and Cuming, 1907, repro. opp. p. 108 (as
"Gathering Sticks"); A. L. Gowan, *The
Masterpieces of George Morland* (London, 1911),
repro. p. 47; Winter, 1977, p. 179 no. P89.

ENGRAVINGS
1. Robert Mitchell Meadows after George
Morland, *Gathering Sticks,* 1795, mezzotint,
22 x 17½" (55.9 x 44.4 cm.). Published: J. R.
Smith.
 LITERATURE: Richardson, 1895, pp. 142,
152; Nettleship, 1898, p. 87; Williamson, 1904,
p. 99.

2. Robert Mitchell Meadows after George
Morland, *Gathering Sticks,* 1795 and 1799,
stipple, 15 x 12" (38.1 x 30.5 cm.). Published:
J. R. Smith.
 LITERATURE: Dawe, 1904, p. 144.

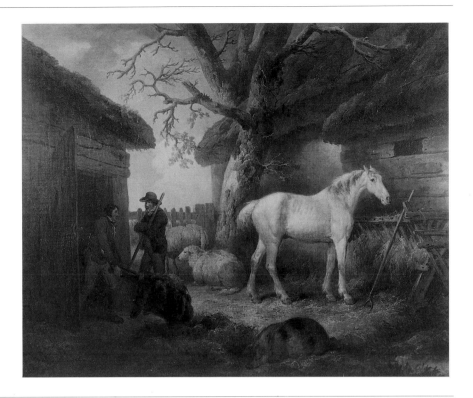

IMITATOR OF GEORGE MORLAND

INTERIOR OF A FARM, early nineteenth century
Oil on canvas, 28 x 36¼" (71.1 x 92 cm.)
Inscribed lower left: *G. Morland Pinx*
The William L. Elkins Collection, E24-3-33

Interior of a Farm is a borderline case of a painting with just enough quality to be by Morland in his late period rather than by an imitator. David Winter discussed the pros and cons of accepting the work as genuine in his 1977 dissertation: "The rather hard outline of the white horse is one of the stylistic features of Morland's late works, and the painterly treatment of the moss on the tree trunk, the texture of the trunk itself, and the hay in the manger more than faintly recall Morland's better works. However, by the time that the outlines in Morland's works had hardened to this extent, even this degree of painterly freedom was lost. Here... the proportions are not Morland's. The men and the horse are too tall."[1]

1. Winter, 1977, p. 160.

PROVENANCE: William L. Elkins, by 1900.

LITERATURE: Elkins, 1887–1900, vol. 2, no. 64, repro.; Elkins, 1925, no. 30; Winter, 1977, pp. 160, 267 fig. 94.

CONDITION NOTES: The original support is medium-weight (14 x 14 threads/cm.) linen. The tacking margins have been removed. Weave cusping is evident along the bottom edge. A horizontal crease is present at mid-image. The painting has been lined with an aqueous adhesive and fine, lightweight linen. An off-white ground is visible along the cut edges. Underdrawing is visible in normal light through the thinnest areas of paint application. The paint is in good condition. Fracture crackle radiates outward from each corner and is coincident with the crease in the support noted above. Local areas of abrasion are apparent in the tree limbs left of center. Under ultraviolet light, small areas of retouching are visible in the tree above the horse.

John Opie was born in 1761 in one of the poorest copper and tin mining districts in England, Mithian in St. Agnes, Cornwall, about seven miles from Truro. After a period in the local school, he was apprenticed to a sawyer to learn his father's trade, carpentry, while at night he conducted evening classes for the inhabitants of the village. He also began to draw. Around 1775 John Wolcot (1738–1819), a physician working in Truro and an amateur painter (a pupil of Richard Wilson [q.v.]), took Opie into his own home, bought him artist's materials, and probably gave him prints to copy. Wolcot helped him develop his natural ability to describe in paint what he saw in front of him, while teaching him to distrust both the imagination and idealization: "Look to originals! Stare volks in the face! Canvas 'em from top to toe! Mark their features, air, manner, gesture, attitude!"[1]

From the content of Wolcot's later writings on art, the *Lyric Odes to the Royal Academicians,* which he published under his pen name Peter Pindar between 1782 and 1786, we can be certain that he steered the boy away from the antinaturalist and generally foreign-born school of painters working in England—Benjamin West (1738–1820), Philipp de Loutherbourg (1740–1812), Angelica Kauffmann (1741–1807), John Francis Rigaud (1742–1810)—toward the works of Hoppner, Reynolds, and Gainsborough (q.q.v.).[2]

Between 1776 and 1779 Opie traveled around Cornwall and Devon as an itinerant face painter, producing quasi-naive portraits of locals, as well as picturesque studies of the heads of old women and beggars. There he might have stayed, a cut above a folk artist, had Wolcot not become what we would today call Opie's agent. When he thought his protégé was ready, he prepared the way for their conquest of London by publicizing him as a kind of noble savage. To the 1780 exhibition at the Society of Artists he sent Opie's *Boy's Head,* described in the catalogue as by "Master Oppey, Penryn, Cornwall. An instance of Genius, not having ever seen a picture."[3] By the time poor James Northcote (1746–1831) returned from Italy in the summer of 1780 hoping to begin his professional career, Sir Joshua Reynolds jokingly advised him to turn around directly, because the whole town could talk of nothing but the newly discovered genius who was "like Caravaggio, but finer."[4]

At the end of 1780, "The Cornish Wonder" actually arrived in London to take up residence in Orange Court, a narrow street (which no longer exists) behind what is today the National Gallery. By the spring of 1781 he had secured the patronage of Mrs. Boscawen, the wife of Admiral Boscawen, and the court favorite Mary Delany (1700–1788). Through them Opie was presented, in March 1782, to George III and Queen Charlotte. The king bought his *Beggar and His Dog* and was presented with a portrait of Mrs. Delany.[5] In the words of Rev. Richard Polwhele, society was entertained by "that unlicked cub of a carpenter Opie . . . who was . . . exhibited by his keeper, Wolcot—a wild animal of St. Agnes, caught among the tin-works."[6] And so society flocked to his studio. To his friend Edward Penwarne, Opie wrote on March 11, 1782, "I have all the quality at my lodgings every day, nothing but Lords, Ladies, Dukes, Duchesses, etc."[7]

But duchesses, etc. can be a fickle lot, and Opie's popularity lasted just long enough for his clients to realize that when this strange, uncouth young man painted their faces, he had no interest in idealizing or prettifying them. Benjamin West said, simply, "He painted what he saw, in the most masterly manner, and he varied little from it."[8] And Wolcot, who had helped create his pupil's style, later criticized it, in a letter to the bookseller Mr. Colborn: "Opie, I fear, is too fond of imitating coarse expression. . . . To him at present elegance appears affectation, and the forms of Raphael unnatural. He too much resembles a country farmer, who never having tasted anything beyond rough cyder, cannot feel the flavour of burgundy or champagne."[9] By 1783 the

vogue for Opie was over, and in some ways this was not a bad thing. From 1783 to 1785, with fewer sitters to fill his time, he painted rustic genre scenes inspired and influenced by Gainsborough's fancy pictures, such as *The Girl with Pigs* (exhibited R.A. 1782, no. 127, 49½ x 58½", Yorkshire, Castle Howard). Among these were two masterpieces, *The Peasant's Family* (1783–85, 59 x 71", London, Tate Gallery) and *The Schoolmistress* (c. 1784, 39 x 49", Wantage, A. T. Lloyd Collection). Opie had seen and therefore portrayed true rural poverty, not Gainsborough's pastoral version of it, and by eighteenth-century standards these pictures were relatively unsentimentalized, influenced less by Murillo (1617/8–1682) than by Caravaggio (1571–1610) and Velázquez (1599–1660). They are painted not in Gainsborough's grays, pinks, and violets but in shades of brown, rust, green, and black. To Opie, coloring consisted in "the truth, harmony, and transparency of the tints, and the depth of the tones,"[10] and he boldly modeled his forms with strong effects of light, more like Wright of Derby (q.v.) than Gainsborough.

Opie was elected an Associate of the Royal Academy in 1786 and a full Academician in 1787. In 1791 he moved to 8 Berners Street, where he lived until his death. By this time he had achieved a solid reputation as a serious painter of history pieces such as *The Assassination of James I* (exhibited R.A. 1786, no. 96, 68 x 85") and *The Death of Rizzio* (exhibited R.A. 1787, no. 26, 96 x 132", both destroyed 1941). What comes across strongly in Opie's work is how serious and thoughtful a man he was, qualities he shared with Sir Joshua. Northcote told Ward that Opie was "the greatest man who ever came under my observation,"[11] and all memoirs of him point out the cultivation of his mind, his love of music and literature, his ability to speak French and Latin. They also agree with the actress Mrs. Inchbald in admiring his "total absence of artificial manners."[12] With this combination of qualities it is no surprise to find that he was a great admirer of Dr. Johnson, whom he painted twice.[13]

We can see this strength of mind in his historical pictures. Opie was one of the principal contributors to Boydell's Shakespeare Gallery (seven scenes) and his illustrations to Shakespeare are among the most carefully thought-out paintings of the series. As a group they are closer to the spirit of the plays than the paintings of any other contributor. Dramatic, robust, concise, and poetic, they reveal the intelligence and sensitivity of Opie's interpretation of Shakespeare. And this is true even though individual pictures by other artists, such as Wright of Derby, may be greater works of art. Opie also contributed to Macklin's illustrations to *British Poets* (three scenes), Macklin's Bible (four scenes), and Robert Bowyer's edition of Hume's *History of England* (eleven scenes).

In 1805 he was elected professor of painting at the Royal Academy, but did not deliver the four traditional lectures on painting until 1807. Then he gave the most important lectures since Sir Joshua's addresses, and in them influenced a generation of young artists such as David Wilkie (1785–1841) and Benjamin Robert Haydon (1786–1846). Farington (1747–1821), on May 29, 1811, noted that Henry Fuseli (1741–1825) and Northcote "spoke much of Opie's powers in Conversation. Fuseli said He had in this greater vigour than in his painting. Northcote particularly dwelt on his originality of thinking; 'He said so many things which sunk into the mind; that which you could not forget.'"[14]

He was married twice, first in 1782 to Mary Bunn, whom he divorced in 1796, and second in 1798 to the poet Amelia Alderson. He moved in the circle around William Godwin and Mary Wollstonecraft, and in the last ten years of his life kept a studio in Norwich, where he became friendly with John Crome (q.v.). He died on April 9, 1807, and is buried next to Reynolds in St. Paul's.

1. Earland, 1911, p. 14.
2. Peter Pindar, "Lyric Odes to the Royal Academicians," in *The Works of Peter Pindar, Esq.,* 2 vols. (Dublin, 1795).
3. Graves, 1907, p. 185.
4. Northcote, 1813, p. 285.
5. *Beggar and His Dog,* "not now in any of the Royal Collections," according to Rogers (1878, p. 200). *Mrs. Delany,* 30⅛ x 25″, Her Majesty Queen Elizabeth II.
6. Quoted by Earland, 1911, p. 15.
7. Rogers, 1878, p. 24.
8. Hoare, ed., 1807, p. 16.
9. Rogers, 1878, pp. 19–20.
10. Opie, 1809, pp. 137–38 (Opie's Royal Academy fourth lecture, March 9, 1807).

11. Fletcher, ed., 1901, pp. 197–98.
12. Hoare, ed., 1807, p. 23.
13. Mrs. Opie, in Opie, 1809, p. 40.
14. Farington Diary, [1793], May 29, 1811.

BIBLIOGRAPHY: Hoare, ed., 1807; Opie, 1809; Northcote, 1813, pp. 285–88; Rogers, 1878; Cunningham, 1879, vol. 1, pp. 435–59; Earland, 1911; Whitley, 1928, vol. 1, pp. 376-78; J. W. Scobell Armstrong, "The Early Work of John Opie, R.A.," *The Connoisseur,* vol. 94 (October 1934), pp. 245–51; Waterhouse, 1953, pp. 204–5.

EXHIBITIONS: Truro, Royal Institution of Cornwall (Arts Council of Great Britain), *John Opie and Henry Bone: An Exhibition of Paintings and Miniatures,* 1951 (introduction to section on Opie by Ian Napier); Plymouth, City Museum and Art Gallery, *John Opie,* 1957; Plymouth, City Museum and Art Gallery, Cardiff, National Museum of Wales, Liverpool, Walker Art Gallery, Nottingham, The University, Southampton, Southampton Art Gallery, London, Tate Gallery (Arts Council of Great Britain), *John Opie, 1761–1807,* October 13, 1962–April 7, 1963 (by Mary Peter).

65 JOHN OPIE
66

ANNE WESTCOTT, AFTERWARDS MRS. FREDERICK WALLER, before 1799
Oil on canvas, 21⅛ x 17⅞″ (53.5 x 43.3 cm.)
Gift of John S. Williams, 47-100-2

MARY WESTCOTT, AFTERWARDS MRS. BENJAMIN WALLER, before 1799
Oil on canvas, 21⅛ x 17⅞″ (53.6 x 44.8 cm.)
Gift of John S. Williams, 47-100-1

FIG. 65-1 X-radiograph of *Anne Westcott,* Philadelphia Museum of Art, Conservation Department, 1980

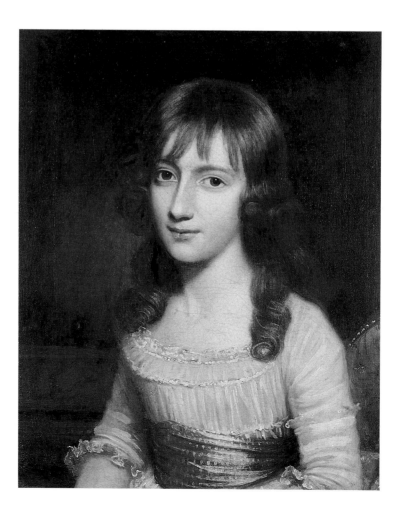

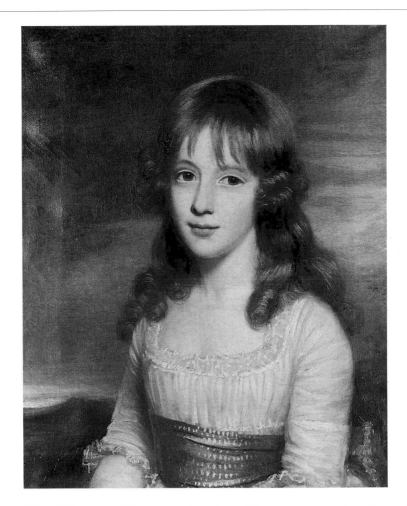

Mary Westcott and its companion *Anne Westcott* are portraits of two sisters from Kingsbridge, Devon, who apparently married two brothers. Anne Westcott was the wife of Frederick Waller, of Doughty Street, London, and her sister Mary married Benjamin Waller of Kilburn. A search of the Kingsbridge baptismal records for 1765 to 1790 has not turned up their dates of birth.

Both girls wear a white dress with a gold sash, and their hairstyles are identical. They may even wear the same dress, either because the family owned but one or because Opie kept one in his studio for his sitters. Anne, the dark-haired, perhaps older girl, sits indoors on a chair visible to our right, the background plain except for a wainscot at the left. Mary, the younger, sits out-of-doors with sky and mountain behind her.

An x-radiograph (fig. 65-1) suggests that the artist worked hard to soften and slim down Anne's strong jaw and bulbous nose, whereas no such pentimenti are visible in Mary's portrait. Technical examination shows that the canvas weave of both pictures is similar and that the canvases are contemporary, although Anne's portrait has received several tears and has been relined. Both paintings have been overpainted, reworked on the surface, especially in the hair, to add highlights and to fill out the original, simpler hairdos by adding ringlets to fall over the right and left shoulders in both cases.

Rogers (1878) gives the date of the paintings as 1799 and notes that Anne is about fifteen years old. As this information presumably came from Anne's son Edmund Waller, who owned the picture in 1878, it should be accepted, although the unsophisticated compositions and technique are perhaps surprising for Opie at this date.

INSCRIPTION FOR NO. 65: *Anne Waller nee Westcott Jn Opie RA* [indistinctly in pencil in a modern hand on the stretcher].

INSCRIPTION FOR NO. 66: *Mary Wall* [er] *nee Westcott J. Opie R.A.* [in pencil in a modern hand on the stretcher].

PROVENANCE OF NO. 65: By descent to the sitter's son Edmund Waller, 1878; John Edmund Linklater; Mrs. John S. Williams, Long Island.

PROVENANCE OF NO. 66: By descent to the sitter's granddaughter, Mrs. Oldham, 1878; John Edmund Linklater, 1911; Mrs. John S. Williams, Long Island.

LITERATURE FOR NOS. 65 AND 66: Rogers, 1878, pp. 173–74; Earland, 1911, p. 321.

CONDITION NOTES FOR NO. 65: The original support is medium-weight (14 x 14 threads/cm.) linen. The tacking margins have been removed. Three major tears in the support are located around the head of the figure. The longest is approximately 7″. Weave cusping is evident along the left side. The painting is lined with an aqueous adhesive and fairly lightweight linen. A light-gray ground has been thinly applied and is visible along the cut edges. The paint is in good condition. Fracture crackle is present overall and is most prominent in the highlight areas of face and bodice. Pinpoint losses are evident in areas of the neck and neckline.

CONDITION NOTES FOR NO. 66: The original support is medium-weight (12 x 12 threads/cm.) linen. The tacking margins have a selvage along the left edge of the support. Creases in the support correspond to stretcher folds evident on all four sides. The painting is presently unlined. A thick, evenly applied, off-white ground is present and extends partially onto the tacking margins. The paint is in good condition overall. A very fine web of fracture crackle extends over the surface. A pattern of traction crackle in the deepest shadow areas of the hair suggests that bitumen was included in the artist's palette.

The son of a fairly prosperous mill owner (or perhaps yarn boiler; his father's trade is not certain), Henry Raeburn was born on March 4, 1756, in Stockbridge, today a part of Edinburgh, then a suburb of the city. When both of his parents died, he was left at age six in the care of his only brother, William (1744–1810), who, on April 15, 1765, placed him in George Heriot's Hospital for orphans, the equivalent in Edinburgh to Christ's Hospital in London. On June 27, 1772, the goldsmith James Gilliland took him on as an apprentice and there he remained until at least 1778.[1] As a jeweler's assistant, Raeburn may have learned a certain amount about design, draftsmanship, sculpture, and engraving, for a jeweler in eighteenth-century Scotland did what today a silversmith does. More important, at Gilliland's Raeburn began to draw and paint in watercolors, perhaps supplying miniatures to go with the frames and lockets sold by his employer. By 1776 he had painted his first full-length portrait in oils, *George Chalmers of Pittencrieff* (83 x 59″, Dunfermline, Town Council, City Chambers), showing the white-haired old gentleman seated in his study, with a landscape behind him. If the perspective and anatomy are faulty, *George Chalmers* is still a remarkable achievement for an (as far as we know) untrained twenty-year-old.

We can only guess about the years between Raeburn's leaving Gilliland around 1778 and his departure for Rome in July 1784. He certainly came into contact with David Martin (1737–1798), a Scottish portrait painter trained in the studio of Allan Ramsay (1713–1784), who had been working in London but came to Edinburgh sometime after the summer of 1778.[2] Raeburn was further encouraged by the seal engraver and etcher David Deuchar (1743–1808), who may also have opened the boy's eyes to engravings after Sir Joshua Reynolds (q.v.), which were by this time becoming well known in Scotland.

Around 1780 Raeburn married a rich widow, the wife of James Leslie of Deanhaugh. At thirty-five, Ann Edgar (d. 1832) was twelve years older than Raeburn. She brought him the property of Deanhaugh House in Stockbridge, and there (and in the adjacent St. Bernard's House, which he began to lease in 1792 and purchased in 1809) Raeburn was to spend the rest of his life. Their children, Peter and Henry, were born in 1781 and 1783, but apart from these events, the years of his early married life are blank to us. As Francina Irwin pointed out, no portraits by Raeburn can be dated with certainty between the *George Chalmers* of 1776 and the artist's departure for Italy in 1784.[3]

In April 1784 he left Scotland and his family for London, where he spent two months as a pupil in Reynolds's studio. Early in July of the same year he set off for Rome, with Reynolds's encouragement and introductions to Pompeo Batoni (1708–1787), the artist and antiquarian Gavin Hamilton (1723–1798), and James Byres (1735?–1817?).

No Roman portraits by Raeburn survive, and any attempt to trace in his later works specific antique or classical sources is useless. What impressed him most in Rome can be inferred, however, from a brief passage in his great-grandson's biography of the artist: "Sculpture was also an object of his peculiar study; and so great was his taste for it, that at Rome he, at one time, entertained the idea of devoting himself to that noble art as a profession in preference to painting."[4]

Raeburn's career can be said to begin only in the summer of 1786 when he returned to Edinburgh. His progress in the next five years was remarkable, for by the early 1790s, working out of a studio in George Street, he was a mature artist. In such paintings as *Sir John and Lady Clerk of Penicuik* (1792, 57 x 80½″, Sir Alfred Beit Collection) and *Dr. Nathaniel Spens* (1791–93, 93¼ x 58¾″, Edinburgh, Royal Company of Archers) he shows his sitters out-of-doors against golden landscape backgrounds, bathed—indeed revealed—by the light, their characters fully explored through easy gestures

and natural poses. Until 1808 there were no public art exhibitions in Edinburgh, and consequently he sent the *Clerks of Penicuik* to the Royal Academy in London, where it arrived too late for inclusion in the exhibition but was shown instead at Boydell's Shakespeare Gallery. The *Clerks of Penicuik* is, therefore, a real exhibition picture, whereas most of Raeburn's commissions were for head-and-shoulders or half-length portraits, meant to be seen only in the houses of their owners. Raeburn's success at this form of portraiture was phenomenal, partly because he was able, through his own easygoing personality, to relax his sitters and partly because he could be relied on by those sitters to supply both accuracy and restraint in the finished product. In 1798 Raeburn built a new studio at 32 York Place; he was by then the leading portrait painter in Scotland. Robert Louis Stevenson (1850–1894), author of the best essay on Raeburn, described him as "a born painter of portraits. He looked people shrewdly between the eyes, surprised their manners in their face, and had possessed himself of what was essential in their character before they had been many minutes in his studio. What he was so swift to perceive, he conveyed to the canvas almost in the moment of conception."[5]

Yet, Raeburn never learned anything at all about the anatomy of human beings, and even in his later paintings we find a basic incomprehension about the structure of the human body. There had been, of course, no Royal Academy schools in Edinburgh where he could have studied, but in 1782 he did join an informal artistic society formed to draw from life. Apparently this was not a success; years later, in 1802, a budding artist named Andrew Robertson wrote to his brother Archibald from London, "I have lost much in neglecting to sketch the figure before. . . . It is very odd that Mr. Raeburn did not recommend it."[6]

How then, did Raeburn learn to paint? A possible explanation is suggested by an entry in Joseph Farington's (1747–1821) diary for 1801 in which the English artist recorded his instinctive reaction upon seeing Raeburn's studio for the first time: "Some of *Mr. Raeburn's portraits have an uncommonly true appearance of Nature and are painted with much firmness,*—but there is a great inequality in his works.—That which strikes the eye is a kind of Camera Obscura effect, and from those pictures which seem to be his best, I shd. conclude He has looked very much at Nature, reflected in a Camera."[7] The camera obscura, a precursor to the modern photographic camera, is a boxlike device in which external images are received through a lens and projected onto paper. It was often used in the eighteenth century by amateur landscape painters who outlined the image on the paper in pencil before filling in colors.[8] By the time Farington saw Raeburn's work, the Scottish artist was surely not still using this device to paint his portraits—indeed, we have descriptions of him at work that prove he did not;[9] but if he did learn from a mechanical device, this explains his ability not only to catch a likeness perfectly but also to realize it on canvas entirely in terms of surface technique—the artful use of chiaroscuro and brushwork—and not through draftsmanship or an understanding of what lies beneath the flesh. This would explain why no drawings by the artist exist, and why he never drew his subject first but set to work with a brush to block out the features, which he then built up out of broad planes and modeled by intense contrasts of light.

As early as a letter dated February 14, 1828, from David Wilkie (1785–1841) to Thomas Phillips (1770–1845), from Spain, Raeburn had been compared to Velázquez (1599–1660);[10] and in the late nineteenth century the critic and artist R.A.M. Stevenson (1847–1900) saw him as the forerunner of French artists like Manet (1832–1883) and (Stevenson's own teacher) Carolus Duran (1838–1917). Stevenson wrote that a portrait "might take minutes, hours, or weeks; but it

passed only through one stage, gradually approaching completion by a moulding, a refining, a correcting of the first lay-in."[11]

From 1809 to 1816 Raeburn exhibited at the Associated Society of Artists in Edinburgh, a forerunner of the Scottish Royal Academy, which was not founded until 1826, three years after Raeburn's death. In 1812 he was elected president of the Associated Society, but the pictures he exhibited there are impossible to identify because the catalogues list his contributions only as "Portrait of a Nobleman," "Portrait of a Lady," and so forth. He exhibited from 1814 to 1816 at the Edinburgh Exhibition Society and in 1821 and 1822 at the Institution for the Encouragement of the Fine Arts in Scotland.[12] From 1792 he had kept an eye on the Royal Academy in London, sending ten portraits to Somerset House before 1812, the year he was elected an Associate. In 1814 he became a full member of that body and afterwards sent four or five pictures annually to the Royal Academy exhibitions. He visited London only five times, in 1785, 1810, 1812, 1813, and 1815.[13] Of these trips the one in 1810 deserves special mention because it was undertaken to survey his prospects for setting up a studio in London after John Hoppner's (q.v.) death in January of that year had left Thomas Lawrence (q.v.) as Raeburn's only serious rival. Otherwise, his contacts with the English capital were few, as he explained to Wilkie in a letter of September 12, 1819: "I do assure you I have as little communication with any [other artists] and know almost as little about them as if I were living at the Cape of Good Hope."[14] In 1822 George IV knighted Raeburn and the following year appointed him King's Limner for Scotland. He was a member of the Imperial Florentine Academy and an honorary member of the academies in New York (1817) and South Carolina (1821).

His private life was a happy one spent golfing, fishing, practicing archery, building model ships, and gardening; he was a distinguished citizen and eventually a prosperous property developer. The only clouds were the death of his older son, Peter, in 1798, and a bankruptcy in 1808 after backing a company formed by his other son, Henry, and a stepson, which failed in that year. He died on July 8, 1823. Raeburn's style changed little over the years, and he is not an artist whose work is easy to date by visual means alone. He left no account books or sitters' books—at least none that have been discovered—and he never signed or dated his portraits. His first biographers, Andrew Duncan and Allan Cunningham, disseminated many inaccuracies about his life, and the first real catalogue of his work, by James Caw in Walter Armstrong's biography of 1901, is not trustworthy. His life and a catalogue of his work have still to be written.

1. The two most accurate biographies of Raeburn are Cumberland Hill, *Historic Memorials and Reminiscences of Stockbridge, The Dean, and Water of Leith with Notices Anecdotal, Descriptive, and Biographical* (Edinburgh, 1887), pp. 59–71; and Irwin and Irwin, 1975, pp. 146ff.
2. Irwin, 1973, p. 239.
3. Ibid., p. 243.
4. Andrew, 1886, pp. 49–50.
5. Stevenson, 1881, p. 221.
6. Irwin and Irwin, 1975, p. 150.
7. Farington Diary, [1793], September 23, 1801.
8. For the camera obscura, see Heinrich Schwarz, "An Eighteenth-Century English Poem on the Camera Obscura," in *One Hundred Years of Photographic History: Essays in Honor of Beaumont Newhall,* ed. Van Deren Coke (Albuquerque, 1975), pp. 128–38.
9. See Irwin and Irwin, 1975, p. 156.
10. Allan Cunningham, *The Life of Sir David Wilkie* (London, 1843), vol. 2, pp. 504–5.

11. Armstrong, 1901, p. 18.
12. Rinder, ed., 1917, pp. 320–22.
13. Whitley, 1928, *1800–1820,* p. 199.
14. MS. 1003, fol. 74, National Library of Scotland, Edinburgh; partially quoted in Irwin and Irwin, 1975, p. 163.

BIBLIOGRAPHY: Andrew Duncan, *A Tribute of Regard to the Memory of Sir Henry Raeburn, R.A., Read at the Forty-third Anniversary Meeting of the Harveian Society of Edinburgh* (Edinburgh, 1824); John Morrison, "Reminiscences of Sir Walter Scott, Sir Henry Raeburn, etc.," *Tait's Edinburgh Magazine,* n.s., vol. 11, no. 121 (January 1844), pp. 15–19; Cunningham, 1879, vol. 2, pp. 257–86; Stevenson, 1881, pp. 219–36; Andrew, 1886; Cumberland Hill, *Historic Memorials and Reminiscences of Stockbridge The Dean, and Water of Leith with Notices Anecdotal, Descriptive, and Biographical* (Edinburgh, 1887), pp. 59–71; Armstrong, 1901; Pinnington, 1904; James L.

Caw, *Raeburn* (London and New York, 1909); Grieg, 1911; Dibdin, 1925; Irwin, 1973; Irwin and Irwin, 1975, pp. 146ff.

EXHIBITIONS: Edinburgh, Artist's Gallery, York Place, *Raeburn Exhibition,* 1824; Edinburgh, Royal Scottish Academy, *Exhibition of Works of Deceased and Living Scottish Artists,* October 1863; Edinburgh, Royal Academy National Galleries, *The Works of Sir Henry Raeburn,* October–November 1876; Edinburgh, National Gallery of Scotland, *Loan Exhibition of Pictures by Sir Henry Raeburn and Other Deceased Painters of the Scottish School,* 1901; New York, M. Knoedler and Co., *Loan Exhibition of Portraits by Sir Henry Raeburn for the Benefit of the Artists' Fund and Artists' Aid Societies,* January 9–25, 1913; Edinburgh, National Gallery of Scotland (Arts Council, Scottish Committee), *Raeburn Bi-Centenary Exhibition,* July 16–September 16, 1956 (by David Baxandall).

67 SIR HENRY RAEBURN

LADY BELHAVEN, C. 1790
Oil on canvas, 36⅛ x 27⅞″ (92.1 x 70.8 cm.)
John H. McFadden Collection, M28-1-21

Penelope MacDonald (d. 1816), daughter of Ranald MacDonald of Clanranald, county Inverness, married William Hamilton of Wishaw, 7th Baron Belhaven and Stenton (1765–1814) on March 2, 1789, at Edinburgh. Lady Belhaven had seven children. Her own family were Jacobites, supporters of the Stuart claim to the throne of England, and her father had fled to France after the battle of Culloden during the Jacobite rising of 1745–46, when the Pretender's hopes were finally crushed by the armies of George II.

This picture is a version of the portrait in the collection of Lord Astor of Hever in which the sitter is shown in the same pose and clothing but with her dark hair in powder. Presuming that the Astor portrait was the first version and therefore accepted by the sitter, it must have left Raeburn's studio about 1790. The Philadelphia version is the one seen by John Brown hanging in a bedroom of the artist's grandson's house, Charlesfield near mid-Calder, in 1876. One more version exists, in the New York Public Library, in which Lady Belhaven has dark hair and is wearing a wedding ring (fig. 67-1). This cannot be the version seen by Brown, as it was acquired by the Lenox Library in 1877 and has some provenance before that date.

Lady Belhaven is the earliest Raeburn in the collection of twelve Raeburn portraits in the Philadelphia Museum of Art, dating from about 1790, the time of the sitter's marriage. As Penelope MacDonald, our sitter was caricatured with her suitors by John Kay in 1787.[1]

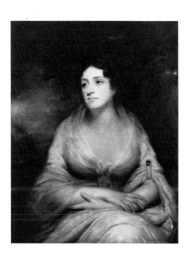

FIG. 67-1 Sir Henry Raeburn, *Lady Belhaven,* oil on canvas, 35½ x 27½″ (90.2 x 69.8 cm.), New York, The New York Public Library

1. John Kay, "A Complete Collection of the Portraits and Caricatures Drawn and Engraved by John Kay, Edinburgh, from the Year 1784 to 1813," no. 282, a.2, 3, nos. 81 ("Love in a Window") and 85 ("Captain Dalyrymple and Miss MacDonald"), British Museum, London.

INSCRIPTION: *Henry Raeburn / Excuic* [?] *+ Bernards / Lady B* [on an old label in an eighteenth-century? hand]; [illegible] / *Lady Beheven* [on another label]; [illegible] *Raeburn*[?] *C. J. Raeburn / L. W. Raeburn* [in script on the back of the canvas]; *Painted by my Grandfather, Sir Henry Raeburn* [in the same hand in script on the stretcher].

PROVENANCE: C. J. Raeburn; L. W. Raeburn, the artist's grandson, Charlesfield, near mid-Calder, 1876; Lord Iveagh; Agnew; bt. John H. McFadden, May 25, 1895.

EXHIBITIONS: London, Royal Academy, *Old Masters' Exhibition,* 1896, no. 4; New York, 1917, no. 22, fig. 22; Pittsburgh, 1917, no. 21; Philadelphia, 1928, p. 20.

LITERATURE: John Brown, *Sir Henry Raeburn and His Works* (Edinburgh, 1876), pp. 13, 16; Armstrong, 1901, p. 96; Pinnington, 1904, p. 220; Roberts, 1917, pp. 43–44, repro. opp. p. 43; Roberts, 1918, "Portraits," p. 130.

CONDITION NOTES: The original support is medium-weight (8 x 8 threads/cm.) linen. The tacking margins have been removed. The painting is lined with an aged aqueous adhesive and medium-weight linen. An off-white ground is present and is visible along the cut edges. The paint is in only fair condition. Fracture crackle of a wide aperture is associated with, and restricted to, the thickest applications of paint in the flesh tones of face and bodice. Areas of abrasion are scattered throughout the thinly applied background. Under ultraviolet light, considerable retouching is evident in the bodice area of the figure and in the area of heaviest abrasion in the background.

VERSIONS
1. Sir Henry Raeburn, *Lady Belhaven,* oil on canvas, 35½ x 27½″ (90.2 x 69.8 cm.), Lord Astor of Hever.
 PROVENANCE: Maj. Thorburn, 1909; A. R. Wilson-Wood, by 1911; anonymous [A. R. Wilson-Wood] sale, Christie's, May 14, 1920, lot 48, bt. Hon. T. S. Astor.
 EXHIBITIONS: Edinburgh, The French Gallery (Wallis and Son), 1909, no. 12; London, The French Gallery, *Pictures by Sir Henry Raeburn, R.A.,* November–December, 1910, no. 17; Dundee, Central Art Gallery, *British Association Fine Art Exhibition,* September 1912, no. 283A (lent by A. R. Wilson-Wood); Edinburgh, National Gallery of Scotland (Arts Council, Scottish Committee), *Raeburn Bi-Centenary Exhibition,* July 16–September 16, 1956, no. 15.

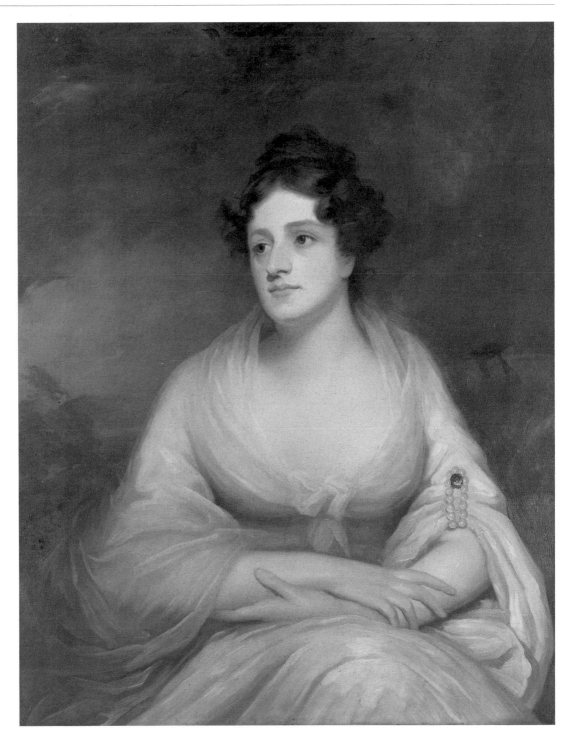

LITERATURE: James L. Caw, ed., *Portraits by Sir Henry Raeburn* (Edinburgh, 1909), pl. 17; Grieg, 1911, pp. xlvii, 38, pl. 30; J.C.F. Brotchie, *Henry Raeburn, 1756–1823* (London, 1924), p. 98; C. Reginald Grundy, "A Raeburn Exhibition," *The Connoisseur,* vol. 29 (February 1911), repro. p. 106.

ENGRAVING: Henry Macbeth-Raeburn (b. 1860) after Sir Henry Raeburn, *Lady Belhaven,* 1922, colored mezzotint.

2. Sir Henry Raeburn, *Lady Belhaven,* oil on canvas, 35½ x 27½" (90.2 x 69.8 cm.), New York, The New York Public Library (fig. 67-1).

PROVENANCE: Richardson; Conolly's Framing Shop; Mr. Hoge of Irvington; acquired by the Lenox Library, 1877, which was consolidated into the New York Public Library, 1895.

LITERATURE: Lenox Library, *Guide to Paintings* (New York, 1878); New York, The New York Public Library, *Catalogue of Paintings* (New York, 1912), no. 5.

3. H. Fuger after Sir Henry Raeburn, *Lady Belhaven,* 7½ x 5¼" (19.3 x 13.6 cm.), Trieste, Josef Posselt Collection, in 1958. Photograph: National Portrait Gallery Archives, London.

4. Attributed to Sir Henry Raeburn, *Lady Belhaven* (in powder), oil on canvas, 33½ x 27⅛" (85 x 69 cm.), international sale, Berlin, October 16, 1934, lot 426.

5. Attributed to Sir Henry Raeburn, *Lady Belhaven* (without powder), oil on canvas, 36¼ x 28" (92 x 71 cm.), Thun sale, Fischer (auctioneer), Lucerne, August 31–September 2, 1933, lot 529 (as by John Opie).

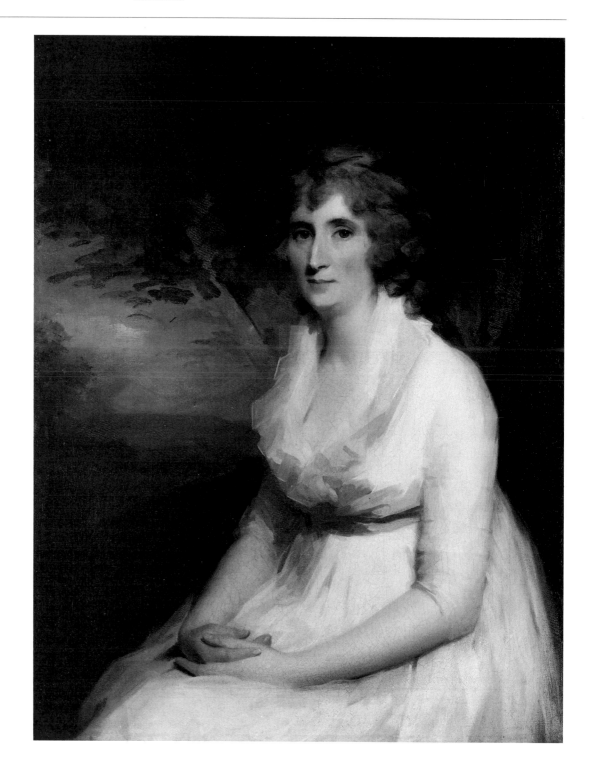

8 SIR HENRY RAEBURN

MRS. WILLIAM STEWART OF SUMMER BANK, C. 1790
Oil on canvas, 35⅞ x 27⅛″ (91.2 x 68.7 cm.)
Bequest of George D. Widener, 72-50-3

Since it was bequeathed to the Philadelphia Museum of Art in 1972, this portrait has been known only as *A Lady in a White Dress*. But when the painting was exhibited at the French Gallery in London in 1913, it was called "Mrs. William Stewart of Summer Bank, Perth." Unfortunately, this information is of little use in identifying the sitter, as no Summer Bank House has been located yet in Perthshire, and a review of the William Stewarts indexed in the *Stewart Society Magazine* yields no family of that name from Summer Bank.

The portrait is nevertheless a fine example of Raeburn's style in the early to middle 1790s. The sitter, dressed in a white muslin dress, ubiquitous in Raeburn's early portraits of females, sits placidly with her hands on her lap against a summery landscape of trees, clouds, and hills in the distance. Within Raeburn's own work, this should be compared in pose, posture, facial type, and style to *Mrs. Elizabeth McQueen of Braxfield*, painted c. 1790 (35 x 26½″, Dolphinton, John Ord Mackenzie, Esq. Collection).[1] To go further afield, the format, background, and dress in this portrait might be found in certain portraits by George Romney (q.v.) about the same date, even though here the sitter is a gray-haired and slightly dowdy matron, a type not usually found among the English artist's portraits.

1. Armstrong, 1901, repro. opp. p. 14 pl. VIII.

PROVENANCE: London, The French Gallery; George D. Widener.

EXHIBITION: London, The French Gallery, *Portraits by British Artists,* November–December 1913, no. 4.

CONDITION NOTES: The original support is twill-weave, medium-weight (10 x 10 threads/cm.) linen. The tacking margins have been removed. The painting is lined with an aqueous adhesive and medium to lightweight linen. A white, thickly applied ground is visible along the cut edges. The paint is in good condition. Brush marking, paint profile, and structure are well preserved. An irregular web of narrow-aperture fracture crackle is visible. Ultraviolet light examination reveals only local areas of retouching.

69 SIR HENRY RAEBURN

JOHN CAMPBELL OF SADDELL, c. 1800
Oil on canvas, 49¼ x 39⅜" (125.1 x 100 cm.)
John H. McFadden Collection, M28-1-24

FIG. 69-1 Photograph of Saddell House and Saddell Castle, Argyll, courtesy of the Royal Commission on the Ancient and Historical Monuments of Scotland, Edinburgh

The village of Saddell, or Glensaddell, lies on the wild east coast of the Kintyre Peninsula, Argyllshire, which projects from the southwest mainland of Scotland. Saddell Castle, the ancestral home of one of the many branches of the Campbell clan, and Saddell House, built by the grandfather of the sitter in this portrait around 1780–84, dominate the coast (fig. 69-1). There, at Saddell House (fig. 69-2), John Campbell (d. 1859) was born in 1796. We do not know for certain the names of his parents, that of his wife, or the number of his children; indeed the biographical information supplied by the portrait itself is the major source of our knowledge of the sitter's life.[1]

John Campbell is shown about the age of four, not yet breeched, wearing an infant's frock with a wide ruffle around the neck. This ruffle has an unfastened black ribbon; in his left hand Master John holds a black bonnet, and on his feet are black booties: in short, he is shown to be in mourning, sitting on a low parapet before a rectangular stone monument. Though it is not inscribed, we can presume that this represents a memorial to a relative of the child's, presumably a dead parent or parents.

Independent evidence, though indirect, confirms this reading of the portrait. In 1827 the poet Laetitia Elizabeth Landon (1802–1838) included a narrative poem "The Dream: The Lay of the Scottish Minstrel" in her collection of verses *The Golden Violet.* Set in the Middle Ages, the poem tells the story of a young wife who prophetically dreams of two dead oak trees and a living sapling, an omen of her own and her husband's death and the survival of their newborn child. Her husband is then killed, and the poet addresses her:

> For the doom of that hunter is as your own.
> Hasten thee home, and kiss the cheek
> Of thy young fair child, nor fear to break
> The boy's sweet slumber of peace; for not
> With his father's or thine is that orphan's lot.
> As the sapling sprang up to a stately tree,
> He will flourish; but not, thou fond mother, for thee.

Laetitia Landon added a note to her poem to explain that "this tale is founded on more modern tradition than that of the distant age to which my minstrel belongs: the vision, the prophecy, and ultimately death of the youthful pair, are actual facts; and the present ———— Campbell, Esq., Laird of Glensaddaell, *Anglicè,* Melancholy Valley, is the very child whose health and prosperity have realised the prediction of his birth."[2]

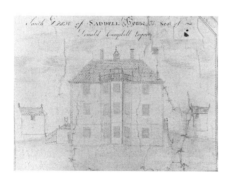

FIG. 69-2 View of Saddell House, Argyll, courtesy of the Royal Commission on the Ancient and Historical Monuments of Scotland, Edinburgh

The stone monument behind Master Campbell therefore symbolizes the tragic circumstances of his childhood. As far as we know it is only a symbol, and not the representation of an actual cenotaph. For one thing, the perspective and proportions are all wrong—either the child is a giant or the memorial stands only about three feet high. Master John Campbell's parents seem not to be buried at Saddell Abbey cemetery, where other Campbells of Saddell lie. But a cenotaph in the abbey churchyard, sacred to the memory of John Campbell's grandfather, Col. Donald Campbell, who died in 1784 at age fifty-eight, is not unlike the one in the Raeburn portrait (fig. 69-3). The actual one has fluted columns, a pediment, and a carved trophy with an inscription in the center, while the fictive cenotaph is plain: but both have the low parapet, the rectangular shape.

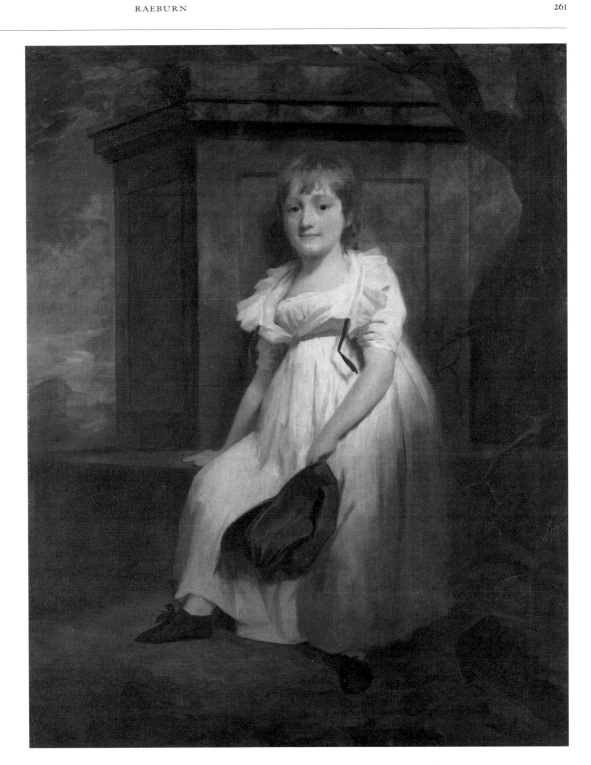

FIG. 69-3 Cenotaph for Col. Donald Campbell, Saddell Abbey cemetery, Argyll, courtesy of the Royal Commission on the Ancient and Historical Monuments of Scotland, Edinburgh

Clearly the artist did not paint Master Campbell from life—even Raeburn was not capable of uniting a child's head to that extraordinary torso while the living model sat in front of him, particularly at this date. Rather, the portrait may well have been painted from a miniature supplemented by a written or verbal description of what was required. This cenotaph thus symbolizes rather than describes the monument of the child's parents. Finally, Laetitia Landon does not say where she heard the story of the omen attending John Campbell's birth; but presumably the story was known to whoever commissioned this portrait. Therefore, worth remarking is the tree that grows at the left and spreads its boughs over the child's head—possibly another, more poetic allusion to the boy's lost parents.

According to W. Roberts, John Campbell of Saddell became a famous sportsman, a noted curler and golfer.

1. Roberts, 1917, pp. 47–48.
2. Laetitia Elizabeth Landon, *The Golden Violet with Its Tales of Romance and Chivalry: And Other Poems* (London, 1827; reprint 1855), pp. 50–63.

PROVENANCE: Bequeathed by the sitter to his son, Rear Adm. Charles Campbell; his sale, Messrs. Foster Auctioneers, London, March 5, 1902, lot 55, Agnew; bt. John H. McFadden, January 13, 1904.

EXHIBITIONS: New York, 1917, no. 24; Pittsburgh, 1917, no. 23; Philadelphia, 1928, p. 21.

LITERATURE: W. D. McKay, "Raeburn's Technique: Its Affinities with Modern Painting," *The Studio,* vol. 43, no. 179 (February 1908), p. 9; Grieg, 1911, p. 40; Roberts, 1913, p. 540; Roberts, 1917, pp. 47–48, repro. opp. p. 47; Roberts, 1918, "Portraits," p. 130, repro. p. 133.

CONDITION NOTES: The original support is twill-weave, medium-weight (10 x 10 threads/cm.) linen. The tacking margins have been removed. The painting has been lined with an aged aqueous adhesive and medium-weight linen. A white, thickly applied ground is evident along the cut edges. The paint is in good condition. The generally low relief of the profile of brush marking has been well preserved. Abrasions and losses are restricted to areas along the edges. Pentimenti can be seen in normal light in the figure's proper right arm and in the tree limb behind the figure. Under ultraviolet light, retouches are evident, particularly in areas of paint loss along the bottom edge and in the shadow area of the lap.

70 SIR HENRY RAEBURN

CHARLES CHRISTIE, ESQ., c. 1800
Oil on canvas, 30½ x 25½" (77.5 x 64.8 cm.)
John H. McFadden Collection, M28-1-25

James Christie (1738–1803), the father of our sitter, immigrated as a young man to Baltimore, Maryland, where he made his fortune in the family mercantile house.[1] But he was expelled from the country during the American Revolutionary War because of his sympathy for the British cause, and he returned to Scotland to purchase the estate of Durie in the parish of Scoonie, Fifeshire (figs. 70-1 and 70-2). The sitter in the portrait is his eldest son, Charles Maitland Christie, by his second wife, Mary Turner Maitland. Born on December 31, 1785, he was commissioned an ensign in the Coldstream Guards on March 5, 1801, and attained the rank of captain in 1805. He served in Germany (1805), Denmark (1807), and in the Peninsular War where, at the

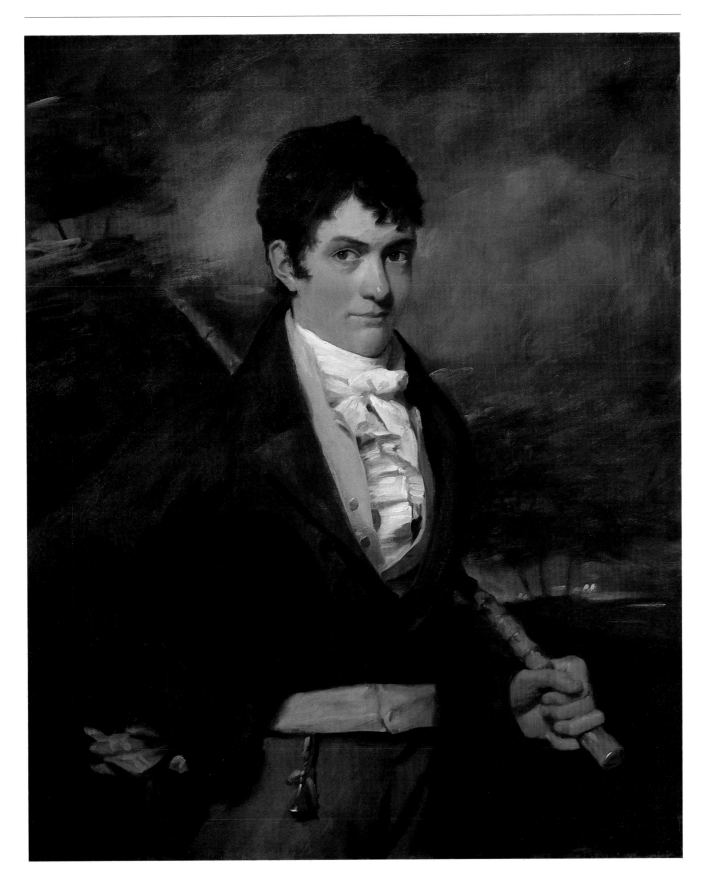

FIG. 70-1 View of Durie House, the seat of Charles Christie, Fife, courtesy of the Royal Commission on the Ancient and Historical Monuments of Scotland, Edinburgh

FIG. 70-2 Photograph of Durie House, Fife, courtesy of the Royal Commission on the Ancient and Historical Monuments of Scotland, Edinburgh

battle of Talavera on July 28, 1809, he was badly wounded. In 1810 the French captured him, but he was soon released. Christie then returned to Durie, to which he had succeeded in 1803. He became a justice of the peace and a deputy lieutenant of Fifeshire, and died at Durie in 1871 at the age of eighty-six. He married first in 1815 Mary Butler, eldest daughter of Hon. Robert Lindsay, son of the 5th Earl of Balcarres; by her he had seven sons and five daughters. His second wife, whom he married in 1830, was Elizabeth Pringle. Together they had five sons and three daughters.

The boy who looks out at us in Raeburn's portrait is still a teen-ager. He wears civilian clothes, so we can assume that he was painted before he joined the Coldstream Guards at the age of sixteen, early in 1801. A reasonable date would therefore be 1800, suggesting perhaps that the portrait was commissioned by his parents before he left Scotland for military service.

A regular dandy, Charles Christie is wearing brown trousers and a dashing cutaway coat, yellow waistcoat, and white ruffled shirt and cravat. He carries a bamboo walking stick in his left hand while in the other, which is resting nonchalantly on his hip, he holds a pair of gloves. From his waist dangles the final touch, a fob and seal. In fact, Charles is overdressed as only a sixteen-year-old can be, and the artist, who was not without a sense of humor, has conveyed the boy's pride in his outfit. The romantic landscape against which he stands is full of scudding clouds and hazy trees; the whole picture is full of movement, and Christie strides out, firm and confident, ready to accept whatever life and destiny have in store for him. The pose, the landscape, the romantic conception of youth look directly to Sir Thomas Lawrence's (q.v.) famous portrait of Arthur Atherley (fig. 70-3), which was exhibited at the Royal Academy in 1792 (no. 209) as "Portrait of an Etonian" and immediately engraved.

FIG. 70-3 Sir Thomas Lawrence (q.v.), *Arthur Atherley as an Etonian*, 1790–91, oil on canvas, 49½ x 39½" (125.7 x 100.3 cm.), Los Angeles, Los Angeles County Museum of Art, William Randolph Hearst Collection

1. This entry is based on Charles Rogers, *Genealogical Memoirs of the Scottish House of Christie Compiled from Family Papers and Public Records* (London, 1878).

PROVENANCE: Family of the sitter; Horsburgh; Agnew; bt. John H. McFadden, August 1, 1902.

EXHIBITIONS: New York, 1917, no. 25; Pittsburgh, 1917, no. 24; Philadelphia, 1928, p. 22.

LITERATURE: Roberts, 1917, p. 49, repro. opp. p. 49; Roberts, 1918, "Portraits," p. 130.

CONDITION NOTES: The original support is medium-weight (18 x 18 threads/cm.) linen. The tacking margins have been removed. The painting was relined in 1984 with a synthetic adhesive and a fiberglass support. An off-white ground is present and visible both through the abraded paint and along the cut edges. The paint is in generally poor condition. Much of the original moderate relief of the paint profile has been flattened by lining. Severe abrasion has occurred throughout the figure, the hat, and the background above the figure's proper right shoulder. In 1943 the entire surface was cleaned and resurfaced with Damar varnish. This surface coating, along with retouches to the abraded areas noted above, was removed by Siegl in 1967. Substantial inpainting is now present over the abraded areas of the face, the hat, the background above the proper right shoulder, and minor areas of abrasion around the head.

71 SIR HENRY RAEBURN *WILLIAM MACDONALD OF ST. MARTIN'S*, c. 1803
 Oil on canvas, 78 x 60″ (198.2 x 152.4 cm.)
 W. P. Wilstach Collection, W95-1-9

 By profession, William MacDonald of St. Martin's, Perthshire (1732–1814), was
 a lawyer—or in Scottish terminology, a writer to the signet. If he is
 remembered today, however, it is as the principal secretary of the Royal
 Highland and Agricultural Society of Scotland from its institution in February
 1784 until July 1804.[1] Thereafter, he served as treasurer of the society until his
 death in 1814. The Highland Society was formed in Edinburgh by about fifty
 gentlemen farmers to improve the living conditions of the inhabitants of the
 wild Scottish Highlands and islands by establishing towns and villages,

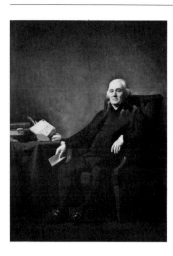

FIG. 71-1 Sir Henry Raeburn, *William MacDonald of St. Martin's*, 1803, oil on canvas, 82½ x 58½" (209.5 x 148.6 cm.), Edinburgh, The Royal Highland and Agricultural Society of Scotland

FIG. 71-2 View of St. Martin's Abbey, 1843, pencil on paper, courtesy of the Royal Commission on the Ancient and Historical Monuments of Scotland, Edinburgh

building roads and bridges, and advancing agriculture, fisheries, trade, and manufacture. In addition, the society aimed at preserving the language, poetry, and music of the Highlands, a reflection of the rediscovery and revitalization of Scotland's indigenous culture paralleled in literature at this time by the novels of Sir Walter Scott and the poetry of Robert Burns. Among their achievements in this area were the publication of an inquiry regarding the poems of Ossian (1805), a collection of Gaelic manuscripts presented to the Advocates Library in Edinburgh, and the compilation of a dictionary of the Gaelic language (1814–28).

The society also acted as a lobby in Parliament to persuade the government to spend money on Highland improvement, and to call attention to the conditions under which, at the beginning of the century, Scottish emigrants were being forced to take passage to America and Canada. William MacDonald played a particularly important role in this cause, for he headed the committee investigating the exploitation of emigrants. In his report on emigration of January 12, 1802, he described how Highlanders, forcibly removed from their land to be replaced by (more profitable) sheep, were enticed by seductive accounts of life in the New World to set sail in unsafe and unhealthy ships fitted out by unscrupulous agents. Peasants deluded by imaginary accounts of a better life were thus prey to false advertisements. He cited the case of a ship sailing to North Carolina with 450 passengers, of whom 25 had no berth. During the passage of twelve weeks and three days, the ship ran short of water, and 23 of its passengers died of dysentery.[2] He called for an act of Parliament regulating the conveyance of emigrants, and through his efforts such an act was passed on June 24, 1803.[3] MacDonald worked for the society without pay, and as the time came for him to retire as principal secretary, the society, at a meeting of June 30, 1800, requested him to sit for his portrait by Raeburn.[4] The project was delayed, but in 1803 the portrait was finished and today hangs in the offices of the Royal Highland and Agricultural Society of Scotland (fig. 71-1).

This picture is similar to the Philadelphia version in several respects, but there are important differences. In both, MacDonald sits in the same upholstered chair at a desk piled high with books and papers, and a quill pen. In both, he is the same age, about seventy-one, dressed in the same clothes, and in both, he holds a folded document in his right hand. But in the Edinburgh picture, the sitter is facing left (not right as in the Philadelphia version); the background is a uniform brown (there is no window or curtains as in the Philadelphia picture); and two objects refer specifically to MacDonald's work for the Highland Society. On the desk lies the red seal of the society's original charter, inscribed with the date of that charter, 1787; and in the sitter's right hand is a document inscribed "AN ACT FOR"—a reference to the emigration act that MacDonald's report of 1803 helped to pass. Finally, in the Edinburgh picture, MacDonald is wearing a ring on the little finger of his left hand.

In the Philadelphia portrait all references to the Royal Highland and Agricultural Society of Scotland are missing. The society's picture must be the first version, because the patron and date of the commission are known; the Philadelphia picture is therefore a version with variations. But it may be slightly more than that, for some evidence suggests that it, too, was a commissioned picture. The variations—the turning of the sitter to another direction, the window and curtains, the absence of references to the society—suggest that it was meant for a specific setting that necessitated the added expense of these changes. There is a slightly mechanical quality to it, which suggests that it was copied from the Edinburgh picture and that MacDonald did not sit twice.

We have no provenance for the picture before its sale in an Edinburgh auction house in 1893. It is still possible to suggest that the Philadelphia portrait was commissioned by MacDonald himself for the house he had just built (1791), St. Martin's Abbey, Strathmore, Perthshire, six miles northeast of Perth (fig. 71-2). The source of light, even the architecture of a particular room in the house, may well have dictated the changes in the posture and the accessories in the Philadelphia version.

1. Ramsay, 1879, passim.
2. "First Report of a Committee of the Highland Society of Scotland on Emigration," GD/51/5/52/1–7, January 12, 1802, Scottish Record Office, Edinburgh.
3. "An Act for Regulating the Vessels Carrying Passengers from the United Kingdom to His Majesty's Plantations and Settlements Abroad, or to Foreign Parts, with Respect to the Number of Such Passengers," June 24, 1803. For the full act, see *A Collection of the Public General Statutes, Passed in the Forty-third Year of the Reign of His Majesty King George the Third: Being the First Session of the Second Parliament of the United Kingdom of Great Britain and Ireland* (London, 1803), pp. 453–62.
4. Ramsay, 1879, p. 514.

PROVENANCE: Family of the sitter?; Dowell's Auction Rooms, Edinburgh, June 10, 1893; Grafton Gallery, New York; purchased for the W. P. Wilstach Collection, December 7, 1895.

EXHIBITION: Philadelphia, 1928, p. 19.

LITERATURE: Wilstach, 1897, suppl., no. 197; Armstrong, 1901, p. 107 (as "Colonel Macdonald of St. Martins"); Pinnington, 1904, p. 264; Grieg, 1911, p. 51, repro. p. 26; Wilstach, 1922, p. 97, no. 248, repro. opp. p. 98, pl. 39.

CONDITION NOTES: The original support is twill-weave, medium-weight (10 x 10 threads/cm.) linen. The tacking margins have been removed. The painting was relined in 1965 with a wax-resin adhesive and medium-weight linen. Siegl noted in 1965 that "the painting had been relined with an aqueous adhesive (starch), enlarged top and bottom, and extensively filled to conceal traction cracks, and repainted." The ground is white. The paint is in poor condition overall. A fine web of variable-aperture traction crackle is present over much of the surface and seems to be associated with brown or black tones. There are pinpoint losses over much of the surface. Both losses and traction crackle were noted by Siegl in 1965 before conservation as being "filled and overfilled." Some of this fill material was removed in the 1965 treatment prior to relining. Much of the original, moderate relief of the paint profile has been flattened by lining. Inpainting is now restricted to areas of loss only but is present in significant proportions in face, hands, and desk-top details.

VERSION: Sir Henry Raeburn, *William MacDonald of St. Martin's,* 1803, oil on canvas, 82½ x 58½" (209.5 x 148.6 cm.), Edinburgh, The Royal Highland and Agricultural Society of Scotland (fig. 71-1).
EXHIBITIONS: Edinburgh, Artist's Gallery, York Place, *Raeburn Exhibition,* 1824; Edinburgh, Royal Academy National Galleries, *The Works of Sir Henry Raeburn,* October–November, 1876, no. 12; Edinburgh, Scottish Royal Academy, 1884, no. 327; Edinburgh, National Gallery of Scotland, *Loan Exhibition of Pictures by Sir Henry Raeburn and Other Deceased Painters of the Scottish School,* 1901, no. 174.
LITERATURE: Ramsay, 1879, p. 514; Armstrong, 1901, p. 107, repro. opp. p. 48, pl. XXVIII.

72 SIR HENRY RAEBURN

LADY ELIBANK, c. 1805
Oil on canvas, 36 x 28″ (89.5 x 71.1 cm.)
John H. McFadden Collection, M28-1-22

Alexander Murray, 7th Lord Elibank (1747–1820) married twice. By his first cousin Mary Clara De Montolieu he had five children. Two years after her death in 1802, he took as his second wife Catherine, daughter of James Steuart, who bore him seven children.[1] Lord Elibank, who succeeded his uncle in 1785, had been commissioned into the Third Regiment of Foot Guards in 1768, advancing to the rank of lieutenant colonel in 1769. He was a Member of Parliament for Peebleshire in 1783 and 1784 and served as lord lieutenant for county Peebles from 1794 to 1820.

According to a letter from the Duke of Buccleuch to an unnamed correspondent, dated May 28, 1798, Lord Elibank was "a very Gentleman like man, but has been unfortunately much reduced in his circumstances by living in a style far beyond his income." The duke mentioned that Elibank lived on an allowance of five hundred pounds per year.[2] He and his second wife lived in rented rooms in Portobello, a watering-place about three miles east of Edinburgh on the southern shore of the Firth of Forth.

Apart from the fact that she was still alive in 1836,[3] little is known about the life of the second Lady Elibank. But whatever is lacking in documentation is more than made up for by the portrait itself, one of the best examples in America of Raeburn's work. In it, she is shown leaning against a garden wall, a livid patch of sky and the spiky branches of a tree behind her. The dramatic lighting of the sky and the strong diagonal of the wall serve to set off the serene self-possession of the sitter. The mellow, golden colors match perfectly her contented expression and pose. A date of about 1805, that is, soon after her marriage, seems probable for this portrait; perhaps the arrangement of the sitter's hands is not accidental, for the wedding ring on her left hand is the only jewelry she wears. The pose was a favorite of Raeburn's (for example, *Mrs. George Kinnear,* c. 1805, 34½ x 26¾″, Edinburgh, National Gallery of Scotland.)

A photograph in the Witt Library, London, of a painting that seems to be a copy after Raeburn is labeled "Baroness Elibank." It shows a woman who could be our Lady Elibank, standing with her left arm on a column and a dog at her feet. The picture was with Neumans in Paris in 1936, but its present location is not known. A pendant, showing the sitter's husband, Lord Elibank, is still in the possession of his descendants.

1. *Scots Peerage,* 1904–14, vol. 3, pp. 520–21.
2. GD 51/6/1256/1 and 2, Scottish Record Office, Edinburgh.
3. Letter from the Dowager Lady Elibank to the British Consul of the Floridas, Mobile, Alabama, August 8, 1836, GD/32/25/109/21, Scottish Record Office, Edinburgh.

PROVENANCE: Family of the sitter; Horsburgh; Agnew; bt. John H. McFadden, May 20, 1895.

EXHIBITIONS: London, Agnew Galleries, *Twenty Masterpieces of the English School,* December 1895, no. 11; New York, 1917, no. 26, fig. 26; Pittsburgh, 1917, no. 25, repro. (frontispiece); Philadelphia, 1928, p. 21.

LITERATURE: Roberts, 1917, p. 51, repro. opp. p. 51; Roberts, 1918, "Portraits," p. 130.

CONDITION NOTES: The original support is twill-weave, medium-weight (10 x 10 threads/cm.) linen. A single tacking edge remains along the bottom. The painting was lined in 1957 with a wax-resin adhesive and medium-weight linen. The buff-colored ground extends partially onto the single remaining tacking margin. The paint is in poor condition overall. A fine, irregular web of fracture crackle with associated cupping has formed. Abrasion, particularly in the mid-tones of the figure, is extensive and small losses are evident overall. Two large areas of retouching in the background above the figure's head and at the left of the face are visible in ultraviolet light and with infrared reflectography.

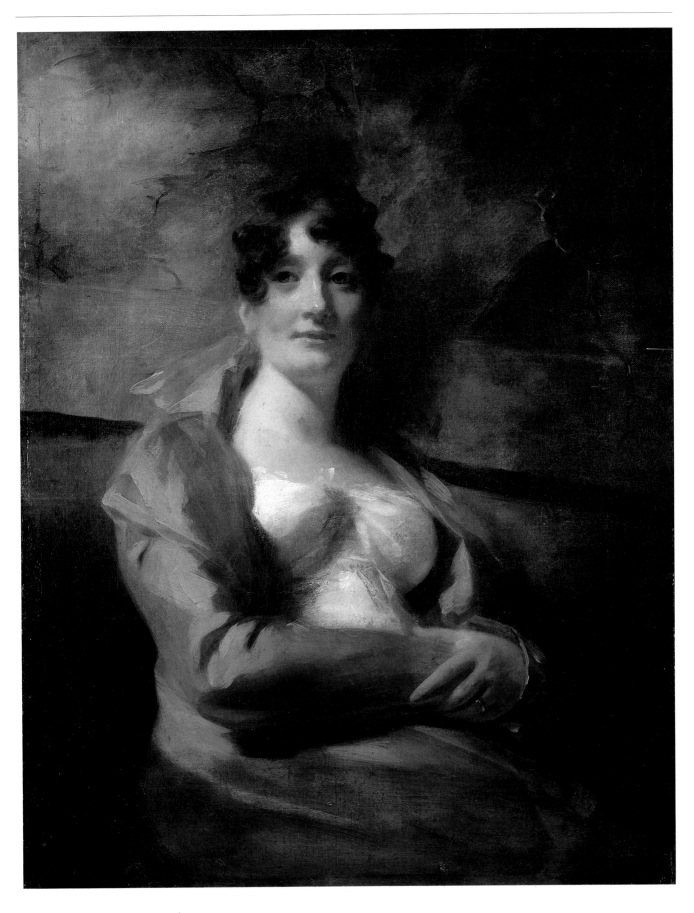

73 SIR HENRY RAEBURN

ELLEN COCHRANE, c. 1808–9
Oil on canvas, 30⅛ x 25⅛" (76.5 x 63.8 cm.)
Gift of Mr. and Mrs. John H. McFadden, Jr., 52-97-1

Ellen Cochrane sits facing us dressed in a white, Empire-style dress, turned to the left, and wrapped in a bright red cloak, which serves to conceal her forearms and hands. Her long brown hair is arranged in a neo-classical fashion, off the neck with little curls at the forehead and sides. Her portrait should be compared to Raeburn's *Mrs. Scott Moncrieff* (29½ x 24½", Edinburgh, National Gallery of Scotland). The anatomy and the perspective here are faulty, and we can assume that part of the purpose of wrapping the sitter in that voluminous cloak was to save the artist the trouble of painting her hands.

We know nothing about Ellen Cochrane, except that she is said to have married her cousin James Cochrane. It is thus possible that the "Portrait of Mrs. Cochran" exhibited at the Society of Artists exhibition held in Edinburgh in Raeburn's own York Place studio in 1809 (no. 192) is the Philadelphia picture.[1]

1. Dibdin, 1925, p. 69.

PROVENANCE: Family of the sitter?; Agnew; M. Knoedler and Co., New York, June 1929; Mrs. Marshall Field, 1930; Carroll Carstairs Gallery, New York; Mrs. Dodge Sloane; M. Knoedler and Co., 1952; bt. Mrs. John H. McFadden, Jr., June 15, 1952.

EXHIBITIONS: Possibly Edinburgh, Society of Artists, 1809, no. 192 (as "Mrs. Cochran"); Cambridge, Massachusetts, Fogg Art Museum, Harvard University, *Exhibition of Eighteenth-Century English Painting in Honor of Professor Chauncey B. Tinker of Yale University*, May 1930, no. 61 (anonymous loan).

LITERATURE: Dibdin, 1925, p. 69.

CONDITION NOTES: The original support is twill-weave, medium-weight (10 x 10 threads/cm.) linen. The tacking margins have been removed. The painting is lined with an aged aqueous adhesive and medium-weight linen. A thick, evenly applied white ground is visible along the cut edges. The paint is in very good condition, with the original, moderate, relief profile and brush marking well preserved. An irregular, narrow-aperture fracture crackle is present overall. Under ultraviolet light, retouching is evident along the losses along the cut edges.

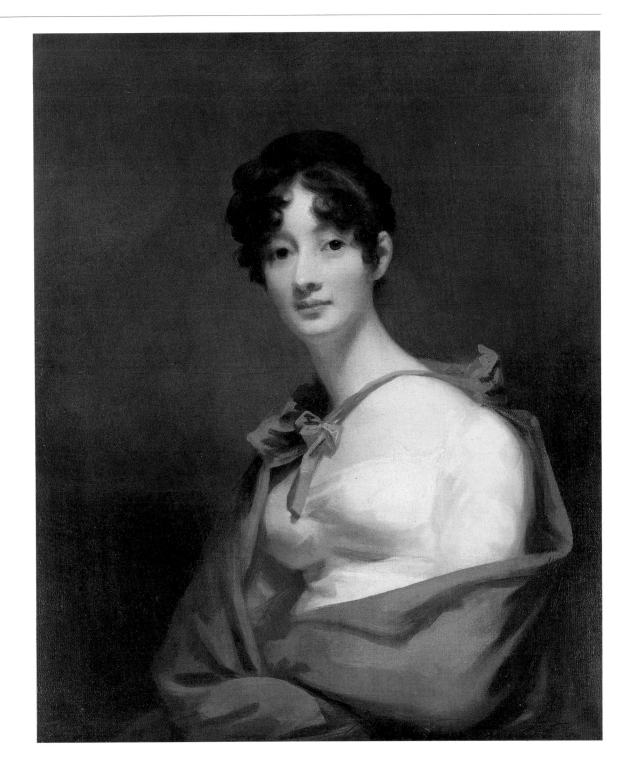

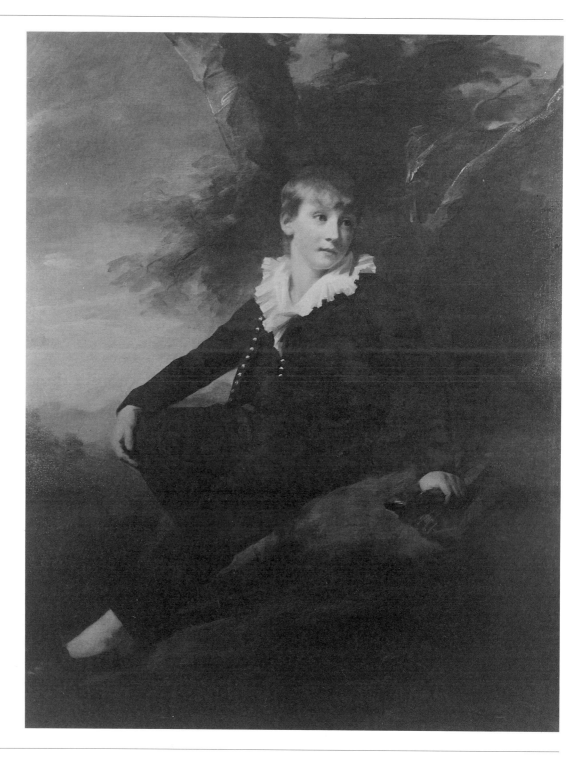

74 SIR HENRY RAEBURN *MASTER THOMAS BISSLAND,* c. 1809–10
 Oil on canvas, 56½ x 44⅜″ (143.5 x 112.5 cm.)
 John H. McFadden Collection, M28-1-23

Thomas Bissland is shown about the age of ten, seated on a grassy bank
beneath a tree in a landscape. He turns his head to his left, resting his right
hand on his knee and holding a boy's cap in his left. His suit is green, with a
ruffled collar and shiny buttons on the jacket; the trousers are short, in the
style that began to become fashionable in the 1780s as an intermediate length
between a child's frock and a teen-ager's breeches.[1]

 Although he was born in Scotland, the son of Thomas Bissland, collector
of customs at the port of Greenock near Glasgow, county Renfrew, our sitter

spent his adult life in England, entering Balliol College, Oxford, at age nineteen in 1818, and receiving his B.A. in 1821 and M.A. in 1824. His first position as a clergyman was at St. Martin's Church, Oxford (1824–27). From 1827 to 1834 he was curate at St. Paul's, Winchmore Hill, Middlesex, and also domestic chaplain to Lord Bexley. His last parish was at Hartley Maudit, Hampshire, where he was rector from 1834 until his death at age forty-seven on May 31, 1846. He married three times, the last time to Christina Grace Turnour, daughter of Rev. J. G. Gibson, rector of Llanthewry Skirrid, Monmouthshire. Bissland published several books of sermons with such titles as *Motives for Contentment* (London, 1833) and *The Preaching of the Cross* (London, 1836).

A date about 1809–10 for Bissland's portrait is compatible with the sitter's age.

1. Irwin and Irwin, 1975, p. 153.

PROVENANCE: Bequeathed by the sitter to his wife, Christina Bissland (Mrs. Leach by her second marriage); bequeathed by Mrs. Leach to Mrs. Treeby, who bequeathed it to her son Maj. H. P. Treeby, Willow Grange, Worplesdon, Surrey; his sale, Christie's, July 2, 1909, lot 97, bt. Agnew; bt. John H. McFadden, July 15, 1911.

EXHIBITIONS: New York, 1917, no. 23; Pittsburgh, 1917, no. 22; Philadelphia, 1928, p. 21.

LITERATURE: Grieg, 1911, p. 38; Roberts, 1913, p. 540; Roberts, 1917, pp. 45–46, repro. p. 45; Roberts, 1918, "Portraits," p. 130.

CONDITION NOTES: The original support is twill-weave, medium-weight (10 x 10 threads/cm.) linen. The tacking margins have been removed. The painting is lined with an aged aqueous adhesive and medium to lightweight linen. A thick white ground is visible along the cut edges. The paint is in good condition. Much of the original texture and brush marking has been preserved. Scattered areas of old cleavage are evident along both sides of the painting. Under ultraviolet light, retouching can be noted in the areas of cleavage as well as in the figure's hair.

75 SIR HENRY RAEBURN

ALEXANDER SHAW, C. 1810–15
Oil on canvas, 30 x 25⅛" (76.2 x 63.8 cm.)
John H. McFadden Collection, M28-1-27

We know nothing about Alexander Shaw (except that he married a Miss Rutherford), shown here as a vigorous old man in a frock coat and a white cravat. Whatever has just amused him has brought out the dimples in each cheek. He might answer R.A.M. Stevenson's (1847–1900) description of Raeburn himself: "a large, bold Scot, full of humour and intelligence, fit to swallow a lot of work and yet keep an appetite for social pleasure."[1]

As always with Raeburn, the sitter is placed in a strong, direct light, which illuminates the head but keeps the body and subordinate parts in shadow. Shaw is seen from below, as Raeburn often placed his sitters on a high platform and painted them in the position from which the completed portrait would be seen when hanging on the wall.[2]

1. Armstrong, 1901, p. 9.
2. Grieg, 1911, p. xxxvii.

INSCRIPTION: *Raeburn / Sir Alex: Shaw (married Miss Rutherford / from whose family the / picture was acquired)* [on an old label on the stretcher].

PROVENANCE: Family of the sitter; W. L. Graham, 1905; Miss Emma Joseph, London; Agnew; bt. John H. McFadden, October 12, 1916.

EXHIBITIONS: New York, 1917, no. 28, fig. 28; Pittsburgh, 1917, no. 27; Philadelphia, 1928, p. 20.

LITERATURE: Grieg, 1911, p. 59; Roberts, 1917, p. 55, repro. opp. p. 55; Roberts, 1918, "Additions," p. 114, p. 109 fig. 2; Roberts, 1918, "Portraits," p. 134.

CONDITION NOTES: The original support is twill-weave, medium-weight (10 x 10 threads/cm.) linen. The tacking margins have been removed. A slight bulge is evident on the right background. The painting is lined with an aqueous adhesive and medium-weight linen. A thick, evenly applied off-white ground is present and evident along the cut edges. The paint is in generally good condition. Traction crackle is present in local areas along the bottom of the painting and in the collar of the figure and indicates that bitumen was included in the artist's palette. An irregular web of narrow-aperture fracture crackle extends overall. Under ultraviolet light, retouches are visible in the face, along the bottom edge, and in small areas throughout the background.

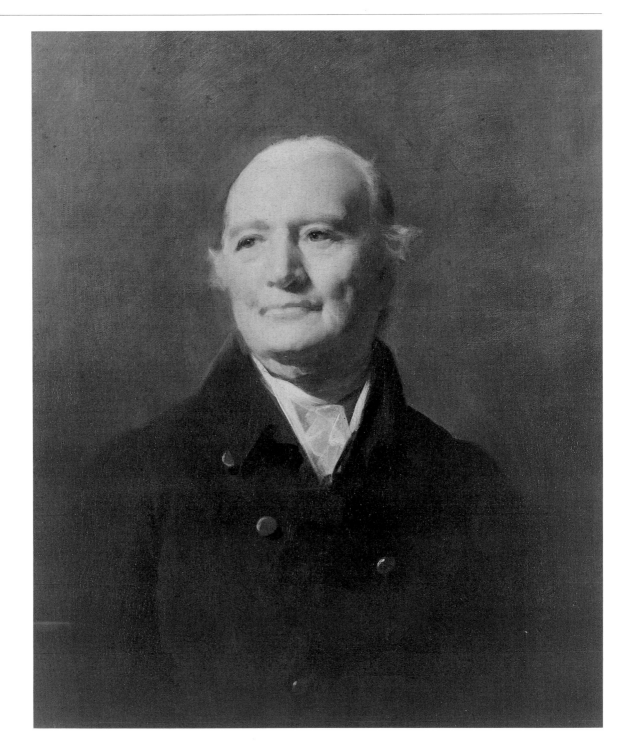

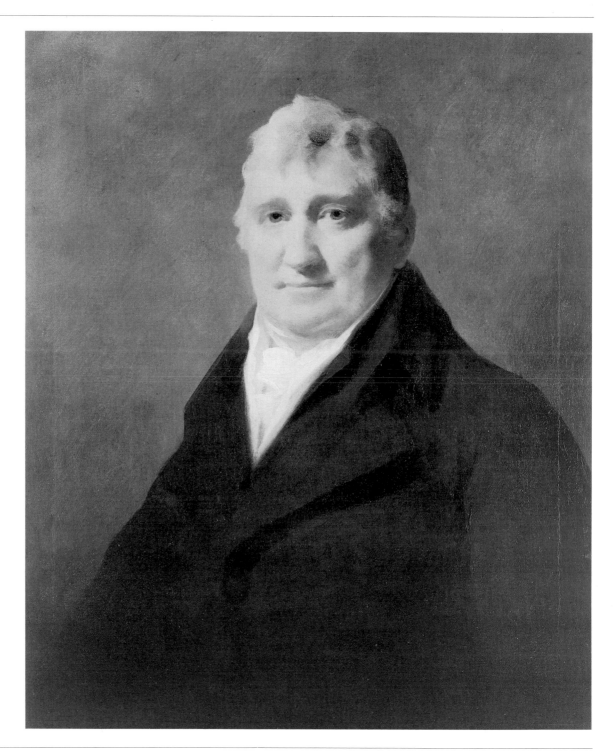

76 SIR HENRY RAEBURN *WALTER KENNEDY LAWRIE OF WOODHALL, LAURIESTON,* C. 1815
 Oil on canvas, 30 x 25″ (76.2 x 63.5 cm.)
 John H. McFadden Collection, M28-1-26

The identity of the sitter in this portrait is not certain. Roberts, on the basis of
the old label on the reverse of the frame, called him Mr. Lawrie (or Laurie, an
alternative spelling) of Woodlea, Castle Douglas, and under this name the
picture has been exhibited at the Philadelphia Museum of Art since 1928.
However, Woodlea House in the town of Castle Douglas does not seem to
have been connected with a family named Lawrie, and no record of a Lawrie
or Laurie of Woodlea has been discovered in the Scottish Record Office. An
alternative identification is supplied through the Scottish Postal Directory for
1843, where a William Kennedy Laurie of Woodhall, Laurieston, county

Kirkcudbright, is listed.[1] Laurieston is a village in Balmaghie parish, Kirkcudbrightshire, seven miles west-northwest of Castle Douglas, in which town it has a post office. According to P. H. M'Kerlie's *History of the Lands and Their Owners in Galloway* (Edinburgh, 1877), the estate of Woodhall was owned by William Kennedy Lawrie's grandfather, Walter Kennedy Lawrie, during the years when, on stylistic grounds, our portrait was painted, that is, about 1810 to 1819.[2] This makes Walter Kennedy Lawrie a strong candidate for the sitter in Raeburn's portrait. He presumably died by 1819 at which date his son, also called Walter Kennedy Lawrie, was in possession of Woodhall. The perfectly plain background and the summary treatment of the clothing of the sitter are characteristics of Raeburn's later work. Raeburn conveys the straightforward, bluff, yet genteel character of the sitter in a portrait that combines both vigor and restraint.

1. James Findlay, *Directory to Gentlemen's Seats, Villages, Etc. in Scotland* (Edinburgh, 1843), p. 198.
2. P. H. M'Kerlie, *History of the Lands and Their Owners in Galloway,* vol. 3 (Edinburgh, 1877), pp. 155–57.

INSCRIPTION: *Raeburn (Sir H.) / Mr Laurie of Woodlea / Castle Douglas / Kirkcudbright* [on an old label on the reverse of the frame].

PROVENANCE: Family of the sitter?; W. B. Paterson; Agnew; bt. John H. McFadden, August 19, 1910.

EXHIBITIONS: New York, 1917, no. 27 (as "Mr. Laurie of Woodlea"); Pittsburgh, 1917, no. 26 (as "Mr. Laurie of Woodlea"); Philadelphia, 1928, p. 20.

LITERATURE: Roberts, 1917, p. 53, repro. opp. p. 53; Roberts "Portraits," repro. p. 130.

CONDITION NOTES: The original support is twill-weave, medium-weight (10 x 10 threads/cm.) linen. The tacking margins have been removed. Stretcher creases are present in the support and paint along all four sides. The painting is lined with an aqueous adhesive and medium-weight linen. A thickly and evenly applied off-white ground can be seen along the cut edges. The paint is in good condition. Local areas of traction crackle are present in the shoulders of the figure. Some abrasion is evident in the mid-tones of facial details. An irregular net of narrow-aperture fracture crackle extends overall. Under ultraviolet light, retouches to the hair and chin of the figure are visible.

77 SIR HENRY RAEBURN *JANE ANN CATHERINE FRASER OF REELIG*, 1816
Oil on canvas, 30⅛ x 25¾" (76.3 x 65.3 cm.)
Gift of Mr. and Mrs. Wharton Sinkler, 63-171-1

According to *Burke's Landed Gentry,* Jane Anne Catherine Fraser of Reelig
(1797–1880) was married at age nineteen on June 10, 1816, to Philip Affleck
Fraser, 8th of Culduthel and of Ravenhead (1787–1862). Raeburn's portrait of
her was commissioned, presumably, to celebrate that marriage. She had five
sons and six daughters, and on the death of her brother's son she succeeded as
17th Lady of Reelig. On her death the position of head of the family of Reelig
devolved on to her own descendant, the eldest male heir of the Culduthel
family. In 1879, the year before her death, she bequeathed her property,
including her portrait, to that descendant, her grandson Philip Affleck Fraser,
18th of Reelig. Reelig House, Bogroy, Inverness, is in northeast Invernesshire,
seven miles west from Inverness.

 The sitter wears a purple dress and a loose, white, ruffled collar; her long
hair is arranged in ringlets around her face. Raeburn has been as careless with
the delineation of the sitter's upper torso as he was thoughtful in rendering
her fresh and open face. The background is plain, with no attempt to
introduce landscape or atmosphere. This is in keeping with a general tendency
in Raeburn's work after about 1808, when his bankruptcy presumably led him
to accept more commissions and finish them faster, to skimp in the rendering
of secondary aspects of a portrait such as hands, accessories, dress, and
backgrounds, as in the portrait of Ellen Cochrane (no. 73). This tendency his
contemporaries deplored, as the Duke of Buccleuch wrote to Sir Walter Scott
in 1819: "Many of his works are shamefully finished. The face is studied but
everything else is neglected."[1]

1. Quoted in Irwin and Irwin, 1975, p. 146.

INSCRIPTION: *Jane Anne Catherine Fraser of
Reelick / AET 19 Raeburn pinx 1816* [on the back
of the original canvas].

PROVENANCE: Philip Affleck Fraser of
Reelig, the sitter's grandson; possibly Christie's
June 11, 1897 ("property of a Gentleman"), lot
83 (as "Portrait of a Lady"), withdrawn from
sale; A. Wertheimer; William Beattie, by 1899;
Maurice Kann, Paris; his sale, Galerie Georges
Petit, Paris, June 9, 1911, lot 41; M. Knoedler
and Co.; bt. Mrs. Wharton Sinkler, February
19, 1920.

EXHIBITIONS: Glasgow, Royal Glasgow
Institute of the Fine Arts, 1899, no. 34;
Edinburgh, National Gallery of Scotland, *Loan
Exhibition of Pictures by Sir Henry Raeburn and
Other Deceased Painters of the Scottish School,*
1901, no. 150 (lent by William Beattie); New
York, M. Knoedler and Co., *Loan Exhibition of
Portraits by Sir Henry Raeburn for the Benefit of
the Artists' Fund and Artists' Aid Societies,*
January 9–15, 1913, no. 11.

LITERATURE: Armstrong, 1901, p. 102, repro.
opp. p. 88, pl. XLVIII; Pinnington, 1904,
pp. 257, 265; R. S. Clouston, *Sir Henry Raeburn*
(London and New York, 1907), pl. 12; James L.
Caw, ed., *The Masterpieces of Raeburn* (London
and Glasgow, 1908), p. 37; Grieg, 1911, p. 46,
pl. 8.

CONDITION NOTES: The original support is
twill-weave, medium-weight (12 x 12
threads/cm.) linen. The tacking margins have
been removed. The painting was relined in 1967
with medium-weight linen and a wax-resin
adhesive over an earlier aqueous adhesive
lining. An off-white ground is visible along the
cut edges. The paint is in only fair condition
overall; local areas of fracture crackle have
appeared in and are restricted to flesh-tone
areas of the figure and correspond to the
thickest applications of paint. Abrasion is
evident locally in the mid-tones of face and
dress. Pentimenti in the drawstring around the
figure's neck are evident in normal light. Under
ultraviolet light, retouches are visible to small
areas in the face and bosom and along both
sides of the painting.

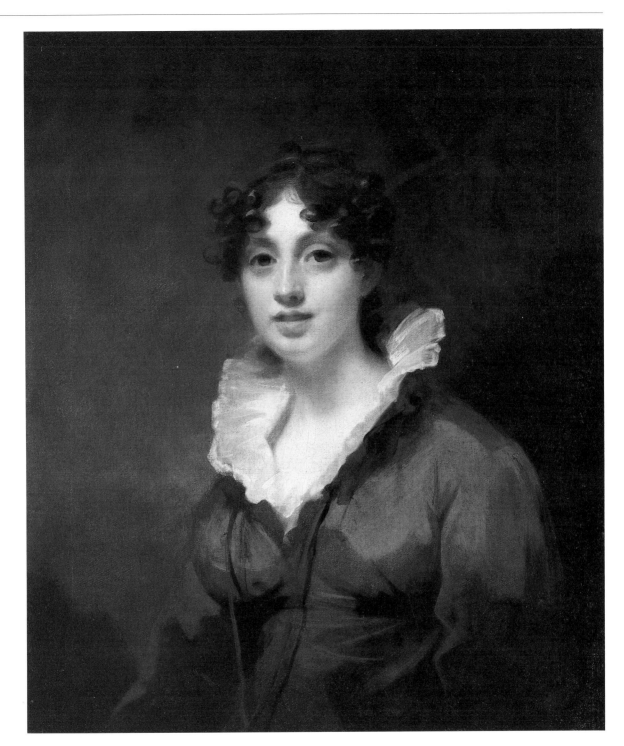

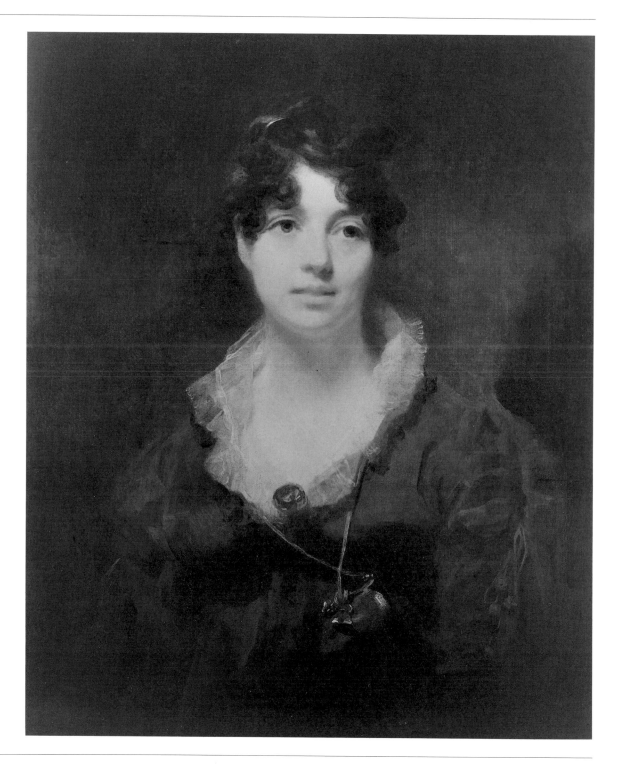

78 SIR HENRY RAEBURN *MRS. JOHN MCCALL OF IBROXHILL*, C. 1820
 Oil on canvas, 30 x 25″ (76.2 x 63.5 cm.)
 The George W. Elkins Collection, E24-4-23

 Isabella McCall (1784–1871) was the only surviving daughter of Archibald
 Smith of Craigend (1747–1820) and his wife, Isobel Ewing (1755–1855).
 Isabella's father had founded the firm of Leitch and Smith, West India Sugar
 Merchants, of Glasgow, thus taking advantage of the deepening of the river
 Clyde in the third quarter of the eighteenth century, which resulted in a vast
 extension of trade to the Far East and West Indies. Isabella was, therefore,
 born into a prosperous and, on the small scale of a provincial city, socially
 prominent family in Glasgow. At the time of Isabella's birth, the Smiths lived

FIG. 78-1 Photograph of Ibroxhill House, courtesy of the Royal Commission on the Ancient and Historical Monuments of Scotland, Edinburgh

in a flat in High Street, Glasgow, but about 1790 moved to a Georgian building on Buchannan Street. Around the corner from both residences, in Black House Mansion, at the junction of Argyll and Queen streets, lived the McCalls, a family of tobacco merchants. Isabella knew her future husband, John McCall (1778–1833), from childhood, although they did not marry until about 1806.

At first Isabella and John McCall lived in a town house in Miller Street, which runs into George's Square in Glasgow, but in 1816 John McCall bought the small estate of Ibrox, which he renamed Ibroxhill (fig. 78-1), about three miles southwest of the old city center (now demolished).[1] The McCalls never had children, and Isabella survived her husband by almost forty years. During that period she lived at Ibroxhill, much loved by her family and friends. A history of the house written seven years after her death included the information that "no one was more widely known and universally respected in Glasgow and the neighborhood than this venerable lady, and her beautiful private life and character are still fresh in the memory of her many friends. Her house was the scene of the kindest and most constant hospitality, and to the poor . . . her aid was unceasing and ungrudging."[2] She died at age eighty-seven.

Dating this portrait is difficult. The usual time for a young woman to have her portrait painted was at her marriage, but here the loose, sketchy brushwork and plain background contradict a dating to c. 1806. It seems likely, on stylistic grounds, to place the portrait after 1816, when the McCalls moved to Ibroxhill. A typewritten label nailed to the stretcher of the work states that it was painted "about 1820," and records show that other members of her family—her brother Archibald, and James and John Smith, and James's wife, Mary—were all painted c. 1820. At the time of Raeburn's death in 1823 the Smiths of Jordanhill still owed the artist's estate £105.[3] If Isabella's portrait was painted around the same date, that is, c. 1820, she was already a matron of thirty-six. Surviving photographs of her in old age show a decidedly stout woman, and a second look at our portrait shows that this tendency was beginning to become evident by the time Raeburn painted her—and that the artist cleverly concealed her girth by blending the outlines of her torso in the background.

1. John Guthrie Smith and John Oswald Mitchell, *The Old Country Houses of the Old Glasgow Gentry: One Hundred Photographs by Annan, of Well Known Places in the Neighborhood of Glasgow, with Descriptive Notices of the Houses and the Families* (Glasgow, 1878), no. LVIII.

2. Ibid.

3. Inventory of the debts owing at the death of Sir Henry Raeburn, Scottish National Portrait Gallery Library, Edinburgh (typescript of original in Register House, Edinburgh).

INSCRIPTION: *Portrait of MRS JOHN MCCALL (nee MISS ISABEL SMITH) Painted by SIR HENRY RAEBURN about 1820 (see letter of MR. DENROCHE-SMITH) / Purchased direct from MR. DENROCHE-SMITH of MEIGLE, N.B. who inherited the portrait from his father (brother of MRS. MCCALL) in 1863, to whom MRS. MCCALL left the portrait at her death in 1871. / EXHIBITED at EDINBURGH LOAN EXHIBITION, 1901. / RECORDED in SIR WALTER ARMSTRONG'S Work on SIR HENRY RAEBURN / RECORDED in JAMES GRIEG'S Work on SIR HENRY RAEBURN / REPRODUCED in "FIFTY PORTRAITS of RAEBURN" 1909* [on a typewritten label on the stretcher]; and an Edinburgh exhibition label from 1901.

PROVENANCE: The sitter, Mrs. John McCall; bequeathed to Mr. Smith, the sitter's brother, 1871; bequeathed to Thomas Denroche-Smith of Meigle, the sitter's nephew, 1883; Scott and Fowles, New York; bt. George W. Elkins, after 1911.

EXHIBITION: Edinburgh, National Gallery of Scotland, *Loan Exhibition of Pictures by Sir Henry Raeburn and Other Deceased Painters of the Scottish School*, 1901, no. 163 (lent by Thomas Denroche-Smith).

LITERATURE: Armstrong, 1901, p. 107; Pinnington, 1904, p. 258; James L. Caw, ed., *Portraits by Sir Henry Raeburn* (Edinburgh, 1909), pl. 52; Grieg, 1911, p. 52; Elkins, 1925, no. 31; Elkins, 1935, p. 15, repro. p. 10.

CONDITION NOTES: The original support is twill-weave, medium-weight (10 x 10 threads/cm.) linen. The tacking margins have been removed. The painting is lined with an aged aqueous adhesive and lightweight linen. An off-white ground has been thickly and evenly applied. The paint is in moderately good condition. Much of the original varied profile in the paint has been flattened by lining. A wide-aperture fracture crackle is especially prominent in the highlight areas of the face and neck, where paint application is heaviest and in highest relief. Abrasion has occurred to the mid-tone areas of the face and neck, exposing ground through the thinned paint layer. Under ultraviolet light, retouching is evident to pinpoint losses in the face and to a large patch of background approximately 3″ square to the right of the figure's head.

VERSION: After Sir Henry Raeburn, *Mrs. John McCall of Ibroxhill*, oil on canvas, 29 x 24″ (73.7 x 61 cm.), location unknown.

PROVENANCE: Archibald Parker Smith; Dowell's Auction Rooms, Edinburgh, August 15, 1958, lot 69.

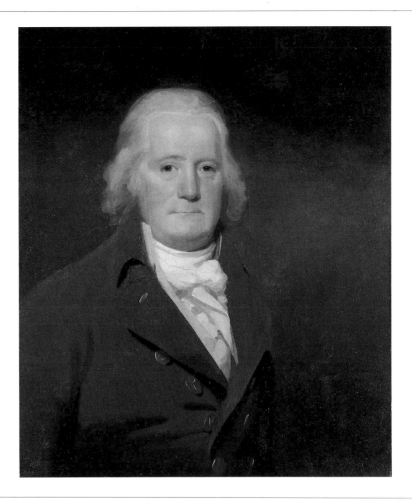

79 FOLLOWER OF SIR HENRY RAEBURN

PORTRAIT OF A GENTLEMAN, nineteenth century
Oil on canvas, 29¾ x 25¼″ (75.6 x 64.2 cm.)
John H. McFadden Collection, M28-1-28

PROVENANCE: W. B. Paterson; Agnew; bt. John H. McFadden, September 5, 1910.

EXHIBITIONS: New York, 1917, no. 29; Pittsburgh, 1917, no. 28; Philadelphia, 1928, p. 20.

LITERATURE: Roberts, 1917, p. 57, repro. opp. p. 57.

CONDITION NOTES: The original support is twill-weave, medium-weight (10 x 10 threads/cm.) linen. The tacking margins have been removed. There are two tears, which have been repaired and compensated, about the proper right collar of the figure. The painting has an aged lining with an aqueous adhesive and medium-weight support. A previous aqueous adhesive lining has been retained as well. A white ground is evident along the cut edges. The paint is in good condition. The original brush marking and the relief of the paint profile have been preserved. A wide-aperture, irregular web of fracture crackle seems to be associated with the areas of thickest application of paint. A less pronounced, narrower and finer irregular web of fracture crackle is present overall. Local areas of minor abrasion are present in the background and mid-tone areas of the face. Under ultraviolet light, retouches are restricted to the tears noted above and to the proper left lapel.

Joshua Reynolds was born on July 16, 1723, the seventh of the eleven children of Rev. Samuel Reynolds (d. 1745), schoolmaster of the village of Plympton in Devonshire. Had Joshua set out to arrange for his character to be as different as possible from his father's he could hardly have succeeded more completely: scatter-brained and improvident, Samuel Reynolds missed wordly success by burdening himself with a family and debts; his son saddled himself with neither, avoiding emotional entanglements, working coolly and steadily to become a complete professional. As a little boy he is said to have announced to his father that "he would rather be an apothecary than an *ordinary* painter";[1] what he actually became was a supremely accomplished artist and, at last, the most honored painter of his time.

In October 1740, with Samuel's encouragement and through the influence of a family friend, the seventeen-year-old boy entered the studio in London of Thomas Hudson (1701–1779), a fellow Devonian and the most fashionable portrait painter of his generation. There Reynolds began to learn what was, at that time, more of a trade than a profession and was introduced to the luminaries of the tiny artistic world in London: the painter Hogarth (q.v.), the sculptor Louis François Roubiliac (1702/5–1762), and the engravers Gravelot (1699–1773) and James McArdell (1728–1765). But two and a half years later, Reynolds left Hudson to set up on his own, working in the 1740s both in Devon and in the capital.[2] From there his life might after all have fallen into a pattern of gifted mediocrity had not chance intervened in a spectacular way.

Chance was Commodore Augustus Keppel's (1725–1786) sailing into Plymouth Harbor in the spring of 1749 for repairs on his ship the *Centurion,* which was taking him from Spithead to Algiers for negotiations with the dey concerning the containment of piracy. Through mutual friends, the Edgcumbe family, Reynolds met Keppel and soon accepted an invitation to sail aboard the *Centurion* to Italy. Leaving Plymouth on May 11, 1749, he arrived in Rome, after stopovers in Algiers, Port Mahon, and Minorca, in January 1750.

Seldom has a man learned as much from Italy as Reynolds did in the two years he lived there, from 1750 to 1752. Like artists before and since, he studied Roman sculpture and the works of Raphael, Michelangelo, Correggio, and Titian; but unlike others, he immersed himself in the past in order to understand it completely—buying the time to do so by resisting the temptation to make money by copying famous works of art or painting the portraits of visiting Englishmen.

Among his miscellaneous writings quoted by Malone is a passage in which Reynolds remembered a difficult youthful struggle. He described his initial indifference to the Raphael frescoes in the Vatican *stanze* and how, rather than pretend to be moved by them, or assume other men to be mistaken in assigning to Raphael one of the highest places in the history of art, he returned again and again until he understood the reasons for Raphael's preeminence.[3] The story illustrates Reynolds's ability to accept his own limitations, to attend to the opinions of other men, and yet to rely on his own perceptions. Applied to portraiture, a branch of painting hitherto taken for granted by English artists and patrons, this capacity to take himself as well as his clients seriously would make him a painter of profound originality.

When Reynolds came to put the lessons of antiquity and the High Renaissance into practice, he brought about his own renaissance in English painting. The graceful poses and powerful compositions of his portraits convey a sense of grandeur and moral gravity that places them in relation to those of his predecessors Allan Ramsay (1713–1784) and Hudson in the same proportion as Raphael's works to Ghirlandaio's or Perugino's.

On October 16, 1752, the painter returned to London by way of Bologna, Parma, Mantua, Venice, and Paris, having filled his notebooks with jottings

and sketches recording techniques, materials, and styles of the masterpieces he saw along the route. The friendships and contacts he had cultivated in Rome served him well on his return. As early as 1753 the Duke of Devonshire sat to the young man, to be followed in short order by the rest of society.

When a sitter arrived at 104 St. Martin's Lane, the first thing he saw was Reynolds's full-length portrait of Commodore Keppel, painted in 1753—not on commission but as an advertisement for the young painter's prowess (91¾ x 57½", Greenich, National Maritime Museum). Keppel stands in the pose of the Apollo Belvedere, a conceit used by Allan Ramsay five years prior, in 1748, in his portrait of *Norman MacLeod, Chief of MacLeod* (88 x 54", Skeye, Dunvegan Castle). But Reynolds's picture is altogether greater than the Ramsay, for where Chief MacLeod looks like a paper doll pasted against a studio backdrop, Keppel commands the space, a man of destiny masterfully striding out toward the spectator. In the distance a shipwreck alludes not just to his profession (the conventional spyglass or compass could have conveyed that information) but to a recent event: through Keppel's heroism during a shipwreck off the French coast in 1747 the lives of his men were saved.[4] This narrative dimension, together with Reynolds's command of his materials and technique, and the double quotation from the antique and from Ramsay combined to make the Keppel portrait a milestone in the history of English painting, comparable in importance to Hogarth's *Captain Thomas Coram* (1740, 94 x 58", London, Thomas Coram Foundation for Children) or Turner's *Hannibal Crossing the Alps* (1812, 54½ x 93½", London, Tate Gallery).

The period that followed, from 1752 to 1768, is generally regarded as Reynolds's golden age, when his response to Italy was fresh, but when his aspirations toward the grand style had not yet utterly taken possession of his soul. Early on he realized the value of prints after his portraits in attracting new clients, and throughout his career he chose his engravers with care. With sitters turning up at a rate of 150 in one year (1759) he was in a position, by 1760, to buy a house in Leicester Square big enough to house his studio and princely household, and also to shelter a little army of apprentices employed in painting draperies and making repairs and copies of his pictures. From the first we can assume that, except for portraits of himself, his family, or his most intimate friends, a canvas by Joshua Reynolds was at some point worked on by one of these studio assistants.

At this time he formed his friendships with famous men in the literary circle surrounding Samuel Johnson (1709–1784), friendships with Oliver Goldsmith (1728–1774), James Boswell (1740–1795), Richard Brinsley Sheridan (1751–1816), and David Garrick (1717–1779). His gift for amiability appears to have been limitless. The esteem in which the greatest writers of the classical age of English literature held him is eloquently revealed by the dedications, both to Reynolds, of James Boswell's *Life of Samuel Johnson* (London, 1791) and of Oliver Goldsmith's *Deserted Village* (London, 1770).

Of these friends the most valued was Johnson himself, who, although he cared little for painting, supplied Reynolds with the education the artist had missed by leaving Plympton at seventeen. After Johnson's death Reynolds himself said, simply, "He may be said to have formed my mind, and to have brushed from it a great deal of rubbish."[5] And it is no specious comparison to see in Reynolds's pictures a visual parallel to the moralist's ability to size up men and situations by brushing aside the trivial in order to reveal the essential.

Reynolds has sometimes been said to have made his sitters more glamorous and more important than they actually were. Bearing in mind that many of his portraits are in fact of men with strong characters and women of extraordinary beauty, it is still true to say that his art lies in the opposite direction: in perceiving the exact position of the sitter in his intellectual or

social world and in stating only this, no more and no less. Of all the portrait painters in England in the eighteenth century, it was not to Reynolds that sitters ambitious for a place in the world were likely to go, but to Romney (q.v.) or Francis Cotes (1726–1770), who were guaranteed to make them look the way they wanted the world to see them. Broadly speaking, Reynolds's perceptive scrutiny was valuable to those whose positions in the world were secure enough to want those places weighed and recorded at their true worth.

There is no doubt that Reynolds liked people and sought to know them as he painted them. Only during a phase of high classicism in the 1770s did he lose contact with his sitters. Then, yielding to a tendency he had hitherto kept within bounds, he attempted to graft the grand manner onto portrait painting by portraying his aristocratic sitters as goddesses or transplanted Romans. As Waterhouse has observed (1965), public portraits from this period manage to be slightly bland and at the same time intensely irritating: the sitters are aloof, complacent, unseeing, the very class and people against whom in that decade the American Revolutionary War was being fought. At the same time, as though in reaction to these theoretical, and indeed quasi-political heights, he began to paint children more often. Here, to the last, his innate kindliness and respect for his sitters, even three-year-olds (no. 82), resulted in magical renderings of their private and untouchable world.

In 1768 he was elected the first president of the Royal Academy of Arts. Although George III never much liked Reynolds or his pictures, he recognized that no other artist possessed the poise, the intellect, or the breadth of vision to guide the king's new academy to a position of preeminence throughout Europe. To add to the institution's prestige, he knighted Reynolds—the first artist to be so honored in England since Thornhill's knighthood in 1692. In 1784 Reynolds succeeded Ramsay as Principal Painter to the king.

Both in what he said in his famous Discourses, delivered in December in each year on the day when prizes were distributed to students at the academy, and by what he exhibited, which from then on consisted largely of public pictures illustrating the lofty ideals expressed in the Discourses, Reynolds tried to instill in English artists a sense of themselves as the successors to the greatest European masters; only then, he insisted, would English art rise above the level of the provincial.

Determined that the students should build on the achievements of the past rather than believe in a specious conception of native genius, leading, in his view, only to chaos, Reynolds drew on the writings of theorists, from Pliny, to Dufresnoy, to his friend Edmund Burke. His Discourses sought to distinguish between what he designated the "great" and the "ornamental" styles. The former meant the representation of ideal perfection in religious, mythological, or history paintings as practiced by artists of the early sixteenth century in Rome and the seventeenth century in Bologna. By the ornamental style he referred to the styles of the Dutch, Flemish, and Venetian schools, which he considered useful only for portrait painting.

His contemporaries, like Henry Fuseli (1741–1825),[6] were quick to point out that Reynolds himself painted pictures almost entirely in the ornamental style of the Venetians whom, in the Discourses, he affected to rate so low. But Reynolds, always sensible, would have answered without missing a brushstroke that "a man [does not] always practise that which he esteems the best; but does that which he can best do."[7]

In the last full decade of his life, the 1780s, his style again altered, possibly in response to the paintings of Rubens (1577–1640) he had seen on his first trip to Flanders in 1781. Now a new informality and simplicity began to be felt in his portraits and once again we feel Reynolds searching for, and revealing, the hearts of his sitters. In these years, too, he experimented more often with

history pictures, contributing three large and noble failures to Boydell's Shakespeare Gallery and a canvas representing the childhood of Hercules to the collection of Catherine the Great.

During the first half of his career, from 1753 to 1768, in pursuit of the secret of Venetian coloring, an ideal as elusive as the philosopher's stone, Reynolds experimented with his materials systematically, using transparent glazes over monochrome underpainting and using a palette of blue-black, white, ocher, and carmine. The last color, used for the flesh, did not always last, and as the carmine faded the pictures took on a pale, ghostly tone.[8] The result is not always unattractive, for when a Reynolds from this period is in a good state of preservation it achieves, as James Northcote (1746–1831) told James Ward (1769–1859), "an atmosphere of light and shade . . . together with a vagueness that gives them a visionary and romantic character, and makes them seem to be dreams or vivid recollections of persons we have seen."[9]

As the results of this palette became obvious with time, however, he began in the 1770s to abandon the blue-black palette for a warmer one, achieved both through the use of vermilion for flesh tones and bitumen. In these years he primed the canvas with white oil paint, then modeled with glazes made of a paste of wax, pigment, and varnish: according to the painter Benjamin Robert Haydon (1786–1846), Reynolds tried in this way to make his pictures look old so that they could hang unobtrusively beside old masters in the great houses and galleries of England.[10] As a result of applying pigment to a wet, white ground and then varnishing it with a waxy glaze before the pigment had time to adhere to the ground, these canvases soon blistered and cracked and lost their fresh colors. Northcote wrote, "His whole life was devoted to his finding out the Venetian mode of colouring; in the pursuit of which he risked both his fame and his fortune."[11]

After suffering two paralytic strokes, he lost the sight of his left eye on July 13, 1789. Within a few weeks he stopped painting, and his last years were taken up with administrative duties at the academy. He died from a disease of the liver on February 23, 1792, and was buried in St. Paul's Cathedral.

Reynolds was famous as a collector, a writer, and a painter. It is difficult to pick out from the many tributes to him by his contemporaries the one phrase that most neatly sums him up, but no discussion of his life can omit Gainsborough's (q.v.) famous tribute uttered as he walked through the annual exhibition at the Royal Academy: "Damn the man, how various he is."[12]

1. Waterhouse, 1953, p. 164.
2. Leslie and Taylor, 1865, vol. 1, pp. 26–27.
3. Malone, ed., 1797, vol. 1, p. xi.
4. C[osmo] M[onkhouse], Dictionary of National Biography, s.v. "Reynolds, Sir Joshua."
5. Leslie and Taylor, 1865, vol. 2, p. 461.
6. Pilkington, 1805, pp. 445–46.
7. Wark, ed., 1959, p. 52, Third Discourse.
8. Horace A. Buttery, "Reynolds' Painting Technique," in Hudson, 1958, pp. 248–50.
9. Stephen Gwynn, ed., Memorials of an Eighteenth-Century Painter (James Northcote) (London, 1898), p. 238.
10. Cotton, 1856, p. 248.
11. Northcote, 1818, vol. 2, p. 269.
12. Wark, ed., 1959, p. xxxii.

BIBLIOGRAPHY: Malone, ed., 1797; Pilkington, 1810, pp. 424–31; Northcote, 1813; Northcote, 1818; Farington, 1819; Beechy, 1835, vol. 1, pp. 31–300; Cotton, 1856; Cotton, 1857; Leslie and Taylor, 1865; Cunningham, 1879, vol. 1, pp. 168–257; Hazlitt, 1894; Stephen Gwynn, ed., Memorials of an Eighteenth-Century Painter (James Northcote) (London, 1898); Graves and Cronin, 1899–1901; Armstrong, 1900; Fletcher, ed., 1901; A. L. Baldry, Sir Joshua Reynolds (London, 1903); William B. Boulton, Sir Joshua Reynolds, P.R.A. (London, 1905); Frederick Whiley Hilles, ed., Letters of Sir Joshua Reynolds (Cambridge, 1929); Frederick Whiley Hilles, The Literary Career of Sir Joshua Reynolds (Cambridge, 1936); Wind, 1938, "Attitudes," pp. 182–85; Waterhouse, 1941; E. H. Gombrich, "Reynolds's Theory and Practice of Imitation," The Burlington Magazine, vol. 80, no. 467 (February 1942), pp. 40–45; Mitchell, 1942; Hudson, 1958; Frederick Whiley Hilles, "Horace Walpole and the Knight of the Brush," in Horace Walpole: Writer, Politician, and Connoisseur, ed. Warren Hunting Smith (New Haven and London, 1967), pp. 141–66; Robert E. Moore in Anderson and Shea, eds., 1967, pp. 332–57; Ellis K. Waterhouse, "Additions to the List of the Pre-Italian Portraits by Reynolds," The Walpole Society, 1966–1968, vol. 41 (1968), pp. 165–67; Ellis K. Waterhouse, "Reynolds's 'Sitter Book' for 1755," The Walpole Society, 1966–1968, vol. 41 (1968), pp. 112–64; Cormack, 1970; Waterhouse, 1973; David Mannings, "The Sources and Development of Reynolds's Pre-Italian Style," The Burlington Magazine, vol. 117, no. 865 (April 1975), pp. 212–23.

EXHIBITIONS: London, 1883–84; London, Arts Council of Great Britian, Sir Joshua Reynolds, an Exhibition of Paintings, 1949 (by Ellis K. Waterhouse); Plymouth, City Art Gallery, Sir Joshua Reynolds, P.R.A., 1973 (foreword by Ellis K. Waterhouse, catalogue by Hazel Berriman); Paris, Grand Palais, London, Royal Academy, Reynolds, October 9, 1985–March 31, 1986 (by Nicholas Penny).

80 SIR JOSHUA REYNOLDS

LADY MARY O'BRIEN, LATER 3RD COUNTESS OF ORKNEY, c. 1772
Oil on canvas, 50 x 40⅛" (127 x 101.8 cm.)
Gift of Mr. and Mrs. William H. Donner, 48-95-1

Lady Mary O'Brien was the only surviving daughter of Murrough O'Brien, 5th Earl of Inchiquin, created Marquess of Thomond in 1801. Her mother was the 2nd Countess of Orkney, a title Mary inherited on her mother's death in 1790. She was born on September 4, 1755, and married on December 21, 1777, Hon. Thomas Fitzmaurice, of Llewenni Hall, county Denbigh, Ireland (1742–1793), a second son of John, Earl of Shelburne, and brother of the 1st Marquis of Lansdowne. According to his former schoolmate Edmund Malone (Reynolds's first biographer), Fitzmaurice was "a light headed foolish Boy."[1] Mary died on December 30, 1831, having borne one son, John Hamilton Fitzmaurice, Viscount Kirkwall (1778–1820). Mary's father married Sir Joshua Reynolds's niece and heir, Mary Palmer, as his second wife, who accordingly became the Marchioness of Thomond and stepmother to Mary.

Although baptized Mary, she was called Nelly at home to distinguish her from her mother, also Mary. Even in the eighteenth century, in Henry Bromley's *Catalogue of Engraved British Portraits* (London, 1793), the sitter in our picture was confused with another, more famous—or rather more notorious—Nelly, Nelly O'Brien, the beautiful courtesan whom Sir Joshua frequently painted.[2] And throughout the nineteenth century the picture was exhibited under the title Nelly O'Brien.

Although we know little about Lady Mary's life or personality from written documents, Reynolds's portrait contrives to tell us a great deal about her—not, as might be the case in a portrait by another artist, by revealing her character through a look, a smile, a turn of the head, or the strength of the face itself, but through costume, props, landscape, and pose. These tell us about her position in the world, her taste, and most important, about how she viewed herself. As Lady Mary was not married at the time the portrait was painted, and the painting was immediately engraved, possibly a covert function of the portrait was to advertise the sitter's charms to eligible young men.

Reynolds shows Lady Mary seated in profile to the left, her right elbow resting on a vase, her right hand propping up her chin, her left arm tucked into the elbow of her bent right arm, looking off into the distance at three poplar trees. The pose is an adaptation in reverse of a figure on a Roman bas-relief in the Musei Capitolini (Palazzo dei Conservatori), Rome, *The Conquered Province (Weeping Dacia)* (fig. 80-1), the pose of which, when it turns up in eighteenth-century paintings (Gainsborough's [q.v.] *Girl with Pigs,* 1782, 49½ x 58½", Yorkshire, Castle Howard), suggested melancholy. Classically draped female figures resting against urns were frequently found on mourning rings or funerary monuments at this period (see Thomas Banks's [1735–1805] monument to Dean William Smith, 1787, Chester Cathedral).[3]

The pose and the urn suggest, at first glance, that we are looking at a lady in mourning; and if, as is the case here, no immediate reason can be cited for her sadness—the death of a parent, a husband, a lover—we should bear in mind that in paintings and sculpture by artists as different as Greuze (1725–1805) (*Young Girl Crying Over the Death of Her Bird,* oil on panel, 26¾ x 21½", Paris, Louvre) and Thomas Banks (*Monument to a Robin Redbreast,* 1803, Aberystwyth, National Library of Wales) young ladies of feeling were shown mourning the death of pet robins or sparrows. But there is no reason to be literal in the case of Lady Mary; rather, she chose to be painted as a lady of "sensibility," that precursor to the romantic mentality in which the feelings of the heart were held sacred, and indeed, as an antidote to an age obsessed with reason, tended and cultivated to a pitch that seems extravagant to

FIG. 80-1 Roman bas-relief, *The Conquered Province (Weeping Dacia),* marble, height 47¼" (120 cm.), Rome, Musei Capitolini, Palazzo dei Conservatori

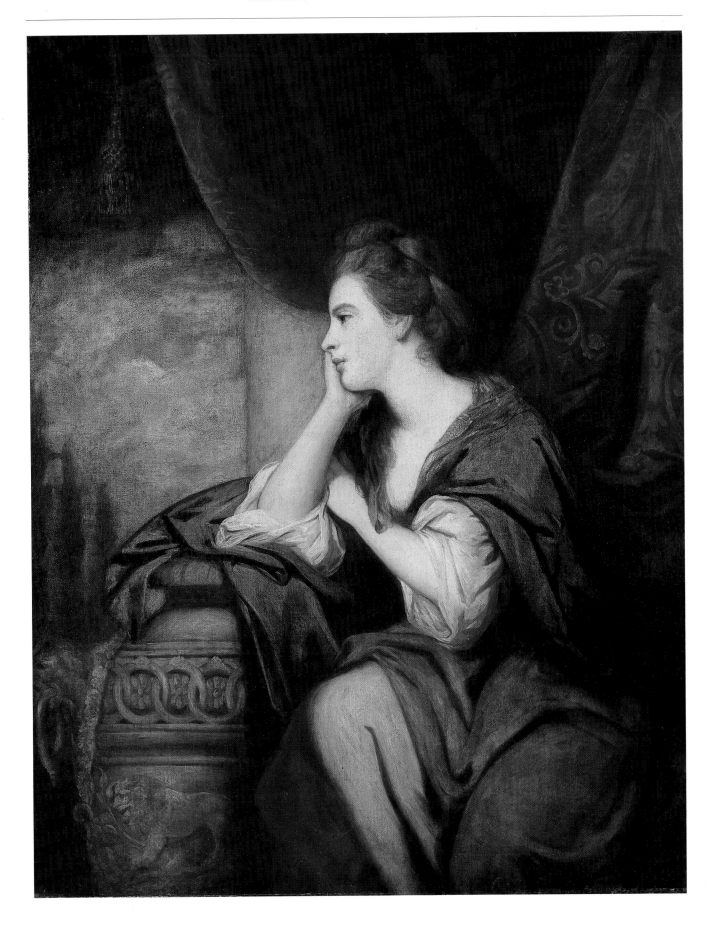

FIG. 80-2 Enea Vico (1520–1567), *Vase with Lion Heads*, 1543, engraving, courtesy of the British Museum, London

FIG. 80-3 John Dixon (1740–c. 1780) after Sir Joshua Reynolds, 1772, mezzotint, 19⅛ x 14″ (48.6 x 35.5 cm.), courtesy of the Fitzwilliam Museum, Cambridge

twentieth-century minds.[4] Like Mrs. Robinson in Reynolds's own *Perdita* (1784, 29 x 24¼″, London, Wallace Collection), where the sitter looks toward the horizon in much the same way as the sitter in this portrait, Lady Mary is supposed to manifest a fashionable touch of melancholy, a sincerity quite different from a lady who would dress up, powder her hair, and face the artist head on for her portrait. Melancholy was, of course, à la mode at this date, not only in art but in poetry, garden design, the cult of ruins, and in novels.

It is possible that Mary's pose and particularly the inclusion of poplar trees in the distance subtly refer to a character in contemporary literature, Laurence Sterne's (1713–1768) Maria, who is described in his *Sentimental Journey,* which was published in 1768 and immediately became a best seller. In that book the character Yorick meets a peasant girl named Maria by the roadside outside Moulins, "sitting under a popular—She was sitting with her elbow in her lap, and her head leaning on one side within her hand.... She was dress'd in white... her hair hung loose."[5] *Sentimental Journey* was one of the first English novels of sensibility, and one that Joseph Wright of Derby (q.v.) would turn to in 1774 as a source for his *Captive* (40 x 50″, Derby, Derby Museum and Art Gallery) and again in 1777 for the first of his two versions of *Maria* (63 x 45½″, Great Britain, private collection).[6] Wright's Maria makes a particularly interesting comparison with Reynolds's portrait because in it he depicted the heroine seated in the Dacia pose chosen by Reynolds for Mary O'Brien, although in reverse. Furthermore, Wright's maiden wears her hair in a coiffure so nearly like Lady Mary's that we might well believe he knew the Reynolds or a print from it. Ironically, Wright's Maria is not seated under poplar trees as she should be (and as she is in the Reynolds), although she is dressed entirely in white, which Lady Mary is not. But then Wright was illustrating a story, while Reynolds merely added an allusion to a contemporary heroine of fiction by way of adding another level of meaning to an already richly suggestive portrait. Robert Moore made this point in his article on Reynolds's method of characterization: "The most important... of Reynolds's modes of exploring character and individualizing portraiture, [is] his appropriation of some pose or fiction from either literature or art that will simultaneously illustrate something about the sitter and lend something dramatic or imaginative to the painting."[7]

But whatever else Reynolds tells us about Lady Mary, he does not allow us to mistake her for anyone other than a respectable scion of the upper classes: a great swag of curtain, a column, the huge urn convey more than a little information about the world of Adam and Chambers houses, of security and established values, to which the sitter was born and in which she moved. Her dress, halfway between a frock of the 1770s and a Roman toga, leaves no doubt that her country and class were the inheritors of the Roman Empire and civilization. In addition, Reynolds put forward in the Seventh Discourse of 1776 a practical reason for this kind of vague costume: "He... who in his practice of portrait–painting wishes to dignify his subject... will not paint her in the modern dress, the familiarity of which alone is sufficient to destroy all dignity.... He... dresses his figure something with the general air of the antique for the sake of dignity, and preserves something of the modern for the sake of likeness."[8]

The urn, ornamented at each side with the head of a lion holding a ring in its jaw and decorated on the body by another lion beneath a festoon, is copied from an engraving by Enea Vico (1520–1567), one of a series of fourteen vases after the antique (fig. 80-2).[9] The Vico itself is a copy in reverse of a print of 1531 by Agostino Veneziano (active c. 1509–36).

Waterhouse dated this portrait to 1774, while a date apparently on the frame when the picture was exhibited in London in 1867 reads 1773. Dixon's

engraving (Smith, 1878, vol. 1, pp. 213–14, no. 26) is generally dated 1774, but this is only the inscribed state that was published on September 29 of that year by W. Wynne Ryland. An earlier state, with an uncleaned edge before the inscription, in scratched letters, reads "Sr Joshua Reynolds pinxt J Dixon Fecit 1772" (an impression in the Fitzwilliam Museum, Cambridge, fig. 80-3), giving us a date before which the portrait must have been completed. This earliest known state was also recorded by C. E. Russell and Hamilton.

1. For Malone's opinion of Fitzmaurice, see Farington Diary, [1793], February 13, 1796. For Lady Mary O'Brien, see Scots Peerage, 1904–14, vol. 6, pp. 580–81.

2. Bromley, 1793, p. 431, s.v. "Nelly O'Brien, Courtezan."

3. Haskell and Penny, 1981, pp. 193–94, fig. 100. Jonathan Richardson (Sr. and Jr.), An Account of Some of the Statues, Bas-reliefs, Drawings and Pictures in Italy, Etc., 2nd ed. (London, 1754), p. 114, described the relief as "incomparable." In the 1750s the sculpture was incorporated in portraits by Batoni (1708–1787) and in views by Panini (c. 1692–1765/8) and was also drawn by Richard Wilson (q.v.) (see Sutton, ed., 1968, vol. 1, repro. p. 7, vol. 2, pp. 29–30). By the time Reynolds used the pose for Lady Mary O'Brien, Dacia was being used in England for jewelry. See A Catalogue of Cameos, Intaglios, Medals and Bas-reliefs, with a General Account of Vases and Other Ornaments after the Antique Made by Wedgwood and Bentley and Sold in Their Rooms in Great Newport Street, London (London, 1773), p. 11 (Class I Cameos and Intaglios), no. 1055, "A Conquered province; in Carnelian." Reynolds also used this pose for his Hon. Mrs. Spencer (Contemplation) (35½ x 28½", Christie's, March 3, 1924, lot 143), engraved by R. B. Parkes, published 1864.

4. For a discussion of sensibilité in France, see Anita Brookner, Greuze: The Rise and Fall of an Eighteenth-Century Phenomenon (London, 1972), chaps. 1–3.

5. A Sentimental Journey through France and Italy by Mr. Yorick (London, 1768), vol. 2, p. 171

6. For the second version see Nicolson, 1968, vol. 1, no. 237, also see vol. 1, pp. 150–51.

7. Moore, 1967, p. 346.

8. Wark, ed., 1959, p. 140.

9. Bartsch, 1803–21, vol. 15, p. 350, no. 420; Walter L. Strauss, ed., The Illustrated Bartsch, vol. 30, ed. John Spike (New York, 1985), repro. p. 259. See also Timothy Clifford, "Polidoro and English Design," The Connoisseur, vol. 192 (August 1976), p. 291 n. 20.

PROVENANCE: Greenwood's, April 16, 1796, lot 39, bt. Lord Inchiquin, the sitter's father; Hon. George Agar-Ellis, later 1st Lord Dover, by 1824; Lady Dover, 1833; her son, Henry, 3rd Viscount Clifden, 1860; Lady Clifden, London, 1867; Agnew; Charles T. Yerkes, New York City, 1899; American Art Association, New York, 1910; Col. and Mrs. Ambrose Monell, Tuxedo Park, New York; American Art Association, Anderson Galleries, Monell sale, New York, November 28, 1930, lot 62, Mr. and Mrs. William H. Donner.

EXHIBITIONS: London, British Institution, 1824, no. 167 (as "Nelly O'Brien," lent by Hon G. Agar-Ellis); London, British Institution, 1833, no. 24 (as "Nelly O'Brien," 1773, lent by Lord Dover); London, British Institution, 1858, no. 156 (as "Nelly O'Brien," lent by Lady Dover); London, National Portrait Exhibition, 1867, no. 580 (as "Nelly O'Brien," dated 1773 on frame); London, Royal Academy, 1877, no. 195 (as "Nelly O'Brien," 1773).

LITERATURE: Bromley, 1793, p. 431 (as "Nelly O'Brien, Courtezan"); Hodgson and Graves, 1836, vol. 2, p. 58 (as "Miss Nelly O'Brien"); Cotton, 1857, p. 56; Leslie and Taylor, 1865, vol. 1, pp. 188–89, n. 7; Smith, 1883, vol. 1, pp. 213–14, no. 26; Graves and Cronin, 1899–1901, vol. 2, pp. 701–2; Armstrong, 1900, p. 222; O'Donoghue, 1908–25, vol. 3, p. 378 (listed under Orkney, Mary O'Brien); Waterhouse, 1941, pp. 64–65; Staley, 1974, p. 35; Timothy Clifford, "Polidoro and English Design," The Connoisseur, vol. 192 (August 1976), p. 291 n. 20.

CONDITION NOTES: The original support is medium-weight (16 x 16 threads/cm.) linen. A repaired tear is evident below the proper left knee of the subject. The painting is lined with an aged aqueous adhesive and medium-weight linen. Siegl noted in 1968 that the painting had been previously relined and retouched. A light gray ground is present and extends partially onto the tacking margins. The paint is in fair to good condition. The original profile varies from high to low relief. The highest points of impasto have been flattened. Abrasion is evident in the mid-tone areas of face and bosom as well as generally throughout the background at the left of the figure. Textural pentimenti are evident in a raking light in the sitter's proper left arm, sleeve, knee and in the drapery at the right of the knee, suggesting that the sitter was shifted to a more upright position. Retouches are evident in normal light in the area of the mended tear and in small losses along the edges.

ENGRAVINGS

1. John Dixon (1740–c. 1780) after Sir Joshua Reynolds, mezzotint, 19⅛ x 14" (48.6 x 35.5 cm.).

BEFORE INSCRIPTION: Sr Joshua Reynolds pinxt J Dixon Fecit 1772 [on uncleaned edge in scratched letters] (fig. 80-3).

INSCRIPTION: Ryland Excudit. Joshua Reynolds Esques, pinxit. JDixon Fecit. Publish'd Sepr.29 1774 by W. Wynne Ryland, London.

2. Samuel William Reynolds (b. 1773) after Sir Joshua Reynolds, Miss Nelly O'Brien, 1774, mezzotint, 5 x 4" (12.7 x 10.1 cm.).

VERSION: Sir Joshua Reynolds, Mary O'Brien, oil on canvas, 30 x 25" (76.2 x 63.5 cm.), location unknown.

PROVENANCE: Arthur Smith, Park Side, Knightsbridge?; Prince von Lichtenstein, Vienna, 1923; Charles Sedelmeyer, Paris, 1923; Jules Baches, New York; Edward Brandus, Paris, 1930; Ehrich Galleries, New York; Lemle sale, Parke-Bernet, New York, October 24, 1946, lot 30.

DESCRIPTION: Half-length to waist.

81 SIR JOSHUA REYNOLDS *PORTRAIT OF A LADY,* c. 1780
 Oil on canvas, 24½ x 20″ (62.2 x 50.8 cm.)
 Bequest of John D. McIlhenny, 43-40-40

 This painting was sold in 1912 as a portrait by Reynolds of Lady Waldegrave.
 Since that time it has been assumed that the sitter was Maria Walpole,
 Dowager Countess Waldegrave (1737–1807), the niece of Horace Walpole,
 who, after the death of her first husband James, 2nd Earl Waldegrave, married
 secretly in September 1766 William Henry, Duke of Gloucester, third son of
 Frederick, Prince of Wales, and brother of George III. She first sat to
 Reynolds in June 1759, and thereafter he painted her seven times both as Lady
 Waldegrave and as the Duchess of Gloucester.[1]

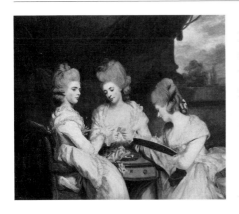

FIG. 81-1 Sir Joshua Reynolds, *The Ladies Waldegrave*, oil on canvas, 56½ x 66" (143.5 x 168 cm.), Edinburgh, National Gallery of Scotland

Two difficulties prevent our fully accepting this identification: first, the lady in profile in this portrait does not look like the much plumper duchess, and second, this is a portrait of a young woman of about twenty to twenty-five years of age and it would therefore be among the earlier portraits of Maria Waldegrave by Reynolds, to be dated c. 1760–64, while the technique and style, the warm colors and waxy, creamy paint seem perhaps more characteristic of Reynolds of the 1770s or 1780s.[2] The unfinished state of the portrait makes dating it particularly difficult.

If we accept the identification of the sitter as a Waldegrave, we might attempt to associate her with one of the duchess's daughters, portrayed in *The Ladies Waldegrave* (fig. 81-1), who sat to Reynolds in 1780–81 and whose triple portrait was exhibited at the Royal Academy in 1781 (no. 187).[3] The profile here is particularly reminiscent of the sister at the right in profile in Reynolds's portrait, Anna Horatia (1762–1801), later Lady Hugh Seymour.

However, the lady in the Philadelphia picture was clearly to be painted with her hair unbound, secured by a fillet, and with her hand to her cheek in an attitude of fashionable melancholy. This seems not to have been the style of any of the Waldegrave sisters, who, whether painted by Gainsborough (q.v.) or Reynolds, dressed conventionally and usually in powder. The least formal portrait of any of them, by John Hoppner (q.v.), shows Elizabeth Laura (1760–1816), later Countess Waldegrave, in profile, her hair out of powder and unbound, wearing a broad-brimmed straw hat.[4]

We need not feel bound by a dealer's undocumented identification: the sitter could be almost anyone. Another candidate is *Hon. Mrs. Spencer (Contemplation)* (fig. 81-2), where the pose to the left, the hand raised to the cheek, the hair falling from the fillet, and above all the profile are very close to our portrait.[5] *Hon. Mrs. Spencer* was engraved by R. J. Lane in 1819.

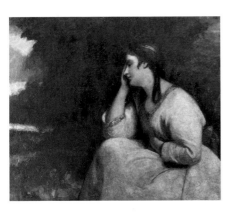

FIG. 81-2 Sir Joshua Reynolds, *Hon. Mrs. Spencer (Contemplation)*, oil on canvas, 34½ x 41½" (87.5 x 105.5 cm.), location unknown

1. See Waterhouse, 1941, pl. 154, for Reynolds's 1774 portrait in the collection of Her Majesty Queen Elizabeth II (73¾ x 53¾"), catalogued by Millar, 1969, vol. 1, no. 1,015, exhibited at the Royal Academy, 1774, no. 214.
2. Marceau, 1944, pp. 55, 59, dated the portrait to c. 1764 and suggested that it may have been a study for the portrait of the countess exhibited by Rev. Edward William Harcourt at the Royal Academy in 1880, no. 64 (36 x 28", location unknown). Waterhouse, on a visit to the Philadelphia Museum of Art, dated this portrait to c. 1764.
3. Elizabeth Laura (1760–1816), later Countess Waldegrave; Charlotte Maria (1761–1808), later Duchess of Grafton; Anna Horatia (1762–1801), later Lady Hugh Seymour.
4. 23½ x 19½", Ruck, London, 1927. Photograph: London, Witt Library.
5. Christie's, May 13, 1983, lot 53. Photograph: London, Witt Library.

PROVENANCE: Purchased from the Ehrich Galleries, June 10, 1912.

EXHIBITIONS: Philadelphia, The Pennsylvania Museum and School of Industrial Art, 1926; Philadelphia, Cosmopolitan Club, 1944.

LITERATURE: Marceau, 1944, pp. 55, 59.

CONDITION NOTES: The original support is medium-weight (10 x 10 threads/cm.) linen. Reflectography reveals a small horizontal tear above the shoulder of the figure, near the right edge of the composition. The painting is lined with an aqueous adhesive and medium-weight linen. An off-white ground is present, evident throughout the lower, unfinished portion of the painting. Abrasion to both ground and paint is extensive overall and most apparent in the areas of thinnest application. The paint is in fair condition; a fine web of fracture crackle extends throughout the areas of flesh color. Abrasion through the paint has exposed pinpoint areas of ground and has given the surface texture a darker, pebbled appearance. Traces of red pigment are still evident in the mid-tones of the cheek shadows. Ultraviolet-light examination reveals retouches in abraded portions of the darkest areas of the background above the figure's head and beneath the chin.

82 SIR JOSHUA REYNOLDS

MASTER BUNBURY, 1780–81
Oil on canvas, 30⅛ x 25⅛″ (77.8 x 63.8 cm.)
John H. McFadden Collection, M28-1-29

Scholars have disagreed over the identity of the little boy in this portrait. He was one of the two sons of Henry William Bunbury (1750–1811), the noted eighteenth-century caricaturist, and Catherine Horneck (c. 1753–1798), whom Oliver Goldsmith nicknamed "Little Comedy" because she was said to have resembled the figure of Comedy in Reynolds's *Garrick between Tragedy and Comedy* (1762, 58¼ x 72″, England, private collection). According to Stephens, the sitter is their older son, Charles John Bunbury (1772–1798), who graduated from Trinity College, Cambridge, in 1795, married Miss Frances Davison, became an officer in the army, and died at the Cape of Good Hope in 1798, aged twenty-six.[1] Graves and Cronin (1899–1901), Armstrong (1900), Christie's sales catalogue of July 5, 1907, O'Donoghue (1908–25, vol. 1, p. 285), and Roberts (1917) all repeat Stephens's identification.

John Chaloner Smith, on the other hand, correctly identifies him as their younger son, Henry Edward Bunbury, born May 4, 1778, who in 1821 succeeded his uncle Thomas Charles Bunbury, 6th Baronet (1740–1821), as the 7th Baronet.[2] In 1830 Henry married as his second wife Lady Emily Napier, to whom he was distantly related through her mother, Lady Sarah Lennox Napier, the woman who, while married to her first husband, Sir Thomas Bunbury (Henry's uncle), had been painted by Reynolds in his famous canvas *Lady Sarah Bunbury Sacrificing to the Graces* (1765, 94 x 60″, Chicago, The Art Institute of Chicago). Henry Edward Bunbury was a distinguished officer, under secretary for war from 1809 to 1816, lieutenant general in 1830, and for many years Member of Parliament for Suffolk. In 1830 he was elected to the Society of Dilettanti. He died on April 13, 1860.

Reynolds was an old friend both of the Bunbury family and of Catherine Horneck.[3] According to family tradition, Sir Joshua actually proposed to her, and true or not, he remained devoted to her throughout his life. This picture of her child he painted for himself, keeping it in his house during his lifetime and bequeathing it to her in his will ("To Mrs. Bunbury, her son's picture").[4] The reason for this is straightforward: according to Whitley, Henry was Sir Joshua's godson.[5]

Assuming that the portrait was executed in the months preceding the Royal Academy exhibition of 1781, Henry is nearly three years old here. He sits on a grassy bank or knoll in a wood, dressed in an open shirt and wine-colored jacket, staring straight at us, his chubby hands resting on his legs, a miniature Dr. Johnson. His open-mouthed, wide-eyed concentration, his vulnerable and slightly anxious expression can be explained by the fact that Sir Joshua kept him still by telling him spellbinding fairy tales during the sittings. According to the *Gazetteer,* Henry was "so vivacious that Sir Joshua could not have settled him in any steady posture if he had not told him an entertaining story, which fixed his attention."[6] And many years later, the sitter himself recalled that his godfather's fairy tales caused "the pleased and wondering attention shown in the child's face."[7] The motif of the portrait seems to have been common knowledge in London. At least, the poet and philosopher Dr. James Beattie (1735–1803) in a letter describing the Royal Academy exhibition written from London in May 1781 observed, "The best pieces . . . are, Thais . . . ; the Death of Dido; and a Boy, supposed to be listening to a wonderful story."[8] Knowing this, it may not be fanciful to see in the woods darkening behind Henry and the (gnarled?) tree trunk to the left, an evocation of the slightly scary settings usual in fairy stories.

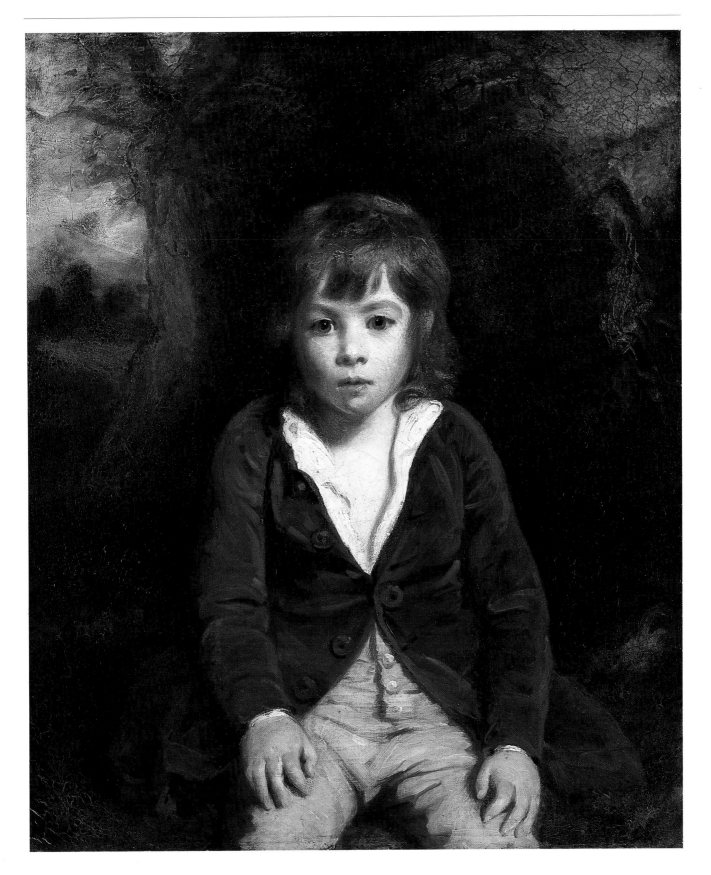

Horace Walpole called the picture "charming,"[9] and the *Morning Chronicle* thought it a portrait "which to uncommon force unites the characteristic simplicity of childhood in a high degree."[10] The pose is simple and straightforward, for although Reynolds first used this full-frontal, three-quarter-length format in his *Nelly O'Brien* of 1760–62 (50 x 39″, London, Wallace Collection) he seems to have preferred it for portraits of children, for example in *Master Crewe as Henry VIII* (54 x 44″, London, Marquis of Crewe Collection) and *Lady Caroline Scott as Winter* (1777, 55½ x 44″, London, Duke of Buccleuch and Queensbury Collection). *Master Bunbury* should also be compared to a child portrait of 1789, Reynolds's *Puck* (oil on panel, 40½ x 31½″, England, Executors of the 10th Earl Fitzwilliam) painted for Boydell's Shakespeare Gallery, where the naked baby is more gremlin than human.

The pigments in the Philadelphia picture have darkened with time, and the extensive use of bituminous paint has left surface traction crackle.

1. Frederic G. Stephens, *English Children as Painted by Sir Joshua Reynolds* (London, 1867), pp. 55–56, 63; Graves and Cronin, 1899–1901, vol. 1, p. 126.

2. Smith, 1883, vol. 2, p. 623.

3. Whitley, 1928, vol. 1, p. 149.

4. Malone, ed., 1797, vol. 1, p. lxvii.

5. Whitley, 1928, vol. 1, pp. 149, 369. In a letter to the author of April 23, 1979, Sir William Bunbury noted that a mezzotint with a contemporary inscription on the reverse identifying the sitter as Henry Bunbury is in the Bunbury family.

6. Whitley, 1928, vol. 1, p. 369.

7. Ibid.

8. Northcote, 1818, vol. 2, p. 114.

9. See Leslie and Taylor, 1865, vol. 2, p. 326.

10. Quoted in Graves and Cronin, 1899–1901, vol. 1, p. 126.

PROVENANCE: Collection of the artist; bequeathed to Mrs. Henry Bunbury, the sitter's mother, 1792; bequeathed to the sitter, Sir Henry Bunbury; Sir C[harles] J[ames] F[ox] Bunbury, by 1861; Sir Edward Bunbury, by 1891; sold by direction of Sir Henry Bunbury, Bart., Christie's, July 5, 1907, lot 105, bt. Agnew; Charles Fairfax Murray; Agnew, 1909; bt. John H. McFadden, November 18, 1909.

EXHIBITIONS: London, Royal Academy, 1781, no. 147 (as "Portrait of a Young Gentleman"); London, British Institution, 1813, no. 20 (lent anonymously); London, British Institution, 1851, no. 123 (lent by Sir Henry Bunbury, Bart.); London, British Institution, 1861, no. 188 (lent by C.J.F. Bunbury); London, Royal Academy, 1891, no. 2 (lent by Sir Edward Bunbury); London, Grafton Gallery, *Fair Children*, 1895, no. 156a; London, Royal Academy, 1908, no. 155 (lent by Charles Fairfax Murray); New York, 1917, no. 30; Pittsburgh, 1917, no. 29, repro.; Philadelphia, 1928, p. 19.

LITERATURE: Malone, ed., 1797, vol. 1, p. lxvii; Northcote, 1818, vol. 2, pp. 114, 299; Waagen, 1854–57, vol. 2, p. 335; Cotton, 1856, p. 156; Cotton, 1857, p. 12; Leslie and Taylor, 1865, vol. 2, pp. 157, 326–27, 636; Frederic G. Stephens, *English Children as Painted by Sir Joshua Reynolds* (London, 1867), pp. 55–56, 63, repro. opp. p. 57; Smith, 1883, pt. 2, p. 623; Claude Phillips, *Sir Joshua Reynolds* (London, 1894), p. 295, mezzotint repro. opp. p. 296; Graves and Cronin, 1899–1901, vol. 1, p. 126, vol. 4, pp. 1,274, 1,476, 1,612; Armstrong, 1900, pp. 74, 90, 121, 196, repro. p. 131; Gower, 1902, p. 98; A. L. Baldry, *Sir Joshua Reynolds* (London, 1903), p. xxxviii; Roberts, 1913, p. 538; Whitley, 1915, p. 174; McFadden, 1917, repro. p. 111; Roberts, 1917, pp. vii, 59–60, repro. opp. p. 59; Roberts, 1918, "Portraits," pp. 126–28; Siple, 1928, p. 255; Whitley, 1928, vol. 1, p. 368, vol. 2, p. 390; C. H. Collins Baker and Montague R. James, *British Painting* (London, 1933), p. 104; *The Philadelphia Museum Bulletin*, vol. 37, no. 193 (March 1942), repro. p. 31; Waterhouse, 1941, p. 72; Guy Paget, *Sporting Pictures of England* (London, 1945), p. 11; Waterhouse, 1973, p. 180; Staley, 1974, p. 34.

CONDITION NOTES: The original support is medium-weight (10 x 10 threads/cm.) linen. The tacking margins have been removed. The painting is lined with an aged aqueous adhesive and medium-weight linen. A thick white ground is present and evident in the apertures of the traction crackle. Large areas of ground have been pulled into wide crackle by the formation of the traction crackle in the paint layer. The paint is generally in poor condition. The bituminous traction crackle has tended to obscure the original brush marking and profile of the paint relief. Under ultraviolet light, retouching is evident in much of the traction crackle and in several large scratches in the neck and face area. The painting appears to have been selectively cleaned in the highlight areas.

ENGRAVINGS

1. Francis Haward (1759–1797) after Sir Joshua Reynolds, *Master Bunbury*, 1781, mezzotint, 13⅛ x 10⅞″ (33.3 x 27.6 cm.).

2. Samuel William Reynolds (1773–1835) after Sir Joshua Reynolds, *Master Bunbury*, mezzotint, 4¾ x 4″ (12.1 x 10.2 cm.).

3. John Cother Webb (1855–1927) after Sir Joshua Reynolds, *Master Bunbury*, 1908, mezzotint, 18¼ x 14⅞″ (46.3 x 37.8 cm).

4. After Sir Joshua Reynolds, *Master Bunbury*, stipple, 4¼ x 3½″ (10.8 x 8.9 cm.).

VERSIONS

1. James Northcote (1746–1831) after Sir Joshua Reynolds, *Master Bunbury*, oil on canvas, 29¼ x 24⅓″ (74.3 x 61.8 cm.), Philadelphia, Rieff Collection.
 PROVENANCE: Sir Henry Bunbury, Bart.; by descent; Christie's, June 18, 1969, lot 119, bt. Winthrop; Rieff Collection, Philadelphia.
 LITERATURE: Armstrong, 1900, p. 74; Ronald Sutherland Gower, *Thomas Gainsborough* (London, 1903), p. 90.

2. John Rising (active 1785–1815) after Sir Joshua Reynolds, *Master Bunbury*, medium, dimensions, and location unknown.
 PROVENANCE: Rising sale, Christie's, May 2, 1818, lot 105 (as "From the original by Sir Joshua, by whom this copy was highly approved").
 LITERATURE: Graves and Cronin, 1899–1901, vol. 1, p. 126.

3. After Sir Joshua Reynolds, *Master Bunbury*, medium, dimensions, and location unknown.
 PROVENANCE: Ex-collection the Earl of Arran.
 LITERATURE: Graves and Cronin, 1899–1901, vol. 1, p. 126.

4. After Sir Joshua Reynolds, *Master Bunbury*, medium, dimensions, and location unknown.
 PROVENANCE: Charles Heath Warner; Christie's, November 28, 1879, lot 86, bt. Durham.

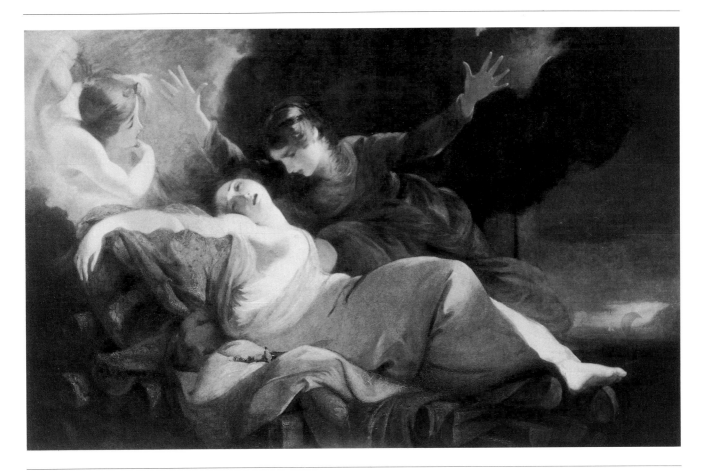

83 AFTER SIR JOSHUA REYNOLDS

THE DEATH OF DIDO, c. 1781
Oil on canvas, 58¼ x 94⅝″ (148 x 240.5 cm.)
The William L. Elkins Collection, E24-3-18

"He, who borrows an idea from an antient ... and so accommodates it to his own work, that it makes a part of it, with no seam or joining appearing, can hardly be charged with plagiarism: poets practise this kind of borrowing, without reserve" (Reynolds, Sixth Discourse).[1]

In Reynolds's view, the highest aim of painting was the representation of ideal perfection achieved both through the imitation of the great masterpieces of Western art and through familiarity with the best productions of ancient and modern poetry. Regarding the former, he told the young artist to borrow poses and gestures from earlier works in such a way that the observer would recognize the source and so associate the modern work with the masterpiece from the past. Of the latter, he advised him to educate himself so that he could choose for his subjects "events and characters so popularly known ... that they may be considered as sufficiently general for all our purposes. Such are the great events of Greek and Roman fable and history."[2]

During the decade 1770–80, Reynolds attempted to incorporate these ideas about the grand style into his portraits, first by placing his sitters in the poses of antique statues or figures on bas reliefs, and then by introducing into his portraits mythological or literary allusions.

By 1780 he must have seen that a decade of experimenting with the melding of the grand style and portraiture had produced a few great pictures but many empty ones. The time had come to apply the theories expressed in his Discourses to his work by actually painting a history picture. The subject he chose was *The Death of Dido,* the first version of which was exhibited at the Royal Academy in 1781 (fig. 83-1). *The Death of Dido* in the Philadelphia

FIG. 83-1 Sir Joshua Reynolds, *The Death of Dido,* 1781, oil on canvas, 58 x 94¼″ (147.3 x 239.4 cm.), Her Majesty Queen Elizabeth II

FIG. 83-2 Guercino (1591–1666), *Dido Transfixed
with the Sword of Aeneas*, c. 1631, oil on canvas,
113 x 131⅞″ (287 x 335 cm.), Rome, Palazzo Spada

FIG. 83-3 Guercino, *Herminia Discovering the
Wounded Tancred*, 1618–19, oil on canvas, 57 x
73½″ (145 x 187 cm.), Rome, Palazzo Doria al
Corso, Galleria Doria-Pamphili

Museum of Art is a copy of that picture, now in the collection of Her Majesty Queen Elizabeth II (version 1). The queen's picture is painted in a rich, smudgy style with Reynolds's unmistakable palette, a palette composed of wax, pigment, bitumen, and varnish. In it the figure of Dido lies against a crimson cloth flecked with gold to suggest embroidery. Anna's dress is an orange-brown color; clouds of smoke from the funeral pyre and the dramatic arch of Iris's rainbow stand out against the dark blue sky. This version is blistered and cracked in a way that marks pictures on which Reynolds himself worked.

The Philadelphia picture is very different. It is painted in blues and reds with oil colors unmixed with the artist's secret recipes for creating the mellow look of old masters. Ironically, this is because Reynolds forbade his assistants or copyists to experiment with their pigments. James Northcote recorded: "Nor would he suffer me . . . to make use of any other materials than the common preparations of colour, just as we have them from the hands of the colourman; and all varnishes, and every kind of experiment, were strictly prohibited. Likewise all his own preparations of colour were most carefully concealed from my sight and knowledge, and perpetually locked secure in his drawers."[3]

Although the picture in Philadelphia was certainly not painted by Reynolds himself, the name of the artist and the date it was executed are not known.[4] Rather than that an assistant was entrusted with the task, it is more likely that a man known to us simply as "Sir Joshua's copyist" painted our picture, and that he was not a studio assistant but an independent craftsman employed full time in making exact repetitions of Reynolds's work. Cotton (1856) quoted a letter from an unnamed correspondent to Joseph Hall, Esq., dated October 7, 1786: "I am sorry that Sir Joshua Reynolds's copyist is dead, as he was a very excellent one."[5] To make the question slightly more obscure, Reynolds may have employed more than one copyist. Northcote mentioned a "Mr. Pack, a native of Norwich, and who, from a fondness for the art, had copied many of Sir Joshua's paintings with great accuracy, having been strongly recommended to him by a friend";[6] he turned professional and traveled to Ireland in 1787 in the entourage of the Duke of Rutland.

The death of Dido is described by Virgil in the fourth book of *The Aeneid*. Aeneas, sailing from Troy to Italy where he is destined to found the Roman State, has stopped at Carthage and there fallen in love with its widowed queen, Dido. But Jove, seeing him linger with his mistress and so neglect his sacred mission, sends Hermes in a dream to instruct Aeneas to set sail. The abandoned Dido is humiliated and enraged but also frantic to keep her lover in Carthage. She sends her sister Anna to beg Aeneas to stay; rebuffed, Anna is then instructed to build a funeral pyre on which Dido heaps the arms, spoils, and gifts of the Trojans, together with the bed she shared with Aeneas. At dawn the ships depart. Vowing vengeance on the descendants of Aeneas, the tragic queen mounts the pyre and falls on his sword. In the sublime last scene, Anna rushes in to embrace her dying sister but in the emotion of the moment forgets to cut a lock of Dido's hair, before which Dido's spirit cannot be released from her body. Seeing the tragedy, Juno dispatches the goddess of the rainbow, Iris, to perform the task. Dido at last is set free:

> Downward the various goddess took her flight,
> And drew a thousand colours from the light;
> Then stood above the dying lover's head,
> And said, "I thus devote thee to the dead:

FIG. 83-4 *Cleopatra*, marble, height 63¾″ (162 cm.), length 76¾″ (195 cm.), Rome, Vatican Museum

This offering to the infernal gods I bear."
Thus while she spoke she cut the fatal hair,
The struggling soul was loosed, and life dissolved in air.[7]

The thought of painting the death of Dido may have been in Reynolds's mind since his stay in Rome in 1750–51. Of the Bolognese artist Guercino's (1591–1666) *Dido Transfixed with the Sword of Aeneas* (fig. 83-2), he noted in his diary: "[Dido] is fallen upon a pile of wood on her face, with a long sword through the body—no very agreeable picture. A woman on the left side of the picture, with her handkerchief to her eyes, is a wonderful genteel figure."[8] And on this Italian tour he also made a note on the inside back cover of his commonplace book to "Bye a Virgil."[9] The Guercino that Reynolds saw in the Palazzo Spada was a late work, in which the artist portrayed a moment of high drama and emotion with an economy of movement, gesture, and expression that is in direct contrast to his earlier style, with which Reynolds was also familiar. If we compare *Dido Transfixed* with Guercino's *Herminia Discovering the Wounded Tancred* of 1618–19, also in Rome, in the Palazzo Doria al Corso, Galleria Doria-Pamphili (fig. 83-3) and compare both with Reynolds's *Death of Dido,* it is clear that while Reynolds's iconography is the same as that of the later work, his composition depends on the earlier one.[10]

In 1938 Edgar Wind pointed out that the pose of Dido in Reynolds's painting is almost identical to that of Psyche in Giulio Romano's (or a pupil's) *Sleeping Psyche* panel in the ceiling of the Sala di Psyche in the Palazzo del Tè, Mantua, of 1528.[11] But Wind did not add that the Giulio Romano (1492/9–1546) itself looks to the famous Cleopatra in the Vatican Museum (fig. 83-4).[12] Moreover, Reynolds certainly knew the statue at first hand, and from his point of view, a reference to Cleopatra in the pose of his Dido displayed true wit, for Dido was the queen of an African empire like Cleopatra, and both women had been abandoned by their lovers. Any educated Englishman at this time would have been familiar with the statue and caught the allusion to history or myth. To "quote" the Psyche panel, on the other hand, was comparatively meaningless: the work was so obscure that far fewer Englishmen would have known it, and, indeed, there was no point in referring to Psyche's story in a painting about Dido. This is not to say that the artist did not modify the pose of the ancient statue in the knowledge of the Psyche panel, but that the latter was not his primary visual reference.

The figure of Anna is also an allusive quotation. Saxl and Wittkower state that she is based on a Magdalen figure in a *Lamentation* by Palma Giovane (1544–1628) in the Redentore, Venice—and Reynolds copied this figure in one of his Italian sketchbooks now in the British Museum.[13] But Henry Fuseli (1741–1825), who watched Reynolds paint the *Dido,* told Sir Thomas Lawrence (q.v.) in 1813 that Reynolds adapted the figure of Anna from one of the lamenting women in Daniele da Volterra's (1509–1566) *Descent from the Cross* in Trinità dei Monte, Rome (fig. 83-5).[14] In either case, Reynolds had in mind one of the attendants of the Virgin Mary at the foot of the cross, a type well known in Renaissance painting, which ultimately derives from antique maenad figures,[15] and on which even the figure of Herminia in Guercino's painting (fig. 83-3) is based. By borrowing an attitude from one master and an expression from another, then combining them to create a completely individual work, Reynolds was following the practice of the great Bolognese masters; and we should look at the *Dido* as an exercise in the Bolognese style, his last before his trips to Flanders in 1781 and 1785, when the influence of Rubens (1577–1640) began to make itself felt on his art.

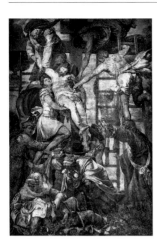

FIG. 83-5 Daniele da Volterra (1509–1566), *The Descent from the Cross,* after 1541, fresco, transferred to leather, 158 x 110″ (400 x 280 cm.), Rome, Trinità dei Monte, Orsini Chapel

FIG. 83-6 Henry Fuseli (1741–1825), *Dido on the Funeral Pyre,* 1781, oil on canvas, 96 x 72″ (243 x 183 cm.), New Haven, Yale Center for British Art

We cannot say for certain when Reynolds began to work on the first version of *Dido.* The first sketch for the figure of Iris appears on a page of the artist's sitters' book for the week of February 7–13, 1780.[16] In August of the same year, the picture must have been well under way because in the inside back cover of his ledger he made notes on pigments: "Aug. 1780 (Dido. Blue umbra. senza nero cancelled)."[17] In March 1781, Fanny Burney visited Sir Joshua: "He is preparing for the Exhibition a new 'Death of Dido.'"[18]

Two artists watched him at work on the picture and recorded their observations. Thomas Stothard (1755–1834) described how Reynolds built up a pile of fagots in the studio on which he placed a lay figure, the jointed wooden model of the human body that artists use in the absence of a human model, around which he arranged drapery to form Dido's dress.[19] Reynolds also seems to have worked from a live model. Just before the opening of the Royal Academy exhibition, on March 18 and 23, he recorded in his sitters' book appointments for Miss Eliz[abe]th Wateridge of King Street, Covent Garden.[20] As there is no portrait of this woman, and it was unusual for Reynolds to note the address of a client, she was probably a professional model, perhaps hired to pose for the expression of Dido or of Anna. The pains Reynolds took over the painting are documented by Fuseli; he wrote that he "has seen the progress of this work,—if not daily, weekly,—and knows the throes which it cost its author before it emerged into the beauty, assumed the shape, or was divided into the powerful masses of chiar'oscuro which strike us now."[21]

Since Fuseli saw the picture being painted, he was probably its first critic. His reaction was mixed: "The principal figure is the best and occupies the most conspicuous place. Riveted to supreme beauty in the jaws of death, we pay little attention to the subordinate parts, and scorn, when recovered from sympathy and anguish, to expiate in cold criticisms on their unfitness or impotence."[22] Fuseli's fascination with the figure of Dido is relevant for his own work, for the next year he was to exhibit his famous *Nightmare* (1781, 39¾ x 49″, Detroit, The Detroit Institute of Arts), in which the figure of the supine dreamer is based on Reynolds's dying queen. Fuseli then went on to criticize Reynolds for relying on Daniele da Volterra for the figure of Anna, and was particularly harsh on Reynolds for introducing the figure of Iris: "That Iris was admitted at all, without adequate room to display her, as the arbitress of the moment, may be regretted; for if she could not be contrived to add sublimity to pathos, she could be no more than what she actually became, a tool of mean conception."[23] As though to illustrate his objections, Fuseli painted his own version of *The Death of Dido* in 1781 (fig. 83-6), in which the same three characters act out the scene in a much more dramatic and violent composition.

Ironically, Reynolds himself later wrote about the propriety of introducing Iris into the subject of *The Death of Dido* in a passage deleted from the Thirteenth Discourse, delivered at the Royal Academy in December 11, 1786. There he discussed the question of how closely the painter should follow a poet's description and concluded that the artist must sometimes omit certain details, "For instance, the gaudiness of Iris, as described by Virgil, would destroy the repose of the picture, and be unsuitable to the solemnity of the subject."[24]

At the Royal Academy the painting met with a mixed critical reception, and when reading contemporary critics it is important to remember that neither the first version nor the copy now in the Philadelphia Museum of Art was sold during Reynolds's lifetime.

1. Wark, ed., 1959, p. 107.

2. Ibid., pp. 57–58 (Fourth Discourse).

3. Northcote, 1818, vol. 2, p. 21.

4. Of the men who worked in Reynolds's studio, Thomas Beach, Hugh Barron, Mr. Berridge, Thomas Clark, Mr. Dusign (or Dusine), Mr. Doughty, Charles Gill, Giuseppe Marchi, James Northcote, Mr. Parry, Mr. Score, and Peter Toms, all but Marchi had left by 1779, and the names of assistants who worked for Reynolds in the 1780s are not recorded. See Northcote, 1818, vol. 1, p. 120; Malone, ed., 1797, vol. 1, p. xliv.

5. Cotton, 1856, p. 87.

6. Northcote, 1818, vol. 2, pp. 236–37.

7. Virgil, *The Aeneid,* trans. John Dryden (London, 1884), p. 102.

8. See Leslie and Taylor, 1865, vol. 1, p. 54.

9. Reynolds's commonplace book, The Metropolitan Museum of Art Archives, New York; cited in Hilles, 1936, p. 10.

10. A version of the Guercino *Herminia* (98 x 113″) was sold at Christie's, February 27–29, 1772, lot 70, and bought for the 5th Earl of Carlisle. It is today in Castle Howard. Waagen, 1854–57, suppl. vol., p. 410, records a copy of Guercino's *Herminia* in England in the collection of Smith Barry of Marbury Hall. As a student, Reynolds is said to have been employed by Hudson in making copies of Guercino drawings. See Cunningham, 1879, vol. 1, p. 173.

11. Wind, 1938, "Attitudes," p. 183; Saxl and Wittkower, 1948, no. 64, "The Epic Style."

12. Haskell and Penny, 1981, pp. 184–87.

13. Saxl and Wittkower, 1948, no. 64; Print Room, 201.a.9., fol. 26 (L.B. 13), British Museum, London.

14. Knowles, 1831, vol. 1, p. 386.

15. Frederick Antal, "The Maenad under the Cross: 2. Some Examples of the Role of the Maenad in Florentine Art of the Later Fifteenth and Early Sixteenth Centuries," *Journal of the Warburg Institute,* vol. 1 (1937–38), pp. 70–73.

16. REY/1/19, Royal Academy, London.

17. Cormack, 1970, p. 169. On the same ledger on the back cover Reynolds wrote: "1781 Dido. oil./1781 Manner Colouri to be used [?] Indian Red Light Do. Blue Black finished with Varnish senza olio—poi relocc—con giallo." After his Italian journey Reynolds had made notes on pigments in Italian, possibly for the benefit of the assistant he brought with him from Italy, Giuseppe Marchi (1735–1808).

18. Burney, 1842, vol. 2, p. 13.

19. Leslie and Taylor, 1865, vol. 2, pp. 326–27.

20. REY/1/20, Royal Academy, London.

21. Quoted in Knowles, 1831, vol. 1, p. 386.

22. Ibid.; partially quoted in Powell, 1972, pp. 67–69.

23. Knowles, 1831, vol. 1, p. 386.

24. Cotton, 1856, p. 227.

PROVENANCE: The artist's studio; bequeathed to the Marchioness of Thomond, the artist's niece; Greenwood's, April 16, 1796, lot 67, bt. Bryant; purchased from the Bryant family by Sir Francis Bolton on behalf of Henry Graves and Co.; Christie's, February 22, 1890, lot 85, bt. Henry Graves and Co.; Charles Wertheimer; Christie's, March 19, 1892, lot 714; E. Benjamin; William L. Elkins.

LITERATURE: Malone, ed., 1797, vol. 1, p. xxxvii; Northcote, 1813, ff. p. clxxvii, "List of the Historical and Fancy Subjects"; Northcote, 1818, vol. 2, pp. 330, 347; Knowles, 1831, vol. 1, pp. 386–87; Williams, 1831, vol. 1, p. 430 (Sir Thomas Lawrence's "Address to the Students of the Royal Academy," December 10, 1823); Beechy, 1835, vol. 1, pp. 284, 289; "Sayings and Doings of Artists and Arts—No. IV," *The Literary Gazette and Journal of the Belles Letters,* no. 498 (August 5, 1826), p. 491; Waagen, 1838, vol. 2, p. 376; Burney, 1842, vol. 2, p. 13; Leslie and Taylor, 1865, vol. 1, p. 54, vol. 2, pp. 321–28, 343; Cunningham, 1879, vol. 1, p. 232, vol. 3, p. 86; London, 1883–84, pp. 22–23; Elkins, 1887–1900, vol. 2, no. 67, repro.; Claude Phillips, *Sir Joshua Reynolds* (London and New York, 1894), p. 295; Graves and Cronin, 1899–1901, vol. 4, pp. 1,453, 1,480YY–80ZZ, 1,639, no. 67; Elsa D'Esterre-Keeling, *Sir Joshua Reynolds, P.R.A.* (London and New York, 1902), p. 149; Elkins, 1925, no. 33; Whitley, 1928, vol. 2, p. 390; Wind, 1938, "Attitudes," p. 183, pl. 30b; Waterhouse, 1941, p. 72; Saxl and Wittkower, 1948, no. 64, fig. 1; Allen Staley, "The Landing of Agrippina at Brundisium with the Ashes of Germanicus," *Philadelphia Museum of Art Bulletin,* vol. 61, nos. 287–88 (1965–66), p. 17, p. 18 fig. 6; Cormack, 1970, p. 169; Bregnez, Vorlarlberger Landesmuseum, *Angelica Kauffman und ihre Zeitgenossen,* July 23–October 13, 1968, cf. no. 59b; Staley, 1974, p. 38.

CONDITION NOTES: The original support is twill-weave, medium-weight (10 x 10 threads/cm.) linen. Two recent tears extend through the lining support. One approximately 3½″ long extends under Dido's proper right arm; the other, approximately 1″ in length, is to the right of the right-hand figure. The painting is lined with an aged aqueous adhesive and medium-weight linen. A thin, white ground is present and has been applied only to the face of the original support, not to the tacking margins. The paint is in poor condition. An area of extremely wide traction crackle has formed just below the figure of Dido. An irregular web of narrow-aperture fracture crackle is present overall. Numerous small losses have occurred overall, primarily at the edges of fracture crackle. Under ultraviolet-light examination, retouching is evident around the face of the figure on the left, over some of the widest traction crackle, along the bottom of the whole image, and coincident with losses along the tacking edges.

VERSIONS

1. Sir Joshua Reynolds, *The Death of Dido*, 1781, oil on canvas, 58 x 94¼″ (147.3 x 239.4 cm.), Her Majesty Queen Elizabeth II (fig. 83-1).

PROVENANCE: Bequeathed by the artist to his niece, the Marchioness of Thomond; Lady Thomond's sale, Christie's, May 19, 1821, lot 72, bt. Sir Charles Long at the command of George IV.

EXHIBITION: London, Royal Academy, 1781, no. 160.

LITERATURE: Ear-Wig, 1781, p. 13; Pasquin, 1796, p. 67; Northcote, 1818, vol. 2, pp. 114, 121; Farington, 1819, p. 181; Beechy, 1835, vol. 1, p. 243; Waagen, 1854–57, vol. 2, p. 24; Cotton, 1856, pp. 154, 156, 198; Roberts, 1897, vol. 1, p. 98; Armstrong, 1900, pp. 121–22, 124, 239; Gower, 1902, p. 98, repro. opp. p. 98; Baldry, 1909, p. xiv, repro. p. 32; Mitchell, 1942, p. 40; London, Royal Academy, *Exhibition of the King's Pictures*, 1946–47, no. 498; Waterhouse, 1953, p. 164, pl. 137; Millar, 1969, vol. 1, p. 106, no. 1,029, vol. 2, pl. 104; Powell, 1972, pp. 67–69, p. 68 fig. 25; Waterhouse, 1973, p. 180.

ENGRAVINGS AFTER VERSION 1
Joseph Grozer, *The Death of Dido*, 1796, engraving, 28¼ x 17¾″ (71.7 x 46 cm.). Samuel William Reynolds (1773–1835), *The Death of Dido*, engraving, 8 x 5″ (20.3 x 127 cm.).

2. Attributed to Sir Joshua Reynolds, *The Death of Dido*, oil on canvas, 18½ x 28½″ (47 x 72.4 cm.), location unknown.

PROVENANCE: Frank Garrett sale, Puttick and Simpson, June 2, 1926, lot 89 (as school of Blake), bt. Morrison.

3. Attributed to Sir Joshua Reynolds, *The Death of Dido*, oil? on canvas, 23 x 40″ (58.4 x 101.6 cm.), location unknown.

PROVENANCE: H.H.J. Munro of Novar; Sir James Linton; A. T. Hollingsworth, Christie's, April 19, 1929, lot 170; R. S. Hellaby; Christie's, November 23, 1951, lot 70; Berlanny; Christie's, March 22, 1974, lot 75.

4. Attributed to Sir Joshua Reynolds, *The Death of Dido*, oil on canvas, 8 x 11½″ (20.3 x 29.2 cm.), formerly Santa Barbara Museum (stolen 1962).

PROVENANCE: John Hoppner; Christie's, May 19, 1810, lot 110 (as "the first sketch"), bt. Owen; Leggatt; W. Pelham Bullwart, Palace Court Mansions; bt. the Hurst family, in England, 1930s; gift of Paul Hurst to the Santa Barbara Museum, 1956.

5. Attributed to Sir Joshua Reynolds, *The Death of Dido*, oil on canvas, 24 x 39½″ (61 x 100 cm.), location unknown.

PROVENANCE: Charles Fairfax Murray; sale, Paris, June 15, 1914, lot 25, bt. Steltimer; Galerie Georges Petit; sale, Petit, Paris, May 4, 1921.

6. Attributed to Sir Joshua Reynolds, *The Death of Dido*, oil on canvas, 22 x 29″ (55.9 x 73.6 cm.), location unknown.

PROVENANCE: Christie's, November 28, 1947, lot 106.

7. Attributed to Sir Joshua Reynolds, *The Death of Dido*, oil on canvas, 23½ x 36″ (59.7 x 91.4 cm.), location unknown.

PROVENANCE: Maurice de Talleyrand-Périgord, Duc de Dino, 1904; his sale, Christie's, May 14, 1904, lot 115, bt. A. Smith; Norman Forbes-Robertson; Christie's, June 19, 1929, lot 90, bt. in; Norman Forbes-Robertson; Christie's, June 24, 1932, lot 95, bt. Scimgeoux.

8. Attributed to Sir Joshua Reynolds, *The Death of Dido*, oil on canvas, 41½ x 69½″ (105.4 x 176.5 cm.), location unknown.

PROVENANCE: Christie's, November 7, 1980, lot 66; Christie's, June 26, 1981, lot 140.

9. Angelica Kauffman (1741–1807) after Sir Joshua Reynolds, *The Death of Dido*, oil on panel, 18½ x 24″ (47 x 61 cm.), Suffolk, Helmingham Hall, Lord Tollemache Collection.

LITERATURE: Ellis K. Waterhouse, *The Collection of Pictures in Helmingham Hall* (Suffolk, 1958), cf. p. 44, no. 190.

10. Attributed to Thomas Stothard (1755–1834) after Sir Joshua Reynolds, *The Death of Dido*, 19½ x 23½″ (49.5 x 59.7 cm.).

PROVENANCE: Sotheby's, January 12, 1966, lot 94, bt. Pethick.

LITERATURE: Millan, 1969, vol. 1, p. 106.

DESCRIPTION: Painted proscenium arch over the design.

11. Henry Pierce Bone (1779–1855) after Sir Joshua Reynolds, *The Death of Dido*, 1804, enamel, Her Majesty Queen Elizabeth II, Windsor Castle.

PROVENANCE: Painted for the Prince of Wales.

LITERATURE: Millar, 1969, vol. 1, p. 106.

84 AFTER SIR JOSHUA REYNOLDS

LADY MONNOUX, NÉE ELIZABETH RIDDELL, after c. 1760
Oil on canvas, 29⅞ x 24⅞" (76.1 x 63.2 cm.)
The George W. Elkins Collection, E24-4-24

Although this portrait has hitherto been called "Lady Mary Nugent Temple," the picture is actually a weak copy of a portrait by Reynolds that was called "Lady Monaux, née Elizabeth Riddell" when it was sold by Sydenham Armstrong Payne, Jr., at Christie's in 1952 (fig. 84-1). This portrait shows a young lady in a white muslin dress with a blue cloak, blue ribbon around her neck with a pearl necklace, earrings, and pearls in her hair. That the Payne version was the original is not in question; the problem is which identification is the correct one.

Lady Mary Elizabeth Nugent (d. 1812) was the daughter of Robert Nugent, Earl Nugent. In 1775 she married George, 3rd Earl Temple (1753–1813). Her husband was created Marquis of Buckingham in 1784 and was twice lord lieutenant of Ireland in 1782–83 and 1787–89. In 1788 he succeeded his father-in-law as Earl Nugent, and in 1800 his wife was created Baroness Nugent of Carlanstown, county Westmeath, Ireland. In 1779 her husband assumed the additional names and arms of Nugent and Temple by royal license. Together they had two sons and one daughter. Horace Walpole, who thought Temple Nugent unfit for the office of lord lieutenant of Ireland, called him "weak, proud, avaricious, peevish, fretful, and femininely observant of the punctilio of visits and he had every one of those defects in the extreme of their natural concomitant, obstinacy. His wife had more sense with as much pride."[1]

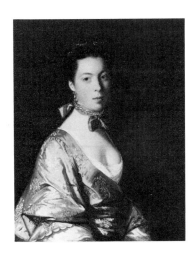

FIG. 84-1 Sir Joshua Reynolds, *Lady Monnoux,* 1761, oil on canvas, 29 x 24" (73.7 x 61 cm.), location unknown

We do not have her date of birth, but since she married Earl Temple in 1775, she is probably not the young woman represented in the Philadelphia picture, which must, on stylistic grounds, be dated to after c. 1760. Reynolds painted Lord and Lady Temple with their son in the 1780s (95 x 72″, Dublin, National Gallery of Ireland), and in this portrait the couple are still young.[2] More likely this represents Elizabeth, daughter of Ambrose Riddell of Eversholt, Bedfordshire, who on June 22, 1762, married Sir Philip Monnoux, of Sandy Place in Bedfordshire. She died at Wootton, Bedfordshire, on September 12, 1770, leaving one son and five daughters. The baronetcy of Monnoux became extinct in 1814.[3]

Reynolds painted a famous portrait of *Elizabeth Riddell* in 1776 (93 x 57″, Newcastle upon Tyne, Laing Art Gallery), but that sitter was the daughter of William Horsley Widdrington of Felton, Northumberland, who married Thomas Riddell of Swinburne Castle (1730–1798). She is not, therefore, the Elizabeth Riddell who married Sir Philip Monnoux, although they may have been distantly related by marriage.

The identification is by no means proved, especially since her date of birth is not known. But the date of her marriage ties in with the date of the portrait, the ordinary time for a young woman to sit. Stylistically, this portrait should be compared to Reynolds's *Miss Boothby* (1758, 29½ x 24¼″, San Francisco, De Young Memorial Museum).

1. For Lady Mary, see *Burke's Genealogical and Heraldic History of the Peerage, Baronetage, and Knightage,* ed. Peter Townend (London, 1970), p. 2,618, s.v. "Temple of Stowe"; for Walpole's comments see *Complete Peerage,* 1910–, p. 407, s.v. "Buckingham (town of) and Buckingham and Chandos, Marquessate."
2. Waterhouse, 1941, p. 72, pl. 218.
3. *Burke's Extinct and Dormant Baronetcies* (London, 1886), pp. 363–64, s.v. "Monnoux, of Wotton."

PROVENANCE: T. J. Blakeslee, New York, sold 1895; Bussold, Valadon and Co.; George W. Elkins, by 1899.

EXHIBITION: Philadelphia, Union League of Philadelphia, *Loan Exhibition by the Union League of Philadelphia of Paintings by Eminent Artists, Belonging to a Few Citizens of Philadelphia,* May 11–27, 1899, no. 78 (lent by George W. Elkins).

LITERATURE: Elkins, 1925, no. 32; *The Pennsylvania Museum Bulletin,* vol. 31, no. 168 (November 1935), p. 15, repro. p. 14.

CONDITION NOTES: The original support is lightweight (20 x 20 threads/cm.) linen. This was extended on three sides (left, right, and top) at a later date with a single piece of twill-weave, medium-weight linen of different density. All tacking margins are missing. The painting was lined in 1940 with an aqueous adhesive and medium-weight linen. An off-white ground is visible along the bottom cut edge. The paint is in fair condition. A fine traction crackle has formed overall, notably in the deepest shadow areas of the dress and necklace, suggesting the presence of bitumen. Retouching is visible in normal light along the join between the original support and its extension.

VERSION: Sir Joshua Reynolds, *Lady Monnaux,* 1761, oil on canvas, 29 x 24″ (73.7 x 61 cm.), location unknown (fig. 84-1).
PROVENANCE: Sydenham Armstrong Payne, Jr.; his sale, Christie's, March 28, 1952, lot 53, bt. Buttery.

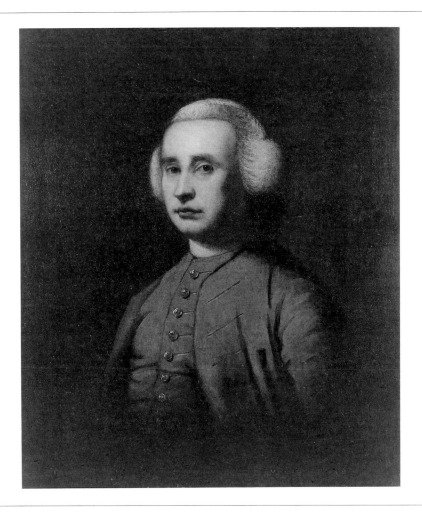

85 CIRCLE OF SIR JOSHUA REYNOLDS *RT. HON. EDMUND BURKE*, c. 1756–60
 Oil on canvas, 30¼ x 25⅛″ (76.8 x 63.8 cm.)
 John H. McFadden Collection, M28-1-30

This portrait is a problem picture. It is said to represent the statesman, orator,
and writer Edmund Burke (1729–1797), who was born in Dublin, educated
there at Trinity College, and went to London in 1750. His famous essay *On the
Sublime and Beautiful* was published in 1756, and presumably about this time
he met Reynolds, although the date of this meeting is not documented.[1]
Certainly by 1761 they were friends, because both were members of the club of
wits who assembled around Samuel Johnson at the Turk's Head Tavern in
Gerrard Street.

 Two questions are to be asked regarding the portrait under discussion.
Is it in fact Burke's portrait, and Is Reynolds the artist? If it is Burke, it is
one of the earliest portraits of him, probably painted in the mid-1750s, in
the blue-black palette and scumbled technique close to Reynolds's work at
this time. The first of the artist's many unquestioned portraits of Burke shows
him with his patron Lord Rockingham and is dated 1766–68 (unfinished,
57½ x 62⅝″, Cambridge, Fitzwilliam Museum), but there he was ten years
older, his face fleshier and more mature. Authentic portraits by Reynolds
possess a weight and a presence that the Philadelphia picture does not have.
The drawing here is weak, the figure lacks volume, and the painting of the
body and wig is flat in a way that is not characteristic of Reynolds in the 1750s
when, in some ways, he was producing his most accomplished and attractive

portraits. Then, too, the composition is perhaps more conservative than a Reynolds of the later 1750s, being more characteristic of his Devon portraits of the late 1740s.[2]

Yet, the face here could be Burke's in the 1750s, that face in which, Northcote told Hazlitt, "there was something I did not like; a thinness in the features, and an expression of *hauteur,* though mixed with condescension and the manners of a gentleman."[3] Here his coat and vest are characteristic of gentlemen's clothes in the 1750s and should be compared to the simple costume of Dr. Johnson in Reynolds's portrait of 1756/7 (48 x 43″, London, National Portrait Gallery).[4]

On balance, we can cautiously say that this is the earliest known portrait of Burke, possibly executed in Reynolds's studio, c. 1756–60.

1. Leslie and Taylor, 1865, vol. 1, p. 126.
2. Compare the reproductions in David Mannings, "The Sources and Development of Reynolds's Pre-Italian Style," *The Burlington Magazine,* vol. 117, no. 865 (April 1975), pp. 212–23.
3. Hazlitt, 1894, p. 67.
4. Waterhouse, 1941, pl. 33(A).

PROVENANCE: Rev. Charles Burney, by 1868; Mrs. Burns; bt. Agnew, 1905; bt. John H. McFadden, September 5, 1910.

EXHIBITIONS: London, South Kensington, *Exhibition of National Portraits, South Kensington,* 1868, no. 820 (as "Bust to r. light plumb coloured coat, 30 x 25 inches," lent by Rev. Charles Burney); London, New Gallery, *Exhibition of the Royal House of Guelph,* 1891, no. 318 (lent by Charles Burney, archdeacon of Kingston); New York, 1917, no. 31; Pittsburgh, 1917, no. 30; Philadelphia, 1928, p. 22.

LITERATURE: Armstrong, 1900, p. 197; Roberts, 1917, pp. 61–62, repro. opp. p. 61; Roberts, 1918, "Portraits," p. 126; Siple, 1928, p. 255; Benson, 1937, p. 7.

CONDITION NOTES: The original support is medium-weight (14 x 14 threads/cm.) linen. The tacking margins have been removed. Weave cusping is evident along both sides, suggesting that the horizontal dimension is close to the original. The painting is lined with an aged aqueous adhesive and medium-weight linen. An off-white ground is evident along the cut edges. The paint is in only fair condition. A traction crackle of fairly wide aperture is present in the highlight whites of the collar and hair. The original profile of the paint has been somewhat flattened by lining. Abrasion has occurred throughout the background to the pebbly, paste-vehicular paint; this resulted in scattered pinpoint abraded peaks at these high points in the paint profile. Under ultraviolet light, retouches are restricted to the edges and to the traction crackle in the face.

Romney was born in Beckside, near Dalton-in-Furness, Lancashire, on December 15, 1734, the third of John and Anne Romney's eleven children. His family moved to Upper Cocken when the boy was eight years old, and his father, a cabinetmaker and joiner, withdrew him at twelve from the local school at Dendron to serve at home as an assistant in the family workshop. There Romney worked with his hands until he was twenty-one, but taught himself to play the violin and to draw both from engravings and from Leonardo da Vinci's *Treatise on Painting*.

In March 1755, encouraged by neighbors, his father indentured George to a young and gifted itinerant artist, Christopher Steele (1733–1767), who had studied in Paris under Carle van Loo (1705–1765).[1] Steele could have taught the young man a great deal, but in the following year at Kendal (Westmorland County), he eloped with a local heiress, leaving his apprentice to cope with unpaid bills and irate clients. In October 1756, Romney was forced to marry a Miss Mary Abbot of Kirkland, who was expecting his child. To support her he rejoined Steele and set off to work the portrait market at York and Lancaster. At the end of 1757 they parted ways. Within a few years Romney came to realize the limitations of working in the provinces; by holding a lottery in which the prizes were his own early efforts at art, he raised one hundred pounds and set off for London on March 14, 1762. He never looked back, returning only twice to Kendal in the next thirty-seven years to see his wife and offspring before his final illness in 1799. Moreover, he told no one in London of his wife's existence, lest the marriage impede his rise to artistic and financial success.

Recognition in the capital was immediate, for in the spring of 1763 he won a premium at the Society for the Encouragement of Arts and Sciences for his *Death of General Wolfe* (location unknown), and in 1764 gained first prize for *Saint Paul Preaching to the Britons* (location unknown). Still, he felt he was barely trained, so for six weeks, in the late summer of 1764, he went to Paris, where he met Jean Baptiste Greuze (1725–1805) and the marine painter Claude Joseph Vernet (1714–1789), and admired the works of Eustache Le Sueur (1616/7–1655) in the Orléans collection.

Back in England, Romney exhibited at the Free Society of Artists until 1770, and then with the Chartered Society in Spring Gardens. The Royal Academy, founded in 1768, invited him to exhibit there, but, perversely, he never did so and never attempted to become a Royal Academician.

On March 20, 1773, traveling with the miniature-painter Ozias Humphry (1742–1810), Romney set out for Italy. In Rome he quarreled with his friend and stood aloof from the other English-speaking painters resident there, including Henry Fuseli (1741–1825) and Joseph Wright of Derby (q.v.), although he was friendly with the painter Edward Edwards (1738–1806), who is said to have turned round to him as the two men first entered the Sistine Chapel with the words, "Egad! George, we're bit!"[2] Romney went about improving his art methodically, drawing from the nude, studying pictures by Raphael (1483–1520) in the Vatican, and drawing from ancient Roman monuments. This routine he kept up in Parma and Venice, where the works of Correggio (1494–1534) and Titian (c. 1487/90–1576) deeply impressed him. After two years in Italy he returned to London by July 1, 1775, aged forty-one and penniless.

To have left London at all had taken courage, for society is apt to forget a portrait painter in his absence; but upon his return the artist did something even more daring: he took a long lease on the substantial house in which the artist Francis Cotes (1726–1770) had lived and worked. There, in Castle Street off Cavendish Square, Romney waited for clients to come, which they did, first in a trickle, and then in waves, until he found himself the rival of

Reynolds (q.v.), and even, because he undercut Sir Joshua's market by charging less, the leading portrait painter in London. As an old man, the Lord High Chancellor, Lord Thurlow (1731–1806), remembered that "at one time there were two factions contending for superiority [in London]; the Reynolds faction and the Romney faction: I was of the Romney faction."[3] Romney worked hard for his success, averaging about a portrait per day during the season,[4] and producing, especially in the years just after his return from Italy, some of the most glamorous society portraits of the eighteenth century in England.

In 1776 the dithering, well-meaning, and hopelessly inept poet William Hayley (1745–1820) took Romney up and, paradoxically, changed the course of his life and art. Not only did Hayley introduce him to a circle of literary celebrities and so stimulate the artist's interest in subjects drawn from literature, but, full of the many theories of the hierarchies of artistic creation that fascinated seventeenth- and eighteenth-century intellectuals, he urged Romney to give up or at least curtail portraiture in favor of history painting. From this time on, Romney began to produce the first of his many hundreds of drawings for historical and mythological compositions, few of which were ever translated onto canvas, but on which his reputation in the second half of the twentieth century is based.[5] For while the endless stream of smiling ladies and gentlemen continued to flow out of his studio, in these sketches, executed rapidly and spontaneously, a different world emerges, a world of extremes in which ideal pastoral subjects are countered by themes of exceptional violence and morbidity.

If, unlike James Barry (1741–1806) or Fuseli, Romney confined his imaginative subjects primarily to sketches, it is due, as Hayley says, to his "not [having] thoroughly acquired that mastery in anatomical science, which should enable a great inventive artist to draw the human figure, in all its variations of attitude, with ease and truth."[6]

Though he could not draw, his forte was the delineation of the human face, but even there the personality of the man is stamped on every picture he painted: "shy, private, studious and contemplative; conscious of all the disadvantages and privations of a very stinted education; of a habit naturally hypochondriac, with aspen nerves, that every breath could ruffle," as the poet and dramatist Richard Cumberland (1732–1811) said;[7] aloof, suspicious, and with a "perpetual dread of enemies" according to Hayley;[8] and driven to accommodate the next client and collect his fee, for Cumberland mentions that he had "the love of gain" and "no dislike to money."[9] Romney seems rarely to have tried to know the people who sat to him; instead, he gave them just what they came for, a flattering mask, which made them look more or less exactly alike. There is little doubt that Romney despised himself and his clients for the life in which they colluded together: "This cursed portrait painting!" he wrote to Hayley in February 1787, "How I am shackled with it! I am determined to live frugally, that I may enable myself to cut it short as soon as I am tolerably independent, and then give my mind up to those delightful regions of the imagination."[10]

Although he could never bring himself to stop portrait painting, its antidote for Romney was the inspiration he received from the beautiful Emma Lyon (1761?–1815), later known as Emma Hart, and later still as Lady Hamilton, whom he met in 1782. The painter fell in love with the sensual and uneducated adventuress, seeing in her, perhaps, both the iron will and vast ambition he himself possessed—and also his sense of himself as an interloper

in London society. He painted her dozens of times, as Cassandra, as Miranda, as Circe or a bacchante, in a corpus of work that forms the middle ground between the portraits he hated and the history paintings he was unable to paint.

After Emma left for Naples in 1786, he threw himself into the painting of scenes from Shakespeare for Boydell's Shakespeare Gallery. A visit to Paris in 1790, where he dined with Greuze and Jacques Louis David (1748–1825), almost revived him, but from this time on it is possible to see a decline in the quality of his work. In the 1790s he suffered several minor strokes, and although he left the Cavendish Square house in 1797 for the clearer air of Hampstead, and his later years were enlivened by his friendship with the sculptor John Flaxman (1755–1826), he never recovered. In 1799 he bought Whitestock Hall, near Kendal, where he was taken to die. He lived on in a semiconscious state until November 15, 1802.

1. See Mary E. Burkett, "A Third Portrait by Christopher Steele," *The Burlington Magazine,* vol. 119, no. 890 (May 1977), p. 347 and fig. 47.

2. Hazlitt, 1894, p. 28.

3. Beechy, 1835, vol. 1, pp. 173–74; Hayley, 1809, p. 92, also quotes Thurlow's remark, but alters it slightly.

4. Hayley, 1809, p. 92.

5. See the exhibitions at Northampton, Massachusetts, Smith College Museum of Art, *The Drawings of George Romney,* May–September 1962, and Cambridge, Fitzwilliam Museum, *Drawings by George Romney from the Fitzwilliam Museum, Cambridge,* 1977.

6. Hayley, 1809, p. 82.

7. Richard Cumberland, *Memoirs of Richard Cumberland, Written by Himself* (London, 1806), p. 464.

8. Hayley, 1809, p. 55.

9. Richard Cumberland, "Memoirs of Mr. George Romney," *The European Magazine and London Review,* vol. 43 (June 1803), p. 423; Cumberland (see note 7), p. 464.

10. Hayley, 1809, p. 123.

BIBLIOGRAPHY: Richard Cumberland, "Memoirs of Mr. George Romney," *The European Magazine and London Review,* vol. 43 (June 1803), pp. 417–23; Hayley, 1809; Romney, 1830; Gamlin, 1894; Maxwell, 1902; Gower, 1904; Ward and Roberts, 1904; Chamberlain, 1910; Waterhouse, 1953, pp. 222–25; Anne Crookshank, "The Drawings of George Romney," *The Burlington Magazine,* vol. 99, no. 647 (February 1957), pp. 43–48; Gerhard Charles Rump, *George Romney (1734–1802): Zur Bildform der Bürgerlichen Mitte in der Englischen Neoklassik,* 2 vols. (Hildesheim and New York, 1974).

EXHIBITIONS: Kenwood, The Iveagh Bequest, *George Romney, Paintings and Drawings,* 1961; Northampton, Massachusetts, Smith College Museum of Art, *The Drawings of George Romney,* May–September 1962 (by Patricia Milne-Henderson [Patricia Jaffé]); Philadelphia and Detroit, 1968; Kenwood, 1972; Cambridge, Fitzwilliam Museum, *Drawings by George Romney from the Fitzwilliam Museum, Cambridge,* 1977 (by Patricia Jaffé).

86 GEORGE ROMNEY

THE SHEPHERD GIRL (LITTLE BO-PEEP), c. 1778
Oil on canvas, 46½ x 35½" (118 x 90.2 cm.)
John H. McFadden Collection, M28-1-38

Romney is not known as a particularly sensitive painter of children's portraits, but the little girl pretending to be a shepherdess in this painting is an outstanding example of the genre, conveying as it does in the child's steady gaze a mixture of openness, vulnerability, and dignity very different from the prepared and defended face an adult sitter might present to the artist.

This solemn two- or three-year-old has the air of a city child dressed in her best frock, all blue ribbons and bows, wearing a hugely fashionable pin-tucked muslin bonnet, and in her right hand holding a toy shepherd's crook: a shepherdess quite oblivious to the lambs drinking from a spring fed by a waterfall behind her. Who she is is unrecorded. Ward and Roberts's dating of the portrait to c. 1778, that is, soon after the artist's return from Rome but before the advent of Emma Hart, accords well with the picture's sense of freshness and commitment. A comparison between *The Shepherd Girl* and the same artist's portrait of *Miss Martindale,* of 1781–82 (30 x 25", Kenwood, The Iveagh Bequest), another little girl with another lamb, shows how quickly Romney could become bored with a formula. Then, too, Romney had been friends in Rome with Joseph Wright of Derby (q.v.), and as Nicolson has pointed out, the years after 1776 are those in which Romney's influence on Wright is first strongly felt (such as *Jane Darwin and Her Son William Brown Darwin,* 1776, 30 x 25", Mrs. Richard Kindersley Collection).[1] Our portrait shows Wright's influence on Romney—in the interest in lustrous materials and the thoughtful description of the child's dress and face.

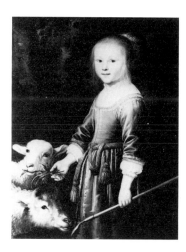

FIG. 86-1 Aelbert Cuyp (1620–1691), *Maria Stricke van Scharlaken,* 1650, oil on panel, 31½ x 24½" (80 x 61.8 cm.), London, Spink and Co., 1975

A tradition of painting adults as well as children as shepherds and shepherdesses was well established in Holland and England by the mid-seventeenth century, but by the latter half of the eighteenth century examples of such pastoral portraits were relatively rare.[2] Without suggesting that Romney was consciously reviving the lapsed seventeenth-century fashion (no adult pastoral portraits by him are known) we can nevertheless compare *The Shepherd Girl* with Aelbert Cuyp's (1620–1691) portrait of *Maria Stricke van Scharlaken,* of 1650 (fig. 86-1), Dirck Santvoort's (1610/11–1680) *Clara Alewijn as a Shepherdess,* of 1644 (48 x 35¼", Amsterdam, Rijksmuseum), or Johannes van der Stock's (active 1656) *Adriaan Pauw as a Shepherd,* of c. 1660 (fig. 86-2).[3] In none of these cases do the role and attributes of the children, the lambs and the shepherd's crook, allude to anything more than the virtue of innocence as symbolized by Cesare Ripa in the *Iconologia.*[4] Likewise, we should take the accouterments in Romney's portrait in the same spirit as we take the use of Van Dyck dress in a Gainsborough or a Reynolds (q.q.v.): a dressing up, a slight removal from the present, a glamorization of a straightforward portrait.

Obvious as this sounds, it is worth stressing, since in the 1770s in England a new kind of children's portraiture arose, which had little to do with this Northern tradition, and which would dominate the way nineteenth-century artists perceived and responded to child sitters. This other tradition can be seen in certain of Gainsborough's fancy pieces and in a Reynolds such as *A Shepherd's Boy,* of 1772 (76 x 63", Viscount Halifax Collection, in 1944). These pictures are related to precedents in Mediterranean sacred art and, as Waterhouse has shown, owe much to the influence of Murillo's (1617/8–1682) *Good Shepherd,* known in the later eighteenth century through Jean Grimou's (1680–1740) copy and the engraving after it by Thomas Major.[5] Though at first glance these pictures represent tattered beggar children and hungry shepherds, they actually idealize and, indeed, Christianize their subjects, who

FIG. 86-2 Johannes van der Stock (active 1656), *Adriaan Pauw as a Shepherd,* c. 1660, oil on canvas, 28½ x 22¾" (72 x 58 cm.), The Hague, Pauw Collection

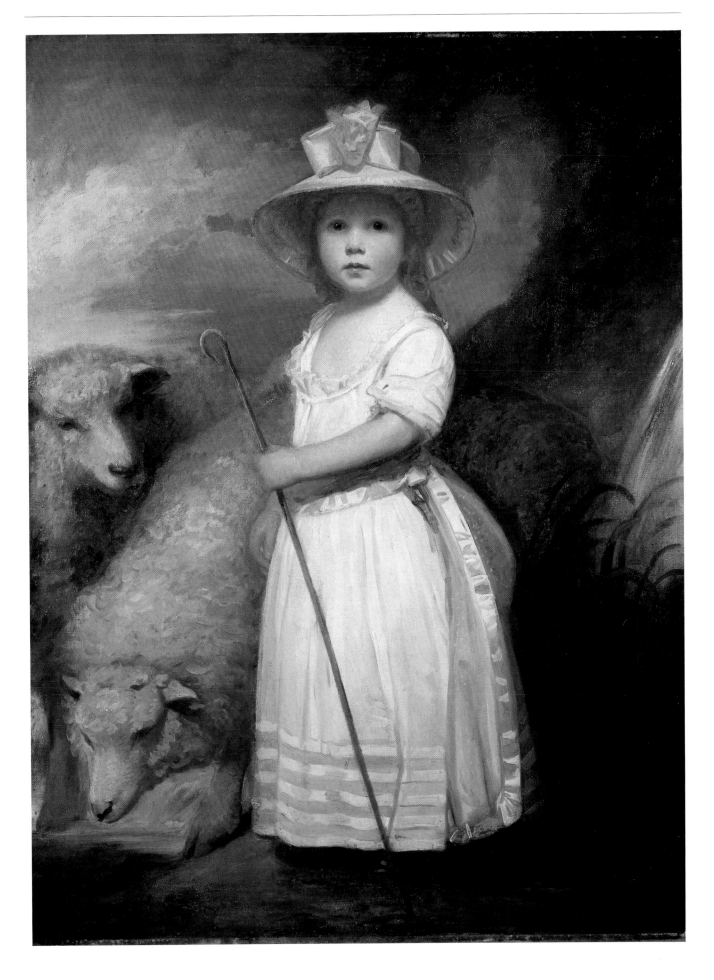

begin to take on the aspects of saints by Carlo Dolci (1616–1686), with all the sweetness that name implies. This is a far cry from Romney's unsentimental record of simplicity and innocence, but one that was to have a profound effect on English artists of the following century.

The title by which this painting has been known since 1885, "Little Bo-Peep," is not necessarily original. There is no recorded reference to the nursery rhyme before the nineteenth century. We therefore cannot assume the title is contemporary with the painting of the picture; the first reference to "Little Bo-Peep" appeared in print in the 1810 edition of *Ganner Gurton's Garland, or the Nursery Parnassus*.[6] This does not prove that the poem was not known before 1810, for nursery rhymes were passed on in an oral tradition for centuries before being written down, but in previous editions of *Ganner Gurton's Garland*, in 1784 and 1799, "Little Bo-Peep" does not appear, indicating, perhaps, that it was a recent composition, or at least not generally known before the edition in 1810. The possibility that our portrait illustrates "Mary Had a Little Lamb" must be ruled out because that rhyme was written in 1830 (by Sarah Joseph Hale [1788–1879] of Boston).[7]

1. Nicolson, 1968, vol. 1, p. 68.
2. Alison McNeil Kettering, *The Dutch Arcadia: Pastoral Art and Its Audience in the Golden Age* (Montclair, New Jersey, 1983).
3. See also Peter Lely's (q.v.) *Henry Sidney as a Shepherd* (1650s, 65 x 49″, Kent, Penshurst Place, Viscount De L'Isle), repro. in London, National Portrait Gallery, *Sir Peter Lely, 1618–80*, 1978 (by Oliver Millar). Examples by Thomas Hudson (1701–1779), Kneller, Reynolds, and Wright of Derby (q.q.v.) can also be cited.
4. In the edition of Cesare Ripa, *Iconologia* (Venice, 1669), p. 286, the emblem for innocence is described as a young girl with a garland of flowers on her hand and a lamb in her arms.
5. Ellis K. Waterhouse, "Gainsborough's 'Fancy Pictures,' " *The Burlington Magazine*, vol. 88, no. 519 (June 1946), p. 137, p. 141 pl. IIIB.
6. "Little Bo-Peep has lost her sheep, / And can't tell where to find them; / leave them alone, and they'll come home, / And bring their tails behind them."
7. Iona Opie and Peter Opie, *The Oxford Dictionary of Nursery Rhymes* (1951; rev. ed. Oxford, 1977), p. 94.

PROVENANCE: Mr. Edwin Humby, by 1885; Sir Hugh Lane; Agnew, 1914; bt. John H. McFadden from Agnew, October 18, 1916.

EXHIBITIONS: London, Royal Academy, winter 1885, no. 24 (as "Little Bo-Peep," lent by Edwin Humby, Esq.); New York, 1917, no. 40, fig. 40; Pittsburgh, 1917, no. 38; Philadelphia, 1928, p. 22; Philadelphia, Pennsylvania Museum, *Children Through the Centuries*, May 7–June 8, 1932; Philadelphia, Philadelphia Museum of Art, *100 Years of Acquisitions*, May 7–July 3, 1983.

LITERATURE: Maxwell, 1902, p. 171, no. 28; Gower, 1904, p. 112; Ward and Roberts, 1904, vol. 2, p. 192 no. 54; Roberts, 1917, p. 77, repro. opp. p. 77; Roberts, 1918, "Additions," pp. 113–14; Roberts, 1918, "Portraits," p. 130; C. H. Collins Baker and Montague R. James, *British Painting* (London, 1933), p. 114, pl. 79 opp. p. 120; Staley, 1974, p. 34.

CONDITION NOTES: The original support is twill-weave, medium-weight (10 x 10 threads/cm.) linen. The tacking margins have been removed. The painting is lined with an aged aqueous adhesive and medium-weight linen. An off-white ground is evident through the thinnest areas of paint as well as along the cut edges. The paint is in fair to good condition. An extensive, wide-aperture, irregular web of traction crackle is present throughout the brown tones of the foliage behind and to the right of the figure. A wide-aperture fracture crackle is present in the face, bodice, and proper left arm of the figure and appears to be consistent with the heaviest application of paint in the highlight features of those areas. Abrasion is evident in the mid-tone details of the face, hair, and dress. The overall profile of the paint relief is low and has been preserved. Under ultraviolet light, retouching is extensive throughout the background and appears to be associated with areas of heaviest traction crackle.

87 GEORGE ROMNEY

LADY GRANTHAM, 1780–81
Oil on canvas, 46½ x 39″ (118 x 99 cm.)
Inscribed at right: *Mary Jemima 2nd Daughter Marchioness Grey and Wife of Thomas Lord Grantham*
John H. McFadden Collection, M28-1-36

"I had heard of Lord Grantham's match," wrote Horace Walpole to the Countess of Ossory on June 29, 1780, "and suppose he has contracted some Spanish ideas, and minds blood more than beauty." Five months later, on November 26, he wrote again to the same correspondent revising his opinion of the new Lady Grantham, whom he had just met at the house of Lady Holdernesse: "As she is not *my* wife, I really think her very tolerable. She was

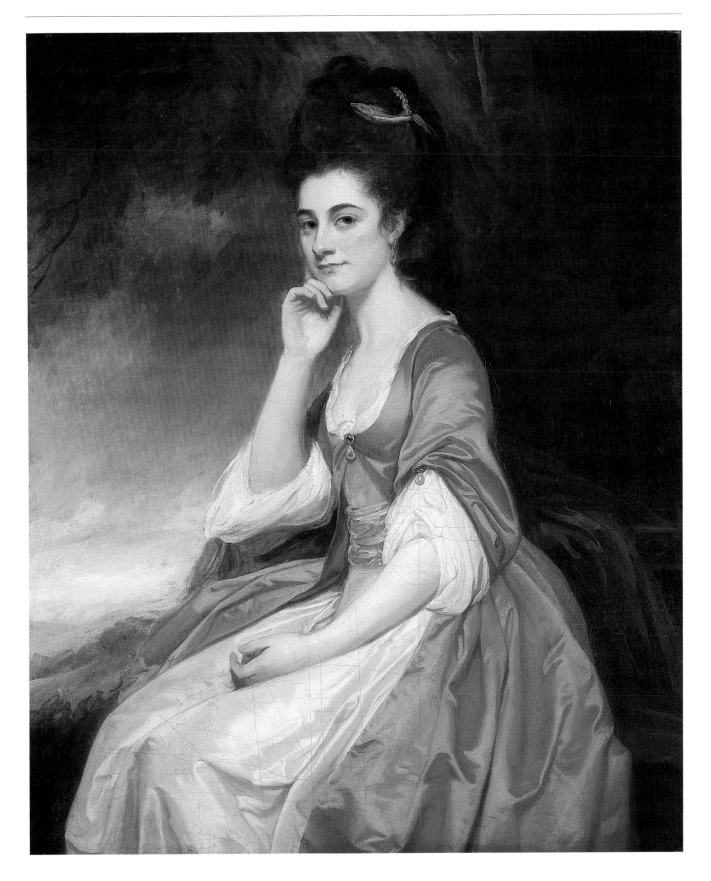

well dressed, behaved like a human creature, and not like her sister or a college-tutor."[1] The lady of whom Walpole thus grudgingly approved was Lady Mary Jemima Yorke (1756–1830), who, as the daughter of Philip, 2nd Earl of Hardwicke, and Jemima, *suo jure* Marchioness Grey and Baroness Lucas of Crudwell, had indeed blood blue enough for the proudest Spanish grandee and who, since her father had no sons, was also a great heiress. Her sister was Amabel Hume-Campbell, Lady Polwarth (1751–1833), later Baroness Lucas of Crudwell and Countess de Grey of Wrest.

Thomas Robinson, 2nd Lord Grantham (1738–1786), whom Lady Mary married on August 17, 1780, soon after Walpole's first letter, had just returned from his post as ambassador to the court of Spain (1771–79), hence Walpole's allusion to "Spanish ideas." In the year of his marriage he became 1st Lord of the Board of Trade and in 1782 would become secretary of state for foreign affairs in the administration of Lord Shelburne (1737–1805), in which capacity he helped the prime minister conduct negotiations leading to the Treaty of Paris (1783) by which the thirteen colonies formally gained their independence. He died, aged forty-eight, on July 20, 1786, after only six years of marriage, leaving his widow with three children, Thomas (1781–1859), Frederick (1782–1859), and Philip (1783–1794).[2] A portrait of him as a young man in his twenties on the Grand Tour is in the Philadelphia Museum of Art in Nathaniel Dance's (q.v.) *Conversation Piece* (no. 22), where he is seated in the center.

Lady Grantham was painted in six sittings between December 1780 and March 1781 to commemorate the marriage of Lord and Lady Grantham. A pendant, showing Lord Grantham seated in his study with the Escorial in the distance, was painted between January and June 1781.[3]

In her portrait Lady Grantham sits facing left, her right hand at her cheek, her dark hair piled high and entwined with pearls. The russet, autumnal colors of the background set off the deep red of the satin overdress covering her white satin gown, or in eighteenth-century terminology, petticoat.

The background of the picture's commission is exceptionally well documented in the Wrest Park papers in the Bedfordshire Record Office.[4] A series of letters between Mary, her mother the Marchioness Grey, and her sister, Lady Polwarth, reveal how complicated the calculations involved in an eighteenth-century arranged marriage could be. Mary (or Mouse, as she was called by her family), although prettier than her older sister Amabel, was proving hard to marry off when, in 1780, Thomas Robinson appeared on the scene. At twenty-four she had received only one offer, and that from a younger son whose inheritance of a title and fortune depended, as her mother explained, "on...the poor Elder Brother really [going] off soon in an Apoplexy."[5] This was too chancy for the Yorke family, and yet other offers from men of very high rank "seem to have no sort of Intention to come."[6] Robinson, by contrast, had almost everything to recommend him—station, character, and disposition—and yet he lacked that one asset vital to a young girl's happiness. About this Lady Polwarth was blunt: "I am sorry that the Fortune of the Gentleman should turn out so much less than was probably imagin'd," for "a *little more* would not have been l'Embarass de Richesses."[7] Still, he was a peer, and this was a great comfort to the marchioness, who knew what she wanted for her daughter: "I readily own my Love for a *Peerage*."[8] Besides, Grantham was by no means penniless, and did own a town house in Whitehall with good china, furniture, and plate, plus a charming country house, Newby Park (today known as Baldersby Park) in Yorkshire. True, the marchioness thought he had "*Something like Gout*," to which Amabel replied, "We agree...in being sorry for the Gout almost as sorry as for the

small Estate."[9] But in the eyes of society the match was ideal. The old marchioness light-heartedly observed, "It seems...as if the World thought it were *All* to Marry him, for I have not heard that it has struck any Body He might be too *Old* for Her."[10] But in the end the family came round, partly because the couple seemed so happy together, with Mary showing "a Preference Visibly for his Company, at least I hope so, & he certainly is a very Lively & Amusing Companion...And with so great a share of Frankness & *Sincerity* of Manner....It must be an absolute Glacier of Reserve & Froideur on her side not to become soon at Ease."[11]

The marriage took place at Lord Hardwicke's house in St. James Square on August 17, 1780. The couple spent their honeymoon at Newby and made plans to improve the house and landscape the grounds. But soon, in October 1780, they went south to London where Mary prepared for her first London season as a peeress. While she was waiting for her Whitehall house to be refurbished, she set about buying clothes for her presentation at court, for her mother explained to her that she "could not properly appear anywhere else till that is done."[12] A series of letters to her mother and sister that autumn document Mary's shopping expeditions in minute detail. On November 1, for example, she wrote to Amabel: "Mama came again this morning & we proceeded to Mr. King's [of the firm of Henchcliffe and King, a fashionable mercer] with an intention to get a slight White and Silver to be trimmed with all the usual appurtenances; but behold! no such thing would we find that was ready at present....Mr. Van Sommer's [Van Sommer, a designer as well as a mercer] Shop was ransacked with no better success & at last after a 2[d] jaunt to King's he promised to try if a slight white & Gold could be ready for the beginning of next week; if not, I must take a white satin to be trimmed."[13] At last, however, Mr. King produced enough silk for the petticoat. However, in November a relation of Grantham's, Mrs. Aislabie, died, and so Mary was presented at court in white and gold with black ornaments and a black ribbon and cap.

All this is pertinent partly because we can presume that Mary is wearing a dress from her trousseau in the Romney portrait of her ("be so good as to tell her [mama] I fetched home my Purple Sattin from Mr. King's which seems to answer very well"),[14] and also because at the very moment when she was buying these clothes she was sitting for that portrait. It is a telling comment on the relative importance of having one's portrait painted versus dressing correctly in the eighteenth century that in dozens of letters taken up with the minutiae of dress, Mary refers to her portrait only twice, and then casually. On January 7, 1781, she asked Amabel to "tell Mama I set to Romney tomorrow with my Hair out of Powder,"[15] and on February 26 she wrote, again to her sister, "what with going out to set for my Picture in the morning, & going to the Opera at Night, it was out of my power to find time to finish a letter."[16]

The history of the picture is also well documented and deserves extended consideration because it is closely bound up with the history of the family descended from the sitter. The portrait passed to Lady Grantham's eldest son, Thomas Philip Robinson, 3rd Baron Grantham, who succeeded his maternal aunt Amabel as 2nd Earl de Grey of Wrest, and as Baron Lucas of Crudwell. With this title came a great house, Wrest Park at Silsoe, Flitton, in Bedfordshire, which he rebuilt after his own designs between 1834 and 1839. There the picture, with its pendant showing Lord Grantham, together with a good collection of portraits by Kneller, Reynolds, Gainsborough (q.q.v.), and Van Dyck (1599–1641) remained until this century. In 1859 both pictures passed from Thomas Philip Robinson's daughter Anne Florence (Pammy) de Grey (1806–1880), Dowager Countess Cowper, to her son Francis Thomas de Grey

(1834–1905), 7th Earl Cowper and 7th Baron Lucas of Crudwell of Panshanger, lord lieutenant of Ireland from 1880 to 1882. Finally, it descended to his nephew, Auberon Thomas (Bron) Herbert (1876–1916), under secretary of state for war and under secretary of the colonies during the Liberal government before World War I. He was killed in action in November 1916.

As a child Lady Grantham appeared with her sister in Joshua Reynolds's (q.v.) double portrait of *The Ladies Amabel and Mary Jemima Yorke* (1760, 76¾ x 67″, Cleveland, Cleveland Museum of Art).

1. Horace Walpole, *Letters Addressed to the Countess of Ossory from the Year 1769 to 1797*, ed. R. Vernon Smith, 2nd ed. (London, 1848), vol. 1, p. 419, vol. 2, p. 7.
2. G[eorge] F[isher] R[ussell] B[arker], *Dictionary of National Biography*, s.v. "Robinson, Thomas"; and the *Complete Peerage*, 1910–, vol. 6, pp. 83–84.
3. Ward and Roberts, 1904, vol. 2, p. 64, no. 2 under Lord Grantham, as measuring 49 x 39½″. Probably the picture sold at Christie's, November 23, 1973, lot 105, bt. Douglas, measuring 37 x 45″. A copy is at Newby Hall, Ripon, Yorkshire. Another copy, by Harrison, was sold out of the Wrest Collection in 1917.
4. Deposited by Lady Lucas. All references to these papers are prefaced by an L. Also in Joyce Godber, "The Marchioness Grey of Wrest Park," *The Bedfordshire Historical Record Society*, vol. 47 (1968).
5. The Marchioness Grey to Lady Polwarth, June 19, 1780, L30/11/122/247.
6. Lady Polwarth to the Marchioness Grey, June 22, 1780, L30/9/60/232.
7. Ibid., and June 29, 1780, L30/9/60/233.
8. The Marchioness Grey to Lady Polwarth, June 26, 1780, L30/11/122/249.

9. Ibid., June 19, 1780, L30/11/122/247, and Lady Polwarth to the Marchioness Grey, June 22, 1780, L30/9/60/232.
10. The Marchioness Grey to Lady Polwarth, June 26, 1780, L30/11/122/249.
11. Ibid., June 24, 1780, L30/11/122/248.
12. The Marchioness Grey to Lady Grantham, October 20, 1780, L30/13/9/21.
13. Lady Grantham to Lady Polwarth, November 1, 1780, L30/11/240/16.
14. Ibid., January 9, 1781, L30/11/240/11.
15. Ibid.
16. Ibid., February 26, 1781, L30/11/240/14.

PROVENANCE: By descent to Auberon Thomas Herbert, 8th Baron Lucas of Crudwell and 11th Baron Dingwall, 1905; A. H. Buttery, 1916; Agnew; bt. John H. McFadden, October 12, 1916.

EXHIBITIONS: New York, 1917, no. 35; Pittsburgh, 1917, no. 34; Philadelphia, 1928, p. 19.

LITERATURE: Ward and Roberts, 1904, vol. 2, p. 64 (as measuring 57½ x 44¼″); Roberts, 1917, pp. 69–70, repro. opp. p. 69; Roberts, 1918, "Additions," pp. 108, 113, p. 109 fig. 1; Roberts, 1918, "Portraits," p. 130; Joyce Godber, "The Marchioness Grey of Wrest Park," *The Bedfordshire Historical Record Society*, vol. 47 (1968), p. 108, after p. 40, pl. VI (Newby Hall version).

CONDITION NOTES: The original support is twill-weave, medium-weight (10 x 10 threads/cm.) linen. The tacking margins have been removed. The painting is lined with an aged aqueous adhesive and medium-lightweight linen. A white ground has been thickly and evenly applied. The paint is in fairly good condition. An irregular web of fracture crackle of a wide aperture is prominent in the area of the proper left arm and shoulder. Visible in normal light are several pentimenti, including changes to the dress profile on either side, the shape of the sitter's proper left shoulder, and the shape of the hair. Under ultraviolet light, retouching is visible in small areas of the hair and the background around the face and at the left of the sitter's head.

VERSION: After George Romney, *Lady Grantham*, a later copy, oil on canvas, 52¼ x 44¾″ (132.7 x 113.7 cm.), Yorkshire, Newby Hall, Robert Compton.

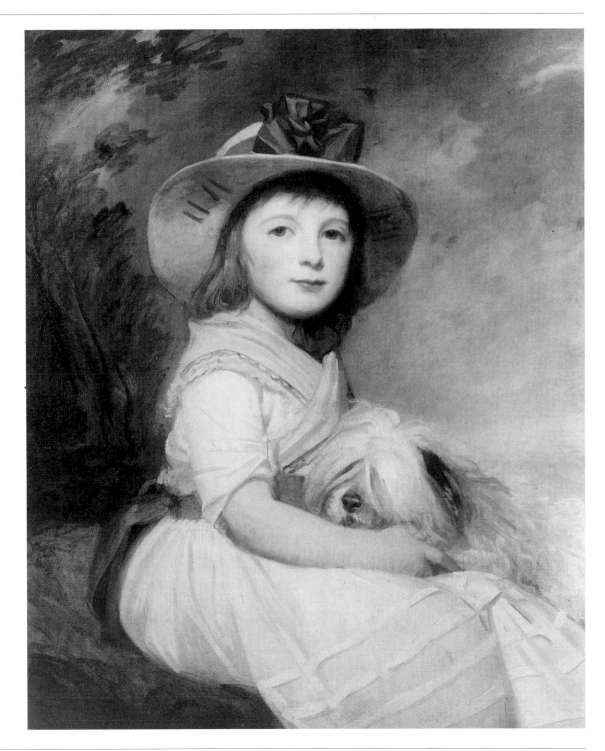

38 GEORGE ROMNEY

MARIANNE HOLBECH, 1781–82
Oil on canvas, 30 x 25″ (76 x 63.7 cm.)
The George W. Elkins Collection, E24-4-25

Marianne Holbech (pronounced Hole-beach), the daughter of William
Holbech of Farnborough Hall, Banbury, Warwickshire,[1] was born in
November 1777, and was christened Mary Ann after twin sisters who had died
in infancy (she changed the spelling of her name in later life).[2] In the portrait,
the five-and-a-half-year-old girl sits facing us, a long-haired Scottish terrier in
her lap. She wears a short-sleeved muslin dress, tied with a wide green sash.
Around her shoulder is pinned a yellow shawl and on her head is a

wide-brimmed leghorn straw hat tied under her chin and decorated with a dark green bow to match her sash. The effect of the hat and the shawl framing her smart, sharp (but not pretty) face is to suggest the precocity and alertness we know she possessed.

In an unfinished attempt to write her autobiography in December 1838, Marianne, as an old woman, looked back on "A Life of Blessings." She described growing up at Farnborough:

> To my 10th year, a happy, well ordered childhood, my affection for Henry [her brother] & my imaginative plays with Charles [another brother] stand out prominently—at 11 until 14 a kind simple minded governess; within that period are the first recollections of pleasure in reading—many of the imaginations connected with the schoolroom reading have stuck by me this life—At 15 the first vivid pleasure in Shakespeare (Hen[ry] 5) & the beginnings of painstaking independent self-education, great enjoyment in the sense of opening & improving faculties, many pleasant readings with Henry, much friendship at Walton [Walton Hall, seat of the Mordaunt family, whose eldest son Charles she was to marry]—After at times dissipated by society, & by being admired etc., but I *think* (without speaking certainly) not very often or exclusively engaged by it, & generally valuing liberty of mind & time above every pleasure.[3]

To the end of her life Marianne read widely, particularly in philosophy and religion, even having a dab at chemistry and mineralogy. Marianne found that, contrary to her early prejudices, women were better off in life when educated: "I once doubted whether a much refined & cultivated education in women conduced to happiness . . . but under experience of the great & lengthened trials of life, I am quite enlightened on the subject & perceive that every power of the mind can be called in at different moments & will conduce to good & happiness in proportion to its sound & solid cultivation."[4] She was also an accomplished amateur artist in watercolor. Paul Oppé, in his catalogue of English drawings at Windsor Castle, singled out her "well-chosen subjects, assured and easy drawing and delicate washes, [which] are excellent examples of the amateur skill of the period, and . . . show the advantage of a restricted medium."[5]

The Holbech family seems to have had only a conventional interest in the arts, although in the dining room at Farnborough hung panels by Canaletto (1697–1768) and Panini (c. 1692–1765/8). Each year, however, they traveled to London for a few months of parties, shopping, and the theater. In 1781 they set out on March 17, as we know from Marianne's father's household account book, and returned around the end of May.[6] This account book records, among the bills for toys, tooth powder, corks, buckles, and toothpicks, several payments on April 6 and May 26 for "a *Picture*." This entry probably does not refer to our portrait of Marianne, but to an addition to the Holbech collection of contemporary or old master paintings. Marianne sat to Romney only once in 1781, on May 17, as Romney's sitters' book records. The portrait was not painted until the following spring when, in March 1782, she sat five times, and in April, once. On October 10, 1782, Romney noted that he was paid twenty-one pounds for the portrait and eight shillings for the case and packing. William Holbech's household account book records a payment on October 21, 1782, to "Romney, for Mary Anne's picture, £21 8s.6d."[7]

Marianne's later life was a happy one, although tinged from her early youth with misfortune. At seventeen her beloved sister Emma died, aged

seven, and after this Marianne began to nurse her mother through an illness that was not to end until Mrs. Holbech's death in 1830. At twenty-two Marianne began an attachment with Charles Mordaunt (1771–1823) of Walton Hall, Warwickshire, which culminated in their marriage on January 29, 1807, when she was twenty-nine. Charles had asthma and suffered from gout and frequent headaches. And although she seems to have been devoted to him, she was not unaffected by his morbid depressions. He was, she wrote, "(alas! for him) a spoiled child."[8] Still, Marianne herself wrote after he died on May 30, 1823, that "our mutual attachment was no common one."[9] They had three children, John (b. 1809), Mary (b. 1811), and Emma (b. 1813), and she lived to 1842, though her last years were clouded by poor eyesight and other infirmities.

1. The Holbech family is said to have come from Holbeach County, Lincoln, to North Warwickshire in the late fifteenth century. They acquired Farnborough Hall in 1684. For the house, see Nikolaus Pevsner and Alexandra Wedgwood, *The Buildings of England: Warwickshire* (London and Beccles, 1966), pp. 292–93. Farnborough was rebuilt after 1684; its north side dates from 1750.
2. Hamilton, 1965.
3. Lady Mordaunt, "The Retrospect of a Life of Blessings," December 1838, CR 1368, Warwickshire County Record Office, Shire Hall, Warwick. Extracts from this passage are quoted in Hamilton, 1965, p. 253.
4. Hamilton, 1965, p. 254.
5. A[dolf] P[aul] Oppé, *English Drawings: Stuart and Georgian Periods, in the Collection of His Majesty the King at Windsor Castle* (London, 1950), p. 76.
6. Holbech of Farnborough, William Holbech's household account books (3) 1771–82, CR 1799/1, Warwickshire County Record Office, Shire Hall, Warwick.
7. Ward and Roberts, 1904, vol. 2, pp. 78–79.
8. Quoted in Hamilton, 1965, p. 234.
9. Ibid., p. 253.

INSCRIPTION: *1781–82,* / *Sometime in 1782 Romney painted the portrait of Mary Anne Holbech* / *(afterwards Lady Mordaunt)* / *—who was born 1777. See entry in her father's account—* "*1782* / *Oct: 21 Romney for Mary Anne's picture 21.8.6.* / *It was paid for, being sent home* / *10 Oct.* / *CWH*" [on an old label pasted onto the canvas].

PROVENANCE: William Holbech, Esq.; by descent to Lt. Col. W. H. Holbech, Farnborough Hall, Banbury, in 1904; C. J. Wertheimer, 1908; George W. Elkins.

EXHIBITIONS: Berlin, Königliche Akademie der Künste, *Ausstellung aelterer Englischer Kunst,* January–February 1908, no. 43 (lent by C. J. Wertheimer); Philadelphia, 1928, p. 17; Philadelphia, Pennsylvania Museum, *Children Through the Centuries,* May 7–June 8, 1932.

LITERATURE: Ward and Roberts, 1904, vol. 2, pp. 78–79; Elkins, 1925, no. 34; *The Pennsylvania Museum Bulletin,* vol. 27, no. 149 (May 1932), repro. p. 155; Elkins, 1935, p. 17.

CONDITION NOTES: The original support is twill-weave, medium-weight (14 x 14 threads/cm.) linen. The tacking margins have been removed. The painting is lined with an aged aqueous adhesive and lightweight linen. An off-white ground has been thinly and evenly applied. The paint is generally in only fair condition. A traction crackle seems to be associated with the use of dark brown pigment. Fracture crackle tends to run parallel with the diagonal twill pattern and is most obvious in the background at the right of the figure. Under ultraviolet light, retouching is evident in traction crackle in the left background and in a line of paint loss at the left of the figure's shoulder.

VERSION: After George Romney, *Marianne Holbech,* oil on canvas, dimensions unknown, Warwickshire, Banbury, Farnborough Hall.

89 GEORGE ROMNEY

LADY HAMILTON AS MIRANDA, 1785–86
Oil on canvas, 14⅛ x 15½″ (35.5 x 39.4 cm.)
John H. McFadden Collection, M28-1-34

In 1786 at a dinner in Romney's house in Cavendish Square, with the poet William Hayley, and the printseller Alderman John Boydell (1719–1804), a plan for a gallery devoted entirely to the exhibition of paintings with Shakespearean subjects was first discussed.[1] On November 4 of that year at the Hampstead house of Boydell's nephew Josiah Boydell (1762–1817), the same group—with Benjamin West (1738–1820), Paul Sandby (q.v.), and other artists—met to give shape to the idea: John Boydell would commission the pictures from English artists, thereby freeing them from the fetters of portrait painting; he would then make his profit from the price of admission to the gallery and from the sale of subscriptions to an edition of engravings after the pictures.[2]

Romney had already painted subjects from Shakespeare several times in his career,[3] and for a fee of six hundred guineas he agreed that the picture on which he was then working, or about to begin work, *The Tempest*, should go to Boydell.[4] Apparently no work in oils was done until the summer of the next year, 1787, when, Hayley tells us, in a studio on the grounds of Hayley's country house at Eartham in Sussex, Romney "formed, on a very large canvas, the first sketch of his scene from the Tempest."[5]

Even at this early stage, however, some observers doubted that the artist would carry off so complicated a picture because, as one of his biographers bluntly concluded, "Romney must be classed with the illiterate."[6] Lord Thurlow, on hearing news of the project from Rev. Thomas Carwardine in November 1787, retorted, "By God, he'll make a balderdash business of it."[7] And the same man told the artist himself, "Mr. Romney, before you paint Shakespeare, I advise you to read him."[8]

Lord Thurlow's misgivings were justified; Romney was no history painter. The picture, which was finished only in 1790 and which measured fifteen feet three inches by nine feet ten and a half inches, has been destroyed (formerly Bolton, Lancashire, Mere Hall Art Gallery); but from the engraving it is clear that its composition was labored and confused and the figures badly drawn (fig. 89-1). When exhibited, it met with critical opprobrium. The artist Joseph Farington (1747–1821) noted in his diary on July 17, 1794, that the entrepreneur Bowyer "is afraid of employing Romney, on acct. of the unpopularity of his Tempest picture in the Shakespeare gallery."[9]

Traditionally, this portrait has been called *Emma Hart (Lady Hamilton) as Miranda in "The Tempest,"* shown at the moment in act 1, scene 2, when she begs Prospero to spare the sailors whom he has shipwrecked in a storm that he has magically raised: "If by your art, my dearest father, you have / Put the wild waters in this roar, allay them." But it is probable that the sketch inspired the picture rather than representing any stage in the development of the picture's composition. In proposing a chronology for the numerous studies for *The Tempest*, we begin with the Philadelphia sketch.

So vivacious is this portrait of Emma Hart (1761?–1815) that it must have been painted from life, that is, in the years between Romney's first meeting with her early in 1782 and her departure from London for Naples on March 14, 1786. In these four years the artist painted his model frequently—in fact obsessively—making an exact date for the Philadelphia sketch hard to fix. Still, its easy, accomplished authority suggests a deep familiarity with the subject and therefore a dating toward the later part of the period. It may even be one of the sketches Romney dashed off in the weeks just before Emma's departure when, from January 5 to March 8, 1786, she sat to him at least fifteen times.

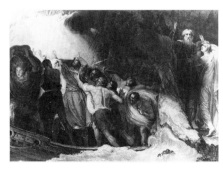

FIG. 89-1 B. Smith after George Romney, *The Tempest*, c. 1790, engraving, 17¼ x 23¼″ (43.8 x 59 cm.), Bolton, Bolton Art Gallery

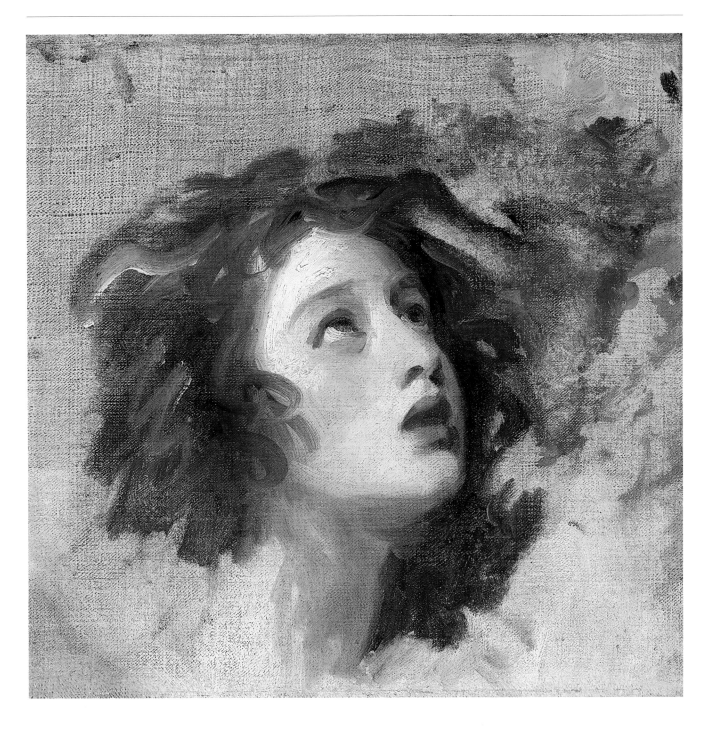

FIG. 89-2 George Romney, *The Tempest: Miranda and Prospero*, pencil on laid paper (verso), 15⅜ x 17⅞″ (39.1 x 45.5 cm.), Cambridge, Fitzwilliam Museum

FIG. 89-3 George Romney, *The Tempest: Miranda and Prospero with Caliban and Ariel*, wash over pencil on laid paper, 15⅜ x 17⅞″ (39.1 x 45.5 cm.), Cambridge, Fitzwilliam Museum

FIG. 89-4 George Romney, *The Tempest: Shipwreck*, brush and wash over pencil on laid paper, 14⅞ x 20½″ (37.9 x 52.2 cm.), Cambridge, Fitzwilliam Museum

Certainly he began the great canvas in which Miranda is the central figure in the months just after Emma's departure, and in part to console himself for the loss of his favorite model. What we do not know is how far the design had evolved before the Boydell Shakespeare Gallery was thought of in November 1786, although John Romney stated that his father had begun work on *The Tempest* before that date and that the original composition (presumably March–November 1786) showed only Miranda, Prospero, and Caliban, "three figures not sufficiently combined."[10] This early stage is represented by two drawings in the Fitzwilliam Museum, Cambridge—the first showing Miranda and Prospero (fig. 89-2), the second the same pair with Caliban crouching between them (fig. 89-3). In both drawings Miranda stands to the left of her father, facing right, with the storm and shipwreck barely indicated by a few swirls of the pencil in the background on the left.

With the birth of the Boydell project, the purpose and destination of the picture altered. The interfering Hayley now opined that this intimate human drama was not a subject elevated or compelling enough for exhibition in a public gallery. He encouraged the artist to alter it drastically, to make it more of a history picture.[11] This entailed removing the figure of Caliban and enlarging the canvas at the left to include a shipwreck in the foreground. The new design can be seen in figure 89-4, where Miranda, still facing right as in the Philadelphia sketch, pleads with Prospero, who is now seated deep in his cave. At the left, a second struggle now takes place, this one physical, as Ferdinand leaps overboard while sailors prevent King Alfonso of Naples, his father, from following him. From then on the subject of the picture was primarily a shipwreck, not Miranda's pleading.[12] Many more drawings for *The Tempest* are known, not all of which can be listed here. But in five more studies in the Fitzwilliam Museum (see fig. 89-5), one in the National Gallery of Canada at Ottawa, one in the British Museum, London, and in a finished oil sketch in the Galleria Nazionale d'Arte Moderna in Rome, Miranda stands to the right of her father, facing left.[13] All other known oil sketches of the head of Miranda, such as figure 89-6, show her facing left and are therefore studies for, or after, this second stage in the design. This means that they were not painted from life and explains their murky, lifeless quality, a quality of pseudospontaneity in which, we must presume, the finished picture was drenched.

The difference between the Philadelphia sketch and the finished canvas (see fig. 89-1) might symbolize the way in which eighteenth-century art theory inhibited and stifled George Romney, for in attempting to conform to other men's notions—which in time became Romney's own—he lost whatever was unique in his own perception of the world and so ceased to be a real artist. On the other hand, another aspect of these same theories of art are, in part, responsible for the brilliant success of the first oil sketch, and so should be discussed here.

As a young man, Romney had studied Roger de Piles's *Art of Painting* (London, 1706) and Charles Le Brun's *Method to Learn to Design the Passions* (London, 1734), both of which stress the importance for the artist of studying and accurately painting the effects of strong emotion on the human face. In reading these authors and also Charles Alphonse Dufresnoy's *Art of Painting* (London, 1695), Romney was by no means alone: Sir Joshua Reynolds (q.v.) throughout his Discourses relied on and referred to their theories, calling the expression of the passions "the most essential part of our art." After Reynolds had provided the preface to William Mason's 1783 translation of Dufresnoy, in 1787 Romney actually planned but never published a rival edition translated by Hayley.[14]

FIG. 89-5 George Romney, *The Tempest: Shipwreck*, pen and wash and ink over pencil on laid paper, 12¼ x 16½″ (31.2 x 42 cm.), Cambridge, Fitzwilliam Museum

FIG. 89-6 George Romney, *Miranda*, oil on canvas, 12½ x 11¼″ (31.7 x 28.6 cm.), Iran, private collection

FIG. 89-7 Lady Hamilton's Attitudes, from Frederick Rehberg, *Drawings Faithfully Copied from Nature at Naples* (London, 1794), plate 4

A more immediate and personal influence on Romney's work was his friendship with Richard Payne Knight (1750–1824), whom he met in Italy in 1772–75. The connoisseur, archaeologist, and philologist who was to write *An Inquiry into the Principles of Taste* (London, 1830), began a discussion with Romney about the passions and how the artist should classify and respond to them. In a long letter to the artist dated November 24, 1776, and published in John Romney's biography of his father, Knight outlined these theories. He divided the human mind into four faculties: senses, memory, reason, and passions. The last faculty he divided into the primary passions (pride, anger, love, envy, sorrow, and fear); the secondary passions (a blend of the primary passions—thus jealousy is formed by a mixture of love and pride and fear); and finally the reflex passions, or our responses to the feelings of others (pity and sympathy). He wrote: "It is to these reflex passions that the painter, as well as the musician, must attend. He must endeavour to give those casts of features and positions of limbs, that are expressive of the passions he wishes to transfuse into the breast of the spectator. This is only to be acquired by a long and accurate study of nature. He must discover the physical effects of each particular passion upon the human frame, and the particular forms or faces that are more or less subject to such passions."[15] The problem for the painter, of course, was to find an opportunity to observe the physical effects of passion long enough to record them. One solution was to attend the theater, and it is no accident that Romney, like Reynolds, moved in theatrical circles. Best of all was to have an actor or actress sit for one, as Reynolds had Garrick or Mrs. Kemble, and Romney, John Henderson (1747–1785) and Emma Hart.

Emma was not exactly an actress, just as she was not exactly a prostitute. Whether or not, as the legend has it, she started her career posing as Hebe Vestina, the rosy goddess of Health, in Dr. Graham's Temple of Health at the Adelphi, she might easily have gone on stage had she not been taken up and kept by a string of protectors. When her lover Charles Greville (1749–1809) brought her to Romney's studio in 1782, she found an outlet for her histrionic ability. At this first meeting, life, in the dazzling form of Emma Hart, collided with art, in the shape of the shy and neurotic Romney, and resulted in one of the most famous and fruitful partnerships in the history of art. Romney seized on Emma's natural beauty and talent for acting, encouraging her to express the gamut of emotions from surprise to joy to rage, and then turned the sketches he made of her into fancy pictures showing characters as diverse as Saint Cecilia and Medea.

As the suppliant Miranda, her eyes brimming with tears, her lips moist and parted, her hair disheveled, Emma exhibits a mixture of pity and fear (secondary passions) and so affects us, ideally, with sympathy (a reflex passion). In later life Emma was to use the skills practiced in Romney's studio under his supervision to create her famous Attitudes: a cross between the *tableau vivant* and pantomime, which she developed in Naples and gave in private performances throughout Europe and England.[16] In them, Emma portrayed classical heroines like Agrippina with the ashes of Germanicus using only a few props, such as an antique vase or a chair, and dressed in a loose classical chemise and a shawl (fig. 89-7). When performing her Attitudes, she apparently never spoke, relying instead on expression and gesture to convey the meaning. Goethe's description of them, written from Naples on March 16, 1787, underlines how they developed naturally from her posing sessions in Romney's studio: "Dressed in this [Greek costume designed for her by Sir William], she lets down her hair and, with a few shawls gives so much variety to her poses, gestures, expressions, etc., that the spectator can hardly believe his eyes. He sees what thousands of artists would have liked to express realised

before him in movements and surprising transformations—standing, kneeling, sitting, reclining, serious, sad, playful, ecstatic, contrite, alluring, threatening, anxious, one pose follows another without a break."[17]

John Romney connected *The Tempest* with "the manner of Correggio," and one can see in the Philadelphia sketch how Emma's soft, yielding, yet rosy beauty could have elicited from the artist memories of the pictures he had admired in Parma in 1775. But the portrait should also be compared to the sentimental maidens in the canvases of the French artist Jean Baptiste Greuze (1725–1805), whom Romney met on his visit to Paris in 1764, and whom he met again on his Parisian visit of 1790.[18] That the Englishman sought Greuze out and dined with him on this visit indicates how important an influence the French artist was for him.

In the light of Emma's subsequent fate, Romney's decision to paint her as Miranda in the opening act of *The Tempest* is one of the little ironies of history. In 1786 the impoverished Greville dispatched his Miranda to Naples to the care of his elderly uncle Sir William Hamilton (1730–1803), ambassador to the court of Naples. A kindly widower and scholar (an archaeologist and volcanologist), Sir William could easily have been cast in the role of the magician Prospero. He took Emma in, first, as his mistress, later, in September 1791, as his wife. As the wife of the British minister to Naples during the first decade of the Napoleonic Wars, and as the intimate friend of the Bourbon Queen Caroline, Marie Antoinette's sister, Lady Hamilton played her part in, and perhaps influenced, the history of Europe. Then, to complete the (imperfect) analogy to the story of *The Tempest*, Admiral Horatio Nelson (1758–1805), like Ferdinand in Shakespeare's play, sailed into the Bay of Naples and won Emma's heart. Their love affair, apparently condoned by Sir William, was the talk of Europe and lasted until Nelson's death at the battle of Trafalgar in 1805. By that time Romney, the Caliban of the story, was also dead. There is little doubt that he had always loved Emma but never possessed her. His hundreds of portraits of her, of which Miranda is one of the finest, must, finally, be seen as his way of holding on to this remarkable woman.

1. Hayley, 1809, pp. 106–9.
2. Friedman, 1976, p. 3 and passim.
3. Romney, 1830, pp. 24–25.
4. Ibid., pp. 151ff.
5. Hayley, 1809, pp. 125–27.
6. Cunningham, 1879, vol. 2, p. 151.
7. Hayley, 1809, pp. 127–28.
8. Ibid., p. 131.
9. Farington Diary, [1793], July 17, 1794.
10. Romney, 1830, p. 153.
11. Ibid.
12. Another reason for the change in emphasis may well have been due to the horrifying wreck of the East Indiaman *Halswelle* on January 6, 1786, off the Dorset coast with a loss of nearly four hundred crew and passengers—an event that caught contemporary imagination like the sinking of the *Titanic* has in this century, and so made the idea of a shipwreck picture far more topical (Whitley, 1915, p. 253).
13. These drawings have been analyzed by Milne-Henderson [Jaffé] in the introduction to the exhibition *The Drawings of George Romney* held at the Smith College Museum of Art, Northampton, Massachusetts, May–September 1962; by Frederick J. Cummings, in Philadelphia and Detroit, 1968, no. 35; and in London, Royal Academy and Victoria and Albert Museum, *The Age of Neo-Classicism*, September 9–November 19, 1972, nos. 226, 772–78.
14. Whitley, 1928, vol. 2, pp. 88–89.
15. Romney, 1830, p. 323.
16. Kenwood, 1972, passim.
17. Quoted in Kenwood, 1972, no. 44, p. 38.
18. In 1789 Mrs. Lock wrote to Fanny Burney that engravings after Greuze were to be found in the shops of London printsellers. See Victoria Caetani, the Duchess of Sermoneta, *The Locks of Norbury* (London, 1940), p. 45.

PROVENANCE: By descent to the artist's great-grandson, Whitestock Hall, England, 1875; his aunt, Miss Elizabeth Romney; her sale, Christie's, May 25, 1894, lot 188, bt. Agnew; Tankerville Chamberlayne, M.P., Cranbury Park, Southampton; Agnew and P. and D. Colnagni (joint), 1903; bt. John H. McFadden, December 12, 1907.

EXHIBITIONS: London, British Institution, 1864, no. 130 (lent by Rev. John Romney); New York, 1917, no. 36; Pittsburgh, 1917, no. 35; Philadelphia, 1928, p. 20; Northampton, Massachusetts, Smith College Museum of Art, *The Drawings of George Romney*, May–September 1962, no. 108 and introduction; Philadelphia and Detroit, 1968, no. 35; Kenwood, 1972, no. 18; Edmonton, Edmonton Art Gallery, *Leader of My Angels: William Hayley and His Circle*, September–October 1982, no. 86.

LITERATURE: Hayley, 1809, pp. 125–36, cf. repro. opp. p. 141; Romney, 1830, p. 265; Horne, 1891, p. 44 no. 54, p. 45 no. 58; Maxwell, 1902, pp. 184–85 nos. 273 and 274 (the same picture), and cf. repro. between pp. 100–101; Gower, 1904, p. 122, cf. repro. in unnumbered pages; Ward and Roberts, 1904, vol. 1, title page, vol. 2, p. 184 no. 18b; Chamberlain, 1910, repro. opp. p. 234, pp. 318–19 (as "Lady Hamilton as 'a Child'"); Roberts, 1917, p. 71, repro. opp. p. 71; Roberts, 1918, "Portraits," pp. 128, 130; Kirsten Gram Holmström, *Monodrama, Attitudes, Tableaux Vivants: Studies on Some Trends of Theatrical Fashion, 1770–1815* (Stockholm, 1967), p. 136, fig. 52; Gerhard Charles Rump, *George Romney (1734–1802): Zur Bildform der Bürgerlichen Mitte in der Englischen Neoklassik* (Hildesheim and New York, 1974), vol. 1, p. 130, vol. 2, fig. 61 (as "Lady Hamilton as a Child"), and cf. fig. 62; Friedman, 1976, pp. 128–33, fig. 29.

CONDITION NOTES: The support consists of medium-weight (10 x 10 threads/cm.) linen with a ¼″ strip of similar fabric butt-joined along the bottom edge, held in place only by the lining. Cusping is visible across the top edge of the support. According to Siegl, in 1967: "The painting came to us relined with a 4″ addition at the bottom . . . the strip at the bottom, while clearly added at a later date, is probably a section from the same canvas in a different position and it carries unrelated brushwork." At that time all but ¼″ of the bottom strip of fabric was removed and the painting was wax-resin lined with medium-weight linen. A recent examination of photographs taken before the added piece of support was cut down suggests that it had originally run vertically along the left side and was a continuous part of the original support; the cusping and threads match exactly. An off-white ground is present, visible through the thinnest areas of paint or where no paint was applied. It is substantially abraded overall, revealing the support. The ground has been darkened by the infusion of wax-resin adhesive. The paint is generally in only fair condition. Abrasion to the mid-tone areas of face details is evident, as well as to a large area of hair above and to the right of the face. Paint texture has been flattened by lining. The painting was cleaned in 1967 by Siegl, who reported removing retouchings. Retouching is evident under ultraviolet light in small areas on or about the face and along the bottom edge of the composition.

VERSIONS

1. George Romney, *Miranda*, oil on canvas, 12½ x 11¼″ (31.7 x 28.6 cm.), Iran, private collection (fig. 89-6).
 PROVENANCE: Rev. Wray Hunt, Trowell Rectory, Nottingham; M. G. Benjamin; Sotheby's, March 17, 1971, lot 76; J. McKenzie; Sotheby's, January 26, 1972, lot 50; Sabin.
 EXHIBITIONS: London, Royal Academy, *Old Masters*, 1895, no. 37; Kenwood, 1972, no. 19.
 LITERATURE: Ward and Roberts, 1904, vol. 2, p. 187, no. 36.
 DESCRIPTION: Head to left.

2. George Romney, *Miranda,* oil on canvas, 12½ x 10½" (31.7 x 26.7 cm.), location unknown.

PROVENANCE: Rev. Wray Hunt, Trowell Rectory, Nottingham; Scott and Fowles, New York, 1927; Esther Slater Kerrigan, New York; her sale, Parke-Bernet, January 10, 1942, lot 276; Mme Rossetta Reine; Christie's, June 23, 1978, lot 146.

EXHIBITION: London, Royal Academy, *Old Masters,* 1895, no. 21.

LITERATURE: Ward and Roberts, 1904, vol. 2, p. 187, no. 35.

DESCRIPTION: Head to left.

3. George Romney, *Miranda,* oil on canvas, 16½ x 15" (41.9 x 38.1 cm.), location unknown.

PROVENANCE: Christie's, November 24, 1972, lot 113 (with provenance, exhibition history, and literature as per the Philadelphia sketch).

DESCRIPTION: Head to left.

4. George Romney, *Miranda,* oil on canvas, dimensions and location unknown.

LITERATURE: Illustrated in Gower, 1904 (unpaginated).

DESCRIPTION: Head to left.

5. George Romney, *Miranda,* oil on canvas, 19½ x 15½" (49.5 x 39.4 cm.), location unknown.

PROVENANCE: Richard Johnson, Manchester; Mrs. R. J. Walker; Morton; Morton sale, Christie's, June 8, 1928, lot 126 (as "in blue and white drapery"); bt. Cochrane.

LITERATURE: Possibly Ward and Roberts, 1904, vol. 2, p. 184, no. 18f.

DESCRIPTION: Head and shoulders to left.

6. George Romney, *A Magdalene,* oil on canvas, 16 x 18" (40.6 x 45.7 cm.), location unknown. Photograph: London, Witt Library.

PROVENANCE: Hoskier sale, New York, March 2–8, 1914.

DESCRIPTION: Head and shoulders to left. Possibly identical with version 5.

7. George Romney, *Miranda,* oil on canvas, 18¾ x 15½" (47.6 x 39.4 cm.), formerly in the collection of Mrs. O. Maund.

LITERATURE: Ward and Roberts, 1904, vol. 2, p. 184 no. 18g.

DESCRIPTION: Head and one shoulder to right.

ENGRAVING: T. G. Appleton, mezzotint, 15 x 18" (38.1 x 45.7 cm.).

8. George Romney, *Miranda,* oil on canvas, dimensions and location unknown.

PROVENANCE: Romney sale, May 10, 1834, lot 91 (as head of Miranda "printed probably in 1788"); Lord Lansdowne.

EXHIBITION: According to Ward and Roberts, 1904, vol. 2, p. 184, this version was exhibited in Birmingham in 1888, no. 211.

LITERATURE: Mrs. Anna Jameson, *Companion to the Most Celebrated Private Galleries of Art in London* (London, 1844), p. 330, no. 167 (as "A Head of Lady Hamilton—as a Bacchante. A slight, but very animated and masterly sketch. B." [Lansdowne Collection]); Ward and Roberts, 1904, vol. 2, p. 184 no. 18a.

9. George Romney, *Miranda,* medium, dimensions, and location unknown.

PROVENANCE: William Hayley; bequeathed to John Flaxman.

LITERATURE: Ward and Roberts, 1904, vol. 2, p. 184 no. 18c.

ENGRAVINGS: Caroline Watson (1760/61–1814), 1809, stipple, 7⅜ x 7" (18.7 x 17.8 cm.). C. Tomkins, 1897, mezzotint, 7⅝ x 9" (19.4 x 22.9 cm.).

DESCRIPTION: Head and left shoulder to left with flash of lightning in the background.

10. George Romney, *Miranda,* oil on canvas, 17½ x 14½" (44.4 x 36.8 cm.), location unknown.

PROVENANCE: Isaac Slater, 1837; James Hughes Anderdon; his sale, Christie's, May 31, 1879, lot 226; Agnew; E. G. Coleman, 1904.

EXHIBITION: London, Royal Academy, *Old Masters,* 1873, no. 5.

LITERATURE: Ward and Roberts, 1904, vol. 2, p. 184 no. 18d.

DESCRIPTION: Head and one shoulder to right.

ENGRAVING: Joseph W. Slater, 1857, lithograph (to left); 5⅜ x 4¾" (13.6 x 12 cm.).

11. George Romney, *Miranda,* oil on canvas, 17¼ x 14½" (43.8 x 36.8 cm.), location unknown.

PROVENANCE: Henry Howard sale, Christie's, June 18, 1898, lot 81; Allantini; Christie's, June 13, 1913, lot 115; T. J. Blakeslee, New York; Blakeslee sale, American Art Galleries, New York, April 22, 1915, lot 167 (sold with lithograph by J. W. Slater [not described]).

LITERATURE: Ward and Roberts, 1904, vol. 2, p. 184 no. 18e.

12. George Romney, *Miranda,* oil on canvas, 21½ x 16½" (54.6 x 41.9 cm.), location unknown.

PROVENANCE: Jeffrey Whitehead, 1889; Sir R. Harvey, Langley Park, Slough.

EXHIBITION: London, Grosvenor Gallery, 1889, no. 7.

LITERATURE: Ward and Roberts, 1904, vol. 2, p. 184 no. 18f.

ENGRAVING: Jounard, 7¾ x 6½" (19.7 x 16.5 cm.).

90 GEORGE ROMNEY

HON. MRS. BERESFORD, C. 1785
Oil on canvas, 30⅛ x 24¾″ (76.5 x 62.9 cm.)
The George W. Elkins Collection, E24-4-26

John Beresford (1738–1805), second son of Marcus, 1st Earl of Tyrone, Member
of Parliament for county Waterford in Ireland from 1760 to 1805, married as
his first wife Annette Constantia de Ligondes, in November 1760.[1] In October
1772 she died in her ninth confinement, leaving her husband with nine
children, the eldest only eleven years old. Two years later, in June 1774,
Beresford married one of the most celebrated beauties of her time, Barbara
Montgomery (1757–1788), the second of the three daughters of Sir William

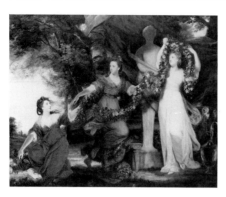

FIG. 90-1 Sir Joshua Reynolds (q.v.), *The Graces Decorating a Term of Hymen*, 1773, oil on canvas, 92 x 114½" (234 x 295 cm.), London, Tate Gallery

Montgomery. Known as the "Irish Graces," the sisters had appeared in Reynolds's (q.v.) famous *Graces Decorating a Term of Hymen*, in 1773 (fig. 90-1), exhibited at the Royal Academy in 1776 and at once widely known through engravings.[2] There sixteen-year-old Barbara, her figure already full, is shown kneeling at the left over a flower basket, and at the same time turning to her sisters, Anne (later the Marchioness Townshend) and Elizabeth (afterward Lady Mountjoy) to proffer a garland, which they offer up hopefully to the god of marriage.

By marrying Beresford, Barbara became the wife of the most powerful man in Ireland. In 1780 he was appointed chief commissioner of revenue there; and when William Pitt the Younger (1759–1806) became prime minister of England in 1783, Beresford was, according to his entry in the *Dictionary of National Biography,* "practically entrusted with the management of Irish affairs, and his advice guided Pitt in his whole policy towards that country." Unfortunately for the history of that country, he was implacably opposed to Irish claims for a greater measure of self-government. On the other hand, his activities as a builder and town planner transformed Dublin into one of the most beautiful cities in Europe; its wide streets, Georgian squares, and several of its largest buildings, such as the Customs House (1781–91), were built by him.

Mrs. Beresford seems to have lived a quiet life. She had five daughters and three sons and helped to raise her husband's nine children by his first marriage—acting as a mother, therefore, to seventeen children. Perhaps as a result of this experience, she was known to friends as "the Barb," and died young, at age thirty-one, in 1788.

Ward and Roberts list two portraits of Mrs. Beresford in Romney's sitters' books. The first, painted in 1779, shows the lady seated to the right, her left elbow on a balcony, her hand to her cheek. The second, which her husband paid for in 1785, shows Mrs. Beresford and a daughter. The Philadelphia picture is not recorded in Romney's sitters' book but is listed for the first time in Frances Gerard's *Some Celebrated Irish Beauties of the Last Century* (London, 1895) as being in the possession of a Barré Beresford in 1895.[3]

The date of the portrait in Philadelphia is hard to fix with accuracy, but the mid-1780s accords well with the sitter's matronly appearance and with her presence in London about that time for sittings for Romney's double portrait of her with her daughter.

1. T[homas] F[inlayson] H[enderson], *Dictionary of National Biography,* s.v. "Beresford, John." See also William Beresford, ed., *The Correspondence of the Rt. Hon. John Beresford, Illustrative of the Last Thirty Years of the Irish Parliament* (London, 1854), vol. 1, pp. viii–xx.
2. Davies, 1959, p. 79.
3. p. 287.

PROVENANCE: J. B. Beresford; sold by Beresford in the Bridport sale, Christie's, July 13, 1895, lot 74, bt. Charles Wertheimer; Lt. Col. Frank Shuttleworth, Old Warden Park, Biggleswade, Bedfordshire; Christie's, May 6, 1905, lot 130; bt. Sulley and Co.; M. Knoedler and Co., 1912; George W. Elkins.

EXHIBITIONS: New York, M. Knoedler and Co., *Exhibition of Old Masters for the Benefit of the Artists' Fund and Artists' Societies,* January 1912, no. 32; Philadelphia, 1928, p. 17.

LITERATURE: Romney, 1830, p. 198; Gamlin, 1894, p. 330; Frances Gerard, *Some Celebrated Irish Beauties of the Last Century* (London, 1895), p. 287; Ward and Roberts, 1904, vol. 2, p. 11 n.; O'Donoghue, 1908–25, vol. 1, p. 173 no. 3; Elkins, 1925, no. 36; Elkins, 1935, p. 17.

CONDITION NOTES: The original support is twill-weave, medium-weight (10 x 10 threads/cm.) linen. The tacking margins are missing. The painting is lined with an aged aqueous adhesive and medium-weight linen.

An off-white ground is partially visible through the thinnest areas of paint and through areas of abrasions. The paint is in fair to good condition. The original profile varies from moderate to low relief and has been flattened somewhat by lining. Accumulated grime in the paint interstices has accentuated the twill pattern of the support in the paint film. An irregular web of wide-aperture fracture crackle is prominent in the areas of heaviest paint, including the whites of the dress and collar. A wide-aperture traction crackle is also present in the brown tones of the background and shadow areas of face and hair. Retouching is visible in the traction crackle and in losses along the edges.

91 GEORGE ROMNEY

MRS. CHAMPION DE CRESPIGNY, 1786–90
Oil on canvas, 51⅛ x 40″ (130 x 101.5 cm.)
John H. McFadden Collection, M28-1-32

On January 20, 1783, Dorothy Scott (1765–1837) of Betton Strange, Salop,
became the fourth wife of Philip Champion de Crespigny (1738–1803) of
Hintlesham Hall near Ipswich, Suffolk, King's Proctor, Member of Parliament
for Sidbury (1774–80) and for Alborough (1780–90), and high sheriff of
Breconshire (1796). Her husband already had eight children by his previous
wives, and Dorothy bore him three children, George (1783–1813), a major in
the army killed at the siege of San Sebastian in Spain; Eliza (1784–1831), who
became the wife of the 1st Baron Vivian; and Charles (1785–1875), through

whom our picture descends. After her husband's death she married in 1804 as his second wife Sir John Keane (1757–1829), of Belmont, county Waterford, Ireland, and by him had one son, Lt. Col. George Keane (1805–1880). She died on July 5, 1837. This Mrs. Champion de Crespigny (pronounced de *Crepp* -ni) should not be confused with her more famous sister-in-law, the wife of Sir Claude Champion de Crespigny, born Mary Clarke (d. 1812), who figured in London's literary, theatrical, and social circles in the 1790s.[1]

Mrs. de Crespigny sat to Romney on March 20 and 28, 1786, and on March 17, 1790. The Philadelphia picture was sent home on April 14, 1790. The sitter is shown in a half-length format which became fashionable only in the 1780s. She is out of powder, sitting in a park, one gloved hand resting on her lap, the other, ungloved, under her chin.

1. As does O'Donoghue, 1908–25, vol. 2, p. 26. For the other Mrs. de Crespigny see "Some Account of Mrs. Crespigny," *The European Magazine and London Review,* vol. 46 (December 1804), pp. 402–8.

PROVENANCE: Philip Champion de Crespigny; Charles James Fox Champion de Crespigny, the sitter's son; by descent to G[eorge] H[arison] C[hampion] H[olden] de Crespigny, in 1901; Edwardes; his sale, Christie's, April 27, 1901, lot 95, bt. Agnew; bt. John H. McFadden, June 1, 1901.

EXHIBITIONS: London, Grafton Galleries, *Exhibition of a Special Selection from the Works by George Romney, Including a Few Portraits of Emma, Lady Hamilton, by Other Artists,* 1900, no. 18; New York, 1917, no. 32; Pittsburgh, 1917, no. 31; Philadelphia, 1928, p. 20.

LITERATURE: Lionel Cust, "The Romney Exhibition at the Grafton Gallery," *The Magazine of Art,* August, 1900, p. 452; Robert C. Witt, "Romney's Portraits at the Grafton Gallery," *The Nineteenth-Century and After,* vol. 49, no. 289 (March 1901), p. 526; W. Roberts, "The Collector: Art Sales of the Season," *The Magazine of Art,* October 1901, p. 556, repro. p. 557; "In the Sale Room," *The Connoisseur,* vol. 1 (September–December 1901), p. 43, repro. p. 43; Maxwell, 1902, p. 93; Ward and Roberts, 1904, vol. 1, repro. between pp. 28–29, vol. 2, p. 36; Chamberlain, 1910, p. 391; Roberts, 1913, p. 540; Roberts, 1917, pp. 65–66, repro. opp. p. 65; Roberts, 1918, "Portraits," p. 128, repro. p. 131.

CONDITION NOTES: The original support is twill-weave, medium-weight (10 x 10 threads/cm.) linen. The tacking margins have been removed. Weave cusping is evident in the support along all four edges, suggesting that the painting is close to its original format. The painting is lined with an aged aqueous adhesive and medium-weight linen. The white ground has been evenly and thickly applied. The paint is in good condition. Much of the original profile of the paint and brush marking has been preserved. There is wide traction crackle in the dark red of the background. A wide aperture, irregular web of fracture crackle is present overall and especially evident in the blacks of the dress. A pentimento to the hair is visible in normal light. Under ultraviolet light, retouching is visible along both sleeves, in the bodice, and in losses along the cut edges.

ENGRAVING: W. Henderson, *Mrs. de Crespigny,* mezzotint, 14⅞ x 18⅞" (37.8 x 47.9 cm.). Published: June 1903.

92 GEORGE ROMNEY

PORTRAIT OF A LADY, c. 1786
Oil on canvas, 30⅛ x 25¼″ (76.6 x 64.1 cm.)
Bequest of George D. Widener, 72-50-2

The sitter must remain unidentified for the present. A date about 1786 is acceptable in terms of the boldness and freedom of Romney's draftsmanship and the style of the lady's fashionable black bonnet. X-radiographs of the portrait reveal a number of major pentimenti in the area around this bonnet (fig. 92-1).

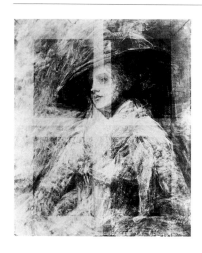

FIG. 92-1 X-radiograph of *Portrait of a Lady*, Philadelphia Museum of Art, Conservation Department, 1981

INSCRIPTION: Royal Academy exhibition label for 188[6], faded and defaced, mostly illegible, except for the title of the work which reads: [?]*phia* [Sophia?] /*gh* [?] / *F* [?]; various inventory or warehouse stickers [on the back of the stretcher]; *894* [incised on frame].

PROVENANCE: Alfred de Rothschild, by 1886; George D. Widener, until 1972.

EXHIBITION: London, Royal Academy, *Exhibition of Works by the Old Masters, and by Deceased Masters of the British School*, winter 1886, no. 29 (as "Portrait of a Lady, Half figure, in front, three-quater profile to r.; white dress, large hat with black and white feathers; sky background," lent by Alfred de Rothschild).[1]

1. Not included in the catalogue of the Rothschild collection (Charles Davis, *A Description of the Works of Art Forming the Collection of Alfred de Rothschild* [London, 1884]). Nor is this portrait mentioned in articles about the Rothschild collection: "Mr. Alfred de Rothschild's Collection," *The Art Journal*, 1885, pp. 216–19, 240–44; or Paul Villars, "La Collection de M. Alfred de Rothschild," *Les Arts*, 1902, pp. 4–14, 15–23.

LITERATURE: Ward and Roberts, 1904, vol. 2, p. 189 no. 7; "La Chronique des Arts," *Gazette des Beaux-Arts*, vol. 81, no. 1,249 (February 1973), p. 133, no. 477.

CONDITION NOTES: The original support is twill-weave, medium-weight (10 x 10 threads/cm.) linen. The tacking margins have been removed. A small semicircular tear in the support is present along the top edge, visible in the x-radiograph. The painting is lined with an aged aqueous adhesive and medium-weight linen. An earlier aqueous lining has been retained. An off-white ground is present and is evident along the cut edges. The paint is generally in good condition. Traction crackle is present in local areas of the hair and hat and along the right and bottom edges of the composition. A coarse web of fracture crackle runs throughout the white and highlight areas of the figure's coat. X-radiographs reveal several pentimenti in the hat as well as the deletion of a chair back under the proper right arm. Retouches are visible under ultraviolet light in small losses along the edges.

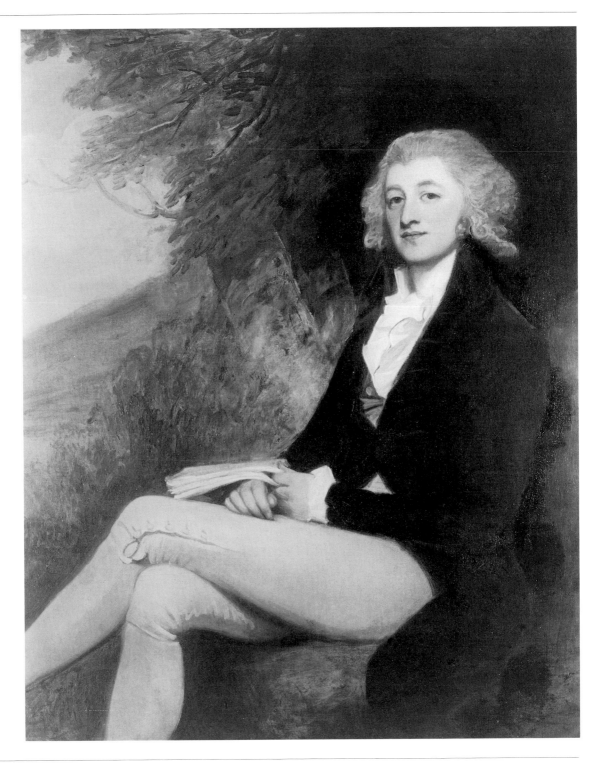

93 GEORGE ROMNEY

SIR JOHN READE, 1788
Oil on canvas, 50 x 39⅞" (127 x 101.3 cm.)
The William L. Elkins Collection, E24-3-19

Descended from an ancient Northumberland family, Sir John Reade
(1762–1789), of Shipton Court, Oxfordshire, succeeded his father in November
1773 as the 5th Baronet. On January 13, 1784, he married June, only daughter of
Sir Charles Hoskyns, Bart.; in November 1789 he died in Harley Street, aged
twenty-seven. On the day of his death his second daughter, Louisa, was
buried, suggesting that the cause of death may have been a contagious disease
such as smallpox or scarlet fever. He had a twin brother, Thomas.

Sir John was clearly an elegant but also a slightly stiff young man. Romney seems to have tried to make the portrait less formal by showing him reading under a tree out-of-doors, but Sir John keeps his powdered wig in place and has forgotten to unbutton his blue coat. His long, slender legs disappear at the left edge of the canvas, a device by which Romney implied that he dashed off this portrait spontaneously and that, as in a snapshot, he caught life as it really was, not as the artist arranged for it to appear. Sittings are recorded in Romney's sitters' books for 1788 on April 15, 21, 28, May 5, 14, 20, 27, and June 2 and 3.

PROVENANCE: By descent to Sir John Chandos Reade, Shipton Court, Oxfordshire; his sale, Christie's, July 13, 1895, lot 15, bt. Tooth; Blakeslee Galleries, New York; William L. Elkins.

LITERATURE: Ward and Roberts, 1904, vol. 2, p. 130; Chamberlain, 1910, p. 335; Elkins, 1887–1900, vol. 2, no. 70, repro.; Elkins, 1925, no. 35; Philadelphia, 1928, p. 17.

CONDITION NOTES: The original support is twill-weave, medium-weight (12 x 12 threads/cm.) linen. The tacking margins have been removed. A severe, U-shaped tear in the support is visible under infrared examination. It extends approximately 48″ in total length and is centered left of the figure. The painting was relined with an aqueous adhesive and double-thread, medium-weight linen. An off-white ground is present, visible through the thinnest areas of paint in the background. The paint is in fair condition. Much of the brushwork retains its original texture. The dark-brown bituminous paint present in the background around the head of the figure has a wide net of traction crackle. Fracture crackle is evident in the highlights of the face and collar. Some abrasion is present in the background and the mid-tones of the face. Retouches are visible under ultraviolet light along the entire length of the tear, in large areas in the figure's coat adjacent to the tear, and in the lip of the figure.

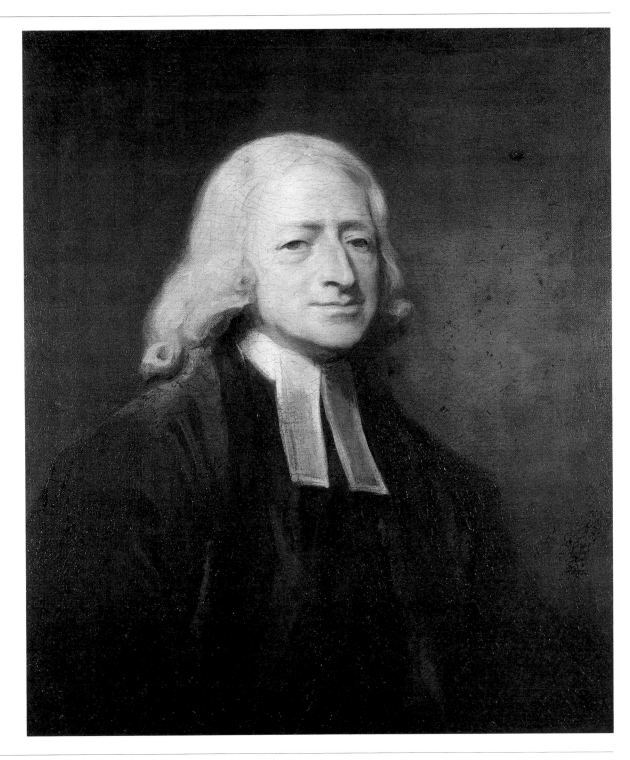

94 GEORGE ROMNEY

JOHN WESLEY, 1788–89
Oil on canvas, 30 x 25″ (76.3 x 63.4 cm.)
John H. McFadden Collection, M28-1-37

"A great and complex character, one of the greatest known to modern times, a
man in some ways comparable to Luther, Lenin, Gandhi, or even Napoleon":[1]
so a recent historian of the eighteenth century evaluates the man who sat to
Romney for this portrait. The achievement of John Wesley (1703–1791),
founder of Methodism in England, has as much to do with social history as
with the history of religion, for at the time he started his ministry in 1738, the
Church of England, weary of the religious strife of the preceding century,
addressed its tepid message of acceptance and conformity only to the upper

classes. Its clergy, notoriously lazy and intemperate, obtained their preferments not through merit but through political and social patronage; as a result, the church lacked men of fervor.

Until Wesley, the church had ignored the spiritual needs of the lowest strata of society—the colliery workers of Bristol, the coal miners of Newcastle, or the tin miners in Cornwall. In consequence such people lived in moral and physical chaos, striking out against their terrible poverty and suffering through drink, gambling, and violence. To them Wesley took a message of hope, and in doing so became the greatest social reformer of his age.[2]

At first Methodism was only a religious society within the Church of England that stressed conversion, personal experience of Christ's love, and the certain conviction of salvation but shunned the grim Calvinist doctrine of predestination. Its preachers, models of rectitude and sobriety, spoke at great outdoor rallies where spectacular mass conversions took place. Methodism stood for simple virtues, for a life centered around the Bible and the family, a life that valued hard work, thrift, and charity. Methodist schools, although they existed only to teach children how to read the Bible and no more, were often the only education the poorest children received. Wesley's admirers as well as his critics point out that by helping the industrial poor a little but not too much, and by teaching them to accept their lot on earth, Wesley may have done much to stifle in England the kind of unrest and resentment that led to the French Revolution.

Nevertheless, Wesley was among the few Englishmen to do more than pity and despise the poor. It is therefore doubly ironic that by helping them he earned the displeasure of the established church and the scorn of the aristocracy. As the Duchess of Buckingham complained, "It is monstrous to be told that you have a heart so sinful as the common wretches that crawl upon the earth."[3] Wesley, in turn, detested the upper classes, although all his life he tried to reconcile his society with the Anglican Church. Finally, however, in 1784, when the Church of England refused either to cooperate with him or to recognize its own social obligations, he was forced to ordain his own ministers: the first step toward the establishment of Methodism as a denomination—although the final break occurred in 1795, four years after his death. By the end of the nineteenth century Methodism in England claimed four hundred fifty thousand members, men and women drawn mainly from industrial areas. The denomination was taken to America by immigrants from Ireland converted by John Wesley himself. Appropriately, the Philadelphia picture was commissioned from Romney by one of Wesley's fervent admirers in Ireland, Mrs. William Tighe (née Fownes).

In 1765 Sarah Fownes married a friend and early follower of Wesley, William Tighe (1738–1783) of Rosanna, Member of Parliament for Athboy from 1761 to 1766, high sheriff for county Wicklow in 1771, and later a representative of county Wicklow in Parliament. He took his bride to his house Rosanna in county Wicklow, "a plain old brick house, fit for a country squire," as a visitor in the 1890s called it.[4] When Rev. S. Pierce visited Rosanna in 1796, Mrs. Tighe, then a widow of about fifty, was still living there. He described her as "of strong sense, friendly manners, and, above all, with a heart warmly devoted to religion" and spoke of her benevolence in establishing new schools for poor children.[5] She turned Rosanna into something of a center for Methodism in Ireland, and on the last of Wesley's frequent missionary trips to that country, in June 1789, he stayed there with Mrs. Tighe, apparently for the first time, although they must have known each other before this. In fact, the previous year he had acquiesced in her desire to possess a portrait of him to be painted by George Romney.

Wesley sat to Romney on December 29, 1788, and on January 5, 12, and 19, 1789.[6] On Monday, January 5, 1789, Wesley wrote in his journal: "Mr. Romney is a painter indeed. He struck off an exact likeness at once; and did more in one hour than Sir Joshua [Reynolds] did in ten."[7] To Mrs. Tighe he wrote on February 7, 1789: "I have sat four times to Mr. Romney, and he has finished the Picture. It is thought to be a good likeness, and many of my friends have desired that I would have an engraving taken from it. But I answer, 'The Picture is not mine but *yours*. Therefore, I can do nothing without your Consent.' But if you have no objection, then I will employ an engraver that I am well assured will do it justice."[8] The man he chose was John Spilsbury, who apparently took several months over the engraving, as the picture was not sent to Mr. Appleyard's of Wimpole Street for shipment to Ireland until July 10, 1789.

As we saw, the sitter himself pronounced it "a good likeness," and certainly it matches two contemporary descriptions of the evangelist—one by an urbane skeptic, the other by a devoted follower. The skeptic was Horace Walpole, who heard Wesley preach in 1776 at Lady Huntington's chapel in Bath: "[He] is a lean elderly man, fresh-coloured, his hair smoothly combed but with a *soupçon* of curl at the ends. Wondrous clean, but as evidently an actor as Garrick."[9] In 1791, the year of Wesley's death, Rev. John Hampson described him more completely, if less amusingly. At five foot five inches, thin and vigorous looking, he had a "clear, smooth forehead, an aquiline nose, an eye the brightest and the most piercing that can be conceived, and a freshness of complection scarcely ever to be found at his years." And Hampson agreed with Walpole that "an air of neatness and cleanliness was diffused over his whole person."[10]

It must be remarked that however vigorous and clean Wesley may have been, Romney's portrait of him is less than inspired. A straightforward, workaday image, the head set foursquare in the center of the canvas, it accurately records Wesley's features, but it also records Romney's lack of interest in the famous man. We may presume that, with his wife and son abandoned, a continuing infatuation with Emma Hart, and a business devoted entirely to flattering aristocratic and theatrical clients, Romney can have had little to say to this most upright and unusual of his sitters. Of the four known versions of the picture, Philadelphia's is certainly the earliest and has been accepted as genuine both by Ward and Roberts and more recently by John Kerslake. Yet the certain provenance of the portrait goes back only to the Butterworth sale at Christie's in 1873; any earlier history is based on the presumption that the Butterworth portrait was the original belonging to Mrs. Tighe at Rosanna—and this presumption must stand unless another version turns up.

Wesley was one of the most famous and admired men of the eighteenth century. He was frequently painted, and O'Donoghue (1908–25, vol. 4, pp. 439–41) lists thirty-three engravings published before 1793. In addition, Kerslake lists portrait busts, jugs, teapots, and plasters bearing Wesley's portrait. For a full discussion of the number and variety of Wesley portraits see Kerslake.[11]

1. J. H. Plumb, *England in the Eighteenth Century*, rev. ed. (London, 1979), p. 90. For Wesley's life, see G. Elsie Harrison, *Son to Susanna: The Private Life of John Wesley* (London, 1937).

2. Rupert Davies and Gordon Rupp, eds., *A History of the Methodist Church in Great Britain* 3 vols. (London, 1965–83); A[lexander] G[ordon], *Dictionary of National Biography*; and *Encyclopaedia Britannica*, s.v. "Wesley, John."

3. Davies and Rupp, eds. (see note 2), vol. 1, p. 54.

4. William Howitt, *Homes and Haunts of the British Poets* (London, 1894), p. 284. Sarah Tighe should not be confused with her more famous daughter-in-law, the poet Mary Tighe (1772–1810).

5. Ibid., p. 290.

6. Ward and Roberts, 1904, vol. 2, p. 169. The artist's fee was thirty pounds.

7. John Wesley, *The Works of the Rev. John Wesley, A.M.* (London, 1872), vol. 4, p. 443.

8. Ward and Roberts, 1904, vol. 2, p. 169.

9. W. S. Lewis, ed., *The Yale Edition of Horace Walpole's Correspondence* (New Haven, Connecticut, 1973), vol. 35, p. 119.

10. John Hampson, *Memoirs of the Late Rev. John Wesley, A.M., with a Review of His Life and Writings, and a History of Methodism . . .* (London, 1791), vol. 3, pp. 167–68.

11. Kerslake, 1977, vol. 1, pp. 297–304, vol. 2, pls. 856–71.

PROVENANCE: Commissioned from the artist by Mrs. William Tighe of Rosanna, county Wicklow, Ireland; presumably Rosanna sale, 1815 (no catalogue); Rev. J.H.H. Butterworth; sold by him, Christie's, March 1, 1873, lot 65, bt. Cassels; W. R. Cassels, until 1906; Christie's, June 30, 1906, lot 62, bt. Agnew; bt. John H. McFadden, September 5, 1910.

EXHIBITIONS: London, Grafton Galleries, *Exhibition of a Special Selection from the Works by George Romney, Including a Few Portraits of Emma, Lady Hamilton, by Other Artists*, 1900, no. 74 (lent by Walter R. Cassels, Esq.); New York, 1917, p. iv, no. 39, fig. 39; Pittsburgh, 1917, no. 37; Philadelphia, 1928, p. 22.

LITERATURE: Romney, 1830, p. 200 (as "Rev. John Westley"); Cunningham, 1879, vol. 2, p. 202; Gamlin, 1894, p. 187; William G. Beardmore, "Portraits of Our Founder," *Wesleyan Magazine*, vol. 119 (March 1896), pp. 175–81; A[lexander] G[ordon], *Dictionary of National Biography*, s.v. "Wesley, John"; Maxwell, 1902, p. 111, p. 193 no. 416; Ward and Roberts, 1904, vol. 1, p. 68, vol. 2, p. 169, repro. between pp. 168–169, Chamberlain, 1910, p. 331; Roberts, 1913, p. 540; Rev. O. S. Duffield, "Romney's Wesley Comes to America," *The Christian Advocate*, March 22, 1917, pp. 278–79, repro. p. 279; Roberts, 1917, pp. 75–76, repro. opp. p. 75; Roberts, 1918, "Portraits," p. 130; John Telford, ed., *Sayings and Portraits of John Wesley* (London, 1924); George Buckston Browne, *A Vindication of the Wesley-Romney Portrait at Wesley House, Cambridge* (London and Harrow, 1926), pp. 4–5, 10; Kerslake, 1977, vol. 1, pp. 299–300, vol. 2, pl. 865.

CONDITION NOTES: The original support is twill-weave, medium-weight (12 x 14 threads/cm.) linen. The tacking margins have been removed. Weave cusping is evident along all four edges of the support. The painting has been lined with an aqueous adhesive and medium-weight linen. An off-white ground is present and evident along the cut edges. The paint is in good condition. A web of narrow-aperture fracture crackle oriented in a horizontal pattern is present overall. Abrasion is present only in local areas of the clothing and in the deepest brown shadows. Under ultraviolet light, retouching is evident in the abraded areas of the clothing, the small losses in the background at the right of the figure's head, and along the edges.

ENGRAVING: John Spilsbury (1730–1795), *John Wesley*, mezzotint, 11⅜ x 9" (28.9 x 22.9 cm.). Published: June 1789.

VERSIONS

1. George Romney, *John Wesley*, oil on canvas, 30 x 24" (76.2 x 61 cm.), Oxford, Christ Church.
 LITERATURE: Kerslake, 1977, vol. 1, p. 300.

2. After George Romney, *John Wesley*, oil on canvas, 29½ x 24" (74.9 x 61 cm.), London, National Portrait Gallery.
 LITERATURE: George Paston, ed., *A Little Gallery of Romney* (London, 1903), unpaginated; Gower, 1904, pp. 60, 128; Kerslake, 1977, vol. 1, p. 299, vol. 2, pl. 866.

3. Copy after George Romney by Mrs. Webber (granddaughter of Mrs. William Tighe), *John Wesley*, Ireland, Kellyvale.
 PROVENANCE: T. W. Webber, in 1904.
 LITERATURE: Kerslake, 1977, vol. 1, p. 300.

95 GEORGE ROMNEY

MR. ADYE'S CHILDREN (THE WILLETT CHILDREN), 1789–90
Oil on canvas, 60 x 48" (152.4 x 122 cm.)
The George W. Elkins Collection, E24-4-27

When John Willett Adye (1744–1815), the father of the three children in this painting, succeeded to the estate of his maternal cousin Ralph Willett (1719–1795), the patron of the landscape painter Richard Wilson (q.v.), of Merley House, Dorsetshire, in 1795, he took the surname Willett (John Willett Willett) and under this name was Member of Parliament for New Romney in Kent from 1796 to 1806. George Romney painted his children's portraits in 1789–90, and so naturally listed them in his sitters' book under the name Adye. After 1795 the surviving children took their father's name.

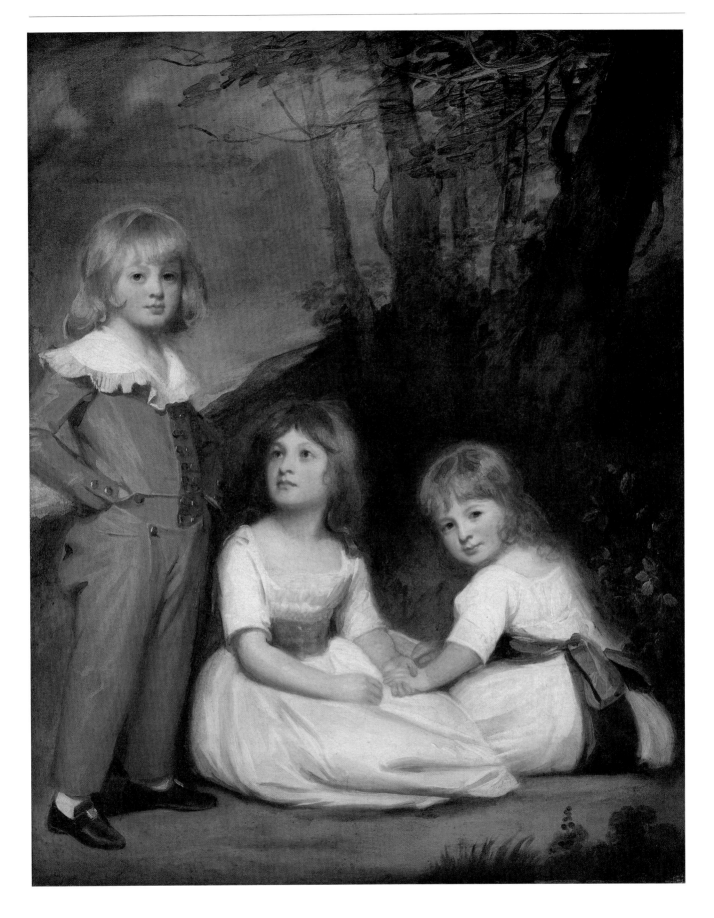

Ward and Roberts, in their catalogue of Romney's work published in 1904, unwittingly listed the picture twice, the first time under Adye as a missing portrait for which documentary evidence survived in the form of a sales receipt and entries in Romney's sitters' book; the second time as a known but undocumented picture, then in New York, showing the three Willett children.

In it, to the left, is John Willett Willett, born on April 25, 1784. He succeeded to Merley after the death of his father and died in 1839. In the center is eight-year-old Anabella Willett, born August 7, 1781, who died at fifteen on October 6, 1795. She holds the hand of three-year-old Henry Ralph Willett, born on April 27, 1786. He grew up to take his M.A. at Christ Church College, Oxford, became a barrister at Lincoln's Inn, and later deputy lieutenant for Dorset. On the death of his brother in 1839, he inherited Merley and died on December 9, 1857.[1]

Although John Willett is shown in a playsuit with a ruffled collar and a child's wide, buttoned fly, he stands with his hands on his hips and legs wide apart in a pose that underlines his importance as the eldest male child and future head of the family. His sister, although several years older than he, sits worshipfully at his feet, while baby Henry (not, of course, breeched, sporting a big satin sash around his middle) stares curiously out at the spectator.

Romney began the portrait of "Mr. Adye's Children in one piece," on June 18, 1789, when his sitters' book records that "Miss A" came for five sittings in June and July. Then, in 1790, Anabella returned to sit nine more times in April, May, and June. At the same time, John went to London to sit twice a month in February and March, once in April, and three times in May, 1790 for a total of eight sittings.[2] Both John and Anabella appear in the portrait full length; clearly Romney painted their costumes as well as their faces from life, although the landscape in which they appear is imaginary. Henry, on the other hand, must have been too young to sit still, for he is not listed in the artist's sitters' book, and a glance at the portrait shows that his head, which fits awkwardly onto his little torso, was painted separately, then added to an imaginary and badly drawn body. Possibly the baby sat on his mother's or father's lap when they came in for the portraits Romney executed of them in 1789 and 1790.[3] By this time Romney must have known the family well. The children's mother, John Willett Willett's first wife, whom he married in 1780, was Catherine (1762–1798), daughter of Henry Brouncker of Saint Kitts, the West Indies, and of Queen Anne Street, London, whose other daughter became Mrs. Finch, painted by Romney in a portrait now in the Philadelphia Museum of Art (no. 96).[4]

The Adye family could not pay for the portrait until the death of cousin Ralph Willett in 1795. On February 17 of that year the artist dispatched the picture to Dorset on receipt of payment. We do not know when it left the Willett family, but it must have been after 1857 when, on the death of Henry Willett, this branch of the family became extinct. At that time Merley passed to Willett Laurence Adye, the eldest son of Henry's first cousin, James Pattison Adye.

1. Information supplied by John Miller Adye, Chislehurst, Kent.
2. Ward and Roberts, 1904, vol. 2, p. 2.
3. Ibid.
4. Ward and Roberts list the numerous portraits of the Willetts and Adyes painted by Romney between 1782 and 1795.

PROVENANCE: Family of the sitters; Agnew; J. S. Inglis, New York; M.C.D. Borden, New York, by 1904; Borden sale, American Art Galleries, New York, February 7, 1913, lot 34, bt. Scott and Fowles; George W. Elkins

EXHIBITIONS: New York, American Art Galleries, *Notable Paintings Collected by the Late M.C.D. Borden, Esq.,* February 7–13, 1913, pp. 13–14, p. 88, repro. p. 89; Philadelphia, 1928, p. 27, repro. p. 26.

LITERATURE: Romney, 1830, p. 212; Gamlin, 1894, p. 197; Ward and Roberts, 1904, vol. 2, p. 2 (as "Mr. Adye's Children") and p. 171 (as "The Willett Children"); Chamberlain, 1910, p. 157; Elkins, 1925, no. 37; Elkins, 1935, p. 17, repro. p. 16; "Memorials in the Museum," *The Philadelphia Museum Bulletin,* vol. 34, no. 182 (May 1939), repro. p. 15; Gerhard Charles Rump, *George Romney (1734–1802): Zur Bildform der Bürgerlichen Mitte in der Englischen Neoklassik* (Hildesheim and New York, 1974), vol. 1, p. 109, vol. 2, fig. 48.

CONDITION NOTES: The original support is twill-weave, medium-weight (10 x 10 threads/cm.) linen. The tacking margins have been removed. Weave cusping in the support on all four sides suggests that the present size is close to the original. The painting has been relined with a wax-resin adhesive and medium-weight linen. A previous, aged aqueous adhesive lining has been retained. A thin, white ground is evident along the cut edges. The paint is in very good condition. The paint profile varies greatly in relief. Some flattening of the highest peaks of paint relief has been caused by lining pressures. Paint consistency varies from paste-vehicular to fairly rich vehicular mixtures. A very narrow aperture web of fracture crackle is present overall. Under ultraviolet light, retouches are evident to small losses in the sky, to a local area of abrasion in the hair of the girl, and along the edges of the composition.

ENGRAVING: Charles W. Beck.

VERSION: Copy after George Romney, *Mr. Adye's Children,* oil on canvas, 59 x 48″ (149.9 x 121.9 cm.), Washington, D.C., Richard N. Tetlie Collection.
 PROVENANCE: Collection of Willett L. Adye, Esq., sold by trustees of his settlement for the late Mrs. Adye, Christie's, December 9, 1905, lot 153, bt. Manuel; presumably the picture in the collection of Richard N. Tetlie of Washington, D.C., in 1974.

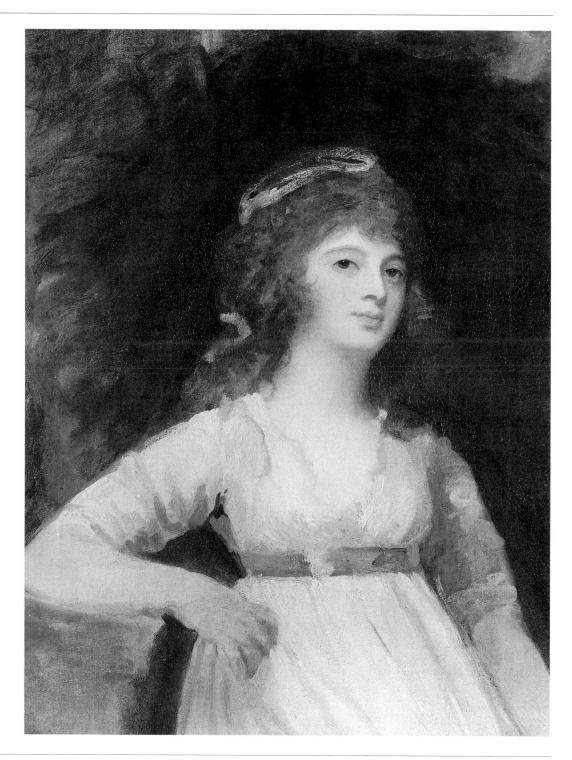

96 GEORGE ROMNEY

MRS. FINCH, 1790
Oil on canvas, 35⅞ x 27¾" (91.1 x 70.5 cm.)
John H. McFadden Collection, M28-1-33

Mary Brouncker, born on the island of Saint Kitts, the West Indies, lived in
London at 4 Queen Anne Street, Westminster. On August 2, 1789, she
married Adm. William Clement Finch (1758–1794), the third son of the 3rd
Earl of Aylesford. To commemorate the marriage she sat to Romney on April
6 and 13, 1790. In doing so she returned to the artist who had painted her
full-length portrait between 1782 and 1787. Her husband was Member of
Parliament for Albury, Surrey, in 1790, and rose to the rank of rear admiral of

the Blue Squadron in 1794. Together they had five children. After his death she married William Strode of Northaw, Hertfordshire. She died on October 6, 1813. Her sister Catherine married John Willett and is the mother of the children in *Mr. Adye's Children (The Willett Children)* (no. 95). The two sisters also had a brother, Henry Brouncker, Esq., of Boveridge, Dorset.

Our picture shows the sitter facing to her left with her right arm resting on a parapet. Unfinished at the arms, hands, and dress, the picture represents a first attempt that the artist discarded to begin afresh. The second attempt may be the finished portrait in the Ruiz Vernaco Collection in Madrid in 1940, which is known only in a black and white photograph in the W. Roberts files now preserved in the National Portrait Gallery, London. Although this photograph is labeled "Mrs. Crouch," the face and pose are the same as in *Mrs. Finch.*

The Philadelphia picture apparently remained in Romney's studio until his sale at Christie's, April 27, 1807, when a portrait of Miss Brouncker (lot 61) brought only two pounds—presumably because it was unfinished.

PROVENANCE: Possibly Romney sale, Christie's, April 27, 1807, lot 61 (as "Miss Brouncker"); T. H. Ward; Agnew, by 1895; bt. John H. McFadden, May 4, 1895.

EXHIBITIONS: New York, 1917, no. 34; Pittsburgh, 1917, no. 33, repro.; Philadelphia, 1928, p. 22.

LITERATURE: Ward and Roberts, 1904, vol. 2, p. 54; Roberts, 1917, pp. 67–68, repro. opp. p. 67; McFadden, 1917, repro. p. 110; Roberts, 1918, "Portraits," p. 130, repro. p. 133.

CONDITION NOTES: The original support is twill-weave, medium-weight (12 x 12 threads/cm.) linen. The tacking margins have been removed. The painting is lined with an aged aqueous adhesive and medium-weight linen. A thinly applied white ground is evident along the cut edges. The paint is in generally only fair condition. A web of traction crackle seems to be associated with the brown pigment of the background. An irregular web of fracture crackle of narrow aperture has formed overall. Under ultraviolet light, retouches are visible over the widest traction crackle next to the figure's face and above her head.

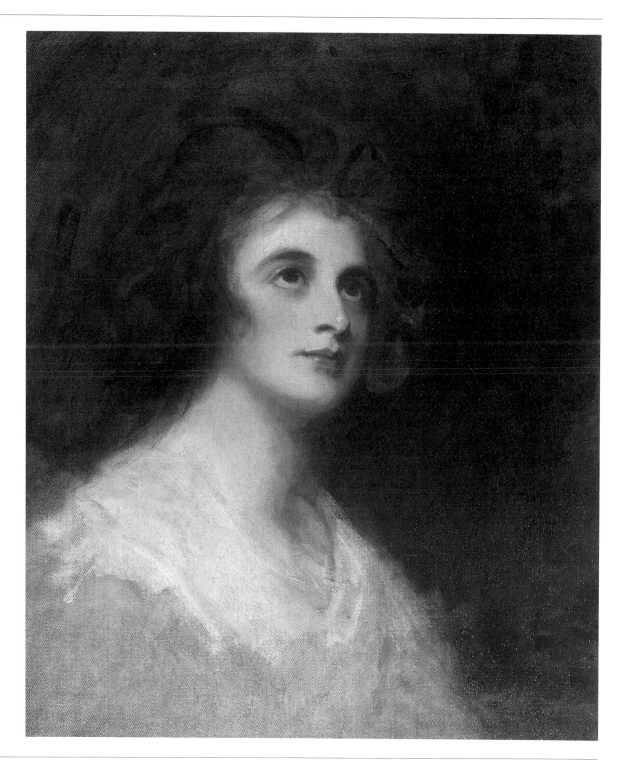

97 GEORGE ROMNEY

MRS. TICKELL, 1791–92
Oil on canvas, 24 x 20⅛″ (61 x 51 cm.)
John H. McFadden Collection, M28-1-35

In July 1780 the pamphleteer and dramatist Richard Tickell (1751–1792)[1]
married as his first wife Maria Linley (1756–1787), daughter of Thomas
Linley, manager at Drury Lane, and sister of Elizabeth Linley, painted by
Gainsborough (q.v.) in the picture now in the Philadelphia Museum of Art
(no. 30). Two years after her death, in 1789, Tickell married Sarah Ley, an
eighteen-year-old girl, the daughter of the commander of the East Indiaman
Berrington. Eliza Linley, who was raising the children of her dead sister, Mary
Tickell, was shocked by the unexpected marriage; she poured out her

indignation to Mrs. Canning: "The evening I left you Mr. Tickell . . . never ceas'd making most violent protestations against any plan of marrying. What will you think of Mr. T's faith and Honour when I inform you that he was absolutely engaged to go out of town the next morning with her. . . . He has seen his children for ten minutes only in the course of a fortnight."[2] And Betsy Sheridan (1758–1837), Richard Brinsley Sheridan's sister, wrote to her elder sister Alicia Le Fanu (1753–1817) on August 20, 1789: "Tickell marries Miss Lee next week and so ends his sentimentalising. She is very pretty, just Eighteen and daughter of an East India Captain, who before he sail'd last forbad her to think of Tickell . . . but he is a Young Man and has another daughter so T. will probably not get much fortune. His whole conduct in this business has been shuffling and paltry to the greatest degree and has of course disgusted those whose good opinion he ought to have endeavour'd to preserve."[3]

This second marriage of Tickell's ended tragically. He and his new wife lived extravagantly, expecting, apparently, to inherit a fortune from Captain Ley. Their debts led to Tickell's despondency and then, on November 4, 1793, to his suicide by jumping from a window at Hampton Court. One contemporary, John Taylor, described the economics of the case: "[Mrs. Tickell's father] had amassed about twenty thousand pounds, but, being afraid to vest it any public securities, he lived upon the capital, which gave . . . little hopes of [Tickell's] deriving much from the death of his father-in-law, and probably augmented that dejection which occasioned the termination of his life."[4]

Another contemporary, Rev. William Smyth, tutor to the son of Eliza Linley and her husband, the dramatist Richard Brinsley Sheridan (1751–1816), described Mrs. Tickell just after her widowhood, emerging from a coach and four, ". . . out of which Mr. Sheridan handed a beautiful lady, dressed in deep black, followed by a chaise, out of which came three young children [Tickell's children by his first wife] and a maid-servant, all in deep mourning also. This was the widow of the celebrated Tickell. . . . In symmetry of form, and beauty of features and complexion, she was eminently handsome; but there was no mind in her countenance or anywhere else."[5]

According to Smyth, although left destitute at her husband's death, she continued to live extravagantly. And John Taylor adds that her life ended sadly when, in 1796, she married Maj. John Cotton Worthington (d. 1826), for "Mrs. Tickell, it is said, found a less indulgent husband in her second marriage, and sank into a despondency like that which attended the last days of her former partner."[6] By Worthington she had seven children and lived in his seat at Newstone, Tunbridge Wells.

In some ways, Mrs. Tickell seems to have filled the place of Emma Hart (later Lady Hamilton) as Romney's favorite model just after Emma's departure for Naples in 1786. Ward and Roberts record that she sat twenty-three times before and fourteen times after her marriage, although only one finished picture is listed as having been sent home. This means that there may be numerous sketches, like this portrait, in which the sitter posed informally—perhaps even, like Emma, miming emotions such as piety or pity or adoration. Certainly the head-and-shoulders format, Sarah Tickell's disheveled hair, suggestion of her loose frock, and, above all, the soulful expression make an interesting comparison to Romney's sketch of *Lady Hamilton as Miranda* in the Philadelphia Museum of Art (no. 89). Ironically, it is through this comparison that we sense Emma Hart's strength of personality and ability to project her own character, traits Sarah Tickell apparently lacked. Still, the comparison also suggests an attempt on Romney's part to find in Mrs. Tickell a substitute for his departed muse.[7]

1. For Tickell, see F[raser] R[ae], *Dictionary of National Biography*, s.v. "Tickell, Richard"; and Richard Eustace Tickell, *Thomas Tickell and the Eighteenth-Century Poets* (London, 1931), pp. 175–80.

2. Margot Bor and Lamond Clelland, *Still the Lark: A Biography of Elizabeth Linley* (London, 1962), p. 140.

3. William Le Fanu, ed., *Betsy Sheridan's Journal* (London, 1960), p. 184.

4 John Taylor, *Records of My Life* (London, 1832), vol. 1, p. 145.

5. William Smyth, *Memoir of Mr. Sheridan* (Leeds, 1840), pp. 53–55.

6. Taylor (see note 4), p. 144.

7. For further portraits of her by Romney, see Ward and Roberts, 1904, vol. 2, pp. 157–58.

PROVENANCE: The artist; artist's sale, Christie's, April 27, 1807, lot 65, bt. Henry Tresham; bt. the artist's family; Elizabeth Romney, the artist's great-niece; her sale, Christie's, May 25, 1894, lot 187, bt. Agnew for Lt. Col. Frank Shuttleworth, Old Warden Park, Biggleswade, Bedfordshire; bt. Agnew; John H. McFadden, July 13, 1899.

EXHIBITIONS: London, British Institution, 1862, no. 166 (lent by Rev. J. Romney); London, Thomas Agnew and Sons, *Twenty Masterpieces of the English School*, December 1895, no. 17 (as "Miss Linley, afterwards Mrs. Tickell"); Port Sunlight, Hulme Hall, *Art Exhibition to Celebrate the Coronation of Their Majesties King Edward VII and Queen Alexandra*, 1902, no. 166; New York, 1917, no. 38, repro.; Pittsburgh, 1917, no. 36.

LITERATURE: Sir George Sharf, Sketchbooks (sketched at the British Institution, London, 1862), vol. 63, p. 52, National Portrait Gallery, London; Maxwell, 1902, p. 192, no. 394; Gower, 1904, p. 128, fig. 27; Ward and Roberts, 1904, vol. 1, repro. between pp. 120–121, vol. 2, pp. 157–58, no. 1; Roberts, 1913, p. 540; Roberts, 1917, pp. 73–74, repro. opp. p. 73; Roberts, 1918, "Portraits," pp. 128, 130, repro. p. 129.

CONDITION NOTES: The original support is twill-weave, medium-weight (10 x 10 threads/cm.) linen. The tacking margins have been removed. The painting is lined with an aged aqueous adhesive and medium-weight linen. An off-white ground is evident where little or no paint was applied to the surface. A drying wrinkle is present in the exposed ground layer and suggests that an especially rich oil medium was employed for the ground. The paint is in good condition. Some flattening of the original moderate to low relief of the paint profile has occurred from lining. A small-web, narrow-aperture traction crackle is present in the brown tones of the hair. A moderately wide-aperture fracture crackle is prominent in the face and neck of the figure. Under ultraviolet light, retouches are restricted to a narrow, horizontal band above the figure's head and may represent damage along a crease from a stretcher member. The pupils of the eyes have been reinforced.

ENGRAVINGS
1. J. B. Pratt after George Romney, *Mrs. Tickell*, 1900, mezzotint, 14⅜ x 17⅛" (36.5 x 44.1 cm.).

2. T. G. Appleton after George Romney, *Mrs. Tickell*, 1903, mezzotint, 15 x 19" (38.1 x 48.3 cm.).

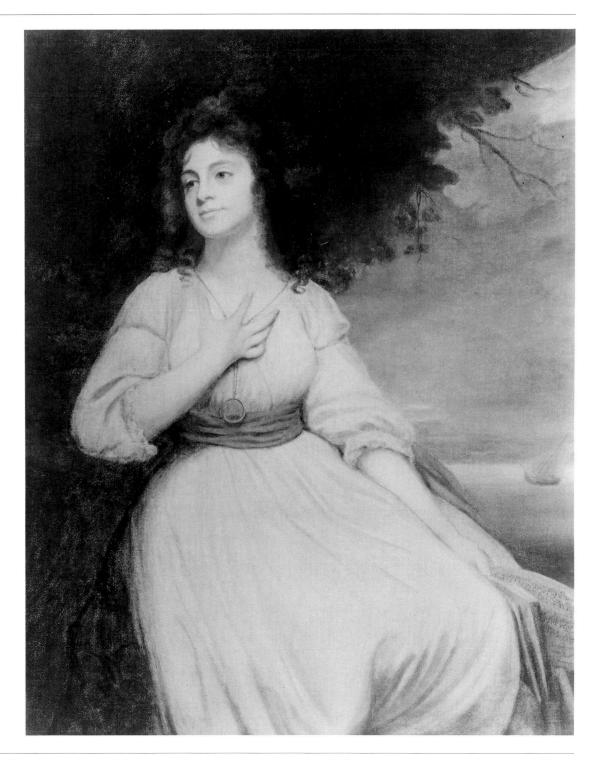

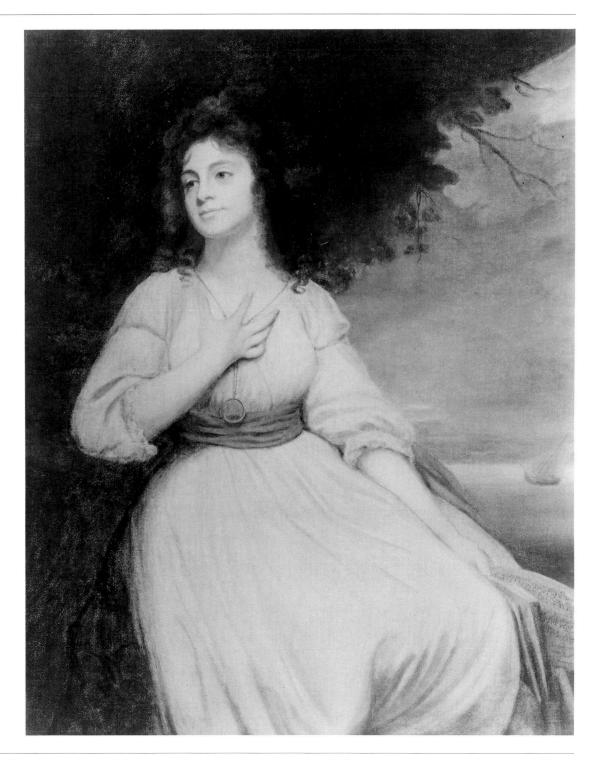

98 GEORGE ROMNEY

MRS. CROUCH, c. 1793
Oil on canvas, 50¼ x 39½" (127.6 x 100.3 cm.)
Inscribed at top of musical score in sitter's left hand: [Hus]*h Ev'ry Breeze
let* [nothi]*ng (or:)* [su]*ng by Mrs. Crouch composed by Hook;* in score:
Andantino Hush ev'ry breeze let nothing
John H. McFadden Collection, M28-1-31

Anna Maria (Nancy) Phillips (1763–1805) was the third of the six children of
Peregrine Phillips (d. 1801), a literary attorney, official in the Wine Office, and
friend of Samuel Johnson.[1] Her mother died when she was a child, but her
musical talent was recognized and cultivated—first by a Mr. Wafter, the

FIG. 98-1 George Romney, *Mrs. Crouch*, 1787, oil on canvas, 50 x 40″ (127 x 101.6 cm.), Kenwood, The Iveagh Bequest

organist of a chapel in Berwick Street, and then, from the age of sixteen, under Thomas Linley (see no. 30) at Drury Lane. There she made her debut on November 11, 1780, as Mandane in Thomas Arne's (1710–1778) *Artaxerxes,* and for the rest of her life continued to appear at that theater. In the 1780s and 1790s she performed on tour in Liverpool and Dublin as an opera singer and as a dramatic actress—sometimes combining the two with typical eighteenth-century insouciance, as when she scored a triumph as a singing witch in *Macbeth* dressed in "a fancy hat, powdered hair, rouge, point lace, and linen enough to enchant the spectator."[2]

In 1784 she enchanted a young naval lieutenant, Edward Rollings Crouch (d. 1847), whom she wed secretly at Twickenham on January 9, 1785.[3] They married for love, as her biographer tells us, for "it is [not] probable that Mr. Crouch, a gay young man, had lived *within his* income."[4] But alas they were not happy together. In 1791, the year the couple separated, gossips whispered that he had actually thrown things at her, but (again, according to her biographer) "although he became a careless, inattentive husband, he was certainly too much the gentleman to be guilty of such an action . . . and . . . Mrs. Crouch . . . never mentioned Mr. Crouch as a passionate, or an ill-natured man."[5]

But more than temperamental differences came between Nancy Crouch and her husband. In 1787 she met the Irish actor and singer Michael Kelly (1764?–1826), who had just returned, barely speaking English, from a long stay in Italy and Vienna where, in the latter city, he had appeared in the first production of *Le Nozze di Figaro* in 1786. At once he was paired with Mrs. Crouch at Drury Lane in *Lionel and Clarissa* and soon he was living with the Crouches in their house near Leicester Square; then, in the summers of 1788, 1789, and 1790, the threesome went on tour together; the separation followed in 1791. Michael Kelly continued to co-star and to live with Mrs. Crouch, whom he described as aggregating, in herself, "all that was exquisite and charming."[6] Although she became the mistress of the Prince of Wales in the 1790s,[7] Kelly stayed with her until her death at Brighton, aged forty-two, on October 2, 1805.

Nancy Crouch's marital vicissitudes are of interest here because this painting is the second version of a portrait commissioned by her husband, now in the Iveagh Bequest, Kenwood (fig. 98-1). In the latter, the lady sits in the shade of a tree—or perhaps an overhanging embankment—wearing a white, low-cut summer dress, with short sleeves. In her left hand she holds a book, while with her right she fingers a gold chain at her breast. A comparison of this portrait to Philadelphia's reveals two important differences. In the Kenwood version a miniature portrait of a gentleman hangs from the gold chain at her breast, and the book she holds is not inscribed. In the Philadelphia picture the portrait is missing (the locket is shown to be either empty or filled with glass), and she does not lift, and does not draw attention to, the chain. Furthermore, the book is carefully inscribed with the title, author, music, and lyrics of a popular song.

Vigorously drawn and richly painted, the Kenwood canvas is unquestionably the first version, commissioned by Edward Crouch himself, who paid Romney a deposit of five pounds five shillings in February 1787; it was executed while the sitter was living at 6 Lisle Street, Leicester Fields, in February, March, and April 1787.[8] The portrait around her neck must therefore show Crouch, while the sailing ship, although more like a racing sloop than a frigate, presumably refers to the sad necessity of his leaving his bride for naval duty.

It was undoubtedly this version that a reporter for the *Morning Herald* referred to in his account of a visit to Romney's studio, published on April 12,

FIG. 98-2 "Hush Ev'ry Breeze" by James Hook. Printed by G. Smart, London, 1800?

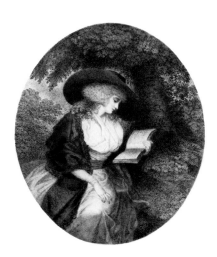

FIG. 98-3 J. R. Smith after George Morland (q.v.), *Delia in the Country*, 1788, stipple, 11¾ x 10¼" (29.8 x 26 cm.)

1787. Then the journalist saw a portrait of Mrs. Crouch in the costume she wore as Adelaide in Robert Jephson's tragedy *The Count of Narbonne*. The reporter emphasized that the picture was "not meant as a theatrical representation—the intention being merely to give a portrait of that charming performer."[9] And a reading of *The Count of Narbonne*, which is an adaptation for the stage of Horace Walpole's *Castle of Otranto*, confirms that nowhere in this Gothic drama of incest, madness, and murder did Mrs. Crouch have a scene in which either a miniature or a sailing boat figured.[10]

In the second version, the portrait around Mrs. Crouch's neck has been omitted, a clue that it was probably painted after the couple's marital difficulties had begun, and very likely after the separation of 1791. A more precise date can be suggested by referring to the musical score in the sitter's hand. This is a transcription of a fragment of James Hook's (1746–1827) rondo "Hush Ev'ry Breeze," (fig. 98-2) first published by Thompson's in Hook's collection of songs *The Hours of Love*, about 1780, where its original title was "Noon." This work ran through several editions and retained its popularity throughout the 1790s, so its inclusion here does not in itself help date the picture. However, on one specific occasion it is connected with Mrs. Crouch, when she sang it as an insertion in George Colman the Younger's (1762–1836) opera *Inkle and Yarico* at Covent Garden on April 25, 1793, along with Handel's *Sweet Bird*, "accompanied," the program notes tell us, "on the flute by Ashe, from the Hanover–Square Concert."[11] The words, in part, are: "Hush ev'ry breeze let no-thing move, / my Delia sings and sings of love, . . . / In the sweet shade my Delia stay, / you'll scorch those charms more sweet than May, / the Sun now rages in his noon, / 'tis pity, 'tis pity sure to part so soon. / Oh! hear me Delia hear me now, / incline propitious to my vow, / so may thy charms no changes prove, / but bloom for ever like my love. . . ."[12]

Mrs. Crouch had appeared in several plays with music by Hook,[13] so she certainly knew "Hush Ev'ry Breeze" before singing it on this occasion. That she sang it only once in an opera by another composer may even argue that this was a favorite song requested by friends or admirers. It is tempting to see in the lyrics the inspiration for the pose of the sitter in both versions of the Romney portrait, for in the first as in the second, she sits in summer muslins well in the shadows of a tree or hillside, while the blazing sun illuminates the seascape behind her; and, of course, sailing ships and sunny, breezy days go together.

However, the absence of Crouch's portrait in the Philadelphia version and the coincidence of the performance of "Hush Ev'ry Breeze" in 1793 argue for a firm dating of the Philadelphia picture to 1793. This accords well with the dry, slightly mechanical quality we would expect in a second version. Unfortunately, a final assessment of the Philadelphia picture is difficult because of its condition. When it was sold at Christie's on May 7, 1898 (lot 31), a note in the catalogue explained that "a portion of the picture had been damaged by damp." The condition can be explained by examining its provenance, for it is one of the pictures sold at the artist's sale at Christie's on April 27, 1807 (lot 109), that came from Romney's studio at Hampstead. There, many canvases had been stored in a low, open gallery built by the artist in 1797–98. The pictures were crammed into an open arcade where they were exposed to air, moisture, frost, and the depredations of thieves and vandals.[14] Those not totally lost were auctioned at Christie's.

The final question to be answered is Who commissioned the second portrait? The obvious candidate, Mrs. Crouch's lover Michael Kelly, we must reject, for no evidence connects the picture with him. Both this portrait and the Kenwood version were in Romney's studio at the time of his death, and the Philadelphia version is a finished work, not one of the numerous

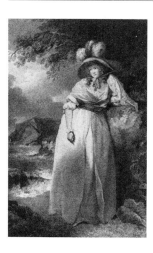

FIG. 98-4 William Ward after George Morland, *Constancy*, 1788, engraving, 13 x 8½″ (33 x 21.7 cm.)

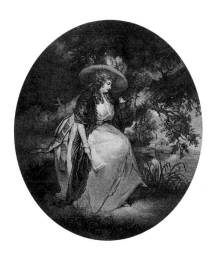

FIG. 98-5 William Ward after George Morland, *The Pledge of Love*, 1788, mezzotint, 12⅝ x 8½″ (32.2 x 20.8 cm.)

canvases with which the artist grew dissatisfied and turned to the wall. As all his biographers tell us that he was a keen and regular visitor to Drury Lane and Covent Garden and had many contacts with the theatrical world, perhaps Romney painted it as a reminder of an actress he admired and a song he liked. In any case, Romney apparently enjoyed painting Mrs. Crouch, for Ward and Roberts list three other portraits of her by the artist.[15]

In 1788, the year after the first version of Romney's portrait of Mrs. Crouch was completed, two mezzotints after George Morland (q.v.) were published that shed an intriguing light on Morland's borrowings of formal and iconographic motifs from Romney, an artist who, one would have thought, had little to give to him. But we should recall that Romney had offered the young Morland an apprenticeship about 1784 at a salary of thirty-three pounds, an offer that, even though Morland turned it down, presumes that the older artist was one of the first to appreciate the younger man's gifts. It is interesting that the relationship between the two men seems to have been maintained to some degree through the 1780s.

The first mezzotint in question is *Delia in the Country* (fig. 98-3), engraved by J. R. Smith and published on February 12, 1788, a pendant to *Delia in Town*. Delia is a poetic character, a city lady with a yen for the country. The inscription under *Delia in the Country* reads: "At length from TOWN the peerless Maid / Disgusted seeks the rural shade. / Retir'd from Sol's Meridian Beam / Here Zepher fans the cooling stream / She yields beneath the sheltring Bowr / To Contemplation's Eye the Hour / Pleas'd with simplicity to live / A Blessing, Cities cannot give." These verses suggest that even in the first version of Romney's portrait, in which the song "Hush Ev'ry Breeze" is not transcribed, and therefore Delia is not mentioned, Romney had a Delia image in mind when he painted Mrs. Crouch.

Furthermore, comparing the Morland engraving *Constancy* (fig. 98-4), published September 4, 1788, with Romney's first version of Mrs. Crouch leaves little doubt that Morland used the pose and motifs of the latter for his image. The verse inscribed here reads: "Firm as the rock on which I lean, / My mind is fixt, and cannot rove, / Tho foaming billows roll between / I'll ne'er forsake the youth I love."

All we can say is that Romney's *Mrs. Crouch* suggested to Morland the image of constancy, not that he is portraying Mrs. Crouch *as* constancy. Still, the latter alternative is attractive, and it is suggestive that the rock, foaming billows, and sentiments of ne'er forsaking a lover are the same in print and picture.

The final Morland that is related to Romney's *Mrs. Crouch* is a mezzotint engraved by William Ward and published in June 1788 called *The Pledge of Love* (fig. 98-5). Here the same type of fashionably dressed and hatted lady sits under a bower. This time she holds a pendant with the portrait of her lover in one hand and a letter in the other. The inscription in this mezzotint reads: "The lovely Fair with rapture views, / This token of their love: / Then all her promises renews, / And hopes he'll constant prove." Thus once again, Romney's sitter seems to be expressing the same sentiments, and with the same gestures, as the symbolic ladies in Morland's prints.

1. For Mrs. Crouch see [W]illiam W[illiam] B[arclay] S[quire], *Dictionary of National Biography*, s.v. "Crouch, Anna Maria"; Obituary, *The Gentleman's Magazine*, vol. 75 (October 1805), p. 977; M[ary] J[ulia] Young, *Memoirs of Mrs. Crouch*, 2 vols. in 1 (London, 1806); Ellen Creathorne Clayton, *Queens of Song: Being Memoirs of Some of the Most Celebrated Female Vocalists Who Have Appeared on the Lyric Stage, from the Earliest Days of Opera to the Present Time* (London, 1863), vol. 1, pp. 186–207; Philip H. Highfill, Jr., Kalman A. Burnim, and Edward A. Langhans, *A Biographical Dictionary of Actors, Actresses, Musicians, Dancers, Managers and Other Stage Personnel in London, 1660–1800* (Carbondale, 1975), vol. 4, pp. 80–88; and George Hogarth, *Memoirs of the Opera in Italy, France, Germany, and England* (London, 1851), vol. 2, pp. 353–56.

2. Harold Child, *The Shakespearian Productions of John Philip Kemble* (London, 1935), p. 20.

3. For Lt. Crouch, see *The Commissioned Sea Officers of the Royal Navy, 1660–1815*, vol. 1, Public Records Office, London. He was commissioned in 1780, made commander in 1843, and died in 1847. Edward Rollings Crouch should not be confused with the more distinguished naval officer Comdr. Edward Thomas Crouch, who was commissioned in 1798 and died in 1846.

For the date of their marriage, see Charles Beecher Hogan, "Eighteenth-Century Actors in the D.N.B.: Additions and Corrections (ii)," *Theatre Notebook*, vol. 6, no. 3 (1952), p. 67. In the parish register at Twickenham, Crouch gave his name as Rollings Edward Crouch, but he is always called Edward Crouch in every issue after 1780 of D. Steel's monthly periodical *Original and Correct List of the Royal Navy*.

4. Young (see note 1), vol. 1, p. 236.

5. Ibid., vol. 2, p. 34.

6. Michael Kelly, *Reminiscences of Michael Kelly, of the King's Theatre, and Theatre Royal Drury Lane, Including a Period of Nearly Half a Century; with Original Anecdotes of Many Distinguished Persons*, 2nd ed. (London, 1826), vol. 1, p. 291.

7. *Farington Diary*, [1793], January 3, 1800, gives details: "The Prince of Wales wished to form a connexion many years ago with Her and settlements were made. Mrs. Crouch had money or Bonds to the amount of £12,000. Her Husband something equivalent to £400 a year to prevent His bringing an action against the Prince. After all this the Prince was only with Her once."

8. Ward and Roberts, 1904, vol. 2, p. 36. Using Romney's sitters' and account books, now in the Victoria and Albert Museum, London, the authors documented the picture precisely but confused the two versions. The following dates for sittings refer to the Kenwood picture: February 7, 15, 21, March 4, 11, April 1, 8, 15, 22, and 29.

9. Whitley, 1928, vol. 2, p. 94.

10. Hogan, 1968, pt. 5, pp. 451, 476. The play opened at Covent Garden on November 17, 1781, in a production in which the staging and costumes were supervised by Walpole himself. The production was revived several times throughout the 1780s. In the first production, Adelaide was played by Miss Satchell. Mrs. Crouch took the role of Adelaide in only two performances, when the play was given at Drury Lane in March 1787. When it was revived for the 1789–90 season, she was no longer in it.

11. See Hogan, 1968, pt. 5, p. 1,541.

12. "Hush Ev'ry Breeze," by James Hook, London, printed by G. Smart, Oxford Street, London, 1800?.

13. As, for example, when she starred as Nancy in John Dent's *Too Civil by Half* in 1783 with music by Hook.

14. Romney, 1830, p. 251.

15. Ward and Roberts, 1904, vol. 2, p. 36.

INSCRIPTION: *Thos. Agnew & Sons* [on label on stretcher].

PROVENANCE: The artist; artist's sale, Christie's, April 27, 1807, lot 109, bt. Dr. Weshop; [sold by Rev. Preby Bolster] Christie's, February 20, 1858, lot 54, bt. Smith, London; J. H. Anderdon, Esq., 1867; J.S.W.S. Erle Drax, by 1887; Different Properties [sold by J.J.W. Deuchar], Christie's, May 7, 1898, lot 31, bt. Frickenhaus; A. Wertheimer, 1901; Agnew, bt. John H. McFadden, May 10, 1901.

EXHIBITIONS: London, South Kensington, *National Portrait Exhibition*, 1867, no. 633 (lent by J. H. Anderdon, Esq.); New York, 1917, no. 33; Pittsburgh, 1917, no. 32; Philadelphia, 1928, p. 19.

LITERATURE: "Noted from Inventory of the Furniture etc. at Holnest Park, Sherborne, Dorset, the Property of the late J.S.W.S. Erle Drax, Feb. 1887": "Gallery, East Side 480, Romney, Half length portrait of Mrs. Crouch in a white dress and cap wearing an oval locket," Archives, National Portrait Gallery, London; Gamlin, 1894, p. 197; Ward and Roberts, 1904, vol. 1, pp. 110–11, repro. between pp. 32–33, vol. 2, p. 36; Roberts, 1913, p. 540; Roberts, 1917, pp. 63–64, repro. opp. p. 63.

CONDITION NOTES: The original support is twill-weave, medium-weight (10 x 10 threads/cm.) linen. The tacking margins have been removed. Weave cusping is evident in the support on all four sides. The painting was relined with medium-weight linen (Siegl, 1965) and a wax-resin adhesive. A previous aqueous lining is retained in the structure. An off-white ground is present, evident at the cut edges. The paint is generally in only fair to poor condition. Severe abrasion has occurred overall; this is especially evident in the mid-tones of the figure's details. An irregular web of fracture crackle with associated cupping is present overall. A pentimento of a branch appears in the sky at the right of the figure and is visible in normal and ultraviolet light. Extensive retouching in the background around the head of the figure is visible in ultraviolet light. The right side of the face and neck have also been heavily retouched.

VERSION: George Romney, *Mrs. Crouch*, 1787, oil on canvas, 50 x 40″ (127 x 101.6 cm.), Kenwood, The Iveagh Bequest (fig. 98-1).

PROVENANCE: W. Rawlinson, Romney's great-grandson; sold May 2, 1889, to Agnew; Edward Cecil Guiness, later 1st Earl of Iveagh, 1889.

LITERATURE: Chamberlain, 1910, pp. 229, 232, 322; Herbert van Thal, ed., *Solo Recital: The Reminiscences of Michael Kelly* (London, 1972), repro. opp. p. 161; Philip H. Highfill, Jr., Kalman A. Burnim, and Edward A. Langhans, *A Biographical Dictionary of Actors, Actresses, Musicians, Dancers, Managers, and Other Stage Personnel in London, 1660–1800* (Carbondale, 1975), vol. 4, p. 87, repro. p. 80; Kenwood, The Iveagh Bequest, *Catalogue of Paintings* (London, 1965), p. 33, no. 34.

ENGRAVINGS

1. Francesco Bartolozzi (1727–1815) after George Romney, *Mrs. Crouch*, 1787–88, stipple, 8 x 6⅜″ (20.3 x 16.2 cm.).

DESCRIPTION: One proof before title; three fully lettered impressions, one printed in colors, dedicated to Mrs. Crespigny (wife of Sir Claude Champion de Crespigny, see no. 91) "by her most obedient servant James Heath," presumably the proprietor of the engraving rights.

2. William Greatbach (b. 1802) after George Romney, *Mrs. Crouch*, 1851, engraving, 3¾ x 3¾″ (9.5 x 9.5 cm.).

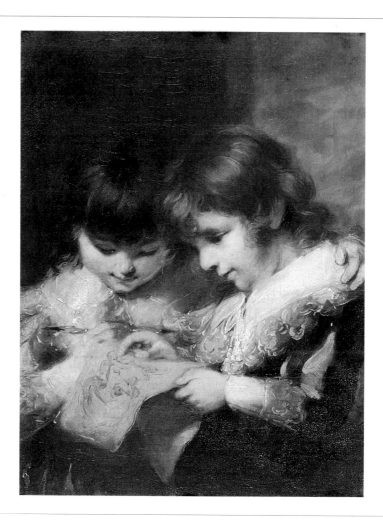

99 WILLIAM RUSSELL *THE YOUNG ARTISTS (WILLIAM AND THOMAS RUSSELL),* after 1793
 AFTER JOHN RUSSELL Oil on canvas, 24 x 18″ (61 x 45.8 cm.)
 Gift of John S. Williams, 47-100-3

This painting entered the Philadelphia Museum of Art catalogued as "School of Thomas Lawrence," but was reattributed in 1965 by Kenneth Garlick to John Russell (1745–1806) (letter, February 17, 1965) on the basis of the reproduction of a pastel version of the picture in Williamson's 1894 monograph on John Russell (then in the collection of Russell's great-grandson Francis H. Webb). However, when the picture was sold at Christie's on July 25, 1913 (lot 10), Webb himself had made a note in his copy of the sales catalogue clarifying its authorship: the painting is a copy in oil by William Russell (1784–1870) after the pastel by his father, John Russell.

John Russell was one of the more colorful figures of the later eighteenth century: a successful pastelist whose clients included both the king and the Prince of Wales; a religious enthusiast whose conviction bordered on mania; and yet an artist/astronomer—a product of the Enlightenment, who spent nearly twenty years of his life drawing and engraving the visible surface of the moon. From 1766 to 1802 he kept a diary in eight volumes, now preserved in the library of the Victoria and Albert Museum.[1] Also in the Victoria and Albert Museum are the copy of Williamson's 1894 biography of Russell, annotated and corrected by Webb, and Webb's own illustrated catalogue of Russell's pictures.

By the age of thirteen John Russell was in London training to be an artist, and at fifteen, in 1760, he was apprenticed to the pastelist and painter Francis Cotes (1726–1770).[2] In 1768 he exhibited for the first time in public at

the Society of Artists in Spring Gardens (two oils and a pastel), and in 1769 two of his oil portraits hung in the first Royal Academy exhibition. In 1772 Russell was elected an Associate member of the Royal Academy, although he had to wait until 1788 for full membership. Royal commissions came only toward the end of the 1780s, but in the 1790 Royal Academy exhibition, where he exhibited a portrait of Queen Charlotte, the catalogue styled him "Painter to the King and the Prince of Wales." In his later years he took up landscape painting but continued to execute portraits. The last years of his life were spent in long visits to Yorkshire, especially to Leeds where his favorite son, Thomas, was working. Russell died of typhus at Hull on April 20, 1806.

It is not certain which of the two little boys dressed in Van Dyck costume is William and which is Thomas. But the fact that the round-faced child on the left holds the pencil with which he has just drawn an old man's face (his father?), and puts his arm around the other child in a protective, fraternal gesture, indicates that he is the older, artistic one, William. The handling of the paint in the picture is uncertain and crude and gives us no reason to doubt either Webb's attribution to William Russell or that the copy was executed after the original pastel was exhibited at the Royal Academy in 1793.

The main source for the life of William Russell are the notes made by Webb in his copy of Williamson's biography. William was the eleventh of John and Hannah Russell's thirteen children, born on November 26, 1784. He was educated with Thomas at Rev. George Gibson's school in London. Later he lived at home in Mortimer Street and was taught to work both in pastels and in miniature by his father. Although John Russell never mentioned him in his diary, William appears to have been a dutiful son, the only one of John's children present at his deathbed in 1806.

After that event he went to live with his mother at 21 Newman Street, off Oxford Street, completing his father's pictures for sale, and also printing his father's engravings of full-moon maps, which were called lunar planispheres, with a pamphlet explaining their use.[3] In 1807 he exhibited a *Gleaner* in pastel at the British Institution (no. 80) and in the following year a pastel *Lighting the Oven* (no. 70) and *A Schoolboy* (no. 191). He seems to have taken on some sitters himself, working mainly in oils; but any surviving paintings, except for *The Young Artists,* are untraced. In March 1809, William told his mother that he was entering the ministry, and on May 21, 1815, he was ordained, taking up a living at Shepperton on Thames, Middlesex, the following year. William married Laetitia Ann Nichols (1795–1879) and had three children. He exhibited eight pictures, all portraits, at the Royal Academy between 1805 and 1809.[4] His will directed that all his pictures be sold, but several family portraits, including the pastel version of *The Young Artists,* were retained and later sold to Webb.

Thomas Russell, on the right, John Russell's youngest child and his favorite, was born at 7 Mortimer Street on December 8, 1785. His father frequently mentioned him in his diary as a good, pious little boy. Like his brother William he was educated by Reverend Gibson, then, in 1800, apprenticed for seven years to Mr. Wormald, a clothier in Leeds. He was never a success at business, but after 1823 he ran a school in Printing House Square, which did well. He died on September 16, 1865, the year after his wife, Maria Hendy (b. 1788). He left eight children.[5]

1. John Russell, Diary, 8 vols. in MS., 1766–89, 1801–2, 86.FF.38–45, Victoria and Albert Museum Library, London.

2. Williamson, 1894, pp. 7–9 (this biography should be used only in conjunction with Webb's corrections, preserved in the Victoria and Albert Museum, London).

3. William Russell, *A Description of the Lunar Planispheres Engraved by the Late John Russell, Esq., R.A., from His Original Drawings* (London, 1809). See also Russell, 1797; E. J. Stone, "Note on a Crayon Drawing of the Moon by John Russell, R.A., at the Radcliffe Observatory, Oxford," *Monthly Notices of the Royal Astronomical Society,* vol. 56, no. 3 (1896), pp. 88–95; "A Portrait-Painter Who Studied the Moon," *The Illustrated London News,* October 18, 1930; W. F. Ryan, "John Russell, R.A., and Early Lunar Mapping," *The Smithsonian Journal of History,* vol. 1, no. 1 (spring 1966), pp. 27–48.

4. Williamson, 1894, Webb's MS. notes opp. pp. 99, 100.

5. Ibid., p. 100.

PROVENANCE: Thomas Russell; his son Rev. Thomas Russell; his sale, Christie's, July 25, 1913, lot 10 (as by John Russell); bt. Wertheimer; John S. Williams.

CONDITION NOTES: The original support is medium-weight (10 x 10 threads/cm.) linen. The tacking margins have been removed. Weave cusping in the support is obvious along the right-hand edge and bottom. The painting is lined with an aqueous adhesive and medium-weight linen. The present lining appears structurally unsound and is beginning to delaminate at the corners. An off-white ground is present, evident along the cut-edges. The paint is in good condition overall. A series of traction crackle extends throughout and is coincident with the white areas of both figures' collars and cuffs. An irregular web of fracture crackle is present overall. Losses are small and occur primarily along the edges. Under ultraviolet light, retouches to the traction crackle and the lower right corner are evident.

VERSION: John Russell (1745–1806), *The Young Artists (William and Thomas Russell),* 1793, pastel, 24 x 18″ (61 x 45.8 cm.), location unknown.

INSCRIPTION: Signed top left corner in pencil.

PROVENANCE: William Russell; his son William Henry Russell; his wife, Highgate; bt. his cousin Francis H. Webb.

EXHIBITIONS: London, Royal Academy, 1793, no. 238; London, Imperial Institute, 1894, no. 107.

LITERATURE: Williamson, 1894, pp. 114, 169, repro. opp. p. 72; R.R.M. See, "Portraits of Children of the Russell Family by John Russell," *The Connoisseur,* vol. 52 (December 1918), p. 186, repro. p. 187.

A pioneer in the medium and technique of watercolor, the primary exponent in England of the Continental technique of gouache, Paul Sandby was the father of the topographical tradition in English landscape and through his works and engravings after them did more than any other individual to bring before his countrymen the natural beauties of their own land. The historian Sir Richard Colt Hoare (1758–1838), reminiscing in 1822, recalled that "during my younger days Paul Sandby was the monarch of the plain and esteemed the best artist in this line."[1] He was also a superb figure draftsman and a brilliant caricaturist, a lively conversationalist, and the patron of, among others, Francis Cotes (1726–1770), William Pars (1742–1782), William Beechey, and Richard Wilson (q.q.v.).

Born in Nottingham in 1730, Sandby went to London some time after 1742 with his older brother Thomas (1723–1798), an architect and draftsman who became secretary and draftsman to William Augustus, Duke of Cumberland, on his Scottish and foreign military campaigns. In 1747, presumably through Thomas's influence, Paul took up a post as draftsman to the survey of the Scottish Highlands, a job requiring detailed accuracy in the delineation of some of the wildest landscapes in Europe and yet giving him time to draw views of Edinburgh and to learn to etch from a Mr. Bell.[2]

Around 1751 Paul went south to join his brother at Windsor Park, where Thomas had worked as deputy ranger, for his patron the Duke of Cumberland. At this time Thomas was altering the park, laying out the artificial lake and grounds at Virginia Water and enlarging Cumberland Lodge. For the next two decades Paul lived at Windsor and in London, and traveled throughout England and Wales as a painter of country houses and picturesque scenery. By 1764 his fame was such that Gainsborough (q.v.) could decline a commission offered by Lord Hardwicke to paint his country seat, with the words, "with respect to *real Views* from Nature in this Country... Paul Sanby is the only Man of Genius... who has employ'd his Pencil that way."[3]

Sandby was a founding member of the Society of Artists, contributing to their first exhibition and exhibiting there throughout the 1760s; then when the Royal Academy was established in 1768 he and his brother were among the founders; and from 1769 until his death in 1809 he exhibited, mainly topographical works, regularly there.

Broadly speaking, Paul Sandby's art can be divided into two styles. On the one hand his landscapes and architectural views, with their clear outlines and strong perspectives, owe much to Canaletto (1697–1768), who had lived in England on and off from 1746 to 1755 or 1756, and to the tradition of topography exemplified by views of Stowe by Jacques Rigaud (c. 1681–1754). This aspect of his work his son described as the reproduction of nature as it appears in the camera obscura with "truth in the reflected lights, the clearness in the shadows, the aërial tint... in the distances, and skies... [without] violent contrast for effect."[4] Often, although not always, these topographical views were carried out in watercolor, a medium he helped to develop as an independent art form. He laid on his pale, transparent colors with delicacy and precision, allowing the white paper underneath to show through, so that his works have a clarity unlike those of any other English watercolors at this date.

On the other hand, his work in body color tends to be more artificial and intellectual. In his gouaches (pigment ground in gum and water, mixed with Chinese white) he was influenced by the artist whose work he ardently collected, Marco Ricci (1676–1730), and the works of Ricci's French imitators Joseph Goupy (1689–1763) and Jean Baptiste Claude Chatelain (1710–1771). Ricci worked in England on and off from 1708 to 1716 primarily as a painter of ideal pastoral landscapes in gouache in the tradition of Claude (1600–1682)

and Gaspard Poussin (1615–1675). In Sandby's middle and later works, he imitated Ricci's use of impasto, his lively figure types and ideal compositions, usually in views of real places in England and Wales, so that he brought to topography the prestige of the classical tradition, just as Reynolds (q.v.), by incorporating classical forms and attributes into portraits of real people, raised portraiture near to the level of history painting.[5]

From 1768 to 1797 Sandby was chief drawing master at the Royal Military Academy, Woolwich. In 1757 he married Anne Stogden, and in 1772 purchased a house in London at 4 St. George's Row (today Hyde Park Place). He is also remembered as the artist who in 1775 introduced the aquatint process of print-making commercially into England, after it had been purchased by his friend Charles Greville (1749–1809) from the French artist Jean Baptiste LePrince (1734–1781).

But Sandby outlived his own innovations, lingering on into the age of Turner (q.v.), Thomas Girtin (1775–1802), and Richard Parkes Bonington (1802–1828). By the 1800s his work seemed outdated and old-fashioned to an artist such as Joseph Farington (1747–1821), who, after viewing Sandby's sale of 1811, remarked in a diary entry of May 2, 1811, on "the great difference between His works & those of Artists who now practise in Water Colours. His drawings so divided in parts, so scattered in effect—detail prevailing over general effect."[6]

1. See Whitley, 1928, vol. 2, p. 363.
2. Herrmann, 1973, p. 37.
3. Woodall, ed., 1963, pp. 87–91.
4. See Oppé, 1946, p. 146.
5. Pointed out by Herrmann, 1973, p. 42.
6. Farington Diary, [1793], May 2, 1811.

BIBLIOGRAPHY: S.T.P. [Thomas Paul Sandby], "Memoirs of the Late Paul Sandby, Esq., R.A.," *The Monthly Magazine*, vol. 31, no. 213 (June 1, 1811), pp. 437–41; William Sandby, *Thomas and Paul Sandby, Royal Academicians: Some Account of Their Lives and Works* (London, 1892); Oppé, 1946, pp. 143–47; E. H. Ramsden, "The Sandby Brothers in London," *The Burlington Magazine*, vol. 89, no. 526 (January 1947), pp. 15–18; Oppé, 1947; Luke Herrmann, "Paul Sandby in Scotland," *The Burlington Magazine*, vol. 106, no. 736 (July 1964), pp. 339–43; Hardie, 1966–68, vol. 1, pp. 97–112; Herrmann, 1973, pp. 36–44; Wilton, 1977, pp. 11–16.

EXHIBITIONS: Nottingham, Midland Counties Art Museum, Nottingham Castle, *Special Exhibition of Drawings and Pictures by Thomas Sandby, R.A., and Paul Sandby, R.A., Natives of Nottingham,* February, 1884; London, Royal Amateur Art Society Exhibition, *Oil Paintings, Water Colour Drawings, Etc., by Paul Sandby, R.A.,* March 1909; London, Guildhall Art Gallery (Corporation Art Gallery), *Paul Sandby, 1725–1809,* June–July 1960; Philadelphia and Detroit, 1968, pp. 55–56; London, 1970; Reading, Reading Museum and Art Gallery, Bolton, Bolton Museum and Art Gallery, *Thomas and Paul Sandby,* January–April 1972 (by Eric J. Stanford); New Haven, Yale Center for British Art, *The Art of Paul Sandby,* April 10–June 23, 1985 (by Bruce Robertson).

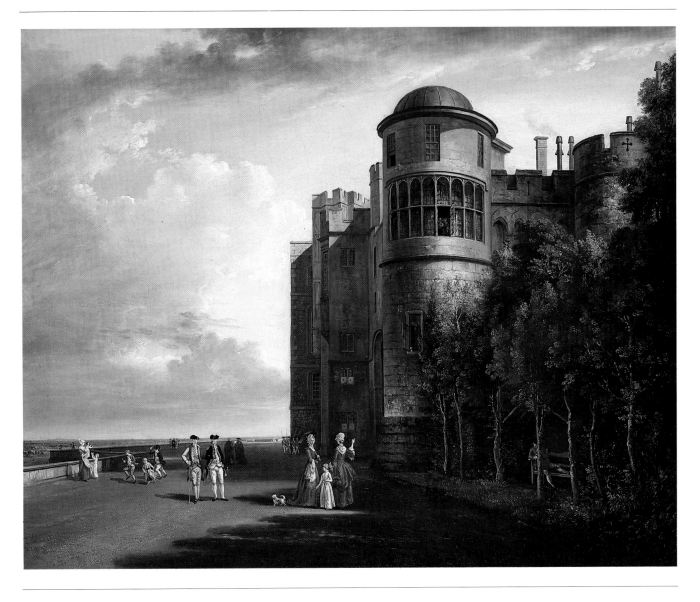

OO PAUL SANDBY

THE NORTH TERRACE AT WINDSOR CASTLE, LOOKING EAST, c. 1775–80
Oil on canvas, 39¾ x 50″ (101.3 x 127.2 cm.)
Gift of John H. McFadden, Jr., 51-125-18

This picture shows the north terrace at Windsor Castle looking east, with the
west end of Queen Elizabeth's Gallery in the right foreground and a view
northeast beyond the parapet to the Thames Valley. It is a summer's day, the
ideal time for tourists to stroll on the terrace beneath the castle's open
windows. In the foreground two fashionable ladies with a child and a dog are
talking: one looks out from under her parasol at us, the other points up to a
kitten perched in the lower window of the circular tower. In the upper
windows of the tower two indistinct figures are visible. In the foreground to
our left, a gentleman and an officer converse; in the background children play
horsy with little reins and a toy whip near their nursemaid. In the distance
two gentlemen in cloaks, like figures out of a Canaletto (1697–1768), turn their
backs to us; far away a file of soldiers marches off. In the copse on the right,
a gentleman reclining with one leg up on a bench under a wooden shelter can
be seen reading his book. The shadows fall toward the northeast, which
means that the time is midday or perhaps early afternoon.

The terrace walk was laid out in wood by Henry VIII between 1533 and
1535, then repaired and enlarged both by Elizabeth I and Charles II. By the
eighteenth century it extended 1,870 feet[1] and was open to the public: a guide

FIG. 100-1 Paul Sandby, *The North Terrace at Windsor Looking West from the Embrasure,* 1771, published 1776, aquatint, 13⅞ x 19½" (35.2 x 49.4 cm.)

FIG. 100-2 Paul Sandby, *The North Terrace at Windsor Looking East,* 1771, published 1776, aquatint, 13½ x 18⅞" (34.3 x 45.4 cm.)

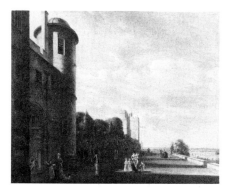

FIG. 100-3 Attributed to Paul Sandby (possibly Benedictus Vanassen?), *The North Terrace at Windsor Looking West toward Winchester Tower,* 1792, oil on canvas, 40 x 50¼" (101.6 x 127.6 cm.), Her Majesty Queen Elizabeth II, Buckingham Palace

to Windsor published in 1768 called the terrace "the noblest walk in Europe."[2] From 1776 to 1789 Windsor was used as a summer residence by George III and his family. By 1800 the king had begun to occupy apartments on the north side of the castle very near the ones we are looking at in Sandby's view. The artist was therefore painting a popular tourist attraction, one famous throughout Europe; thus sheer commercial appeal would account for the many repetitions in watercolor and gouache that he made of the scene.[3] From 1800 to 1810, under the direct supervision of the king, the architect James Wyatt (1746–1813) remodeled Windsor Castle in an effort to recreate the original medieval structure; the scene today, although recognizable, has altered. The trees and bench to the right are gone, and the round-topped turret of the Queen's Gallery has been medievalized—its windows changed to pointed gothic shapes, the domed tower given crenelations to match those on the tower to the far right.[4]

Sandby began treating the theme as early as 1766 when he showed a *View of the North Side of the Terrace at Windsor* in watercolor or gouache at the Society of Artists (no. 146). He exhibited a pair of north terrace views looking east and west at the Royal Academy in 1774 (nos. 259, 260; possibly version 4 and related work 4) and published two aquatints of the subject in 1776 (figs. 100-1 and 100-2). Finally, Sandby exhibited a north terrace view at the Royal Academy in 1802 (no. 601), but whether the view was to the east or west is not recorded. In between, he depicted the terrace many times, often (but not always) in pairs or trios of works, which showed dramatically different effects of light so that a morning view to the east was contrasted to an evening view toward the setting sun (for example, version 2 and related work 2).

In 1969 Oliver Millar published an oil painting in the royal collection, a view of *The North Terrace at Windsor Looking West toward Winchester Tower* (fig. 100-3).[5] This picture, with its groups of strolling figures, a nursemaid and her charges, and an officer, is closely related to an earlier watercolor now in the collection of Her Majesty, Queen Elizabeth, the Queen Mother (related work 11). At first glance the former would seem to be a pendant to the Philadelphia view to the east, which itself is closely related in composition to a gouache formerly in the collection of the Princess Royal (fig. 100-4), dating from the same period as the Queen Mother's landscape. On this basis, Millar cautiously attributed the picture in the royal collection (fig. 100-3) to Sandby and suggested that it and the Philadelphia view may have been the pictures exhibited at the Royal Academy in 1774, although he pointed out that no medium or dimensions were given in the academy catalogue.

The hypothesis is attractive, but it may be challenged after a close visual examination of the two pictures. In the view in the royal collection (fig. 100-3), the figures, which are based, in part, on those in Sandby's 1776 aquatint, are colorless, very unlike the vigorously rendered Hogarthian types usually painted by Sandby; they seem to float above the ground, not to occupy the space. The trees to the left are schematic, their trunks and foliage are painted without any sense of the artist's understanding the underlying structure of its branches and leaves. The architecture in general is as flat as a painted stage backdrop. In particular, in the artist's or copyist's treatment of Winchester Tower in the background, forgotten is the third and lowest horizontal ribbing, which is visible in every genuine Sandby watercolor and gouache showing the tower. Finally, the riding hat of the woman to the left in the royal collection picture cannot be earlier than the fashions of the 1790s.

In the Philadelphia painting, by contrast, the figures are fully three dimensional, the shadows they cast are realistic, their faces are individual and particular. The structure of the trees is completely convincing. In sum, on visual evidence alone, we may be justified in doubting whether the two

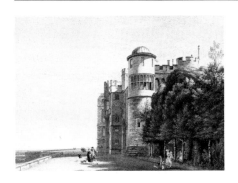

FIG. 100-4 Paul Sandby, *The North Terrace at Windsor Looking East*, 1768, watercolor and body color, 15 x 21¼" (38.1 x 54 cm.), New Haven, Yale Center for British Art, Paul Mellon Collection

pictures are by the same hand, for the Philadelphia view is finer in quality. It is true that the figures in the Philadelphia oil are for the most part taken from the aquatint, as are a few of the figures in the oil in the royal collection, but this does not weigh heavily as evidence for an attribution for or against Sandby.

In addition, there is no evidence, other than their nearly identical sizes, that the two pictures were ever a pair. The provenance of the Philadelphia picture can be traced with certainty only as far as 1919 to the 2nd Viscount Escher, deputy constable and lieutenant governor, governor of Windsor Castle from 1901 to 1928 and constable of the castle from 1928 to 1930. (Although, as we shall see, the Philadelphia picture may be the one sold in the Sandby sale of 1817.) The landscape in the royal collection is first recorded at Windsor in an inventory of 1878 when Redgrave noted that formerly there had been a paper label on the stretcher inscribed "View of the North Terrace Van Assam 1792." Millar stated that very faint traces of this label can still be seen, but he was inclined to disregard it because no Van Assam who could have painted the royal collection picture is recorded.

There is, however, listed in Richard and Samuel Redgrave (1866) a Benedictus Antonio Vanassen (d. c. 1817), engraver and designer, who worked in London toward the end of the eighteenth century, and who exhibited twenty-nine pictures at the Royal Academy beginning in 1788 and thereafter every year from 1790 to 1804. This Vanassen was also a designer of emblematic devices and a portrait, landscape, genre, and history painter—exhibiting at the Royal Academy paintings with such titles as *A Cottage Scene* (1793, no. 550), *Erictho: A Sketch from Lucan's Pharsalia* (1793, no. 618), *Maternal Attention* (1794, no. 393), and *Christ at Emmaus* (1803, no. 412). What is awkward about suggesting that the picture in the royal collection may have been correctly labeled on the stretcher after all, and that it is actually a copy or variation by Vanassen of a lost Sandby, is that Vanassen's pictures are difficult to find to see what they looked like. Drawings and prints of his in the British Museum show that he was a feeble artist—but not too feeble to have worked as a copyist and to have painted the picture in the royal collection.

The Philadelphia picture is, therefore, not necessarily a pendant to a view looking west—or, if it is, the view to the west is now lost. Millar's suggestion that the Philadelphia and the queen's pictures were the ones exhibited at the Royal Academy in 1774 can at best be only a partial possibility, that is, if we presume that the queen's picture is a copy of a lost Sandby that once formed a pendant to the Philadelphia painting. More likely the pair exhibited at the Royal Academy were those formerly belonging to the Duke of Montagu, Sandby's patron and governor of Windsor Castle, to whom the 1776 aquatints were dedicated.[6] Today they belong to the Duke of Montagu's descendant, the Duke of Buccleuch and Queensberry at Drumlanrig Castle (version 4 and related work 4). In one of Paul Sandby's posthumous sales, on April 18, 1817, at Christie's, lot 74 was "Windsor Castle Terrace, looking Eastward (oil painting)," which was bought for £215 by Seguier.[7] The price paid indicates a large finished picture, and it may be that this picture is the one today in Philadelphia.

Dating the Philadelphia *North Terrace* is difficult because so few certain oil paintings by Sandby are known that a comparison is hard to make. Looking at the listing of versions and related works accompanying this entry, we can see that Sandby's terrace views fall roughly into two different periods, those executed in the 1760s and 1770s, culminating with the aquatint of 1776; and those executed after a lapse of about twenty years, from the late 1790s to about 1800 and after. On stylistic grounds, we might suggest a date for the Philadelphia picture of c. 1775–80, when Sandby still used watercolor and

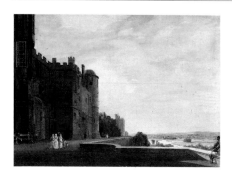

FIG. 100-5 Paul Sandby, *The North Terrace at Windsor Looking West from the Embrasure*, 1800, gouache, 15 x 21¼″ (38.1 x 54 cm.), London, Victoria and Albert Museum

gouache, at least, in a precise and detailed manner, quite distinct from the much broader handling of his later years. Then, too, the costumes of the figures are from the 1770s, and Sandby certainly updated his costumes, as we can see from gouaches of about 1800 (figs. 100-5–8). Although as his son pointed out,[8] Sandby turned more and more to oils toward the turn of the century, our picture is still more likely to be earlier rather than later, and the slight muddiness and stiffness in the handling of paint in comparison to his use of watercolor in the 1760s and 1770s may be due to his relative unfamiliarity with the medium. Against this, in an oil painting certainly by Sandby, *A View of Hackwood Park Hampshire* (exhibited Society of Artists, 1764, no. 101, 39 x 49¼″, New Haven, Yale Center for British Art), formerly in the collection of Lord Bolton, the colors are fresh and clear, the handling of paint free and unforced, making the Philadelphia picture seem, by comparison, labored and harsh.

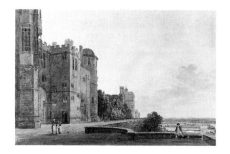

FIG. 100-6 Paul Sandby, *The North Terrace at Windsor Looking West from the Embrasure*, c. 1800, watercolor with touches of gouache, 13⅝ x 20⅞″ (34.7 x 53 cm.), Her Majesty Queen Elizabeth II, Windsor, Royal Library

1. St. John Hope, 1913, p. 579; H. M. Colvin, ed., *The History of the King's Works*, vol. 6, 1782–1851, by J. Mordaunt Crook and M. H. Port (London, 1973), pp. 373–402.
2. *Windsor and Its Environs* (London and Windsor, 1768), p. 6.
3. Sandby sketched many views of the castle and the park at Windsor, but the north terrace views are among the most numerous. They can be divided into three types: views looking west from the embrasure (related works 1–10); views looking west straight along the terrace (related works 11–16); and views looking east, which are all taken from the same viewpoint (versions 1–10). It would appear that in no two landscapes are the figures or groups of figures identical, although the same figures and poses turn up in various combinations and places in different views.
4. A watercolor of the same view by Paul Fisher in the library of Windsor Castle is inscribed "North Terrace, Windsor Castle, 1810." In it, the copse at the right has been cut down to expose the wall.
5. Millar, 1969, vol. I, p. 111.
6. Although dated indistinctly 177[?], no labels or inscriptions on these pictures indicate their exhibition history.

7. William Seguier (1771–1843) was a pupil of George Morland (q.v.) and painter primarily of topographical scenes. He became a leading connoisseur and art dealer employed by George IV in assembling the Dutch and Flemish pictures in the royal collection. He was conservator of the royal picture galleries (also under William IV and Queen Victoria) and first Keeper of the National Gallery in London. He was also superintendent of the British Institution. His partner in art dealing was his brother John (1785–1856), a topographical artist specializing in views of London and a picture restorer. For both men, see their entries in the *Dictionary of National Biography*.
8. See Oppé, 1946, pp. 146–47.

INSCRIPTION: *1135* / I [on the stretcher in ink].

PROVENANCE: Possibly the artist's sale, Christie's, April 18, 1817, lot 74, bt. Seguier; Viscount Escher, Orchard Lea, Windsor; Arthur Tooth and Sons, before 1920; sold to Agnew, January 9, 1920; bt. John H. McFadden, Jr., January 12, 1920.

LITERATURE: Millar, 1969, vol. I, p. 111, fig. 34; London, 1970, p. 19, no. 23; Staley, 1974, p. 36.

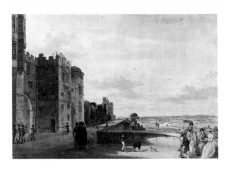

FIG. 100-7 Paul Sandby, *The North Terrace at Windsor Looking West from the Embrasure,* c. 1800, pencil, pen, and watercolor with gouache, 14⅜ x 21⅛" (36.5 x 53.5 cm.), Her Majesty Queen Elizabeth II, Windsor, Royal Library

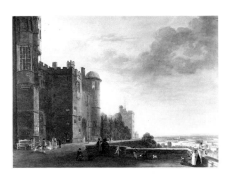

FIG. 100-8 Paul Sandby, *The North Terrace at Windsor Looking West from the Embrasure,* c. 1800, gouache on canvas, 24⅝ x 34¼" (62.5 x 87 cm.), Her Majesty Queen Elizabeth II, Windsor, Royal Library

CONDITION NOTES: The original support is single-thread, medium-weight (10 x 10 threads/cm.) linen. The tacking margins have been removed. The painting is lined with an aged aqueous adhesive and medium-weight linen. An off-white ground can be seen along the cut edges. The paint is in excellent condition. The brush marking and paint profile are well preserved. A wide aperture web of fracture crackle is present overall. Infrared reflectography shows pentimenti in the clouds at the left of the castle. Ultraviolet light indicates that retouches are restricted to an area of foliage along the extreme right edge.

VERSIONS

1. Paul Sandby, *The North Terrace at Windsor Looking East,* 1768, watercolor and body color, 15 x 21¼" (38.1 x 54 cm.), New Haven, Yale Center for British Art, Paul Mellon Collection (fig. 100-4).
 PROVENANCE: Hon. Sir Richard Molyneux; the Princess Royal; the Earl of Harewood; his sale, Christie's, July 13, 1965, lot 172.
 LITERATURE: Borenius, 1936, no. 430; Oppé, 1947, p. 21 fig. 7.
 DESCRIPTION: Pendant to related work 1.

2. Paul Sandby, *The North Terrace at Windsor Looking East at Dawn,* 1765–70, gouache, 17¼ x 24⅛" (43.8 x 61.3 cm.), Eton, Eton College Collection.
 PROVENANCE: Bequeathed by Miss F.A.C.M. Biddulph, 1948.
 DESCRIPTION: Pendant to related work 2.

3. Paul Sandby, *The North Terrace at Windsor Looking East,* c. 1765–70, gouache on paper laid on board, 18⅝ x 24½" (47.3 x 62.2 cm.), Her Majesty Queen Elizabeth II, Windsor, Royal Library.
 PROVENANCE: Probably purchased from the artist by William Hawker; by descent to Roger Helgar; his sale, Sotheby's, July 10, 1980, lot 103.

4. Paul Sandby, *The North Terrace at Windsor Looking East,* 1774, watercolor, 19½ x 23¾" (49.5 x 60.3 cm.), Drumlanrig Castle, the Duke of Buccleuch and Queensberry, K.T.
 EXHIBITION: Possibly London, Royal Academy, 1774, no. 260.
 DESCRIPTION: Pendant to related work 4.

5. Paul Sandby, *The North Terrace at Windsor Looking East,* c. 1777, pencil, 6⅜ x 9¼" (16.2 x 23.5 cm.), Her Majesty Queen Elizabeth II, Windsor, Royal Library.
 INSCRIPTION: *Star Chamber Wr Castle 1777.*
 LITERATURE: St. John Hope, 1913, pl. CXXII; Oppé, 1947, no. 7.
 DESCRIPTION: Compare to related work 12.

6. Paul Sandby, *The North Terrace at Windsor Looking East at Dawn,* 1770s, gouache, 18½ x 23⅞" (47 x 60.6 cm.), Anglesey Abbey, National Trust.

7. After Paul Sandby, *The North Terrace at Windsor Looking East,* watercolor, 11⅝ x 17¾" (29.5 x 45 cm.), Her Majesty Queen Elizabeth II, Windsor (no. 14530).
 LITERATURE: Oppé, 1947, no. 8.

8. After Paul Sandby, *The North Terrace at Windsor Looking East,* watercolor, with pen and white, 6¾ x 10¾" (17.1 x 27.3 cm.), London, British Museum (I.B. 12).

9. After Paul Sandby, *The North Terrace at Windsor Looking East,* pen and watercolor over pencil, 5¼ x 8" (13.5 x 20.2 cm.), Her Majesty Queen Elizabeth II, Windsor (no. 14532).
 LITERATURE: Oppé, 1947, no. 9.

10. After Paul Sandby, *The North Terrace at Windsor Looking East,* gouache, 15¼ x 21" (38.8 x 53.3 cm.), Her Majesty Queen Elizabeth II, Windsor, Royal Library (no. 14531).
 INSCRIPTION: *P. Sandby, R.A., 1803.*
 LITERATURE: Oppé, 1947, no. 10.

ENGRAVING: Paul Sandby, *The North Terrace at Windsor Looking East,* 1771, published 1776, aquatint, 13½ x 18⅞" (34.3 x 45.4 cm.) (fig. 100-2).
 INSCRIPTION: *P. Sandby Fecit. / Publish'd according to Act of Parliament by P. Sandby St. Georges Row Sepr. 1st 1776 / Windsor Terrass Looking Eastward.*
 DESCRIPTION: Pendant to engraving after related works.

RELATED WORKS

1. Paul Sandby, *The North Terrace at Windsor Looking West from the Embrasure,* c. 1768, watercolor and body color, 15 x 21½" (37.8 x 54.6 cm.), New Haven, Yale Center for British Art, Paul Mellon Collection.
 PROVENANCE: Hon. Sir Richard Molyneux; the Princess Royal; the Earl of Harewood; his sale, Christie's, July 13, 1965, lot 172; Paul Mellon.
 EXHIBITION: New Haven, Yale Center for British Art, *English Landscape, 1630–1850: Drawings, Prints and Books from the Paul Mellon Collection,* April–July 1977, no. 38, pl. LXIX (by Christopher White).
 LITERATURE: Borenius, 1936, no. 429.
 DESCRIPTION: Pendant to version 1.

2. Paul Sandby, *The North Terrace at Windsor Looking West from the Embrasure at Sunset,* c. 1765–70, gouache, 17 x 24" (43.2 x 61 cm.), Eton, Eton College Collection.
 PROVENANCE: Bequeathed by Miss F.A.C.M. Biddulph, 1948.
 DESCRIPTION: Pendant to version 2.

3. Paul Sandby, *The North Terrace at Windsor Looking West from the Embrasure,* c. 1765–70, watercolor, dimensions unknown, Miss Redcliffe Platt. Photograph: London, Witt Library.
 PROVENANCE: Leggatt; bt. Agnew, 1945; C.R.N. Routh, 1945; Miss Redcliffe Platt, 1949.

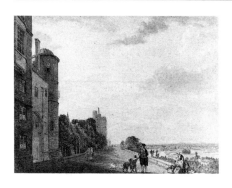

FIG. 100-9 Paul Sandby, *The North Terrace at Windsor Looking West toward Winchester Tower,* after 1778, pencil and watercolor, 12⅜ x 16⅞" (31.5 x 43 cm.), Her Majesty Queen Elizabeth II, Windsor, Royal Library

4. Paul Sandby, *The North Terrace at Windsor Looking West from the Embrasure,* c. 1774, watercolor, 18¾ x 24" (47.6 x 61 cm.), Drumlanrig Castle, the Duke of Buccleuch and Queensberry, K.T.

INSCRIPTION: signed and dated *177*[?].

PROVENANCE: The Duke of Montagu; his daughter, the Duchess of Buccleuch; by descent.

EXHIBITION: Possibly London, Royal Academy, 1774, no. 259.

LITERATURE: Unpublished catalogue, Drumlanrig Castle, no. 65.

DESCRIPTION: Pendant to version 4.

5. Paul Sandby, *The North Terrace at Windsor Looking West from the Embrasure at Sunset,* c. 1770s?, gouache on primed mahogany panel, 18¼ x 24¼" (46.7 x 61.7 cm.), London, Victoria and Albert Museum (P. 7-1945).

PROVENANCE: Mrs. Norman, 1943; Miss Georgiana Angerstein; Leggatt.

LITERATURE: Lionel Lambourne and Jean Hamilton, *British Watercolours in the Victoria and Albert Museum* (London, 1980), p. 337.

6. Paul Sandby, *The North Terrace at Windsor Looking West from the Embrasure,* c. 1775, outline etching tinted with sepia, 17½ x 11½" (44.4 x 29.2 cm.), London, Victoria and Albert Museum (D. 745 DG36).

7. Paul Sandby, *The North Terrace at Windsor Looking West from the Embrasure,* 1800, gouache, 15 x 21¼" (38.1 x 54 cm.), London, Victoria and Albert Museum (D. 1832–1904) (fig. 100-5).

INSCRIPTION: *P. Sandby 1800.*

PROVENANCE: Bequeathed by W. A. Sandby, by 1904.

EXHIBITIONS: London, Guildhall Art Gallery (Corporation Art Gallery), *Paul Sandby, 1725–1809,* June–July, 1960, no. 72; Reading, Reading Museum and Art Gallery, Bolton, Bolton Museum and Art Gallery, *Thomas and Paul Sandby,* January–April, 1972, no. 72.

LITERATURE: Hardie, 1966–68, vol. 1, p. 106; Lionel Lambourne and Jean Hamilton, *British Watercolours in the Victoria and Albert Museum* (London, 1980), p. 337.

8. Paul Sandby, *The North Terrace at Windsor Looking West from the Embrasure,* c. 1800, watercolor with touches of gouache, 13⅝ x 20⅞" (34.7 x 53 cm.), Her Majesty Queen Elizabeth II, Windsor, Royal Library (no. 14525) (fig. 100-6).

LITERATURE: Oppé, 1947, no. 4.

9. Paul Sandby, *The North Terrace at Windsor Looking West from the Embrasure,* c. 1800, pencil, pen, and watercolor with gouache, 14⅜ x 21⅛" (36.5 x 53.5 cm.), Her Majesty Queen Elizabeth II, Windsor, Royal Library (no. 14527) (fig. 100-7).

EXHIBITIONS: London, Royal Academy, 1934, no. 593; London, 1970, no. 30.

LITERATURE: Oppé, 1947, no. 3.

10. Paul Sandby, *The North Terrace at Windsor Looking West from the Embrasure,* c. 1800, gouache on canvas, 24⅝ x 34¼" (62.5 x 87 cm.), Her Majesty Queen Elizabeth II, Windsor, Royal Library (no. 14526) (fig. 100-8).

LITERATURE: Oppé, 1947, no. 5.

11. Paul Sandby, *The North Terrace at Windsor Looking West toward Winchester Tower,* [c. 1768?], gouache, dimensions unknown, Her Majesty, Queen Elizabeth, the Queen Mother.

PROVENANCE: Banks sale, Christie's, 1876, lot 12; Hon. Sir Richard Molyneux.

LITERATURE: Oppé, 1947, fig. 6, discussed in no. 1.

12. Paul Sandby, *The North Terrace at Windsor Looking West toward Winchester Tower,* c. 1777, pencil, 6⅝ x 9⅛" (16.8 x 23.2 cm.), Her Majesty Queen Elizabeth II, Windsor (no. 14523).

INSCRIPTION: *Windsor Terrace, W. 1777.*

LITERATURE: Oppé, 1947, no. 1.

DESCRIPTION: Related to version 5.

13. Paul Sandby, *The North Terrace at Windsor Looking West toward Winchester Tower,* after 1778, pencil and watercolor, 12⅜ x 16⅞" (31.5 x 43 cm.), Her Majesty Queen Elizabeth II, Windsor, Royal Library (no. 14524) (fig. 100-9).

LITERATURE: Oppé, 1947, no. 2.

14. Attributed to Paul Sandby (possibly Benedictus Vanassen?), *The North Terrace at Windsor Looking West toward Winchester Tower,* 1792, oil on canvas, 40 x 50¼" (101.6 x 127.6 cm.), Her Majesty Queen Elizabeth II, Buckingham Palace (fig. 100-3).

INSCRIPTION: *View of the North Terrace Van Assam 1792* [on paper label formerly on stretcher].

PROVENANCE: Recorded at Windsor, 1878 (as by Van Assam).

LITERATURE: Millar, 1969, vol. 1, p. 111, no. 1,055, vol. 2, pl. 87.

15. Paul Sandby, *The North Terrace at Windsor Looking West (Tower and Canon's House Only),* pen and watercolor with traces of pencil, 6 x 7½" (15.4 x 19.1 cm.), Her Majesty Queen Elizabeth II, Windsor, Royal Library (no. 14528).

LITERATURE: Oppé, 1947, no. 6.

16. Paul Sandby, *The North Terrace at Windsor Looking West,* pencil on prepared paper, 4⅜ x 5¼" (11.1 x 13.3 cm.), London, British Museum (L.B. 18 [a]).

ENGRAVING: Paul Sandby, *The North Terrace at Windsor Looking West from the Embrasure,* 1771, published 1776, aquatint, 13⅞ x 19½" (35.2 x 49.4 cm.) (fig. 100-1).

INSCRIPTION: Initialed and dated *1771,* published 1776; lettered: *P. Sandby Fecit. / Published according to Act of Parliament by P. Sandby St. Georges Row Sepr. 1st 1776 / Windsor Terrass looking Westward.* Published: *Windsor Castle from the North West;* lettered: *To His Grace the Duke of Montagu, etc. . . . these Views of the Royal Castle of Windsor are most respectfully inscribed . . . by P. Sandby, R.A.*

DESCRIPTION: Pendant to engraving after versions.

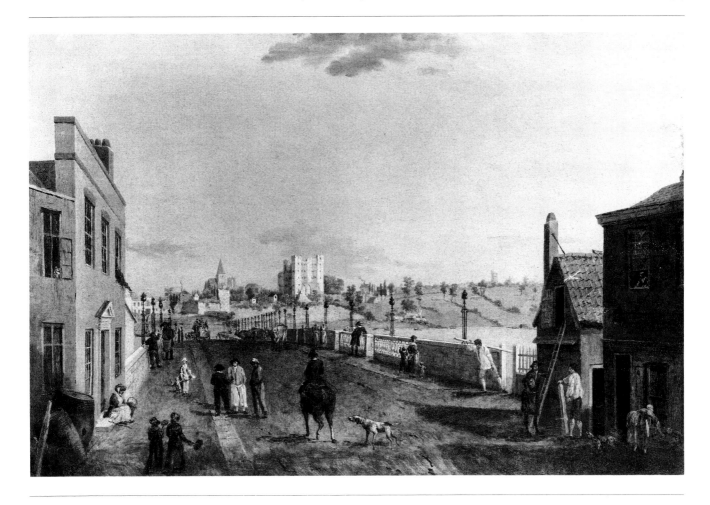

01 CIRCLE OF SAMUEL SCOTT *VIEW OF OLD ROCHESTER BRIDGE*, C. 1732–40
Oil on canvas, 22⅝ x 34⅝″ (57.5 x 88 cm.)
W. P. Wilstach Collection, W06-1-5

The first bridge over the Medway at Rochester was built by the Romans,
followed by a Saxon bridge, burned down in 1264. What we see in this picture
is the bridge built by Sir John de Cobham and Sir Robert Knowles in 1387. Its
architect was Henry Yevele, the king's stonemason and architect of the western
bays of Westminster Abbey. The balustrades seen in the picture are from the
eighteenth century. The medieval bridge lasted until 1857, when for safety
reasons it was blown up by the Royal Engineers, having been replaced by
Sir William Cubitt's bridge of 1850–56. Today a modern bridge (1970) spans
the Medway.[1]

This work is a view of the bridge looking toward the castle. The costume
of the figures suggests a date in the 1730s, or perhaps early 1740s. The
awkwardness of the drawing of the figures and the faulty perspective might
indicate a provincial artist. The infelicities in proportion—for example, the
diminutive size of the lady in the upstairs window in the house on the right,
or the odd height of the lady and child walking toward the viewer on the
footpath on the left—argue against Samuel Scott's (c. 1702–1772) hand.[2] The
treatment of the architecture is stronger, although even here the thin, flimsy
painting of the balustrades on the bridge or the inaccurately receding
perspective of the house to the left are not like the carefully drawn buildings in
Scott's authentic inland views to which we might compare this, such as *Ludlow*
(29 x 43¼″, London, Midland Bank). Richard Kingzett, who prepared a
checklist of Scott's works for the Walpole Society's annual volume, does not
accept the attribution to Scott.[3]

There the question of attribution might rest. However, worth recording is that Scott is known to have visited Rochester in 1732 on the Five Days' Peregrination, in the company of Hogarth (q.v.), Ebenezer Forrest (an attorney), John Thornhill (son of the painter), and William Tothall (a cloth merchant). The party arrived by foot in Rochester on May 27 at ten in the morning: "There wee Survey'd the Fine Bridge, The Cathedrall and the Castle." The next morning, Sunday, May 28, "at Seven awak'd, Hogarth and Thornhill related their Dreams and wee entered into a Conversation. . . . Wee arose and Miss'd Scott, who soon came and acquainted us that he had been on the Bridge Drawing a Veiw of some part of the River . . . and Wondred at people's Staring at him, till he recollected t'was Sunday."[4] Scott was drawing a view *from* the bridge, not the bridge itself,[5] and it is not known that at this date Scott painted inland views at all: the drawings executed on this trip are his earliest documented ones. Nevertheless, the connection of Scott with the bridge at about the date of *Old Rochester Bridge* is noteworthy, if only to raise the possibility that the painting may reflect the existence of a lost drawing by Scott.[6]

Born c. 1702, Samuel Scott never intended to become a painter. As a young man he purchased for one thousand pounds a sinecure as an accountant in the Stamp Office in Lincoln's Inn Square, a post that required his presence only two or three times a week but yielded an income of one hundred pounds a year, and so he found himself with plenty of spare time. For amusement he took up painting, starting by imitating the popular sea pieces of Van de Velde (1633–1707) in the 1720s.[7]

His earliest dated marine picture is from 1726, while his first known commission came from the view painter George Lambert (1710–1765), who in 1731–32 had Scott add the shipping to his six views of the East India Company's settlements, which were destined for the company's courtroom in Leadenhall Street. By the mid-1730s, Scott had taken up topography, concentrating especially on views of the Thames almost ten years before Canaletto's (1697–1768) arrival in London in 1746 would make such scenes fashionable. By the later 1740s, Scott was benefiting from Canaletto's popularity, although he was never a real imitator of the Italian artist.

Scott's huge success as a painter of views of London meant that he did not need to exhibit to make a living. He showed two pictures at the Society of Artists in 1761 (*View of London Bridge*, no. 99, and *The Taking of Quebec*, no. 100) and exhibited there in 1764 a *View of Bear Quay* (no. 105). The following year he was elected a Fellow of the society. He submitted only one of his pictures to the Royal Academy, a *View of the Tower of London* (no. 179) in 1771. His pupils were Sawrey Gilpin (1733–1807) from 1749 to 1756 and William Marlow (q.v.) from 1754 to 1759.[8]

1. Rochester Bridge Trust, *The Bridges of Rochester* (Rochester, 1970).
2. However, see William Gilpin, *Observations on the Western Parts of England, Relative Chiefly to Picturesque Beauty* (London, 1798), p. 298: "Scot, . . . was very deficient in the necessary addition of figures. He could not place their heads on their shoulders, nor hang on their arms, nor set them on their legs, nor give them an easy action."
3. Richard Kingzett, "A Catalogue of the Works of Samuel Scott," *The Walpole Society, 1980–1982*, vol. 48 (1982), pp. 1–134.
4. Forrest, 1952, pp. 4–5.
5. See Forrest, 1952, drawing repro. opp. p. 8.
6. No print after *View of Old Rochester Bridge* has been discovered. See London, Langford and Son, *A Catalogue of the Entire Collection of Prints, Books of Prints, Drawings and Casts in Plaster, of Mr. Samuel Scott, Painter, and Another Gentleman (Both Retiring to the Country)*, April 1–4, 1765; London, Langford and Son, *A Catalogue of the Genuine and Entire Collection of Pictures of Mr. Samuel Scott, Painter*, April 4, 1765; and London, Langford and Son, *A Catalogue of the Entire Collection of Pictures, Finished and Unfinished, of Mr. Samuel Scott, Painter, Late of Bath, Deceased . . .* , January 13, 1773.
7. Farington Diary, [1793], February 8, 1797. See also C[osmo] M[onkhouse], *Dictionary of National Biography*, s.v. "Scott, Samuel."
8. See London, Thomas Agnew and Sons, *Loan Exhibition of Paintings and Drawings by Samuel Scott in Aid of the Victoria Art Gallery, Bath*, April 1951 (by Harold Peake); London, Guildhall Art Gallery (Corporation Art Gallery), *An Exhibition of Paintings and Drawings by Samuel Scott, c. 1702–1772*, July–August 1955 (introduction by John Hayes); London, Guildhall Art Gallery (Corporation Art Gallery), *Samuel Scott Bicentenary, Paintings, Drawings, and Engravings*, May 4–June 3, 1972 (by Kenneth Sharpe and Richard Kingzett); and London, Somerset House, *London and the Thames, Paintings of Three Centuries*, July–October 1977 (by Harley Preston).

INSCRIPTION: *Scott / Old Rochester Bridge* [on rectangular label on back frame].

PROVENANCE: Purchased for the W. P. Wilstach Collection, October 1, 1906.

LITERATURE: Wilstach, 1908, no. 264; Wilstach, 1922, p. 115, no. 287, repro. opp. p. 114.

CONDITION NOTES: The original support is medium-weight (12 x 12 threads/cm.) linen. The tacking margins have been removed. The painting is lined with an aged aqueous adhesive and medium-weight linen. A white ground has been thickly applied. The paint appears to be in fairly good condition, except for several areas that need consolidation and have been faced locally. An irregular web of narrow-aperture fracture crackle with slight, associated cupping has formed overall. Under ultraviolet light, two small retouches can be seen in the sky.

William Bell Scott was the son of the Scottish landscape artist and engraver Robert Scott (1777–1841), a devout Baptist, who responded to the early loss of all but two of his children by withdrawing into the gloom and austerity of his Edinburgh home. Into this dark house he brought to his sons David (1806–1849) and William this ray of light: he would return from Printing House Square with his pockets stuffed full of engravings to show his sons, and so passed on to them his own enthusiasm for the art of Michelangelo and Blake (q.v.). David Scott became one of the most significant visionary artists of the romantic period, exhibiting in his engravings for the *Monograms of Man* (1831) his deep understanding of John Flaxman (1755–1826) and Blake. William, though a serious and original poet and painter in his own right, would attach himself to a much greater figure: the one later nineteenth-century artist who can be said to have followed in some measure in Blake's footsteps, Dante Gabriel Rossetti (1828–1882).

William was trained under William Allan (1782–1850) at the Trustees Academy in Edinburgh and also received instruction from his father in the art of engraving. He visited London twice, in 1831 and 1833, to draw from the antique in the British Museum, and in 1837 settled in the capital in rooms in Coventry Street, off Leicester Square.

One of Scott's earliest pictures, *The Old English Ballad Singer,* was exhibited at the British Institution in 1842 (no. 115). He began to exhibit at the Suffolk Street Gallery in 1840, and in 1842 sent his first historical subject to the Royal Academy. The artists he admired at this date were the historical and imaginative painters known as The Clique: Richard Dadd (1817–1887), William Powell Frith (1819–1909), Augustus Egg (1816–1863), and Henry Nelson O'Neill (1817–1880). In 1843 he entered the competition for the murals in the newly built Houses of Parliament, with his cartoon *The Britons Surprising the Roman Wall between the Tyne and Solway* (132 x 108″). His entry was not successful, but (perhaps because of the subject) he was offered the job of supervisor of the Government School of Design in Newcastle upon Tyne, a post he accepted in 1843 and held for the next twenty-one years. Because he lived away from the capital, he sought inspiration for his paintings after 1843 in the landscape of the north, although he came south to London every summer to renew his association with other artists.

Not his painting but his poetry brought him into contact with the young men who would form the Pre-Raphaelite Brotherhood. In 1847 Rossetti read Scott's "Rosabell," a poem about modern life, which Scott would later claim inspired Rossetti's *Found* (1854, 36 x 31½″, Wilmington, Delaware, Wilmington Society of Fine Arts), and also William Holman Hunt's (1827–1910) *Awakening Conscience* (1852, 29¼ x 21¾″, Trustees of Sir Colin and Lady Anderson). Rossetti wrote to Scott about his poems: "So beautiful, so original did they appear to me, that I assure you I couldn't think of anything else for several days."[1] Scott never became a Pre-Raphaelite brother, but was in close contact with the brotherhood from the late 1840s through the 1860s. His best paintings date from the later part of his career, when he began to work in their characteristic glowing colors and fine detail. In 1857–58 Rossetti invited him to assist in the Arthurian murals that he and other members of the Pre-Raphaelite circle were painting on the walls of the Oxford Union. Scott declined but undertook during the same period (1857–61) his own mural scheme at Wallington Hall, the Northumberland home of Sir Walter and Lady Trevelyan, patrons whom he had met in 1854. These illustrate scenes from the history of Northumberland and the border, and with the fading of the frescoes in the Houses of Parliament and those in the Oxford Union, they represent the most successful fully extant mural scheme of the first half of

Victoria's reign. Later, during the summers of 1865–68, he painted encaustic murals on the circular staircase at Penkill Castle in Ayrshire for his friend Miss Alice Boyd with the subject of *The Kingis Quair*.

Miss Boyd, whom Scott met in 1859, occupied the role in his life of best friend and confidante. He spent every summer in her Ayrshire castle, and after his early retirement in 1864 (age fifty-three) from the Newcastle schools, she stayed with him in Chelsea at Bellvue, the house he bought in 1870. Scott died at Penkill of angina pectoris in 1890.

Personally, Scott seems to have been among the least attractive figures in the Pre-Raphaelite circle. His dour, flat Scottish accent, his almost complete absence of humor were in no way enlivened by his appearance: in 1863 he lost all his hair (including his eyebrows and beard) from a disease contracted in Italy, and was therefore obliged to wear a wig, kept in place by a bowler hat.[2] When his autobiographical notes appeared posthumously in 1892, they revealed him to have harbored a number of resentments against the more successful Pre-Raphaelites. Reaction from all quarters to the autobiography was sharp, but Swinburne probably conveyed best the opinion of most of his surviving contemporaries, when he described Scott as a "lying, backbiting, drivelling, imbecile, doting, malignant, mangy old son of a bitch … whose name would never have been heard … but for his casual and parasitical association with the Trevelyans, the Rossettis and myself."[3]

Scott was a frequent visitor to the Continent, traveling there first in 1833 to visit his brother in Paris. Other trips were to Paris again (1852), Nürnberg (1854), Venice (1863), and Rome (1873). He published a seminal life of Albrecht Dürer (1471–1528) in 1869 and his *Gems of Modern German Art* (London and New York, 1873) was the first appraisal in English of contemporary German painting.

1. Quoted by Austin Chester, "The Art of William Bell Scott," *The Windsor Magazine*, vol. 40 (1914), pp. 416–17.
2. Trevelyan, 1978, p. 193.
3. Quoted in ibid., p. 135.

BIBLIOGRAPHY: "William Bell Scott, Poet and Painter," *The London Quarterly Review*, vol. 45 (October 1875), pp. 149–67; Obituary, *The Athenaeum*, November 29, 1890, p. 747; Cosmo Monkhouse, "William Bell Scott, LL.D., H.R.S.A.," *The Academy*, vol. 38 (December 6, 1890), pp. 529–30; Herbert P. Horne, "William Bell Scott," *The Century Guild Hobby Horse*, n.s., vol. 6 (January 1891), pp. 16–27; William Bell Scott, *Autobiographical Notes of the Life of William Bell Scott and Notices of His Artistic and Poetic Circle of Friends, 1830 to 1882*, ed. W. Minto, 2 vols. (London, 1892); John Skelton, "Dante Rossetti and Mr. William Bell Scott," *Blackwood's Magazine*, vol. 153 (February 1893), pp. 229–35; R[onald] B[ayne], *Dictionary of National Biography*, s.v. "Scott, William Bell"; Austin Chester, "The Art of William Bell Scott," *The Windsor Magazine*, vol. 40 (1914), pp. 413–28; Robin Ironside, "Preraphaelite Paintings at Wallington: Note on William Bell Scott and Ruskin," *The Architectural Review*, vol. 92, no. 552 (December 1942), pp. 147–49; William E. Fredeman, "A Pre-Raphaelite Gazette: The Penkill Letters of Arthur Hughes to William Bell Scott and Alice Boyd, 1886–97," *Bulletin of the John Rylands Library, Manchester*, vol. 49, no. 2 (spring 1967), pp. 323–62, vol. 50, no. 1 (fall 1967), pp. 34–82; Staley, 1973, pp. 90–92; Irwin and Irwin, 1975, pp. 277–82; Raleigh Trevelyan, "William Bell Scott and Wallington," *Apollo*, n.s., vol. 105 (February 1977), pp. 117–20; Trevelyan, 1978, pp. 107ff.; William Vaughan, *German Romanticism and English Art* (New Haven and London, 1979), pp. 22, 55, 120, 121, 169, 170, 247, 249, 255, 263.

102 WILLIAM BELL SCOTT *THE GLOAMING: MANSE GARDEN IN BERWICKSHIRE*, 1863
 Oil on canvas, 16 x 24″ (40.6 x 61 cm.)
 Inscribed lower left: *WB Scott 1863*
 Purchased: John H. McFadden, Jr., Fund, 71-164-1

When it was exhibited during Scott's lifetime in Liverpool in 1864 and again
in Newcastle in 1887, this picture was entitled simply "Gloaming." After his
death, however, its title (at the Goupil Gallery, London, in 1896) was
expanded to "The Gloaming: Manse Garden in Berwickshire."[1] In fact, the
painting shows Ayton Castle, Berwickshire, viewed from the old walled garden
of the manse. Ayton, a neobaronial mansion, was built in 1856 to replace its
predecessor, destroyed by fire in 1834.[2] In the manse garden today, from
approximately the spot where the artist stood, one can still see Ayton to the
left, where it stands in Scott's picture. The slim, romantic silhouette of its
turrets appears today just as it was seen by Scott, but other elements in the
view have changed: the present parish church, which now stands to the right
of the castle from this viewpoint, and which does not appear in the painting,
was built in 1864, two years after Scott's first oil version of *The Gloaming*
(version 2), and the old garden wall has disappeared, although it
certainly existed.[3]

Very little is known about Scott's visits to Berwickshire in the 1860s.
During this period he was teaching in Newcastle, and from there he wrote to
William Michael Rossetti (1829–1919) on January 12, 1862, "I went down to
Fairbairn's in Berwickshire and spent a few days."[4] This is Rev. J. C.
Fairbairn, a friend of Scott since at least the 1830s, who, according to Scott's
Autobiographical Notes, "spent his life as a much-beloved minister in a parish in
Berwickshire."[5] Presumably during this winter visit of 1862 Scott executed the
watercolor version of *The Gloaming* (version 1); the first oil (version 2) is dated
1862; the Philadelphia picture is a version of 1863.[6] The old manse was the
home of the parish minister of Ayton, who from 1843 to 1882 was Daniel
Cameron, not J. C. Fairbairn. Presumably Fairbairn took Scott to his fellow
minister's home.

It is not surprising that on one level *The Gloaming* should prove to be a
topographically accurate view of a country house. William's father, Robert,
was a landscape artist who every month executed a print showing a castle or
gentlemen's seat for publication in the *Scots Magazine*.[7] William's earliest
references in landscape painting were, therefore, to a tradition of country
house view-making, which had begun in England in the late seventeenth
century and reached its apogee in the later eighteenth.[8]

But *The Gloaming* is more. Scott described himself in his autobiographical
notes in words that suggest that he saw himself more as a visionary than as a
straightforward landscape or history painter. "Introspection was my pleasure
and my curse. . . . I was an absentee, a somnambule, and gave myself much to
subjects no one else cared for."[9] The subject of the garden wall of a country
manse must have awakened in Scott memories of his own childhood visits
each autumn to the manse at Kippen in Stirlingshire, the home of relatives.
He described the view from that house as at once beautiful and dreadful: "The
whole range of . . . mountains, separated from us by the sloping garden and a
wide stretch of moor, . . . was visible from our bedroom windows. . . . Close by
the front of the manse was the churchyard wall, a closely serried muir of
tombstones." One day the local minister told the boy, "William, you must be
baptised. What should I do were you to die? I would have to bury you
without the wall!"[10]

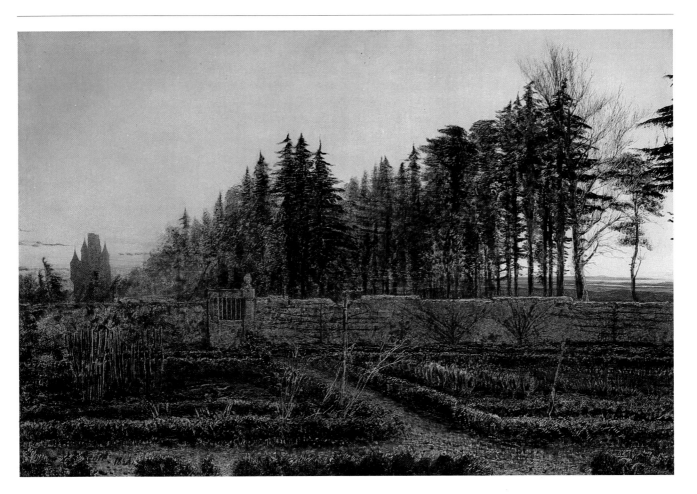

The melancholy beauty of the Scottish landscape at dusk is a theme Scott returned to over and over in his writings. From song nine of his poem "Rosabell" comes one example:

> The chill of eve is stayed from closing yet—
> By the roseate golden streaks
> Pressing back the impending dusk;
> Day, like an eye that ought to watch,
> Closes but by slow degrees...

In mood, the autumnal melancholy of *The Gloaming* ought to be compared to the Scottish landscape in the background of John Everett Millais's (1829–1896) *Autumn Leaves* (fig. 102-1)—a painting Scott knew well because it was in the collection of his patron James Leathart of Newcastle (who also owned the Philadelphia version of *The Gloaming*), and a picture Ruskin had praised as "the first instance existing of a perfectly painted twilight."[11] A comparison to the work of another artist, which is less obvious because his approach to landscape composition differs so radically, is to that of John Linnell (q.v.). Scott's technicolor effects of red cloud against purple hill, or his use of small, glancing brushstrokes, are close in range and technique to Linnell's lurid sunset and storm scenes, with their panoramic views of the rolling Surrey Hills, which were at the peak of their popularity in the 1850s and 1860s. Finally, pictures like *The Gloaming* may have influenced the younger artist Atkinson Grimshaw (1836–1893), who specialized in views of mysterious mansions seen by twilight or moonlight such as *The Old Mill, Audby* of 1869 (24½ x 34½", oil on panel, Leeds, City Art Gallery).[12]

FIG. 102-1 John Everett Millais (1829–1896), *Autumn Leaves*, 1856, oil on canvas, 41 x 29½" (104 x 75 cm.), Manchester, City Art Gallery

FIG. 102-2 William Bell Scott, *The Manse Garden at Dusk*, c. 1862, watercolor, 8¾ x 12" (22.2 x 30.5 cm.), location unknown

FIG. 102-3 William Bell Scott, *The Gloaming*, 1862, oil on canvas, 13⅛ x 19" (33.2 x 48.3 cm.), Dobbs Ferry, New York, E. J. McCormack Collection

Staley (1973) first pointed out Scott's debt in *The Gloaming* to German romantic landscapes by such artists as Caspar David Friedrich (1774–1840), Carl Gustav Carus (1789–1869), and Karl Wagner (1796–1867); and of all English artists of his generation, Scott is the one who looked most thoughtfully at German painting. He collected prints by Albrecht Dürer (1471–1528), publishing a monograph on the artist in 1869. In the 1850s he traveled in Germany and in 1873 Scott published his *Gems of Modern German Art*.

Friedrich, although much neglected in his own lifetime and after his death, was noticed by at least one English writer on art. In 1834, Mrs. Anna Jameson, in her *Visits and Sketches at Home and Abroad*, called him "the most *poetical* of German landscape painters.... His genius revels in gloom, as that of Turner revels in light."[13] Books in German on Friedrich were published in 1841, 1859, and 1863, so it is not unlikely that an artist with a deep interest in German painting should have known his work.[14] Numerous elements in *The Gloaming* remind us of Friedrich, beginning with the sheer emptiness of Scott's landscape. Friedrich sought to express the symbolic meaning of his pictures through the landscape elements themselves, and Scott here eliminated incident and narrative to depend entirely on composition, color, and atmosphere for his effects. Both artists do away with introductory foreground motifs, thus enhancing the expressive directness of their imagery. Finally, like Friedrich, Scott chose to show a moment of transition, dusk, as the light is waning, and the whole scene shimmers with a sense of instability.

Friedrich's landscapes rarely show real scenes from nature but were composed from various elements taken from his sketchbooks or his other paintings. His frequently recurring motifs—the sickle moon, the sunset, and the gate—were chosen for their value as symbols in landscape paintings, which recent critics have interpreted as Christian allegories. Most pertinent to the Scott are the sunset, Friedrich's symbol for death or the transience of human life, and the gate, his symbol for transition from life to death. The motif of the gate appears in a number of Friedrich's landscapes, notably the *Landscape with Crumbling Wall* (1837–40, pencil and watercolor, 4¾ x 7¼", Hamburg, Kunsthalle), in which the open gate with a landscape beyond has been interpreted as an allegory on mortality and eternity.[15]

Possibly Scott, too, had some such symbolic intention in mind when he painted *The Gloaming*. Although the painting is a view of a real place, one element seems to be completely imaginary: the gate. In the watercolor version (fig. 102-2), presumably executed on the spot and therefore the closest record of what Scott saw in front of him, the garden wall has no gate and is seen to recede in space toward the left, just slightly on an angle. Both in the early oil (fig. 102-3) and in the Philadelphia version, Scott included a gate, but each one is quite different from the other, leaving no question that these are artistic inventions. He also straightened the wall, transforming the natural but angled line of the real wall as depicted in the watercolor version into a stark barrier running straight across the picture, and thus insisting on the division of the composition not only into foreground and background but also into earth and sky. The foreground is painted in strong linear detail; the background—and particularly the castle—is seen in an atmospheric haze.

We might suggest that Scott's intention in painting this wall was not merely to record its picturesque qualities but to symbolize the barrier between life and death, this world and the next. That Scott did not give the picture a full topographical title when it was exhibited during his lifetime may indicate that he intended the landscape to be taken not as a literal view but as a symbolic one.

1. Because the watercolor study (version 1) for the painting has a provenance to Penkill Castle, we must ask whether the view shows the home of Scott's patron and friend Alice Boyd. The answer is negative, for three reasons: Penkill is in Ayrshire; a comparison of the turrets of the castle in the painting and the much blunter outlines of Penkill shows that the two cannot be the same; and the hilly topography around Penkill is very different from that shown in the painting. For Penkill, see David Macgibbon and Thomas Ross, *The Castellated and Domestic Architecture of Scotland from the Twelfth to the Eighteenth Century* (Edinburgh, 1889), vol. 3, pp. 204–6.

2. For the identification of this structure as Ayton, I am indebted to Ian Gow of the Royal Commission on the Ancient and Historical Monuments of Scotland, Edinburgh.

3. Information on Ayton Castle and the old manse was kindly provided by Rev. H. S. Ross of the Berwickshire Naturalists' Club, Berwick-upon-Tweed.

4. William Michael Rossetti, *Ruskin, Rossetti: Preraphaelitism, Papers 1854 to 1862* (London, 1899), pp. 307–8.

5. For Fairbairn see William Bell Scott, *Autobiographical Notes of the Life of William Bell Scott and Notices of His Artistic and Poetic Circle of Friends, 1830 to 1882*, ed. W. Minto (London, 1892), vol. 1, p. 92.

6. A letter from Arthur Hughes to Alice Boyd quoted by William E. Fredeman, "A Pre-Raphaelite Gazette: The Penkill Letters . . . ," *Bulletin of the John Rylands Library, Manchester*, vol. 49, no. 2 (spring 1967), p. 350, may cause some confusion, because in this letter, of April 5 (dated March), 1891, Hughes mentions that he is about to purchase at Christie's a picture by William Bell Scott called *The Gloaming*. But his description of the picture makes it clear that this was not one of the three versions of *The Gloaming* under discussion, but a view of Penkill, with "prettily touched in croquet balls & mallets lying below in the quiet grass." This corresponds to a picture now known as *Gloaming in the Garden, Penkill Castle, Ayrshire* (12⅞ x 18⅞", Sir James Hunter Blair Collection).

7. Minto, ed. (see note 5), vol. 1, p. 13.

8. John Harris, *The Artist and the Country House: A History of Country House and Garden View Painting in Britain, 1540–1870* (London, 1979).

9. Minto, ed. (see note 5), vol. 1, p. 3.

10. Ibid., pp. 51–52.

11. Ruskin, 1903–12, vol. 14, pp. 66–67.

12. London, Ferrers Gallery, *Atkinson Grimshaw, 1836–1893*, 1970, p. 18, repro. p. 19. In 1862 Scott exhibited at the Liverpool Institute of Fine Arts a painting called *The Haunted House on Halloween* (no. 1,186), and although this and *The Gloaming* are not necessarily identical, the title shows that Scott was thinking in terms of the mystery evoked by houses and landscapes in autumn.

13. *Visits and Sketches at Home and Abroad* (London, 1834), vol. 2, p. 144.

14. See London, Tate Gallery, *Caspar David Friedrich (1774–1840)*, 1972 (essays by William Vaughan and Hans Joachim Neidhardt, catalogue by Helmut Börsch-Supan). The present discussion of Friedrich's landscapes relies on this catalogue and particularly on William Vaughan's introductory essay.

15. Ibid., no. 111. Other important landscapes with the gate symbolism in the Tate exhibition are *A Picture in Remembrance of Johann Emanuel Bremer*, no. 51 (1817, 17 x 22½", Schloss Charlottenburg, West Berlin, Staatliche Schlösser und Gärten), and *The Churchyard*, no. 90 (1825–30, 12¼ x 10", Bremen, Kunsthalle).

PROVENANCE: James Leathart, Bracken Dene, Gateshead, probably by 1864; his sale, Christie's, June 19, 1897, lot 48, bt. Beausire (bt. in by the Leathart family); Leathart family; their sale, Anderson and Garland, Newcastle, April 6, 1971, lot 335, bt. Hartnoll and Eyre.

EXHIBITIONS: Liverpool, Academy of Arts, 1864, no. 17 (as "Gloaming"); Newcastle, *Royal Jubilee Exhibition*, 1887, no. 770 (as "The Gloaming"); London, Goupil Gallery, *A Pre-Raphaelite Collection*, 1896, no. 52 (as "The Gloaming: Manse Garden in Berwickshire"); Newcastle-upon-Tyne, Laing Art Gallery, *Paintings and Drawings from the Leathart Collection*, 1968, no. 70; London, Hartnoll and Eyre, *Catalogue No. 17*, summer 1971, no. 1.

LITERATURE: Mary Bennett, "A Check List of Pre-Raphaelite Pictures Exhibited at Liverpool 1846–67, and Some of Their Northern Collectors," *The Burlington Magazine*, vol. 105, no. 728 (November 1963), p. 490; Staley, 1973, p. 92, pl. 47a; Staley, 1974, p. 37, pl. V.

CONDITION NOTES: The original support is medium-weight (10 x 10 threads/cm.) linen. The painting is lined with a wax-resin adhesive and medium-weight linen. A white ground extends onto the tacking margins, covering them completely. The paint is in very good condition. A fine web of traction crackle is present in the brown tones of the trees and foliage. A fine, irregular net of narrow-aperture fracture crackle extends over the entire surface. Brush marks are varied in profile and unusual in technique. The paint has an extremely vehicular, resinous consistency. Details have been indicated by scratching or removing paint from a wet layer rather than adding layers consecutively or directly. Ultraviolet light reveals only slight retouches to the sky and background trees.

VERSIONS

1. William Bell Scott, *The Manse Garden at Dusk*, c. 1862, watercolor, 8¾ x 12" (22.2 x 30.5 cm.), location unknown (fig. 102-2).

PROVENANCE: Arthur Hughes; Alice Boyd, Penkill Castle, Ayrshire; Hartnoll and Eyre; Sotheby's, Belgravia, July 1, 1975, lot 23.

EXHIBITION: Paris, Galerie de Luxembourg (organized by Hartnoll and Eyre, London, and Norman House Gallery, Cockermouth), *Le Paysage anglais*, 1974, no. 17.

2. William Bell Scott, *The Gloaming*, 1862, oil on canvas, 13⅛ x 19" (33.2 x 48.3 cm.), Dobbs Ferry, New York, E. J. McCormack Collection (fig. 102-3).

INSCRIPTION: *Gloaming. 1862* [signed twice on obverse and signed on the reverse; inscribed and dated on the stretcher].

PROVENANCE: Sotheby's, Belgravia, December 6, 1977, lot 46, bt. Christopher Wood; Shepherd Gallery, New York.

EXHIBITION: New York, Shepherd Gallery Associates, *English Nineteenth Century Paintings, Watercolors, Drawings*, spring 1978, no. 16.

Williamm Shayer, Sr., was born in 1781 in Southampton on the south coast of England. He spent his entire life in this area, dying in Shirley, near Southampton, on December 21, 1879. A landscape artist who might best be described as a follower of George Morland (q.v.), he chose virtually all his subjects from the local scenery of Hampshire, the New Forest, and the Isle of Wight—hayfields, woods, and beaches peopled by gypsies, farmers, and fisherfolk.

Shayer began his career as an ornamental furniture painter. After an apprenticeship to a coach painter, by 1809 he had set up as an independent coach painter, working first in Guildford, Surrey, and then, from 1810 to 1819, in Chichester. Shayer returned to Southampton in 1819. The following year, 1820, he sent his first picture to London for exhibition at the Royal Academy. Between 1820 and 1870 he exhibited 426 works, including 6 at the Royal Academy, 82 at the British Institution, and 308 at the Royal Society of British Artists. In addition, he exhibited at Henry Buchan's Hampshire Gallery in High Street, Southampton, from 1827. During these fifty years of unremitting productivity neither his subject matter nor his style seems to have changed.

BIBLIOGRAPHY: Maurice Harold Grant, *A Dictionary of British Landscape Painters from the Sixteenth to the Early Twentieth Century* (Leigh-on-Sea, 1952), p. 175; Brian Stewart and Mervyn Cutten, *The Shayer Family of Painters* (London, 1981).

103 WILLIAM SHAYER, SR.

FISHING SCENE, c. 1850?
Oil on canvas, 26 x 36⅛″ (66 x 91.7 cm.)
Inscribed lower left: *G. Morland Pinx 1797*
Gift of Walter Lippincott, 23-59-11

On the basis of the inscription and its iconography, this painting entered the Philadelphia Museum of Art as a fishing scene by George Morland (q.v.). Allan Staley first suggested that the attribution be changed to William Shayer, Sr., who specialized in scenes with fisherfolk and horses by the seashore (Archives, Philadelphia Museum of Art). This attribution has been confirmed by the appearance of an almost identical composition at Sotheby's, Belgravia, December 11, 1979 (lot 147): *Low Tide, Isle of Wight* (25¼ x 35½″). The basis for the title was not indicated. The two pictures differ only in small details such as the inclusion of a few fish in the lower right foreground in the Sotheby's picture and the pose of the fisherman at the left, who kneels by his basket in the Sotheby's painting rather than standing with his net resting on his shoulders. Another near replica of the Philadelphia picture, differing only in details in the background and in the pole of the fisherman in the left foreground, was sold at Christie's on March 18, 1981 (lot 86), as *The Fishermen's Return* (24 x 30½″).

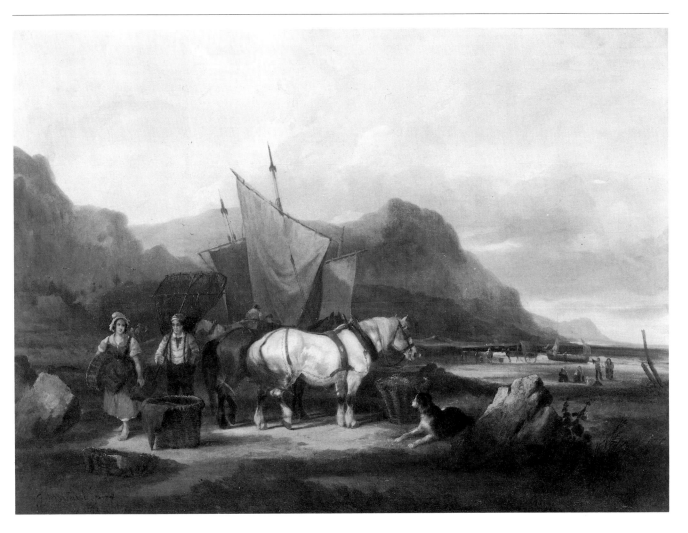

To compare *Fishing Scene* with other Shayers would be pointless, as he painted dozens of such scenes, all more or less similar, all rearrangements of the same elements: ships, horses, baskets, fish, and picturesque fisherfolk. All such compositions seem based ultimately on the example of Morland's beach scenes, such as *Coast Scene with Smugglers,* in the Philadephia Museum of Art (no. 58). Shayer's works are harder in outline and darker and more labored than Morland's. He concentrated on showing off the colorful costumes worn by the fishergirls and men, and tended to show his figures close to rather than from the distance.

INSCRIPTION: *Philadelphia Art Galleries / Church Sale 7 Feb. 21, 1913 / George Morland 1763–1804* [on a label on the stretcher].

PROVENANCE: Philadelphia, Philadelphia Art Galleries, sale, February 21, 1913 (as by Morland); Walter Lippincott.

LITERATURE: "The Walter Lippincott Collection," *The Pennsylvania Museum Bulletin,* vol. 19, no. 81 (December 1923), pp. 45–46, repro. p. 47 (as "Landscape by George Morland").

CONDITION NOTES: The original support is medium-weight (14 x 14 threads/cm.) linen. The tacking margins have separated and have been reattached with local mending material along the original fold. The painting is unlined at present. An off-white ground is visible along the torn tacking folds. The paint is in very good condition. The original moderate to low relief of the paint profile has been preserved. The brush marking is generally intact. A wide, irregular web of narrow-aperture traction crackle has formed overall.

The son of a Scottish dyer settled in Norwich, James Stark was born on November 19, 1794, the youngest son in a family of three boys and one girl. He was educated at Norwich Grammar School, where he became friends with John Crome's (q.v.) son John Bernay Crome (1793–1842). In 1809, at fifteen, Stark exhibited his first pencil sketch at the Norwich Society and the following year his first oil. In 1811 he showed five landscapes in oil in Norwich, as well as one oil at the Royal Academy in London. The year 1811 saw Stark indentured to John Crome (q.v.), with whom he worked for three years. Stark was Crome's most talented and important follower.

In 1814 the young man moved to London, where he remained until 1819. He lived in the artists' district, first in Wigmore Street off Cavendish Square, then in Newman Street, and became friendly with the landscape painter William Collins (1788–1847), who moved in the circle around John Linnell and John Constable (q.q.v.). To contemporaries, James Stark may have seemed about to become one of the foremost landscape artists of his generation. Even before he was accepted at the Royal Academy schools in 1817, he had sold his *Bathing Place, Morning* (1815, 21 x 23″, location unknown) to the dean of Windsor, and in 1818 the Countess de Grey bought his *Lambeth from the River, Looking toward Westminster Bridge* (34¾ x 54″, New Haven, Yale Center for British Art) out of the exhibition at the British Institution. Other early patrons included the Marquis of Stafford (1758–1833), Sir Francis Chantrey (1781–1841), and Sir George Beaumont (1753–1827).

Stark's early work is his most beautiful. He painted in a broad, free style, often concentrating on carefully observed, modest scenes from nature such as his lovely *Penning the Flock* of c. 1818 (oil on panel, 9 x 11″, Norwich, City of Norwich Museums). Unlike his teacher John Crome, Stark based many of his paintings on outdoor chalk studies, watercolors, and oil sketches. Unlike Crome, too, is the sense of incident and life in Stark's countryside. Dogs, cattle, donkeys, and gypsies inhabit Stark's world, a world full of people working, arguing, and resting.

But this promising start was interrupted by some unspecified failure of health, and in 1819 Stark was forced to return to Norwich, where he remained for the next twelve years. Although he was not as prolific in the 1820s as in the previous decade, these Norwich years constitute the backbone of Stark's mature work; throughout this period he exhibited at the Norwich Society, the Royal Academy, and the British Institution.

The move seems to have been fatal, however, for his continued development as an artist. Perhaps because ill health prevented outdoor sketching, or because his marriage in 1821 forced him to take up a commercially assured line in painting, he turned his hand almost exclusively to accomplished pastiches of Hobbema (1638–1709) in which the brownish palette and dry, tight handling do nothing to lighten the heavy, densely packed compositions. In September 1825, *The London Magazine* complained, "We must object to his iteration of subject; a practise which shows that he is more conversant with Hobbema and Ruysdael than with nature. . . . If there is but one subject, there is also but one system of colour and of management. . . . What he has done is good; but he has as yet painted but one picture."[1] In his later work of the 1830s and 1840s he returned to a fresher, more naturalistic style. In 1839 the *Norwich Mercury* described his landscapes as "brilliant with beauty and light. The exchange from Hobbima to nature is indeed a marvellous improvement."[2]

Between the years 1827 and 1834 Stark worked on thirty-five sketches that were engraved in 1834 as the *Scenery of the Rivers of Norfolk,* dedicated to William IV. Before its publication, Stark left Norwich, never to return. He settled in London, in Chelsea, for nine years; then in 1839, moved to Windsor, where he concentrated on painting scenes in Windsor Forest. Finally, in 1850 Stark moved back to London. He died at Mornington Crescent in March 1859. His most important pupil was Alfred Priest (1810–1850).

1. Quoted by Hemingway, 1979, p. 58.
2. Ibid., p. 59.

BIBLIOGRAPHY: J. W. Robberds, ed., *Scenery of the Rivers of Norfolk . . . from Pictures Painted by James Stark, with Historical and Geological Description by J. W. Robberds* (Norwich and London, 1834); *The Art Journal,* 1850, p. 182; Obituary, *The Art Journal,* 1859, p. 135; Reeve MSS., 167.c.5 and 9, British Museum Print Room, London. R[obert] E[dmund] G[raves], *Dictionary of National Biography,* s.v. "Stark, James"; Dickes, 1905, pp. 443–93; Cundall, 1920, pp. 25–26; Clifford, 1965, pp. 36–37, 72, 86–87; Mallalieu, 1974, p. 51; Miklós Rajnai, *The Norwich School of Painters* (Norwich, 1978), unpaginated; Day, 1979, pp. 48–65; Hemingway, 1979, pp. 52–60.

EXHIBITIONS: Norwich, Norwich Art Circle, *Catalogue of the Sixth Exhibition Held at the Society's Room, Old Bank of England Chambers, Queen Street* [The works of James Stark], June 1887 (repr. in Day, 1979); Manchester, Whitworth Art Gallery, University of Manchester, *The Norwich School, Loan Exhibition of Works by Crome and Cotman and Their Followers,* 1961, nos. 25, 26 (by Francis Hawcroft).

104 JAMES STARK

LANDSCAPE WITH CATTLE, c. 1820–30
Oil on panel, 16½ x 21⅞″ (41.9 x 55.8 cm.)
John H. McFadden Collection, M28-1-39

Roberts (1917) suggested that this landscape is the picture exhibited at the British Institution in 1817 as "Lane Scene" (no. 205). The review of that exhibition in *The Literary Gazette* does not describe the picture in enough detail, however, to connect it with our painting.[1] The dependence on Hobbema (1638–1709), the lack of fresh observation, and the rather tight handling would indicate a slightly later date, in the 1820s.

The painting is, however, a Stark of very high quality, if not originality. The nervous, calligraphic quality of Stark's hand in passages such as the painting of the fence on the hill to the left should be compared to similar passages in masterpieces such as Stark's *Sheep Washing,* c. 1822–24 (oil on panel, 24¼ x 32⅛″, Norwich, Norwich Castle Museum).

1. W. C. [William Carey?], "Fine Arts: Review of Pictures in the British Institute," *The Literary Gazette,* March 8, 1817, p. 108.

PROVENANCE: Onley Savill-Onley, Stisted Hall, Essex; his sale, Christie's, June 16, 1894, lot 66, bt. Agnew; bt. John H. McFadden, May 20, 1895.

EXHIBITIONS: New York, 1917, no. 41; Pittsburgh, 1917, no. 39.

LITERATURE: Dickes, 1905, p. 490; Roberts, 1917, p. 79, repro. opp. p. 79; Cundall, 1920, pl. LVI.

CONDITION NOTES: The original support is a single piece of tangentially cut mahogany (½″ thick). No secondary support system (cradling) has been added. The panel appears to be in plane and without checks. A white, thinly applied ground is present and evident along the panel's edges. The paint is in good condition. The moderate to low relief of the paint profile has been preserved along with much of the brush marking. A narrow-aperture traction crackle appears to be associated with the brown shadow tones of the foliage. The interstices of the brushwork contain brown-pigmented resinous material, which may have been applied by the artist.

05 JAMES STARK

A MILLSTREAM, NORFOLK, C. 1830–40
Oil on panel, 19¾ x 29⅞" (50.2 x 75.8 cm.)
The William L. Elkins Collection, E24-3-46

The difficulty of associating pictures with those exhibited by Stark during his lifetime is exemplified by this painting. At the Royal Academy of 1841 Stark showed *A Trout Stream* (no. 395), but whether it was the picture in Philadelphia cannot be ascertained. The reviews of the academy exhibition in *The London Magazine* (1841, pp. 66–76), *The Athenaeum* (June 5, 1841, p. 443), and the *Art Union* (1841, p. 78) do not describe the exhibited picture in enough detail to connect it with the Philadelphia work. Furthermore, Stark exhibited other pictures at the Royal Academy with titles such as *Fishing* (1839) and *A Trout Stream* (1854). Even the title could be misleading, for he showed numerous paintings at the Royal Academy and British Institution entitled *Watermill* and *Waterfall.*

Nevertheless, *A Millstream, Norfolk* can be attributed to Stark and roughly dated. The refinement of the handling of the foliage and the fishing rod, and the liveliness of the figures are typical of his touch. The summary treatment of the rocks and ground, though not of a high standard of execution, do not rule out Stark as the painter. A date after the artist's Hobbema (1638–1709) phase from 1820 to 1830 would seem safe—perhaps in the 1830s.

PROVENANCE: William L. Elkins, by 1900.

LITERATURE: Elkins, 1887–1900, vol. 2, no. 73, repro.

CONDITION NOTES: The support is comprised of a single piece of radially cut oak (⅜" thick) with grain running horizontally, with two slight concave warps running inward part way from each side in the sky area. Bevels on the bottom and left edges are apparent, viewed from the reverse. There is a large knot in the lower right corner coincident with a 2 to 3" horizontal crack. An off-white ground can be seen at the edges of the panel. This same material has been applied to the reverse of the panel. The paint is in good condition overall. A fine web of traction crackle and wrinkle extends over the surface and indicates the use of bitumen in the artist's palette. A large diagonal scratch 5 to 6" in length is centered above the figures.

106 AFTER JAMES STARK

THE DEVIL'S TOWER, after 1831
Oil on canvas, 19¼ x 26¼" (48.9 x 66.7 cm.)
Inscribed lower left: *J. Stark*
The William L. Elkins Collection, E24-3-45

This picture is a copy after an engraving by James Stark published in Stark's *Scenery of the Rivers of Norfolk* showing the Devil's Tower, Norwich.[1] This was a fortification built in the fourteenth century by the side of the river with another identical tower on the opposite bank. To defend the city of Norwich against invasion on water, a chain could be stretched between the two towers. This precaution also insured the payment of the corporation tolls. Only the stump of the Devil's Tower now remains near Carrow Bridge in Norwich; the surrounding scene has completely changed.

1. J. W. Roberds, ed. (Norwich and London, 1834), pl. 15.

PROVENANCE: William L. Elkins, by 1900.

LITERATURE: Elkins, 1887–1900, vol. 2, no. 72, repro.

CONDITION NOTES: The original support is medium-weight (12 x 12 threads/cm.) linen. The tacking margins have been removed. The painting has a relining, which consists of an aged aqueous adhesive and medium-weight linen. An earlier aqueous adhesive lining has been retained. A white ground has been thickly and evenly applied. The paint is in poor condition. The moderate to low relief of the paint profile has been flattened overall by lining. There is bituminous traction crackle associated with the darker brown tones of the landscape and sky. Ultraviolet light reveals retouches that are restricted to the apertures of some of the widest traction crackle in the sky.

ENGRAVING: G. Cooke after James Stark, *Devil's Tower*, 1831, engraving, 7⅗ x 10½" (19.3 x 26.6 cm.).
 INSCRIPTION: *Drawn by J. Stark. Engraved by G. Cooke. Printed by S. H. Hawkins. London—Published 1831 by J Stark 14 Beaufort Row Chelsea.*
 LITERATURE: J. W. Robberds, ed., *Scenery of the Rivers of Norfolk . . .* (Norwich and London, 1834), pl. 15.

As the son of a currier (a dresser of tanned animal hides), George Stubbs grew up in Dele Street, Liverpool, surrounded by the sight of bloody carcasses, membranes, and the flayed muscles of animals. As a child he is said to have dissected dogs and hares to make drawings of their bones; later, when he began to dissect animal carcasses and human corpses, he was undeterred neither by the process nor the stench. After his father's death in 1741, George apprenticed himself to a copyist named Hamlet Winstanley (1698–1756), then working for Lord Derby at Knowsley near Liverpool. After three months and an argument over which of the two was to copy a Van Dyck, he bolted, to spend the next three years studying anatomy and drawing on his own. "Henceforward," runs the relevant passage in Ozias Humphry's "Life of Stubbs," "he would look to Nature for himself and consult and study her Only."[1] Short spells as a portrait painter in Wigan and Leeds followed, and then, in 1743, at age twenty, he moved to York. In the eighteenth century York was a city as advanced in the teaching and practice of medicine as London, and Stubbs found work as a lecturer on anatomy in the newly founded York County Hospital. Through his medical connections he was able to procure cadavers for dissection, a practice that was not part of an English artist's usual training and that brought him "vile renown" in the city—partly because he may occasionally have purchased a corpse or two from body-snatchers.[2] In 1751 he provided the etched illustrations for Dr. John Burton's (1710–1771) *Essay towards a Complete New System of Midwifery*.

There was little thus far in Stubbs's career to foreshadow his future reputation as one of the supreme masters in the history of English painting. Few early portraits are known, the earliest being a double portrait of Sir Henry Nelthorpe (d. 1746) of Scawby, Lincolnshire, and his second wife. In 1754, however, possibly through the patronage of Lady Nelthorpe, Stubbs sailed for Rome. In his biography, based on Stubbs's own recollections as taken down by Ozias Humphry in the 1790s, Stubbs "desire[d] it to be noticed that his motive for the voyage was to convince himself that Nature is superior to all art, whether Greek or Roman, ancient or contemporary." In Rome "whenever he accompanied the students . . . to view the palaces of the Vatican, Borghese, Colonna, etc. and to consider the pictures there, he differed always in opinion from his companions, and when it was set to the vote, found himself alone on one side and his friends on the other."[3] But these disclaimers are deceptive. In fact, Stubbs was imbued in Rome with a deep feeling for the antique, later borrowing a specific classical motif for his most famous animal painting, *Horse Attacked by a Lion* (1762?, 96 x 131", New Haven, Yale Center for British Art). This understanding of the clarity, the order, the rhythms of classical art would enable him to create out of straightforward portraits of horses and farm laborers serene and near-perfect studies in composition, color, tone, and proportion.

Upon his return to England by way of Morocco in 1756, Stubbs spent eighteen months in Liverpool. In 1756 he began work on his great anatomical volume, *The Anatomy of the Horse*. Working in an isolated farmhouse at Horkstow, Lincolnshire, with only his mistress, Mary Spencer, for company, he spent nearly two years defying the conventions of society and risking death from putrid fever to produce the most important and beautiful study of the horse's anatomy since Carlo Ruini's *Dell' Anatomia . . . del Cavallo* of 1598. Finding no engraver capable of undertaking the translation of his drawings, Stubbs, indomitable, moved to London, to Somerset Street off Oxford Street, sometime before September 1758. He learned to engrave himself and worked on his plates part time for the next seven years. With its publication on March 4, 1766, Stubbs took his place as the greatest artist/scientist since Leonardo.

During the 1760s Stubbs also established himself as the most brilliant animal painter in England. Young and aristocratic Whig patrons such as the lords Rockingham, Torrington, and Portland, and the Duke of Richmond, keenly interested in racing and hunting, members of the Jockey Club (founded 1750), and great landowners, had the money and the intelligence to commission masterpieces from Stubbs: *The Grosvenor Hunt* (fig. 107-1) or *Racehorses Belonging to the Duke of Richmond Exercising at Goodwood House* (1760–61, 55½ x 80½", Chichester, Sussex, Goodwood House).

Stubbs also began exhibiting at the Society of Artists in 1761, becoming president in 1772 and remaining faithful to it until it folded in 1774. The next year, 1775, he exhibited for the first time at the Royal Academy, but like Wright of Derby (q.v.), he was never at home there. Elected an Associate in 1780 and a full Royal Academician in 1781, he lost his status in 1782 after refusing to submit a diploma work in protest at the skying of his pictures in the annual exhibitions.

Around 1770 Stubbs began to experiment with the chemistry of pigments and learned to paint with enamels on panel and copper from the miniaturist Richard Cosway (1742–1821). Metal offered the artist the smoothest possible support on which to lay his pigments, enabling him to achieve a perfectly neutral surface, free from all evidence of the application of paint such as canvas texture or brushstrokes. This is an aesthetic very different from the prevailing tastes of the eighteenth century for brilliant brushwork (Romney), complicated technique (Gainsborough or Reynolds), and dramatic tonal values (Wright of Derby) (q.q.v.). Despite the commercial risks, Stubbs carried his interest to the point of asking Josiah Wedgwood to create for him ceramic tablets as large as his normal canvases, which would permit him to work in enamels at full scale, something impossible on copper because sheets of the metal larger than ten by fifteen inches could not then be made. The result was a series of about thirty-six enamel-on-ceramic paintings, many copies of earlier works, less than half of which found buyers during Stubbs's lifetime.

In 1795 he began a second anatomical work, the *Comparative Anatomical Exposition of the Structure of the Human Body with That of a Tiger and a Common Fowl* (eighty-one drawings, New Haven, Yale Center for British Art), which was not finished at his death on July 18, 1806.[4]

Stubbs was far more than a simple sporting painter, like his nearest rival, Sawrey Gilpin (1733–1807). In the 1760s he became, in Taylor's words, "the most talented, responsive and versatile interpreter of such an iconography of rural life"[5] at the moment in English history when many of its greatest country houses were being built, and when, therefore, the iconography of aristocratic country-house life was invented. He was also in some ways a naturalist, painting exotic animals whenever he could, such as tigers (1763–68, 53½ x 83½", Viscount Portman Collection), a zebra (1762–63, 40 x 50", New Haven, Yale Center for British Art), a cheetah (1764–65, 71 x 107", Manchester, City Art Gallery), and a rhinoceros (c. 1790, 27½ x 36½", London, Royal College of Surgeons), the first really accurate representation of this beast in Western art. He was one of the great practitioners of the conversation piece in his *Lord and Lady Melbourne, Sir Ralph Milbanke, and John Milbanke* (1763–70, 38¼ x 58¾", London, National Gallery). And although none of his four history paintings survives,[6] we know from a letter written by Josiah Wedgwood to Bentley of September 25, 1780, that Stubbs "repents much his having established this character for himself. I mean that of horse painter and wishes to be considered as an history and portrait painter."[7]

But his masterpieces are the farming pictures of the 1780s, the *Haymakers* and the *Reapers* (1785, oil on panel, 35½ x 53½" each, London, Tate Gallery). In them, the intricate, rhythmic frieze made by the laborers against the haycart and wheat fields owes more to the disposition of figures and animals in antique friezes than to any farming activities in eighteenth-century England. Still less is there a sense of incident or narrative, but rather, as John Barrell has written, Stubbs suspended his figures in time, as Keats did his figures on the Grecian urn.[8] Barrell related them less to the work of any of Stubbs's contemporaries who specialized in rural subjects (Gainsborough and Morland [q.v.]) than to Poussin (1594–1665), in whose *Summer* (46½ x 63", Paris, Louvre) rural occupations are seen as timeless embodiments of unchanging seasonal activity.

At the heart of Stubbs's art there is something cold and unflinching, a relentless compulsion to describe reality unmitigated by any need on the artist's part to muddy the images with his own subjective comments or emotions: in short, a deeply classical attitude toward painting. Seen from this point of view, we can look back to Stubbs's later reworkings of his paintings in enamel on pottery as a manifestation of the neo-classical tendency to remove as nearly as possible from painting all traces of the process of the artist's intervention, and to concentrate on purely aesthetic questions such as technique, color, and composition. A first-rate Stubbs in any medium, from a horse portrait such as *Whistlejacket* (1762, 115 x 97", Trustees of Rt. Hon. Olive, Countess Fitzwilliam's Chattels Settlement) to his brilliant *Soldiers of the 10th Light Dragoons* (1793, 40 x 50", Her Majesty Queen Elizabeth II), has a stillness and perfection about it that can only be classed with certain Japanese prints or perhaps the paintings of Piero della Francesca.

1. Quoted by Mayer, 1879, p. 7.
2. For Stubbs as an anatomist see Doherty, 1974; and Judy Egerton, "Stubbs and the Scientists," in London, Tate Gallery, *George Stubbs: Anatomist and Animal Painter*, 1976, pp. 24–40.
3. Ozias Humphry, "Memoir of the Life of George Stubbs," MS., c. 1790, Brown, Picton and Hornsby Libraries, Liverpool.
4. London, Arts Council of Great Britian, *George Stubbs: Rediscovered Anatomical Drawings from the Free Public Library, Worcester, Massachusetts*, 1958.
5. Taylor, 1971, p. 12.
6. Ibid., p. 36.
7. Quoted by Bruce Tattersall, "Stubbs and Wedgwood," in London, Tate Gallery, 1974, p. 28.
8. Barrell, 1980, p. 30.

BIBLIOGRAPHY: Ozias Humphry, "Memoir of the Life of George Stubbs," MS., c. 1790, Brown, Picton and Hornsby Libraries, Liverpool; T. N., "Memoirs of George Stubbs, Esq.," *The Sporting Magazine*, vol. 32 (May 1808), pp. 55–57, and "The Lion and Horse" (July 1808), pp. 155–57; Mayer, 1876; Mayer, 1879; Gilbey, 1898; E. Rimbault Dibdin, "Liverpool Art and Artists in the Eighteenth Century," *The Walpole Society, 1917–1918*, vol. 6 (1918), pp. 59–93; Sparrow, 1922; Sparrow, 1931, pp. 2–28; Grigson, 1940, pp. 15–32; Constantine, 1953; McKendrick, 1957; Denys Sutton, "George Stubbs's Many-Sided Genius," *Country Life*, December 5, 1957, pp. 1,204–10; Basil Taylor, "Josiah Wedgwood and George Stubbs," *Proceedings of the Wedgwood Society*, no. 4 (1961), pp. 209–24; Basil Taylor, "George Stubbs: 'The Lion and Horse' Theme," *The Burlington Magazine*, vol. 107, no. 743 (February 1965), pp. 81–86; Parker, 1971; Taylor, 1971; Doherty, 1974, pp. 1–24; William Gaunt, *Stubbs* (Oxford, 1977); Cormack, 1979.

EXHIBITIONS: London, J. and W. Vokins Gallery, *Loan Collection of Pictures by George Stubbs, A.R.A., and Engravings from His Works*, 1885; Liverpool, Walker Art Gallery, *George Stubbs, 1724–1806*, July 13–August 25, 1951; London, Whitechapel Art Gallery, *George Stubbs, 1724–1806*, February 27–April 7, 1957; London, Arts Council of Great Britain, *George Stubbs: Rediscovered Anatomical Drawings from the Free Public Library, Worcester, Massachusetts*, 1958; Aldeburgh and London, 1969; London, Thomas Agnew and Sons, *Stubbs in the 1760s*, November–December 1970 (introduction by Basil Taylor); London, Tate Gallery, 1974; London, Tate Gallery, *George Stubbs: Anatomist and Animal Painter*, 1976 (by Judy Egerton, David Brown, and Basil Taylor); London and New Haven, 1984–85 (by Judy Egerton).

107 GEORGE STUBBS

HOUND COURSING A STAG, c. 1762–63
Oil on canvas, 39⅜ x 49½″ (100 x 125.9 cm.)
Inscribed lower right: *Geo. Stubbs pinx.*
Purchased for the W. P. Wilstach Collection, and with the John D. McIlhenny
Fund and gifts (by exchange) of Samuel S. White, 3rd and Vera White,
Mrs. R. Barclay Scull, and Edna M. Welsh, W1984-57-1

FIG. 107-1 George Stubbs, *The Grosvenor Hunt*, 1762, oil on canvas, 59 x 95″ (149 x 241 cm.), His Grace the Duke of Westminster Collection

FIG. 107-2 Hellenistic figure of a dog, reworked eighteenth century, marble, Rome, Vatican Museum

FIG. 107-3 Hellenistic figure of stag and dog, reworked eighteenth century, marble, Rome, Vatican Museum

Stubbs exhibited two paintings as pendants in 1763 at the Society of Artists of Great Britain: "A horse and a lion" (no. 119) and "It's companion" (no. 120). In Horace Walpole's catalogue of this exhibition, John Sheepshanks added a note to his copy at this entry—the words, "A stag and hound."[1] There is no other candidate for a picture showing a hound and stag by Stubbs, and as a companion to a horse and lion theme, the Philadelphia group would fit well: two scenes of predatory violence.[2] Judy Egerton has dated the Philadelphia canvas to c. 1762–65, contradicting Taylor's (1971) misreading of the almost illegible inscription "pinx" for dated "1769." She further observed that the stag appears in a similar position, with identical antlers, in Stubbs's famous *Grosvenor Hunt* of 1762 (fig. 107-1). In the Philadelphia picture the legs of the stag make sense as running through a park rather than, as in *The Grosvenor Hunt*, floundering in water. However, just as the horse and lion theme is taken from the antique sculpture of a lion attacking a horse that Stubbs saw in Rome,[3] so it is possible that *Hound Coursing a Stag* is drawn not from nature but from the *animalier* figures of stags and dogs that went on view in the Pio-Clementio galleries shortly before Stubbs arrived in Rome in 1754 (figs. 107-2 and 107-3).[4]

One stumbling block to our acceptance of the Philadelphia picture as the one shown in the Society of Artists exhibition of 1763 is its provenance, which goes back certainly only to George Brodrick, 4th Viscount Midleton and Baron Brodrick of Peper Harow (1754–1836). This person was only nine years old in 1763. Possibly his father, also George, the 3rd Viscount (1730–1765), patronized Stubbs.

This Lord Midleton commissioned Sir William Chambers (1726–1796) to design a new house at Peper Harow, which was not completed at the time of the patron's death. He was also responsible for first employing Capability Brown (1715–1783) to begin the landscaping of the park at Peper Harow; clearly he was an enlightened man. The Midleton papers in the Guildford Record Office show that on the death of the 3rd Viscount Midleton in 1765, his widow, Rt. Hon. Viscountess Midleton (d. 1808) began to keep the ledger and account books on behalf of her son, then at Eton. These ledgers seem to be complete for the years 1765–71.[5] In them, she records payments to William Chambers; she pays Alderman Boydell for prints and Angelica Kauffmann (1741–1807) "for large picture"; she settles bills from booksellers and furniture makers for items ordered by her late husband as well as recording the minutiae of the expenses of running her house in Charles Street in London. In January 1771, her son George was still receiving an allowance from his mother, who emerges—as nearly as one can divine from dry lists—as an intelligent and cultivated woman with a strong taste for the arts, books, prints, the theater, and cards. Because the ledgers are so complete from September 1765 through 1771, it is tempting to draw conclusions from what they omit. Within that period there was no payment to Stubbs, so one might argue that the Philadelphia picture was purchased either before the ledgers were begun or after they cease. Stylistically, the picture is compatible with a date before 1765.

Surrey had at the beginning of the nineteenth century three packs of stag hounds, so the sport certainly was popular in this part of England in the eighteenth century. The Midleton family also owned Stubbs's *Mares and Foals in a River Landscape* of c. 1763–68 (40 x 63¾″, London, Tate Gallery).

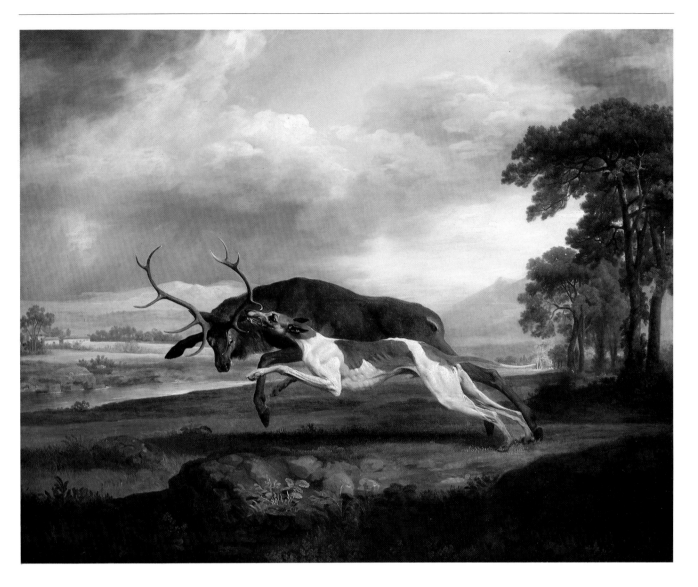

1. "Notes by Horace Walpole, Fourth Earl of Orford, on the Exhibitions of the Society of Artists and the Free Society of Artists, 1760–1791. Transcribed and Edited by Hugh Gatty," *The Walpole Society, 1938–1939,* vol. 27 (1939), p. 78.

2. The only other candidate showing a stag and hound is a doubtful attribution, more likely a reflection by another hand of the present picture (*Stag and Greyhound,* 27½ x 40½", formerly Lulworth Manor, Joseph Weld Collection. Photograph: London, Witt Library [New Haven, Yale Center for British Art, microfilm no. 102811]).

3. Roman copy of a late Pergamene original, *Horse Attacked by a Lion,* marble, height 58", Rome, Museo del Palazzo dei Conservatori. See Taylor, 1971, pp. 33–34.

4. This observation was made by Joseph Rishel, to whom I am indebted for making available to me his research on the painting.

5. 145/44/1, Guildford Record Office.

PROVENANCE: Presumably George Brodrick, 3rd Viscount Midleton (1730–1765); George Brodrick, 4th Viscount Midleton and Baron Brodrick, of Peper Harow (1754–1836); George, 5th Viscount Midleton, 1848; Charles, 6th Viscount Midleton, 1863; William, 7th Viscount Midleton, 1870; William, 8th Viscount Midleton, 1907; William, 9th Viscount and 1st Earl of Midleton, 1942; George, 2nd Earl of Midleton; sale, Peper Harow, Godalming, October 26, 1945, lot 35; Henry L. Straus sale, Parke-Bernet, New York, November 8, 1950, lot 52; E. J. Rousuck, New York; Edgar Thom; Christie's, New York, January 18, 1984, lot 170; Leger Galleries Ltd., London.

EXHIBITIONS: Possibly London, Society of Artists, 1763, no. 120 (as "It's companion" [to "A horse and a lion"]); Liverpool, Walker Art Gallery, *George Stubbs, 1724–1806,* July–August 1951, no. 23 (as "The Monarch o' th' Moor"); London and New Haven, 1984–85, no. 80 (by Judy Egerton).

LITERATURE: Taylor, 1971, pl. 46 and p. 208.

CONDITION NOTES: The original support is medium-weight linen. The tacking margins have been removed. The painting is lined with an aged aqueous adhesive and medium-weight, linen. A creamy peach-toned ground is present and is evident in many areas through the traction crackle, which has formed throughout almost the entire paint film. The paint appears to be in good condition. The paint has been applied consistently with thin washes laid over stronger tones below. In many cases, the upper layer of paint appears to have contracted upon drying to form a very fine, irregular web of narrow-aperture traction crackle. The entire surface has been abraded, causing the removal of paint along the edges of crackle, appearing to widen the crackle line. Under magnification, fresh-looking extrusions of ground at the ends of some crackle lines suggest that the paint has continued to respond to heat or moisture. Under ultraviolet light, retouching is restricted to small areas of loss throughout the sky and to the ground immediately beneath the stag and hound.

108 GEORGE STUBBS

LABORERS LOADING A BRICK CART, 1767
Oil on canvas, 24 x 42" (61 x 106.7 cm.)
Inscribed very faintly, abraded, lower right: *Geo: Stubbs 1767*
John H. McFadden Collection, M28-1-40

Laborers Loading a Brick Cart was commissioned by George Byng, 4th Viscount Torrington, of Southill, Bedfordshire. In his manuscript "Life of George Stubbs," Ozias Humphry described the circumstances surrounding the commission:

> At Southill the Seat of Lord viscount Torrington he [Stubbs] painted the celebrated picture of the labourers/Bricklayers, loading Bricks into a Cart—This Commission he rec[d] from the Noble Viscount in London who had often seen them at their Labours appearing like a Flemish subject and therefore he desired to have them represented—Mr: Stubbs arrived at Southill a little before dinner where he found with Lord Torrington the duke of Portland and other Noblemen and Gentlemen. during dinner the old men were ordered to prepare themselves for their Labours with a little cart drawn by Lord Torrington's favourite old Hunter w[ch] was used only for these easy tasks—for this being the first Horse his Lordship ever rode was the principal motive for ordering this picture—Mr Stubbs was a long time loitering about drawing the old Men without drawing anything that engaged them *all* so as to make a fit subject for a picture till at length they fell into a dispute ab[t] the manner of putting the Tail piece into the Cart, w[ch] dispute so favourable for his purpose lasted long enough for him to make a sketch of the picture Men, Horse and Cart as they have been represented. Thus having made the design as far as opportunity served he removed the Cart Horse and Men to a Neighbouring barn where they were kept well pleas'd and well fed till the picture was completed.[1]

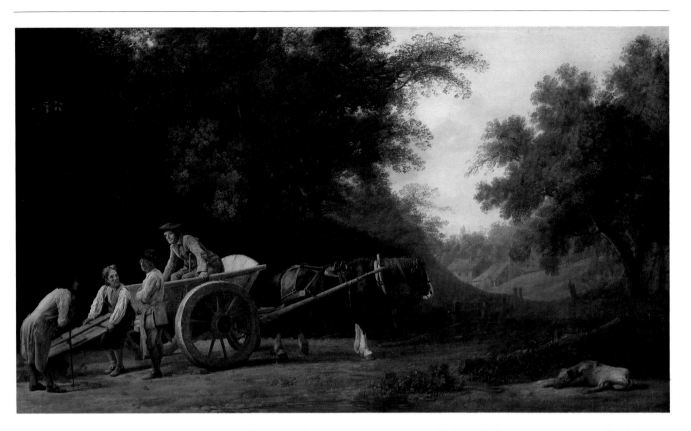

When the picture was shown at the Vokins Gallery in 1885, an inscribed date, which is now abraded, was read as 1767, a date that its style, size, and medium all tend to confirm.

When the *Laborers* was engraved by Henry Birche in 1790, the inscription in the plate read: "Painted by George Stubbs, R.A.—Landscape by Amos Green, Esq. of Bath." Until recently it was thought that, following his practice in the 1760s,[2] Stubbs painted only the figures, horse, and dog, leaving the entire background and landscape to Amos Green (1734–1807).[3] That the backgrounds of Josiah Wedgwood's version of the *Laborers*, executed entirely by Stubbs himself in enamel on ceramic (fig. 108-1), and that a large version in enamel on panel exhibited by the artist at the Royal Academy of 1779 (no. 332) (version 1) both differed from the Philadelphia picture in showing a Palladian building in the background to the right (where picturesque cottages appear in the Philadelphia picture) seemed to confirm Amos Green's free hand in the landscape. However, an x-radiograph (fig. 108-2) of the Philadelphia picture reveals that a view of this Palladian building (now destroyed but formerly known as New Lodge),[4] a small farmhouse on the Southill estate designed by Isaac Ware (c. 1707–1766) for Lord Torrington,[5] had been painted out and replaced by the cottages. The provenance of the Philadelphia version confirms that this is the picture originally commissioned by Torrington, making it certain that the outbuilding and landscape were painted first by Stubbs himself. At Lord Torrington's sale at Christie's in 1778, the Philadelphia *Laborers* was still described as "the brickmakers, with a view of the new lodge," so the overpainting by Green occurred after this date but before the publication of Birche's print in 1790. Presumably Green painted out the specific reference to Southill at the request of the current owner (in 1790, Andrews Harrison), and possibly also to broaden the commercial appeal of the print by eliminating a reference to a specific location and substituting a less classical, more picturesque (and therefore, for 1790, more modern) background. We do not know how much of the landscape Green repainted,

FIG. 108-1 George Stubbs, *Laborers*, 1781, enamel on Wedgwood biscuit earthenware, oval, 27½ x 36″ (69.8 x 91.4 cm.), Upperville, Virginia, Paul Mellon Collection

FIG. 108-2 X-radiograph of right background of *Laborers Loading a Brick Cart*, Philadelphia Museum of Art, Conservation Department, showing painted-out Palladian structure

although in comparing the backgrounds of the versions at Upton House (version 1), in the Mellon Collection (fig. 108-1), and in Philadelphia apparently only the right half of the landscape was affected.

Francis Russell has shown that the Philadelphia picture was one of at least three views of the Southill estate painted by Stubbs for Lord Torrington.[6] All three were sold at the 1778 sale, the other two being number 51, "Three horses and grooms with dogs, &c. belonging to Lord Torrington" (24 x 41½″, Lord Bute Collection), and number 52, "Portraits of his steward and gamekeeper with dogs, &c." (24 x 42″, Kenwood, The Iveagh Bequest). The three pictures are all the same size and were presumably meant to hang together, a series illustrating life at Southill. Until the Huth sale in 1905, the Philadelphia *Laborers* hung as a pendant to the Iveagh *Gamekeepers*. When the *Laborers* and *Gamekeepers* were engraved as a pair by Birche in 1790, the former was dedicated to their current owner, Andrews Harrison, the latter to their former owner, Lord Torrington.

The substitution between 1778 and 1790 of tumbledown cottages for a Palladian farmhouse represents a fascinating glimpse into changing tastes in the later eighteenth century—and not only as an indication of the replacement of a classical aesthetic with a romantic one. In the repainted picture, the truth of rural life has been sweetened: the men were no longer seen as portraits of real (if comical) people working for the benefit of the owner of a real property, but as anonymous dithering yokels taking their bricks to some unspecified destination. Both the laborers and the cottages are now picturesque, and therefore distanced from us, a change that fits well with the late eighteenth-century penchant for viewing the peasant as idealized, happy, lazy, and above all—at the time of the French Revolution—reassuringly harmless.[7] The repainted version can be compared with any number of works by artists whose style develops from Gainsborough's (q.v.) late fancy pictures—the so-called mezzotint school of Bigg, Wheatley, and Morland (q.q.v.).

1. Quoted by Taylor, 1971, pp. 40–41.
2. Constantine, 1953, p. 237.
3. Philadelphia and Detroit, 1968, no. 13. Amos Green worked in both oils and watercolor, first as a specialist in still-life subjects and later as a landscape artist. He was born in 1734 in Halesowen, near Birmingham, and around 1750 apprenticed as a decorative painter to John Baskerville, a manufacturer of lacquer boxes, fans, and ornaments. By 1760 Green had made a reputation for himself as an artist. In that year the minor poet William Shenstone (1714–1763) described him to Rev. Richard Graves as "esteemed inferior to no one in England for fruit. He also paints flowers, insects, and dead-game, *very* well" (Johnson Ball, "Amos and Harriet Green: Topographical Painters of the Late Eighteenth Century," *Leeds Art Calendar*, no. 44 [1960], p. 14). At the first exhibition of the Incorporated Society of Artists in 1760, he exhibited two fruit pieces and continued to show game, fruit, and flower pictures there in the style of Jean Baptiste Monnoyer (1636–1699) and Jan van Huysum (1682–1749) in 1763 and 1765. He stopped exhibiting in 1765 and from this time on must be classified as an accomplished amateur artist. Green died in 1807, aged seventy-three.
4. Catalogue of Lord Torrington's sale, Christie's, January 23–24, 1778, published by Francis Russell, "Lord Torrington and Stubbs: A Footnote," *The Burlington Magazine*, vol. 122, no. 925 (April 1980), p. 253.
5. The suggestion that the building was by Ware was first made by St. John Gore, *Catalogue of the Bearsted Collection, Upton House* (London, 1964), no. 85. Compare, for example, the elevation of Ware's small farm near Biggleswade at Calcot in Isaac Ware, *A Complete Body of Architecture Adorned with Plans and Elevations from Original Designs* (London, 1756), pl. 36, opp. p. 349.
6. Russell (see note 4), p. 253.
7. Barrell, 1980, passim.

PROVENANCE: Commissioned by George Byng, 4th Viscount Torrington; his sale, Christie's, January 23–24, 1778, lot 53, bt. Wildman; Andrews Harrison, by 1790; W. Kinleside Gratwicke, Ham Place, Sussex; his sale, Christie's, March 23, 1868, lot 54, bt. Whitehead; Louis Huth (d. 1905), London and Possingworth, Surrey; his sale, Christie's, May 20, 1905, lot 135, bt. Agnew; Romer Williams, Esq., 1909; John H. McFadden.

EXHIBITIONS: London, Royal Academy, 1875, no. 15 (as "Landscape and Figures" lent by Huth); Brighton, Museum and Art Gallery, Brighton Art Loan Exhibition, 1884, no. 238; London, J. and W. Vokins Gallery, *Loan Collection of Pictures by George Stubbs, A.R.A., and Engravings from His Works,* 1885, no. 4; Manchester, City Art Gallery, *Loan Exhibition of Works by Early British Masters,* winter 1909, no. 4 (lent by Romer Williams, Esq.); New York, 1917, no. 42; Pittsburgh, 1917, no. 40; Philadelphia, 1928, p. 21; Liverpool, Walker Art Gallery, *George Stubbs, 1724–1806,* July 13–August 25, 1951, no. 1; Indianapolis, Herron Museum of Art (Art Association of Indianapolis), *The Romantic Era, Birth and Flowering, 1750–1850,* February–April 1965, no. 18; Philadelphia and Detroit, 1968, no. 13; London and New Haven, 1984–85, no. 47.

LITERATURE: Mayer, 1876, pp. 120–21 (wrongly dated 1778); Mayer, 1879, pp. 29, 35; Gilbey, 1898, pp. 175, 207; Roberts, 1917, p. 81, repro. opp. p. 81; Sparrow, 1922, pp. 19–20, 30–31, 34; Grant, 1925, vol. 1, p. 102; Sparrow, 1931, pp. 5, 26; Grigson, 1940, p. 17; McKendrick, 1957, p. 508; Johnson Ball, "Amos and Harriet Green: Topographical Painters of the Late Eighteenth Century," *Leeds Arts Calendar,* no. 44 (1960), p. 17; Aldeburgh and London, 1969, pp. 7–9, 46(a); Parker, 1971, pp. 110, 115–16, 130, 132, 158, 179; Taylor, 1971, pp. 20, 40–41; Basil Taylor, "Farming as Stubbs Saw It," *Country Life,* June 28, 1973, p. 1,859; Staley, 1974, p. 38, repro. p. 39; Anne Buck, *Dress in Eighteenth-Century England* (London and New York, 1979), p. 141, fig. 70; Cormack, 1979, pp. 57–59; Francis Russell, "Lord Torrington and Stubbs: A Footnote," *The Burlington Magazine,* vol. 122, no. 925 (April 1980), pp. 250–53.

CONDITION NOTES: The original support is twill-weave, medium-weight (12 x 12 threads/ cm.) linen. The tacking margins have been removed. The painting is lined with an aged aqueous adhesive and twill-weave, medium-weight linen. The aqueous lining was infused with a wax-resin mixture in 1967 in an attempt to relax an overall cupping problem.

An off-white ground is evident along the cut edges. The paint is in very good condition. Brush marking and paint profile have been well preserved. A wide interval, irregular web of fracture crackle with a narrow aperture is present overall. An irregular web of narrow-aperture traction crackle is present in the brown tones of the foliage. The mid- and shadow tones of the figures are slightly abraded. X-radiographic details (fig. 108-2) show that the fence and buildings in the distance have been altered; the cottages apparent now were painted over a Palladian dwelling. Under ultraviolet light, retouches are visible to the apertures of the widest fracture crackle, especially in the sky area, and to local areas of abrasion in the foliage above the figures at the left.

VERSIONS
1. George Stubbs, *Laborers,* 1779, enamel on panel, 36 x 54″ (91.4 x 137.2 cm.), Upton House, National Trust.
 INSCRIPTION: *Geo:Stubbs P 1779.*
 PROVENANCE: Possibly Stubbs's common-law wife, Mary Spencer, 1809; Sir Walter Gilbey, by 1898; his sale, Christie's, June 11, 1915, lot 386, bt. Agnew with Knoedler, 1919, bt. Lord Bearsted.
 EXHIBITION: London, Royal Academy, 1779, no. 332.
 LITERATURE: Gilbey, 1898, pp. 46–47, 155–56, app. B, no. 16; Sparrow, 1922, p. 34; McKendrick, 1957, p. 508; Walter Horace Samuel [2nd Viscount Bearsted], *Catalogue of Pictures and Porcelain at Upton House, Banbury* (London, 1950), no. 85; St. John Gore, *Catalogue of the Bearsted Collection, Upton House* (London, 1964), no. 85; Aldeburgh and London, 1969, p. 46(b); Doherty, 1974, p. 13; Cormack, 1979, p. 57.

2. George Stubbs, *Laborers,* 1781, enamel on Wedgwood biscuit earthenware, oval, 27½ x 36″ (69.8 x 91.4 cm.), Upperville, Virginia, Paul Mellon Collection (fig. 108-1).
 INSCRIPTION: *Geo Stubbs pinxit 1781* [lower right].
 PROVENANCE: Painted for Josiah Wedgwood; Josiah Wedgwood III, and by descent to his grandson, Ralph Vaughan Williams, O.M.; by descent to Sir John Wedgwood Bart., T.D., Christie's, June 23, 1978, lot 147.
 EXHIBITIONS: London, Tate Gallery, 1974, no. 11; London and New Haven, 1984–85, no. 48.
 LITERATURE: Mayer, 1876, pp. 120–21; Mayer, 1879, p. 29; Gilbey, 1898, p. 47; Sparrow, 1922, p. 19; Basil Taylor, "Josiah Wedgwood and George Stubbs," *Proceedings of the Wedgwood Society,* no. 4 (1961), p. 223; Aldeburgh and London, 1969, p. 46(c); Taylor, 1971, p. 213, nos. 108–9; Basil Taylor, "Farming as Stubbs Saw It," *Country Life,* June 28, 1973, p. 1,858, fig. 1; London, Tate Gallery, 1974, pp. 11, 14, 23; Cormack, 1979, p. 57, repro. (cover).

3. George Stubbs, *Laborers,* enamel on Wedgwood biscuit earthenware, dimensions and location unknown.
 PROVENANCE: Painted for Thomson West.
 LITERATURE: Mayer, 1876, pp. 120–21; Sparrow, 1922, p. 19.

4. George Stubbs, *Laborers,* enamel on Wedgwood biscuit earthenware, oval, 27½ x 36″ (69.8 x 91.4 cm.), location unknown.
 PROVENANCE: Painted for Erasmus Darwin.
 LITERATURE: Mayer, 1876, pp. 120–21.

5. After George Stubbs, *The Laborers,* oil on panel, 29¾ x 25¼″ (75.5 x 64.1 cm.), location unknown.
 PROVENANCE: Spink and Co.; anonymous sale, Christie's, March 23, 1979, lot 23.

6. Charles Towne (d. 1850?) after George Stubbs, *The Laborers,* oil on canvas, 29½ x 39½″ (74.9 x 100.3 cm.), London art market, 1980.

ENGRAVINGS
1. George Stubbs, 1788, *Laborers,* mezzotint (mixed method), 20⅝ x 27⅝″ (52.4 x 70.1 cm.).
 INSCRIPTION: *LABOURERS / Painted, Engraved & Published by Geo. Stubbs / 1 Jan.y. 1789, No. 24, Somerset Street, Portman Sq., London.*
 LITERATURE: Aldeburgh and London, 1969, p. 46, no. 15, repro. p. 47; London, Thomas Agnew and Sons, *Stubbs in the 1760s,* November–December 1970, no. 10; London and New Haven, 1984–85, no. 186.

2. Henry Birche [Richard Earlom], *Laborers,* 1790, mezzotint, 15½ x 25½″ (39.4 x 64.8 cm.).
 INSCRIPTION: *Painted by George Stubbs, R.A.—Landscape by Amos Green, Esq. of Bath Engraved by Henry Birche Published March 25, 1790 by B. B. Evans in the Poultry London. To Andrew Harrison Esq. this Plate from the Original Picture in his collection is most respectfully Inscribed by his much obliged and obedient servant.*
 EXHIBITION: Aldeburgh and London, 1969, no. 1.
 LITERATURE: Sparrow, 1922, repro. opp. p. 30.

PREPARATORY STUDIES
1. George Stubbs, *Compositional Study ?,* medium, dimensions and location unknown.
 PROVENANCE: Artist's sale, Peter Coxe (auctioneer), 24 Somerset Street, May 26, 1807, lot 29 (as "A capital drawing, the original design for the Painting of Men Unloading a Cart, being a scene from nature in Lord Torrington's Garden").

2. George Stubbs, *Study for the Head of a Cart Horse,* pencil, 6¼ x 8½″ (15.9 x 21.6 cm.), Liverpool, Brown, Picton and Hornby Libraries.
 PROVENANCE: Joseph Mayer.
 LITERATURE: Grigson, 1940, p. 17; Parker, 1971, p. 132.

John MacAllan Swan is one of the rare artists whose work as a sculptor is equally balanced by his work as a painter. He was a leading exponent in England of a movement loosely known as the New Sculpture, as practiced by Alfred Gilbert (1854–1934), Hamo Thornycroft (1850–1925), Alfred Drury (1857–1944), and Onslow Ford (1852–1901). The term referred to a new naturalism, a fresh emphasis on the techniques and possibilities of the bronze medium, a fascination first with cire perdue and later with oriental casting techniques and especially with polychromy. Among these artists Swan was the only real *animalier,* and his particular contribution to the movement consisted in his close study of Japanese metalwork and casting techniques.[1]

Born of Scottish parents in Old Brentford on December 9, 1847, Swan studied art at the Worcester Art School, the Lambeth School of Art, and the Royal Academy. In 1874, realizing that instruction at the academy could not compare with the artistic training available in France, he left for Paris armed with introductions to the English embassy from the president of the Royal Academy, Sir Francis Grant (1803–1878), as well as to artists from Frederic Leighton (q.v.), Edward Armitage (1817–1896), and William Frederick Yeames (1835–1918). At once he was accepted into the life class at the École des Beaux-Arts. There he studied painting under Jean Léon Gérôme (1824–1904) with fellow students Pascal Adolphe Jean Dagnan-Bouveret (1852–1929) and Jules Bastien-Lepage (1848–1884). Besides the rigorous schedule of drawing from life pursued by the students at the Beaux-Arts, study of anatomy was also required not only in textbooks and in the lectures of Gervais and Duval but also through dissection. Gérôme, a sculptor as well as a painter, also encouraged Swan to realize his drawings in three dimensions, and through his teacher, Swan met and studied with the greatest realist sculptor and *animalier* in France, Emmanuel Frémiet (1824–1910), many of whose works included animals used in an anecdotal way: *The Centaur and the Bear, The Gorilla Carrying Off a Woman.* Under Frémiet's guidance Swan began to sketch at the Jardin des Plantes in Paris and studied, too, the works of Antoine Louis Barye (1796–1875), especially his *écorché* models preserved in the École des Beaux-Arts.

In Paris he lived at 24 rue Bonaparte. His closest friend was the English sculptor and (after 1876) fellow pupil at the Beaux-Arts, Alfred Gilbert. In 1879 both young men were in Rome where Swan is said to have mingled with the French artists at the Villa Medici. Since 1878 he had sent pictures back to England to exhibitions at the Grosvenor Gallery and the Royal Academy (*Dante and the Leopard,* exhibited R.A. 1878, no. 94). Then, sometime in the early 1880s, he returned to live in London. Success was slow in coming, partially because his painstaking, perfectionist approach to his art made finishing pictures hard for him, but also because he chose to continue his studies on his own, sketching at the Zoological Gardens in Regents Park (he was elected a Fellow in 1890 and lived nearby at 12 Acacia Road, St. John's Wood), and renewing his anatomical studies at St. Bartholomew's and St. Thomas's hospitals.

Real recognition in England came only in 1888, when he exhibited his painting *The Prodigal Son* at the Royal Academy (no. 136, 44 x 62″, London, Tate Gallery). The following year, 1889, he exhibited his first work of sculpture at the Royal Academy, *Young Himalayan Tiger* (no. 2,061). There followed several small bronzes in the manner of Barye, *An African Panther* and *Lioness Drinking,* 1892 (nos. 1,992 and 1,994). As in his paintings, Swan eventually combined his study of human and animal anatomy in statues such as *Orpheus* (exhibited R.A. 1895, no. 1,705). Only in 1894 was he elected an Associate of

the Royal Academy and he became a full Academician in 1905. Swan was also a member of the Royal Watercolour Society (1899) and received an honorary LL.D. from Aberdeen University.

Abroad, recognition came sooner. In 1885 he was elected to the Dutch Watercolor Society; in 1889 he won the silver medal at the Paris Exhibition and gold medals at the Munich exhibitions of 1893 and 1897 and at the world's fairs in Chicago (1893) and Paris (1900). He was a member of the Vienna and Munich Secession.

1. *Catalogue of . . . Chinese and Japanese Works of Art, the Property of the Late J. M. Swan, Esq., R.A.,* Sotheby's, February 19–20, 1912, lots 158–311.

BIBLIOGRAPHY: A. L. Baldry, "Drawings by Mr. J. M. Swan, A.R.A.," *The Studio,* vol 11 (1894), pp. 236–43; R.A.M. Stevenson, "J. M. Swan," *The Art Journal,* 1894, pp. 17–22; A. L. Baldry, "The Work of J. M. Swan, A.R.A.," pt. 1, *The International Studio,* vol. 13, no. 49 (March 1901), pp. 75–86, pt. 2 (April 1901), pp. 151–61; M. H. Spielmann, *British Sculpture and Sculptors of To-Day* (London, 1901), pp. 66–71; A. L. Baldry, *Drawings of J. M. Swan, R.A.* (London and New York, 1905); W[alter] A[rmstrong], *Dictionary of National Biography,* 2nd supp., s.v. "Swan, John MacAllan."

EXHIBITION: London, Royal Academy, *Works by Five Deceased British Artists,* winter 1911.

109 JOHN MACALLAN SWAN

LIONESS AND CUBS, c. 1890
Oil on canvas, 17⅛ x 24½″ (43.5 x 62.2 cm.)
Inscribed lower left: *J. M. Swan*
The William L. Elkins Collection, E24-3-65

PROVENANCE: William L. Elkins, by 1900.

EXHIBITION: Chicago, Illinois, World's
Columbian Exposition, *Loan Collection of
Foreign Works from Private Galleries in the
United States,* 1893, p. 153.

LITERATURE: Elkins, 1887–1900, vol. 1,
no. 49, repro.

CONDITION NOTES: The original support is
medium-weight (16 x 16 threads/cm.) linen.
The painting is lined with an aqueous adhesive
and medium-weight linen. A thin, off-white
ground extends partially onto the tacking
margins. The paint is in good condition
overall. A light traction crackle radiates inward
from each corner. Two large horizontal
scratches (2 to 3″) are present on the right-hand
side of the background. Much of the original
brush-marking texture has been preserved.

RELATED WORK: John MacAllan Swan,
Lioness and Cubs, canvas?, 14¼ x 20¾″
(36.2 x 52.7 cm.), Alice R. Donnely Collection.
Photograph: London, Witt Library.
 INSCRIPTION: *J. M. Swan.*

JOHN MACALLAN SWAN

IN AMBUSH, 1894
Oil on canvas, 32¼ x 52⅛" (82 x 132 cm.)
Inscribed lower left: *John M. Swan 1894*
The William L. Elkins Collection, E24-3-81

Baldry was the first to point out that Swan's unusual sense of the distribution and spacing of his figures owed something to his study of Japanese art.[1] According to his entry in the *Dictionary of National Biography,* Swan contributed papers to the *Proceedings of the Japanese Society,* and his own collection of Japanese vases, bronzes, screens, drawings, color prints, and objects was formidable.[2] A comparison with the painter Ganku's (1749/56–1838) *Tiger by a Torrent* (fig. 110-1) shows that although the compositions are not at all similar, Swan's sensibility is much closer to the Japanese artist's than, for example, to that of Stubbs (q.v.) or Landseer (1803–1873).

In the 1890s the Zoological Society owned a number of leopards, thus identifying these particular ones is not possible. *In Ambush* is a version of Swan's *East African Leopards* in the Art Gallery of New South Wales (fig. 110-2).

FIG. 110-1 Ganku (1749/56–1838), *Tiger by a Torrent,* watercolor, 66 x 45" (168 x 114 cm.), London, British Museum

1. A. L. Baldry, *Drawings of J. M. Swan, R.A.* (London and New York, 1905).
2. *Catalogue of . . . Chinese and Japanese Works of Art, the Property of the Late J. M. Swan, Esq., R.A.,* Sotheby's, February 19–20, 1912, lots 158–311.

PROVENANCE: William L. Elkins, by 1900.

LITERATURE: Elkins, 1887–1900, vol. 1, no. 48, repro.

CONDITION NOTES: The original support is medium-weight (12 x 12 threads/cm.) linen. The painting was lined with a wax-resin adhesive and medium-weight linen in 1969. A white ground has been evenly and thickly applied and extends onto the tacking margins in an irregular manner. The ground has been darkened appreciably by infusion with the linen adhesive. The paint is in good condition overall. Small, local areas of traction crackle are present in the brown/black areas along the right-hand edge of the composition. An irregular net of narrow-aperture fracture crackle exists overall. Under ultraviolet light, retouches are evident on the foreground leopard's haunches.

VERSION: John MacAllan Swan, *East African Leopards,* 1896, oil on canvas, 30⅛ x 50" (76 x 127 cm.), Sydney, Art Gallery of New South Wales (fig. 110-2).
 INSCRIPTION: *John M. Swan.*
 PROVENANCE: Messrs. Boussod, Valadon and Co. (dealers); purchased by the Art Gallery of New South Wales, 1898.
 EXHIBITION: London, Royal Academy. 1896, no. 323.
 LITERATURE: *The Art Journal,* 1896, p. 176, repro. p. 181; *Royal Academy Pictures 1896 (Being the Royal Academy Supplement of "The Magazine of Art")* (London, Paris, and Melbourne, 1896), repro. p. 108.

FIG. 110-2 John MacAllan Swan, *East African Leopards,* 1896, oil on canvas, 30⅛ x 50" (76 x 127 cm.), Sydney, Art Gallery of New South Wales

When his son was only about ten years old, Turner's father, William (1745–1829), a barber and wigmaker living in Maiden Lane, Covent Garden, and "a chatty old fellow, [who] talked fast,"[1] told one customer, the Royal Academician Thomas Stothard (1755–1834), "My son is going to be a painter."[2] Accordingly, in 1789 he placed the boy in the Royal Academy schools and in the studio of the watercolorist and architectural draftsman Thomas Malton (1726–1801).

One contemporary described Turner at this period as "not like young people in general, he was singular and very silent . . . exclusively devoted to his drawing,"[3] so even at this stage his personality was marked by an obsessive dedication to his art. By the early 1790s Turner was touring England, working as a topographical draftsman in the tradition of Edward Dayes (1763–1804) and Paul Sandby (q.v.). Slightly later, from 1794 to 1797, he worked with Thomas Girtin (1775–1802) in the evenings for the collector Dr. Thomas Monro (1759–1833) in his house at the Adelphi, copying drawings by John Robert Cozens (1752–1797).

The range of influences forming Turner's early style is formidable. His first watercolor, a view of Lambeth Palace executed in the most fashionable topographical manner, appeared on the walls of the Royal Academy as early as 1790, when he was fifteen. In 1796 he exhibited his first oil, a moonlit seascape, *Fishermen at Sea* (36 x 48⅛", London, Tate Gallery), which revealed how closely he had looked at the marine paintings by Willem van de Velde the Younger (1633–1707) and also at the then-popular seascapes of the French artists Claude Joseph Vernet (1714–1789) and Philipp de Loutherbourg (1740–1812). Above all, Turner's oil paintings of the later 1790s, and particularly his composition of 1800 *The Fifth Plague of Egypt* (49 x 72", Indianapolis, Indiana, The Indianapolis Museum of Art), reflect his close study of the paintings of the founder of the English classical landscape tradition, Richard Wilson (q.v.).

Turner also seems to have revered the president of the Royal Academy Sir Joshua Reynolds (q.v.) and may even have worked for a time in the aging president's studio, during "the happiest of my days," 1789–92.[4] Certainly the boy accepted the values and dictates of the president, wholeheartedly embracing a system of teaching derived from the art theorists of the seventeenth century and disseminated in Sir Joshua's Discourses. From Reynolds, Turner learned to differentiate between the hierarchies of history, landscape, and genre painting, and to idealize nature, transcending the particular to express the general truth. But more than this, he learned from Reynolds to appeal in his art to the imagination and not simply to the eye.[5]

Among landscape painters, the Academicians held in highest esteem the seventeenth-century French classicists Poussin (1594–1665), Claude Lorrain (1600–1682), and Gaspard Dughet (1615–1675)—artists who had set into the noblest landscapes stories from the classical past illustrating profound moral lessons. Turner's ambition was to emulate these masters by melding the relatively lowly category of landscape painting with the highest achievement possible for an artist, the history picture painted in the grand manner. But this much Richard Wilson had done. Turner's achievement would be to extend the definition of what a history picture was, to transform through his genius not merely idealized classical landscapes, but also the seascape, the genre subject, and the picturesque view, into potent statements about nature's awesome power to destroy or to heal.

Turner, like Reynolds, was a genius who worked dispassionately and thoughtfully within the establishment; only when he had secured a place in the Royal Academy—first as an Associate member in 1799 (at twenty-four, the earliest possible age), and then as a full Academician in 1802—did he begin to experiment in extending the definitions of his art. Even then, and until around

1819, his palette remained relatively subdued, in accordance with the most conservative theories of the picturesque and the sublime, while his compositions often paid homage to one of the most revered old masters, Claude Lorrain, as in *Dido Building Carthage* (1815, 61¼ x 91¼″, London, National Gallery) or *Crossing the Brook* (1815, 76 x 65″, London, Tate Gallery).

Having noted this cautious streak, however, we must at once point to such an astonishingly avant-garde work as his great machine of 1812, *Snow Storm: Hannibal and His Army Crossing the Alps* (57½ x 93½″, London, Tate Gallery), a painting that announced a whole new genre of cataclysmic history painting in England, later to be exploited by John Martin (1789–1854) and Francis Danby (1793–1861). *Hannibal* was remarkable not only for its fascinating iconography—its subject from ancient history refers at once to the recent Napoleonic invasion of Italy, the possible invasion of England, and the eventual decline of all empire—but also for its composition; it is amazing that the picture was accepted by the public of 1812 as a finished picture at all: composed simply of vast arcs of dark and light tone, it draws the eye into a chaotic vortex of swirling wind, rain, and snow, from which, only slowly, the eye picks out the progressing army, with the tiny figure of Hannibal on his elephant in the distance.

Turner had actually seen the Alps on his first visit to the Continent during the few months in 1802 when Europe was at peace. Throughout his life he was to return to Switzerland, drawn to its mountains, crags, gales, and avalanches as the very embodiment of nature at its most extreme. But on this first trip he also could view the art treasures amassed in the Louvre by Napoleon, and on his return to England he seems systematically to have set out to imitate those old masters he most admired. In the Royal Academy of 1803 he paid tribute to Poussin and Dughet in *Bonneville, Savoy, with Mont Blanc* (36 x 48″, Switzerland, private collection); to Titian (c. 1487/90–1576) in *The Holy Family* (40¼ x 55¾″, London, Tate Gallery); and to van de Velde in *Calais Pier, with French Poissards Preparing for Sea: An English Packet Arriving* (67¾ x 94½″, London, National Gallery).

War prevented a second trip abroad until the artist's visit to the Low Countries in 1817. His first trip to Italy took place in 1819, when he traveled for four months to Venice, Rome, and Naples. In the watercolors executed in twenty Italian sketchbooks of 1819, particularly those of Venice, a new phase in Turner's art began. These luminous studies of architecture dissolving in light and water seem to have triggered some mechanism whereby his way of seeing the world was turned inside out: before them, he viewed objects as volume and outline, tinted with color; after 1819 he began to see color predominating over form—to see the world as light and color infusing matter with life.

As the culmination of this middle period, 1819 to c. 1834, Ruskin pointed to Turner's mythological painting of 1829 *Ulysses Deriding Polyphemus—Homer's Odyssey* (52¼ x 80″, London, National Gallery), as "the *central picture* in Turner's career."[6] In it, all his early themes—the obsession with the mythological past and the subject drawn from classical literature, the passion for the history of art, the increasing devotion to lurid, vivid effects of light at dawn or sunset—come together in a fairy-tale description of the minute Ulysses defying the mountainous giant Polyphemus from an outlandish galley puffed up by the wind and attended by phosphorescent Nereids.

Turner was now fifty-nine, and it might have been that *Ulysses* would mark the high point of his artistic achievement: by this date his father and most of his early patrons such as William Beckford, Walter Fawkes (1769–1825) of Farnley Hall in Yorkshire, and Sir John Fleming Leicester (1762–1827) were dead. But Turner's greatest achievements were yet to come, sparked by two elements that entered his life in the 1830s. The first, beginning around 1827,

was his intimacy with George Wyndham, 3rd Earl of Egremont (1751–1837), and his close association with the earl's house Petworth in Sussex. The paintings commissioned by Lord Egremont from Turner are not so remarkable as those pictures of Petworth that Turner executed entirely as private statements. In these, his love for the house, its park, and his patron seems to have given him the security to test still further the limits of what could be described in paint. And so, in a masterpiece that has always been called *Interior at Petworth* and is certainly to be dated to c. 1837 (35¾ x 48″, London, Tate Gallery), he painted objects dissolving in light and color in a way that verges on the visually incomprehensible. Writing of this painting, Luke Herrmann said, "Turner left all conventions of style and technique behind him. In the history of art he is breaking new ground here."[7] Herrmann did not add that if, as is thought, the *Interior at Petworth* was painted after Lord Egremont's death in token of the desolation felt by the painter for the patron he had lost, then it is also a most moving expression of personal sorrow.[8]

The second turning point that may have led to his late style was Turner's witnessing of the burning of the Houses of Parliament in October 1834. There the conflagration, reflected in the waters of the Thames, may, as Gowing suggested,[9] have broken down the barriers for Turner between imagination and reality, which were never quite to separate again: the most evanescent effects—fire, steam, spray, wind, sheer motion—are the themes that dominate Turner's late paintings from 1834 to 1851. Ruskin described such masterpieces as *The Slave Ship* (1840, 35¾ x 48″, Boston, Museum of Fine Arts), *Peace— Burial at Sea* (1842, 34¼ x 34⅛″, London, Tate Gallery), and *Rain, Steam, and Speed—The Great Western Railway* (1844, 35¾ x 48″, London, National Gallery) as "the noblest landscapes ever yet conceived by human intellect";[10] and they are pictures so powerful that they strike at the deepest chords of human experience—for they are about, respectively, the nature of evil, of grief, and the inevitability of change.

Turner was an artist who, like Picasso, could hardly touch a canvas or a sheet of paper without shaping it with his own protean originality. Discussing his work as an engraver is impossible in a biographical note of this length, except to point to his famous *Liber Studiorum* (published in fourteen parts between 1807 and 1819), in which he set out to illustrate in seventy-one prints the various categories of landscape scenery, from the historical and the pastoral to the marine and the architectural; nor, from the many projects illustrating English and Continental scenery can we single out one series, although his watercolors for Charles Heath's *Picturesque Views in England and Wales,* which came out in twenty-four parts between 1827 and 1838, have been described as "among the most wonderful objects of their kind ever produced."[11]

Turner lived from 1799 at 64 Harley Street, an address changed in 1810 to 47 Queen Anne Street. At various points in his life he also took houses at Upper Mall, Hammersmith (1806–11), Twickenham (1813), and finally from 1846 until his death in 1851 in a cottage in Cheyne Walk in Chelsea. Throughout his life he exhibited at the Royal Academy and the British Institution, and from 1804 until 1816 he also held annual exhibitions of his own works in the gallery he built onto his Harley Street house—exhibitions that were the successors to Gainsborough's (q.v.) private exhibitions at Schomberg House in Pall Mall and contemporary with Blake's (q.v.) famous one-man show in 1809.

Turner was hardly educated in the formal sense, and unlike the eloquent John Constable (q.v.), his rival for the title of the greatest of all English landscape painters, was barely able to express himself clearly even in the

simplest business correspondence. Yet, throughout his career he wrote poetry and after 1813 attached to his exhibits at the Royal Academy quotations from his own gloomy epic poem *Fallacies of Hope*.

In *Modern Painters* (1842–60) when Ruskin came critically to examine the iconography of Turner's works, he interpreted them didactically, unraveling their hidden meanings for the public in brilliant exegeses, much as though he were an evangelical preacher propounding the significance of passages from the Bible. Ruskin believed that the themes of many of Turner's oil paintings warned against the moral and physical decline of his country. Whether this is true is open to question; but what we can say with confidence is that Turner, like Blake, was a visionary, a man out of his own time rather than, like Constable, a seeker after the truth of external sensation.

When Turner died in 1851 he had amassed a fortune of £140,000 and left over thirty thousand sketches from his studio to the nation. When in 1975 his bicentennial was celebrated by a vast exhibition at the Royal Academy, comprising 450 works, what was remarkable was that not one of those works could have been removed without diminishing our knowledge of some facet of his overwhelming achievement.

1. According to F. E. Trimmer. See Finberg, 1961, p. 9.
2. Ibid., p. 16.
3. Ibid., p. 27.
4. According to Gage, 1969, p. 33.
5. Kitson, 1964, p. 16.
6. Ruskin, 1903–12, vol. 13, p. 136.
7. Herrmann, 1975, p. 37.
8. See Butlin and Joll, 1977, vol. 1, no. 449.
9. Gowing, in New York, 1966, p. 45.
10. Ruskin, 1903–12, vol. 12, p. 391.
11. London, Royal Academy, *Turner, 1775–1851*, November 16, 1974–March 2, 1975, p. 121.

SELECTED BIBLIOGRAPHY: Walter Thornbury, *The Life of J.M.W. Turner, R.A., Founded on Letters and Papers Furnished by His Friends and Fellow Academicians*, 2 vols. (London, 1862); Thornbury, 1877; Bell, 1901; Armstrong, 1902; Ruskin, 1903–12, passim; Finberg, 1909; Falk, 1938; A. J. Finberg, *The Life of J.M.W. Turner, R.A.* (Oxford, 1939); Clare, 1951; Finberg, 1961; Kitson, 1964; Rothenstein and Butlin, 1964; Lindsay, 1966; Luke Herrmann, *Ruskin and Turner* (London, 1968); Gage, 1969; Reynolds, 1969; John Gage, *Turner: Rain, Steam and Speed* (London, 1972); Herrmann, 1975; Butlin and Joll, 1977; Wilton, 1979, *Turner*; John Gage, ed., *Collected Correspondence of J.M.W. Turner, with an Early Diary and a Memoir by George Jones* (Oxford, 1980); Butlin and Joll, 1984.

SELECTED EXHIBITIONS: Boston, Museum of Fine Arts, *An Exhibition of Paintings, Drawings, and Prints by J.M.W. Turner, John Constable, R.P. Bonington*, March–April 1946; Toronto, Art Gallery of Toronto, Ottawa, National Gallery of Canada, *Paintings by J.M.W. Turner*, October–December 1951; New York, 1966; London, Thomas Agnew and Sons, *Paintings and Watercolours by J.M.W. Turner, R.A.*, November–December 1967; Philadelphia and Detroit, 1968; Dresden, Gemäldegalerie Neue Meister, Berlin, Nationalgalerie Staatliche Museen Preussischer Kulturbesitz, *William Turner, 1775–1851*, July–November 1972; Lisbon, Calouste Gulbenkian Foundation (organized by the Tate Gallery and the British Museum), *Turner (1775/1851): Drawings, Watercolours, and Oil Paintings*, June–July 1973 (by Andrew Wilton and Luke Herrmann); London, Tate Gallery, *Landscape in Britain, c. 1750–1850*, November 1973–February 1974; London, Royal Academy, *Turner, 1775–1851*, November 16, 1974–March 2, 1975 (by Martin Butlin, Andrew Wilton, and John Gage); London, British Museum, *Turner in the British Museum: Drawings and Watercolours*, May 1975–February 1976 (by Andrew Wilton); Paris, Grand Palais, *J.M.W. Turner*, October 1983–January 1984.

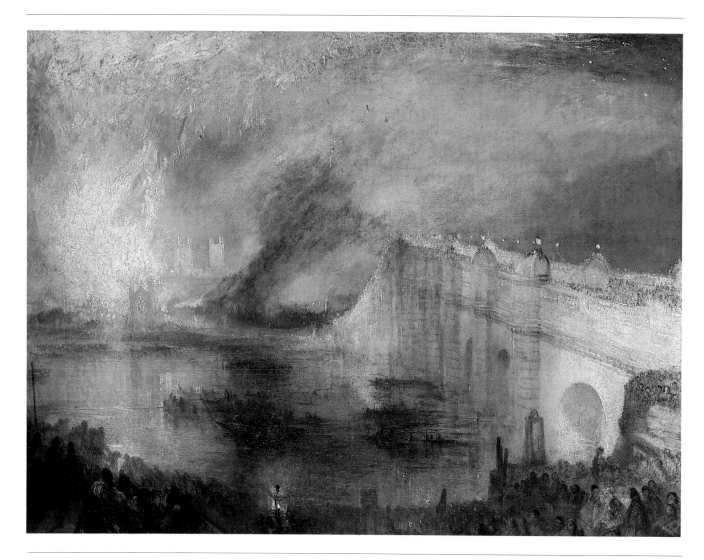

III J.M.W. TURNER

THE BURNING OF THE HOUSES OF LORDS AND COMMONS,
OCTOBER 16, 1834, exhibited 1835
Oil on canvas, 36¼ x 48½″ (92 x 123 cm.)
John H. McFadden Collection, M28-1-41

FIG. III-I J.M.W. Turner, *The Burning of the*
Houses of Lords and Commons, October 16, 1834,
exhibited 1835, oil on canvas, 36½ x 48½″ (92.7 x
123 cm.), Cleveland, The Cleveland Museum of
Art, Bequest of John L. Severance

This painting shows the conflagration of the Houses of Parliament on the
night of October 16, 1834. The view is taken from almost directly opposite the
Palace of Westminster on the Surrey side (south bank) of the Thames, slightly
to the left of Westminster Bridge, which is shown, greatly exaggerated in
scale, on the right. In the center of the flames, the shape of St. Stephen's
Chapel, which served as the House of Commons, is clearly visible, with the
towers of Westminster Abbey in the background. Another oil painting of the
subject, now in the Cleveland Museum of Art (fig. III-I), shows the scene from
down river by Waterloo Bridge, still on the Surrey side of the Thames, but
later in the evening. Again, we can see the abbey, but now the end of
Westminster Hall stands out from the flames. In the Cleveland picture we are
looking upstream.

 The event that both pictures record was reported in the *Times* (London)
for Friday, October 17, 1834. This account should be quoted at length:

 Shortly before 7 o'clock last night the inhabitants of Westminster, and of
 the districts on the opposite bank of the river, were thrown into the
 utmost confusion and alarm by the sudden breaking out of one of the

FIG. III-2 *The Burning of the Houses of
Parliament, from Westminster Bridge,* 1834,
colored woodcut, 14⅛ x 10⅞″ (36 x 27.6 cm.),
London, British Museum

most terrific conflagrations that has been witnessed for many years past.
Those in the immediate vicinity of the scene of this calamity were quickly
convinced of the truth of the cry, that the Houses of the Lords and
Commons and the adjacent buildings were on fire; the ill news spread
rapidly through the town, and the flames increasing, and mounting
higher and higher with fearful rapidity, attracted the attention not only of
the passengers in the streets, but if we may judge from the thousands of
persons who in a few minutes were seen hurrying to Westminster, of the
vast majority of the inhabitants of the metropolis. We scarcely ever
recollect to have seen the large thoroughfares of the town so thronged
before. Within less than half an hour after the fire broke out, it became
impossible to approach nearer to the scene of the disaster than the foot of
Westminster-Bridge on the Surrey side of the river, or the end of
Parliament Street on the other, except by means of a boat, or with the
assistance of a guide, who, well acquainted with the localities, was
enabled to avoid the crowd and reach Abingdon-Street by the streets at
the back of the Abbey.... There was, however, nothing surprizing in the
multitude that flocked to the spot—in the crowded boats that floated on
the river immediately in the front of the blazing pile—or in the countless
numbers that swarmed upon the bridges, the wharfs, and even the
housetops; for the spectacle was one of surpassing though terrific
splendor, and the stately appearance of the Abbey, whose architectural
beauties were never seen to greater advantage than when lighted by the
flames of this unfortunate fire, would of themselves have attracted as
many thousands to the spot.

In order to visualize the scene Turner saw before him that night, it is useful to
refer, in addition to the *Times* description, to two popular prints published
soon after the fire, which show the buildings, the boats, and the blaze in much
more detail than they appear in the Philadelphia oil (figs. III-2 and III-3).[1]

Lawrence Gowing compared the painting to a scene in a grand opera,
where the spectators gape at the spectacle before them[2]—and Turner did
emphasize the horror-stricken crowd, turning to face us like a chorus, while
the projecting parapet at the lower right, filled with spectators, might be a box
in a theater. This theatrical element is not Turner's invention but a feature of
the actual event. The reporter for *The Gentleman's Magazine* described how
"about half past nine an immense column of flame burst forth through the
roof and windows of the House of Lords; ... and so struck were the
bye-standers with the grandeur of the sight at this moment, that they
involuntarily (and from no bad feeling) clapped their hands, as though they
had been present at the closing scene of a dramatic spectacle, when all that the
pencil and pyrotechnic skill can affect is put in action to produce a striking
coup d'oeil." This same reporter captured in words the very sounds and
smells of the scene Turner so vividly depicted: "The bell of St. Margaret's
tolling—the fire men shouting—the crash of falling timbers—the drums of the
foot-guards beating to arms, and the clarions of the horse [guards] wailing
through the air. Amidst all this din and confusion the river calmly glided on,
gleaming with reflected fires."[3]

The dark boats on the Thames in Turner's painting are filled with
spectators seeking to get closer to the fire, as described by the account
published in the *Times:* "The anxiety displayed by the populace to witness the
conflagration was so great, that much difficulty was experienced in
approaching any part from which a view could be taken, and the river was
covered with innumerable wherries, which were plying the whole time, taking
persons abreast of the House of Commons."

FIG. III-3 *A View of the Conflagration of the
Houses of Lords and Commons,* 1834, engraving,
7⅝ x 11¾″ (19.5 x 30 cm.), London, British
Museum

The view in the Cleveland picture (fig. III-I) is not only less consciously theatrical than that in the Philadelphia painting, but it is in some ways more a journalistic exercise in rendering an account of a specific moment during the evening. It depicts the blaze some hours after that shown in the Philadelphia version. The *Times* report, describing the events of the evening in chronological order, reaches the hour of half past two in the morning, when it became generally known that Westminster Hall had been preserved from the flames. Fire-fighting equipment had been brought earlier in the evening, of course, but because the tide had come in at twenty after one that afternoon, and the fire broke out at seven o'clock when the tide was low, water could be pumped only with difficulty to the engines fighting the fire from the land. Likewise, towing the new floating fire-fighting apparatus to the scene was initially impossible because the shallowness of the Thames prevented steamers from coming up river. However, after about half past two in the morning, the reporter noted: "On our return home by water we met a steam-vessel towing up to Westminster the floating engine. It might have been of great service had it arrived earlier; but the state of the tide and the shallowness of the water prevented the steamer from coming sooner up the river. We have since heard that nearly an hour was lost before it could be brought into play, but when it did commence, the effect which it produced on the burning embers was said to be positively prodigious."

The Cleveland painting shows the steamer towing the floating fire-fighting engine to the scene hours after the engine could have done any real good, for by eleven o'clock the fire engines on land had abandoned trying to fight the blaze in Westminster Palace and instead had begun to pour water on the neighboring houses to prevent the spread of the fire. Turner thus shows us a scene of the deepest irony, emphasizing man's helplessness when confronted with the combined hostility of fire and tide. With this in mind, we might feel, in his depiction of the watching yet passive crowd on the left, a sense of impotence and despair, very different from the frenzy and horror of the crowds in the Philadelphia picture.

Turner filled nine pages of a sketchbook now in the British Museum (Turner Bequest CCLXXXIII) with watercolor studies of the fire (figs. III-4–12). Finberg (1909) believed that these watercolors were related to the burning of the Houses of Parliament, while Gowing (New York, 1966) went further to suggest that their immediacy and sense of excitement indicated that Turner had actually executed them during the night of the fire as he watched from the south bank—an opinion that has been repeated by several writers, including Butlin and Joll (1977).

Wilton (in conversation with the author, May 1982) pointed out that for an artist actually to work in watercolor on such a night amid such crowds, and in the half light of the fire, would have been, at best, difficult. Moreover, there is nothing other than Finberg's identification to firmly link these watercolors with the burning of Parliament in 1834, or even to be certain that they date from the 1830s. And the watercolors can only be described with absolute certainty as showing a conflagration of some kind reflected in water; the unmistakable shape of St. Stephen's Chapel, or of Westminster Abbey, both of which appear in the Philadelphia oil, for example, are not definitely shown in this series of watercolors. Turner is thought to have worked directly from nature only rarely, and Wilton considered it more likely that the sketchbook was executed from memory in Turner's studio, when the violent impressions of that night were still fresh. Looked at in this way, the watercolors are, in a sense, Turner's way of thinking through different compositions that resulted in in the two oils.

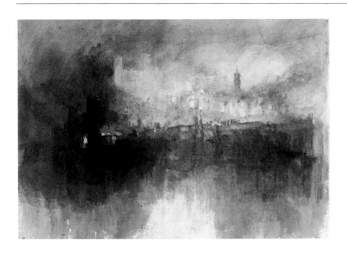

FIG. III-4 J.M.W. Turner, Page 2 from Sketchbook, 1834, watercolor on paper, 9¼ x 12¾″ (23.5 x 32.4 cm.), London, British Museum, Turner Bequest CCLXXXIII-2

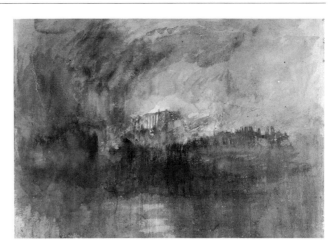

FIG. III-5 J.M.W. Turner, Page 1 from Sketchbook, 1834, watercolor on paper, 9¼ x 12¾″ (23.5 x 32.4 cm.), London, British Museum, Turner Bequest CCLXXXIII-1

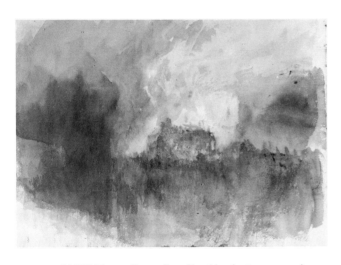

FIG. III-6 J.M.W. Turner, Page 7 from Sketchbook, 1834, watercolor on paper, 9¼ x 12¾″ (23.5 x 32.4 cm.), London, British Museum, Turner Bequest CCLXXXIII-7

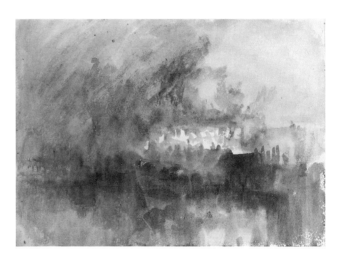

FIG. III-7 J.M.W. Turner, Page 4 from Sketchbook, 1834, watercolor on paper, 9¼ x 12¾″ (23.5 x 32.4 cm.), London, British Museum, Turner Bequest CCLXXXIII-4

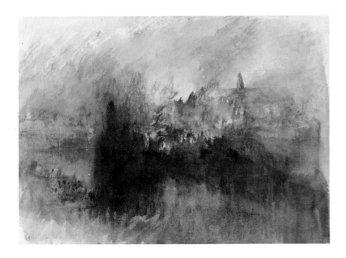

FIG. III-8 J.M.W. Turner, Page 5 from Sketchbook, 1834, watercolor on paper, 9¼ x 12¾″ (23.5 x 32.4 cm.), London, British Museum, Turner Bequest CCLXXXIII-5

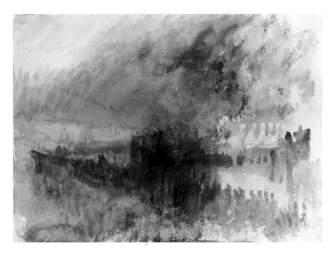

FIG. III-9 J.M.W. Turner, Page 6 from Sketchbook, 1834, watercolor on paper, 9¼ x 12¾″ (23.5 x 32.4 cm.), London, British Museum, Turner Bequest CCLXXXIII-6

Against this, one would argue that the lack of specific detail is just what one would expect in the haste the artist presumably made to catch the transient effects of firelight on water, knowing that topographical detail could be added later. In addition, in one watercolor (fig. III-4) shapes can be made out that look as though they might be intended for the towers of the abbey. A case can be made out for this sketchbook as the product of the artist's walking, over the course of several hours, from Westminster to Waterloo bridges, describing the fire at various stages and at different times during the night. Finally, it is possible that even though the artist did not habitually work from nature, the exceptionally dramatic nature of the events on the night of October 16 would have prompted such an on-the-spot record.

In the following discussion I propose a chronology for the watercolors that would indicate that the artist moved from Westminster Bridge down river to Waterloo Bridge, and that he spent the whole night watching the course of the blaze, at its height, from around half past seven to nine o'clock, to dawn the next morning, when only embers and smoke remained.

The order in which the nine watercolors appear in the sketchbook, where they are numbered from page one to nine, is not necessarily the order in which they were executed. The earliest views may be those on pages 1, 2, and 7 (figs. III-4–6), perhaps showing the conflagration from a viewpoint just to the left of Westminster Bridge on the south bank of the Thames looking directly across to the Palace of Westminster. Closely related to these three watercolors is that on page 4 (fig. III-7), which seems to show the blaze from closer to, in a view taken from an angle slightly to the right of the Houses of Parliament, perhaps from a vantage point on Westminster Bridge, about halfway down. In the watercolor on page 4 the beams and rafters of the buildings are no longer visible, as they are in the view on page 1 (fig. III-5), possibly because the roof of the Houses of Parliament had by this time fallen in, making an even more bulbous and amorphous blaze, and lighting the sky with its flames. Page 4 would, therefore, have been executed after pages 1, 2, and 7. Still related to this this earlier batch of sketches made as the artist milled with the crowds around Westminster Bridge, but harder to place in any precise chronological order, are the views on page 5 and perhaps 6 (figs. III-8 and III-9), in which Turner may have been standing farther back from the bridge, with the south-bank parapet stretching off to the left, crowded with spectators. The pinnacle of the north end of Westminster Hall may be the architectural shape visible above the flames on page 5 (fig. III-8).

The view on page 8 (fig. III-10) is the first in which the artist appears to have moved to the left of Westminster Bridge, with the Houses of Parliament in flames in the center and center left. No structures are visible there at all, making this one of the most difficult watercolors to read, although the abbey may be the form looming in the center distance.

With the watercolor on page 3 (fig. III-11), the artist seems to have moved a considerable distance downstream in the direction of Waterloo Bridge. The conflagration is no longer seen from head on, but has shifted over to the right. Here the dark riverside buildings on the left, which take up three-quarters of the page, contrast with the fire on the right.

Next in order might be page 9 (fig. III-12), where Turner is still downstream, with the Houses of Parliament at the right. A suggestion of gray sky might indicate that the time is now dawn and that the fire is almost out. Red embers are visible, although to the left flames still burn—but more tamely, straight up now, against the gray sky. Black marks at the right of the page are hard to read, but may represent one of the fire-fighting ships, and perhaps the little flicking brushstrokes at the bottom left indicate sprays of water escaping from the hoses.

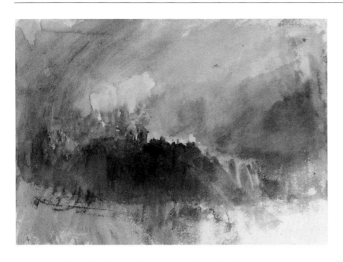

FIG. III-10 J.M.W. Turner, Page 8 from Sketchbook, 1834, watercolor on paper, 9¼ x 12¾" (23.5 x 32.4 cm.), London, British Museum, Turner Bequest CCLXXXIII-8

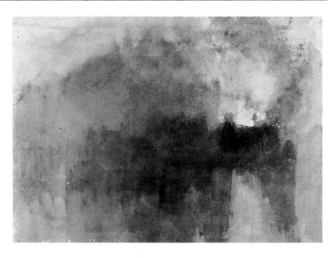

FIG. III-11 J.M.W. Turner, Page 3 from Sketchbook, 1834, watercolor on paper, 9¼ x 12¾" (23.5 x 32.4 cm.), London, British Museum, Turner Bequest CCLXXXIII-3

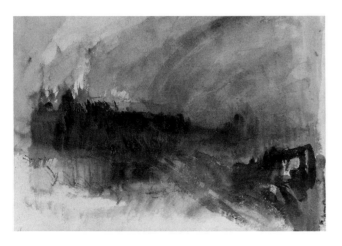

FIG. III-12 J.M.W. Turner, Page 9 from Sketchbook, 1834, watercolor on paper, 9¼ x 12¾" (23.5 x 32.4 cm.), London, British Museum, Turner Bequest CCLXXXIII-9

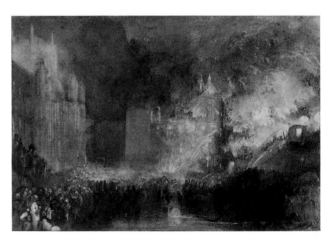

FIG. III-13 J.M.W. Turner, *The Burning of the Houses of Parliament,* 1834, watercolor on paper, 17¾ x 11¾" (45.1 x 29.8 cm.), London, British Museum, Turner Bequest CCCLXIV-373

Given this hypothesis, Turner spent the earlier part of the night near the Westminster Bridge (pages 1, 2, 4, 5, 6, 7) (figs. III-4–9), then worked his way downstream to Waterloo Bridge (pages 3, 8, 9) (figs. III-10–12) after the initial violence of the blaze had abated slightly. If so, these movements correspond to the above proposed chronology of the moments depicted in the Philadelphia and Cleveland pictures. A more finished watercolor in the British Museum showing the fire-fighters in Palace Yard on the Middlesex side of Westminster Bridge (fig. III-13) proves that he crossed the bridge at some point during the evening; and a vignette suggests that he walked down to, or was rowed under, the arches of Westminster Bridge to view the fire from water level (fig. III-14).

However, not one of the British Museum watercolors corresponds to the scene in the Philadelphia picture, nor, for that matter, to the one in Cleveland. As we shall see, the Philadelphia version was painted, or at least finished, to a large extent in public, on varnishing day at the British Institution, but this does not mean that Turner worked entirely by instinct or that the composition had not been fully determined beforehand. It is interesting then, to note that Turner's vision in the Philadelphia painting is closest not to any visual record, whether taken at the scene of the conflagration or worked up in the studio, but to the written account in the *Times* the following morning. This is

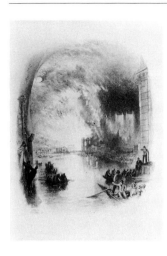

FIG. III-14 J.M.W. Turner, *Destruction of Both Houses of Parliament by Fire, October 16, 1834,* c. 1835, watercolor on paper, 5½ x 4⅜″ (14 x 11 cm.), Englewood, Colorado, Museum of Outdoor Arts

obviously a complicated proposition, because both the *Times* reporter and Turner witnessed the same events from the same viewpoint. Yet, reading the reporter's words and looking at Turner's vision, one is struck by the details both men chose to emphasize. Speaking of the fire around eight or nine o'clock, the *Times* correspondent wrote: "There was an immense pillar of bright clear fire springing up behind it, and a cloud of white, yet dazzling smoke, careering above it, through which as it was parted by the wind, you could occasionally perceive the lantern and pinnacles, by which the building is ornamented. At the same time a shower of fiery particles appeared to be falling upon it with... unceasing rapidity.... Westminster bridge, covered as it was with individuals standing on its balustrades, was a curious spectacle, as the dark masses of individuals formed a striking contrast with the clean white stone of which it is built, and which stood out well and boldly in the clear moonlight."

Likewise, looking at the vignette (fig. III-14) we might almost be viewing an illustration of this reporter's next sentence, a possibility that is particularly striking because none of the British Museum sketches is taken from a point of view under one of the arches of the bridge: "As you approached the bridge you caught a sight through its arches of a motley multitude assembled on the strand below the Speaker's garden, and gazing with intense eagerness on the progress of the flames.... As soon as you shot through the bridge, the whole of this melancholy spectacle stood before you." Or again, when the critic of the *Spectator* complained (February 14, 1835) that the effect in the version now in Philadelphia was one of daylight, Turner could have quoted the *Times* journalist who wrote: "The light reflected from the flames of the fire, as it shone on the Abbey and the buildings in the vicinity, had a most extraordinary effect, and every place in the neighborhood was visible, so that a person could have been enabled to read as in the day time."

The direction in which the wind was blowing on this night is an important consideration in measuring the accuracy of Turner's observation of the scene. Butlin and Joll wrote that the flames actually blew back toward the abbey and not over the river as Turner shows in both of his paintings.[4] The account in *The Gentleman's Magazine* and other journals would tend to confirm this, stating that the wind was blowing due south when the fire broke out but veered soon to the west and continued to blow fresh toward the southwest, thus keeping the flames from Westminster Hall. But according to the *Times,* the wind blew sharp to the northeast at first (the direction they blow in the Philadelphia painting) and "during the whole of this time... immense volumes of fire, sparks, and smoke, poured out... and were carried away in the direction of Westminster-bridge." This is what Turner shows in the Philadelphia oil.

Whether or not Turner made use of the *Times* description, he certainly failed to rely on his watercolor sketches when he came to paint the Philadelphia picture, which he did on one of the varnishing days before the opening of the British Institution in February 1835. Here is the Norfolk artist E. V. Rippingille's (1798?–1859) noteworthy description of Turner at work on *The Burning of the Houses of Lords and Commons:*

Turner was there, and at work before I came, having set-to at the earliest hour allowed. Indeed it was quite necessary to make the best of his time, as the picture when sent in was a mere dab of several colours, and "without form and void", like chaos before the creation... for the three hours I was there—and I understood it had been the same since he began in the morning—he never ceased to work, or even once looked or turned

from the wall on which his picture hung. All lookers-on were amused by the figure Turner exhibited in himself, and the process he was pursuing with his picture. A small box of colours, a few very small brushes, and a vial or two, were at his feet . . . In one part of the mysterious proceedings Turner, who worked almost entirely with his palette knife, was observed to be rolling and spreading a lump of half-transparent stuff over his picture, the size of a finger in length and thickness. . . . Presently the work was finished: Turner gathered his tools together, put them into and shut up the box, and then, with his face still turned to the wall, and at the same distance from it, went sideling off, without speaking a word to anybody, and when he came to the staircase, in the centre of the room, hurried down as fast as he could. All looked with a half-wondering smile, and Maclise, who stood near, remarked, "There, that's masterly, he does not stop to look at his work; he *knows* it is done, and he is off."[5]

Both Gowing and Gage have discussed Turner as a performer, as the artist emphasizing by the execution of his work in public his role as a virtuoso, as the sole genius responsible for the creation of the work of art. Gage has shown that his contemporaries compared the Turner of these varnishing days to the violinist Paganini who was at just this period (1831–34) astounding audiences in England with his virtuoso playing. Gowing further stressed Turner's place as the precursor to the modern idea of art as a performance, a process rather than simply the result hung on the wall.[6]

Lindsay has suggested that *The Burning of the Houses of Lords and Commons* with its apocalyptic overtones may have suggested to Turner, at a time in English history of serious political agitation, the collapse of the political system. Staley has dismissed the suggestion, pointing out that the sheer spectacle of fire reflected in water could have touched no artist's imagination deeper than Turner's.[7] But no Englishman watching the disaster could have failed to have been moved simply by the magnitude of the loss of part of his country's history. Throughout the early evening, it had seemed as though not only the Houses of Lords and Commons but also Westminster Hall would burn. Westminster Hall was the oldest part of Westminster Palace, built by William II Rufus between 1097 and 1099, and rebuilt by Richard II between 1394 and 1399. The significance of Westminster Hall lay in its original use as the meeting place of the king's great council, out of which developed both the royal courts of justice and Parliament itself. The reporter for *The Gentleman's Magazine* (November 1834) summed up his own feelings thus: "St. Stephen's Chapel in flames, with the House of Lords a little further south, and (the sensation which I felt at the sight as an antiquary and a British subject, I shall not easily forget) the gable of Westminster Hall . . . apparently alight . . . I felt as if a link would be burst asunder in my national existence, and that the history of my native land was about to become, by the loss of this silent but existing witness, a dream of dimly shadowed actors and events."

When it was exhibited at the British Institution, in 1835 (no. 58), the painting attracted favorable critical attention. The *Spectator* (February 14) wrote that "Turner's picture transcends its neighbours as the sun eclipses the moon and stars. The burst of light in the body of the flame, and the flood of fiery radiance that forms a luminous atmosphere around all the objects near, cannot be surpassed for truth."[8] However, Thornbury quoted a letter of 1835 from the painter John Scarlett Davis (active 1841) to David Cox's pupil Joseph Murray Ince (1806–1859) saying, "Turner has painted a large picture of the 'Burning of the Houses of Parliament'; but I have heard it spoken of as a failure—a devil of a lot of chrome."[9]

As early as the Royal Academy exhibition of 1792 (no. 472), when he exhibited the watercolor *The Pantheon, the Morning after the Fire* (dated 1792, watercolor over pencil, 15½ x 20½", London, British Museum) showing the ruins of the Pantheon in Oxford Street, Turner showed his interest in recording spectacular current events. Throughout his career he chose topical subjects, which might draw attention to his work in the exhibition simply by the novelty of what they depicted. Examples are *The Battle of Trafalgar* (exhibited Turner's gallery, 1806, 67¼ x 94", London, Tate Gallery) and *Life-Boat and Manby Apparatus Going off to a Stranded Vessel Making Signal (Blue Lights) of Distress* (exhibited R.A. 1831, no. 73, 36 x 48", London, Victoria and Albert Museum).

The Burning of the Houses of Lords and Commons looks forward to and perhaps helped inspire Turner's later interest in effects of fire and water by moonlight. An example exhibited at the Royal Academy in 1835 (no. 24), and therefore contemporary with the two burning of the Houses of Parliament pictures, is *Keelmen Heaving in Coals by Night* (35½ x 48", Washington, D.C., National Gallery of Art).

1. For other views of the fire, see London, Guildhall Art Gallery (Corporation Art Gallery), *1666 and Other London Fires,* August 18–September 16, 1966, nos. 64–69.

2. Gowing in New York, 1966, p. 33.

3. A.J.K., "Conflagration of the Two Houses of Parliament (*with a Plan*)," *The Gentleman's Magazine,* n.s., vol. 2 (November 1834), pp. 477–83.

4. Butlin and Joll, 1977, vol. 1, p. 189; however, see also Butlin and Joll, 1984, vol. 1, p. 208.

5. E. V. Rippingille, "Personal Reminiscences of Great Artists," *The Art Journal,* 1860, p. 100.

6. Gowing in New York, 1966, p. 43; Gage, 1969, pp. 165–72.

7. Lindsay, 1966, pp. 180–81; Philadelphia and Detroit, 1968, p. 196.

8. Quoted by Finberg, 1961, p. 352.

9. Thornbury, 1877, p. 452.

PROVENANCE: Purchased from the British Institution exhibition of 1835 by Chambers Hall; sold by Hall to Mr. Colls; Charles Birch, Westfield House, Edgbaston, by 1852; Lloyd Bros. sale, Foster's, June 13, 1855, lot 59, bt. Wallis; H. Wallis sale, Christie's, November 16, 1860, lot 209, bt. White; C. J. Palmer of Portland Place, London; executors of Palmer sale, Christie's, May 16, 1868, lot 133, bt. Agnew; bt. John Graham; bt. back from him by Agnew, 1873; Holbrook Gaskell of Woolton Wood, Liverpool; Christie's, June 24, 1909, lot 97, bt. Agnew; John H. McFadden.

EXHIBITIONS: London, British Institution, 1835, no. 58; Birmingham, Royal Birmingham Society of Artists, 1852, no. 114 (lent by Charles Birch); London, Royal Academy, 1885, no. 197 (lent by Gaskell); London, Royal Academy, 1907, no. 113 (lent by Gaskell); New York, M. Knoedler and Co., *Old Masters Exhibition,* January 1911; New York, 1917, no. 43, fig. 43; Pittsburgh, 1917, no. 41; Philadelphia, 1928, p. 21; New York, 1966, no. 9; Philadelphia and Detroit, 1968, no. 120; Dresden, Gemäldegalerie Neue Meister, Berlin, Nationalgalerie Staatliche Museen Preussischer Kulturbesitz, *William Turner, 1775–1851,* July–November 1972, no. 18; London, Royal Academy, *Turner, 1775–1851,* November 1974–March 1975, no. 512; Cleveland and Philadelphia, 1984, no. 11.

LITERATURE: E. V. Rippingille, "Personal Recollections of Great Artists," *The Art Journal,* 1860, p. 100; Thornbury, 1877, pp. 313, 452–53?, 582; F. G. Stephens, "The Private Collections of England: No. LXXIX—Allerton, Liverpool," *The Athenaeum,* no. 2,971 (October 4, 1884), p. 438; Bell, 1901, pp. 128–29, no. 199; Armstrong, 1902, vol. 1, pp. 117, 120, 146, 236; Ruskin, 1903–12, vol. 3, p. 423, vol. 12, p. 389; Finberg, 1909, vol. 2, pp. 909–10; Roberts, 1913, p. 542; Roberts, 1917, pp. 85–87; Whitley, 1930, pp. 292–94; Hinks and Royde-Smith, 1930, pp. 123–24, 155, 173, 213, repro. following p. 154; Falk, 1938, pp. 137–38, 157, 250–51; Clare, 1951, pp. 101–2; Finberg, 1961, pp. 351–52, 354?, 499 no. 458; Rothenstein and Butlin, 1964, pp. 48, 50, 54; Alastair Gordon, "Art in the Modern Manner," *The Connoisseur,* vol. 163 (November 1966), p. 186, repro.; Lindsay, 1966, pp. 178–81, 187, 204; New York, 1966, pp. 33, 36, 42, 45,

repro. p. 33; Gage, 1969, p. 73 fig. 11, 117, 169; Reynolds, 1969, pp. 164–65; Kenneth Clark, *The Romantic Rebellion: Romantic versus Classic Art* (London, 1973), p. 256, repro. p. 257; Staley, 1974, p. 36; Herrmann, 1975, pp. 41–42, pl. 141; M. H. Port, ed., *The Houses of Parliament* (New Haven and London, 1976), pp. 249 pl. XI, 268; Butlin and Joll, 1977, vol. 1, pp. x, xii, 193, 188, no. 359, pp. 189–91, 195, 257, vol. 2, pl. 338; Wilton, 1979, *Turner,* pp. 199 fig. 215, 281 no. P359; Butlin and Joll, 1984, vol. 1, no. 359, pp. 207–10, vol. 2, pl. 364.

CONDITION NOTES: The original support is medium-weight (16 x 16 threads/cm.) linen. The tacking margins have been removed. The painting was wax-resin lined with medium-weight linen (Siegl, 1966). At least two previous aqueous linings were retained. An off-white ground is visible at the cut edges. The paint is in fairly good condition. A severe, active cleavage problem was treated in 1982. A fine web of fracture crackle extends over most of the surface. Traction crackle is evident in the darkest tones of the foreground. The painting was cleaned in 1966. Numerous small losses are visible with infrared reflectography examination. Under ultraviolet light, inpaints are evident along all four edges and in the lower right corner. Inpaints in traction crackle at the extreme left in the highlights of the flames appear in normal light to have darkened in relation to the surrounding paint. The overall condition is fair; while the paint retains much of its texture and resinous quality, the incipient cleavage problem is of a longstanding and serious nature.

RELATED WORKS

1. J.M.W. Turner, *The Burning of the Houses of Lords and Commons, October 16, 1834,* exhibited 1835, oil on canvas, 36½ x 48½" (92.7 x 123 cm.), Cleveland, The Cleveland Museum of Art, Bequest of John L. Severance (fig. III-1).

PROVENANCE: Bt. from the artist by J. G. Marshall of Headingly, Leeds; Christie's, April 28, 1888, lot 32, bt. in and then by descent in the Marshall family through Victor Marshall of Mark Coniston, Lancashire, to James Marshall; M. Knoedler and Co.; bt. from Knoedler by John L. Severance, 1922, and bequeathed by him to the museum, 1936.

EXHIBITIONS: London, Royal Academy, 1835, no. 294; London, British Institution, 1836, no. 69; Leeds, *National Exhibition of Works of Art, Section 2, British Deceased Painters in Oil,* 1868; London, Royal Academy, 1883, no. 215; Cleveland, The Cleveland Museum of Art, *Twentieth Anniversary Exhibition,* 1936, no. 249; Cleveland, The Cleveland Museum of Art, *Severance Collection,* 1942, no. 16; Boston, Museum of Fine Arts, *An Exhibition of Paintings, Drawings, and Prints by J.M.W. Turner, John Constable, R. P. Bonington,* March–April 1946, no. 11; Toronto and Ottawa, 1951, no. 9; Indianapolis, Indiana, John Herron Museum, *Turner in America,* November–December 1955, no. 38; London, Tate Gallery (Council of Europe and Arts Council Gallery), *The Romantic Movement,* July–September 1959, no. 353; Cleveland and Philadelphia, 1984, no. 12.

LITERATURE: Ruskin, 1903–12, vol. 2, p. 423, vol. 12, p. 389; Butlin and Joll, 1977, vol. 1, no. 364; Butlin and Joll, 1984, vol. 1, no. 364 (with bibliography).

2. J.M.W. Turner, *Destruction of Both Houses of Parliament by Fire, October 16, 1834,* c. 1835, watercolor on paper, 5½ x 4⅜" (14 x 11 cm.), Englewood, Colorado, Museum of Outdoor Arts (fig. III-14).

PROVENANCE: Agnew, 1982.

DESCRIPTION: A finished vignette showing the fire from under the arches of Westminster Bridge, which is not directly related to either the Philadelphia or Cleveland versions in oil or the studies in watercolor.

3. J.M.W. Turner, *The Burning of the Houses of Parliament,* 1834, watercolor on paper, 17¾ x 11¾" (45.1 x 29.8 cm.), London, British Museum, Turner Bequest CCCLXIV-373 (fig. III-13).

DESCRIPTION: A large, finished watercolor showing the conflagration from Palace Yard on the Middlesex side of the Thames, with crowds of onlookers. It is directly related neither to the Philadelphia nor to the Cleveland picture.

4. J.M.W. Turner, Sketchbook, 1834, nine watercolors on paper, 9¼ x 12¾" (23.5 x 32.4 cm.), London, British Museum, Turner Bequest CCLXXXIII (figs. III-4–12).

5. J.M.W. Turner, Sketchbook, c. 1834?, pencil on paper, 4 x 6" (10.2 x 15.2 cm.), London, British Museum, Turner Bequest CCLXXXIV.

LITERATURE: Finberg, 1909, vol. 2, pp. 909–10, 1,207; Cleveland and Philadelphia, 1984, p. 43.

DESCRIPTION: The pencil studies in the small sketchbook are too slight to confirm that they represent either the Houses of Parliament or a fire.

6. After J.M.W. Turner, *The Burning of the Houses of Parliament,* oil on canvas, 19¾ x 23½" (50.2 x 59.7 cm.), location unknown. Photograph: London, Witt Library.

PROVENANCE: Formerly with Sedelmeyer, Paris.

LITERATURE: Butlin and Joll, 1977, vol. 1, p. 191; Butlin and Joll, 1984, vol. 1, p. 210.

DESCRIPTION: Pastiche after the Philadelphia version.

7. After J.M.W. Turner, *The Burning of the Houses of Parliament,* oil on panel, 5½ x 7½" (14 x 19 cm.), Upperville, Virginia, Paul Mellon Collection.

EXHIBITION: Washington, D.C., National Gallery of Art, *J.M.W. Turner: A Selection from the Collection of Mr. and Mrs. Paul Mellon,* October 1968–April 1969, no. 12.

LITERATURE: Butlin and Joll, 1977, vol. 1, p. 191; Butlin and Joll, 1984, vol. 1, p. 210.

DESCRIPTION: Pastiche after the Philadelphia version.

Frederick William Watts lived in Hampstead all his life, the close neighbor of John Constable (q.v.) during the 1820s and 1830s. Even during Constable's lifetime the work of the two men was sometimes confused, though there is no proof that Watts ever painted in Suffolk or ever exhibited a Suffolk subject. A letter from Watts dated 1859, which is preserved in the Tate Gallery, describes his working methods. Writing of a picture of his, a lock scene, he noted: "It is composed from Sketches. on the River Itchin between Winchester & Southampton In fact. but few of my Landscapes are. actual views therefore I doubt. if I saw the picture I could give it a place [?it is] no doubt much altered—It is in fact more the character of the Country generally The latter picture I know is composed from Sketches in my possession no actual View In fact. Lee & Creswick paint but seldom real scenes their pictures are generally Composition."[1] Watts exhibited mainly at the British Institution between 1823 and 1862 and also at the Royal Academy between 1821 and 1860.

1. Quoted by Leslie Parris, in London, 1976, p. 194.

112 FREDERICK WATTS

LANDSCAPE WITH RIVER AND BOATS, 1840
Oil on canvas, 25⅛ x 30⅜″ (64.5 x 77.1 cm.)
Inscribed on the railing: *F. Watts Pintx 1840*
The William L. Elkins Collection, E24-3-41

This painting is presumably the "River Scene" exhibited by F. W. Watts at the Royal Academy in 1840 (no. 454). On the evidence of a Royal Academy exhibition label pasted onto the stretcher, in the 1870s it belonged to the portrait painter, miniaturist, engraver, and Academician Lumb Stocks (1812–1892) when it was attributed to John Sell Cotman (1782–1842).[1] However, on the only occasion when this landscape is confirmed as having been exhibited at the Royal Academy, in 1878, the catalogue of the exhibition of old masters listed the owner as a Frederick Piercy, in whose sale the picture appeared in 1884. Stocks may either have sold the picture to Piercy just before the 1878 exhibition, or perhaps he was simply a restorer or framer acting on

FIG. 112-1 Detail of *Landscape with River and Boats* showing signature

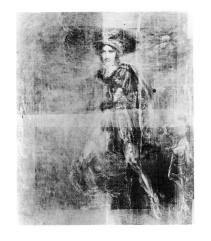

FIG. 112-2 X-radiograph of *Landscape with River and Boats*, Philadelphia Museum of Art, Conservation Department, 1980

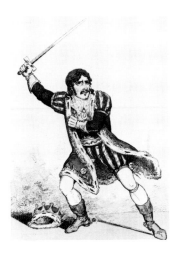

FIG. 112-3 J. R. Cruikshank, *Mr. Kean in the Character of Richard III*, engraving

Piercy's behalf. The picture acquired its attribution to Cotman as early as the exhibition of 1878 and retained it until the discovery in the 1960s of the Watts signature on the railing (fig. 112-1). There is no reason to doubt the authenticity of this signature or of Watts's authorship, though the painting is a far cry from Watts's usually more poetic and fluent landscapes.

X-radiographs of it taken in 1980 reveal a full-length theatrical portrait, probably by another hand, on top of which Watts painted his landscape (fig. 112-2). This shows Edmund Kean (1787–1833) in the character of Shakespeare's Richard III, as a comparison with contemporary prints confirms (see fig. 112-3). The date of the actor's popular success was about 1814. Attributions made on the basis of x-radiographs are at best tentative; but Geoffrey Ashton has suggested the name of John Boaden (d. 1839), an artist who specialized in small-scale theatrical portraits. Comparison of our x-radiograph with Boaden's portrait of *Thomas Potter Cooke as Roderick Dhu in "The Lady of the Lake"* (27½ x 20″), in the Somerset Maugham collection of theatrical paintings, strengthens the attribution; the small scale and lively pose suggest Boaden's work.[2] However, no portrait by Boaden or print after Boaden showing Kean as Richard III has come to light nor were any among the portraits exhibited by him either at the Royal Academy or British Institution. Boaden exhibited at the Royal Academy from 1810 to 1833 and the British Institution from 1810 to 1839. His first theatrical portrait showed *Miss Booth in the Character of Puck* (exhibited R.A. 1816, no. 1,133). His address then was given in the Royal Academy catalogue as 60 Warren Street, Fitzroy Square.

1. The label gives Stocks's address as 12 Orchard Villas, Holloway. According to the postal directory *Kelly's Highgate, Holloway, and Tufnell Park* (London, 1888–89), Lumb Stocks then lived at 9 Richmond Villas, Holloway, off the Seven Sisters Road. Presumably Orchard Villas was an earlier address.

2. Raymond Mander and Joe Mitchenson, *Guide to the Maugham Collection of Theatrical Paintings* (London, 1980), no. 70. Other examples are *S. Drummond* (exhibited R.A. 1814, no. 315); *J. J. Halls* (exhibited R.A. 1815, no. 189); *Miss S. E. Reynolds* (exhibited R.A. 1822, no. 779); and *J. W. Gear* (exhibited R.A. 1822, no. 718). The miniaturist Walter Henry Watts (1776/84–1842) painted a portrait of Edmund Kean in the character of *Shylock Holding a Knife* (engraved by H. Meyer, mezzotint, 1814). It would be tempting to link this Watts both with the portrait of Kean and the landscape on top of it, but the landscape is unmistakably signed *F. Watts*.

INSCRIPTION: *EXHIBITION OF WORKS OF THE OLD MASTERS 187* [illegible] [?]*12 St*[?]*ck Orchard Villas Holloway* [on a Royal Academy exhibition label pasted onto the stretcher]; the remains of what may have been a red wax French customs stamp; *N03202* [stenciled in black on the back of the canvas].

PROVENANCE: Possibly Lumb Stocks, Royal Academician; Frederick Piercy, by 1878; his sale ("The Property of an Amateur"), Christie's, January 19, 1884, lot 118 (as "Noon" by John Sell Cotman); bt. M. Coe; William L. Elkins, by 1900.

EXHIBITIONS: Presumably London, Royal Academy, 1840, no. 454 (as "River Scene" by F. W. Watts, High Street Hampstead); London, Royal Academy, *Exhibition of Old Masters,* winter 1878, no. 37 (as "Landscape: Mid-Day" by J. S. Cotman, lent by Piercy); Iowa City, Iowa, University of Iowa Gallery of Art, *Impressionism and Its Roots,* 1964, no. 5, repro. p. 19 (as by John Sell Cotman).

LITERATURE: Elkins, 1887–1900, vol. 2, no. 57, repro. (as by John Sell Cotman).

CONDITION NOTES: The original support is medium-weight (14 x 14 threads/cm.) linen. The tacking margins have been removed. The painting is lined with an aqueous adhesive and medium-weight linen. An off-white ground is present, evident along the cut edges. The paint is in only fair condition. A variable-size web of fracture crackle with slight, associated cupping is present overall. A wide traction crackle is evident in the foliage along the riverbank above the barges. A red oil paint is evident within the traction fissures and belongs to a portrait that underlies the present landscape. Radiographic and infrared examinations reveal the figure underneath to be a man in theatrical costume (fig. 112-2). Retouches, visible in ultraviolet light, are present over traction crackle along the horizon line, in the sky, and in a large, round loss located right of center in the foliage.

Print-maker, decorator, portrait, history, genre, and landscape painter, Francis Wheatley was an artistic jack-of-all-trades, able to adapt to and therefore reflect changing public tastes in the last quarter of the eighteenth century. He was born the son of a Covent Garden tailor in 1747, and, although he worked under two (now forgotten) artists, Daniel Fournier (1710–1766) and William Shipley (1714–1803), he was basically self-taught. He won his first premium at the Society of Arts in 1762, and the following year traveled abroad—probably to the Low Countries and to Paris where, in the Salon, he could have seen paintings by Boucher (1703–1770), Lagrenée (1739–1821), Claude Joseph Vernet (1714–1789), and especially Greuze (1725–1805), whose *La Piété Filiale* of that year would deeply influence the formation of his art. By 1769 he was a student at the Royal Academy, but from September 1770 until 1777 he exhibited exclusively at the Society of Arts, whose director he became in 1774.

During his early years, both Wheatley's portrait style and the course of his career were affected by his friendship with John Hamilton Mortimer (1741–1779). Wheatley imitated his friend's formulas for the informal conversation piece—small scale, middle class, a direct continuation of the tradition of Francis Hayman (1708–1776) and early Dance (q.v.)—the opposite of the great style of Reynolds or Romney (q.q.v.). Mortimer introduced Wheatley to the proprietor of the Vauxhall Pleasure Gardens, who commissioned a picture of a large waterfall, which was then illuminated as part of the decorations of the gardens (March 1771). From 1771 to 1773, together with Mortimer, Wheatley worked on the decoration of the ceiling of the saloon at Brocket Hall for Peniston Lamb, 1st Viscount Melbourne (1748–1819). This commission led to Wheatley's decoration of Lord Melbourne's town house in Piccadilly.

Wheatley's versatility is astonishing, for he was able to succeed in imaginary rococo landscapes in the style of Gainsborough (q.v.), such as *The Harvest Wagon* of 1774 (50½ x 40″, Nottingham, Castle Museum and Art Gallery), straightforward topographical views in the manner of Sandby (q.v.) (such as *The Medway at Rochester*, 1776, 21¾ x 31″, Upperville, Virginia, Paul Mellon Collection), or the theatrical conversation piece, deeply influenced by Zoffany (1733–1810) (such as *The Duel from Twelfth Night*, 1772, 40 x 50″, Manchester, City Art Gallery). All were painted in strong, light colors, with a feeling for the solidity of forms and the careful delineation of textures and fabrics.

Wheatley was apparently a success in London in the 1770s, but in 1779, fleeing from a combination of unpaid debts and an irate husband, he set up in Dublin and there re-created his London success with two vast paintings of contemporary political events—*A View of College Green with a Meeting of the Volunteers* (1779, 72 x 128″, Dublin, National Gallery) and the *Irish House of Commons* (1780, 64 x 85″, Leeds, City Art Gallery). Both contained scores of portraits of the Irish political, social, and military elite, and, through contacts with these men, he gained favor with Irish Protestant families who commissioned individual and group portraits. At the same time he continued to paint landscapes, developing a more natural, less dense style, a softening and blanching of color, and a greater facility in the placement of his figures within the landscape. An example of his Irish landscape style is *Salmon Leap at Leixlip with Nymphs Bathing* of 1783 (26⅛ x 25½″, Upperville, Virginia, Paul Mellon Collection).

Several of his Irish history pictures were engraved, and this led Wheatley, particularly after his return to London at the end of 1783, and with his introduction to the printseller Alderman Boydell, to concentrate on the then-fashionable subject paintings that could be engraved and sold easily. A

picture painted specifically to be engraved need not be highly finished, since much of the finish can be translated into another medium only by the most highly skilled engraver. Thus, in Wheatley's late works, brushstrokes are much freer, landscape more sketchy, expression kept to a minimum, and gesture allowed to carry the burden of the narrative. Wheatley, like William Hamilton (1751–1801), and even Henry Fuseli (1741–1825) (to name but two of the artists who were most successfully employed by Boydell), painted with the engraving in mind. In pictures by these artists of the "mezzotint school" it was the composition of the picture and not the execution that really counted. The ability to convey the essence of a story or a scene sparely, dramatically, and affectingly took precedence over anything else—whether color, subtlety of the emotions portrayed, or complexity of technique.

Mary Webster has divided Wheatley's prints, almost all of which date from the 1780s or 1790s, into scenes from literature, bourgeois life, and fancy pictures, but somehow Wheatley had the ability to transform whatever he depicted, whether *Saint Preux and Julia* (1785, pen and wash, 20½ x 14¾", London, British Museum) or *The Brickmakers* (exhibited R.A. 1786, no. 194, 16 x 23½", location unknown) into pictures with precisely the same tepid emotional temperature.

His most famous works are *The Cries of London*. These were originally fourteen small paintings, showing the street calls of itinerant London traders, exhibited at the Royal Academy between 1792 and 1795. Twelve prints after them were published between 1793 and 1794, a thirteenth in 1797, and the last in 1927. They show impossibly pretty, sentimentalized lads and lasses, the urban equivalent of shepherds and shepherdesses, capitalizations on the late eighteenth-century vogue for the pastoral applied to the city. Each scene so completely minimizes narrative, expression, gesture, and even color, that the set as a whole is closer to a pack of playing cards than to conventional decorative prints.

By contrast, Wheatley's paintings for Boydell's Shakespeare Gallery, scenes from *A Midsummer Night's Dream, The Taming of the Shrew*, and *The Winter's Tale* work successfully as narratives while retaining Wheatley's undoubted period charm. He was well known through his work for Boydell, and prints after his work were perhaps more popular than those of any other eighteenth-century artist except Morland (q.v.); he had been elected an Associate of the Royal Academy in 1790 and full Academician in 1791; and yet Wheatley had serious financial problems throughout the 1790s. He died, crippled and in debt, on June 28, 1801. His widow, Clara Maria Leigh, whom he married before 1788, was a flower painter who exhibited under her second husband's name, as Clara Maria Pope (d. 1838).

BIBLIOGRAPHY: Roberts, 1910; Mary Webster, *Francis Wheatley* (London, 1970).

EXHIBITIONS: Aldeburgh, Aldeburgh Festival of Music and the Arts, Leeds, City Art Gallery (in association with the Paul Mellon Foundation for British Art), *Francis Wheatley R.A., 1747–1801*, June–August 1965 (by Mary Webster).

113 FRANCIS WHEATLEY

THE FISHERMAN'S RETURN, C. 1790
Oil on canvas, 18 x 22⅛" (45.7 x 56.2 cm.)
Inscribed lower right on the boat: *F. Wheatley Pinxt 1790*
The William L. Elkins Collection, E24-3-85

The Fisherman's Return is a companion to Wheatley's *Fisherman's Departure,*
which shows a group of six figures, three of them children, in front of a rustic
cottage by the river or sea, with a young boy hoisting the sail for the
departure (see related work). The Philadelphia painting and the print after it
are identical, except that the head of the figure on the right, whose face has
been clumsily repainted in the Philadelphia picture, is shown turned away
from the spectator in the print.

 The Fisherman's Return and its companion are fancy pictures, or "genre
pictures of sentimental realism," as Mary Webster described the mode. In *The
Fisherman's Return,* a father has come home from his day's work apparently
empty-handed, disappointing his wife and two small, and perhaps hungry,
children. But everyone appears to be healthy and cheerful: the rural poor are
shown to be clean (washing on the line) and warm (smoke from the chimney)
and (because they are seen to work) honest. This is precisely the image of the

peasantry that would not offend a middle-class buyer of prints, and the picture was painted with such a client in mind. Its first recorded owner, and the man who certainly commissioned the pair of pictures (as well as paying J. Barney to engrave them),[1] was Thomas Macklin (d. 1800), whose Poets' Gallery in Pall Mall was begun in 1787, and whose illustrated Bible was published in 1800.[2]

The style of this painting is loose and a bit slapdash, characteristic of many of Wheatley's late paintings intended for engraving and very different from the more solid delineation of form typical of his earlier periods.

1. *The Monthly Magazine*, vol. 2 (March 1, 1801), p. 155.
2. T.S.R. Boase, "Macklin and Bowyer," *Journal of the Warburg and Courtauld Institutes*, vol. 26 (1963), pp. 148–77.

PROVENANCE: Thomas Macklin; his sale, Peter Coxe, Burrell and Foster, May 5, 1800, lot 14; William Wells of Redleaf, Kent; Christie's, May 10, 1890, lot 80, bt. Agnew; M. Knoedler and Co.; William L. Elkins.

LITERATURE: *The Monthly Magazine*, vol. 2 (March 1, 1801), p. 155; Roberts, 1910, pp. 16, 23, 46; Mary Webster, *Francis Wheatley* (London, 1970), p. 151, no. 110, repro.

CONDITION NOTES: The original support is medium-weight (12 x 12 threads/cm.) linen. The painting was relined with a wax-resin adhesive and double-thread, primed linen in 1968. An earlier aqueous adhesive lining was retained. A white ground is present and extends uniformly onto the tacking margins. The paint is generally in only fair condition. Much of the original brushwork profile has been flattened by lining. An irregular web of wide-aperture fracture crackle with severe, associated cupping is present overall. There are numerous small losses overall. Underdrawing is visible in normal light in the outline of most of the figures, suggesting a thin, rapid execution of the composition. Under ultraviolet light, retouches can be seen in the two figures on the right and around the hanging wash at the extreme left.

ENGRAVING: J. Barney, *The Fisherman's Return*, engraving, 17½ x 21½" (44.5 x 54.6 cm.).
INSCRIPTION: *Wheatley RA pinx / J. Barney sculpt.*
LITERATURE: Roberts, 1910, p. 46; Mary Webster, *Francis Wheatley* (London, 1970), p. 189, no. E171.

RELATED WORK: Francis Wheatley, *The Fisherman's Departure*, oil on canvas, 18 x 22¼" (45.7 x 56.5 cm.), location unknown.
PROVENANCE: American Art Association, New York, February 10–11, 1919, lot 5, bt. Scott and Fowles.
ENGRAVING: J. Barney, *The Fisherman's Departure*, engraving, 17½ x 22½" (44.5 x 54.6 cm.).
INSCRIPTION: *F. Wheatley RA pinx / J. Barney sculpt.*

Benjamin Wilson was born in Leeds, the fourteenth child of a rich clothier or wool merchant named Major Wilson. Educated at Leeds Grammar School, he was first exposed to the company of artists as a child when his father commissioned the itinerant French artist Jacques Parmentier (1658–1730) to paint frescoes on the walls and ceilings of his house on Mill Hill (today, City Square, Leeds). Before the age of about fifteen, Wilson apprenticed himself for one year to another Frenchman, Longueville (otherwise unrecorded), then working on murals for the house of Thomas Lister, Member of Parliament for Gisburne-in-Craven near Leeds.

When his father's business failed, Wilson was sent to London, more or less penniless, to fend for himself. He found employment as a clerk, first in the Prerogative Court in Doctor's Commons, where he stayed about four years, then as a clerk in the Charter House Registrar. By saving his money, he freed himself to devote time to his earliest interest, painting, and so was drawn into the circle of Hogarth (q.v.), Thomas Hudson (1701–1779), Gravelot (1699–1773), and Francis Hayman (1708–1776) at the St. Martin's Lane Academy in the early 1740s. Apparently he spent some time in Hudson's studio before 1746, although his life at this period is poorly documented.

What is certain is that in August 1746 he spent three weeks in Ireland, then returned to Dublin for two years from 1748 to 1750 on the advice of the president of the Royal Society Martin Ffolkes (1690–1754), who told him that "early works painted there would not appear against him [in England] and that . . . he would start here with a fuller mastery of his pencil and better chances of success."[1]

In 1750 he returned to London to set up a studio in Great Queen Street, Lincoln's Inn Fields, in a house previously occupied by Sir Godfrey Kneller (q.v.) and next door but one to Thomas Hudson's house. His first patrons included Ffolkes, the Earl of Orrery, Lord Chesterfield, and David Garrick; and soon, according to his own memoirs, published by his son's nephew in 1862, "the greatest personages of the world of fashion visited his studio, and he made by his art 1,500 l. a year."[2]

Wilson's success in London was indeed phenomenal. He made his name not only as a portraitist but as a painter of candle-lit theatrical conversation pieces such as *Garrick as Romeo and Miss Bellamy as Juliette in the Tomb Scene*, of 1753 (London, Old Vic Theatre) and *Lady Stanhope as Callista in "The Fair Penitent"* (1772, Agnew, in 1981). Many of the history pictures mentioned in his memoirs are untraced: *Belshazzar's Feast* (c. 1762–76), *Clive Enthroning Meer Jaffier* (c. 1766). His *Raising of Jarius's Daughter* (exhibited R.A. 1783, no. 135, formerly Leeds Infirmary) has been destroyed. By 1757 Wilson could reject Hogarth's offer of a partnership, and as late as 1759 a contemporary inspecting Sir Joshua Reynolds's (q.v.) studio declared that a portrait there was "charming, almost as well as Wilson could have done."[3] He was also well known as an etcher and engraver, and notorious as a political caricaturist (such as "The Repeal; or the Funeral Procession of Miss Americ-Stamp," a satire upon the ministry who supported the repeal of the Stamp Act). In 1760 and 1761 he exhibited five portraits at the Society of Artists in Spring Gardens, and in 1783 he exhibited for the only time at the Royal Academy, his *Raising of Jarius's Daughter*.

In 1766 Wilson speculated and lost on the stock exchange, and as a result seems to have spent some months in prison. But his luck changed in the same year when he was introduced to the Duke of York, who put him in charge of the amateur theatricals presented in the duke's private theater in Pimlico. Through the duke's influence, he was appointed Master Painter to the Board

of Ordonnance in 1767,[4] a sinecure that brought him the huge income of four thousand pounds a year with few duties, and so enabled him to pursue his interest in scientific experiments.

This interest had developed from his earliest London days alongside his career as an artist. Then he formed a resolution to "know something of everything." To achieve this he systematically read through the leading periodicals and novels of his day as well as historical and literary classics. His taste for science led him to experiment in electricity, then a fashionable hobby, and by 1746, at the age of twenty-five, he published "An Essay towards and Explication of the Phaenomena of Electricity," which led to his advocacy of the rounded lightning rod in a controversy with Benjamin Franklin, who held the theory that pointed rods were more effective (see no. 10).

With his dual interest in science and art he might have been expected to appeal to George III, and this was the case, although they met only in 1776, when the king (after he had carefully ascertained that this was not Richard Wilson [q.v.], whose landscapes he disliked) treated Wilson with marked favor, although he did not commission a portrait. Wilson married in 1771 a Miss Hetherington and had seven children. After about 1773, he more or less stopped painting. He died on June 6, 1788, in his house at 56 Great Russell Street.

His memoirs say very little about his work on individual paintings, although he did tell George III that he "never made sketches or drawings for his pictures, but painted them on the canvas at once; that before he attempted anything he settled the plan and conduct of the whole in his mind as to composition, light, shade, etc."[5] In his earliest period, in London and Dublin in the 1740s, his style is almost indistinguishable from his master's, Hudson. However, in the early 1750s he developed a new style based on the heavy use of chiaroscuro, which led *The London Magazine* of 1752 to compare him to Rembrandt.[6] Painting in this way he was a pioneer in the theatrical conversation piece, which his apprentice (from 1760 to 1762) Johann Zoffany (1733–1810) brought to perfection in the 1760s.

1. Randolph, 1862, p. 9.
2. "Life of General Sir Robert Wilson, from Autobiographical Memoirs, Journals, Narratives, Correspondence, &c.," *The Athenaeum,* January 31, 1863, p. 150.
3. Letter from John West to Viscount Nuneham of 1759, quoted by Whitley, 1928, vol. 1, p. 154.
4. E[dward] I[rving] C[arlyle], *Dictionary of National Biography,* s.v. "Wilson, Benjamin."
5. Randolph, 1862, p. 30.
6. Hulton, 1947, p. 14; Whitley, 1928, vol. 1, p. 154.

BIBLIOGRAPHY: Edwards, 1808, pp. 145–50; Randolph, 1862, pp. 3–41; "Life of General Sir Robert Wilson," *The Athenaeum,* January 31, 1863, pp. 150–52; E[dward] I[rving] C[arlyle], *Dictionary of National Biography,* s.v. "Wilson, Benjamin"; Hulton, 1947, pp. 10–14; Waterhouse, 1953, pp. 228–29.

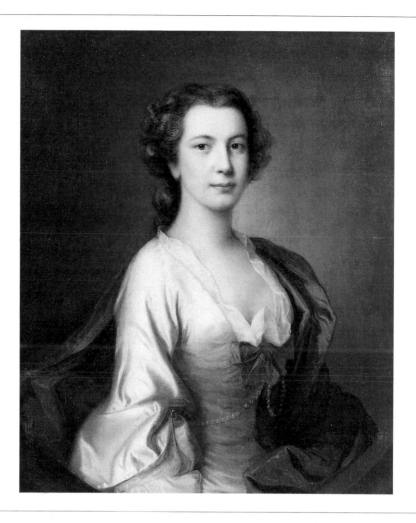

114 ATTRIBUTED TO BENJAMIN WILSON *PORTRAIT OF A LADY,* c. 1745–50
Oil on canvas, 29⅞ x 25″ (75.9 x 63.5 cm.)
Gift of Sol M. Flock, 66-121-1

This portrait came to the Philadelphia Museum of Art as the work of the
Scots artist Allan Ramsay (1713–1784), but was reattributed to Thomas
Hudson (1701–1779) on the basis of the style, the composition, and the
inscription on the reverse. The composition, including the pose and costume,
is certainly very similar to Hudson's work in the 1740s, for example, his
portraits of *Mrs. Lambard* (1742, 50 x 40″, London, The Draper's Company)[1]
and *Mrs. Champernoune* (c. 1747, 49¾ x 40″, private collection),[2] and
particularly to his portrait of *Susannah Maria Cibber* in the National Portrait
Gallery, London (c. 1749?, 30 x 24¾″). However, Ellen G. Miles, on the basis
of a photograph, has suggested that the technique here is quite different from
Hudson's, who laid on paint with brushstrokes that follow the contours of the
face and drapery and loaded his brush with wetter, thicker oil paint than is the
case here. She has proposed Benjamin Wilson as the artist, who is said to have
studied with Hudson in the 1740s, and whose documented early works do
depend directly on the example of Hudson.[3] A comparison of this portrait

with Wilson's signed and dated portrait of *Judge Christopher Robinson* (1750, 29½ x 24½", Leeds, City Art Gallery) confirms the attribution. Wilson's work differs from Hudson's in that the outlines are more vague, the focus softer, particularly around the hair, giving the portrait a slightly fuzzy quality. His handling of paint is flatter, less robust than Hudson's, and the draftsmanship is less searching, more bland, as we might expect from a close imitator or studio assistant. The identity of the sitter (possibly a Mrs. Lyke, as inscribed on the relined canvas) has not so far been determined.

1. Kenwood, The Iveagh Bequest, *Thomas Hudson, 1701–1779; Portrait Painter and Collector: A Bicentenary Exhibition,* July–September 1979, no. II, repro. (introduction by Ellen G. Miles, catalogue by Jacob Simon).
2. Ibid., no. 29, repro.
3. Letter to the author, October 19, 1979.

INSCRIPTION: *Hudson* [on the stretcher]; *Mrs. Lyke* [in pencil on the back of the relined canvas].

PROVENANCE: Knox sale, Parke-Bernet, New York, February 28–March 1, 1945, lot 164, repro. (as by Allan Ramsay, 30 x 15", "Lyke").

CONDITION NOTES: The original support is medium-weight (18 x 18 threads/cm.) linen. The tacking margins have been removed. The painting is lined with an aged aqueous adhesive and loosely woven, medium-weight linen. A white ground is present, evident along the cut edges. The paint is in good condition. The low relief of the paint profile and most of the brush marking generally have been preserved. Some abrasion has occurred throughout and is most evident in the mid-tones and shadow tones of the figure and the dress. Under ultraviolet light, retouches are apparent only in small losses at the left of the figure's head.

Although he drew directly from nature to learn the grammar of his art, Richard Wilson's paintings never betray an interest in mere description. One of his students, Joseph Farington (1747–1821), wrote: "Wherever Wilson studied it was to nature that he principally referred. His admiration of the pictures of Claude could not be exceeded, but he contemplated those excellent works and compared them with what he saw in nature to refine his feeling and make his observations more exact; but he still felt independently without suffering his own genuine impressions to be weakened."[1]

Richard Wilson is one of the supreme masters of the art of landscape painting in Britain. As early as 1811 Robert Archer called him "the founder of an English School of landscape painting";[2] Ruskin, speaking in 1883, perceived that with Wilson "the history of sincere landscape art, founded on a meditative love of nature, begins in England";[3] and in this century Waterhouse pointed to Wilson as the first artist who "charged the 'landscape' in Britain with the values of an independent work of art."[4]

Wilson was born in Wales, in Penegoes, Montgomeryshire, in 1713, one of seven children. From his father, a clergyman, he gained a superb education in the classics, and men who knew him in later life such as James Northcote (1746–1831), Beechey (q.v.), and the collector Benjamin Booth (1732–1807) all remarked on his erudition and the refinement of his mind.[5] The Wilsons were a middle-class, well-connected family, and under the patronage of a relation, Sir George Wynne, Richard was sent to London at sixteen to study under a now-forgotten portrait painter and copyist, Thomas Wright. For twenty-one years, from 1729 until his departure for Italy in 1750, Wilson carved out a career for himself in London as a portrait painter. The surviving portraits by his hand are at least as accomplished as those by any other limner working in London in the 1740s, and the evidence of his address from 1747 to 1750 (the former house in Covent Garden Market of the successful marine painter Samuel Scott [c. 1702–1772]) and Nolleken's contemporary description of the fine clothes Wilson sported when he attended the St. Martin's Lane Academy indicate that he prospered.[6]

Invited to donate two paintings to the Foundling Hospital in 1746, however, Wilson submitted not portraits but landscape views of two London hospitals in the topographical style of George Lambert (1710–1765). These, together with two versions of *View of the Thames: Westminster Bridge under Construction* (no. 115 and fig. 115-1), *A View of Dover* (c. 1746–47, 11 x 21½″, New Haven, Yale Center for British Art), and *The Hall of the Inner Temple after the Fire of January 4, 1736/7* (1737, 25⅝ x 37½″, London, Tate Gallery), are among the relatively rare landscapes painted before his seven-year visit to Italy.

In the autumn of 1750, at the age of thirty-seven, Wilson set out for Venice. There he stayed for about a year, meeting Consul Joseph Smith (1682–1770), patron of Canaletto (1697–1768), executing a few portraits, studying the paintings of Titian (c. 1487/90–1576), and making friends with the highly successful Venetian landscape painter Francesco Zuccarelli (1702–1788), whose portrait by Wilson is now in the Tate Gallery. He saw, too, the works of other contemporary Venetians, Giuseppe Zais (1709–1784) and Gasparo Diziani (1689–1767), and his first-hand experience of their success may well have led him to think of abandoning portraiture for landscape. Whether the final push came from Zuccarelli, as Farington tells the story, or from Claude Joseph Vernet (1714–1789), who admired Wilson's landscapes in Rome, the real impetus to follow in the footsteps of Claude Lorrain (1600–1682) and Gaspard Dughet (1615–1675) came simply from Wilson's encounter with the countryside around Rome itself.

There he arrived in January 1752, overlapping by four months the stay of the young Joshua Reynolds (q.v.), and there he remained, with at least two visits to Naples and innumerable expeditions into the Tiber Valley, the Campagna, and Tivoli, until 1756 or 1757. In these years Italy inflamed Wilson with the inspiration his life and career had withheld so far. Waterhouse justly compared his reaction to the landscape of the Campagna with Reynolds's first vision of the works of Michelangelo and Raphael. Out of each man's intense reaction to Italy and the classical past, Wilson in his landscapes and Reynolds in his portraits would elevate their respective branches of painting to an entirely new level of seriousness in England.

In Rome, Wilson was at the heart of the international artistic community. Anton Raphael Mengs (1728–1779) painted his portrait; Vernet befriended and praised him; Scandinavian artists copied his drawings, and the French artists in Rome, as John Flaxman (1755–1826) told Farington, "held the character of Wilson, as an Artist, very high."[7] Among his English patrons two of the most important were William Legge, 2nd Earl of Dartmouth (1731–1801), and the Earl of Leicester. Significantly, both bought paintings and drawings of ideal landscapes, not topographical views of the city as Englishmen did with Canaletto in Venice.

Wilson returned to England by 1758, preceded by his reputation, and throughout the 1760s he prospered. His most ambitious works, six canvases painted in the decade 1758–68, were attempts to combine history painting with landscape on a large scale, as in his *Niobe,* shown at the first exhibition of the Society of Artists in 1760 (no. 72), and bought by the Duke of Cumberland (58 x 74″, New Haven, Yale Center for British Art). In the late 1750s and throughout the 1760s, Wilson also continued to paint his deeply poetic Italian landscapes, variations and repetitions of the works of the Roman years, showing lakes Albano, Nemi, or Avernus, and particularly the countryside around Tivoli and the Campagna. In general these works are somber in tone, the palette consciously limited, and yet they glow with the melancholy stillness of the late afternoon sun, impregnated with a feeling, Waterhouse wrote, "either solemn or lyrical, for the divine element in nature."[8]

In addition to his history pictures and views of Italy, Wilson worked as a painter of country houses, such as Croome Court (1758), Wilton, Woburn, and Moor Park. And perhaps his most original contribution to the history of landscape art in Britain is his application of lessons learned from Gaspard Dughet and Claude Lorrain to these country house portraits and to his views of England and Wales. Later, his most fascinating experiments in this vein are his views of Cader Idris in Merionethshire, North Wales. *Cader Idris* (c. 1765–67, 19⅝ x 28⅜″, London, Tate Gallery) shows the vast water-filled crater of an extinct volcano viewed from above, a near-abstract series of concentric circles filling most of the canvas. Not a blade of grass or a tree is in sight; the colors are muted; even the few tiny figures that give the whole its scale scarcely relieve the bleakness. In their subject, the views of Cader Idris could be compared to the pictures of Vesuvius in eruption by Wilson's admired friend Joseph Wright of Derby (q.v.). But beside the austerity of Wilson, Wright's views seem positively to pander to the sensational. Nothing in English landscape painting in the eighteenth century was tougher or more original.

Wilson was not an artist who developed radically different styles of painting throughout his career. All his best work was done between 1750 and 1774. By the late 1760s his fortunes began to change, for although his pupil William Hodges (1744–1797) described him as a "pleasant, a good-natured, a very honest and upright man," he also added that Wilson "gave himself too

little trouble about forming connections that might have been of use to him in his profession."[9] He made himself agreeable neither to George III, who disliked him and his works, nor to the powerful Joshua Reynolds, a man whose aims in art were so like his own but whose cool and assured character contrasted with Wilson's more voluble temper.

To earn more money Wilson churned out careless copies and repetitions of his own canvases; he allowed his pupils to work on his pictures and encouraged them to copy his drawings. Even in his own lifetime a prospective buyer may not have been sure he was getting a good Wilson, or even a genuine one, and today the problem of variations, repetitions, copies, collaborations, and fakes of Wilsons is notorious.

By the mid-1770s his vogue was over; probably he had begun to drink, and certainly he grew fat, disheveled and eventually senile. Moving from one lodging to another, unable to sell his pictures, he was buoyed up financially by the fifty pounds a year he earned as librarian of the Royal Academy, a post he assumed in 1775, replacing Francis Hayman (1708–1776). In 1781 he left London to live in his native Wales with a cousin, and there died suddenly on May 11, 1782.

Wilson was a foundation member of the Incorporated Society of Artists in 1759, and exhibited with them every year from 1760 to 1768. He was one of the original thirty-four members of the Royal Academy, exhibiting there from 1769 until 1780.

1. Farington's "Biographical Note" in Kingston upon Hull, Ferens Art Gallery, *Exhibition of Works by Richard Wilson, R.A.,* November–December 1936, pp. 10ff.

2. Archer, ed., 1811, p. 1.

3. Ruskin, 1903–12, vol. 33, p. 378.

4. Waterhouse, 1978, p. 232.

5. For Northcote's comments, see T. Wright, *Some Account of the Life of Richard Wilson, Esq., R.A.* (London, 1824), p. 56; for Beechey see Whitely, 1928, vol. 1, p. 381; Booth's notes are quoted by Adrian Bury, *Richard Wilson, R.A.: The Grand Classic* (Leigh-on-Sea, 1947), p. 14.

6. Smith, 1828, vol 2, p. 343.

7. Farington Diary, [1793], December 12, 1795.

8. Waterhouse, 1978, p. 232.

9. Hodges, 1790, p. 404.

BIBLIOGRAPHY: Hodges, 1790, pp. 403–5; Edwards, 1808, pp. 77–83; William Carey, *Letter to I*** A*****, Esq., A Connoisseur in London* (Manchester, 1809), pp. 24–30; Archer, ed., 1811; T. Wright, *Some Account of the Life of Richard Wilson, Esq., R.A.* (London, 1824); Thomas Hastings, Esq., *Etchings from the Works of Richard Wilson with Some Memoirs of His Life, &c.* (London, 1825); Cunningham, 1879, vol. 1, pp. 152–67; C. J. Holmes, "The Landscapes of Richard Wilson," *The Burlington Magazine,* vol. 8, no. 33 (December 1905), pp. 173–80; Beaumont Fletcher, *Richard Wilson, R.A.* (London and New York, 1908); Frank Rutter, *Wilson and Farington,* British Artists Series, ed. S. C. Kaines Smith (London, 1923); Adrian Bury, *Richard Wilson, R.A.: The Grand Classic* (Leigh-on-Sea, 1947); Douglas Cooper, "The Iconography of Richard Wilson," *The Burlington Magazine,* vol. 90, no. 541 (April 1948), pp. 109–18; Douglas Cooper, "Richard Wilson's Views of Kew," *The Burlington Magazine,* vol. 90, no. 549 (December 1948), pp. 346–48; Brinsley Ford, "The Dartmouth Collection of Drawings by Richard Wilson," *The Burlington Magazine,* vol. 90, no. 549 (December 1948), pp. 337–45; Ford, 1951; Brinsley Ford, "Richard Wilson in Rome: I—The Wicklow Wilsons," *The Burlington Magazine,* vol. 93, no. 578 (April 1951), pp. 157–67; Brinsley Ford, "Richard Wilson in Rome: II—The Claudean Landscapes," *The Burlington Magazine,* vol. 94, no. 596 (November 1952), pp. 307–13; Constable, 1953; Waterhouse, 1953, pp. 232–41; W. G. Constable, "Richard Wilson: Some Pentimenti," *The Burlington Magazine,* vol. 96, no. 614 (May 1954), pp. 139–47; Michael Levey, "Wilson and Zuccarelli at Venice," *The Burlington Magazine,* vol. 101, no. 673 (April 1959), pp. 139–43; W. G. Constable, "Richard Wilson: A Second Addendum," *The Burlington Magazine,* vol. 104, no. 709 (April 1962), pp. 138–45; Sutton, ed., 1968; Herrmann, 1973, pp. 51–62; Einberg, 1977; Inger Hjorth Nielsen, "Richard Wilson and Danish Artists in Rome in the 1750s," *The Burlington Magazine,* vol. 121, no. 916 (July 1979), pp. 439–42; Robin Simon, "New Light on Richard Wilson," *The Burlington Magazine,* vol. 121, no. 916 (July 1979), pp. 437–39; Robin Simon, "Richard Wilson's 'Meleager and Atalanta,'" *The Burlington Magazine,* vol. 123, no. 940 (July 1981), pp. 414–17; David H. Solkin, "Richard Wilson's Variations on a Theme by Gaspard Dughet," *The Burlington Magazine,* vol. 123, no. 940 (July 1981) pp. 410–14.

EXHIBITIONS: London, National Gallery and Tate Gallery, *Loan Exhibition of Works by Richard Wilson,* June–September 1925; Kingston upon Hull, Ferens Art Gallery, *Exhibition of Works by Richard Wilson, R.A.,* November–December 1936 (with Farington's "Biographical Note," pp. 10–14); Birmingham, City Museum and Art Gallery, *Richard Wilson and His Circle,* November 1948–January 1949 (introduction by Mary Woodall, catalogue by Brinsley Ford); Arts Council of Great Britain (Welsh Committee), *Richard Wilson: Painter, 1713–1782,* 1969 (introduction by David Wildeboer); New Haven, 1981; London, Tate Gallery, Cardiff, National Museum of Wales, New Haven, Yale Center for British Art, *Richard Wilson: The Landscape of Reaction,* November 2, 1982–June 19, 1983 (by David H. Solkin).

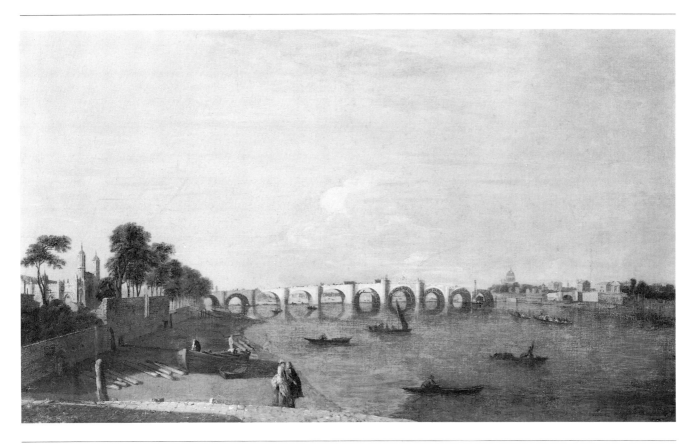

115 RICHARD WILSON

VIEW OF THE THAMES: WESTMINSTER BRIDGE UNDER CONSTRUCTION, 1745
Oil on canvas, 32⅛ x 54″ (81.7 x 137.2 cm.)
Inscribed lower left: *R. Wilson 1745*
John H. McFadden Collection, M28-1-43

The only important building activity in London during the 1740s was the
construction of Westminster Bridge, the first modern bridge over the Thames
and the first to be built in London since the Middle Ages. Its designer, the
Swiss-born engineer Charles Labelye (1705–1762?) was also responsible for its
construction, and the problems he faced were enormous.[1]

The Thames at that point is eight hundred eighty feet wide; its waters
there are tidal and its river traffic exceptionally heavy. Construction of a new
bridge had been discussed as early as 1734, but had been delayed until 1738
largely because of the resistance of Londoners reluctant to deflect trade from
its ancient route across the Old London Bridge. But London Bridge was filthy
and densely built over on top, while below, the passages between its ancient
pilings were so narrow that boating accidents were frequent.

Labelye, resident in England since about 1720, had been employed in the
1730s to take soundings of the river and to bore the riverbed to find a suitable
site for the new bridge. He also seems to have been responsible for the design,
which is based on a plan for the improvement of London Bridge by
Christopher Wren. In June 1738 Labelye was appointed engineer in charge of
laying the foundations for Westminster Bridge.

Labelye's method of laying the piers was new. He first constructed a
caisson, a flat-bottomed boat or box, eighty feet long, thirty feet wide, and
sixteen feet high, which was towed out at high tide to the spot where the pier
was to be built. At low tide, sluices were opened to sink the caisson, which
was then pumped dry so that the masons could descend to build the pier
inside the caisson, working until high tide, when they scrambled out. Then,
the sluices were again opened to prevent the giant caisson from floating away.

When the masonry rose above water level, the box was dismantled and floated to the next pier. In addition, Labelye employed a new method for driving piles, invented by James Valoue. A giant capstan was mounted on a raft, which was then floated to the place where the pile was to be driven. Turned by two or three horses, the capstan hauled a weight of 1,700 pounds twenty feet in the air; this was then released, crashing down to drive in the piling. In Wilson's view, presumably the scaffold or derrick of the pile driver, with the horses in the hut on the raft, is at the right side of the bridge, where the east sixty-eight-foot arch (ninth from the left) is under construction.

After the foundations and piers had been laid, the next stage, begun in 1740, was to erect the "centering," or temporary structure used to support an arch while it is under construction. Labelye worked from the center out, building the middle three arches first. These were finished by June 1742. Apparently centerings were not difficult to build but were hard to remove gently enough so that the arch above each would not crack from the sudden loss of support. The first centering was not struck until January 1744, eighteen months after the first three arches had been finished, and centers were standing in the river for six or seven arches at this date, all of which would soon be completed.

In the version of Wilson's *Westminster Bridge* in a private collection in London (fig. 115-1), seven arches are shown completed, while two more are under construction, making a total of nine arches visible. In the Philadelphia version, a tenth arch is under construction, indicating that this version was painted after the London picture, and also that it is not a copy but a freshly observed view. Various changes in the details, such as the shape of the foliage of the single tree at the left (which perhaps indicates a change in the season) and a different pattern of river traffic, further confirm that the Philadelphia version is not simply a copy. However, any final assessment of the Philadelphia version is complicated by its poor condition, for the picture has been badly rubbed, and certain areas have been repainted. For example, in the area of the river in the right foreground, one or perhaps two additional boats are revealed by x-radiographs, which also show two figures on the quay, facing in different directions from those there now. Finally, photographs of the picture under ultraviolet light show that the line of the bank at the left has been shifted

FIG. 115-1 Richard Wilson, *View of the Thames, with Westminster Bridge under Construction,* 1744, oil on canvas, 28½ x 57½" (72.4 x 146 cm.), London, private collection

more than once. However, the picture is so abraded that the images are very unclear throughout, including those that appear on x-radiographs.

We can be fairly precise in dating the Philadelphia landscape by examining the Westminster Bridge Commission records in the Public Record Office in London. The bridge commissioner's minutes show that the contracts for the east sixty-eight-foot and sixty-four-foot arches (the two last arches toward the right, numbers nine and ten from the left) were agreed upon May 23, 1744. By April 23, 1745, the east sixty-eight-foot arch (number nine) was completed, while the east sixty-four-foot arch (number ten) was partly completed. In the painting the east sixty-eight-foot arch is incomplete and the east sixty-four-foot arch not yet started except for the erection of centerings.

Labelye reported on January 22, 1745, that the centerings for the middle arch (number seven from the left) and the west fifty-two-foot arch (first from the left) had been eased. In the painting it is hard to see whether the centering for the first arch at the left is still standing, although that for the middle arch certainly is. On the same day, January 22, 1745, Labelye was ordered to take down the center of the west fifty-six-foot arch (second arch from the left and still standing in the painting) and to erect the east fifty-six-foot and fifty-two-foot centers (neither started in Wilson's painting).

The Philadelphia version must therefore date from between May 23, 1744, when the ninth and tenth arches were begun, and January 22, 1745 (by which time the centering on the middle arch was eased). But, to allow time for the amount of building already done on the east sixty-eight-foot arch (number nine from the left), we may presume that the view was painted at least after September 1744, confirming the inscribed date of 1745. The picture probably was finished January 1745, perhaps begun late in the previous year. In the London version, the centering on the ninth arch (east sixty-eight-foot arch) only has been erected, so we can confidently assign a date between May and September 1744 for that painting.

If the tall structure on the right is a piling machine, it is of interest that Labelye proposed on November 14, 1744, that the machine should be laid up to save it from damage by ice as no further piling was required. Labelye, in his book about the building of the bridge of 1751, stated that the last arch was keyed and the bridge made passable for foot passengers and horses on July 26, 1746.[2] Writing in 1752, Bélidor, the greatest writer on engineering of his time, described the bridge as "the most magnificent monument of our times."[3] The subject of the building of Westminster Bridge appealed to artists and collectors in the 1740s and 1750s. Perhaps they were struck by the historical importance of so drastic a change in the landscape of the city, for drawings and engravings of the bridge are so numerous that a catalogue here would be pointless. Constable lists, for example, twelve oil paintings and five drawings by Canaletto (1697–1768) showing the bridge,[4] the earliest dated to late 1746 or early 1747, when the bridge was already complete for pedestrian traffic. The bridge was closed in 1846 and a new bridge started in 1854.

Our picture shows the bridge from the Westminster side of the Thames looking north toward St. Stephen's Chapel and Westminster Hall to the left, with St. Paul's Cathedral in the distance across the river on the right.

1. See John Summerson, *Architecture in Britain: 1530 to 1830,* 7th ed. (London, 1983), p. 362. This entry is indebted to Ted Ruddock's discussion of the building of Westminster Bridge in Ted Ruddock, *Arch Bridges and Their Builders: 1735–1835* (Cambridge and New York, 1979), pp. 3–18, and a letter from Professor Ruddock to the author, November 11, 1980. See also R.J.B. Walker, *Old Westminster Bridge: The Bridge of Fools* (London and North Pomfret, Vermont, 1979).

2. Charles Labelye, *Gephyralogia: An Historical Account of Bridges Antient and Modern Including a More Particular History and Description of the New Bridge at Westminster* (London, 1751).

3. B. F. Bélidor, *Architecture hydraulique* (Paris, 1752), vol. 4, p. 191; quoted by Ruddock (see note 1), pp. 18, 218 n. 54.

4. W. G. Constable, *Canaletto: Giovanni Antonio Canal, 1697–1768,* 2 vols. (Oxford, 1962).

PROVENANCE: Robert Palmer (d. 1787), Holme Park, Berkshire; Lady Beauchamp (his daughter); Richard Palmer (d. 1806), Rev. H. Palmer; by descent through the Palmer family, until 1916; Agnew; bt. John H. McFadden, October 20, 1916.

EXHIBITIONS: London, British Institution, 1847, no. 100 (lent by Rev. H. Palmer); New York, 1917, p. vi, no. 44; Pittsburgh, 1917, no. 44; London, Somerset House (organized by the National Maritime Museum on behalf of the Department of Environment), *London and the Thames: Painters of Three Centuries,* 1977, no. 31 (by Harley Preston).

LITERATURE: Roberts, 1917, pp. 89–90, repro.; Roberts, 1918, "Additions," pp. 108, 117, p. 111 fig. 3; Roberts, 1919, pp. 6–7, repro.; Hinks and Royde-Smith, 1930, pp. 155, 191–92, 213, repro. following p. 192; Constable, 1953, pp. 20, 70, 76, 77, 78, 118, 180, pl. 44a; Waterhouse, 1965, p. 6; Herrmann, 1973, p. 52; Staley, 1974, p. 36, fig. 4; Einberg, 1977, p. 438; R.J.B. Walker, *Old Westminster Bridge: The Bridge of Fools* (London and North Pomfret, Vermont, 1979), p. 154; London, Tate Gallery, Cardiff, National Museum of Wales, New Haven, Yale Center for British Art, *Richard Wilson: The Landscape of Reaction,* November 2, 1982–June 19, 1983, pp. 146–47.

CONDITION NOTES: The original support is medium-weight (10 x 10 threads/cm.) linen. The tacking margins have been removed. The painting is lined with an aged aqueous adhesive and medium-lightweight linen. A white, thickly and evenly applied ground is evident along the cut edges. The paint is in poor condition. The moderate to low relief of the paint profile has generally been abraded overall. The paint film is broken with an irregular web of medium-aperture fracture crackle, which has associated cupping. Several large, feathered, fracture cracks are obvious in the sky area. Under ultraviolet light, substantial overpaints can be detected in the foreground in the river, including changes in the position of the shoreline at left. A large area of sky along the extreme right edge of the composition has been overpainted.

VERSION: Richard Wilson, *View of the Thames, with Westminster Bridge under Construction,* 1744, oil on canvas, 28½ x 57½" (72.4 x 146 cm.), London, private collection (fig. 115-1).

INSCRIPTION: *R. Wilson 174*[4?] [lower left on the wall].

PROVENANCE: F. H. Durrell; Spink and Son.

EXHIBITION: London, Tate Gallery, Cardiff, National Museum of Wales, New Haven, Yale Center for British Art, *Richard Wilson: The Landscape of Reaction,* November 2, 1982–June 19, 1983, no. 5.

116 RICHARD WILSON

LAKE AVERNUS I, mid-1760s
Oil on canvas, 27¾ x 35¼″ (70.5 x 89.5 cm.)
The William L. Elkins Collection, E24-3-39

Wilson visited Naples at least twice, probably three times, between 1752 and
1756, working chiefly in the countryside outside the city—at the Bay of
Pozzuoli, and at lakes Agnano, Avernus, and Baiae.[1] On the eastern banks of
Lake Avernus, a volcanic crater between Pozzuoli and Baiae, stand the remains
of Roman baths and of the temple variously thought to have been dedicated
to Apollo, Mercury, or Pluto. On the south bank is the cavern of the
Cumaean sibyl, who, according to Christian legend, predicted the birth of
Christ in Virgil's fourth Eclogue. Although Wilson's painting is not
topographically accurate, the suggestion has been made that it may be based
on a view south from Avernus toward Baiae, with the Roman baths, therefore,
appearing on the wrong side of the lake.[2] On the other hand, David Solkin
has pointed to the compositional similarities between the version of *Lake
Avernus III* belonging to the Duke of Buccleuch and Queensberry (24 x 32″,
Boughton House) and Gaspard Dughet's (1615–1675) *Ideal Landscape*
at Glasgow (36⅞ x 52⅜″),[3] a similarity that naturally applies to the
Philadelphia version.

 In classical tradition Avernus was one of the entrances to the underworld,
a belief inspired perhaps by the reputed depth of the lake, the dark woods

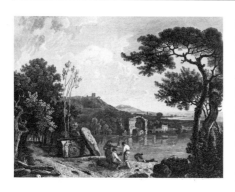

FIG. 116-1 James Roberts after Richard Wilson, *A View in Italy*, 1765, engraving, 13½ x 17" (34.3 x 43.2 cm.)

surrounding it, and its mephitic exhalations. In book six of *The Aeneid,* Virgil wrote, "Facilis descensus Averno:/noctes atque dies patet atri janua Ditis," and Lucretius and Livy also refer to Avernus as a place of the dead. In *Lake Avernus* and most of its variants, two peasants in contemporary dress, possibly fishermen, stand in the foreground listening to a robed figure who gestures toward the lake. The sarcophagus to the right with its lid resting against its side surely indicates that the monk (or poet or sibyl) is explaining that the dead have been given up to the eternal regions.

Constable calls the Philadelphia picture an unfinished copy after the landscape from the Clarke collection (see version 1 and fig. 116-1). Comparing the Philadelphia painting to versions such as the one in the Worcester Art Museum (fig. 116-2) does reveal the weakness in the drawing of the trees to the left, and a tentative, rather flat touch in the way the leaves are painted. Yet the spatial structure, the sensitive treatment of the background landscape and reflections in the water suggest that this is an autograph repeat of the Clarke picture, but that it was perhaps then worked on by an imitator.[4]

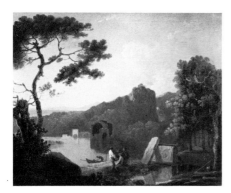

FIG. 116-2 Richard Wilson, *Lake Avernus I,* oil on canvas, 24⅛ x 30¼" (61.3 x 76.7 cm.), Worcester, Massachusetts, Worcester Museum of Art

1. Constable, 1953, p. 37.
2. Worcester, Massachusetts, Worcester Art Museum, *European Paintings in the Collection of the Worcester Art Museum,* 1974, p. 71.
3. For *Lake Avernus III* see Constable, 1953, pl. 70a; Kenwood, 1980, nos. 13, 72, pp. 41, 88.
4. For variations of the composition showing Lake Avernus, see Constable, 1953, pp. 194–95, notes on pls. 69b–71b, dividing the variations into the following categories: *Lake Avernus I,* as in the Philadelphia Museum of Art painting; *Lake Avernus II,* with a long bridge in the background and no building on the hilltop (pl. 69b); *Lake Avernus III,* with only two figures in the foreground, no boat, bridge, or buildings on the lake edge, and a large ruin on the hill (pls. 70a, b); *Lake Avernus IV,* variant of *Lake Avernus I* in reverse (pl. 70c); *Lake Avernus V,* two figures in the foreground, rocks instead of the tomb and its cover, trunk without leaves, and a sapling to the left (pls. 71a, b). For versions doubtfully by Wilson of *Lake Avernus I,* or versions of *Lake Avernus I* recorded whose locations are not known, see Constable, 1953, p. 194, notes on pl. 69a.

PROVENANCE: William L. Elkins, by 1900.

LITERATURE: Elkins, 1887–1900, vol. 2, no. 76, repro.; Hinks and Royde-Smith, 1930, p. 191 (as "View of Tivoli"); Constable, 1953, p. 194, notes on pl. 69a; Hugh Brocklebank, *A Turn or Two I'll Walk to Still My Beating Mind: Commentary on a Private Collection* (London, 1955), p. 43; Staley, 1974, p. 36.

CONDITION NOTES: The original support is medium-lightweight (16 x 16 threads/cm.) linen. The tacking margins have been removed. The painting's aged lining consists of medium-weight linen and an aqueous adhesive. A white ground has been thickly and evenly applied and is evident along the cut edges and through the thinnest areas of paint application. The paint is in good condition. The relief varies from high to moderate profile with considerable brush marking evident. Much of the original profile has been flattened by lining. An irregular web of moderate-aperture fracture crackle is present overall and is especially prominent in the central sky area.

VERSIONS

1. Richard Wilson, *Lake Avernus I,* oil on canvas, 16 x 20½" (40.6 x 51.4 cm.), London, the late Frederick Seymour Clarke Collection (present location unknown).

INSCRIPTION: *RW* [the R reversed] *1764.*

PROVENANCE: Col. Hugh Baillie; Christie's, May 15, 1858, lot 21, bt. Farrer; Louis Huth; Christie's, May 20, 1905, lot 137, bt. Grego; Sir Thomas Devitt, Bart.; his sale, Christie's, May 16, 1924, lot 174, bt. Leggatt; Frederick Seymour Clarke (not in his sale, February 10, 1933).

EXHIBITIONS: London, Royal Academy, 1884, no. 33; London, National Gallery and Tate Gallery, *Loan Exhibition of Works by Richard Wilson,* June–September 1925, no. 18.

LITERATURE: Constable, 1953, pl. 69a, p. 194, notes on pl. 69a as the prime version.

DESCRIPTION: Prime version.

ENGRAVING: James Roberts after Richard Wilson, *A View in Italy,* 1765, engraving (image reversed), 13½ x 17" (34.3 x 43.2 cm.) (fig. 116-1).

INSCRIPTION: *A View in Italy—Rich. Wilson pinxit James Roberts Sculpsit. / Publish'd by J. Boydell / Engraver, in Cheapside, London, 1765.*

2. Richard Wilson, *Lake Avernus I,* oil on canvas, 17 x 21" (43.2 x 53.3 cm.), location unknown.

PROVENANCE: Capt. E. G. Spencer-Churchill, Northwick Park, Gloucestershire, 1953; Christie's, June 25, 1965, lot 78, bt. Myers.

LITERATURE: Constable, 1953, p. 194, notes on pl. 69a (under "Repetitions of the Clarke picture, with variations in detail, acceptable as by Wilson" [no. 1]); Edward George Spencer-Churchill, *The Northwick Rescues, 1912–1961* (Northwick, 1961), no. 116.

3. Richard Wilson, *Lake Avernus I,* oil on canvas, 24⅛ x 30¼" (61.3 x 76.7 cm.), Worcester, Massachusetts, Worcester Art Museum (fig. 116-2).

PROVENANCE: Mrs. Clayton; her sale, Christie's, December 3, 1926, lot 98, bt. Leggatt; C. M. Spink, 1936; T. T. Ellis, Worcester, Massachusetts; bequeathed to the museum by Mary G. Ellis, 1940.

EXHIBITIONS: Kingston upon Hull, Ferens Art Gallery, *Exhibition of Works by Richard Wilson, R.A.,* November–December 1936, no. 63; Birmingham, Alabama, Birmingham Museum of Art, *British Painting, 1640–1840,* February–May 1970.

LITERATURE: Constable, 1953, p. 194, notes on pl. 69a (under "Repetitions of the Clarke picture, with variations in detail, acceptable as by Wilson" [no. 2]); Worcester, Massachusetts, Worcester Art Museum, *European Paintings in the Collection of the Worcester Art Museum,* 1974, pp. 70–72.

4. Richard Wilson, *Lake Avernus I,* oil on canvas, 16 x 20¾" (40.6 x 52.7 cm.), Boston, Museum of Fine Arts.

PROVENANCE: Turner-Sargent Bequest, 1894.

EXHIBITIONS: Andover, Massachusetts, Addison Gallery of American Art, 1934; New Haven, Gallery of Fine Arts, Yale University, *Eighteenth Century English and Italian Landscape Painting,* 1940, no. 43, repro.; Northampton, Massachusetts, Smith College Museum of Art, *The Art of Eighteenth Century England,* January 1947, no. 90; Northampton, Massachusetts, Smith College Museum of Art, *English Late Eighteenth Century Art,* April–May 1950.

LITERATURE: Constable, 1953, p. 194, notes on pl. 69a (under "Repetitions of the Clarke picture, with variations in detail, acceptable as by Wilson" [no. 3]).

5. Richard Wilson, *Lake Avernus I,* oil on canvas, 16½ x 21¼" (41.9 x 54 cm.), location unknown.

PROVENANCE: R. B. Beckett, London, Christie's, November 17, 1967, lot 98.

LITERATURE: Constable, 1953, p. 194, notes on pl. 69a (under "Repetitions of the Clarke picture, with variations in detail, acceptable as by Wilson [no. 4]).

6. Richard Wilson, *Lake Avernus I,* oil on canvas, 15½ x 20¾" (39.4 x 52.7 cm.), Stratford-upon-Avon, the late Lt. Col. Hugh R. Brocklebank Collection, 1953.

PROVENANCE: Purchased from Col. M. H. Grant, 1935.

LITERATURE: Constable, 1953, p. 194, notes on pl. 69a (under "Repetitions of the Clarke picture, with variations in detail, acceptable as by Wilson" [no. 5]); Hugh Brocklebank, *A Turn or Two I'll Walk . . .* (London, 1955), pp. 39–44.

7. Richard Wilson, *Lake Avernus I,* oil on canvas, dimensions unknown, Prestonfield House, Sir Robert Dick-Cunyngham. Photograph: London, Witt Library.

LITERATURE: Worcester, Massachusetts, Worcester Art Museum, *European Paintings in the Collection of the Worcester Art Museum,* 1974, p. 72.

8. Ascribed to Richard Wilson, *Lake Avernus I,* oil on canvas, 16⅝ x 20¾" (42.2 x 52.7 cm.), York, City Art Gallery.

INSCRIPTION: *1764* [and signed].

PROVENANCE: Mrs. Moira; Mr. Collins; Mr. White; John White, 1820; Agnew; Colnaghi, 1948; F. D. Lycett Green, gift to the gallery, 1955.

LITERATURE: Constable, 1953, p. 194, notes on pl. 69a (under "Recorded versions" [no. 3]); York, City Art Gallery, *Catalogue of Paintings, English School,* no. 834, p. 84, pl. 19.

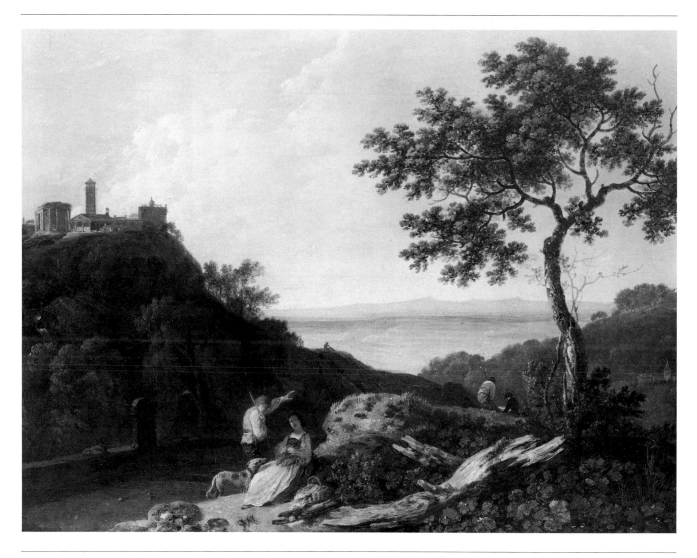

117 RICHARD WILSON

TIVOLI: TEMPLE OF THE SIBYL AND THE CAMPAGNA I, c. 1760–65
Oil on canvas, 25 x 33⅛″ (63.5 x 84.1 cm.)
Inscribed in the foreground under the woman's foot: *RW* [the R reversed]
The William L. Elkins Collection, E24-3-47

Tivoli lies on the Sabine Hills at the end of the Aniene Valley, twenty-five miles from Rome. Joseph Farington (1747–1821), Wilson's pupil, in his biographical note on Wilson, published in the catalogue of the Richard Wilson exhibition in Kingston upon Hull in 1936, tells us how the artist "made [studies] in Tivoli, Albano, Larici, Frascati, Terni and the vicinity of Rome ... and from the various matter which he found in those celebrated places he composed many pictures, and stored his mind with classical ideas which enabled him to form those beautiful compositions which are now the objects of general admiration."[1]

In the Philadelphia picture in the right middle distance sits an artist sketching the circular Temple of the Sibyl, or of Vesta, one of the most popular sights for artists to record in the eighteenth century. In sketching this particular view from nature, Wilson may even have been imitating Claude Lorrain (1600–1682) who, as we know from Sandrart's *Teutsche Akademie,* worked here, although none of his paintings exactly matches the view Wilson has selected.[2] The view in *Tivoli* is taken from the present Via Quintilio Varro, outside the Porta S. Angelo, toward the Grande Cascata.[3]

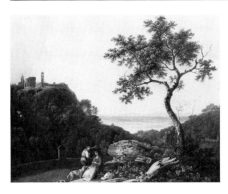

FIG. 117-1 Richard Wilson, *Tivoli: The Temple of the Sibyl and the Campagna,* oil on canvas, 39½ x 49½″ (100.3 x 125.7 cm.), London, Tate Gallery

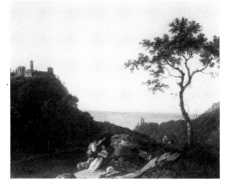

FIG. 117-2 Richard Wilson, *View near Tivoli,* oil on canvas, 40 x 50″ (101.6 x 127 cm.), Cardiff, National Museum of Wales

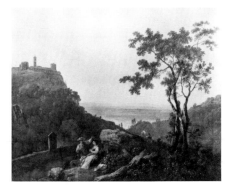

FIG. 117-3 Richard Wilson, *Tivoli: The Temple of the Sibyl and the Campagna,* oil on canvas, 39 x 49½″ (99 x 125.7 cm.), Boston, Museum of Fine Arts

1. Kingston upon Hull, Ferens Art Gallery, *Exhibition of Works by Richard Wilson, R.A.,* November–December 1936, pp. 12–13.
2. The closest is Claude's *View of the Campagna from Tivoli* in the collection of Her Majesty Queen Elizabeth II, which was bought by Frederick, Prince of Wales (1707–1751) and was therefore in England by 1751. See Marcel Röthlisberger, *Claude Lorrain: The Paintings* (New Haven, 1961), vol. 1, no. LV89, pp. 244–45, vol. 2, fig. 169.
3. See Constable, 1953, pp. 222–23 for copies, versions doubtfully by Wilson, and for recorded versions that have not yet been identified. For a variant composition of the scene taken from a different viewpoint, see Constable, 1953, pl. 116b, and notes on pl. 116b, pp. 223ff.

PROVENANCE: William L. Elkins, by 1900.

LITERATURE: Elkins, 1887–1900, vol. 2, no. 75, repro.; Elkins, 1925, no. 44; Constable, 1953, pp. 72, 89, 222, notes on pl. 115a; Sutton, ed., 1968, vol. 1, pp. 31–32, p. 31 fig. 32; Staley, 1974, p. 36; Butlin and Joll, 1977, vol. 1, p. 24; Kenwood, 1980, p. 88.

CONDITION NOTES: The original support is medium-weight (12 x 12 threads/cm.) linen. The tacking margins have been removed. The painting is lined with an aged aqueous adhesive and medium-weight linen. A white ground has been thickly and evenly applied. The paint is in good condition. The relief varies from moderate to thin profile. Much of the original profile has been flattened by lining. A local area of traction crackle is associated with the two figures at the left. There are several small, retouched losses to the left of the smaller figures on the right and in the tree branches above them. The entire composition has been extended on the top and right edges by adding design elements over fills laid upon the lining fabric. Under ultraviolet light, retouches are coincident with the losses noted above around the two figures at right and along the top and right edges.

ENGRAVING: William Byrne after Richard Wilson, *Tivoli: Temple of the Sibyl and the Campagna,* 1765, engraving (image reversed), 13¼ x 16½″ (33.6 x 41.9 cm.).
INSCRIPTION: *Rich. Wilson pinx.ᵗ Engraved from the Original picture Painted by Mr. Richard Wilson. Willᵐ Byrne Sculpt—Publish'd according to Act of Parliament by J. BOYDELL, Engraver in Cheapside. London. Aug.ᵗ.1.1765.*

VERSIONS
1. Richard Wilson, *Tivoli: The Temple of the Sibyl and the Campagna,* oil on canvas, 39½ x 49½″ (100.3 x 125.7 cm.), London, Tate Gallery (fig. 117-1).
PROVENANCE: Capt. T. A. Tatton; Christie's, November 20, 1936, lot 36, bt. Agnew; E. F. Collingwood; Agnew; Tate Gallery, 1973.
EXHIBITION: London, Thomas Agnew and Sons, May–June 1937, no. 11.
LITERATURE: Constable, 1953, p. 222, notes on pl. 115a, pl. 115a.

2. Richard Wilson, *View near Tivoli,* oil on canvas, 40 x 50″ (101.6 x 127 cm.), Cardiff, National Museum of Wales (fig. 117-2).
INSCRIPTION: *RW* [on the stone, left foreground] [the *R* reversed].
PROVENANCE: George Harland-Peck, Different Properties, Christie's, June 25, 1920, lot 146, bt. Paterson; Sir Edward Baron; Tooth, c. 1940; purchased by the museum, 1945.
EXHIBITION: Hamburg, *British Painting from Hogarth to Turner,* 1949–50, no. 117.
LITERATURE: Constable, 1953, pp. 72, 222, notes on pl. 115a and b, and 116a under version [no. 3].

3. Richard Wilson, *Tivoli: The Temple of the Sibyl and the Campagna,* oil on canvas, 39 x 49½″ (99 x 125.7 cm.), Boston, Museum of Fine Arts (fig. 117-3).
PROVENANCE: Benjamin Booth; Lady Ford; Joseph Gillot, his sale, April 26, 1872, lot 238, bt. Coe; W. Angerstein, Christie's, June 20, 1874, lot 110, bt. White: Sir Henry Hawly, Bart.; Mrs. S. D. Warren, American Art Galleries, New York, January 8–9, 1903, lot 117, bt. in; bequeathed to the museum by Mrs. Warren, 1903.
EXHIBITION: London, Royal Academy, 1777, no. 378.
LITERATURE: Constable, 1953, p. 223, notes on pls. 115a and b and 116a under version [no. 5].

4. After Richard Wilson, *Tivoli,* oil on canvas, 13½ x 17″ (34.3 x 43.2 cm.), Glasgow, Corporation Art Gallery.
PROVENANCE: Acquired with the McLellan Collection, 1856.
DESCRIPTION: Copy after version 3.

5. Richard Wilson and assistants, *Tivoli: The Temple of the Sibyl and the Campagna,* 1763–67, oil on canvas, 90 x 72″ (228.6 x 182.9 cm.), private collection.

PROVENANCE: Commissioned by Henry Blundell of Ince Hall; by descent in the Blundell and Weld-Blundell families at Ince Blundell Hall, until 1957; Col. Joseph Weld, Lulworth, Dorset.

LITERATURE: Constable, 1953, pp. 163–64, 222–23, pl. 115b; Kenwood, 1980, no. 71, p. 103 fig. 71.

6. J.M.W. Turner (q.v.) after Richard Wilson, *Tivoli: Temple of the Sibyl and the Roman Campagna,* c. 1798, oil on canvas, 29 x 38″ (73.6 x 96.5 cm.), London, Tate Gallery.

EXHIBITION: London, Royal Academy, *Turner, 1775–1851,* November 1974–March 1975, no. B36.

LITERATURE: Butlin and Joll, 1977, vol. 1, p. 24, no. 44.

RELATED WORKS

1. Richard Wilson, *Tivoli: The Temple of the Sibyl,* chalk heightened with white on prepared paper, 9¾ x 14″ (24.8 x 35.6 cm.), London, Victoria and Albert Museum.

PROVENANCE: Paul Sandby.

LITERATURE: Constable, 1953, p. 223 pl. 116a.

DESCRIPTION: Preliminary drawing.

2. Attributed to William Hodges after Richard Wilson, *Tivoli,* chalk heightened with white on paper, 9¾ x 16⅛″ (24.9 x 41 cm.), Edinburgh, National Gallery of Scotland.

PROVENANCE: Sir Edward Marsh.

LITERATURE: Ford, 1951, no. 83, pl. 83.

3. Attributed to Johnson Carr after Richard Wilson, *Tivoli,* chalk and stump heightened with white on paper, 11 x 16¼″ (28 x 41.3 cm.), location unknown.

INSCRIPTION: [signed and inscribed on reverse].

PROVENANCE: Mrs. F. L. Evans; Sotheby's, 1957, bt. Brandt.

LITERATURE: Ford, 1951, no. 82, pl. 82.

The third son of an attorney, Joseph Wright was born in Derby on September 3, 1734, and was educated at Derby Grammar School. He went to London in the autumn of 1751, aged seventeen, to work as an apprentice in the studio of Thomas Hudson (1701–1779), where Joshua Reynolds (q.v.) had studied and where John Hamilton Mortimer (1740–1779) was a fellow pupil. In 1753 he returned to Derby, presumably to start a portrait practice; but three years later, in a gesture that seems in retrospect characteristic of his stubbornness and intellectual rigor, he returned for another fifteen-month stint with Hudson. Rather like Stubbs (q.v.), he seems to have approached painting first as a scientific discipline in which a complete mastery of optics, anatomy, and chemistry preceded any experiments in composition, lighting, or characterization. Although alike in many ways, Wright's vision was infinitely more ambitious than Stubbs's. His progress from a provincial face painter steeped in the conventions of Hudson's studio, in such pictures as the Carver portraits of 1760, to the perfection of his first mature portrait style in the Markeaton Hunt portraits of c. 1762–63 is thrilling to follow.[1] In the former, the artist described the transparency of gauze or the luster of satin with the same deadpan precision with which he recorded the stiff postures of the stylized bodies, or the smooth contours of porcelain heads. In the latter he has mastered the description of the external world and can allow the face and clothing to belong to persons of flesh and blood, moving and relaxing in a real space.

No sooner had Wright achieved this early perfection in portraiture than he embarked on a ten-year series of ambitious subject pictures, most of them innovations in England in scale, lighting, and iconography—and arguably in the art of group portraiture as well. Between 1764 and 1773 Wright became the successor to Georges de La Tour (1593–1652) as a painter of candlelights, the first English artist to paint moonlight views, and the first artist to specialize in industrial and scientific subjects. As genre pictures, *An Experiment on a Bird in the Air Pump* (c. 1767–68, 72 x 96", London, National Gallery) or *A Philosopher Giving a Lecture on the Orrery* (c. 1764–66, 58 x 80", Derby, Museum and Art Gallery) are of a size quite unprecedented in the history of art in England,[2] and whether these masterpieces are genre at all, or whether they are more akin to history paintings, is debatable. What is certain is that Wright managed to infuse into works that are nominally genre subjects, such as *Three Persons Viewing the Gladiator by Candlelight* (1764–65, 40 x 48") and *The Blacksmith's Shop* (first version, 1771, 50½ x 41", both New Haven, Yale Center for British Art),[3] all the awe and sense of the miraculous that we are accustomed to find in such traditional Christian themes as the Supper at Emmaus or the Nativity. In his scientific or industrial subjects the realistic and secular nature of the pictures may depend on Dutch or French precedents, but the attitude toward light as signifying the unfathomable and miraculous reminds one of Bellini's or Caravaggio's sacred paintings—suggesting, however, not miracles of faith but miracles of beauty or technology. Wright's pictures must find a place in any discussion of the culture of the Enlightenment and industrial revolution in England, for they beautifully illustrate the replacement of the obsessions and vocabulary of medieval Christianity with a new reverence for reason and scientific inquiry. Wright himself was surely conscious of this specific theme in his work as he shows in his fascinating variation on the traditional Christian subject of St. Andrew adoring his own cross, *The Alchemist in Search of the Philosopher's Stone Discovers Phosphorus* (1771/95, 50 x 40", Derby, Museum and Art Gallery) in which the medieval scientist kneels in wonder and near-adoration before a miracle that he, and not God, has effected.

Wright's subject pictures should also be seen in relation to the inception of the public art exhibition in England, which began properly with the foundation of the Society of Arts in 1760 and continued with its successor of 1761, the Incorporated Society of Artists. For his were not commissioned pictures but were meant to hang (in a free market, as it were) in competition with other pictures in a public space. Wright, like the early capitalists who were to become his patrons, was forced to rely on inventions of his own, capitalizing on hitherto undervalued qualities in painting such as novelty (of subject and presentation), startling dramatic effect, and—not least—sheer size to attract potential clients.

Partly because of the popularity of early engravings after his pictures, Wright soon achieved success in England without having, like Benjamin West (1738–1820) or Reynolds, a royal or aristocratic clientele. Nevertheless, he had to exploit new markets away from the competition of the portrait painters of London. From 1768 to 1771 he lived in Liverpool, where his portraits were in great demand among the mercantile classes, particularly men and women connected with the slave trade, and from 1770 to 1772 he worked with Mortimer on the decoration of Radburne Hall, Kirk Langley, near Derby, the residence of Col. Sacheverell Pole.

In a letter of March 29, 1772, Northcote called Wright "the most famous painter now living for candlelight."[4] But in eighteenth-century hierarchies of the various branches of painting (which Reynolds was at this very moment discoursing upon in his Royal Academy addresses), the painter of candlelight ranked far behind the painter of a history picture. Wright may well have taken note of the tremendous prestige accorded to Benjamin West's early neo-classical machines, such as *Agrippina Landing at Brundisium with the Ashes of Germanicus* (1770, 65 x 94″, Philadelphia, Philadelphia Museum of Art), and resolved to approach the highest reaches of artistic creation himself.

Therefore, on October 31, 1773, newly married, he sailed for Rome where he joined the circle around Henry Fuseli (1741–1825) (including Romney [q.v.] and John Downman [1750–1824]).[5] That Wright's contemporaries thought his journey an exceptional undertaking for an established artist is revealed by a letter from Father Thorpe to Lord Arundell of Wardour written from Rome on September 3, 1774: "Mr. Wright of Derby . . . is thought to have more genius than any of the great number of English painters in town; but he has come late to this school."[6] Wright's sojourn in Rome lasted until June 1775, when he left for home by way of Bologna, Perugia, and Venice, arriving in Derby on September 26, 1775.

The effect of Rome on Wright's art is not hard to gage but is hard to assess critically. It turned him from a painter of dramatic and sometimes terrifying masterpieces into a painter of noble neo-classical pictures, distant echoes of Benjamin West's history paintings, in which mourning ladies such as *The Indian Widow* (1783–85, 40 x 50″, Derby, Museum and Art Gallery) or *Maria* from Sterne's *Sentimental Journey* (1781, 63 x 45½″, Derby, Museum and Art Gallery)[7] sit correctly in neo-classical profile, like cameos, in lovely landscapes or candle-lit interiors. Wright simply gave up narrative excitement for a kind of codified neo-classicism which, although serenely perfect in its way, was also unmoving. After his return from Italy he began to work for Josiah Wedgwood (*The Corinthian Maid*, c. 1783–84, 42 x 50″, Upperville, Virginia, Paul Mellon Collection)[8] and chose as his literary adviser, the poet (and patron of Romney, Blake [q.q.v.], and John Flaxman [1755–1826]) William Hayley.

Immediately after his return from Italy, Wright tried to set himself up as the successor to Gainsborough (q.v.) in Bath. But Gainsborough presumably left Bath in the first place because portrait commissions were drying up; after

two years (1775–77) and few commissions, Wright gave up and returned to Derby, never to leave for long again. There he worked on repetitions of landscape themes he had developed in Italy; his famous grottoes, and views of Lake Nemi or Vesuvius. He also painted his most beautiful portraits, *Brooke Boothby* (1780–81, 58¼ x 81¼", London, Tate Gallery) and *Christopher Heath* (c. 1781, 50 x 40", Philadelphia, Rieff Collection), and a little later, his masterpiece in portraiture *Rev. and Mrs. Thomas Gisborne* (1786, 74 x 60", Upperville, Virginia, Paul Mellon Collection). He contributed two of the most successful pictures to Boydell's Shakespeare Gallery, *Ferdinand and Miranda in Prospero's Cell* (c. 1789, 102 x 144", formerly Earl of Crawford and Balcarres Collection) and *Antigonus in the Storm, from "The Winter's Tale"* (second version, 1790, 61 x 85", Viscount Scarsdale Collection).[9]

Wright's exhibiting history is complicated. He first exhibited with the Incorporated Society of Artists in 1765, and like Romney, Stubbs, and Mortimer, remained loyal to the Incorporated Society after the foundation of the Royal Academy, continuing to exhibit in Spring Gardens through 1776 and once again in 1791. On three occasions, 1778, 1783 and 1791, he showed with the original Free Society of Artists. His prickly relationship with the Royal Academy began in 1778. He was made an Associate in 1781 and offered full membership in 1784. Like Stubbs he declined the offer with some vehemence, for during these years the authorities at the Royal Academy managed to alienate a number of artists, from Nathaniel Hone (1718–1784) to Gainsborough, Stubbs, and Romney. Wright's Royal Academy exhibition record runs as follows: 1778–82, 1788–90, and finally 1794. He also held a one-man exhibition of twenty-five works at Mr. Robins's Rooms, 9 Great Piazza, Covent Garden, in April 1785.

1. *Miss Ann Carver*, Mr. and Mrs. Ronald Tree Collection, *Rev. John C. Carver of Morthen* and *Miss Elizabeth Carver*, both formerly Althorpe Collection, all 50 x 40"; see Nicolson, 1968, vol. 2, pls. 26–28. For Markeaton portraits, Maj. Peter Miller Mundy Collection, see Nicolson, 1968, vol. 2, pls. 33–38.
2. Respectively, Nicolson, 1968, vol. 2, pls. 58 and 54.
3. Ibid., pls. 52 and 100.
4. Whitley, 1928, vol. 2, p. 288.
5. New Haven, Yale Center for British Art, *The Fuseli Circle in Rome: Early Romantic Art of the 1770's*, September–November 1979 (by Nancy Pressly).
6. Quoted by Nicolson, 1968, vol. 1, p. 9.
7. Ibid., vol. 2, pls. 247 and 220.

8. Ibid., pl. 245.
9. Ibid., pls. 219, 209, 269, 299, and 304, respectively.

BIBLIOGRAPHY: Bemrose, 1885; S. C. Kaines Smith and H. Cheney Bemrose, *Wright of Derby* (London, 1922); Benedict Nicolson, "Joseph Wright's Early Subject Pictures," *The Burlington Magazine*, vol. 46, no. 612 (March 1954), pp. 72–80; Francis D. Klingender, *Art and the Industrial Revolution*, ed. and rev. by Arthur Elton (Chatham, 1968), pp. 43–64; Nicolson, 1968; Benedict Nicolson, "Addenda to Wright of Derby," *Apollo*, suppl., Notes on British Art, vol. 88 (November 1968), pp. 1–4.

EXHIBITIONS: Derby, Corporation Art Gallery, *Paintings by Joseph Wright, A.R.A.*, 1883; London, Royal Academy, *Exhibition of Works by the Old Masters, Including a Selection from the Works of Joseph Wright (of Derby), A.R.A.*, winter 1886; Derby, Corporation Art Gallery, *Wright of Derby: Bi-Centenary Exhibition of Paintings*, 1934 (by F. Williamson); Northampton, Massachusetts, Smith College Museum of Art, *Joseph Wright of Derby, 1734–1797*, January 1955; London, Tate Gallery, Liverpool, Walker Art Gallery (Arts Council of Great Britain), *Joseph Wright of Derby, 1734–1797: An Exhibition of Paintings and Drawings*, April–June 1958 (by Benedict Nicolson); Derby, Derby Museum and Art Gallery, *Joseph Wright of Derby (1734–1797)*, April 21–July 21, 1979 (introduction by David Fraser).

118 JOSEPH WRIGHT OF DERBY

MRS. ANDREW LINDINGTON, NÉE BENTLEY, c. 1761–63
Oil on canvas, 30 x 24⅛″ (76.2 x 62.8 cm.)
Gift of Mr. and Mrs. Henry W. Breyer, Jr., 68-73-1

In his sitters' book for February 1, 1760, onward, Wright recorded a "Mrs. Lindigton," a name that occurs again twice among the sitters of the early 1760s as Mrs. Lindegten and Mrs. Ligdinton. For this three-quarter-length portrait Wright charged £6.6. Nicolson noted that Wright's uncertainty about the woman's name suggests that he knew his sitter only slightly.[1] Nothing can be discovered about her under her married name, or its variations (or Liddington) through the name indexes in the Derby Central Library, the Derbyshire Record Office, or the Scropton (Derbyshire) marriage registers 1740–60. It is just possible that she was a relation of Josiah Wedgwood's partner Thomas Bentley (1730–1780), but this is conjecture.

Whoever she may have been, Mrs. Lindington was a prosperous middle-class woman, if we are to judge by the exquisite shawl she wears over her blue silk dress. Made of silk, net-grounded blonde lace, it is probably from France. Her triple-ruffled lace sleeves, attached at the elbow to the ruching of her dress, are made of a different pattern of lace, possibly net-grounded thread lace of either French or English make. At her breast she wears pink roses or camellias, and around her neck a blue silk ribbon over which she has wrapped a collar of crystal beads with a teardrop pendant. Her ruched cap is trimmed with smaller crystal beads and crowned with a jeweled aigrette, which seems to match her earrings.

Nicolson compared this painting with Wright's portrait of *Hon. Mrs. Boyle* (c. 1761–63, 30 x 25″, Auckland, City Art Gallery), commenting that in both portraits Wright is seen to move away from his first style, formed in imitation of Thomas Hudson (1701–1779), toward the more intimate, prettier style of the Scottish-born artist Allan Ramsay (1713–1784).[2] *Mrs. Lindington* can be compared to Ramsay's *Miss Woodford* (30 x 25″, formerly London, Thomas Agnew and Sons),[3] the type of painting by Ramsay that is itself influenced by the informal, realistic style of Continental pastelists, such as Jean Étienne Liotard (1702–1789), popular in court and aristocratic circles in England in the 1750s.[4]

Wright's interest in this portrait focuses on the still-life elements in the picture, treating the sitter's face with care, but reserving his greatest powers of description for her clothing and jewelry. The most beautiful passages of painting occur in the rendering of the complicated and graceful twist of the sitter's right arm and wrist; in the color and texture of pink flowers set against white lace over blue silk; the obsessive description of the complex pattern of the interstices of the lace through which the arm and dress are visible; and the bunching of the tiers of lace sleeves on the left arm. As Nicolson says of Wright's artistic intentions at this date, he wished "to paint what the mind knew, helped on by what the eye saw, instead of responding conventionally to drapery as he had done earlier."[5]

Mrs. Lindington, with *Hon. Mrs. Boyle,* is an important transitional picture between the stylized figurines of 1760 and the living men and women who people the great subject pictures, beginning with *Three Persons Viewing the Gladiator by Candlelight* and *A Philosopher Giving a Lecture on the Orrery,* both begun c. 1764, a year or so after our picture was painted.[6]

Wright's near-obsession with the realistic description of what he saw in front of him is paralleled in English art at this moment in the work of George Stubbs (q.v.). But as Nicolson pointed out, an even closer parallel, and

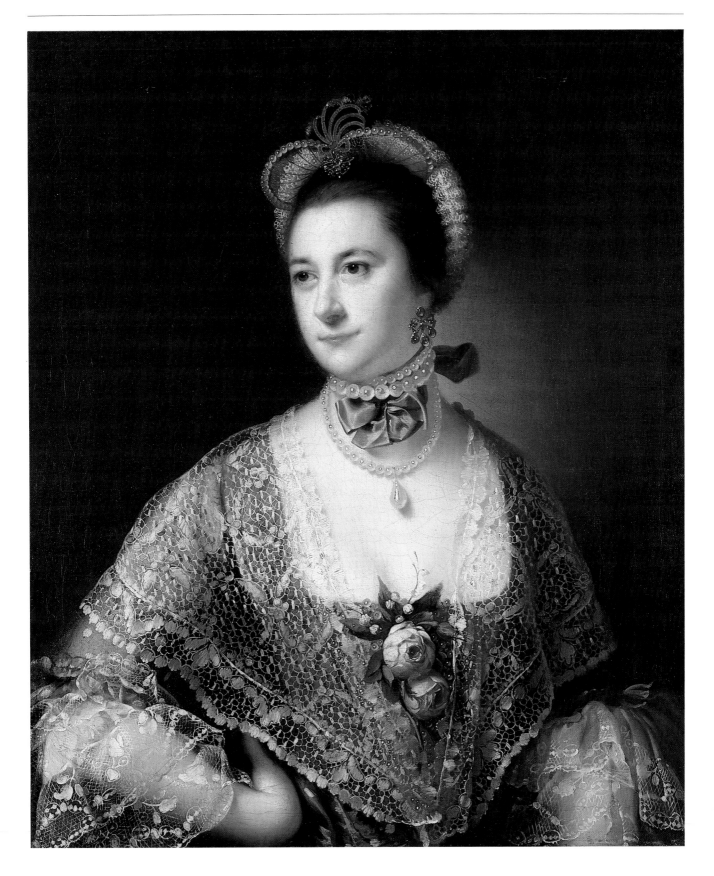

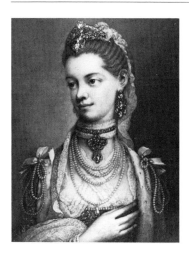

FIG. 118-1 Thomas Frye (1710–1762), *Queen Charlotte,* 1762, mezzotint

undoubtedly an influence on Wright at this date, is to be found in the mezzotints of Thomas Frye (1710–1762), first published in 1760 and 1761.[7] Specifically, we can compare *Mrs. Lindington* to Frye's surprisingly uncompromising portrait of *Queen Charlotte,* published on May 24, 1762 (fig. 118-1), where the composition, pose, and fascination with accessories is very close to Wright.

1. Benedict Nicolson, "Addenda to Wright of Derby," *Apollo,* suppl., Notes on British Art, vol. 88 (November 1968), p. 2.
2. Nicolson, 1968, vol. 1, no. 23, and ibid.
3. Ibid., p. 32 fig. 25.
4. Johnson, 1976, p. 10.
5. Nicolson, 1968, vol. 1, p. 30.
6. Ibid., vol. 2, pls. 52 and 54.
7. Ibid., vol. 1, p. 31.

INSCRIPTION: *Mrs. Andrew Lindington (née Bentley)* [an old hand-written label from Vicars Brothers, 12 Old Bond Street, London].

PROVENANCE: Vicars Brothers, London; Mr. and Mrs. Henry W. Breyer, Jr.

EXHIBITION: Philadelphia, Shipley School, *75th Anniversary Exhibition,* October 1969.

LITERATURE: Bemrose, 1885, pp. 118–19; Nicolson, 1968, vol. 1, p. 210; Benedict Nicolson, "Addenda to Wright of Derby," *Apollo,* suppl., Notes on British Art, vol. 88 (November 1968), p. 2, p. 3 pl. 7; Staley, 1974, p. 35.

CONDITION NOTES: The original support is medium-weight (12 x 12 threads/cm.) linen. The tacking margins have been removed. Weave cusping is evident in the support along the bottom and side edges. The painting is lined with an aqueous adhesive and medium-weight linen. A very thin off-white ground can be seen along the cut edges. The paint, applied in a medium-rich vehicular consistency, is in good condition overall. An irregular web of very narrow-aperture fracture crackle extends over the surface. Losses are small and restricted to the areas along the cut edges. By visible and ultraviolet light, retouches are evident in the fracture crackle of the bodice and the face of the figure. With infrared reflectography, retouching in the lace of the shawl is visible.

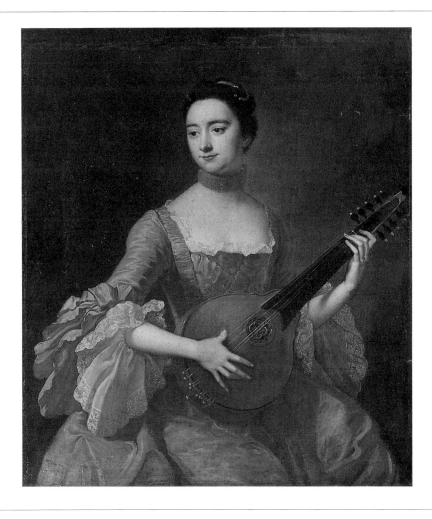

119 ENGLISH SCHOOL,
 FORMERLY ATTRIBUTED TO
 WILLIAM HOGARTH

WOMAN WITH A CITTERN, 1725–50
Oil on canvas, 41½ x 36⅛″ (105.4 x 91.7 cm.)
Gift of Mr. Rodman A. Heeren, 71-262-1

This painting entered the Philadelphia Museum of Art attributed to William
Hogarth (q.v.) as a portrait of the courtesan Kitty Fisher. The artist is
certainly not Hogarth. It has proved difficult to say who painted this picture
or even, with certainty, whether the artist was English or Irish.

 Anne O. Crookshank has, on the basis of a photograph, tentatively
suggested the name of John Lewis, and in the book by Anne Crookshank and
The Knight of Glin, *The Painters of Ireland, c. 1660–1920* (London, 1978), the
picture *An Unknown Lady* attributed to Lewis makes an interesting, if not fully
convincing, comparison with our portrait.[1]

1. p. 47 fig. 29.

PROVENANCE: John Wanamaker; by descent
to his great-grandson Rodman A. Heeren.

EXHIBITION: Philadelphia, Philadelphia
Museum of Art, *Images of Women in the
Performing Arts,* April 1974.

CONDITION NOTES: The original support is
a composite of two pieces of medium-weight
(10 x 10 threads/cm.) linen. The larger carries
most of the figure and background. A 3″ strip
has been added to this along the length of the
left-hand edge. The original tacking margins

have been flattened, filled, and overpainted to
extend the composition. The painting is lined
with an aqueous adhesive and medium-weight
linen. No evidence of the presence or the color
of a ground layer could be found. The paint is
in fair condition overall with local areas of
abrasion. Numerous small losses have occurred
in the background. An irregular net of fracture
crackle is present over the surface. Ultraviolet
light examination reveals extensive retouches
throughout the background.

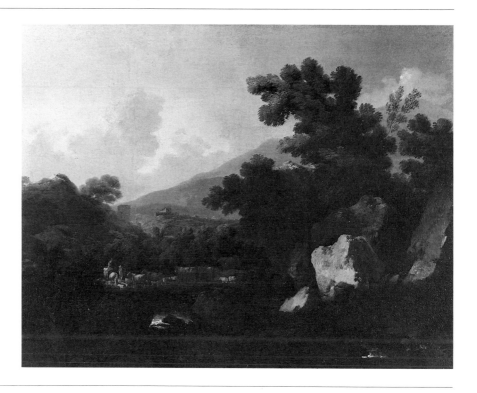

120 ENGLISH SCHOOL, *LANDSCAPE WITH CATTLE AND A HORSEMAN,* eighteenth century
 FOLLOWER OF MARCO RICCI Oil on canvas, 28¾ x 38¾″ (73 x 98.4 cm.)
 Bloomfield Moore Collection, 83-101

This painting came to the Philadelphia Museum of Art attributed to the Swiss painter Philipp de Loutherbourg (1740–1812). However, the method of composing landscape is nothing like de Loutherbourg's Dutch-inspired distribution of trees, hills, and figures. Nor does the style, the handling of paint, have anything of his assured touch or luminosity. And de Loutherbourg's figures and animals are usually prominently placed, large in proportion to the landscape background, which is not the case here.

De Loutherbourg was a rococo artist inspired by Dutch seventeenth-century painters, and as such can be seen as an artist in the same mold as Gainsborough (q.v.). By contrast, *Landscape with Cattle* was painted by an artist who had looked at Italian landscape painting of the seventeenth and eighteenth centuries, and in particular at the classically composed landscapes of Gaspard Dughet (1615–1675). One could leave the attribution simply as English school, and, indeed, a more precise attribution is not possible, except to point out that in certain ways the landscape can be seen as inspired by the example of the Italian artist Marco Ricci (1676–1730), who lived in England between 1710 and 1717, and whose works were popular in England in the mid-eighteenth century, collected particularly by Paul Sandby (q.v.) and by the royal family. In composition, this picture might be compared to Ricci's *Landscape with a Hill Town* (tempera on leather, 12½ x 18″) or *Landscape with a Torrent* (tempera on leather, 12⅜ x 18⅜″, both Her Majesty Queen Elizabeth II).[1] These Riccis include some of the same elements as the Philadelphia landscape—the tiny figures of peasants, the glimpse of a hill town, the even progression into the distance.

However, Ricci's technique, whether in his works in tempera or in oils, is very different from the technique in *Landscape with Cattle*. Where Ricci was an artist of extreme delicacy and finesse, the artist of this work could handle the brush but crudely. This very awkwardness suggests an English hand, but the anonymous and styleless quality of the landscape allows us to continue to speculate as to the artist's nationality.

1. Michael Levey, *The Later Italian Pictures in the Collection of Her Majesty the Queen* (London, 1964), pp. 94–96, see nos. 591–622.

EXHIBITION: West Chester, Pennsylvania, West Chester Normal School, August 1923.

CONDITION NOTES: The original support is coarse, medium-weight (8 x 8 threads/cm.) linen. Weave cusping is evident in the support on all four sides. A large vertical tear in the support (5 to 6″) is present in the sky at the left of center. The painting has been lined with a wax-resin adhesive and medium-weight linen. An off-white ground is present and extends partially onto the tacking margins. The paint is generally in poor condition. Two major losses to ground and paint exist: one is coincident with the tear in the support noted above and the other in the large boulder in the right foreground. Numerous small losses are apparent overall. A fine web of narrow-aperture fracture crackle covers the surface. Under ultraviolet light, retouches are apparent along the tacking margins, in the numerous losses, and over much of the left side of the sky.

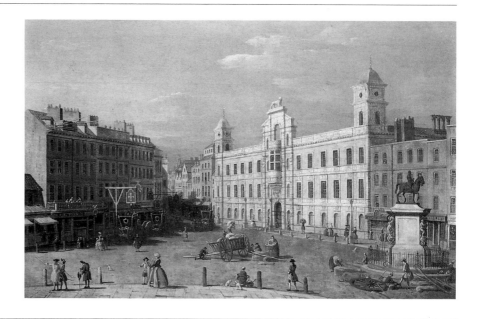

121 ENGLISH SCHOOL,
 AFTER CANALETTO

NORTHUMBERLAND HOUSE, after 1752
Oil on canvas, 22½ x 35¼" (57.2 x 89.5 cm.)
Gift of John H. McFadden, Jr., 46-36-2

This picture shows Northumberland House, residence in London of the dukes of Northumberland. The facade as shown here was constructed in 1752, giving us a date after which the Canaletto (1697–1768) on which it is based was painted. Northumberland House stood at the beginning of the Strand (visible in the distance) near what is today Trafalgar Square, at Charing Cross. On the left the Golden Cross Coaching Inn is recognizable by its sign. On the right is the equestrian statue of Charles I by Hubert Le Sueur (active 1610–43), which today looks down Whitehall from Trafalgar Square. The distribution of the figures in the Philadelphia picture is very different from that in the Canaletto drawing at Minneapolis (fig. 121-1) and the oil at Alnwick Castle (related work 1). Our picture cannot be called a direct copy and is probably based on the print after Canaletto's painting published in 1753.

The painting with its pendant, *Old Somerset House* (no. 122), has been attributed to Samuel Scott (c. 1702–1772) and, of course, to Canaletto himself, but neither attribution is possible in terms of quality. A further suggestion that they may be by Modena-born *vedute* painter Antonio Joli (c. 1700–1777) is more attractive.[1] Joli arrived in England before Canaletto, in 1744, and stayed until 1750, when he moved on to Spain.[2] However, Joli was not in London in 1752–53, and the painting of these London scenes implies an English outlet for their sale. Although possibly Joli painted the two pictures from engravings, it is unlikely: he seems to have been an independent and successful artist in his own right and is not known to have copied other works by Canaletto. Furthermore, Joli's real interest was in panoramic view paintings, often with aerial perspective. In London he worked at the King's Theatre, Haymarket, and at the Italian Opera as a scene painter and set designer, training that lends to the figures in his canvases an air of theatricality and liveliness of characterization not found in the Philadelphia pair.

Therefore safest is calling *Northumberland House* and *Old Somerset House* works of the English school, by an artist eager to benefit from the popularity of Canaletto's London views. Perhaps we could suggest that this artist may have moved in the circle of Samuel Scott.

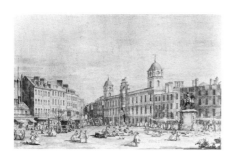

FIG. 121-1 Canaletto (1697–1768), *Charing Cross and Northumberland House,* c. 1752, pen and ink over pencil with wash, 11⅜ x 18¾ (28.9 x 47.6 cm.), Minneapolis, Minnesota, The Minneapolis Institute of Arts

1. Allen Staley, Philadelphia Museum of Art Archives.
2. For Joli, see London, Colnaghi, *Pictures from the Grand Tour,* November–December 1978, n.p.

INSCRIPTION: Various inventory numbers, a French customs stamp, and an Agnew label [on the stretcher].

PROVENANCE: Sir William Neville Abdy, Bart.; his sale, Christie's, May 5, 1911, lot 91 (pair) (as by Canaletto); bt. Gooden and Fox; Tancred Borenius; Christie's, July 4, 1924, lot 106 (pair) (as by Canaletto); bt. Tooth; M. Knoedler and Co., New York; bt. John H. McFadden, Jr., November 10, 1927.

LITERATURE: Finberg, 1921, pp. 60–63; Constable, 1927, pp. 17–18; Constable, 1976, vol. 2, no. 419 version a.

CONDITION NOTES: The original support is medium-weight (12 x 12 threads/cm.) linen. The tacking margins have been removed. A large vertical tear, now repaired, is visible above the entrance of the building at the right. The painting is lined with an aged aqueous adhesive and medium-weight linen. A white ground has been thickly and evenly applied. The paint is in good condition. Several small losses in paint and ground in the left-hand portion of the sky have been filled and inpainted. Siegl noted in 1966 that "some of the architectural details may be reglazed." The original low relief of the paint profile and the brush marking have been preserved. Under ultraviolet light, retouches are evident in the losses noted in the left sky area and around the large tear.

RELATED WORKS
1. Canaletto (1697–1768), *Northumberland House,* 1752–53, oil on canvas, 33 x 54" (83.8 x 137.1 cm.), Alnwick Castle, the Duke of Northumberland.
LITERATURE: Constable, 1976, vol. 2, no. 419 (lists numerous other versions).
DESCRIPTION: Prime version.

2. Canaletto, *Charing Cross and Northumberland House,* c. 1752, pen and ink over pencil with wash, 11⅜ x 18¾" (28.9 x 47.6 cm.), Minneapolis, Minnesota, The Minneapolis Institute of Arts (fig. 121-1).
LITERATURE: Briganti, 1970, fig. 207; Constable, 1976, vol. 2, no. 740.

ENGRAVINGS: T. Bowles after Canaletto, *A View of Northumberland House, Charing Cross, &c.,* 1753, engraving, 10¼ x 15¾" (26 x 40 cm.).
INSCRIPTION: *Canaleti Pinxᵗ et Delinᵗ T. Bowles Sculpᵗ. Publish'd According to the Act of Parliament, 1753.*
Published: Robert Sayer.
Republished: May 12, 1794, by Laurie and Whittle, 53 Fleet Street, London.
INSCRIPTION: *Canaleti Pin.ᵗ et Delin.ᵗ In the Collection of the Earl of Northumberland. Publish'd according to Act of Parliament. T Bowles Sculp.ᵗ/A View of Northumberland House, Charing Cross, & cc. Vüe de la Maison de Northumberland a Charing Cross.*

122 ENGLISH SCHOOL,
 AFTER CANALETTO

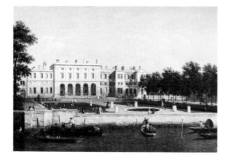

FIG. 122-1 Canaletto (1697–1768), *Old Somerset House from the River Thames*, 1752–53, oil on canvas, 31⅛ x 46⅞″ (79.7 x 117.8 cm.), Mr. and Mrs. Harry Brooks Collection

OLD SOMERSET HOUSE FROM THE RIVER THAMES, after 1752
Oil on canvas, 22½ x 35¼″ (57.1 x 89.5 cm.)
Gift of John H. McFadden, Jr., 46-36-3

This picture is an exact copy, though of different dimensions, of Canaletto's (1697–1768) painting of 1752–53 of *Old Somerset House from the River Thames* (fig. 122-1).[1] Shown are the south facade, garden, and river walk of Old Somerset House, built in 1549 by the Duke of Somerset, Edward Seymour, Lord Protector of England and then governor of the boy Edward VI. After his execution it was used as a royal palace, occupied by foreign ambassadors. Some time before 1763 it was used by the Venetian envoy, hence a probable reason for Canaletto's interest in painting it. The house was demolished in 1766 to be replaced by Sir William Chambers's building, used as the first home of the Royal Academy. For questions of dating and authorship see the entry for its pendant (no. 121).

1. See Constable, 1976, vol. 2, no. 423 for numerous other versions.

INSCRIPTION: Various inventory numbers, a French customs stamp, and an Agnew label [on the stretcher].

PROVENANCE: Sir William Neville Abdy, Bart.; his sale, Christie's, May 5, 1911, lot 91 (pair) (as by Canaletto, wrongly described as "Northumberland House from the River"); bt. Gooden and Fox; Tancred Borenius; Christie's, July 4, 1924, lot 106 (pair) (as by Canaletto), bt. Tooth; M. Knoedler and Co., New York; bt. John H. McFadden, Jr., November 10, 1927.

LITERATURE: Finberg, 1921, pp. 60–63; Constable, 1927, pp. 17–18; Constable, 1976, vol. 1, pp. 42, 144, vol. 2, pp. 412, no. 419, 414–15, no. 423 version b.

CONDITION NOTES: The original support is medium-weight (12 x 12 threads/cm.) linen. The tacking margins have been removed. A 1½″ tear in the upper left quadrant of the sky has been repaired. The painting is lined with an aged aqueous adhesive and medium-weight linen. A white ground has been thickly and evenly applied. The paint is in very good condition. A very narrow-aperture traction crackle is evident in the darkest brown passages of the foliage at the right. The original low relief of the paint profile and brush marking are well preserved. Under ultraviolet light, a 12″ horizontal scratch in the mid-sky area appears to have been retouched. Retouches are also evident in the traction crackle noted above and in several small losses along the left edge.

RELATED WORKS
1. Canaletto (1697–1768), *Old Somerset House from the River Thames*, 1752–53, oil on canvas, 31⅛ x 46⅞″ (79.7 x 117.8 cm.), Mr. and Mrs. Harry Brooks Collection (fig. 122-1).
 PROVENANCE: Minneapolis, Minnesota, The Minneapolis Institute of Arts, sold 1956.
 EXHIBITION: London, Somerset House (Department of the Environment), *London and the Thames: Paintings of Three Centuries,* July–October 1977, no. 12.
 LITERATURE: Constable, 1976, vol. 2, no. 423 (as in The Minneapolis Institute of Arts).

2. Canaletto, *Old Somerset House from the River Thames,* pen and bister with wash on paper, 15¾ x 28¼″ (40 x 71.7 cm.), Lady Du Cane Collection, 1962.
 LITERATURE: London, Burlington Fine Arts Club, *Exhibition of Venetian Painting of the Eighteenth Century,* 1911, no. 73 (lent by Christopher Head); Constable, 1976, vol. 2, no. 743.

123 ENGLISH,
NORWICH SCHOOL

RINGLAND HILL, c. 1820–30?
Oil on canvas, 33⅛ x 40¼″ (84 x 102.2 cm.)
The William L. Elkins Collection, E24-3-43

There is little in the style of this picture to suggest the Norwich School, yet it came to the Philadelphia Museum of Art in 1924 as a view of or near Ringland Hill, a location about ten miles south of the city of Norwich. A visit to Ringland Hill confirms that the view is topographically possible, although, of course, this stone wall and house could not be identified. The traditional identification and the provenance, listed in the catalogue of the Elkins Collection, to the famous family of patrons the Custance family in Norwich, allow us to attach the name Norwich School to this picture.[1] However, the almost rococo prettiness, the dainty house and figures, and the feathery trees cannot be associated with the style of any one artist or school of painters who exhibited with the Norwich Society.

1. Elkins, 1887–1900, vol. 2, no. 60.

INSCRIPTION: *Blakeslee* [Gallery] [on a label on the stretcher].

PROVENANCE: John Custance Collection, Norwich; Blakeslee Gallery, New York; William L. Elkins.

LITERATURE: Elkins, 1887–1900, vol. 2, no. 60, repro. (as by John Crome); Goldberg, 1960, p. 214.

CONDITION NOTES: The original support is medium-weight (10 x 10 threads/cm.) linen. The tacking margins have been removed. The painting is lined with an aged aqueous adhesive and medium-weight linen. A white ground has been evenly and thickly applied. The paint is in only fair condition. Small-web, narrow-aperture traction crackle extends throughout much of the brown tones of the foliage. The original moderate to low relief of the paint has been substantially flattened by lining. A series of small losses, now filled, runs in a straight, vertical line near the middle of the image, suggesting an old fold along a stretcher cross member. Under ultraviolet light, retouches are evident in the vertical line of losses and along the cut edges.

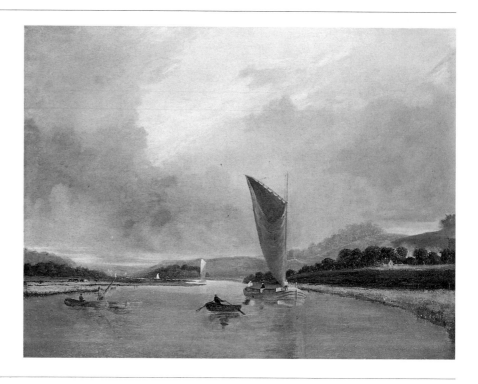

124 ENGLISH, NORWICH SCHOOL, IMITATOR OF JOHN CROME

HAY BARGES ON THE YARE, second quarter of the nineteenth century
Oil on canvas, 30 x 40″ (76.2 x 101.6 cm.)
W. P. Wilstach Collection, W06-1-4

Perhaps by an amateur or pupil of John Crome (q.v.), this view of a wherry and rowboats on the Yare bears no trace of Crome's hand. In 1921 Collins Baker suggested an attribution to John Thirtle (1777–1839), and in 1960 Goldberg accepted the work as by Crome, executed on a visit to Wales, Weymouth, the Lake District, or London. However, it is not included in Goldberg's 1978 monograph on Crome.

PROVENANCE: W. P. Wilstach Collection, by 1906.

LITERATURE: Wilstach, 1908, no. 78; Collins Baker, 1921, p. 175; Wilstach, 1922, no. 75, repro. opp. p. 32; Goldberg, 1960, p. 217, fig. 11; Clifford and Clifford, 1968, p. 250 (no. P 130).

CONDITION NOTES: The original support is medium-weight (12 x 12 threads/cm.) linen. The tacking margins have been removed. The painting is lined with an aged aqueous adhesive and medium-weight linen. An off-white ground has been thinly applied. The paint is in only fair condition. An extensive traction crackle of wide aperture is present in the foreground, associated with the brown shadow tones of the water. The original paint profile varies considerably and has been somewhat flattened by lining. The interstices of the paint are filled with a brown resinous material, which may be toned varnish applied by the artist. A small series of horizontal losses along the top edge suggests damage along an old stretcher member. Ultraviolet light reveals extensive retouches, primarily to the traction crackle in the boat, water, and sky.

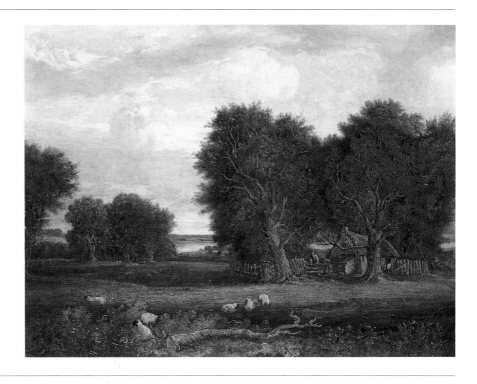

125 ENGLISH SCHOOL,
FORMERLY ATTRIBUTED TO
JOHN CROME

LANDSCAPE, second quarter of the nineteenth century
Oil on canvas, 29¾ x 39¼″ (76 x 100 cm.)
Gift of Mrs. Robert M. Hogue, 43-50-1

This landscape came to the Philadelphia Museum of Art attributed to John
Crome (q.v.). There is nothing here to connect it stylistically with Crome or
any member of the Norwich School.

PROVENANCE: Mrs. Robert M. Hogue.

CONDITION NOTES: The original support
is twill-weave, medium-weight (10 x 10
threads/cm.) linen. The tacking margins have
been removed. The painting is lined with an
aqueous adhesive and medium-weight linen.
An earlier aqueous adhesive lining also has
been retained. A thickly applied, off-white
ground is visible along the cut edges. The
paint is in only fair condition. Traction crackle
of wide aperture extends throughout the
foreground foliage and is consistent with the
darkest brown tones, suggesting the use of
bitumen. Fracture crackle radiates outward
from each corner. Paint losses are evident
around the cottage. The profile of the
brush-marking texture has been flattened by
lining. Retouches are visible in normal and
ultraviolet light in the uncompensated losses
around the cottage and in the traction crackle
in the left foreground.

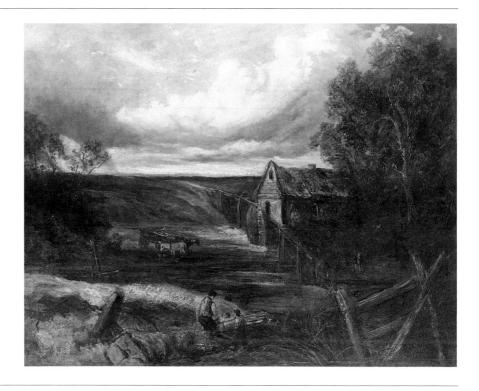

126 ENGLISH SCHOOL,
 FORMERLY ATTRIBUTED TO
 JOHN CONSTABLE

LANDSCAPE: OVERSHOT MILL, nineteenth century
Oil on canvas, 39¾ x 51½″ (101 x 131 cm.)
The William L. Elkins Collection, E24-3-1

PROVENANCE: Elkington, Holland?; William
L. Elkins.

EXHIBITION: Philadelphia, 1928, p. 17.

LITERATURE: Elkins, 1887–1900, vol. 2,
no. 56, repro.; Elkins, 1925, no. 7 (as
"Overshot Mill" by John Constable).

CONDITION NOTES: The original support is
medium-weight (16 x 16 threads/cm.) linen.
The tacking margins have been removed. The
painting is lined with an aged aqueous
adhesive and medium-weight linen. An
extremely thin, white ground is evident along
the cut edges and through areas with little or
no paint. The paint is in fairly good condition.
Much of the original texture of relief has been
flattened by lining, which has also accentuated
the weave texture of the support in areas of
thinnest paint application. Minute flake loss
has occurred overall. Under ultraviolet light,
retouches are restricted to small losses in the
upper-right quadrant.

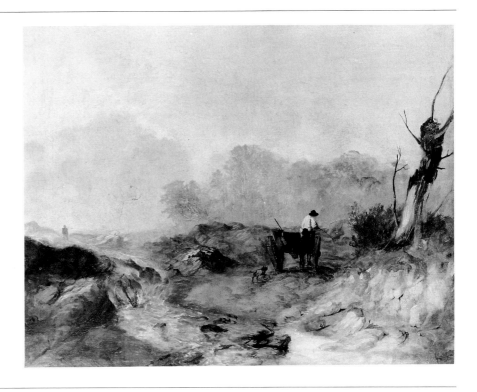

127　ENGLISH SCHOOL,
FORMERLY ATTRIBUTED TO
RICHARD PARKES BONINGTON

LANDSCAPE, nineteenth century
Oil on canvas, 25 x 30″ (63.5 x 76.2 cm.)
Bequest of T. Edward Hanley, 70-76-1

This landscape has in the past been attributed to Richard Parkes Bonington
(1802–1828) but bears no relation to that artist's style or technique.

PROVENANCE: Julius Weitzner, New York;
Mr. and Mrs. T. Edward Hanley.

EXHIBITION: Columbus, Ohio, Columbus
Gallery of Fine Arts, *The Hanley Collection,*
November–December 1968.

CONDITION NOTES: The original support
consists of a single piece of medium-weight
(12 x 12 threads/cm.) linen. The tacking
margins have been removed. A large irregular
tear, now repaired, is evident left of center,
above the stream. The painting is lined with an
aged aqueous adhesive and medium-weight
linen. A white ground is evident through the
thinnest areas of paint and along the cut edges.
The paint is in moderately good condition.
The original profile varies from moderate to
low relief. Washlike glazes of rich vehicular
consistency have been applied over
paste-vehicular mixtures and appear to be
intact. A minor traction crackle is present in
the purest brown tones used overall. Under
ultraviolet light, retouches can be seen to have
been liberally applied over the tear repair and
to numerous small losses and abraded areas in
the sky.

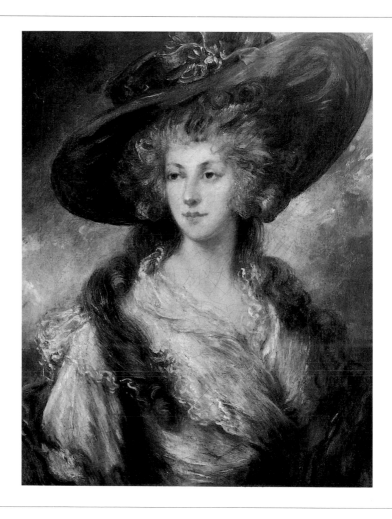

128 ENGLISH SCHOOL,
STYLE OF GAINSBOROUGH

PORTRAIT OF A LADY (LADY CAVENDISH), nineteenth century
Oil on canvas, 30 x 25⅛″ (76.1 x 63.8 cm.)
Walter Lippincott Collection, 23-59-13

This portrait entered the Philadelphia Museum of Art attributed to
Gainsborough's nephew Gainsborough Dupont (1754–1794), but is rather a
late pastiche in the general style of Gainsborough (q.v.).

CONDITION NOTES: The original support is medium-weight (10 x 10 threads/cm.) linen. Stretcher creases are evident on all four sides. The painting has been lined with a wax-resin adhesive and medium-weight linen. A thick white ground is present and extends partially onto the tacking margins. The paint is generally in only fair condition. An irregular net of wide-aperture fracture crackle extends over the surface and is most prominent in the fleshtones of the face and neck. The paint is severely cupped with numerous losses. Under ultraviolet light, local areas of retouches are visible in the figure, in the background, and in a large loss in the upper left-hand corner.

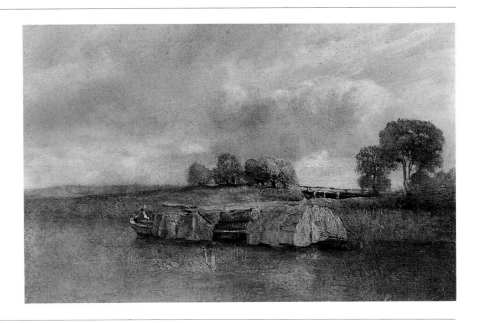

129 ENGLISH SCHOOL,
FORMERLY ATTRIBUTED TO
JOHN SELL COTMAN

RIVER SCENE, nineteenth century
Oil on canvas, 8⅞ x 14″ (22.5 x 35.5 cm.)
The William L. Elkins Collection, E24-3-42

This landscape was attributed to the Norwich artist John Sell Cotman
(1782–1842), but this label has been rejected by both Andrew Hemingway and
Miklós Rajnai. Museum files note a provenance to Frederick Piercy (see no.
112), but this has been impossible to confirm.

INSCRIPTION: *J.S. Cotman RYC* [or *BYC*]
284 N.Y. / 23538 [on the back of the stretcher].

PROVENANCE: Frederick Piercy?; William L.
Elkins.

LITERATURE: Elkins, 1887–1900, vol. 2,
no. 58, repro. (as "Landscape" by John Sell
Cotman); Hinks and Royde-Smith, 1930, p. 155.

CONDITION NOTES: The original support is
medium-weight (10 x 10 threads/cm.) linen.
The tacking margins have been removed. The
painting has been lined with an aqueous
adhesive and medium-weight linen. A white
ground is evident along the cut edges. The
paint is in very good condition. A web of
narrow-aperture fracture crackle with slight
cupping is present and radiates from each
corner. The brush-work profile is varied.

130 ENGLISH SCHOOL,
FORMERLY ATTRIBUTED TO
DAVID COX

SEASCAPE, nineteenth century
Oil on fiberboard, 5⅜ x 9⅝″ (13.6 x 24.4 cm.)
Inscribed lower left: *Cox*
Gift of Joseph K. Eddleman and Mrs. William M. Dunlap, in memory of
Dr. J. S. Ladd Thomas, 74-160-1

This picture entered the Philadelphia Museum of Art ascribed to David Cox
(q.v.), but on stylistic grounds the attribution cannot be sustained. The
signature at the lower left is a later addition.

INSCRIPTION: *Off Flushing / Holland* [on the
reverse].

CONDITION NOTES: The primary support is
pressed fiberboard panel, primed on its reverse
with an oil paint. Numerous small losses and
abrasions are present along the perimeter. A
thick white ground has been applied overall
and is thicker along the edges. The paint is in
only fair condition. There are local flake losses
and active cleavage over most of the surface.
An irregular web of narrow-aperture fracture
crackle with slight, associated cupping has
formed. The paint profile is varied and largely
intact with some flattening of the highest
points of impasto. Under ultraviolet light,
retouches to the damages along the perimeter
can be seen.

WALPOLE, 1771: Horace Walpole. *Anecdotes of Painting in England . . . Collected by the Late Mr. George Vertue*. Vol. 4. London, 1771.

EAR-WIG, 1781: *The Ear-Wig; Or an Old Woman's Remarks on the Present Exhibition of Pictures at the Royal Academy*. London, 1781.

THICKNESSE, 1788: Philip Thicknesse. *A Sketch of the Life and Paintings of Thomas Gainsborough, Esq*. London, 1788.

HODGES, 1790: [William Hodges]. "An Account of Richard Wilson, Esq., Landscape Painter, F.R.A." *The European Magazine and London Review*, vol. 17 (June 1790), pp. 403–5.

IRELAND, 1791: John Ireland. *Hogarth Illustrated*. 2 vols. London, 1791.

BROMLEY, 1793: Henry Bromley. *A Catalogue of Engraved British Portraits*. London, 1793.

FARINGTON DIARY, [1793]: Joseph Farington. *The Diary of Joseph Farington*. [1793–1821]. Edited by Kenneth Garlick and Angus Macintyre (vols. 1–6) and Kathryn Cave (vols. 7–16). 16 vols. New Haven and London, 1978–84. Vol. 1, *July 1793–December 1794*; Vol. 2, *January 1795–August 1796*; Vol. 3, *September 1796–December 1798*; Vol. 4, *January 1799–July 1801*; Vol. 5, *August 1801–March 1803*; Vol. 6, *April 1803–December 1804*; Vol. 7, *January 1805–June 1806*; Vol. 8, *July 1806–December 1807*; Vol. 9, *January 1808–June 1809*; Vol. 10, *July 1809–December 1810*; Vol. 11, *January 1811–June 1812*; Vol. 12, *July 1812–December 1813*; Vol. 13, *January 1814–December 1815*; Vol. 14, *January 1816–December 1817*; Vol. 15, *January 1818–December 1819*; Vol. 16, *January 1820–December 1821*. The MS. of the diary is in the Royal Library, Windsor.

HARINGTON, 1793: Edward Harington. *A Schizzo on the Genius of Man: In Which, Among Various Subjects, the Merit of Mr. Thomas Barker, the Celebrated Young Painter of Bath, Is Particularly Considered, and His Pictures Reviewed*. Bath, 1793.

IRELAND, 1794–99: Samuel Ireland. *Graphic Illustrations of Hogarth from Pictures, Drawings, and Scarce Prints in the Possession of Samuel Ireland*. 2 vols. London, 1794–99.

PASQUIN, 1796: Anthony Pasquin [John Williams]. *Memoirs of the Royal Academicians, Being an Attempt to Improve National Taste*. London, 1796. Reprint, with introduction by R. W. Lightbown. London, 1970.

MALONE, ed., 1797: Edmond Malone, ed. *The Works of Sir Joshua Reynolds, Knt., Late President of the Royal Academy . . .* 2 vols. London, 1797.

RUSSELL, 1797: John Russell. *A Description of the Selenographia: An Apparatus for Exhibiting the Phenomena of the Moon, Together with an Account of Some of the Purposes Which It May Be Applied To*. London, 1797.

IRELAND, 1798: John Ireland. *A Supplement to Hogarth Illustrated; Compiled from His Original Manuscripts, in the Possession of John Ireland*. Vol. 3 of *Hogarth Illustrated*. London, 1798. [containing Hogarth's *Anecdotes of an Artist*].

BARTSCH, 1803–21: Adam Bartsch. *Le Peintre Graveur*. 21 vols. Vienna, 1803–21.

COLLINS, 1805: William Collins. *Memoirs of a Picture*. 2 vols. Vol. 2, *Memoirs of a Painter*. London, 1805.

PILKINGTON, 1805: M. Pilkington. *A Dictionary of Painters from the Revival of the Art to the Present Period*. London, 1805.

BLAGDON, 1806: Francis William Blagdon. *Authentic Memoirs of the Late George Morland . . .* London, 1806.

HASSELL, 1806: J. Hassell. *Memoirs of the Life of the Late George Morland; with Critical and Descriptive Observations on the Whole of His Works Hitherto before the Public*. London, 1806.

DAWE, 1807: George Dawe. *The Life of George Morland, with Remarks on His Works*. London, 1807.

HOARE, ed., 1807: Prince Hoare, ed. *The Artist*, vol. 7 (April 25, 1807). [memorial issue for Opie, with contributions by Benjamin West, James Northcote, Mrs. Inchbald, and Martin Archer Shee].

EDWARDS, 1808: Edward Edwards. *Anecdotes of Painters Who Have Resided or Been Born in England; with Critical Remarks on Their Productions.* London, 1808. Reprint, with introduction by R. W. Lightbown. London, 1970.

NICHOLS AND STEEVENS, 1808–17: John Nichols and George Steevens. *The Genuine Works of William Hogarth.* 3 vols. London, 1808–17.

HAYLEY, 1809: William Hayley. *The Life of George Romney, Esq.* Chichester, 1809.

OPIE, 1809: John Opie. *Lectures on Painting, Delivered at the Royal Academy of Arts: With a Letter on the Proposal for a Public Memorial of the Naval Glory of Great Britain . . . to Which Are Prefixed a Memoir by Mrs. Opie, and Other Accounts of Mr. Opie's Talents and Character.* London, 1809.

LONDON, 1809–10: London, 28 Broad Street. *A Descriptive Catalogue of Pictures, Poetical and Historical Inventions, Painted by William Blake in Water Colours, Being the Ancient Method of Fresco Painting Restored; and Drawings, for Public Inspection, and for Sale by Private Contract,* May 1809–c. June 1810.

PILKINGTON, 1810: M. Pilkington. *A Dictionary of Painters from the Revival of the Art to the Present Period.* 2nd ed., rev. and enl. London, 1810.

ARCHER, ed., 1811: Robert Archer, ed. *Studies and Designs by Richard Wilson, Done at Rome in the Year 1752.* Oxford, 1811.

NORTHCOTE, 1813: James Northcote. *Memoirs of Sir Joshua Reynolds, Knt. . . .* London, 1813.

NORTHCOTE, 1818: James Northcote. *The Life of Sir Joshua Reynolds.* 2nd ed., rev. and enl. 2 vols. in 1. London, 1818.

FARINGTON, 1819: Joseph Farington. *Memoirs of the Life of Sir Joshua Reynolds with Some Observations on His Talents and Character.* London, 1819.

SMITH, 1828: John Thomas Smith. *Nollekens and His Times: Comprehending a Life of That Celebrated Sculptor; and Memoirs of Several Contemporary Artists, from the Time of Roubilliac, Hogarth, and Reynolds, to That of Fuseli, Flaxman, and Blake.* 2 vols. London, 1828.

WALPOLE, 1828: Horace Walpole. *Anecdotes of Painting in England . . . Collected by the Late Mr. George Vertue . . . with Considerable Additions by the Rev. James Dallaway.* [1765–71]. Rev. ed. 5 vols. London, 1828.

ROMNEY, 1830: John Romney. *Memoirs of the Life and Works of George Romney, Including Various Letters, and Testimonies to His Genius . . .* London, 1830.

KNOWLES, 1831: John Knowles. *The Life and Writings of Henry Fuseli, Esq., M.A., R.A.* 3 vols. London, 1831.

WILLIAMS, 1831: D. E. Williams. *The Life and Correspondence of Sir Thomas Lawrence, Knt.* 2 vols. London, 1831.

CUNNINGHAM, 1830–33: Allan Cunningham. *The Lives of the Most Eminent British Painters, Sculptors, and Architects.* 6 vols. London, 1830–33.

CUNNINGHAM, 1832: Allan Cunningham. *The Lives of the Most Eminent British Painters and Sculptors.* 3 vols. New York, 1832.

NICHOLS, 1833: John Bowyer Nichols, ed. *Anecdotes of William Hogarth Written by Himself.* London, 1833. Reprint. London, 1970.

TRUSLER, 1833: John Trusler. *The Works of William Hogarth; In a Series of Engravings; with Descriptions, and a Comment on Their Moral Tendency . . . To Which Are Added, Anecdotes of the Author and His Works, by J. Hogarth and J. Nichols.* [1768]. Rev. ed. 2 vols. London, 1833.

BEECHY, 1835: Henry William Beechy. "Memoir of Sir Joshua Reynolds." In *The Literary Works of Sir Joshua Reynolds, First President of the Royal Academy, to Which Is Prefixed a Memoir of the Author. . . .* 2 vols. London, 1835.

HODGSON AND GRAVES, 1836: Hodgson and Graves. *Engravings from the Works of Sir Joshua Reynolds.* 3 vols. London, 1836.

CUNNINGHAM, 1838: Allan Cunningham. *The Cabinet Gallery of Pictures, Selected from the Splendid Collections of Art, Public and Private, Which Adorn Great Britain.* Vol. 2. London, 1838.

WAAGEN, 1838: G. F. Waagen. *Works of Art and Artists in England.* 3 vols. London, 1838.

PILKINGTON, 1840: Matthew Pilkington. *A General Dictionary of Painters; Containing . . . Twenty-six New Lives of Artists of the British School, by Allan Cunningham*. London, 1840.

BURNEY, 1842: Frances Burney [Madame D'Arblay]. *Diary and Letters of Madame D'Arblay, Edited by Her Niece*. Vol. 2. London, 1842.

LESLIE, 1843: C. R. Leslie. *Memoirs of the Life of John Constable, Esq. R.A., Composed Chiefly of His Letters*. London, 1843.

TURNER, 1848: Dawson Turner. *Sepulchral Reminiscences of a Market Town. . . .* Yarmouth, 1848.

BURNEY, 1854: Frances Burney [Madame D'Arblay]. *Diary and Letters of Madame D'Arblay, Edited by Her Niece*. 7 vols. London, 1854.

WAAGEN, 1854–57: G. F. Waagen. *Treasures of Art in Great Britain*. 3 vols. London, 1854. [with suppl. vol. *Galleries and Cabinets of Art in Great Britain*. London, 1857].

COTTON, 1856: William Cotton. *Sir Joshua Reynolds and His Works*. London, 1856.

FULCHER, 1856: George Williams Fulcher. *Life of Thomas Gainsborough, R.A.* 2nd ed. Edited by E. S. Fulcher. London, 1856.

COTTON, 1857: William Cotton. *A Catalogue of the Portraits Painted by Sir Joshua Reynolds, Knt., P.R.A.: Compiled from His Autograph Memorandum Books, and from Printed Catalogues, &c.* London, 1857.

DAFFORNE, 1859: James Dafforne. "British Artists: Their Style and Character, with Engraved Illustrations. no. XLIV—John Linnell." *The Art Journal*, 1859, pp. 105–7.

RANDOLPH, 1862: Herbert Randolph. *Life of General Sir Robert Wilson . . . from Autobiographical Memoirs, Journals, Narratives, Correspondence, &c.* Vol. 1. London, 1862.

SHUM, 1862: Frederick Shum. "Reminiscences of the Late Thomas Barker: A Paper Read at the Royal Literary and Scientific Institution on Friday April 11th, 1862." *The Bath Chronicle*, April 17, 1862.

GILCHRIST, 1863: Alexander Gilchrist. *Life of William Blake, "Pictor Ignotes," with Selections from His Poems and Other Writings*. 2 vols. London and Cambridge, 1863. [with an annotated catalogue of Blake's paintings and drawings by William Michael Rossetti].

LESLIE AND TAYLOR, 1865: Charles Robert Leslie and Tom Taylor. *Life and Times of Sir Joshua Reynolds, with Notices of Some of His Contemporaries*. 2 vols. London, 1865.

REDGRAVE AND REDGRAVE, 1866: Richard Redgrave and Samuel Redgrave. *A Century of Painters of the English School*. London, 1866. Rev. ed. London, 1947.

COOK, 1869: Dutton Cook. *Art in England: Notes and Studies*. London, 1869.

SOLLY, 1873: Nathaniel Neal Solly. *Memoir of the Life of David Cox, with Selections from His Correspondence and Some Account of His Works*. London, 1873. Reprint. London, 1973.

MAYER, 1876: Joseph Mayer. *Early Exhibitions of Art in Liverpool with Some Notes for a Memoir of George Stubbs, R.A.* Liverpool, 1876.

WOODERSPOON, 1876: John Wooderspoon. *John Crome and His Works*. [1858]. 2nd ed. Norwich, 1876.

THORNBURY, 1877: Walter Thornbury. *The Life of J.M.W. Turner, R.A., Founded on Letters and Papers Furnished by His Friends and Fellow Academicians*. Rev. ed. London and New York, 1877.

REDGRAVE, 1878: Samuel Redgrave. *A Dictionary of Artists of the English School*. London, 1878.

ROGERS, 1878: John Jope Rogers. *Opie and His Works: Being a Catalogue of Seven hundred sixty Pictures by John Opie, R.A., Preceded by a Biographical Sketch*. London and Truro, 1878.

SCOTT, 1878: William Bell Scott. *William Blake: Etchings from His Works*. London, 1878.

CUNNINGHAM, 1879: Allan Cunningham. *The Lives of the Most Eminent British Painters*. Rev. ed., annotated by Mrs. Charles Heaton. 3 vols. London, 1879.

MAYER, 1879: Joseph Mayer. *Memoirs of Thomas Dodd, William Upcott, and George Stubbs, R.A.* Liverpool, 1879.

RAMSAY, 1879: Alexander Ramsay. *History of the Highland and Agricultural Society of Scotland with Notices of Anterior Societies for the Promotion of Agriculture in Scotland.* Edinburgh and London, 1879.

GILCHRIST, 1880: Alexander Gilchrist. *Life of William Blake with Selections from His Poems and Other Writings.* 2nd ed., rev. and enl. London, 1880.

HALL, 1881: William Hall. *A Biography of David Cox with Remarks on His Works and Genius.* Edited by John Thackray Bunce. London, Paris, and New York, 1881.

STEVENSON, 1881: Robert Louis Stevenson. "Some Portraits by Raeburn." In *Virginibus Puerisque and Other Papers.* London, 1881, pp. 219–36.

GOWER, 1882: Ronald Sutherland Gower. *Romney and Lawrence.* London, 1882. [with a catalogue of their exhibited works by Algernon Graves].

PATTISON, 1882: Emilia F. S. Pattison. "Sir Frederick Leighton, P.R.A." In *Modern Artists: A Series of Illustrated Biographies,* edited by F. G. Dumas. London and Paris, 1882.

SMITH, 1883: John Chaloner Smith. *British Mezzotinto Portraits.* 4 vols. London, 1883.

LONDON, 1883–84: London, Grosvenor Gallery. *Exhibition of the Works of Sir Joshua Reynolds, P.R.A., 1883–84.* (by F. G. Stephens).

BEMROSE, 1885: William Bemrose. *The Life and Works of Joseph Wright, A.R.A., Commonly Called "Wright of Derby."* London, 1885.

ANDREW, 1886: William Raeburn Andrew. *Life of Sir Henry Raeburn, R.A.* London and Edinburgh, 1886.

EBERS, 1886: Georg Ebers. *Lorenz Alma Tadema: His Life and Works.* Translated by Mary J. Safford. New York, 1886.

ZIMMERN, 1886: Helen Zimmern. "L. Alma Tadema, Royal Academician: His Life and Work." *The Art Annual for 1886.* London, 1886. [suppl. monograph to *The Art Journal,* 1886].

ELKINS, 1887–1900: *Catalogue of Paintings in the Private Collection of W. L. Elkins.* 2 vols. Philadelphia, 1887–1900.

WALPOLE, 1888: Horace Walpole. *Anecdotes of Painting in England; with Some Account of the Principal Artists . . . with Additions by the Rev. James Dallaway . . . a New Edition Revised, with Additional Notes by Ralph N. Wornum.* Rev. ed. 3 vols. in 2. London, 1888.

BIRMINGHAM, 1890: Birmingham, City of Birmingham Museum and Art Gallery. *Collection of Paintings and a Special Collection of Works by David Cox.* Birmingham, 1890. (introduction by J. Thackray Bunce).

HORNE, 1891: Henry Percy Horne. *An Illustrated Catalogue of Engraved Portraits and Fancy Subjects Painted by Thomas Gainsborough, R.A., Published between 1760 and 1820 and by George Romney, Published between 1770 and 1830, with the Variations of the State of the Plates.* London, 1891.

STORY, 1892: Alfred T. Story. *The Life of John Linnell.* 2 vols. London, 1892.

WILSTACH, 1893: *Catalogue of the W. P. Wilstach Collection, Memorial Hall, Fairmount Park, Philadelphia.* Edited by Carol H. Beck. Philadelphia, 1893.

GAMLIN, 1894: Hilda Gamlin. *George Romney and His Art.* London, 1894.

HAZLITT, 1894: William Hazlitt. *Conversations of James Northcote, R.A.* Edited by Edmund Gosse. London, 1894.

WILLIAMSON, 1894: George C. Williamson. *John Russell, R.A.* London, 1894. (introduction by Ronald Gower). [edition in the library of the Victoria and Albert Museum, London, with MS. notes, additions, letters, illustrations, and photographs, by the artist's great-grandson, Francis H. Webb, c. 1922].

RHYS, 1895: Ernest Rhys. *Sir Frederic Leighton, Bart., P.R.A.: An Illustrated Chronicle.* London, 1895. (introduction by F. G. Stephens).

RICHARDSON, 1895: Ralph Richardson. *George Morland: Painter, London, 1763–1804.* London, 1895.

STEPHENS, 1895: F. G. Stephens, ed. *Laurence Alma Tadema, R.A.: A Sketch of His Life and Work.* London, 1895.

SPIELMANN, 1896: M. H. Spielmann. "Laurence Alma-Tadema, R. A.: A Sketch." *The Magazine of Art,* vol. 20 (1896), pp. 42–50.

BINYON, 1897: Laurence Binyon. *John Crome and John Sell Cotman.* London, 1897.

ROBERTS, 1897: William Roberts. *Memorials of Christie's: A Record of Art Sales from 1766 to 1896.* 2 vols. London, 1897.

WILSTACH, 1897: *Catalogue of the W. P. Wilstach Collection, Memorial Hall, Fairmount Park, Philadelphia.* Suppl. Edited by Carol H. Beck. Philadelphia, 1897.

ARMSTRONG, 1898: Walter Armstrong. *Gainsborough and His Place in English Art.* London and New York, 1898.

GILBEY, 1898: Walter Gilbey. *Life of George Stubbs, R. A.* London, 1898.

GREGO, 1898: Joseph Grego. "The Art Collection at 'Bell-Moor,' The House of Mr. Thomas J. Barratt." *The Magazine of Art,* vol. 22 (1898), pp. 132–39, 189–96, 261–68, 289–94.

NETTLESHIP, 1898: J. T. Nettleship. *George Morland and the Evolution from Him of Some Later Painters.* London, 1898.

RHYS, 1898: Ernest Rhys. *Frederic, Lord Leighton, Late President of the Royal Academy of Arts: An Illustrated Record of His Life and Work.* 2nd ed. London, 1898.

MONKHOUSE, 1899: Cosmo Monkhouse. *British Contemporary Artists.* London, 1899.

TEMPLE LEADER, 1899: John Temple Leader. *Rough and Rambling Notes, Chiefly of My Early Life.* Florence, 1899.

GRAVES AND CRONIN, 1899–1901: Algernon Graves and William Vine Cronin. *A History of the Works of Sir Joshua Reynolds, P. R. A.* 4 vols. London, 1899–1901.

ARMSTRONG, 1900: Walter Armstrong. *Sir Joshua Reynolds, First President of the Royal Academy.* London and New York, 1900.

GILBEY, 1900: Walter Gilbey. *Animal Painters of England from the Year 1650: A Brief History of Their Lives and Works.* Vol. 2. London, 1900.

GOWER, 1900: Ronald Sutherland Gower. *Sir Thomas Lawrence.* London, Paris, and New York, 1900. [with a catalogue of the artist's exhibited and engraved works compiled by Algernon Graves].

WILSTACH, 1900: *Catalogue of the W. P. Wilstach Collection, Memorial Hall, Fairmount Park, Philadelphia.* Edited by Carol H. Beck. Philadelphia, 1900.

ARMSTRONG, 1901: Walter Armstrong. *Sir Henry Raeburn, with an Introduction by R. A. M. Stevenson and a Biographical and Descriptive Catalogue by J. L. Caw.* London and New York, 1901.

BELL, 1901: C. F. Bell. *A List of the Works Contributed to Public Exhibitions by J. M. W. Turner, R. A.* London, 1901.

FLETCHER, ed., 1901: Ernest Fletcher, ed. *Conversations of James Northcote, R. A., with James Ward on Art and Artists.* London, 1901.

ARMSTRONG, 1902: Walter Armstrong. *Turner.* 2 vols. London and New York, 1902.

GOWER, 1902: Ronald Sutherland Gower. *Sir Joshua Reynolds: His Life and Art.* London, 1902.

HOLMES, 1902: C. J. Holmes. *Constable and His Influence on Landscape Painting.* London, 1902.

MAXWELL, 1902: Herbert Maxwell. *George Romney.* New York and London, 1902.

ZIMMERN, 1902: Helen Zimmern. *Sir Lawrence Alma Tadema, R. A.* London, 1902.

BALDRY, 1903: A. L. Baldry. "The Life and Work of David Cox." In *Masters of English Landscape Painting.* London, 1903. [special summer issue of *The Studio,* 1903].

WINDSOR, 1903: Lord Windsor. *John Constable, R. A.* London and New York, 1903.

RUSKIN, 1903–12: John Ruskin. *The Works of John Ruskin.* Edited by E. T. Cook and Alexander Wedderburn. 39 vols. London, 1903–12.

ARMSTRONG, 1904: Walter Armstrong. *Gainsborough and His Place in English Art*. Rev. ed. London, 1904.

CORKRAN, 1904: Alice Corkran. *Frederic Leighton*. London, 1904.

DAWE, 1904: George Dawe. *The Life of George Morland, with an Introduction and Notes by J. J. Foster*. London, 1904.

FRY, 1904: Roger E. Fry. "Three Pictures in Tempera by William Blake." *The Burlington Magazine*, vol. 4, no. 12 (March 1904), pp. 204–11.

GOWER, 1904: Ronald Sutherland Gower. *George Romney*. London, 1904.

PINNINGTON, 1904: Edward Pinnington. *Sir Henry Raeburn, R.A.* London, 1904.

WARD AND ROBERTS, 1904: Humphry Ward and W. Roberts. *Romney: A Biographical and Critical Essay with a Catalogue Raisonné of His Works*. 2 vols. London and New York, 1904.

WILLIAMSON, 1904: George C. Williamson. *George Morland: His Life and Works*. London, 1904.

WILSTACH, 1904: *Catalogue of the W. P. Wilstach Collection, Memorial Hall, Fairmount Park, Philadelphia*. Edited by Carol H. Beck. Philadelphia, 1904.

SCOTS PEERAGE, 1904–14: *The Scots Peerage Founded on Wood's Edition of Sir Robert Douglas's Peerage of Scotland Containing an Historical and Genealogical Account of the Nobility of That Kingdom*. Edited by James Balfour Paul. 9 vols. Edinburgh, 1904–14.

DICKES, 1905: William Frederick Dickes. *The Norwich School of Painting*. London and Norwich, 1905.

STANDING, 1905: Percy Cross Standing. *Sir Lawrence Alma-Tadema, O.M., R.A.* London, Paris, New York, and Melbourne, 1905.

GRAVES, 1905–6: Algernon Graves. *The Royal Academy of Arts: A Complete Dictionary of Contributors and Their Work from Its Foundation in 1796 to 1904*. 8 vols. London, 1905–6.

BARRINGTON, 1906: Mrs. Russell Barrington. *The Life, Letters, and Work of Frederic Leighton*. 2 vols. London and New York, 1906.

LAYARD, ed., 1906: George S. Layard, ed. *Sir Thomas Lawrence's Letter Bag*. London, 1906.

STALEY, 1906: Edgcumbe Staley. *Lord Leighton of Stretton, P.R.A.* London and New York, 1906.

THEOBALD, 1906: Henry Studdy Theobald. *Crome's Etchings: A Catalogue and Appreciation with Some Account of His Paintings*. London, 1906.

WILSTACH, 1906: *Catalogue of the W. P. Wilstach Collection, Memorial Hall, Fairmount Park, Philadelphia*. Edited by Carol H. Beck. Philadelphia, 1906.

DOBSON, 1907: Austin Dobson. *William Hogarth*. [1879]. 2nd ed., rev. London, 1907.

GILBEY AND CUMING, 1907: Walter Gilbey and E. D. Cuming. *George Morland: His Life and Works*. London, 1907.

GRAVES, 1907: Algernon Graves. *The Society of Artists of Great Britain, 1760–1791; The Free Society of Artists, 1761–1783*. London, 1907.

ROBERTS, 1907: William Roberts. *Sir William Beechey, R.A.* London and New York, 1907.

WILLIAMSON, 1907: George C. Williamson. *George Morland: His Life and Works*. London, 1907.

GRAVES, 1908: Algernon Graves. *The British Institution, 1806–1867*. London, 1908.

WILSTACH, 1908: *Catalogue of the W. P. Wilstach Collection, Memorial Hall, Fairmount Park, Philadelphia*. Edited by Carol H. Beck. Philadelphia, 1908.

O'DONOGHUE, 1908–25: Freeman O'Donoghue. *Catalogue of Engraved British Portraits . . . in the British Museum*. 6 vols. London, 1908–25.

FINBERG, 1909: A. J. Finberg. *The National Gallery: A Complete Inventory of the Drawings of the Turner Bequest: With Which Are Included the Twenty-three Drawings Bequeathed by Mr. Henry Vaughan*. 2 vols. London, 1909.

MCKAY AND ROBERTS, 1909: William McKay and William Roberts. *John Hoppner, R.A.* London, 1909.

CHAMBERLAIN, 1910: Arthur B. Chamberlain. *George Romney.* London, 1910.

DIRCKS, 1910: Rudolf Dircks. "The Later Works of Sir Lawrence Alma-Tadema, O.M., R.A., R.W.S." *The Art Journal,* 1910. [special Christmas issue].

ROBERTS, 1910: W[illiam] Roberts. "F. Wheatley, R.A.: His Life and Works; A Catalogue of His Engraved Pictures." *The Connoisseur,* extra number, 1910.

WOODGATE AND WOODGATE, 1910: G. Woodgate and G.M.G. Woodgate. *A History of the Woodgates of Stonewall Park and Summerhill in Kent and Their Connections.* Wisbech, 1910.

COMPLETE PEERAGE, 1910–: G.E.C[ockayne]. *Complete Peerage.* London, 1910–.

EARLAND, 1911: Ada Earland. *John Opie and His Circle.* London, 1911.

GRIEG, 1911: James Grieg. *Sir Henry Raeburn, R.A.: His Life and Works with a Catalogue of His Pictures.* London, 1911.

ARMSTRONG, 1913: Walter Armstrong. *Lawrence.* London, 1913.

COLLIER, 1913: John Collier. "The Art of Alma-Tadema." *The Nineteenth Century and After,* vol. 73 (1913), pp. 597–607.

LAYARD, ed., 1913: George S. Layard, ed. *Sir Thomas Lawrence's Letter-Bag.* London, 1913.

ROBERTS, 1913: William Roberts. "English Pictures in America." *The Nineteenth Century,* September 1913, pp. 534–42.

ST. JOHN HOPE, 1913: St. John Hope. *Windsor Castle: An Architectural History.* Vol. 2. London, 1913.

MCKAY AND ROBERTS, 1914: William McKay and William Roberts. *Supplement and Index to "John Hoppner, R.A."* London, 1914.

WHITLEY, 1915: William T. Whitley. *Thomas Gainsborough.* London and New York, 1915.

MCFADDEN, 1917: "A Group of Paintings in the McFadden Collection." *The American Magazine of Art,* vol. 8, no. 3 (January 1917), pp. 108–12.

NEW YORK, 1917: New York, The Metropolitan Museum of Art. *Catalogue of Portraits and Landscapes of the British School Lent by John H. McFadden,* June–October, 1917 (introduction by Bryson Burroughs).

PITTSBURGH, 1917: Pittsburgh, Carnegie Institute. *Founder's Day Exhibition, Early English Portraits and Landscapes Lent by Mr. John H. McFadden,* April 26–June 15, 1917.

RINDER, ed., 1917: Frank Rinder, ed. *The Royal Scottish Academy, 1826–1916 . . . by W.D. McKay.* Glasgow, 1917.

ROBERTS, 1917: William Roberts. *Catalogue of the Collection of Pictures Formed by John H. McFadden, Esq., of Philadelphia, Pa.* London, 1917.

ROBERTS, 1918, "Additions": William Roberts. "Recent Additions to Mr. McFadden's Collection." *Art in America,* vol. 6, no. 2 (February 1918), pp. 108–17.

ROBERTS, 1918, "Portraits": William Roberts. "The John H. McFadden Collection I.—Portraits." *The Connoisseur,* vol. 52 (November 1918), pp. 125–37.

ROBERTS, 1919: William Roberts. "The John H. McFadden Collection II: Landscape and Subject Pictures." *The Connoisseur,* vol. 53 (January 1919), pp. 5–17.

CUNDALL, 1920: H.M. Cundall. "The Norwich School." *The Studio,* special issue, 1920.

ROBERTS, 1920: William Roberts. *The Sharpe Family: A Conversation Piece by William Hogarth.* London, 1920.

COLLINS BAKER, 1921: C.H. Collins Baker. *Crome.* London, 1921. (introduction by C.J. Holmes).

FINBERG, 1921: Hilda F. Finberg. "Canaletto in England." *The Walpole Society, 1920–1921,* vol. 9 (1921), pp. 21–76.

NORWICH, 1921: Norwich, Norwich Castle Museum. *Centenary Exhibition of Oil Paintings, Water-Colours, Drawings, etc. by John Crome, 1768–1821*, April 1921 (introduction by Laurence Binyon).

SPARROW, 1922: Walter Shaw Sparrow. *British Sporting Artists from Barlow to Herring*. London and New York, 1922.

WILSTACH, 1922: *Catalogue of the W. P. Wilstach Collection, Memorial Hall*. Philadelphia, 1922.

DUBUISSON, 1924: A. Dubuisson. *Richard Parkes Bonington: His Life and Work*. Translated by C. E. Hughes. London, 1924.

ROE, 1924: Frederick Gordon Roe. *David Cox*. London, 1924.

DIBDIN, 1925: E[dward] Rimbault Dibdin. *Raeburn*. London, 1925.

ELKINS, 1925: Philadelphia, Philadelphia Museum of Art. *Catalogue of Paintings in the Elkins Gallery*. Philadelphia, 1925.

GRANT, 1925: Maurice Harold Grant. *A Chronological History of the Old English Landscape Painters (in Oil) from the XVIth Century to the XIXth Century*. 3 vols. Leigh-on-Sea, 1925. Rev. ed. 8 vols. Leigh-on-Sea, 1942.

COMPLETE PEERAGE, 1926: G. E. C[ockayne]. *The Complete Peerage: Or, a History of the House of Lords and All Its Members from the Earliest Times*. Rev. ed., enl. London, 1926.

CONSTABLE, 1927: W. G. Constable. "Canaletto in England: Some Further Works." *The Burlington Magazine*, vol. 50, no. 286 (January 1927), pp. 17–23.

WILSON, 1927: Mona Wilson. *The Life of William Blake*. London, 1927.

PHILADELPHIA, 1928: Philadelphia, Pennsylvania Museum and School of Industrial Art. "The Inaugural Exhibition of the New Museum of Art Fairmount." *The Pennsylvania Museum Bulletin*, vol. 23, no. 119 (March 1928).

SIPLE, 1928: Ella S. Siple. "Art in America: Philadelphia's New Museum." *The Burlington Magazine*, vol. 52, no. 302 (May 1928), pp. 254–56.

WHITLEY, 1928: William T. Whitley. *Artists and Their Friends in England, 1700–1799*. 2 vols. London and Boston, 1928.

WHITLEY, 1928, *1800–1820:* William T. Whitley. *Art in England, 1800–1820*. Cambridge, 1928.

HINKS AND ROYDE-SMITH, 1930: Roger Hinks and Naomi Royde-Smith. *Pictures and People: A Transatlantic Criss-Cross Between Roger Hinks in London and Naomi Royde-Smith (Mrs. Ernest Milton) in New York, Boston, Philadelphia During the Months of January, February, March in the Year 1930*. London, 1930.

SHIRLEY, 1930: Andrew Shirley. *The Published Mezzotints of David Lucas after John Constable, R.A.: A Catalogue and Historical Account*. Oxford, 1930.

WHITLEY, 1930: William T. Whitley. *Art in England, 1821–1837*. New York and Cambridge, 1930.

MOTTRAM, 1931: R. H. Mottram. *John Crome of Norwich*. London, 1931.

SPARROW, 1931: Walter Shaw Sparrow. *A Book of Sporting Painters*. London and New York, 1931.

VERTUE, 1932: George Vertue. "The Note-Books of George Vertue Relating to Artists and Collections in England." *The Walpole Society, 1931–1932* [Vertue Note Books, vol. 2], vol. 20 (1932).

BEACH, 1934: Elise S. Beach. *Thomas Beach: A Dorset Portrait Painter, Favourite Pupil of Sir Joshua Reynolds*. London, 1934.

VERTUE, 1934: George Vertue. "The Note-Books of George Vertue Relating to Artists and Collections in England." *The Walpole Society, 1933–1934* [Vertue Note Books, vol. 3], vol. 22 (1934).

ELKINS, 1935: Henry Clifford. "The George W. Elkins Collection." *The Pennsylvania Museum Bulletin*, vol. 31, no. 168 (November 1935), pp. 2–19.

SPARROW, 1935: Walter Shaw Sparrow. "Ben Marshall's Centenary." *The Connoisseur*, vol. 95 (February 1935), pp. 63–67.

BORENIUS, 1936: Tancred Borenius. *Catalogue of the Pictures and Drawings at Harewood House*. Oxford, 1936.

BENSON, 1937: E. M. Benson. "Problems of Portraiture." *Magazine of Art*, vol. 30 (November 1937), pp. 1–28.

SITWELL, 1936: Sacheverell Sitwell. *Conversation Pieces: A Survey of English Domestic Portraits and Their Painters.* London, 1936.

LESLIE, 1937: C. R. Leslie. *Memoirs of the Life of John Constable, R.A.* Edited by Andrew Shirley. London, 1937.

SITWELL, 1937: Sacheverell Sitwell. *Narrative Pictures: A Survey of English Genre and Its Painters.* London, 1937.

WALPOLE, 1937: Horace Walpole. *Anecdotes of Painting in England; 1760–1795.* Edited by Frederick W. Hilles and Philip B. Daghlian. Vol. 5. New Haven and London, 1937.

FALK, 1938: Bernard Falk. *Turner the Painter: His Hidden Life.* London, 1938.

VAN DOREN, 1938: Carl Van Doren. *Benjamin Franklin.* New York and London, 1938.

WIND, 1938, "Attitudes": Edgar Wind. "Borrowed Attitudes in Reynolds and Hogarth." *Journal of the Warburg Institute,* vol. 2 (1938–39), pp. 182–85.

WIND, 1938, "Charity": Edgar Wind. "Charity: The Case History of a Pattern." *Journal of the Warburg Institute,* vol. 1 (1937–38), pp. 322–30.

WALPOLE, 1939, *Notes:* Hugh Gatty, ed. "Notes by Horace Walpole, Fourth Earl of Orford, on the Exhibitions of the Society of Artists and the Free Society of Artists, 1760–1791." *The Walpole Society, 1938–1939,* vol. 27 (1939), pp. 55–88.

GRIGSON, 1940: Geofrey Grigson. "George Stubbs, 1724–1806." *Signature,* vol. 13 (January 1940), pp. 15–32.

SHIRLEY, 1940: Andrew Shirley. *Bonington.* London, 1940.

WATERHOUSE, 1941: Ellis K. Waterhouse. *Reynolds.* London, 1941.

GILCHRIST, 1942: Alexander Gilchrist. *Life of William Blake.* [1863]. 2nd ed., rev. Edited by Ruthven Todd. London and New York, 1942.

MITCHELL, 1942: Charles Mitchell. "Three Phases of Reynolds's Method." *The Burlington Magazine,* vol. 80, no. 467 (February 1942), pp. 35–40.

MARCEAU, 1944: Henri Marceau. "Paintings from the McIlhenny Collection." *The Philadelphia Museum Bulletin,* vol. 39, no. 200 (January 1944), pp. 54–59.

BOSTON, 1946: Boston, Museum of Fine Arts. *An Exhibition of Paintings, Drawings, and Prints by J.M.W. Turner, John Constable, R. P. Bonington,* March–April 1946.

OPPÉ, 1946: Paul Oppé. "The Memoir of Paul Sandby by His Son." *The Burlington Magazine,* vol. 88, no. 519 (June 1946), pp. 143–47.

ROE, 1946: Frederic Gordon Roe. *Cox the Master: The Life and Art of David Cox, 1783–1859.* Leigh-on-Sea, 1946.

HULTON, 1947: John Hulton. "A Native Painter: Benjamin Wilson, 1721–1788." *Leeds Art Calendar,* vol. 1, no. 2 (fall 1947).

OPPÉ, 1947: A[dolf] P[aul] Oppé. *The Drawings of Paul and Thomas Sandby in the Collection of His Majesty the King at Windsor Castle.* London, 1947.

REDGRAVE AND REDGRAVE, 1947: Richard Redgrave and Samuel Redgrave. *A Century of British Painters.* London, 1947.

BECKETT, 1948: R. B. Beckett. "Famous Hogarths in America." *Art in America,* vol. 36, no. 4 (October 1948), pp. 159–92.

KEY, 1948: Sydney J. Key. *John Constable: His Life and Work.* London, 1948.

SAXL AND WITTKOWER, 1948: Fritz Saxl and Rudolf Wittkower. *British Art and the Mediterranean.* London, New York, and Toronto, 1948.

BECKETT, 1949: R. B. Beckett. *Hogarth.* London, 1949.

CLARE, 1951: Charles Clare. *J.M.W. Turner: His Life and Work.* London, 1951.

FORD, 1951: Brinsley Ford. *The Drawings of Richard Wilson.* London, 1951.

GOLDRING, 1951: Douglas Goldring. *Regency Portrait Painter: The Life of Sir Thomas Lawrence, P.R.A.* London, 1951.

LESLIE, 1951: C. R. Leslie. *Memoirs of the Life of John Constable, Composed Chiefly of His Letters.* Rev. ed. Edited by Jonathan Mayne. London, 1951.

LONDON, 1951: London, Tate Gallery (Arts Council of Great Britain). *William Hogarth, 1697–1764,* June–July 1951 (by R. B. Beckett).

SHIRLEY, 1951: Andrew Shirley. "John Constable's 'Lock': The Newly Discovered Study." *The Connoisseur,* vol. 127 (May 1951), pp. 71–75, 132.

BECKETT, 1952: R. B. Beckett. "Constable's 'Lock.'" *The Burlington Magazine,* vol. 94, no. 594 (September 1952), pp. 252–56.

FORREST, 1952: Ebenezer Forrest. *Hogarth's Peregrination.* Edited by Charles Mitchell. Oxford, 1952.

SIMPSON, 1952: Frank Simpson. "Constable's 'Lock': A Postscript." *The Connoisseur,* vol. 129 (March 1952), p. 39.

CONSTABLE, 1953: W. G. Constable. *Richard Wilson.* London, 1953.

CONSTANTINE, 1953: H. F. Constantine. "Lord Rockingham and Stubbs; Some New Documents." *The Burlington Magazine,* vol. 95, no. 604 (July 1953), pp. 236–39.

WATERHOUSE, 1953: Ellis K. Waterhouse. *Painting in Britain, 1530 to 1790.* London and Baltimore, Maryland, 1953.

WATERHOUSE, 1953, "Gainsborough": Ellis K. Waterhouse. "Preliminary Check List of Portraits by Thomas Gainsborough." *The Walpole Society, 1948–1950,* vol. 33 (1953).

GARLICK, 1954: Kenneth Garlick. *Sir Thomas Lawrence.* London, 1954.

FORD, 1955: Brinsley Ford. "A Portrait Group by Gavin Hamilton with Some Notes on Portraits of Englishmen in Rome." *The Burlington Magazine,* vol. 97, no. 633 (December 1955), pp. 372–78.

COMSTOCK, 1956: Helen Comstock. "Constable in America." *The Connoisseur,* vol. 137 (May 1956), pp. 282–88.

KITSON, 1957: Michael Kitson. "John Constable, 1810–1816: A Chronological Study." *Journal of the Warburg and Courtauld Institutes,* vol. 20 (1957), pp. 338–57.

MCKENDRICK, 1957: Neil McKendrick. "Josiah Wedgwood and George Stubbs." *History Today,* vol. 7, no. 8 (August 1957), pp. 504–14.

SAWYER, 1957–58: Paul Sawyer. "John Rich: A Biographical Sketch." *The Theatre Annual,* vol. 15 (1957–58).

HUDSON, 1958: Derek Hudson. *Sir Joshua Reynolds: A Personal Study.* London, 1958.

LONDON, 1958: London, Thomas Agnew and Sons. *Crome and Cotman,* 1958.

WATERHOUSE, 1958: Ellis K. Waterhouse. *Gainsborough.* London, 1958.

BLUNT, 1959: Anthony Blunt. *The Art of William Blake.* New York and London, 1959.

BOASE, 1959: T.S.R. Boase. *English Art, 1800–1870.* Oxford, 1959.

DAVIES, 1959: Martin Davies. *National Gallery Catalogues: The British School.* 2nd ed., rev. London, 1959.

HAWCROFT, 1959: Francis W. Hawcroft. "Crome and His Patron: Thomas Harvey of Catton." *The Connoisseur,* vol. 144, no. 582 (December 1959), pp. 232–37.

WARK, ed., 1959: Robert R. Wark, ed. *Sir Joshua Reynolds: Discourses on Art.* San Marino, California, 1959.

LABAREE AND WILLCOX, eds., 1959–84: Leonard W. Labaree and William B. Willcox, eds. *The Papers of Benjamin Franklin.* 24 vols. New Haven and London, 1959–84.

GOLDBERG, 1960: Norman L. Goldberg. "Old Crome in America." *The Connoisseur,* vol. 146, no. 589 (November 1960), pp. 214–17.

GOWING, 1960: Lawrence Gowing. *Constable.* London, 1960.

REYNOLDS, 1960: Graham Reynolds. *Catalogue of the Constable Collection in the Victoria and Albert Museum.* London, 1960. Rev. ed., London, 1973.

BECKETT, 1961: R. B. Beckett. "Constable's 'Helmingham Dell.'" *The Art Quarterly,* vol. 24, no. 1 (spring 1961), pp. 2–14.

FINBERG, 1961: A. J. Finberg. *The Life of J.M.W. Turner, R.A.* 2nd ed., rev., with a supplement by Hilda F. Finberg. Oxford, 1961.

MANCHESTER, 1961: Manchester, Whitworth Art Gallery, University of Manchester. *The Norwich School, Loan Exhibition of Works by Crome and Cotman, and Their Followers,* February 10–March 11, 1961 (by Francis W. Hawcroft).

AMAYA, 1962: Mario Amaya. "The Roman World of Alma-Tadema." *Apollo,* n.s., vol. 76 (December 1962), pp. 771–78.

ANTAL, 1962: Frederick Antal. *Hogarth and His Place in European Art.* London and New York, 1962.

FLEMING, 1962: John Fleming. *Robert Adam and His Circle in Edinburgh and Rome.* London, 1962.

NOTTINGHAM, 1962: Nottingham, University Art Gallery. *Landscapes by Thomas Gainsborough,* 1962 (by John Hayes).

SELLERS, 1962: Charles Coleman Sellers. *Benjamin Franklin in Portraiture.* New Haven and London, 1962.

BECKETT, ed., 1962–68: R. B. Beckett, ed. *John Constable's Correspondence.* 6 vols. Ipswich, 1962–68.

BARBIER, 1963: Carl Paul Barbier. *William Gilpin.* Oxford, 1963.

HAYES, 1963: John Hayes. "Gainsborough and Rubens." *Apollo,* n.s., vol. 78 (August 1963), pp. 89–97.

MILLAR, 1963: Oliver Millar. *The Tudor, Stuart, and Early Georgian Pictures in the Collection of Her Majesty the Queen.* 2 vols. London, 1963.

WOODALL, ed., 1963: Mary Woodall, ed. *The Letters of Thomas Gainsborough.* Rev. ed. Bradford, 1963.

CONSTABLE, 1964: W. G. Constable. "'The Lock' as a Theme in the Work of John Constable." In *In Honour of Daryl Lindsay: Essays and Studies,* edited by Franz Philipp and June Stewart. Melbourne, 1964.

GARLICK, 1964: Kenneth Garlick. "A Catalogue of the Paintings, Drawings, and Pastels of Sir Thomas Lawrence." *The Walpole Society, 1962–1964,* vol. 39 (1964), pp. 1–323.

KITSON, 1964: Michael Kitson. *J. M. W. Turner.* London, 1964.

ROTHENSTEIN AND BUTLIN, 1964: John Rothenstein and Martin Butlin. *Turner.* London and Melbourne, 1964.

STEWART, 1964: J. D. Stewart. "Some Drawings by Sir Godfrey Kneller." *The Connoisseur,* vol. 156 (July 1964), pp. 192–98.

CLIFFORD, 1965: Derek Clifford. *Watercolours of the Norwich School.* London, 1965.

HAMILTON, 1965: Elizabeth Hamilton. *The Mordaunts: An Eighteenth-Century Family.* London, 1965.

REYNOLDS, 1965: Graham Reynolds. *Constable: The Natural Painter.* London, 1965. 2nd ed., London, 1976.

WATERHOUSE, 1965: Ellis K. Waterhouse. *Three Decades of British Art, 1740–1770.* Philadelphia, 1965.

GIROUARD, 1966, "Hogarth": Mark Girouard. "Hogarth and His Friends, English Art and the Rococo-II." *Country Life,* January 27, 1966, pp. 188–90.

GIROUARD, 1966, "Slaughter's": Mark Girouard. "Coffee at Slaughter's, English Art and the Rococo-I." *Country Life,* January 13, 1966, pp. 58–61.

HAYES, 1966: John Hayes. "British Patrons and Landscape Painting: 2. Eighteenth-Century Collecting." *Apollo,* n.s., vol. 83 (March 1966), pp. 188–97.

LINDSAY, 1966: Jack Lindsay. *J. M. W. Turner: His Life and Work; A Critical Biography.* London, 1966.

NEW YORK, 1966: New York, The Museum of Modern Art. *Turner: Imagination and Reality,* 1966 (by Lawrence Gowing).

WATERHOUSE, 1966: Ellis K. Waterhouse. *Gainsborough.* 2nd ed. London, 1966.

HARDIE, 1966–68: Martin Hardie. *Water-colour Painting in Britain.* 3 vols. Edited by Dudley Snelgrove with Jonathan Mayne and Basil Taylor. London, 1966–68.

ANDERSON AND SHEA, eds., 1967: Howard Anderson and John S. Shea, eds. *Studies in Criticism and Aesthetics, 1660–1800: Essays in Honor of Samuel Holt Monk.* Minneapolis, 1967.

BALDINI AND MANDEL, 1967: Gabriele Baldini and Gabriele Mandel. *L'opera completa di Hogarth pittore.* Milan, 1967.

JACKSONVILLE, 1967: Jacksonville, Florida, Cummer Gallery of Art, Nashville, Tennessee, Tennessee Fine Arts Center, New Orleans, Louisiana, Isaac Delgado Museum of Art. *Landscapes of the Norwich School, An American Debut,* 1967 (by Norman L. Goldberg).

CLIFFORD AND CLIFFORD, 1968: Derek Clifford and Timothy Clifford. *John Crome.* London, 1968.

DALLETT, 1968: Francis James Dallett. "The Barkers of Bath in America." *Antiques,* vol. 93, no. 5 (May 1968), pp. 652–55.

HOGAN, 1968: Charles Beecher Hogan. *The London Stage, 1660–1800.* Carbondale, Illinois, 1968.

KITSON, 1968: Michael Kitson. "Hogarth's 'Apology for Painters.'" *The Walpole Society, 1966–1968,* vol. 41 (1968), pp. 46–111.

NICOLSON, 1968: Benedict Nicolson. *Joseph Wright of Derby: Painter of Light.* 2 vols. London, 1968.

NORWICH AND LONDON, 1968: Norwich, Norwich Castle Museum, London, Tate Gallery. *John Crome, 1768–1821,* 1968 (by Francis W. Hawcroft).

PHILADELPHIA AND DETROIT, 1968: Philadelphia, Philadelphia Museum of Art, Detroit, The Detroit Institute of Arts. *Romantic Art in Britain: Paintings and Drawings, 1760–1860,* 1968 (by Frederick Cummings, Allen Staley, and Robert Rosenblum).

SUTTON, ed., 1968: Denys Sutton, ed. *An Italian Sketchbook by Richard Wilson, R.A.* 2 vols. London, 1968.

ALDEBURGH AND LONDON, 1969: Aldeburgh, Suffolk, The Festival Gallery, London, Victoria and Albert Museum. *The Prints of George Stubbs,* July–August 1969 (by Basil Taylor).

BENTLEY, ed., 1969: G. E. Bentley, Jr., ed. *Blake Records.* Oxford, 1969.

GAGE, 1969: John Gage. *Colour in Turner: Poetry and Truth.* London, 1969.

MILLAR, 1969: Oliver Millar. *The Later Georgian Pictures in the Collection of Her Majesty the Queen.* 2 vols. London, 1969.

REYNOLDS, 1969: Graham Reynolds. *Turner.* London, 1969.

WASHINGTON, D.C., 1969: Washington, D.C., National Gallery of Art. *John Constable: A Selection of Paintings from the Collection of Mr. and Mrs. Paul Mellon,* 1969 (by Ross Watson and John Walker).

BRIGANTI, 1970: Giuliano Briganti. *The View Painters of Europe.* London, 1970.

CORMACK, 1970: Malcolm Cormack. "The Ledgers of Sir Joshua Reynolds." *The Walpole Society, 1968–1969,* vol. 42 (1970), pp. 105–69.

HAYES, 1970: John Hayes. *The Drawings of Thomas Gainsborough.* 2 vols. London, 1970. New Haven, 1971.

LONDON, 1970: London, The Queen's Gallery, Buckingham Palace. *Gainsborough, Paul Sandby, and Miniature-Painters in the Service of George III and His Family,* 1970 (by Oliver Millar).

PARKER, 1971: Constance-Anne Parker. *Mr. Stubbs: The Horse Painter.* London, 1971.

PAULSON, 1971: Ronald Paulson. *Hogarth: His Life, Art, and Times.* 2 vols. New Haven and London, 1971.

TAYLOR, 1971: Basil Taylor. *Stubbs.* London, 1971.

LONDON, 1971–72: London, Tate Gallery. *Hogarth,* December 2, 1971–February 6, 1972 (by Lawrence Gowing and Ronald Paulson).

EDWARDS, 1972: Ralph Edwards. "The Dumb Rhetoric of the Scenery." *Apollo,* n.s., vol. 95 (January 1972), pp. 14–21.

KENWOOD, 1972: Kenwood, The Iveagh Bequest. *Lady Hamilton in Relation to the Art of Her Time,* July 18–October 16, 1972 (by Patricia Jaffé).

KROENIG, 1972: Wolfgang Kroenig. "Storia di una veduta di Roma." *Bollettino d'Arte*, ser. 5, vol. 57, nos. 3–4 (1972), pp. 165–98.

POWELL, 1972: Nicolas Powell. *Fuseli: The Nightmare*. Art in Context, edited by John Fleming and Hugh Honour. New York, 1972.

WALKER, 1972: Stella A. Walker. *Sporting Art in England, 1700–1900*. London, 1972.

FIRESTONE, 1973: Evan R. Firestone. "John Linnell and the Picture Merchants." *The Connoisseur*, vol. 182 (February 1973), pp. 124–31.

HERRMANN, 1973: Luke Herrmann. *British Landscape Painting of the Eighteenth Century*. London, 1973.

IRWIN, 1973: Francina Irwin. "Early Raeburn Reconsidered." *The Burlington Magazine*, vol. 115, no. 841 (April 1973), pp. 239–44.

STALEY, 1973: Allen Staley. *The Pre-Raphaelite Landscape*. Oxford, 1973.

WATERHOUSE, 1973: Ellis K. Waterhouse. *Reynolds*. London, 1973.

AUCKLAND, 1973–74: Auckland, New Zealand, City Art Gallery. *John Constable: The Natural Painter*, 1973–74 (by Graham Reynolds).

DOHERTY, 1974: Terence Doherty. *The Anatomical Works of George Stubbs*. London, 1974.

LONDON, 1974: London, Hayward Gallery, Leicester, Leicestershire Museum and Art Gallery, Liverpool, Walker Art Gallery (Arts Council of Great Britain). *British Sporting Painting, 1650–1850*, from December 13, 1974 (by Mary Webster, Lionel Lambourne, and Oliver Millar).

LONDON, TATE GALLERY, 1974: London, Tate Gallery. *Stubbs and Wedgwood: Unique Alliance between Artist and Potter*, June 19–August 18, 1974 (by Basil Taylor and Bruce Tattersall).

MALLALIEU, 1974: Huon Mallalieu. *The Norwich School: Crome, Cotman, and Their Followers*. London and New York, 1974.

STALEY, 1974: Allen Staley. "British Painting from Hogarth to Alma-Tadema." *Apollo*, n.s., vol. 100 (July 1974), pp. 34–39.

BENTLEY, ed., 1975: G. E. Bentley, Jr., ed. *William Blake: The Critical Heritage*. London and Boston, 1975.

HAYES, 1975: John Hayes. *Gainsborough: Paintings and Drawings*. London, 1975.

HERRMANN, 1975: Luke Herrmann. *Turner: Paintings, Watercolours, Prints, and Drawings*. London, 1975.

IRWIN AND IRWIN, 1975: David Irwin and Francina Irwin. *Scottish Painters at Home and Abroad, 1700–1900*. London, 1975.

ORMOND, 1975: Leonée Ormond and Richard Ormond. *Lord Leighton*. New Haven and London, 1975.

PAULSON, 1975: Ronald Paulson. *Emblem and Expression: Meaning in English Art of the Eighteenth Century*. London, 1975.

TAYLOR, 1975: Basil Taylor. *Constable: Paintings, Drawings, and Watercolours*. 2nd ed., rev. and enl. London, 1975.

BURKE, 1976: Joseph Burke. *English Art, 1714–1800*. Vol. 9 of *The Oxford History of English Art*. Edited by T.S.R. Boase. Oxford, 1976.

CAMBRIDGE, 1976: Cambridge, Fitzwilliam Museum (Arts Council of Great Britain). *John Constable, R.A., 1776–1837: A Catalogue of Drawings and Watercolours with a Selection of Mezzotints by David Lucas . . . in the Fitzwilliam Museum, Cambridge*, 1976 (by Reg Gadney).

CONSTABLE, 1976: W. G. Constable. *Canaletto: Giovanni Antonio Canal, 1697–1768*. 2nd ed., rev. by J. G. Links. 2 vols. Oxford, 1976.

FRIEDMAN, 1976: Winifred H. Friedman. *Boydell's Shakespeare Gallery*. New York and London, 1976.

JARRETT, 1976: Derek Jarrett. *The Ingenious Mr. Hogarth*. London, 1976.

JOHNSON, 1976: Edward Mead Johnson. *Francis Cotes*. Oxford, 1976.

LONDON, 1976: London, Tate Gallery. *Constable: Paintings, Watercolours, and Drawings*, February 18–April 25, 1976 (by Leslie Parris, Ian Fleming-Williams, and Conal Shields).

BINDMAN, 1977: David Bindman. *Blake as an Artist*. Oxford, 1977.

BUTLIN AND JOLL, 1977: Martin Butlin and Evelyn Joll. *The Paintings of J. M. W. Turner*. 2 vols. New Haven and London, 1977.

EDWARDS, 1977: Ralph Edwards. "Georgian Conversation Pictures." *Apollo*, n.s., vol. 105 (April 1977), pp. 252–61.

EINBERG, 1977: Elizabeth Einberg. "Richard Wilson's Earliest Dated Painting: The Story of a Dreadful Calamity." *The Burlington Magazine*, vol. 119, no. 891 (June 1977), pp. 437–41.

KENWOOD, 1977: Kenwood, The Iveagh Bequest. *Nathaniel Dance, 1735–1811*, June 25–September 4, 1977 (by David Goodreau).

KERSLAKE, 1977: John Kerslake. *National Portrait Gallery: Early Georgian Portraits*. 2 vols. London, 1977.

LINDSAY, 1977: Jack Lindsay. *Hogarth: His Art and His World*. London, 1977. New York, 1979.

SWANSON, 1977: Vern G. Swanson. *Alma-Tadema: The Painter of the Victorian Vision of the Ancient World*. London and New York, 1977.

WILTON, 1977: Andrew Wilton. *British Watercolours, 1750 to 1850*. Oxford, 1977.

WINTER, 1977: David Winter. *George Morland (1763–1804)*. Stanford, California, 1977.

GOLDBERG, 1978: Norman L. Goldberg. *John Crome the Elder*. 2 vols. Oxford, 1978.

LONDON, 1978: London, Tate Gallery. *William Blake*, March 9–May 21, 1978 (by Martin Butlin).

NOAKES, 1978: Aubrey Noakes. *Ben Marshall, 1768–1835*. Leigh-on-Sea, 1978.

PALEY, 1978: Morton D. Paley. *William Blake*. Oxford, 1978.

TREVELYAN, 1978: Raleigh Trevelyan. *A Pre-Raphaelite Circle*. London, 1978.

WATERHOUSE, 1978: Ellis K. Waterhouse. *Painting in Britain, 1530 to 1790*. 4th ed. New York and Middlesex, 1978.

WILSON, 1978: Mona Wilson. *The Life of William Blake*. 4th ed. London, Toronto, Sydney, and New York, 1978.

CORMACK, 1979: Malcolm Cormack. "Anatomy of a Painter." *The Yale Literary Magazine*, vol. 148, no. 2 (September 1979), pp. 45–63.

DAY, 1979: Harold A. E. Day. *The Norwich School of Painters*. Eastbourne, Sussex, 1979.

HEMINGWAY, 1979: Andrew Hemingway. *The Norwich School of Painters, 1803–1833*. Oxford, 1979.

HOOZEE, 1979: Robert Hoozee. *L'Opera completa di Constable*. Milan, 1979.

POINTON, 1979: Marcia Pointon. "Gainsborough and the Landscape of Retirement." *Art History*, vol. 2, no. 4 (December 1979), pp. 441–55.

POTTER, 1979: Beatrix Potter. *The Journal of Beatrix Potter from 1881 to 1897 Transcribed from Her Code Writing by Leslie Linder*. Rev. ed. London and New York, 1979.

WALKER, 1979: John Walker. *John Constable*. London, 1979.

WEBSTER, 1979: Mary Webster. *Hogarth*. London, 1979.

WILTON, 1979: Andrew Wilton. *Constable's "English Landscape Scenery."* London, 1979.

WILTON, 1979, *Turner*: Andrew Wilton. *The Life and Work of J. M. W. Turner*. London, 1979.

LONDON, 1979–80: London, National Portrait Gallery. *Sir Thomas Lawrence, 1769–1830*, November 9, 1979–March 16, 1980 (by Michael Levey).

BARRELL, 1980: John Barrell. *The Dark Side of the Landscape: The Rural Poor in English Painting, 1730–1840*. Cambridge, London, and New York, 1980.

KENWOOD, 1980: Kenwood, The Iveagh Bequest. *Gaspard Dughet Called Gaspar Poussin, 1615–75: A French Landscape Painter in Seventeenth Century Rome and His Influence on British Art*, July 11–September 28, 1980 (by Anne French).

KEYNES, ed., 1980: Geoffrey Keynes, ed. *The Letters of William Blake with Related Documents*. 3rd ed. Oxford, 1980.

LONDON, 1980–81: London, Tate Gallery. *Thomas Gainsborough,* October 8, 1980–January 4, 1981 (by John Hayes).

HASKELL AND PENNY, 1981: Francis Haskell and Nicholas Penny. *Taste and the Antique: The Lure of Classical Sculpture, 1500–1900.* New Haven and London, 1981.

NEW HAVEN, 1981: New Haven, Yale Center for British Art. *Classic Ground: British Artists and the Landscape of Italy, 1740–1830,* July–September, 1981 (by Duncan Bull, Linda Cabe, and Peter Nisbet).

PARIS, 1981: Paris, Grand Palais. *Gainsborough, 1727–1788,* February 6–April 27, 1981 (by John Hayes).

PARRIS, 1981: Leslie Parris. *The Tate Gallery Constable Collection.* London, 1981.

HAYES, 1982: John Hayes. *The Landscape Paintings of Thomas Gainsborough: A Critical Text and Catalogue Raisonné.* 2 vols. London and Ithaca, New York, 1982.

NEW YORK, 1983: New York, The Metropolitan Museum of Art. *Constable's England,* April 16–September 4, 1983.

BUTLIN AND JOLL, 1984: Martin Butlin and Evelyn Joll. *The Paintings of J.M.W. Turner.* Rev. ed. 2 vols. New Haven and London, 1984.

CLEVELAND AND PHILADELPHIA, 1984: Cleveland, The Cleveland Museum of Art, Philadelphia, Philadelphia Museum of Art. *Dreadful Fire! Burning of the Houses of Parliament,* 1984 (by Katherine Solender).

REYNOLDS, 1984: Graham Reynolds. *The Later Paintings and Drawings of John Constable.* 2 vols. New Haven and London, 1984.

LONDON AND NEW HAVEN, 1984–85: London, Tate Gallery, New Haven, Yale Center for British Art. *George Stubbs, 1724–1806,* October 17, 1984–April 7, 1985 (by Judy Egerton).

My greatest debt in preparing this catalogue is to the staff of the Philadelphia Museum of Art, and in particular to Dr. Evan Turner, its former director, who commissioned the project. The research and preparation of the catalogue were made possible by the National Endowment for the Arts.

The catalogue was written in England, not Philadelphia. It was therefore of immeasurable importance that the Curator of European Paintings before 1900 at Philadelphia, Joseph Rishel, patiently coordinated my work with that of the various departments in the Museum, seeing that my questions were dealt with swiftly and thoroughly.

To deal with these departments in turn: to Martha Small and Alice Lefton in the Department of European Paintings I owe thanks for efficiently coping with the secretarial side of the enterprise, for overseeing the typing and proofreading the first draft of the manuscript, and checking many facts for me.

The head of Conservation, Marigene Butler, gave freely of her valuable time to discuss questions of condition and authenticity with me on my visits to the Museum over the last few years; x-radiographs and full condition reports were made by Richard Wolbers when asked for, and the formidable resources of her remarkable staff, in particular of Al Albano, Harriet Irgang, Joe Mikuliak, Laurence Pace, Jean Rosston, and Mark Tucker were placed at my disposal.

In the John G. Johnson Collection Louise Lippincott cleared up a number of questions for me. Barbara Sevy performed the same task in the library.

To George Marcus and especially Jane Watkins I owe the impeccable editing of this book as well as its splendid appearance. No one could wish for more professional or enthusiastic colleagues. Laurence Channing developed the initial scheme for the design of this book. Mark La Rivière did the layout and Charles Field facilitated the production.

Every historian depends on his fellow scholars for their assistance and opinions in their own specialized fields. At the outset, Allen Staley, former Associate Curator of European Paintings in the Philadelphia Museum of Art made available to me his notes on the English paintings. Barbara Bryant worked as a research assistant in preparing bibliographies and checking provenance on a number of paintings, mainly of the nineteenth century. Sir Oliver Millar, Keeper of the Queen's Pictures, was unfailingly helpful and informative, especially with regard to questions relating to Reynolds, Sandby, and Lely. Lucy Oakely must also be singled out for her help with the Marquand correspondence in the Metropolitan Museum of Art. Miklós Rajnai and Andrew Hemingway both gave their opinions on the difficult questions of attribution and connoisseurship presented by our many landscapes of the Norwich School.

My text on Watson Gordon's portrait of Sir Walter Scott could not have been written without the help of Francis Russell at Christie's. Also at Christie's, the librarian, Margaret Christian, answered dozens of questions and gave me the run of the muniment room.

I am especially grateful to the staffs of the British Library, the British Museum Print Room, and the Witt Library.

A comparison between the list of names that follows and the surnames of the eighteenth-century sitters will reveal how cooperative the descendants of those men and women painted by Gainsborough, Raeburn, or Romney have been. I wish to single out for their particular kindness to me Mr. and Mrs. John Miller Adye, Mr. and Mrs. John Brinton, Andrew Fountaine, Christopher Harley, Lady Elizabeth Hamilton, and Baroness Lucas of Crudwell.

Other descendants who answered my questions and provided documents were Mr. and Mrs. B. Babington-Smith, Lord Belhaven and Stenton, Sir William Bunbury, Peter Christie, Robert Compton, Lord Elibank, J.A.G. McCall, Maj. George Pollock-McCall, Lord Rodney, and Crispin Tickell.

To the following people I owe thanks: Donald F. Anderele, Geoffrey Ashton, Melanie Bartlett, Mary Bennett, Adrien Biddell, James D. Boyd, Prof. Kalman H. Burnin, Robin Bush, Eric Chamberlain, Irene Cioffi, Timothy Clifford, Malcolm Cormack, John Cornforth, Anne Crookshank, Sir Francis Dashwood, Bart., Richard Dell, Peter De V. B. Dewar, Sister Monica Edwards, Lord Esher, M. W. Farr, Sarah Faunce, Anne French, James D. Galbraith, Charlotte Gere, The Knight of Glin, Ian Gow, Richard Green, Marion Halford, Hon. James Hamilton, Francis Haskell, John Hayes, Ulrich Hiesinger, John Jackson, Edward Mead Johnson, Evelyn Joll, William Joll, Richard Kingzett, Grace Lane, Mrs. Theo Larsson, Dr. Gilbert Leathart, Richard D. Leppert, Nancy C. Little, Michael Liversidge, Timothy Llewellyn, James Lomax, Edward McParland, P. R. Mann, Joanna Martin, Ellen G. Miles, Leslie March Mitchell, Edward Morris, Andrew W. Moore, Katherine Moore, Helen Neithammer, Lord Newborough, Leonée and Richard Ormond, J. A. Parkinson, Leslie Parris, Mrs. Mary Pearce, Phoebe Pebbles, Nicholas Penny, Jean Radford, Mrs. M. N. Ramsay, Bruce Robinson, Malcolm Rogers, Rev. H. S. Ross, Ted Ruddock, Maj. D.J.W. Sayer, Wendy Shadwell, Frank Simpson, Douglas F. Stewart, J. Douglas Stewart, David Solkin, Marion Spencer, Dorothy Stroud, Duncan Thomson, Veronica Tonge, Lord Torrington, Rev. J. A. Turner, Robert R. Wark, Christopher White, Scott Wilcox, Andrew Wilton, Christopher Wood, and W. G. Wright.

INDEX OF DONORS